THE WILCOX

GUIDE

TO THE FINEST

WATERCOLOR
PAINTS

by Michael Wilcox

The Michael Wilcox
School
of Colour
Artist Quality products created by Artists

SCHOOL OF COLOUR PUBLICATIONS

www.schoolofcolor.com

Acknowledgements

This book is an honest attempt to put right the muddle of centuries. It has only been made possible by the hard work, expertise and dedication of those who have worked with me.

Chris Dorey and Gary Hatcher worked tirelessly to enter the technical detail and carry out the complex task of scanning and adjusting the colour images. Their expertise made the colour reproductions possible. They are as accurate as colour printing will allow.

Anne Gardner researched, contacted and liaised with the watercolour manufacturers to obtain technical information and samples. Her professionalism, encouragement and support during the very difficult preliminary stages for this book is greatly appreciated and made it all possible. Anne was ably assisted by Barbara Roach.

Joy Turner Luke, one of the world's leading experts on artists' paints has given valued support. Her vast knowledge and dedication to her subject, have put my mind at rest on many of the technical aspects of this book.

Peter Jeremiah, Graham Briggs, Julia Dunn and Jenny Jacobs worked long and hard to input very detailed information, best described as a long hard slog.

Jo Holness, Stephen Holnes, Maureen Bonas and Donna Barton organised the sampling of colours and carried out the proof reading, an exacting task.

Desmond Heng, KC Ng and Poh Lin of Imago Productions FE, organised the printing and colour proofing. Every aspect of the production was handled in a most professional way.

First edition.
Research:
Michael Wilcox
Carol Ann Smith
Paul Harris
Lyndel D'Arche
Peggy Lang
Phillipa Nikulinsky
Dawn Wilcox
Denver Wilcox

Technical consultant:
Joy Turner Luke

Page compilation:
Franka Yarrick

This edition.
Research:
Michael Wilcox
Anne Gardner
Barbara Roach
Jo Holness

Technical consultant:
Joy Turner Luke

Colour scanning:
Gary Hatcher
Chris Dorey

Progress manager:
Chris Dorey

Page compilation:
Peter Jeremiah
Graham Briggs
Julia Dunn
Jenny Jacobs
Donna Barton
Maureen Bonas
Stephen Holness

Printed in Singapore through:
Imago Productions (F.E.)

Text, Illustrations and Arrangement, Copyright
The School of Colour Ltd.

First published in 1991.
Reprinted 1993 and 1995.
Updated 1995.
Updated 2000

ISBN USA 0 89134 409 8
ISBN UK 0 89134 409 8

Foreword

This is a landmark book for artists. It contains a surprising amount of information that is not available elsewhere. Equally important, the information is presented in a handsome, easily referenced format. No matter how knowledgeable you are as an artist, you are going to be surprised by some of the facts in this book. It is the first publication to cover the wide range of pigments currently used in artists' watercolours, many of them almost unknown in the art community. In fact, it is the first to completely document the pigments used in any artists' medium.

This book summarizes what is known about these pigments and gives the watercolours that contain each pigment. The major watercolour manufacturers around the world are covered, along with a thumbnail sketch of the individual companies. No matter where you live some of the brands described in the book will be available. Colour reproductions of each watercolour, coupled with a description of its handling qualities, add another essential piece of information. The guidance on colour mixing is a bonus.

It was a herculean task to gather, evaluate and compile this information, and even more difficult to present it in a practical form, as Michael Wilcox has done. When I heard his plan for this book I realized how valuable it would be, but wondered if it would be possible to acquire the necessary information and put it together in one manageable book. It is a great pleasure to see what can be accomplished through courage, determination and skill.

The pigment used in a paint determines how long the colour will last. It is also the most expensive ingredient in a paint, so there is a strong economic incentive for companies to use the less expensive pigments. Sometimes this works to the artist's advantage since the best pigments are not always the most expensive ones, but it can also lead to use of inferior pigments. Knowledge on the part of artists counter balances this pressure. The more knowledgeable you are, the better supplies you will have.

Many books on artists' paints are based on obsolete reference sources. A few recent books contain an accurate pigment section, but do not cover all the pigments in use nor indicate which watercolours contain a particular pigment. In the last 50 years there has been a revolution in both the development of new pigments and their introduction into artists paints. Two engines have driven this revolution, One has been the need to develop pigments for use in automobile paints, where the colour must endure for years in direct sunlight. This market has led to the introduction of families of pigments that surpass in permanence and sometimes in brilliance, many, but certainly not all, traditional artists' pigments. The second impetus for the development of new pigments was not so favourable.

The biggest market for pigments is in the printing industry, where permanence is not a major concern since most printed material is closed away from light in books or magazines.

Taken together these two factors have greatly expanded the number of pigments offered. At the same time, since the art material industry represents a very small part of pigment sales, those traditional pigments not used in other industries are disappearing from the market (even if their names linger on), or are becoming ever more expensive. Another factor affecting art materials is that, with the exception of a few newly formed smaller companies, independent art material companies are also disappearing. Most major companies are now divisions of large corporations, some changing hands several times in the last few years. Corporations are interested in the hobby, craft and school markets because they represent a larger volume of sales than the fine art market.

Because these changes have been taking place in the industrial world they are relatively invisible to artists. Established companies resort to fancy, but meaningless names: or rely on historic but obsolete names, to sell more paints. As Wilcox points out, many manufacturers do not identify the pigments in their watercolours on the container, or in their literature. Even in the case of companies that do identify pigments on the tube, in conformance with the labelling requirements of the American Society for Testing and Materials Specification D 5067 for watercolours, there is still a problem because the Common Name and Colour Index Name for the newer pigments are unfamiliar to artists.

The art teacher and the artist buying paints, have been looking at a giant jigsaw puzzle with most of its pieces missing.

Michael Wilcox has supplied those pieces. This book provides the tools to safeguard your work and to reform the industry. Companies will supply what artist will buy.

Joy Turner Luke

Former Chair, Artist Equity Association Materials Research Committee. Former Chair, American Society for Testing & Materials Subcommittee on Artists' Paints. Former member of U.S. Bureau of Standards Committee on Artists' Paints. Past President Inter-Society Colour Council.

Contents

Foreword .. 3

Introduction 6

Built In Confusion 7

The work of the ASTM Subcommittee 8

 Impermanent Colours 11

About This Book................................ 12

Lightfast Ratings 12

Paint Assessments 13

Overall Assessments 14

Health Information 15

Pigment identification 15

The Colourmen 15

Manufacturers 16

YELLOWS................................... 33

History of Yellow Pigments 34

Modern Yellow Pigments...................... 36

Yellow Watercolours 53

Aureolin .. 55

Cadmium Yellow Light 57

Cadmium Yellow (Medium) 60

Cadmium Yellow Deep....................... 62

Chrome Yellow 65

Gamboge.. 66

Indian Yellow 69

Lemon Yellow 71

Cadmium Yellow Lemon 74

Mars Yellow.................................... 75

Naples Yellow 76

Miscellaneous Yellows 79

ORANGES 91

History of Orange Pigments 92

Modern Orange Pigments 93

Orange Watercolours 101

Cadmium Orange 102

Chrome Orange 105

Miscellaneous Oranges...................... 106

REDS 111

History of Red Pigments 112

Modern Red Pigments 114

Red Watercolours 139

Alizarin Crimson 141

Cadmium Red Light 143

Cadmium Red 145

Cadmium Red Deep 148

Carmine 150

Crimson Lake 153

Madders 155

Rose Madder 157

Quinacridones................................ 159

Scarlet .. 161

Vermilion 163

Miscellaneous Reds 166

VIOLETS 179

History of Violet Pigments 180

Modern Violet Pigments..................... 181

Violet Watercolours 189

Cobalt Violet 190

Magenta 193

Mauves 195

Purples.. 197

Miscellaneous Violets 199

BLUES 209

History of Blue Pigments 210

Modern Blue Pigments 212

Blue Watercolours 219

Cerulean Blue 221

Cobalt Blue 225

Indigo... 229

Manganese Blue 232

Contents

Phthalocyanine Blue 234

Prussian Blue 236

Turquoise .. 239

Ultramarine Blue 241

Miscellaneous Blues 246

GREENS .. 255

History of Green Pigments 256

Modern Green Pigments 258

Green Watercolours 266

Cadmium Green 267

Chrome Green 268

Chromium Oxide Green 268

Cobalt Green 270

Emerald Green 272

Green Earth (Terre Verte) 274

Hookers Green 276

Olive Green 280

Phthalocyanine Green 282

Sap Green ... 285

Viridian .. 288

Miscellaneous Greens 292

BROWNS .. 305

History of Brown Pigments 306

Modern Brown Pigments 308

Brown Watercolours 313

Brown Madder 315

Burnt Sienna 316

Burnt Umber 320

English Red 323

Indian Red .. 324

Light Red .. 326

Ochres ... 327

Raw Sienna 330

Raw Umber 334

Sepia ... 337

Van Dyke Brown 341

Venetian Red 344

Yellow Ochre 345

Miscellaneous Browns 350

GREYS .. 355

History of Grey Pigments 356

Grey Watercolours 357

Davy's Grey 358

Neutral Tint 359

Payne's Grey 361

Miscellaneous Greys 364

BLACKS .. 367

History of Black Pigments 368

Modern Black Pigments 369

Black Watercolours 373

Ivory Black 374

Lamp Black 376

Miscellaneous Blacks 378

WHITES .. 381

History of White Pigments 382

Modern White Pigments 383

White Watercolours 387

Chinese White 388

Titanium White 390

Miscellaneous Whites 391

Blockx Watercolour Paints 393

Index of Colours 397

Our Overall Aim 405

Home Study Courses 406

School of Colour Products 407

Manufacturers Addresses 408

Introduction

The thoughts behind this book came together gradually over many years. Like countless other painters, I have spent many hours wandering around art material shops looking blankly at the wide array of colours on offer. The choice can be bewildering.

Books which offered advice invariably promoted one brand or the other. Conflicting snippets of information about colours which faded, or were in some other way unsuitable, added to the confusion. Much of the manufacturers' literature seemed to be little more than sales hype.

Most fellow painters seemed to stick to a certain brand, often without sound reason, apart from hearsay. I eventually ended up with a mishmash of colours which I hoped would be suitable. I never once purchased with absolute confidence.

One thing was very clear in my mind, I wanted to know more about the materials that I used.

If you feel as I once did, you are not alone. There is enormous confusion amongst artists when it comes to the selection of paints.

My interests turned towards the history of artists' pigments and I spent many years researching this fascinating subject. My search for information showed very clearly that confusion has always existed when it comes to the selection of paints and pigments.

The cave painter probably had the best deal, colouring matter which came to hand was used without a care in the world. Ironically, the materials that they used, coloured earths and soot in the main, have turned out to be the most reliable of pigments.

Artists ever since have been prepared to try any material, from whatever source, in the quest for colours to suit particular needs.

Countless thousands of substances have been tried, from the mundane to the bizarre, with varying degrees of success.

High prices were paid for particularly bright pigments. Prepared colorants became a valuable part of commerce. With human nature being what it is, many substances were adulterated or imitated. False descriptions abounded. The naming of colours added to the confusion, often several substances would have the same title. Poor communication added to the muddle.

This situation existed until the emergence of the colourmen in the mid 1800's. Since then it has become worse! Pigments and paints are still adulterated and imitated, false descriptions still abound and colour names are as misleading and confusing as ever. I say that the situation has become worse, because we do not now have the excuse of poor communication.

When I first started to research this book I had little idea of the actual situation. At one stage I wondered if it were even required. Could one not simply be guided by the available literature?

As work progressed and an overall picture started to emerge, my attitude changed. Keeping in mind always that there are paint manufacturers doing a superb job, it has to be said that, overall, confusion is still the order of the day.

The difference of approach taken by the Colourmen varied dramatically. Some offered samples and information readily, others had to be persuaded, some simply refused.

Attitudes varied from full cooperation and encouragement to the threat of legal action from one of the larger and better known companies. The threat was made in

case I should find myself unable to recommend any of their products. As certain of their watercolours are unreliable and I have said so, I await the reaction.

Being able to select with confidence from the manufacturers' literature, I now know is impossible. Very few companies publish reliable information. The lists of pigments provided vary from being accurate to hopelessly incorrect. One company could only provide hand written notes and another openly admitted to being unsure of the pigments used.

After many years of research and the help of some very talented people I can now go into an art shop and select with confidence. I hope that this book will enable you to do likewise.

Let me quickly add (and stress) that there are, fortunately, producers who put the interest of the artist as a first priority, but they often work at a disadvantage. It has never seemed right to me that expensive materials, of the highest quality, have had to compete with low grade, inexpensive colorants, sold under the same or a very similar name.

Such conscientious manufacturers should be encouraged to the fullest, they are certainly out there.

It is intended to update this book regularly. Manufacturers have been invited to supply information on any changes that they make to their watercolour ranges.

In time, perhaps, we will end up with a much slimmer volume, recording a reduced number of colours, each of a high quality.

All proceeds from the sale of this book will go towards further research.

Michael Wilcox

Built in Confusion

Prior to the emergence of the 'Artists Colourman' during the 1800's, there was incredible confusion, almost chaos, surrounding the naming and make-up of artists' paints and pigments.

This earlier muddle is perhaps understandable, there were countless people preparing pigments and paints, many Guilds intent on keeping formulas and techniques secret and poor communication in general.

Pigment names often changed places with each other, sometimes in a quite random fashion and a particular material often had a variety of names.

Alternatively, several quite different substances might share the one title. Poor quality or adulterated products were sold by dealers and substitutes offered under misleading names.

Since the arrival of the Colourmen, the situation, to my mind, has hardly changed. If anything, it has become worse, not in effect but in manner.

Full advantage has been taken by certain manufacturers of the trust placed in them by the artist.

The vast majority of painters have little understanding of their materials, through teaching methods, (which place little credence on the craft of the artist) and the lack of opportunity to become involved in the practical side of paint making. The information and range of colours is now so confusing that few could ever hope to fully grasp the situation.

Many cling to the belief that the excellence of the work of the earlier masters was in some way due to the materials at their disposal.

Van Dyke Brown	Carmine
Sap Green	Indigo
Caput Mortuum	Dragon's Blood
Stil De Grain	Bitume
Rose Madder	Tyrian Rose

'Tradition', backed by hype will always allow those Colourmen who wish to take advantage, to sell poor materials to the unwary or unknowing artist.

This, unfortunately, has led to the retention of many romantic but nonsensical paint names.

Thus we have a situation whereby many recent and excellent additions to the range are marketed under often quite meaningless names.

The descriptions employed, in many cases, relate to pigments which were either discarded by earlier artists as being unreliable or tolerated by them as they had little alternative.

But the names do sound nice and reassuring. If the information provided by the Colourman is also well packaged, and every effort made to convince of the highest integrity and tradition, few will notice the emptiness behind certain product descriptions.

The work of the ASTM Sub Committee

The remarks on the previous page do not, of course, apply to all colourmen. There are those who have the interests of the artist as a first priority, but few have resisted the temptation to hard sell tradition, or rather, our *concept* of tradition.

Another temptation hard to overcome is the ease with which pigments can be adulterated or imitated.

Many of todays' pigments are particularly powerful and *require* a certain amount of 'letting down' with an inert filler. When it comes to an expensive pigment, the choice is often to unnecessarily adulterate it, (particularly if little change is caused to the colour), or to approximate the colour with cheaper materials and retain the name of the more expensive.

My research has led me to believe that there have been and still are, too few honest or competent manufacturers.

In an effort to obtain a share of the market, paint manufacturers in general have caused a lot of unnecessary confusion, they offer many quite useless colours and simple mixes and are often guilty of being less than straightforward. In the naming of colours there is a definite advantage in misleading the artist, and it has been all too easy.

Much of this is understandable, there have, unfortunately, been too few areas of common understanding in product description and labelling.

The ASTM Standards

In 1977, Artists Equity Association, a major organisation representing American visual artists, together with certain manufacturers approached the American Society of Testing and Materials (ASTM), with a view to developing new standards.

Other manufacturers were informed of the proposals and some contributed, others have joined since the completion of the main work.

Subcommittee D01.57 of the ASTM was formed. It consisted of representatives of artists organisations, manufacturers and independent technical experts.

The New Standards

New standards have been written and published which are of particular importance to the artist.

New and explicit labelling requirements are described, covering the *Common* name of the pigment, the *Colour Index Name* and other pertinent information that will identify the materials used.

Also covered are the requirements for lightfastness.

Of particular value is a list of pigments which have passed stringent lightfastness tests.

Only pigments that are rated as being in:

Category I *(excellent lightfastness)* or

Category II *(very good lightfastness)*

are included on this list of approved pigments.

Manufacturers, artists, retailers, and wholesalers are, through this specification, provided with a basis for common understanding as to nomenclature, performance and composition of artist's watercolours.

As far as the artist is concerned, all manufacturers labelling their products as conforming to ASTM D 5067 are offering paint that has been formed to meet the very exacting standards of the ASTM Subcommittee. Further, the paint will be accurately named and the ingredients fully disclosed.

not in any way do is restrict our choice. There will still be variation in manufacturing processes which will give paints produced by the different colourmen subtleties of chemical and physical make-up. We will still have every reason to prefer one brand over another, or one particular colour over alternatives.

Effects of the New Labelling

The standards written by the ASTM subcommittee, will, it seems certain, eliminate a lot of the nonsense as far as the labelling of artists paints is concerned.

Although still few, there are sufficient manufacturers, at the time of writing, adopting the ASTM standards to make a significant difference to the way in which we decide between one product and another.

This new approach to labelling encompasses the following:

Common Name

This will identify the established and commonly used name of the principal pigment, for example:

> CADMIUM YELLOW

Hue Name

If a manufacturer wishes to use substitute pigments in order to *imitate* the colour of the *Common Name*, then the word *Hue* must be added in the same size letters as the name of the pigment being simulated.

If for example, Arylide Yellow G was being used in a paint to give a colour which closely resembled *genuine* Cadmium Yellow, then the main name on the tube would read:

> CADMIUM YELLOW HUE

The work of the ASTM Sub Committee

Under this name would appear the common name for the pigment being used, in this case:

> CADMIUM YELLOW HUE
> ARYLIDE YELLOW G

This secondary name, which in this case is the one to take notice of, must be in letters which are no smaller than the next size of print down.

Trade Names

Where neither the *Common* nor the *Hue* name appears, but a *Trade Name* is given in their place, for example:

> SMITHS YELLOW

The dominant pigment used must be identified clearly, directly under the *Trade Name*. In letters no smaller than the next size print down, must appear the *Common Name* for the actual pigment used.
In this case it might be:

> SMITHS YELLOW
> ARYLIDE YELLOW G

Added to these three categories: *Common Name, Hue Name* and *Trade* (or propriety name), there is another; the *Mixed Pigments Name*.

Mixed Pigments

In the case of a paint containing a mixture of two or more pigments, the ASTM ruling is that all ingredients must be on the suitable pigments list. Furthermore, the lightfastness rating given on the tube must be that of the contributing pigment with the *lowest* lightfastness rating.

If, for example, a mixed green was composed of Arylide Yellow G and Prussian Blue, the label might read:

> PERMANENT GREEN
> ARYLIDE YELLOW 10G
> AND PRUSSIAN BLUE
> LIGHTFASTNESS II

The Arylide Yellow 10G has been given a lightfastness rating of II and Prussian Blue is rated I , on the list of suitable pigments. The rating for the mixed colour is therefore II, that of the Arylide Yellow 10G.

Colour Index Names

As a further means of identifying the pigment used in a paint, the Colour Index Name will be printed, probably on the back of the tube. This is a particularly vital part of the new labelling. It will identify very precisely the pigments used, in a way that no Common or Trade Name could.

The Colour Index Names are a type of international shorthand for identifying colorants. The name consists of three parts:

1) The category and type of dye or pigment.
2) General hue.
3) Assigned number.

For example: Cadmium Yellow Light is, *Pigment Yellow 35.*

The word *Pigment* identifies the type of colorant, *Yellow* the hue and *35* the assigned number. This may be further abbreviated to *PY 35.*

Other examples:

Cobalt Blue is *Pigment Blue 28* or *PB28.* Viridian is *Pigment Green 18,* or *PG18.*

The main abbreviations used for Colour Index Names are:

PY	Pigment Yellow
PO	Pigment Orange
PR	Pigment Red
PV	Pigment Violet
PB	Pigment Blue
PG	Pigment Green
PBr	Pigment Brown
PBk	Pigment Black
PW	Pigment White
NR	Natural Red

and so on.

The Colour Index Numbers

You may also find a five digit number in the literature. This number identifies, very precisely, the chemical composition of the colouring. There is no obligation to print this number on the product.

You should be aware of its existence as it often appears in manufacturers literature.

As examples:

Cadmium Yellow Light (PY35) has as its Colour Index Number, **77205**

Phthalocyanine Blue (PB 15) is **74160**

Chemical Description

A simple chemical description of the dominant pigment may also be included on the label, this is not mandatory as far as ASTM D4302 is concerned.

The Standard does encourage the inclusion of this further description, where space on the label allows.

Examples:

Aureolin, would be further described as:

Potassium Cobaltnitrite

Cobalt Blue:

Oxides of Cobalt and Aluminum

The work of the ASTM Sub Committee

Lightfastness

The ASTM Standards apply only to *Artists' Quality* paints. It has at last been recognised as a contradiction in terms to have a fugitive colour described as an Artists' Quality. Only pigments found to have a lightfastness rating of **I** (Excellent Lightfastness), or **II** (Very Good lightfastness), are to be used in paints conforming to ASTM requirements.

The word Lightfastness followed by the appropriate rating will be given. For example:

Lightfastness II

Toxicity

If applicable, a warning and safe handling statement will be printed on the label. This information will be more explicit and more carefully researched than ever before. A statement to the effect that the health labelling is certified by 'The Arts and Craft Materials Institute' will be carried .

If, however, the product has been found to be safe (based on current knowledge) by an approved toxicologist, it will carry the seal of The Art and Craft Materials Institute, which will declare it to be *Non-Toxic*.

Statement of Conformance

The wording will be similar to:

Conforms to the Quality and Health Requirements of ASTM Standard D 5067 and D 4236.

The Significance of the New Labelling

From the manufacturer's point of view, the work of the ASTM subcommittee will lead to fairer competition and a rationalisation of nomenclature. It will certainly be of benefit to those companies producing a quality product.

It has never seemed right that expensive materials, of the highest quality, have had to compete with low grade inexpensive colorants, sold under the same or a very similar name.

As for the consumer, the ASTM Standards are like a breath of fresh air. Not only will we be able to know exactly what we are buying, but we can be certain that the product has passed many very stringent tests. Paints conforming to ASTM D 5067 will have met exacting standards of composition, performance and labelling.

A paint made with pigments included in the *Suitable Pigments List* of that standard, will fully justify being described as *Artist Quality*.

There will be long term benefits to be enjoyed by the discerning artist. As, hopefully, more and more manufacturers become involved, we shall see the removal of many of the poor pigments from paint ranges.

At the time of writing there are still many fugitive and otherwise worthless pigments, being made up into paint described as being of 'Artists' Quality'.

With an unravelling of the incredible muddle that we are slowly emerging from, will come a new awareness of materials and hopefully a return of artists also wishing to understand their craft.

ASTM Subcommittee DO1.57 Artists' Paints

The members of the Committee are owed a debt by artists that will probably take a long time to be realised.

Their work and that of others before them, is leading to the most important breakthrough in the history of the materials of the artist.

Special mention should be made of the immediate past Chairperson of the Subcommittee, Mrs. Joy Turner Luke. Joy has put in an enormous effort over many years, so that you, the artist, can purchase and use your materials with confidence.

If the art world needs a heroine, it need look no further.

The immense workload has now been taken over by Mr. Mark Gottsegen, another person with a genuine interest in the needs of the artist. Mark works long, hard, unpaid hours for your benefit.

Mention must also be made of the invaluable work of Henry Levison. Henry undertook the immense task of testing the majority of the pigments for the standards. He worked largely at his own expense.

Behind the scenes there has been a lot going on.

Many artists, by their very nature, shy away from details, facts and figures. I can fully sympathise with this.

However, a glance through the pages of this book will convince most that coming to terms with the new labelling will be more than worth the effort.

It should not be thought for one moment that the Standards apply only to North American paints and artists. Manufacturers from around the world have become fully involved.

The new Standards will only become fully effective if artists make sure that manufacturers have an incentive to become involved. *That incentive will be linked directly to sales.*

See the opportunity for what it is and do not let it slip away.

Impermanent Colours

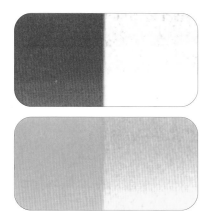

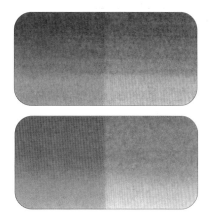

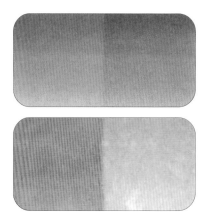

Countless paintings have been ruined because unreliable paints have been employed. This need no longer happen.

In the majority of cases the artist will not have realised the limitations of his or her materials.

It is not only the cheaper ranges that are at fault. Many 'Artist Quality' paints are also unreliable.

The usual reason given for the inclusion of impermanent colours in a particular range is 'demand'. To quote one leading manufacturer:

'We do not put ourselves in the position of dictating to artists what materials to use and if there is a demand for particular impermanent colours we will continue to supply'.

This is all very noble and suggests the existence of a core of artists who demand certain colours despite having full knowledge of the way in which they will deteriorate.

Can there really be painters with such refined tastes as to insist on using a particular colour, with the full knowledge that it will have the shortest of lives?

It all has a delicious air of decadence about it, *particularly when virtually all impermanent colours have a reliable alternative or are very easily matched through mixing.*

In truth, such artists would be hard to find. Impermanent colours are in 'demand' because many of the purchasers are not well informed. They are not well informed because of the very sophisticated smoke screen that has been thrown up by colourmen over the centuries.

During the course of a year I give many seminars and talks to artists. Of the many thousands of painters that I have spoken to I have yet to find one who is not horrified by the way many of the fugitive colours deteriorate.

The word 'demand' can have several meanings. Such colours are in 'demand' because they can be sold.

There is of course a place in art for short lived materials and colours, as there is a place for everything. If you are looking for such paints in watercolour then I have identified them for you.

My real interest however, is towards those whose work has more of a purpose.

In time it will be realised that the artist has a most valuable place in society. That place, I feel, is to help in the interpretation of the world for others. It will indeed be tragic if much of the work of our generation should be unavailable, through deterioration, for the future.

About This Book

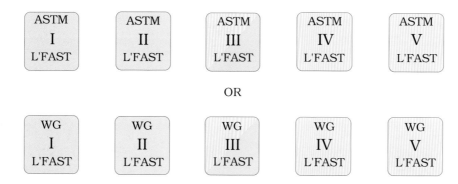

Lightfastness

Impermanence is not just to do with fastness to light. Certain colours are damaged by weak acids, alkalis and impurities in the atmosphere. Such weaknesses have been noted in the sections on modern pigments.

Exposure to light is the major concern as it can cause change over a wide selection of hues. Watercolours are at most risk as they do not have the protection of the binder enjoyed by pigments bound in oil or acrylic.

Many pigments are reasonably lightfast at full strength but fade when in a tint.

Watercolours, of course, are usually applied in thin films. This exposes the pigment to increased radiation and leads to damage to the colour.

These factors put watercolours at the forefront where damage from light is a concern.

Lightfast Ratings

Wherever possible I have used the results of ASTM testing when giving lightfast ratings. The testing procedures are very exacting and the findings are reliable.

The descriptions that I have used are:

ASTM I Excellent lightfastness.

ASTM II Very good lightfastness.

ASTM III Not sufficiently lightfast to be used in paints conforming to the specification. Such colours can fade rather badly, particularly the tints.

ASTM IV Pigments falling into this category will fade rapidly.

ASTM V Pigments will bleach very quickly.

Where the pigment has not been tested as a watercolour, I have given a WG, (Wilcox Guide) rating. Wherever possible this rating is backed up by the results of ASTM testing in other media. Very occasionally a pigment is rated which has not been subjected to any recognised testing for which I have results. In almost every case the pigment has clearly indicated its reliability.

In every instance the rating is based as far as possible on the known performance of the pigment. It is very difficult to be absolutely exact in some cases and I have always erred on the conservative side.

In-house Testing

Every pigment discussed has been subjected to our own controlled lightfast testing. Every manufactured colour has also been tested. Although carefully controlled, these tests have been carried out **only** to confirm the results of previous testing. If, for example, I point out that the blue and yellow in a particular green will fade, I will have first tested both the blue and the yellow individually to confirm previous finding. The resulting green was also exposed so that the actual changes could be discussed.

I wish to make it very clear that I have offered the lightfast ratings only after careful and thorough research of all available information. More work needs to be done in this area.

Paint Assessments

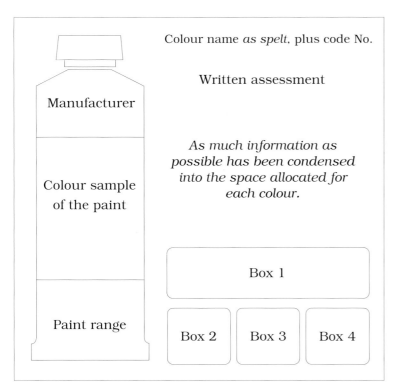

Colour name *as spelt*, plus code No.

Written assessment

As much information as possible has been condensed into the space allocated for each colour.

Box 1

Box 2 Box 3 Box 4

Manufacturer

Colour sample of the paint

Paint range

Additional printing inks were used in the production of this book and every care taken to match the manufacturers colour. It must be borne in mind however that printed colours can never quite match the actual paint.

Box 3 cont.

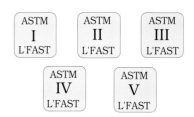

The above are my own assessments offered where a pigment has not been subjected to ASTM testing.

Box 4

The ratings given here are based on several factors:

1. The reliability of the pigment.

2. The suitability of the pigment for the particular hue.

3. The qualities of the paint: how it brushed out, whether it was over bound with gum etc.

The ratings, *which are based purely on my own assessments,* are:

Box 1

PY1 ARYLIDE YELLOW ASTM IV (37)

The **Colour Index Name** (PY1) and **Common Name** (ARYLIDE YELLOW) are given, together with the **Lightfast Rating** (ASTM IV) and **Page Number** (37) for further reference.

Box 3

The overall lightfastness rating is given here. The lightfastness category is that of the least reliable pigment. If a paint contained, say, four pigments and three were lightfast I (excellent) and one was lightfast III (unsatisfactory) the entire paint would be classified as lightfastness III. The single unreliable pigment will tend to spoil the colour as it deteriorates.

Box 2

In previous editions this box was used to identify any health warnings or 'non toxic' labelling. Now that virtually all labels carry this information I will turn my attention to the ease with which the pigments can be identified. The box to the left above is 'as it should be', in the centre, 'not good enough', to the right 'most definitely not good enough'.

 An excellent all-round watercolour paint, highly recommended.

 Has slight imperfections but is otherwise a perfectly good watercolour, recommended.

 This paint has serious drawbacks for artistic use.

 Most unsuitable for artistic use.

 An assessment could not be given for one reason or another.

Overall Assessments

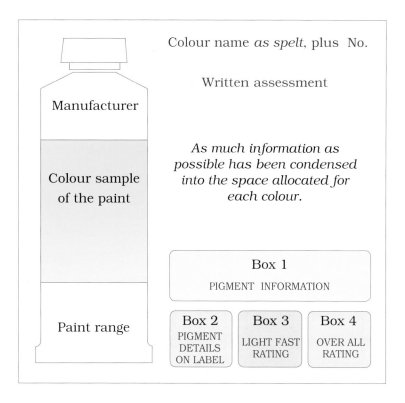

I should like to make the following absolutely clear: The information on the pigments used, (given in box 1) was supplied by the manufacturers. Every possible effort was made to ensure accuracy. Much of the detail was provided in a very confusing manner, with many changes and corrections being made at the last moment. Whereas I feel that the final information is as accurate as possible, I cannot be absolutely certain in every case. The lightfast ratings (box 3) are as accurate as existing information allows. W.G. Ratings are my own assessment and should be treated as such.

The ratings in Box 4 are my own assessment and are offered as guidance only. I have tried to keep personal preferences to one side by always seeking the opinions of others.

My written assessments of the paints are necessarily subjective and should be regarded as such.

Where a paint has been described as gummy or over bound, the opinion of others was always sought for confirmation.

Every attempt has been made to ensure fairness to both manufacturer and consumer. In the main, tubed paints were supplied and examined.

Several companies also produce their colours in pan form.

In just about every case the same pigments are used in the pans as in the tubes.

The main difference between the two generally lies in the make-up of the binder.

Some pigments are naturally difficult to use in watercolour paints. This is due to the very nature of the colorant.

It may well be the case that a manufacturer resists adding thickeners or extenders so that such differences are a feature of the particular colour.

I can only point out the characteristics of the paint as I see them. If an artist wishes to use very gummy paints, for example, I have identified them.

Health Information

Relatively few watercolours warrant health warnings as little or no hazard is presented when they are used in a normal and sensible way.

The possible dangers occur when the colours are applied with an airbrush, allowed onto food or ingested in some other way.

Seals and statements to cover all aspects of health labelling are now in much wider use.

Different systems operate in the USA and Europe.

As the situation has improved I will no longer identify colours which are correctly labelled in this respect.

Pigment identification

Just a few years ago it was very difficult to identify the pigments used in a particular paint.

Some manufacturers gave no indication whatsoever of the pigments that they had employed, other provided literature which was supposedly available within each art store.

I cannot speak for others but I always found it difficult if not impossible to obtain such literature.

The usual explanation was that it had not been provided or had all been given out already. The situation has now changed for the better, with the majority of manufacturers giving such detail on the tube or pan label. Artists have come to look for such information.

The detail is not always easy to read, as the smallest possible typeface is often used, but at least it is there.

Where a manufacturer has declined to offer such information, in an easily accessible form, I would suggest that you purchase with caution, if at all.

The very poor practice of printing complex chemical formulations instead of the *Colour Index Name* just adds to the confusion. Maybe its meant to!

The Colourmen

I have been very direct about some of the practices of certain of the Colourmen or paint manufacturers. Most, if not all, have come in for criticism one way or the other.

This has come about, in part, due to practices which have been handed down over the years. I have been direct because I feel that, although major changes have been made, many more are required and required urgently.

It must be borne in mind however, that this book has only been made possible because of the vital assisstance that has been given by the majority of manufacturers.

Most of the participating companies supplied a full range of product samples and compre-

hensive technical information.

I hope that this book will be seen as an attempt to help rationalise the situation as it exists and to encourage a new spirit of openness.

The paint manufacturers have played their part in this new approach and I thank them for it.

Da Vinci (USA)

Da Vinci Co. is a family owned and operated manufacturer of artists' colours, mediums and varnishes. The company was founded in California in 1975. Experience in artists' paint manufacturing dates back some 60 years to work in Northern Italy.

A limited range of excellent watercolours are sold under the description 'First Quality'.

The recently introduced 'Scuola' 2nd range is less expensive but not such good value for money in my opinion. Quality pigments but generally with a rather gummy consistency. I feel sure that this problem will be sorted out quickly.

DVP tubes are of a generous size and are well made. A large cap, together with a strong neck and shoulders on the tube make for easier removal of a stuck cap. The labelling is very good. The Colour Index Number, ingredients, and binder are given. Health information is also provided.

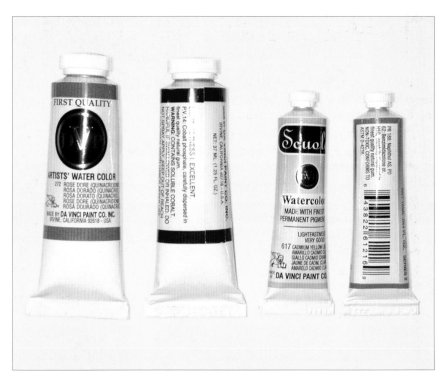

'First Quality' range available in 37ml 'Studio" size tubes.
The Scuola range is presented in 16 ml tubes.

Grumbacher (USA)

I cannot give details of the history of the company as our requests for information were not responded to. Samples were provided but little else. I do not accept responsibility if I have made any mistakes in the description of their products.

Two watercolour ranges are produced :

'Finest Artist Watercolours' and 'Academy Watercolours'.

The label design has recently been improved and gives full details of the pigments used. The printing is so small on the Artists' Quality label that many will have difficulty in reading it. There is space available for clearer detail.

The earlier 16ml Artists' Quality tubes seem to have been replaced by 5ml. I say 'seem' because no information was given.

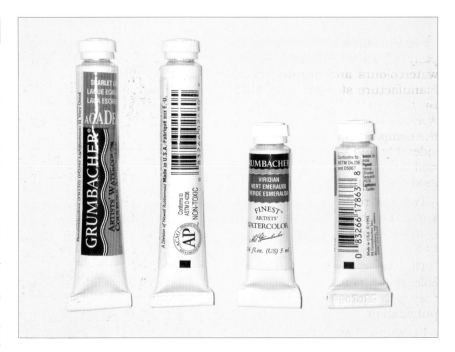

The main catalogue gives good examples of the colours and, most importantly, full Colour Index Names and Numbers in the technical section.

The 'Artist Quality are available in tubes of 5ml as shown here.
'Academy' watercolours are in tubes of 7.4ml. At left.

Art Spectrum (Australia)

I am afraid that I do not have any information on the history or philosophy of this company.

Art Spectrum are featured for the first time. Full samples and cooperation were provided.

The tubes are well produced and labelled. A large cap, together with a strong neck and shoulders to the tube make for easier removal of a stuck cap.

The labels are very clear and carry full information.

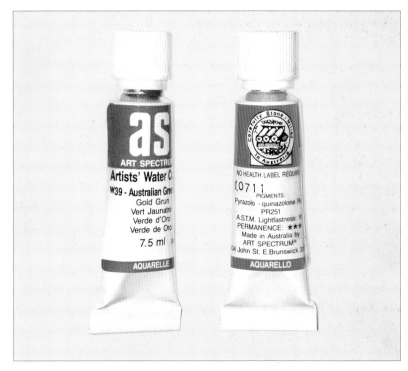

Available in 7.5 ml tubes

Royal Talens (Holland)

Martin Talens started the company in 1899 with a range of watercolours and drawing inks. Manufacture started at his villa in the quiet Dutch town of Apeldoorn. Four generations later the company has expanded considerably and production is carried out in a well equipped, very modern colour works.

Two watercolour ranges are offered. Rembrandt are the 'Artist Quality' range and are available in 80 tube colours.

The Van Gogh range offers 40 colours. Pans are also available, they were not examined for this publication.

Packaging has been very much improved with clear information being provided on the label of both ranges. A new 2nd range has been introduced under the name 'Van Gogh. These have replaced the 'Talens Watercolours'

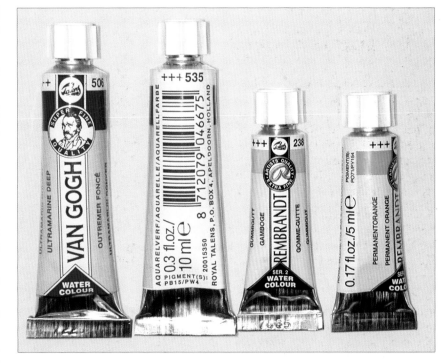

Although now phased out, I have included details of the earlier range as many will still have samples in use.

The 'Rembrandt' range is avalable in 5ml tubes. Certain colours are also in 17ml tubes. The 'Van Gogh' range is in 10ml tubes.

17

Blockx (Belgium)

Founded in the 1860's by Jacques Blockx. A chemist by profession, he was persuaded by his many artist friends to produce a range of paints comparable to earlier products.

Traditional Blockx tube watercolours have a high honey and glycerine content. This, it is claimed, assists with the creation of free flowing washes and interesting colour mixing effects.

The drawback to this approach is that the paint does not dry out when applied at all heavily. Blockx report that whilst sales of the 'moist' watercolours are buoyant in France, they sell less well in other countries.

To overcome consumer resistance, an alternative tube formula has recently been introduced. The 'moist' colours have a black cap, the new formula (which behaves like other watercolours) has a white cap. You now have a choice not offered by any other manufacturer.

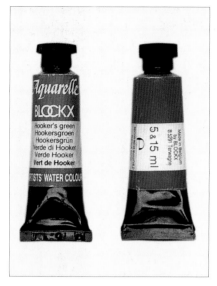

Available in 5 and 15 ml tubes. Also in pans using same pigments.

Blockx have been particularly helpful in the past, supplying samples and full information. Their literature gives a good colour example of each paint, but is limited in pigment description.

Colour Index names and numbers are not given. Vague descriptions such as 'Azo pigment' find their way in amongst the more accurate nomenclature.

Lightfast ratings are not given by the company. They state : *'We do not, and never have done, prepare transient or unstable shades. A classification by degree of stability would therefore be out of place'.* Not all of their colours bear this statement out however.

The drawbacks associated with true Vermilion are pointed out and I am informed that the intention is to replace Alizarin by Quinacridone.

Several minor changes have been made to the pigmentation. As no samples at all were sent for this edition and letters not responded to concerning any other possible developments, I have placed the entire range together at the back of the book.

Lefranc & Bourgeois (France)

The company trace their origin back to 1720. An ancestor of the Lefranc family, a Mr. Laclef, had a spice shop beneath the studio of Jean-Baptiste Chardin. Laclef was requested to grind pigments for Chardin and the foundations were laid for the present company.

In 1836, the great grand nephew of Mr. Laclef took over the company and opened a factory, business expanded rapidly. A Mr. Bourgeois formed a similar company in 1867 which was in direct competition. In 1965 the two amalgamated.

Available in both tube and pan, the Linel range of watercolours are well presented and packaged. The tubes are strong, particularly at the shoulders. Ingredients are given on the tube in the form of a brief chemical description. The value of the information varies

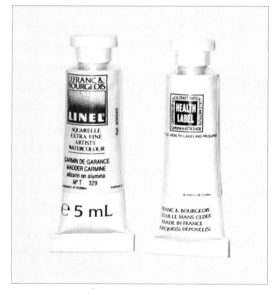

Available in 5 ml tubes. Also in half pans.

from being accurate to vague. Meaningless terms such as 'Azo pigment' find their place. Lightfast Raw Umber is described as 'Natural Earth' the same description given to the fugitive Van Dyke Brown. The all important Colour Index Numbers are not given.

But they are provided in the literature. Their colour chart being the finest example that I have come across with hand painted colour chips.

The Linel range replaces the earlier '600' series. Lefranc & Bourgeois were particularly helpful in the compilation of information and the supply of samples.

Binney & Smith (USA) Liquitex

Joseph Binney established the Peekskill Chemical Co. in 1864. Based in New York, he produced and sold charcoal and Lamp Black, the latter made by burning whale oil.

Over the years other lines such as shoe polish, crayons and pencils were introduced. The company became known as Binney & Smith in 1885.

Further lines were included such as tempera, finger paint and watercolours in 1948. A major break through came in 1964 when Permanent Pigments Inc. was acquired. This brought into the company the now familiar Liquitex lines.

The President of Permanent Pigments had been Henry Levison, on his retirement Henry set about testing many of the pigments featured in the ASTM listing. He received the cooperation of Binney & Smith in this invaluable work.

The watercolour tubes are reasonably strong and well made. The labelling is excellent. Full information on the vehicle and ingredients is given, including the Colour Index Name.

The labelling conforms to ASTM standards. Binney & Smith have made a valuable contribution to the vital work of the ASTM in drawing up the new standards.

Available in 15 ml tubes.

The company have now decided to concentrate on their acrylic ranges and ceased the production of watercolour paints several years ago. If you still have earlier watercolours from this company you can always check the ingredients on the very informative label.

Lukas (Germany)

Stephan Schoenfeld opened a business supplying artists' requirements in 1829. It was ideally located opposite the famous Art Academy of Düsseldorf.

Stephan's son, Franz, went on to form Dr. Fr. Schoenfeld & Co., a company specialising in the manufacture of artists' colours. At the turn of the century the patron Saint of painters, 'Saint Lukas' gave his name to all artists' colours produced by Dr. Fr. Schoenfeld & Co. The company and trade name have continued to the present day.

Lukas watercolours are available in both pan and tube. We examined only the tubed colours. Since the last edition of this book the tube has been changed from 7.5 ml to 24ml.

Chemical descriptions of the pigments are given on the tube labels but a magnifying glass is required (literally) in order to read them. Vague, meaningless terms such as 'Monoazo pigment' are amongst the more accurate descriptions.

The important Colour Index Numbers are given in the literature but should also be on the tube as artists now look for such detail.

Samples were provided but no literature.

Available in 24ml. tubes, (shown here). I believe that 1/2 and full pans are also available.

Holbein (Japan)

This leading Japanese company, based in Osaka, was formed in 1900. Holbein have been very successful in marketing their products to a world wide audience.

The development of their paint making techniques was largely independent of European and American influence. Japan of course, has a long history of producing pigments and paints.

The watercolour range is presented in tube form. These used to be rather basic in appearance and tended to twist. Now very much improved.

There are two parallel ranges. 'Artists' Watercolor ' and 'Irodori'. The latter range claims to reproduce the 'delicate hues typical in ancient oriental artistic use'.

The labelling has also been very much improved since the last edition. Conformance to ASTM D-4236 and health warnings (which were only given on tubes for the North American market) are now in use world wide.

The Artists' Watercolours (right) are available in 5 and 15 ml. tubes. 24 new colours have been introduced. The Irodori range are available in 5ml tubes.

The colours are produced without the use of wetting agents. This allows, it is claimed, for improved brushing technique. Adequate water must be used or the paint will seem rather opaque at first.

It can also appear to be over bound because of this, with a slightly gummy consistency.

Holbein have been particularly helpful in the compilation of this book. They have supplied samples, full technical information and answers to all questions.

Pebeo (France)

Despite many requests we were not provided with information on the history of the company.

A range of 48 colours are produced and are available in both pan and tube. We examined only the tubed colours, but the pans have exactly the same ingredients.

The information provided on the labels and in the literature is excellent. Lightfast ratings conform to ASTM standards. This should be noted as some might think that the ASTM Standards apply only to certain companies based in the USA. They are in fact spreading worldwide, albeit slowly.

Another point worth noting is the fact that the all important Colour Index Numbers are given on the product and in the literature.

Produced in 5ml. tubes and 1 ml. 1/2 pans. Both contain the same pigments.

Pigment descriptions are accurate and meaningful.

This approach is to be encouraged as it marks a major breakthrough from the past. As artists become more aware and informed, they will seek out companies who give clear and concise information on the ingredients of their products.

Increased sales will not only reward such manufacturers but will encourage others.

Schmincke (Germany)

The artists' colour manufacturer H. Schmincke & Co. was founded in 1881 by Hermann Schmincke and Josef Horadam. Four generations later the company is run by the direct descendants of the founding families.

Operating from a modern factory near Düsseldorf, they produce a wide range of artists' colorants.

Their 'Artist Quality' Horadam watercolours are available in both tube and pan. Great pride is taken in the fact that pan colours are poured rather than pressed when dry. The colour picks up well from the pans as they are slightly moist. The paint is ground on slow turning stone mills.

The tubes are strongly made and resist twisting should the cap

Produced in 5 and 15 ml. tubes. The 5 ml. is shown here. Also available in 1/2 and full pans.

stick. An inherent weakness in the caps caused them to fracture easily. This has now been overcome with a new, shorter design. Colour Index names are not given. A 'coin slot' on top of the cap will help should one become stuck.

Details of the pigments employed are given on the labels, but in tiny print. More should be made of making such information readily available. We were provided with full and accurate information on all ingredients.

Winsor & Newton (UK)

Two young painters with a scientific background, William Winsor and Henry Charles Newton founded Winsor and Newton in 1832. In 1892 they became the first Artists' Colourmen to publish a complete list of colours, together with details of their chemical composition and permanence.

A booklet giving such information is still published. It is most useful and carries full information on the ingredients, including the vital Colour Index Name and Number. The booklets are not always readily available in art stores.

Winsor and Newton watercolours are available in both tube and pan. We only examined the former in detail. The tubes are strong and well produced, the caps resist sticking.

The tubes are well labelled, giving the CI Name. Albeit in tiny print on the Cotman range.

Winsor and Newton were most helpful in the supply of technical information and samples of their new and reformulated colours.

The 'Artists Quality', shown on the right are available in 5 and 14 ml. tubes. Also in 1/2 and whole pans. 'Cotman colours', on the left, are produced in 8 and 21 ml. tubes. The 'Cotman' colours for the USA market are in 8ml. tubes.

Sennelier (France)

The company was founded by Gustave Sennelier in 1887. His sons, Charles and Henri eventually took over the running of the business. Today his grandson, Dominique Sennelier, manages this well established paint company.

Large granite mullers were used originally to grind and blend the pigment and binder. Today, slowly turning granite rollers have taken over the job.

Watercolours are produced in both pan and tube. We examined the latter.

The tubes are well produced and strong.

Eighty colours are offered. Information on the tube, at one time very limited has been much improved. The Colour Index name is given in a type size which is easy to read.

Produced in 10ml tubes. There might be other sizes.

Also available in 1/2 pans

Sennelier were most helpful in the supply of samples and technical information.

This company have made many significant improvements since the first edition of this book. Colours have been reformulated and fugitive paints replaced by lightfast examples. The labelling has also been much improved.

Old Holland (Holland)

Established in 1664, this company has had a long and steady history and claims to be the oldest artists' paints factory in the world. It is stated that the company was established by artists and is still under the control of artists, not business people.

Slow, stone mills are, I am informed, still used to grind the paints rather than the faster steel rollered variety. This, it is claimed, helps to preserve the colour.

The lead tubes are rather soft. If a cap should stick the shoulders of the tube should be held during its removal rather than the body.

Information on the pigments used is given on each tube but as a chemical description. This is of little help to the average artist.

Whereas many have come to terms with Colour Index names, PY3 etc. descriptions such as 'contains Dioxine Nickel Complex Sta-

Although I cannot be certain, it would appear that the tubes are available in 6 and 25 ml. sizes.

Half pans are also produced.

ble Di-Arylide, will be harder to take in.

A very wide range is offered, in fact it is vast, with 168 colours in total.

Old Holland are a small company who say that they take pride in following the methods of the colourmen of yesteryear.

Whereas in previous editions I have commented on the fact that certain of their colours were rather over bound, I have found this fault (as I would put it), to be very prevalent in their newly presented samples.

They offer both tubes and pans. I have not examined the pans for this edition.

Maimeri (Italy)

The Maimeri brothers Gianni and Carlo founded the company in 1923. They made a good combination, Gianni being an artist and Carlo a research chemist. Their factory, located at Barona was destroyed in an air raid towards the end of the Second World War. It was rebuilt in 1946 and relocated to Milan in 1968. Maimeri produce a wide range of colorants and other art materials.

Two watercolour ranges are offered, 'MaimeriBlu Superior Watercolours', replacing 'Extra Fine Artist Quality' and 'Venezia' replacing 'Studio'. Both are available in tubes, the 'Artist' range is also produced in pan form.

The tubes are well produced. They are strong enough to resist twisting yet collapse readily.

Full information, including the vital Colour Index Name is provided in the literature. It has also now found its way onto the tube label, although difficult to find.

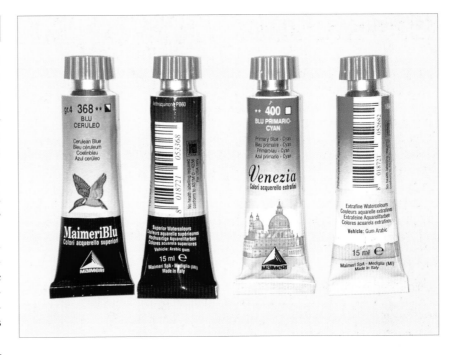

Maimeri rendered every possible assistance. They have made many improvements to their paints, tubes and labelling since the first edition of this book.

Both ranges are produced in 15ml. tubes. The 'MaimeriBlu', shown on the left, also comes in 1/2 and full pans I believe.

Daler Rowney (England)

The brothers Thomas and Richard Rowney started preparing and selling artists' colours a little over 200 years ago. Their products were sought after by notable artists of the time such as Constable and Turner. Rowneys merged with the canvas board manufacturers, Daler Board, in 1983.

Rowney watercolours are available in two ranges: 'Artists' Quality' and their 'second' range 'Georgian'. Available in both tube and pan.

The tubes are reasonably strong and well made. Information on the pigments used in the Artist Quality is available in the main catalogue and now, finally, on the paint label.

No information on ingredients is given on the tubes of the 'Georgian' range. Daler Rowney have been very helpful in supplying

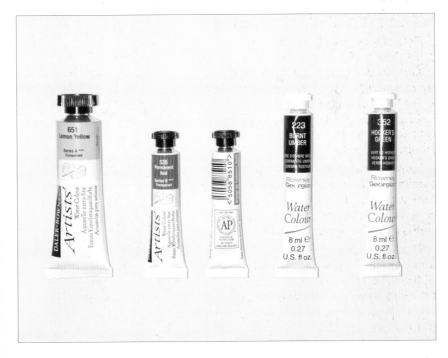

samples and technical information. All questions were answered frankly.

The 'Artist Quality' range, shown on the left, is available in 5 ml and 15ml tubes, 1/2 and whole pans.

Georgian colours are produced in 8ml. tubes. Certain of them are also available in 1/2 pans.

Hunts (USA)

I am afraid that I do not have a lot to report on this company.

Hunts International Co., based in Philadelphia, manufacture a range of tubed watercolours described as 'Speedball Professional Watercolours'.

Several samples and a limited amount of information were sent to us for the first edition.

When a request was made for the very important Colour Index Names and Numbers of the ingredients we received the following, and I quote. 'We consider the Colour Numbers you are requesting as privileged, confidential manufacturer's information and we are unable to provide such information'.

For this edition a list was provided giving the Colour Index names. I am happy to have been able to record them with the earlier colour samples.

Certain of the earlier range have been discontinued, particularly the Cadmium colours.

Reeves (UK)

The Reeves company have informed us they no longer offer their watercolour paints to artists, but describe for the use of 'hobbyists'. As such they will no longer be featured in this publication.

I had previously written:

The Reeves company, under the same ownership as Winsor and Newton, was formed in 1766. A very old company, Reeves joined the Winsor and Newton group in 1976.

The policy on labelling and product information is identical to that of the parent company.

There are many similarities between this range and 'Cotman' the Winsor and Newton 'second' range.

However I am informed the two paint ranges are not identical.

Available in tubes only, these are strong and well produced. Information on the ingredients is limited, with many general terms such as 'Azo red' being used. The tubes carry this limited information.

It must be remembered however that the range is intended more for the beginner, where perhaps less detail is required.

Twenty seven colours are on offer. Reeves gave every assistance and a full range of samples. All questions of a technical nature were answered without delay.

Produced in 7.5 ml. tubes

Utrecht (USA)

Utrecht Linens was formed in 1949 by two brothers. Quality European linens were offered to American artists.

Oil paints were developed in the early 1950's followed by acrylics in 1957. The watercolour line was introduced in the early 60's.

These products were added to a wide range of artists materials and are sold through their own chain of retail stores and art supply catalogue.

Samples were provided for this edition and a basic colour chart but little else.

Vital information concerning the Colour Index Name is given clearly on the label.

Hopefully we will receive more cooperation for the next edition and I will try and fill in any gaps on this well known company.

Available in 7.5ml tubes. There might be other sizes.

Barvy Umton (Czechoslovakia)

I do not have a great deal of information on the Czech manufacturer Umpton Barvey. They only came to my notice quite recently, and then via their distributor in the United Kingdom, Vintr Vintr Ltd.

The latter have been most helpful in obtaining full technical detail on the pigments used.

I believe that only pan colours are offered. Our samples painted out very well.

Details of the pigments employed are not given on the packaging, which is very basic . I feel that this omission might be corrected in the future.

I hope to bring more information on this company in the next edition.

Available in 3/4 pans.

Cheap Joes' Art Stuff (USA)

Apart from samples I was provided with little else.

Cheap Joes' Art Stuff are a mail order company offering a wide selection of products. They now have their own range of watercolours under the name 'American Journey'.

The product is very well packaged with a most informative label.

That is about all that I can tell you.

Available in 37ml tubes.

Martin F. Weber Co. (USA) (Permalba)

Martin F. Weber have now discontinued their line of watercolours paints and are now concentrating on their oil paints.

If you have examples of their watercolours you will find pigment details etc. in earlier editions of this publication. In the previous edition I had written:

Founded in 1853, Martin F. Weber Co. claim to be the oldest manufacturers of artists' supplies in the United States. They were the first Colourmen to develop Titanium White as an artist pigment.

A range of 36 watercolours is offered under the name 'Permalba'. The tubes are well produced and reasonably strong. Serrations on the edge of the cap ease removal and sticking is not really the problem that it is with some makes.

Useful information is given on the tube. Pigment descriptions plus Colour Index Names are printed very clearly. Each tube also carries pertinent health information. We were given every possible assistance in the compilation of information.

Available in tubes of 25 fl.oz. (7ml). As shown here.

Jaurena S.A. (Spain)

I am afraid that I know virtually nothing about this company. Samples were provided on request but were not accompanied by any literature.

The tubes are of a good quality and are well labelled, giving the vital CI Name.

Available in 8ml tubes

Daniel Smith (USA)

Based in Seattle, Daniel Smith commenced business producing printing inks. Papers were then added plus other requirements of the print maker.

The business was later expanded to include artists materials.

Full information plus samples were provided and every help given. Interference and Pearlescent colours are produced by the company. We did not try these for lack of space. Perhaps in a future edition.

The tubes and caps are of a high quality and the labelling gives full information in a very clear layout. Very comprehensive detail is published concerning the technical aspects of the range.

Available in 15ml tubes

Pentel (Taiwan)

I have virtually no information on this company. Knowing the nature of this book I would have thought that manufacturers would have been keen to put their company in the best possible light.

Although the presentation would suggest that the metal and poly tubed paints were possibly for the hobbyist, the packaging does describe the paints as being for the use of artists.

No information on the pigments used is given on the product or packaging.

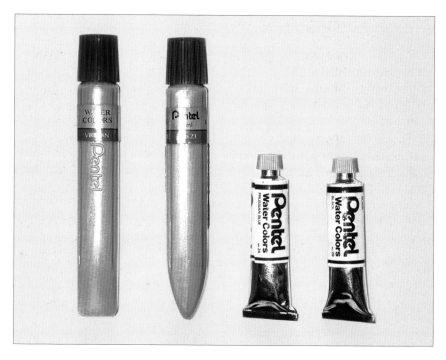

Available in 5cc (metal tubes) and 12ml (poly tubes).

Caran D'Ache (Switzerland)

Founded in 1924 the company produce a wide range of goods, from mechanical pencils, to luxury lighters art materials.

The name is derived from the Russian 'Karandash' for pencil.

A total of 48 half pans make up the watercolours range. These will be joined by a parallel series of tubed watercolours sometime in 2001.

The only binder used is Traganth and the only plasticizer is honey. The paint lifted very well from the pan without the 'scrubbing' required in some makes.

Very few of the colours are susceptible to damage from light and nearly all handled well. Details of the pigments used are printed on the label and are very clear. The company were most helpful in supplying clear and detailed information.

Available in half pans

St. Petersburg (Russia)

The following is taken from the literature published by the USA distributors of this well known range of Russian made watercolour pans.

'Our Goal: To bring you, the artist, the most exciting materials to be found in the world. Products that will help you fulfil your vision, and paint your dreams. The St. Petersburg watercolour set has been popular in Europe for over 80 years. Just recently it has become available in the western world. It was an immense success in England, the home of watercolor and it has experienced record sales all over the world'.

All very well and good so far. For the purposes of this book I naturally need to know which pigments have been used. It can be an uphill task to find out but we get there in the end.

It was quite a different story in this case.

After considerable correspondence it emerged that the distributors in the USA and the UK could tell me nothing at all about the pigments that are employed in this range. The product label carries no information and neither does the packaging.

As the presentation is very basic and the pans filled less than neatly, one assumes that the range has become popular because of the perceived value. 'A very good price for artists' quality, I often hear'.

But if nobody outside of Russia knows what pigments have been used how can the description 'artists quality' have caught on? The answer is simple. 'Via marketing hype'. So those marketing the product must know more, I assumed.

Following pressure on the distributors for further information we received a quite amazing letter.

We were informed, and I quote.

'Getting information from Russia is quite difficult'....'They are wary of providing Westerners with too much information'.

The vast numbers taken in by the hype might have purchased artists' quality paints or they might have bought a quality more suited to the class room. Who knows? Apart from the manufacturers.

Many watercolourists have been money wise and pigment foolish, as far as knowing what they were doing.

M. Graham Co. (USA)

This company offer a range of well made watercolours. These are well packaged, clearly labelled and employ reliable pigments.

To quote from their literature. 'Handmade with pure honey, gum arabic, glycerine and the most lightfast pigments available, each color is individually crafted to develop its own unique character. Because of its love of moisture, honey absorbs water from the atmosphere. Colors made with honey do not dry up in the tube or on the palette and always dilute easily, often after months or years of disuse'.

The company were most helpful in the supply of samples and literature.

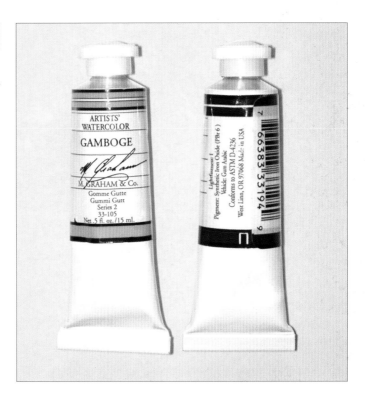

Available in 15ml tubes.

Paillard (France)

It appears that this company no longer exists.

If you still have examples of their watercolour paints you will find little information in the earlier editions of this book concerning ingredients. I had previously written:

I can tell you very little about this company. Paillard, who produce a range of pan colours, are part of the Lefranc and Bourgeois group.

Intended for the student, the range is reasonably extensive and quite widely available. For these reasons I wanted to provide full coverage.

Samples and limited information were provided initially and the range was included in the book. Despite promises of further information it never materialised. No indication whatsoever is given in the literature or on the pan as to the ingredients used.

Dr. Ph. Martins (USA)

This company manufacture various colour ranges. For the purposes of this publication we examined their 'Hydrus Fine Art Watercolor'.

To quote from the literature accompanying this range:

'Hydrus is fine art, lightfast, transparent watercolor at its best.....in a bottle. This liquid product delivers the same brilliance and permanency of traditional watercolor that one finds in a tube'.

Unfortunately I could find no reference as to the pigments that are used in this product. The label only mentions that they are 'lightfast' and the literature supplied gave no further information.

This being the case I have been rather direct in some of my remarks with each colour outline.

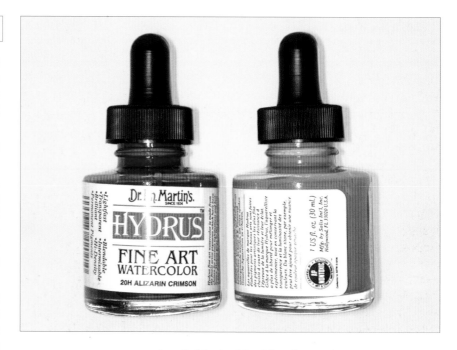

Available in 30ml bottles.

If the pigmentation is given elsewhere it would have been helpful to have been provided with a copy.

If not, I feel it is outdated practice to supply products intended for artistic use without declaring the contents.

Brusho (UK)

Based in the United Kingdom, I can tell you very little about this company. They are mentioned here only because their product is used by watercolourists. (The colorant is in powder form which is added to large amounts of water).

On hearing of their product I contacted them by telephone, gave an outline of this book and requested samples and technical information. They were loath to become involved and stated that they only supplied to schools. They did not wish to disclose the pigments and *dyes* that were used in the product.

I had decided to leave it at that until I saw their product being demonstrated at an art material show in London.

It was clearly being promoted as being entirely suitable for conventional watercolour painting.

They receive a mention here because I wish to cover as many products described as being suitable for artistic endeavour as possible.

A School of Colour Member, concerned that the colours were being promoted to artists purchased a set.

He produced a painting from the colours, cut it into two and exposed half to the light from a window for ten weeks. The result is shown above.

It is not shown as the result of a scientifically based test, but a practical example of the damage that can be caused through even brief exposure to light.

How can we ensure that our pigments have been properly tested?

Whilst working on this edition I have observed that many new and untested pigments are being introduced at the same time that formal testing has all but stopped.

A very wide range of pigments are available which have been tested under the conditions set by the ASTM sub committee on artists paints. The range is sufficiently wide to offer all an artist could ever need.

Manufacturers look outside of this range for reasons of their own. The results can often mean that colours known to fade or darken are on offer to the unwary.

We can help to bring about a situation whereby only pigments which have been approved of by the ASTM, are used by selecting products which are clearly marked as being either

ASTM Lightfast 1 Excellent or

ASTM Lightfast II Very good

and boycotting all others unless

we are satisfied that the colorants used have a sound reputation.

Simple commercial pressure will bring about change and persuade manufacturers not to use pigments which are untried in art materials.

Before I became involved in the area of artist's materials I imagined that when a paint was described as being of *Artist' Quality* that it would contain lightfast pigments of the finest quality.

I also imagined that each pigment would have been put through very vigorous tests to make sure that it would not fade and that the manufacturer actually had my interests at heart.

After all, I was paying a premium for the higher grade and I did not wish my work to deteriorate. In other words, I put my money and my faith in the integrity of the art materials trade.

I have come to realise just how very naive I was.

It has taken a dramatic change in the buying practices of the artist, (assisted, I hope by previous editions of this book), to oblige certain (by no means all), manufacturers to 'lift their act' and offer a greater proportion of reliable paints and clearer labelling.

Whilst some pat themselves on the back and offer the reasons for the changes that they have 'decided' to make, do not forget that reputations and extensive businesses have been built on the misplaced trust of the artist.

Instead of 'well dones' we should be asking why it took so long and why it took commercial pressure from the buying artist.

Major improvements have been made but there is still a long way to go.

Fortunately there are many manufacturers who do care about your work and take steps to ensure that you have the very best.

Why are so many watercolours very gummy?

During the compilation of this book I painted out all of the colours represented here.

During this exercise I came to the conclusion that a much higher proportion of paints are being made with an excess of gum. This made them very difficult to brush out and many dried to an unnatural shine.

As with filler, gum is much less

expensive than coloured pigment. If the texture can be rebuilt using certain additives the manufacturer will make a very definite saving.

I tend to suspect that certain manufacturers, obliged to offer costlier pigments to the more knowledgeable artist, are making up the difference with an excess of inexpensive binder.

Hopefully this is not the case,

but watercolours in general seem to be more frequently over bound.

A few drops of gum at the top of a tube are not a problem and can be expected with the heavier pigments, but some of the samples that I examined were not paint but a mixture up to 60% gum and 40% coloured gum.

Where do the School of Colour paints fit in?

This is a difficult question. I produced the first edition of this book some years before we introduced our own, extremely limited range of watercolours.

Because I could be accused of a possible conflict of interests, I put off the updating of the last edition for some years.

However, I feel that there are still a few changes that need to be brought about and have decided to continue for the following reasons:

1. We have no more than 12 colours in the range and they are for the use of Members of the School of Colour.

2. We are, first and foremost, publishers. Our paints are a support product designed around our books for those with a strong interest in colour.

3. I feel that our work in this area is important and that it cannot simply be left to those who would copy us.

Yellows

A brief history of yellow pigments

The main requirement of a yellow pigment during ancient and Medieval times was to imitate gold. To a lesser extent, yellows were used to modify other colours, still less important seems to have been the representation of yellow objects.

A freer use was made of yellow in paintings by Renaissance artists and many new pigments were introduced.

It was fully realized that overuse of a bright yellow could quickly disturb the balance of a painting. For this reason, yellow ochre was usually thought of as being strong enough for most purposes.

The book illustrator however, required much brighter yellows. Orpiment, an orange yellow of some brilliance found favour with the illuminator as it closely resembled gold in colour.

Unfortunately it caused problems in mixes.

Yellows produced from fish and animal bile, gall stones and various vegetable extracts were >

employed. Many of them tended to fade quickly, especially the vegetable yellows.

Other imitations of gold were used by artists in the middle ages. Mercury was whipped into egg yolk and a yellow dye such as bile or saffron was added. This gave a metallic but short lived effect. Gold was also depicted by glazing over powdered tin with a transparent yellow paint.

Many of the earlier yellow pigments have been replaced on the artists' palette by recent, more permanent yellows. Occasionally we have lost a particularly useful colour and have had to make do with a less than perfect replacement.

There were a few problems associated with the earlier Cadmium Yellows, the paler varieties particularly being less than lightfast. However the modern Cadmiums, offered by reputable manufacturers, are extremely permanent, very bright and opaque. >

Modern Cadmium Yellows are superb pigments with outstanding qualities.

Arylides are recent additions to the range of available yellows. Originally known as Hansa Yellow they vary widely in reliability.

Genuine Indian Yellow was produced from concentrated cows urine.

The urine was mixed with mud and sent to London for refining.

The resulting pigment was valued for its hue and transparency.

The modern synthetic dye stuffs will, we hope, provide us with an ever widening range of yellows that promise to remain permanent even when diluted or reduced with white.

Most of the earlier transpar-

ent yellows such as Indian Yellow and Gamboge have been replaced by imitations bearing the same names. Many of these replacements are based on inferior pigments and are not worth considering. Of real value

however, is the very delicate, transparent Aureolin, also known as Cobalt Yellow. Only of use in thinly glazed layers, for when it is applied heavily it is dull and leathery in appearance.

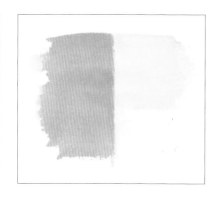

Genuine Gamboge is taken from the bark of a tree native to several East Asian countries.

The sap is often collected in short lengths of bamboo, these act as moulds.

Despite the romance and tradition of it all, Gamboge fades rapidly.

Arylides have withstood the severest of testing procedures and have found a permanent place on the palette of many an artist. >

A wide range of Arylides are available. Unfortunately they are often poorly described. A variety of meaningless terms are in use. >

Descriptions such as 'Hansa Pigment' or 'Arylide Base' give no indication at all of the actual pigment used.

We have a wide range of yellows at our disposal, from the absolutely reliable to the fugitive. It has become more important than ever to have a clear understanding of the pig-

ments that are used in their make-up.

If the actual pigments which have been used to produce the paint cannot be accurately identified - either from the tube

or pan, or from the literature - the colour is not worth considering.

You could be spending more to purchase a less than reliable paint.

Modern Yellow Pigments

PY1	ARYLIDE YELLOW G	37
PY1:1	ARYLIDE YELLOW G	37
PY3	ARYLIDE YELLOW 10G	37
PY4	ARYLIDE YELLOW 13G	38
PY12	DIARYLIDE YELLOW AAA	38
PY13	DIARYLIDE YELLOW AAMX	38
PY14	DIARYLIDE YELLOW OT	39
PY15	DIARYLIDE YELLOW 5	39
PY17	DIARYLIDE YELLOW AO	39
PY20	BENZIDINE YELLOW B	40
NY24	GAMBOGE	40
PY31	BARIUM CHROMATE LEMON	40
PY34	CHROME YELLOW LEMON	41
PY35	CADMIUM YELLOW LIGHT	41
PY35:1	CADMIUM-BARIUM YELLOW LIGHT	41
PY37	CADMIUM YELLOW MEDIUM OR DEEP	42
PY37:1	CADMIUM-BARIUM YELLOW MEDIUM OR DEEP	42
PY40	AUREOLIN	42
PY42	MARS YELLOW	43
PY43	YELLOW OCHRE	43
PY53	NICKEL TITANATE YELLOW	43
PY55	DIARYLIDE YELLOW PT	44
PY65	ARYLIDE YELLOW RN	44
PY74LF	ARYLIDE YELLOW 5GX	44
PY81	DIARYLIDE YELLOW H10G.	45
PY83HR70	DIARYLIDE YELLOW HR70	45
PY95	DIARYLIDE YELLOW	45
PY97	ARYLIDE YELLOW FGL	46
PY100	TARTRAZINE LAKE	46
PY108	ANTHRAPYRIMIDINE YELLOW	46
PY110	ISOINDOLINONE YELLOW R	47
PY119	ZINC IRON YELLOW	47
PY120	BENZIMIDAZOLONE YELLOW H2G	47
PY129	AZOMETHINE YELLOW 5GT	48
PY138	QUINOPHTHALONE YELLOW	48
PY139	ISOINDOLINE YELLOW	48
PY150	NICKEL AZO YELLOW	49
PY151	BENZIMIDAZOLONE YELLOW H4G	49
PY152	DIARYLIDE YELLOW YR	49
PY153	NICKEL DIOXINE YELLOW	50
PY154	BENZIMIDAZOLONE YELLOW H3G	50
PY155	DIARYLIDE YELLOW	50
PY175	BENZIMIDAZOLONE YELLOW H6G	51
PY177	IRGAZIN YELLOW 4GT	51
PY184	BISMUTH VANADATE YELLOW	51

PY1 ARYLIDE YELLOW G

A bright transparent to semi-transparent yellow which is compatible with all other pigments. Possessing a high tinting strength, PY1 can quickly influence other colours in a mix. Covering, or hiding power is moderate.

The drawback to this very popular pigment is that it fades rapidly, rating only V in ASTM testing. Relatively cheap, it is used as a substitute for Cadmium Yellow or blended into other colours, which it will eventually spoil.

Our sample was quickly on its way back to white paper when applied as a wash and exposed to light. It darkened at full strength. Unsuitable for artistic use. Also called Hansa Yellow Light

PY1:1 ARYLIDE YELLOW G

A bright semi-transparent orange-yellow. Like its close relative, PY1, it has many industrial applications and is relatively cheap. Although it fared slightly better than PY1 during ASTM testing, with a rating of III, it is still unsuitable for artistic use. Our sample faded rapidly on exposure to light.

When this range of pigments were introduced in 1910 they were known as HANSA Yellows.

Although this name is still used the preferred term is ARYLIDE.

Unreliable, our sample faded quickly on exposure to light, particularly when applied as a thin wash. Worth avoiding.

Also called Hansa Yellow Medium.

PY3 ARYLIDE YELLOW 10G

The 'G' stands for green. Arylide yellow 10G is much greener than other Arylide Yellows on offer. A very practical pigment, it is compatible with all others. Fairly transparent and reliable. ASTM rating II.

The optional additional name is HANSA YELLOW LIGHT. If you come across pigments described simply as ARYLIDE or HANSA Yellow treat them with caution, they could be the reliable PY3 or a fugitive member of the family.

PY3 is on the list of ASTM approved pigments for watercolours.

Also called Hansa Yellow Light

PY4 ARYLIDE YELLOW 13G

There can be some confusion about the common name. This pigment is sometimes given a trade name followed by 5G. The Colour Index Number PY4 will identify it for the artist.

A bright greenish-yellow discovered in 1909. Sensitive to lime. The main use of this pigment is in the manufacture of printing inks.

Not yet tested in any artists' paint. Rated W/Guide III on the

strength of our own preliminary testing. Treat with caution. Also called Fast Yellow 13G.

PY12 DIARYLIDE YELLOW AAA

Vast amounts of this pigment are used in industry, particularly in the manufacture of printing inks. PY12 represents over 55% of all organic yellow production.

Semi-opaque and quite strong. One example of its use in artists' watercolours is as an ingredient in a Sepia, which would be less severely damaged than most other colours. This is fortunate as PY12 has a very poor reputation as far as its lightfastness is concerned.

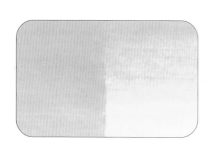

An unreliable pigment which will quickly fade. Also called Benzidine AAA DI.

PY13 DIARYLIDE YELLOW AAMX

A brownish orange-yellow. When applied heavily it takes on a rather dull, heavy appearance but washes out to a reasonably clean yellow. Semi-opaque, it has reasonable covering power.

This is another fugitive yellow which is best avoided. Rather more orange than PY12 but sharing the same failings. Such yellows are relatively cheap due to their industrial applications, but should not be considered for artistic expression.

After only a brief exposure to light our sample had changed considerably. After the full exposure the tint had faded and the mass tone had become very dull.

PY14 DIARYLIDE YELLOW OT

L/FAST W/GUIDE IV

Pigment Yellow 14 is a rather bright greenish-yellow. Although semi-opaque, it is strong enough to give a reasonably clear wash when applied well diluted.

Diarylide yellows as a group are twice as strong as Arylide Yellows but less resistant to light. This pigment is popular in the printing industry where fastness to light is less important. Recognised as having poor resistance to light when applied thinly.

Our sample faded considerably.

Deterioration of the wash commenced after only a short exposure to light. Best avoided. Also known as Benzidine Yellow AAOT.

COMMON NAME

DIARYLIDE YELLOW OT

COLOUR INDEX NAME

PY14

COLOUR INDEX NUMBER

21095

CHEMICAL CLASS

DISAZO TYPE 11 TOLUIDIDE

PY15 DIARYLIDE YELLOW 5

L/FAST NOT OFFERED

A yellow with a definite leaning towards green.

PY15 has not been examined in any art material under the regulations applicable to ASTM testing.

More of an industrial colorant but even in that area of use it was considered to be of little importance.

By reputation this pigment is susceptible to damage on exposure to light.

As insufficient information is available on this pigment I will not offer a rating.

COMMON NAME

DIARYLIDE YELLOW 5

COLOUR INDEX NAME

PY15

COLOUR INDEX NUMBER

21220

CHEMICAL CLASS

DISAZO: DIARYLIDE

PY17 DIARYLIDE YELLOW AO

L/FAST W/GUIDE V

A bright slightly greenish-yellow which is transparent to semi-opaque. PY17 is quite a strong pigment which will quickly influence many others when mixed. Its strength makes it popular in the printing industry.

Unfortunately it has a very poor reputation for lightfastness.

There are many instances of colorants more suited to industrial purposes which have found their way into artists' paints.

When applied as a thin wash

our sample disappeared rapidly. The mass tone became duller. A material well worth avoiding.

COMMON NAME

DIARYLIDE YELLOW AO

COLOUR INDEX NAME

PY17

COLOUR INDEX NUMBER

21105

CHEMICAL CLASS

DISAZO TYPE 11. ANISIDINE

PY20 BENZIDINE YELLOW B

This pigment is used industrially in the colouring of plastics and rubber and has a good reputation in this area. Seldom used in artists' paints, it has not been subjected to any formal testing that I am aware of.

So how could it find its way into watercolours produced and sold for artistic use, you might ask? Diarylides are usually considered to be unsuitable for artistic use.

Judging by the speed that our sample deteriorated I will rate it as WG IV pending further testing. Unreliable.

NY24 GAMBOGE

First imported to West in 1615 this is an example of a traditional organic pigment which has lingered on well past its time. A fairly bright orange-yellow, which has long been valued for its transparency.

The mass tone is a rather heavy, dull colour and the true beauty is only revealed when it is applied thinly. Unfortunately, it is a temporary beauty, as the colour tends to disappear rather quickly. If faded examples are kept in the dark some colour might return.

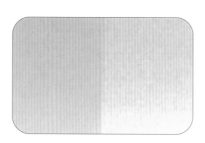

The wash on our sample bleached out within a very short time, in keeping with the reputation that this colorant has built up. This substance is most unsuitable for artistic expression.

PY31 BARIUM CHROMATE LEMON

This is an example of the sort of pigment which artists should be more aware of.

Absolutely lightfast, it was rated I during ASTM testing.

A quite definite green yellow with a rather dull, flat appearance. The quiet coolness of the hue has many applications for the watercolourist. Tinctorial power is rather low so it will have a limited influence when blended with stronger colours.

Our sample was unaffected by light in any way. An excellent pigment which is on the ASTM list of recommended pigments.

PY34 CHROME YELLOW LEMON

Usually a definite green yellow, but orange yellows are available. PY34 is often used in 'Lemon Yellows'. Fairly strong with good covering power. Known to be darkened by light and the Hydrogen Sulphide of the atmosphere. Although it has been rated ASTM I as a watercolour I have decided, unusually, not to follow this assessment as all of our samples darkened.

It has been suggested to me that one of the new encapsulated varieties of the pigment could have been used in the ASTM tests.

Poor acid and alkali resistance. Work glazed over in a frame, will be protected from the atmosphere at least. I would suggest caution in its use until the situation is fully clarified.

L/FAST NOT OFFERED

COMMON NAME

CHROME YELLOW LEMON

COLOUR INDEX NAME

PY34

COLOUR INDEX NUMBER

77600 & 77603

CHEMICAL CLASS

LEAD CHROMATE AND LEAD SULPHATE

PY35 CADMIUM YELLOW LIGHT

A clean, strong, bright yellow. Noted for its opacity, it has very good covering power. This of course is a quality usually more valued in other media. When made into a paint without unnecessary additives, it is strong enough to allow for reasonably clear washes when well diluted. Extremely lightfast, it rated I during ASTM testing.

A fine yellow with a useful range of values which is considered by many, including the author, to be the most important light yellow of the palette.

Unaffected by light under normal circumstances, it is however, sensitive to moisture in strong light. An outstanding pigment. On the ASTM recommended list.

L/FAST ASTM I

COMMON NAME

CADMIUM YELLOW LIGHT

COLOUR INDEX NAME
PY35

COLOUR INDEX NUMBER
77205
Former CI No 77117
CHEMICAL CLASS
CONCENTRATED CADMIUM ZINC SULPHIDE (CC) (SM)

PY35:1 CADMIUM-BARIUM YELLOW LIGHT

An excellent alternative to the more expensive chemically pure Cadmium Yellow Light. In the watercolour ranges it is invariably blended with other colours. Although cheaper than Cadmium Yellow Light, it is usually as bright and as permanent. It does however, share that pigments' sensitivity to a combination of moisture and strong light.

Finished paintings must be kept perfectly dry, as of course should all artwork, (with the possible exception of swimming pool mosaics).

Absolutely lightfast under normal conditions. Our sample remained unaffected. On the list of ASTM approved pigments after testing I in watercolour.

L/FAST ASTM I

COMMON NAME

CADMIUM-BARIUM YELLOW LIGHT

COLOUR INDEX NAME
PY 35 : 1

COLOUR INDEX NUMBER
77205 : 1

CHEMICAL CLASS

CADMIUM ZINC SULPHIDE COPRECIPITATED WITH BARIUM SULPHATE (SM)

PY37 CADMIUM YELLOW MEDIUM OR DEEP

A bright, strong, orange yellow. Although opaque and possessing excellent covering power, it is strong enough (when unadulterated), to allow for reasonably clear washes when well diluted. There have been moves to ban the use of the Cadmium colours on environmental grounds. If such a ban should come into effect, artists will lose some of the most valuable pigments ever invented. As with other Cadmium Yellows, it is sensitive to a combination of light and moisture.

Absolutely lightfast, PY37 is on the list of pigments approved by the ASTM. An invaluable colour for the discerning artist.

Also known as Aurora Yellow.

L/FAST ASTM I

COMMON NAME

CADMIUM YELLOW MEDIUM OR DEEP

COLOUR INDEX NAME

PY37

COLOUR INDEX NUMBER

77199

CHEMICAL CLASS

CONCENTRATED CADMIUM SULPHIDE (CC) (SM)

PY37:1 CADMIUM-BARIUM YELLOW, MEDIUM OR DEEP

A rich, deep, orange-yellow. Being opaque, PY37:1 has good covering power. Although this is arguably a property more of interest to users of media such as acrylics or oils, it is nevertheless of value to the watercolourist.

There can be occasions where work has to be carefully and delicately painted out. Better to use an opaque colour which will hide others with a relatively thin film. As lightfast and usually as bright as the chemically pure PY37.

Absolutely lightfast and on the list of pigments approved by the ASTM. A reliable colour, well worth any extra cost over inferior deep yellows.

L/FAST ASTM I

COMMON NAME

CADMIUM-BARIUM MEDIUM OR DEEP

COLOUR INDEX NAME

PY37:1

COLOUR INDEX NUMBER

77199:1

CHEMICAL CLASS

CADMIUM SULPHIDE COPRECIPITATED WITH BARIUM SULPHATE (SM)

PY40 AUREOLIN

Aureolin, or Cobalt Yellow as it is sometimes called, is a reliable and very transparent yellow. Fast to light under normal circumstances, it can be affected by weak acids and alkalis. The use of neutral Ph watercolour paper and quality framing will overcome this. If applied heavily it looks hard and leathery, when well diluted it reveals its true beauty and transparency. Fairly high tinting strength, hiding power relatively low.

With an ASTM lightfast rating of II it can be considered amongst the more trustworthy yellow pigments available to the artist.

L/FAST ASTM II

COMMON NAME

AUREOLIN

COLOUR INDEX NAME

PY40

COLOUR INDEX NUMBER

77357

CHEMICAL CLASS

POTASSIUM COBALTINITRITE

PY42 MARS YELLOW

A neutralised or dulled orange yellow, Mars Yellow can be considered to be a synthetic version of naturally occurring Yellow Ochre. High quality grades have very good tinting strength and high covering power.

It is often slightly brighter and stronger than natural Yellow Ochre. It can also be more transparent due to the absence of clay. Inert and compatible with all other pigments, it is a reliable addition to the artists' palette.

Absolutely lightfast, it was rated I after ASTM testing and is on the list of approved pigments.

PY43 YELLOW OCHRE

A soft dull golden yellow which brushes and mixes well.

A naturally occurring iron oxide, Yellow Ochre is considered by many to be less brash than its artificial counterpart, Mars Yellow.

It is one of the oldest known pigments and has been in constant use by artists since the cave painter. Tinting strength and covering power are usually high. The better grades are reasonably transparent.

Absolutely lightfast, a most reliable pigment. Rated I during ASTM testing and on the list of approved pigments.

PY53 NICKEL TITANATE YELLOW

A recently introduced artificial mineral pigment. Being a greenish-yellow it lends itself to the manufacture of 'Lemon Yellows'. Now tested by the ASTM in watercolours, it rated I as it did in oils and acrylics.

It does have a good reputation for lightfastness in both mass tone and tint. Our sample, however, altered very slightly under exposure. Moderately transparent to opaque, with reasonable hiding power. Having a rather weak tinting strength limits its value in mixing.

Although our sample did change very slightly during exposure to light, Nickel Titanate Yellow can be considered to be reliable.

PY55 DIARYLIDE YELLOW PT

Although twice as strong as the Arylides, Diarylide Yellows are significantly less lightfast. Popular in the printing industry where strength of colour is usually more important than permanence, few of the Diarylides can be considered suitable for artistic use. PY55 is a bright orange-yellow of reasonable transparency.

Not yet tested under ASTM conditions as a watercolour. It has a poor reputation for fastness to light. Our sample faded rapidly under exposure, particularly the tint.

Reputation alone makes this a pigment to be wary of. The deterioration of our sample would seem to back this up.

COMMON NAME

DIARYLIDE YELLOW PT

COLOUR INDEX NAME
PY55
COLOUR INDEX NUMBER

21096
CHEMICAL CLASS

BENZIDINE AAPT

PY65 ARYLIDE YELLOW RN

This is a bright orange-yellow with superior lightfastness to its cousin, Arylide Yellow G (PY1). Semi-transparent, it has a useful range of values. This pigment has now been tested under ASTM conditions as a watercolour. When protected by the binder it stood up very well as an acrylic and oil paint, with a rating of I. As a watercolour it rated II.

Our sample started to fade only very slightly towards the end of

the light exposure period which would bear out the rating of II. Also called Hansa Yellow RN.

COMMON NAME

ARYLIDE YELLOW RN

COLOUR INDEX NAME
PY65
COLOUR INDEX NUMBER
11740
CHEMICAL CLASS
MONOARYLIDE OR MONOAZO: ACETOACETYL

PY74LF ARYLIDE YELLOW 5GX

A bright yellow, slightly on the green side. Although usually considered to be semi transparent, this can vary depending on whether filler has been added. There are two versions of PY74, LF and HS. The LF stands for Light Fast and the HS for High Strength, (which is less lightfast). Manufacturers seldom differentiate between the two.

Unless identified you might come across the even less reliable HS version.

Rated ASTM III this pigment can be considered to be less than sound. Also called Hansa Yellow 5GX.

COMMON NAME

ARYLIDE YELLOW 5GX

COLOUR INDEX NAME
PY74LF
COLOUR INDEX NUMBER
11741
CHEMICAL CLASS
MONOARYLIDE OR MONOAZO : ACETOACETYL OR ARYLIDE AAOA

PY81 DIARYLIDE YELLOW H10G

COMMON NAME

DIARYLIDE YELLOW H10G

COLOUR INDEX NAME

PY81

COLOUR INDEX NUMBER

21127

CHEMICAL CLASS

DISAZO TYPE II

A bright semi-opaque greenish yellow, similar in hue to PY3. It is not as lightfast as PY3 but has greater tinting strength. Although in use by manufacturers, this pigment has not yet been subjected to ASTM testing in any media. I cannot offer a lightfast rating until further research has been carried out.

Disazo types are not usually considered to be suitable for use in artists' materials. But when would that factor slow many a manufacturer down when considering its use?

PY83 HR70 DIARYLIDE YELLOW HR70

COMMON NAME

DIARYLIDE YELLOW HR70

COLOUR INDEX NAME

PY83 HR70

COLOUR INDEX NUMBER

21108

CHEMICAL CLASS

DISAZO

This is a very orange yellow of reasonable brightness. PY83 HR70 makes up into a transparent watercolour which is easily clouded by the addition of filler. Not yet tested as a watercolour under ASTM conditions, it rated I in both oils and acrylics. What must be remembered however, is that the pigment is given extra protection by the binder in these media.

Our samples varied, some faded, others resisted the light. This could well be to do with a difference in manufacture.

There are several versions of this pigment. HR70 will be rated WG II for the purposes of this book. Also called Benzide Yellow AAHR.

PY95 DIARYLIDE YELLOW

COMMON NAME

DIARYLIDE YELLOW

COLOUR INDEX NAME

PY95

COLOUR INDEX NUMBER

20034

CHEMICAL CLASS

DISAZO, TYPE 1 DIARYLIDE

An opaque yellow, high in tinting strength, with a definite leaning towards orange. Mainly used in plastics and speciality inks, the pigment has not been tested in any art material under ASTM conditions.

From other test reports, not associated with art materials, it would seem that this pigment might not be suitable for artists' paints.

A lightfast rating cannot be offered until further research has been carried out.

PY97 ARYLIDE YELLOW FGL

Introduced in the 1950's, PY97 has a reputation for being one of the more lightfast of the Arylide Yellows. A bright greenish-yellow, it mixes into clean greens when combined with any of the green-blues. Reasonably strong, it will influence most other colours in a mix.

Being both strong in colour and semi-transparent it provides a useful range of hues. When diluted its strength allows for reasonably clear washes.

Rated II as a watercolour under ASTM controlled lightfast testing. A reliable pigment under normal conditions. Our sample was unaffected by light.

L/FAST ASTM II

COMMON NAME
ARYLIDE YELLOW FGL

COLOUR INDEX NAME
PY97

COLOUR INDEX NUMBER
11767

CHEMICAL CLASS
MONOAZO : ARYLIDE

PY100 TARTRAZINE LAKE

Tartrazine Lake bleached out very early under both ASTM testing and our own. Recognised as having very poor fastness to light and a low tinting strength, one wonders how it ever came to find its way into artists' paints. Amongst other industrial uses it is employed to dye wool, silk, drugs and food.

We might inadvertently eat the substance in our breakfast cereal, but we can choose whether or not to paint with it.

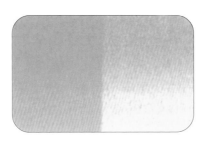

Our sample had changed dramatically after only a very short exposure. An utterly worthless substance as far as the artist is concerned. Parent dye is Acid Yellow 23.

L/FAST ASTM V

COMMON NAME
TARTRAZINE LAKE

COLOUR INDEX NAME
PY100

COLOUR INDEX NUMBER
19140:1

CHEMICAL CLASS
MONOAZO TARTRAZINE

PY108 ANTHRAPYRIMIDINE YELLOW

Available in several versions, the colour varies from a neutral orange-yellow (similar to most

Naples Yellow), to a more brownish yellow. Rarely used in modern watercolours, I could only find one example and that was in a mix. Not yet tested as a watercolour under ASTM conditions, it was rated I when made up into both oil and acrylic paints. PY108 has a very good reputation for lightfastness with good tinting strength.

Our sample was unaffected by light. A reliable colour with little application. The base dye is Vat Yellow 20. Also called Anthra Yellow.

L/FAST W/GUIDE II

COMMON NAME
ANTHRAPYRIMIDINE YELLOW

COLOUR INDEX NAME
PY108

COLOUR INDEX NUMBER
68420

CHEMICAL CLASS
ANTHRAQUINONE

PY110 ISOINDOLINONE YELLOW R

A neutralised or dulled orange-yellow. Transparent washes result when well it is well diluted with water. This is a good example of the protection offered by the binder in other media, which is not available in watercolours. ASTM testing of this pigment gave a rating of I when made up into an oil or acrylic paint, but only rated III as a watercolour. A little violet added to a reliable orange - yellow gives a similar colour. Our sample faded considerably on exposure which would confirm the ASTM rating of III.

Please note: This pigment has, by error now appeared on the ASTM list both as III (not approved) and I (approved). Until clarification I will stay with the original ASTM III given my own findings as back up.

PY119 ZINC IRON YELLOW

A soft brownish-yellow, Zinc Iron Yellow was developed as a heat resistant alternative to the iron oxide yellows.

Opaque, with good covering power it has an excellent reputation for reliability. I have found few examples of its use in artists' watercolours, and then usually employed as a minor ingredient.

Based on our own observations and the reputation of the

pigment, rated WG II pending further testing.

Also called Zinc Ferrite.

PY120 BENZIMIDAZOLONE YELLOW H2G

A semi-opaque yellow, recommended for automobile finishes and commonly used in plastics. As it has not been officially tested in any art material it follows that any manufacturer using it to produce watercolours must have either:

1. Found far more information on this pigment than I and my expert advisor have been able to.

2. Have carried out the common practice of exposing samples in the office window or,

3. Not be concerned as to the possible final outcome.

I am afraid that I cannot offer a lightfast rating.

PY129 AZOMETHINE YELLOW 5GT

A greenish yellow reputed to have good lightfastness and used in the automobile industry. Given an ASTM rating of I in resin-oils but not yet tested in watercolours.

I feel that I cannot offer a rating for lightfastness until full testing has been carried out when made up into a watercolour. As such it will not have the protection offered in the resin-oils test.

This, of course, might not be a problem, but who knows?

PY138 QUINOPHTHALONE YELLOW

PY138 is a bright greenish yellow of reasonable transparency. Introduced in 1974, it is considered to be a high performance pigment. Now tested under ASTM conditions as a watercolour, it was rated II. It had previously received a listing of I in both oil and acrylics.

Our sample faded only very slightly following exposure to light.

PY138 can be considered to be reliable under normal circumstances.

PY139 ISOINDOLINE YELLOW

PY139 is an expensive, high performance yellow introduced in 1979. Normally semi-opaque, an opaque version is available. In hue it is similar to PY34, Chrome Yellow Lemon, and is sometimes used as a replacement for that colorant in artists' paints.

Isoindoline Yellow tested extremely well in all media so far chosen, with a rating of ASTM 1

in acrylics, oils and gouache. With this in mind I will rate it W/Guide II pending ASTM testing.

PY150 NICKEL AZO YELLOW

A yellow which leans very definitely towards green. A particularly reliable pigment as far as its resistance to light is concerned.

Following the stringent tests required for ASTM ratings it was given a listing of I in watercolours, acrylics and oils. The watercolours rating is fairly recent, in previous editions of this book I have rated it W/Guide II.

Has a well deserved place on the ASTM list of approved pigments.

L/FAST ASTM I

COMMON NAME

NICKEL AZO YELLOW

COLOUR INDEX NAME
PY150

COLOUR INDEX NUMBER
12764

CHEMICAL CLASS
MONOAZO: NICKEL COMPLEX OF A PYRIMIDINE DERIVATIVE

PY151 BENZIMIDAZOLONE YELLOW H4G

A semi-opaque greenish yellow with a reputation as a high grade industrial colorant.

Not yet subjected to ASTM testing as a watercolour paint. However, as it rated particularly well in other media, category I in acrylics and oils, I will rate it as WG II for this edition.

This pigment is known under a variety of names such as Highlight Yellow 12305, Hostaperm Yellow H4G, Kenalake Yellow 4GO and Symuler Fast Yellow 4GO.

L/FAST W/GUIDE II

COMMON NAME

**BENZIMIDAZOLONE
YELLOW H4G**

COLOUR INDEX NAME
PY151

COLOUR INDEX NUMBER
13980

CHEMICAL CLASS
MONOAZO: BENZIMIDAZOLONE

PY152 DIARYLIDE YELLOW YR

Diarylide Yellow YR is a dull, opaque yellow with a leaning towards orange.

Not yet tested under ASTM conditions. If it ever is I will predict a finding of V given its reputation. This pigment is well known for its inability to withstand light. In one test it faded as a tint after 10-20 hours of exposure.

PY152 is high in tinting strength, but this factor will be irrelevant when it fades away.

I cannot understand how it ever found its way into artists' watercolours. But then I am not an accountant looking at the bottom line.

L/FAST W/GUIDE II

COMMON NAME

**DIARYLIDE
YELLOW YR**

COLOUR INDEX NAME
PY152

COLOUR INDEX NUMBER
21111

CHEMICAL CLASS
DIAZO: DIARYLIDE

PY153 NICKEL DIOXINE YELLOW

L/FAST ASTM II

A rather bright orange-yellow. Reasonably strong, it washes out to give quite transparent tints. When I compiled previous editions of this book, PY153 has not been tested under ASTM conditions as a watercolour. As an oil and as an acrylic, it did very well with a rating of I. It has now returned a finding of ASTM II as a watercolour.

Sensitive to acids, which is another reason for using a neutral Ph watercolour paper.

Our sample was unaffected by light, supporting the excellent reputation and test results of this pigment.

COMMON NAME

NICKEL DIOXINE YELLOW

COLOUR INDEX NAME
PY153

COLOUR INDEX NUMBER
NA

CHEMICAL CLASS
DIOXINE YELLOW NICKEL COMPLEX

PY154 BENZIMIDAZOLONE YELLOW H3G

L/FAST ASTM I

A bright, reasonably strong yellow, PY154 is semi-opaque, but powerful enough to give a fairly transparent wash when well diluted.

Benzimidazolone Yellows are recently introduced Monoazo compounds and are available in a range of colours, from bright to brownish yellow. Free of heavy metal salts, they are not considered to pose a health hazard.

Rated I in ASTM testing for both oils and acrylics and recently

given a rating of ASTM as a watercolour. In addition to these results, PY154 has an excellent reputation for lightfastness.

COMMON NAME

**BENZIMIDAZOLONE
YELLOW H3G**

COLOUR INDEX NAME
PY154

COLOUR INDEX NUMBER
11781

CHEMICAL CLASS
MONOAZO BENZIMIDAZOLONE

PY155 DIARYLIDE YELLOW

L/FAST ASTM I

A bright, transparent yellow. Available in two particle sizes, the coarser size being more reliable. Not yet tested in any art material. I cannot offer a rating for lightfastness until full testing has been carried out.

Known to be less lightfast that PY97 (ASTM II).

COMMON NAME
DIARYLIDE YELLOW

COLOUR INDEX NAME
PY155

COLOUR INDEX NUMBER
N/A

CHEMICAL CLASS
DISAZO, TYPE 1: DIARYLIDE

PY175 BENZIMIDAZOLONE YELLOW H6G

One of the greenest of all yellows, this variety of Benzimidazolone Yellow is semi-opaque, giving it limited covering power. Pending verifiable test results, I have given a rating of W/Guide II for the purposes of this book.

This assessment is based on the fact that the pigment fared very well as both an acrylic and an oil paint, with ASTM ratings of I in both media.

Hopefully it will have been examined as a watercolour by the time this book is updated.

PY177 IRGAZIN YELLOW 4GT

PY177 is a comparatively new pigment. So far not registered which is why it does not have a Colour Index Number.

A very dull greenish yellow which is reasonably transparent in thin washes. As far as I can ascertain it has yet to be subjected to controlled testing as an artists' paint. No other information seems to be available. Judging solely on the performance of our own sample when tested, I will give a rating of W/Guide II pending possible ASTM testing.

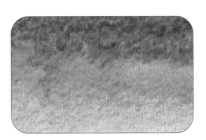

In fact, it should not be 'possible' testing, before using any pigment it should surely be properly examined by an independent body, the ASTM sub committee.

PY184 BISMUTH VANADATE YELLOW

I can find little information on this pigment apart from the fact that it is used in automobile finishes and has been given an ASTM rating of I when made up into an acrylic paint.

Watercolours, without the protection of the binder are more susceptible to damage from exposure to light than other media.

A pigment rated as ASTM I in acrylics might also be given a I as a watercolour, or II or even III.

For this reason I do not feel that I can offer an assessment until further testing has been carried out.

Introducing further colours

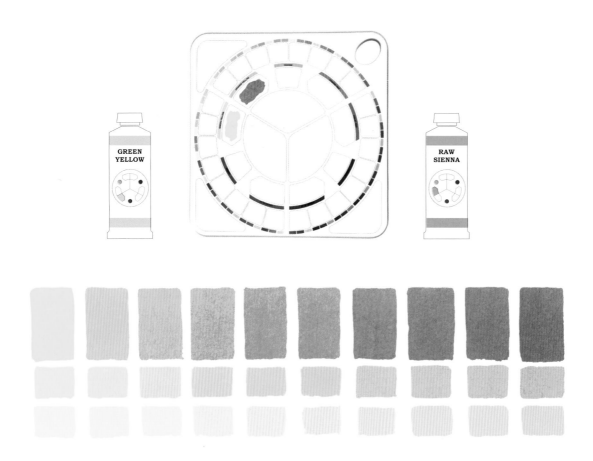

As with the previous exercise, this combination will give an indication of the versatility of the colour.

As soon as you use colours for specific purposes, following their 'colour-type' description, you will find it easy to mix any colour that you wish,

As we are using Raw Sienna as a semi-transparent neutral orange-yellow it follows that we will produce a range of soft, dulled, semi transparent yellows when mixed with Hansa Yellow, our green-yellow. The latter being a semi-transparent green-yellow.

The colour descriptions take a little thinking about at first but it will all come together as you work.

This exercise is intended as an introduction to further experiments and to encourage you to 'think through' a mix before commencing.

You can expect brighter, slightly dulled yellows when Yellow Ochre is used with the green-yellow instead of Raw Sienna. Yellow Ochre being slightly brighter. The mixes will also cover better as Yellow Ochre is more opaque.

If, instead of the green-yellow used above you chose Cadmium Yellow Light with the Raw Sienna, you would produce a range of softened yellows with a definite leaning towards orange.

This of course is because the Cadmium Yellow Light will introduce more orange to the mixes than the Hansa Yellow. Such experiments are worth carrying out.

Yellow Watercolours

Contents

Aureolin ... 55

Cadmium Yellow Light .. 57

Cadmium Yellow (Medium) 60

Cadmium Yellow Deep .. 62

Chrome Yellow .. 65

Chrome Yellow Lemon .. 66

Gamboge.. 66

Indian Yellow.. 69

Lemon Yellow ... 71

Cadmium Yellow Lemon ... 74

Mars Yellow ... 75

Naples Yellow .. 76

Miscellaneous.. 79

Colour Mixing

For the benefit of those who follow my approach to colour mixing, outlined in the book 'Blue and Yellow Don't Make Green', I have included an outline guide with each colour section.

The guide is based on my mixing palette. This will help you to identify colours according to type.

When mixing, 'colour type' is always more important than 'colour name'. See appendix at end of book for further information.

Aureolin

A particularly transparent yellow which takes on a dull leathery appearance when applied heavily. The true beauty is only revealed in thin washes.

Varies in hue between green - yellow and orange yellow, depending on manufacturer.

In either case the bias is only slight. Highly recommended.

AUREOLIN W6

ART SPECTRUM

ARTISTS' WATER COLOUR

Produced from the genuine pigment, this is a reasonably bright, transparent yellow.

The sample handled very well giving smooth, even washes. A staining colour.

PY40 AUREOLIN ASTM II (42)

| PIGMENT DETAIL ON LABEL YES | ASTM II L'FAST | |

AUREOLIN 007

AMERICAN JOURNEY

PROFESSIONAL ARTISTS' WATER COLOR

This should, correctly, be called Aureolin Hue as PY3 has been added.

A transparent, staining colour which washed out very well.

PY40 AUREOLIN ASTM II (42)
PY3 ARYLIDE YELLOW 10G ASTM II (37)

| PIGMENT DETAIL ON LABEL YES | ASTM II L'FAST | |

AUREOLIN (COBALT YELLOW) 006

DANIEL SMITH

EXTRA-FINE WATERCOLORS

A semi transparent, staining colour (ideal for very thin highlights), which gave very smooth washes. A reliable, well made product.

PY40 AUREOLIN ASTM II (42)

| PIGMENT DETAIL ON LABEL YES | ASTM II L'FAST | |

AUREOLIN 39

HOLBEIN

ARTISTS' WATER COLOR

Imitation Aureolin. Less transparent than the genuine article. The word 'Hue' would help with identification. Both pigments are reliable. Semi-transparent, non staining, easy to lift.

PY42 MARS YELLOW ASTM I (43)
PY3 ARYLIDE YELLOW 10G ASTM II (37)

| PIGMENT DETAIL ON LABEL YES | ASTM II L'FAST | |

AUREOLIN 559

SENNELIER

EXTRA-FINE WATERCOLOUR

As with all paints employing this pigment it washes out particularly well but is difficult to use at full strength, very transparent and lightfast. An excellent watercolour.

PY40 AUREOLIN ASTM II (42)

| PIGMENT DETAIL ON LABEL YES | ASTM II L'FAST | |

AUREOLINE 242

TALENS

REMBRANDT

When well made, as this is, and not over-burdened with gum, as some examples are, Aureoline gives reasonable layers even when applied heavily. An excellent product.

PY40 AUREOLIN ASTM II (42)

PIGMENT DETAIL ON LABEL	ASTM	
YES	II L'FAST	

AUREOLIN (MIXTURE) 201

DA VINCI PAINTS

PERMANENT ARTISTS' WATER COLOR

The addition of PY3, an excellent pigment in its own right, moves the colour away from that associated with un-adulterated Aureolin. A reliable, transparent combination.

PY40 AUREOLIN ASTM II (42)
PY3 ARYLIDE YELLOW 10G
ASTM II (37)

PIGMENT DETAIL ON LABEL	ASTM	
YES	II L'FAST	

AUREOLIN 601

DALER ROWNEY

ARTISTS' WATER COLOUR

A particularly transparent, vibrant mid-yellow employing the correct pigment. Sample handled very well giving good range of values and even washes. Transparent, staining.

PY40 AUREOLIN ASTM II (42)

PIGMENT DETAIL ON LABEL	ASTM	
YES	II L'FAST	

AUREOLIN 016

WINSOR & NEWTON

ARTISTS' WATER COLOUR

The correct pigment, PY40, ensures particularly transparent, clean tints. Brushed out very smoothly when thinly applied. Rather heavy going when laid on at all heavily. Transparent and staining.

PY40 AUREOLIN ASTM II (42)

PIGMENT DETAIL ON LABEL	ASTM	
YES	II L'FAST	

AUREOLIN 511

CARAN D'ACHE

FINEST WATER COLOUR

The paint lifted with ease from the pan and washed well.

The genuine pigment gives very clear washes which will resist fading. A well made product.

PY40 AUREOLIN ASTM II (42)

PIGMENT DETAIL ON LABEL	ASTM	
YES	II L'FAST	

AUREOLIN MODERN 208

SCHMINCKE

HORADAM FINEST ARTISTS' WATER COLOURS

A greenish, semi-transparent yellow giving very smooth, even washes. Not yet subjected to ASTM testing as a watercolour but rated I in oils and acrylics. Previously called Aureolin Hue.

PY151 BENZIMIDAZOLONE YELLOW H4G WG II (49)

PIGMENT DETAIL ON LABEL	WG	
YES	II L'FAST	

COBALT (AUREOLIN) YELLOW LAKE 119

OLD HOLLAND

CLASSIC WATERCOLOURS

Sample provided was little more than coloured gum. Only light washes were possible.

Assessments are not offered.

PY40 AUREOLIN ASTM II (42)

PIGMENT DETAIL ON LABEL	ASTM	RATING
CHEMICAL MAKE UP ONLY	II L'FAST	

Cadmium Yellow Light

A clean, strong, bright yellow with a bias towards green, although it can be rather orange, depending on manufacturer. Opaque, with good covering power, its strength does allow for its use in very thin washes. A fine yellow, with a very useful range of application. It is justifiably considered by many artists to be the most important light yellow of the palette. Be wary of imitations, they are not always described correctly.

For mixing purposes it is important to first establish the bias or leaning of the yellow you have. (Information on deciding bias is given on page 89). If the leaning is towards green, the yellow will give bright greens with a green-blue such as Cerulean Blue. Oranges will always be dull with any red. If the bias is towards orange-expect bright oranges with an orange-red and dull greens with any blue.

CADMIUM YELLOW LIGHT 126

UTRECHT

PROFESSIONAL ARTISTS' WATER COLOR

A fine, strong yellow with a bias towards orange. PY37 is lightfast but can be damaged if exposed to moisture as well as light.

PY37 CADMIUM YELLOW MEDIUM OR DEEP ASTM I (42)		
PIGMENT DETAIL ON LABEL YES	ASTM I L'FAST	

CADMIUM YELLOW PALE 118

WINSOR & NEWTON

ARTISTS' WATER COLOUR

An excellent mid yellow which is absolutely lightfast.

Brushed out particularly well giving a good range of values. Bright and strong. Opaque.

PY35 CADMIUM YELLOW LIGHT ASTM I (41)		
PIGMENT DETAIL ON LABEL YES	ASTM I L'FAST	

CADMIUM YELLOW LIGHT 113 (USA ONLY)

WINSOR & NEWTON

COTMAN WATER COLOURS 2ND RANGE

It is unusual to see such an excellent pigment used in other than 'Artists' Quality'. Brushed out particularly well. Opaque.

PY35 CADMIUM YELLOW LIGHT ASTM I (41)		
PIGMENT DETAIL ON LABEL YES	ASTM I L'FAST	

CADMIUM YELLOW PALE HUE 119 (308)

WINSOR & NEWTON

COTMAN WATER COLOURS 2ND RANGE

The pigment failed ASTM testing. Most unreliable, particularly when thin. The USA version is far superior in this range. Transparent.

Reformulated>

PY1 ARYLIDE YELLOW G ASTM V (37)		
PIGMENT DETAIL ON LABEL YES	ASTM V L'FAST	RATING ★

CADMIUM YELLOW PALE HUE 119

WINSOR & NEWTON

COTMAN WATER COLOURS 2ND RANGE

Handled far better in medium to thin applications as the paint appeared to be somewhat over bound.

PY175 BENZIMIDAZOLONE YELLOW H6G WG II (51) PY65 ARYLIDE YELLOW RN ASTM II (44)		
PIGMENT DETAIL ON LABEL YES	ASTM II L'FAST	RATING ★ ★★

CADMIUM YELLOW LIGHT 224

SCHMINCKE

HORADAM FINEST ARTISTS' WATER COLOURS

Slightly on the orange side. Brushed out very well over a good range of values. Possesses good covering and tinting strength. Opaque. Recommended.

PY35 CADMIUM YELLOW LIGHT ASTM I (41)		
PIGMENT DETAIL ON LABEL YES	ASTM I L'FAST	

CADMIUM YELLOW PALE 611

DALER ROWNEY

ARTISTS' WATER COLOUR

Highly recommended. This paint brushes out into excellent gradated washes.

Strong, vibrant and absolutely lightfast. Opaque.

Reformulated>

PY37 CADMIUM YELLOW MEDIUM OR DEEP ASTM I (42)		
PIGMENT DETAIL ON LABEL YES	ASTM I L'FAST	

CADMIUM YELLOW PALE 611

DALER ROWNEY

ARTISTS' WATER COLOUR

A well made watercolour. Very smooth washes running effortlessly from one value to the next.

An excellent, reliable product.

PY35 CADMIUM YELLOW LIGHT ASTM I (41)		
PIGMENT DETAIL ON LABEL NO	ASTM I L'FAST	

CADMIUM YELLOW PALE W2

ART SPECTRUM

ARTISTS' WATER COLOUR

Good, smooth even washes. Sample was slightly gummy but handled well.

A strong, dependable colour.

PY35 CADMIUM YELLOW LIGHT ASTM I (41)		
PIGMENT DETAIL ON LABEL YES	ASTM I L'FAST	RATING ★ ★★

CADMIUM YELLOW LIGHT (AZO) 213

TALENS

As the PY74 is not specified LF (Lightfast) or HS (High Strength) I am assuming the latter. Brushed out well. Semi-opaque.

Range discontinued.

PY74LF ARYLIDE YELLOW 5GX
ASTM III (44)
PW4 ZINC WHITE ASTM I (384)
PY3 ARYLIDE YELLOW 10G ASTM II (37)

WATER COLOUR 2ND RANGE

| PIGMENT DETAIL ON LABEL YES | ASTM III L'FAST | RATING ★★ |

CADMIUM YELLOW LIGHT 208

TALENS

A bright, strong orange yellow which handled very well.

Previously contained PO20, Cadmium Orange. An absolutely lightfast watercolour. Opaque.

PY35 CADMIUM YELLOW LIGHT
ASTM I (41)

REMBRANDT

| PIGMENT DETAIL ON LABEL YES | ASTM I L'FAST | |

CADMIUM YELLOW LIGHT 11

OLD HOLLAND

A most reliable pigment which will not change on exposure. Brushed out well despite being rather gummy, dries to a shine when heavy due to excess of gum. Opaque.

PY37 CADMIUM YELLOW MEDIUM
OR DEEP ASTM I (42)

CLASSIC WATERCOLOURS

| PIGMENT DETAIL ON LABEL CHEMICAL MAKE UP ONLY | ASTM I L'FAST | RATING ★★ |

CADMIUM YELLOW LIGHT 529

SENNELIER

Quality ingredients giving an excellent yellow.

Strong, bright and brushes out very well giving a good range of values. Opaque.

PY35 CADMIUM YELLOW LIGHT
ASTM I (41)

EXTRA-FINE WATERCOLOUR

| PIGMENT DETAIL ON LABEL YES | ASTM I L'FAST | |

CADMIUM YELLOW LIGHT 158

LEFRANC & BOURGEOIS

Washes out very well. Strong enough to be reasonably transparent in tints. Ideal pigment used, but this was not clear on the label. An excellent watercolour. Opaque.

PY35 CADMIUM YELLOW LIGHT
ASTM I (41)

LINEL EXTRA-FINE ARTISTS' WATERCOLOUR

| PIGMENT DETAIL ON LABEL CHEMICAL MAKE UP ONLY | ASTM I L'FAST | |

LIGHT CADMIUM YELLOW 332

PÈBÈO

Brushed out particularly well giving good gradated washes.

Pigment absolutely lightfast. A highly recommended, reliable orange-yellow.

PY35 CADMIUM YELLOW LIGHT
ASTM I (41)

FRAGONARD ARTISTS' WATER COLOUR

| PIGMENT DETAIL ON LABEL YES | ASTM I L'FAST | |

CADMIUM YELLOW PALE 41

HOLBEIN

Ideal ingredient. PY37 will not change on exposure to light.

An intense, none staining, opaque yellow which handled very well.

PY37 CADMIUM YELLOW MEDIUM
OR DEEP ASTM I (42)

ARTISTS' WATER COLOR

| PIGMENT DETAIL ON LABEL YES | ASTM I L'FAST | |

CADMIUM YELLOW LIGHT 42

HOLBEIN

An excellent watercolour. Brushed out very smoothly. Most reliable pigment, unaffected by light. Opaque and non staining.

PY37 CADMIUM YELLOW MEDIUM
OR DEEP ASTM I (42)

ARTISTS' WATER COLOR

| PIGMENT DETAIL ON LABEL YES | ASTM I L'FAST | |

CADMIUM YELLOW LIGHT 081

MAIMERI

Absolutely lightfast. Well ground and brushes out well. Reasonably transparent when diluted. A superb watercolour, highly recommended.

PY35 CADMIUM YELLOW LIGHT
ASTM I (41)

MAIMERIBLU SUPERIOR WATERCOLOURS

| PIGMENT DETAIL ON LABEL YES | ASTM I L'FAST | |

CADMIUM YELLOW LIGHT 070

M.GRAHAM & CO.

This is a very well made product which brushed out beautifully.

To my mind PY35 is the ideal orange yellow by a long way.

PY35 CADMIUM YELLOW LIGHT
ASTM I (41)

ARTISTS' WATERCOLOR

| PIGMENT DETAIL ON LABEL YES | ASTM I L'FAST | |

CADMIUM YELLOW LIGHT 1026

LUKAS

A strong, opaque, orange-yellow. PY37 is a very reliable pigment which is unaffected by light. Brushes out very smoothly giving excellent washes.

PY37 CADMIUM YELLOW MEDIUM
OR DEEP ASTM I (42)

ARTISTS' WATER COLOUR

| PIGMENT DETAIL ON LABEL CHEMICAL MAKE UP ONLY | ASTM I L'FAST | |

CADMIUM YELLOW LIGHT 515

MIR (JAURENA S.A)

Washed out into a series of values with extreme ease, A quality product employing a quality pigment.

Opaque, bright and strong.

PY35 CADMIUM YELLOW LIGHT
ASTM I (41)

ACUARELA

| PIGMENT DETAIL ON LABEL YES | ASTM I L'FAST | |

CADMIUM YELLOW LIGHTEST 2208

UMTON BARVY

The paint lifted with ease from the pan and handled very well.

Reliable, quality pigment used. A first class product.

ARTISTIC WATER COLOR

PY37 CADMIUM YELLOW MEDIUM OR DEEP ASTM I (42)		
PIGMENT DETAIL ON LABEL **NO**	ASTM **I** L'FAST	

CADMIUM YELLOW LIGHT 2209

UMTON BARVY

A paint which washes out very well over a useful range. Absolutely lightfast.

Closer in hue to PY35 Cadmium Yellow Light.

ARTISTIC WATER COLOR

PY37 CADMIUM YELLOW MEDIUM OR DEEP ASTM I (42)		
PIGMENT DETAIL ON LABEL **NO**	ASTM **I** L'FAST	

LIGHT CADMIUM YELLOW 51

CARAN D'ACHE

The paint lifted easily from the surface of the pan and handled very well. Although many look for 'semi moist' pans, (which these are not), the addition of a component to attract moisture will continue to do so (towards the painting), if the paint is applied heavily.

FINEST WATERCOLOURS

PY37 CADMIUM YELLOW MEDIUM OR DEEP ASTM I (42)		
PIGMENT DETAIL ON LABEL **YES**	ASTM **I** L'FAST	

CADMIUM YELLOW PALE HUE A036

GRUMBACHER

Sample not supplied

The inclusion of PY1, has led to the low lightfast rating. The word hue in the name indicates that this is not genuine Cadmium Yellow.

ACADEMY ARTISTS' WATERCOLOR 2ND RANGE

PY1 ARYLIDE YELLOW G ASTM V (37) PY3 ARYLIDE YELLOW 10G ASTM II (37)		
PIGMENT DETAIL ON LABEL **YES**	ASTM **V** L'FAST	RATING ★

CADMIUM YELLOW LIGHT 033

GRUMBACHER

The inclusion of a little PO20 takes the colour towards orange.

Both pigments particularly reliable. Handles very well over a good range. Opaque.

FINEST ARTISTS' WATER COLOR

PY35 CADMIUM YELLOW LIGHT ASTM I (41) PO20 CADMIUM ORANGE ASTM I (94)		
PIGMENT DETAIL ON LABEL **YES**	ASTM **I** L'FAST	

CADMIUM YELLOW LIGHT

HUNTS

As bright and certainly as lightfast as the chemically pure Cadmium Yellows. Brushed out smoothly. Recommended.

Discontinued

SPEEDBALL PROFESSIONAL WATERCOLOURS

CADMIUM SULPHIDE COPRECIPITATED WITH BARIUM SULPHATE		
PIGMENT DETAIL ON LABEL **NO**	ASTM **I** L'FAST	

CADMIUM YELLOW LIGHT 217

DA VINCI PAINTS

Brushed out particularly well over a good range, giving smooth gradated washes.

Absolutely lightfast. Highly recommended, an excellent, watercolour. Opaque.

PERMANENT ARTISTS' WATER COLOR

PY35 CADMIUM YELLOW LIGHT ASTM I (41)		
PIGMENT DETAIL ON LABEL **YES**	ASTM **I** L'FAST	

CADMIUM YELLOW LIGHT (HUE) 617

DA VINCI PAINTS

Correctly named as a 'Hue'. This is a vital aspect of correct labelling as it makes clear that the paint is an imitation. Handled very well across a useful range.

SCUOLA 2ND RANGE

PY97 ARYLIDE YELLOW FGL ASTM II (46) PO62 BENZIMIDAZOLONE ORANGE H5G ASTM II (97)		
PIGMENT DETAIL ON LABEL **YES**	ASTM **II** L'FAST	

CADMIUM YELLOW LIGHT 018

DANIEL SMITH

PY35 is a superb pigment. It is absolutely lightfast under normal conditions but can fade when exposed to both light and humidity.

This is an excellent watercolour paint.

EXTRA-FINE WATERCOLORS

PY35 CADMIUM YELLOW LIGHT ASTM I (41)		
PIGMENT DETAIL ON LABEL **YES**	ASTM **I** L'FAST	

CADMIUM YELLOW LIGHT 034

AMERICAN JOURNEY

Smooth, very even washes, strength of colour and resistance to damage from the light. What else could you wish for?

PROFESSIONAL ARTISTS' WATER COLOR

PY35 CADMIUM YELLOW LIGHT ASTM I (41)		
PIGMENT DETAIL ON LABEL **YES**	ASTM **I** L'FAST	

Cadmium Yellow (Medium)

A clean, strong, bright orange - yellow. As with the other Cadmiums it is valued for its opacity. Its strength of colour does allow for its use in thin washes however. Although permanent, it is susceptible to damp and will fade when exposed to light in a humid atmosphere. Will give bright oranges when mixed with an orange - red such as Cadmium Red Light and dull greens with any blue.

Due to environmental and health concerns, legislation might well remove the Cadmiums from circulation. They will be difficult to replace.

CADMIUM YELLOW MEDIUM 016

DANIEL SMITH

A very made product. Described by the company as semi-transparent. Such descriptions tend to vary. When applied heavily this is an opaque colour. As the paint is thinned, its very strength allows for fairly clear washes.

EXTRA-FINE WATERCOLORS

PY35 CADMIUM YELLOW LIGHT
ASTM I (41)

PIGMENT DETAIL ON LABEL: YES | ASTM I L'FAST

CADMIUM YELLOW MEDIUM 031

AMERICAN JOURNEY

It is good to see that this company has resisted what is a great temptation to them elsewhere in the range. That is, to use very fanciful names to describe their colours. A well made product.

PROFESSIONAL ARTISTS' WATER COLOR

PY35 CADMIUM YELLOW LIGHT
ASTM I (41)

PIGMENT DETAIL ON LABEL: YES | ASTM I L'FAST

CADMIUM YELLOW 060

M.GRAHAM & CO.

The sample handled very well, from rich opaque layers to relatively clear thin washes. An excellent product.

ARTISTS' WATERCOLOR

PY35 CADMIUM YELLOW LIGHT
ASTM I (41)

PIGMENT DETAIL ON LABEL: YES | ASTM I L'FAST

CADMIUM YELLOW MEDIUM 216

DA VINCI PAINTS

A well produced colour which handles smoothly over a good range of values.

Opaque, bright and fast to light. Non bleeding. An excellent all round watercolour.

PERMANENT ARTISTS' WATER COLOR

PY35 CADMIUM YELLOW LIGHT
ASTM I (41)

PIGMENT DETAIL ON LABEL: YES | ASTM I L'FAST

CADMIUM YELLOW MIDDLE 225

SCHMINCKE

Pigment was recently changed from PY37:1 to the chemically pure Cadmium Yellow Light, PY35.

Brushed out particularly well. Opaque.

HORADAM FINEST ARTISTS' WATER COLOURS

PY35 CADMIUM YELLOW LIGHT
ASTM I (41)

PIGMENT DETAIL ON LABEL: YES | ASTM I L'FAST

CADMIUM YELLOW 108

WINSOR & NEWTON

Strong, bright, good covering power and completely fast to light. Ideal pigment used. Handles very well. Opaque.

Reformulated >

ARTISTS' WATER COLOUR

PY35 CADMIUM YELLOW LIGHT
ASTM I (41)

PIGMENT DETAIL ON LABEL: YES | ASTM I L'FAST

CADMIUM YELLOW 108

WINSOR & NEWTON

As soon as the loaded brush touched the damp paper the paint started to spread. An excellent product. Lightfast, bright and strong.

ARTISTS' WATER COLOUR

PY35 CADMIUM YELLOW LIGHT
ASTM I (41)
PO20 CADMIUM ORANGE
ASTM I (94)

PIGMENT DETAIL ON LABEL: YES | ASTM I L'FAST

CADMIUM YELLOW HUE 109 (307)

WINSOR & NEWTON

Both pigments failed ASTM testing. Reliable, low cost alternatives are available for second range colours. Semi-transparent.

Reformulated >

COTMAN WATER COLOURS 2ND RANGE

PY1 ARYLIDE YELLOW G
ASTM V (37)
PO13 PYRAZOLONE ORANGE
ASTM V (94)

PIGMENT DETAIL ON LABEL: YES | ASTM V L'FAST | RATING ★

CADMIUM YELLOW HUE 109

WINSOR & NEWTON

Sample gave very smooth, even washes with absolute ease. A reliable watercolour paint correctly labelled as a 'Hue'.

COTMAN WATER COLOURS 2ND RANGE

PY97 ARYLIDE YELLOW FGL
ASTM II (46)
PY65 ARYLIDE YELLOW RN
ASTM II (44)

PIGMENT DETAIL ON LABEL: YES | ASTM II L'FAST

CADMIUM YELLOW 108 (USA ONLY)

WINSOR & NEWTON

COTMAN WATER COLOURS 2ND RANGE

As far as the pigment is concerned, superior to the equivalent colour marketed outside of the USA. Why should this be?

Excellent pigment, absolutely lightfast. Well labelled. Opaque.

PY35 CADMIUM YELLOW LIGHT ASTM I (41)

PIGMENT DETAIL ON LABEL	ASTM	
YES	I L'FAST	

MIDDLE CADMIUM YELLOW 520

CARAN D'ACHE

FINEST WATERCOLOURS

Although I would not describe this as a 'semi moist' colour, the paint lifted very well, and with ease. This is a well made product which will not let you down.

PY35 CADMIUM YELLOW LIGHT ASTM I (41)

PIGMENT DETAIL ON LABEL	ASTM	
YES	I L'FAST	

GOLDEN CADMIUM YELLOW 530

CARAN D'ACHE

FINEST WATERCOLOURS

A strong yellow with a pronounced leaning towards orange. Far more so than PY35 alone would normally appear. An addition of PY37 perhaps?

PY35 CADMIUM YELLOW LIGHT ASTM I (41)

PIGMENT DETAIL ON LABEL	ASTM	
YES	I L'FAST	

CADMIUM YELLOW MEDIUM W034

GRUMBACHER

FINEST ARTISTS' WATER COLOR

The inclusion of Cadmium Orange takes the colour towards Cadmium Yellow Deep. Washes well. Most dependable orange yellow. Opaque.

PY35 CADMIUM YELLOW LIGHT ASTM I (41)
PO20 CADMIUM ORANGE ASTM I (94)

PIGMENT DETAIL ON LABEL	ASTM	
YES	I L'FAST	

CADMIUM YELLOW MEDIUM A034 HUE

GRUMBACHER

ACADEMY ARTISTS' WATERCOLOR 2ND RANGE

Both the PO1 and the PY1 are particularly fugitive. Alternative, low cost pigments for students' work are available. Most unreliable. Transparent.

Reformulated >

PO1 HANSA ORANGE WG V (94)
PY1 ARYLIDE YELLOW G ASTM V (37)
PY3 ARYLIDE YELLOW 10G ASTM II (37)

PIGMENT DETAIL ON LABEL	ASTM	RATING
YES	V L'FAST	★

CADMIUM YELLOW MEDIUM HUE

GRUMBACHER

ACADEMY ARTISTS' WATERCOLOR 2ND RANGE

Correctly named as a 'Hue' this imitation will not have the same characteristics as the genuine article but it at least it will be lightfast. Handled very well.

PY3 ARYLIDE YELLOW 10G ASTM II (37)
PY65 ARYLIDE YELLOW RN ASTM II (44)

PIGMENT DETAIL ON LABEL	ASTM	
YES	II L'FAST	

CADMIUM YELLOW MEDIUM 271

TALENS

REMBRANDT ARTISTS' QUALITY EXTRA FINE

A very dependable, well made product. Only the determined manufacturer will make a bad job of converting this excellent pigment into a watercolour.

PY35 CADMIUM YELLOW LIGHT ASTM I (41)

PIGMENT DETAIL ON LABEL	ASTM	
YES	I L'FAST	

CADMIUM YELLOW 209

TALENS

REMBRANDT ARTISTS' QUALITY EXTRA FINE

Strong, bright and produced from a first class pigment.

Handles very well giving good washes.

Dependable. Opaque.

Discontinued

PY35 CADMIUM YELLOW LIGHT ASTM I (41)
PO20 CADMIUM ORANGE ASTM I (94)

PIGMENT DETAIL ON LABEL	ASTM	
YES	I L'FAST	

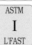

CADMIUM YELLOW 002

ST. PETERSBURG

ARTISTS' WATERCOLOURS

I cannot offer any assessments as I do not have a clue as to the ingredients.

Neither do the distributors, despite the hype in their literature.

INFORMATION ON THE PIGMENTS USED KEPT FROM THE ARTIST AS A MATTER OF COMPANY POLICY

PIGMENT DETAIL ON LABEL	ASTM	RATING
NO	L'FAST	

CADMIUM YELLOW MEDIUM 13

OLD HOLLAND

CLASSIC WATERCOLOURS

Excellent pigment. The sample was strong, bright and washed out very smoothly despite being a little over bound. Opaque.

PY37 CADMIUM YELLOW MEDIUM OR DEEP ASTM I (42)

PIGMENT DETAIL ON LABEL	ASTM	RATING
CHEMICAL MAKE UP ONLY	I L'FAST	★ ★★

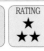

CADMIUM YELLOW MIDDLE 2100

UMTON BARVY

ARTISTIC WATER COLOR

A very well produced pan colour which allowed easy lifting of the paint. Washed out beautifully.

An excellent product.

PY37 CADMIUM YELLOW MEDIUM OR DEEP ASTM I (42)

PIGMENT DETAIL ON LABEL	ASTM	
NO	I L'FAST	

CADMIUM YELLOW MEDIUM 5711

HUNTS

SPEEDBALL PROFESSIONAL WATERCOLOURS

Ingredients are as lightfast as the chemically pure Cadmium Yellows. Strong, bright and opaque.

As with all of their Cadmiums, this colour is now discontinued.

CADMIUM SULPHIDE COPRECIPITATED WITH BARIUM SULFIDE

PIGMENT DETAIL ON LABEL	ASTM	
NO	I L'FAST	

CADMIUM YELLOW MEDIUM 159

LEFRANC & BOURGEOIS

LINEL EXTRA-FINE ARTISTS' WATERCOLOUR

A first rate watercolour which handled particularly well, giving smooth washes. Excellent pigment, strong, bright and reliable. Was previously PY37. Opaque.

PY35 CADMIUM YELLOW LIGHT
ASTM I (41)

| PIGMENT DETAIL ON LABEL CHEMICAL MAKE UP ONLY | ASTM **I** L'FAST | |

CADMIUM YELLOW 612

DALER ROWNEY

ARTISTS' WATER COLOUR

First rate pigment used which is completely unaffected by light. Brushes well giving good range of values. Pigment was previously PY37, which is also excellent.

PY35 CADMIUM YELLOW LIGHT
ASTM I (41)

| PIGMENT DETAIL ON LABEL YES | ASTM **I** L'FAST | |

CADMIUM YELLOW (HUE) 620.

DALER ROWNEY

ARTISTS' WATER COLOUR

An imitation which employs the unreliable PY74LF.

This company will certainly be aware of the ASTM lightfast test results.

PY74LF ARYLIDE YELLOW 5GX
ASTM III (44)
PY153 NICKEL DIOXINE YELLOW
ASTM II (50)

| PIGMENT DETAIL ON LABEL YES | ASTM **III** L'FAST | RATING ★★ |

CADMIUM YELLOW (HUE)

DALER ROWNEY

GEORGIAN WATER COLOUR 2ND RANGE

I can see no reason why students' colours should be so fugitive. Reliable alternatives are available.

Brushed out poorly. Transparent.

PY1 ARYLIDE YELLOW G
ASTM V (37)

| PIGMENT DETAIL ON LABEL NO | ASTM **V** L'FAST | RATING ★ |

CADMIUM YELLOW W4

ART SPECTRUM

ARTISTS' WATER COLOUR

An opaque, staining colour which handled beautifully. The word 'staining' puts many painters off. It should not do so as it is a factor easily taken into account, and can be used to advantage (creating highlights for example).

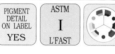
PY37 CADMIUM YELLOW MEDIUM OR DEEP ASTM I (42)

| PIGMENT DETAIL ON LABEL YES | ASTM **I** L'FAST | 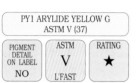 |

All Cadmium Yellows are prone to fade if exposed to light in a humid atmosphere.

Cadmium Yellow Deep

A very definite orange-yellow. Will give bright oranges when mixed with an orange-red such as Cadmium Red Light, mid greens with a green blue and dull greens when mixed with Ultramarine, a violet-blue.

Strong, opaque and absolutely lightfast. An invaluable colour. Beware of poorly labelled imitations.

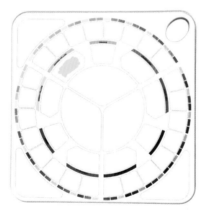

CADMIUM YELLOW DEEP 111

WINSOR & NEWTON

ARTISTS' WATER COLOUR

Both pigments are equally lightfast and opaque. When applied thinly is reasonably transparent due to its strength. Staining and opaque. Dependable.

PY35 CADMIUM YELLOW LIGHT
ASTM I (41)
PY108 ANTHRAPYRIMIDINE
YELLOW WG II (46)

| PIGMENT DETAIL ON LABEL YES | WG **II** L'FAST | |

CADMIUM YELLOW DEEP (AZO) 215

TALENS

WATER COLOUR 2ND RANGE

The red content will fade rapidly followed closely by the yellow. Most unreliable. A rather dull, brownish yellow.

Range discontinued

PY74LF ARYLIDE YELLOW 5GX
ASTM III (44)
PR4 CHOLINATED PARA RED
WG V (115)

| PIGMENT DETAIL ON LABEL YES | WG **V** L'FAST | RATING ★ |

CADMIUM YELLOW DEEP 210

TALENS

REMBRANDT ARTISTS' QUALITY EXTRA FINE

Dense pigment, well ground. Handles particularly well across the range of washes.

A strong, bright, reliable opaque watercolour.

PY35 CADMIUM YELLOW LIGHT
ASTM I (41)
PO20 CADMIUM ORANGE
ASTM I (94)

| PIGMENT DETAIL ON LABEL YES | ASTM **I** L'FAST | |

CADMIUM YELLOW DEEP

UTRECHT

PROFESSIONAL ARTISTS' WATER COLOR

There might be some confusion here. The tube gives the pigment as PY37 but the literature states PO20. Either way the paint will be absolutely lightfast.

PO20 CADMIUM ORANGE
ASTM I (94)

| PIGMENT DETAIL ON LABEL YES | ASTM **I** L'FAST | |

CADMIUM YELLOW DEEP 226

SCHMINCKE

HORADAM
FINEST
ARTISTS'
WATER COLOURS

Pigment was previously changed from PY37:1 to the chemically pure Cadmium Yellow Light. Washes out very well. Absolutely lightfast.

Reformulated >

PY35 CADMIUM YELLOW LIGHT
ASTM I (41)

PIGMENT DETAIL ON LABEL	ASTM	
YES	I L'FAST	

CADMIUM YELLOW DEEP 226

SCHMINCKE

HORADAM
FINEST
ARTISTS'
WATER COLOURS

Gave a beautiful series of washes. A well balanced watercolour paint, such as this is, should flow from the brush on to dampened paper with ease.

PY35 CADMIUM YELLOW LIGHT
ASTM I (41)
PO20 CADMIUM ORANGE
ASTM I (94)

PIGMENT DETAIL ON LABEL	ASTM	
YES	I L'FAST	

CADMIUM YELLOW DEEP 533

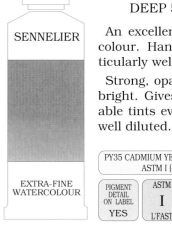

SENNELIER

EXTRA-FINE
WATERCOLOUR

An excellent watercolour. Handles particularly well.

Strong, opaque and bright. Gives reasonable tints even when well diluted.

PY35 CADMIUM YELLOW LIGHT
ASTM I (41)

PIGMENT DETAIL ON LABEL	ASTM	
YES	I L'FAST	

CADMIUM YELLOW DEEP W031

GRUMBACHER

FINEST
ARTISTS'
WATER COLOR

Produced using two absolutely lightfast ingredients, very similar chemically. Brushes out very well.

An excellent watercolour. Opaque.

PY35 CADMIUM YELLOW LIGHT
ASTM I (41)
PO20 CADMIUM ORANGE ASTM I
(94)

PIGMENT DETAIL ON LABEL	ASTM	
YES	I L'FAST	

CADMIUM YELLOW DEEP HUE 031

GRUMBACHER

ACADEMY
ARTISTS'
WATERCOLOR
2ND RANGE

As with many second range, or student colours, it would be better to buy the artists quality as far as value for money is concerned.

Reformulated >

PY1 ARYLIDE YELLOW G
ASTM V (37)
PO1 HANSA ORANGE
ASTM V (94)

PIGMENT DETAIL ON LABEL	ASTM	RATING
YES	V L'FAST	★

CADMIUM YELLOW DEEP HUE

GRUMBACHER

ACADEMY
ARTISTS'
WATERCOLOR
2ND RANGE

Correctly named as a 'Hue' or imitation. Reliable pigments have been used, which is not always the case with 2nd range colours.

PY65 ARYLIDE YELLOW RN
ASTM II (44)
PY97 ARYLIDE YELLOW FGL
ASTM II (46)

PIGMENT DETAIL ON LABEL	ASTM	
YES	II L'FAST	

CADMIUM YELLOW DEEP 017

DANIEL
SMITH

EXTRA-FINE
WATERCOLORS

A typical example of this pigment when made up carefully into a paint. Strong, and dependable.

A well made product which will not fail you.

PY37 CADMIUM YELLOW MEDIUM OR
DEEP ASTM I (42)

PIGMENT DETAIL ON LABEL	ASTM	
YES	I L'FAST	

CADMIUM YELLOW DEEP W5

ART
SPECTRUM

ARTISTS'
WATER COLOUR

This is an excellent product which brushed well.

As with all colours, I suggest that before purchasing you know exactly what pigments have been used and whether or not they have bee tested under ASTM conditions.

PO20 CADMIUM ORANGE
ASTM I (94)

PIGMENT DETAIL ON LABEL	ASTM	
YES	I L'FAST	

CADMIUM YELLOW DEEP HUE 510

MIR
(JAURENA S.A)

ACUARELA

A bright, reliable imitation which resembles genuine Cadmium Yellow Deep quite closely. Sample brushed out very well.

PY83HR70 DIARYLIDE YELLOW
HR70 WG II (45)

PIGMENT DETAIL ON LABEL	WG	
YES	II L'FAST	

CADMIUM YELLOW DEEP 613

DALER
ROWNEY

ARTISTS'
WATER COLOUR

A strong, bright opaque orange-yellow which brushed out very well over a useful range of values.

Densely packed pigment. Recommended.

PY35 CADMIUM YELLOW LIGHT
ASTM I (41)
PO20 CADMIUM ORANGE ASTM I
(94)

PIGMENT DETAIL ON LABEL	ASTM	
YES	I L'FAST	

CADMIUM YELLOW DEEP (HUE) 618

DALER
ROWNEY

ARTISTS'
WATER COLOUR

A bright orange yellow without quite the depth of the colour it is imitating.

Reliable pigments have been used.

PY3 ARYLIDE YELLOW 10G
ASTM II (37)
PY65 ARYLIDE YELLOW RN
ASTM II (44)

PIGMENT DETAIL ON LABEL	ASTM	
YES	II L'FAST	

CADMIUM YELLOW DEEP 084

MAIMERI

MAIMERIBLU
SUPERIOR
WATERCOLOURS

Densely packed, genuine pigment. The paint brushes out beautifully giving very even washes.

A most reliable watercolour. Opaque.

PY35 CADMIUM YELLOW LIGHT
ASTM I (41)

PIGMENT DETAIL ON LABEL	ASTM	
YES	I L'FAST	

CADMIUM YELLOW DEEP 16

OLD HOLLAND

CLASSIC WATERCOLOURS

A well made water-colour. Dense pigment, a well produced paint. Handles particularly smoothly. Strong, opaque and particularly lightfast.

PY37 CADMIUM YELLOW MEDIUM OR DEEP ASTM I (42)

PIGMENT DETAIL ON LABEL CHEMICAL MAKE UP ONLY | ASTM I L'FAST |

CADMIUM YELLOW EXTRA-DEEP 139

OLD HOLLAND

CLASSIC WATERCOLOURS

Despite the title this is not an extra deep version of Cadmium Yellow, it is Cadmium Orange. Such descriptions do not help to unravel the confusion which still surrounds the naming of artists colour. Brushed out smoothly, well made and reliable.

PO20 CADMIUM ORANGE ASTM I (94)

PIGMENT DETAIL ON LABEL CHEMICAL MAKE UP ONLY | ASTM I L'FAST |

CADMIUM YELLOW DEEP 160

LEFRANC & BOURGEOIS

LINEL EXTRA-FINE ARTISTS' WATERCOLOUR

Smooth, bright and strong. A well produced watercolour. Absolutely lightfast ingredients used. Brushed out well over a good range. Previously PY37. Opaque.

PY35 CADMIUM YELLOW LIGHT ASTM I (41)

PIGMENT DETAIL ON LABEL CHEMICAL MAKE UP ONLY | ASTM I L'FAST |

CADMIUM YELLOW DEEP 43

HOLBEIN

ARTISTS' WATER COLOR

Strong, opaque colour. Brushes out very well giving good gradated washes. Strong enough to provide reasonable tints. The PO20 is a recent addition

PY37 CADMIUM YELLOW MEDIUM OR DEEP ASTM I (42)
PO20 CADMIUM ORANGE ASTM I (94)

PIGMENT DETAIL ON LABEL YES | ASTM I L'FAST |

DARK CADMIUM YELLOW 333

PÈBÈO

FRAGONARD ARTISTS' WATER COLOUR

Handles particularly well, giving a versatile range of values. Particularly lightfast pigment used. Well prepared. Opaque.

PY37 CADMIUM YELLOW MEDIUM OR DEEP ASTM I (42)

PIGMENT DETAIL ON LABEL YES | ASTM I L'FAST |

CADMIUM YELLOW DEEP 1028

LUKAS

ARTISTS' WATER COLOUR

Brushes out *reasonably* well. PO20 has been used instead of the more usual Cadmium Yellow. Completely fast to light. Opaque.

PO20 CADMIUM ORANGE ASTM I (94)

PIGMENT DETAIL ON LABEL CHEMICAL MAKE UP ONLY | ASTM I L'FAST | RATING ★ ★★

CADMIUM YELLOW DEEP 2110

UMTON BARVY

ARTISTIC WATER COLOR

Despite the popularity of 'moist' pan colours, a well produced pan should allow the paint to lift without an overdose of glycerine etc. This is an example of such a balanced product.

PY37 CADMIUM YELLOW MEDIUM OR DEEP ASTM I (42)

PIGMENT DETAIL ON LABEL NO | ASTM I L'FAST |

CADMIUM YELLOW DEEP 215

DA VINCI PAINTS

PERMANENT ARTISTS' WATER COLOR

A very well labelled paint. Full information on ingredients, binder and health risks are given. Handles very well. The PO20 is a recent addition.

PY35 CADMIUM YELLOW LIGHT ASTM I (41)
PO20 CADMIUM ORANGE ASTM I (94)

PIGMENT DETAIL ON LABEL YES | ASTM I L'FAST |

CADMIUM YELLOW DEEP (HUE) 615

DA VINCI PAINTS

SCUOLA 2ND RANGE

The paint was under pressure in the sample tube, suggesting an imbalance between the type of binder and the pigments. Handled very well and is dependable.

PY97 ARYLIDE YELLOW FGL ASTM II (46)
PO62 BENZIMIDAZOLONE ORANGE H5G ASTM II (97)

PIGMENT DETAIL ON LABEL YES | ASTM II L'FAST | RATING ★ ★★

Chrome Yellow (Light, Medium, Deep)

Fairly strong with good covering power.

A most unreliable colour which can become very dark on exposure to light or the atmosphere. The atmosphere in fact might cause even more damage than the light. Imitations are usually little better.

For mixing purposes, varies between green-yellow and orange yellow.

It can spoil any colour with which it is combined. Personally I would not even consider it.

CHROME YELLOW LIGHT 165

LEFRANC & BOURGEOIS

LINEL EXTRA-FINE ARTISTS' WATERCOLOUR

The pigment used, PY34 can gradually darken, greying the colour considerably. Reliable alternatives are available. Semi-opaque.

Discontinued

PY34 CHROME YELLOW LEMON LF NOT OFFERED (41)		
PIGMENT DETAIL ON LABEL CHEMICAL MAKE UP ONLY	ASTM L'FAST	RATING ★

CHROME YELLOW DEEP 551

SENNELIER

EXTRA-FINE WATERCOLOUR

This can darken on exposure to light or the atmosphere. A most unreliable pigment which will usually gradually spoil. Semi-opaque.

Discontinued

PY34 CHROME YELLOW LEMON LF NOT OFFERED (41)		
PIGMENT DETAIL ON LABEL YES	ASTM L'FAST	RATING ★

CHROME YELLOW LIGHT 549

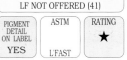

SENNELIER

EXTRA-FINE WATERCOLOUR

Can darken quite dramatically on exposure to the atmosphere and to light. An unreliable pigment. Brushes out quite well. Semi-opaque.

Discontinued

PY34 CHROME YELLOW LEMON LF NOT OFFERED (41)		
PIGMENT DETAIL ON LABEL YES	ASTM L'FAST	RATING ★

CHROME YELLOW 164

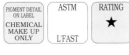

WINSOR & NEWTON

ARTISTS' WATER COLOUR

Difficult to remove from tube as very densely packed. PY 34 tends to darken when exposed to light and the atmosphere. Semi-opaque.

Discontinued

PY34 CHROME YELLOW LEMON LF NOT OFFERED (41)		
PIGMENT DETAIL ON LABEL YES	ASTM L'FAST	RATING ★

CHROME YELLOW DEEP 152

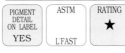

WINSOR & NEWTON

ARTISTS' WATER COLOUR

Similar in hue to a Cadmium Yellow Medium. That is as far as the comparison goes. Most unreliable.

Discontinued

PY34 CHROME YELLOW LEMON LF NOT OFFERED (41)		
PIGMENT DETAIL ON LABEL YES	ASTM L'FAST	RATING ★

CHROME YELLOW 662

DALER ROWNEY

ARTISTS' WATER COLOUR

So densely packed that the tube was damaged trying to remove the paint. A most unreliable pigment, can darken considerably. Semi-opaque.

Discontinued

PY34 CHROME YELLOW LEMON LF NOT OFFERED (41)		
PIGMENT DETAIL ON LABEL NO	ASTM L'FAST	RATING ★

CHROME YELLOW DEEP, NO LEAD 213

SCHMINCKE

HORADAM FINEST ARTISTS' WATER COLOURS

This is not Chrome Yellow at all, which is an advantage. Pigment recently upgraded from the unreliable PY83 to PY65. The word 'Hue', once added, has now been removed.

Semi-trans. Excellent.

PY65 ARYLIDE YELLOW RN ASTM II (44)		
PIGMENT DETAIL ON LABEL YES	ASTM II L'FAST	

CHROME YELLOW LIGHT 212

SCHMINCKE

HORADAM FINEST ARTISTS' WATER COLOURS

I feel that I need further information on PY155 before offering assessments as it has not been subjected to ASTM testing. The PY153 is lightfast.

PY155 DIARYLIDE YELLOW LF NOT OFFERED (50) PY153 NICKEL DIOXINE YELLOW ASTM II (50)		
PIGMENT DETAIL ON LABEL YES	ASTM L'FAST	RATING

PY34, Chrome Yellow Lemon, can become very dark on exposure to light or the atmosphere.

65

Chrome Yellow Lemon

Genuine Chrome Yellow Lemon, (PY34), can become very dark on exposure to light and the atmosphere.

A definite green-yellow which is easily matched.

CHROME LEMON 621

The fact that Chrome Yellow Lemon tends to darken on exposure has been known for a long time. Yet it is still in use. Semi-opaque.

Discontinued

PY34 CHROME YELLOW LEMON LF NOT OFFERED (41) PY3 ARYLIDE YELLOW 10G ASTM II (37)		
PIGMENT DETAIL ON LABEL YES	ASTM L'FAST	RATING ★

DALER ROWNEY — ARTISTS' WATER COLOUR

CHROME LEMON 158

Paint so densely packed it was difficult to remove. Our sample darkened considerably on exposure to light.

Discontinued

PY34 CHROME YELLOW LEMON LF NOT OFFERED (41)		
PIGMENT DETAIL ON LABEL YES	ASTM L'FAST	RATING ★

WINSOR & NEWTON — ARTISTS' WATER COLOUR

CHROME YELLOW LEMON 209

The use of chalk is quite noticeable, giving a rather clouded, dull, light Lemon Yellow. Reliable pigments. Semi-transparent.

Discontinued

 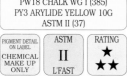

PW18 CHALK WG I (385) PY3 ARYLIDE YELLOW 10G ASTM II (37)		
PIGMENT DETAIL ON LABEL CHEMICAL MAKE UP ONLY	ASTM II L'FAST	RATING ★ ★★

LEFRANC & BOURGEOIS — LINEL EXTRA-FINE ARTISTS' WATERCOLOUR

CHROME YELLOW LEMON NO LEAD 211

PY175 has not been ASTM tested as a watercolour but fared very well as an oil paint and as an acrylic. Sample provided brushed out very well.

PY175 BENZIMIDAZOLONE YELLOW H6G WG II (51)		
PIGMENT DETAIL ON LABEL YES	WG II L'FAST	

SCHMINCKE — HORADAM FINEST ARTISTS' WATER COLOURS

Gamboge

Genuine Gamboge, long employed in Asia, has been used by European artists for several hundred years.

First used as a colorant for spirit varnishes, but now almost exclusively as a watercolour.

Originally imported by the East Indian Company around 1615. It is unique as an artist's colour in that it is a complete paint in its natural state, being colouring matter in a gum.

A fugitive substance, it should have been replaced many years ago by other, more reliable yellows.

An unimportant relic from the past.

GAMBOGE (HUE) 239

Both pigments are reliable. This colour has been reformulated and now handles particularly well. Tends to granulate when applied in a wet layer.

Semi-transparent.

PY42 MARS YELLOW ASTM I (43) PY3 ARYLIDE YELLOW 10G ASTM II (37)		
PIGMENT DETAIL ON LABEL YES	ASTM II L'FAST	

DA VINCI PAINTS — PERMANENT ARTISTS' WATER COLOR

GAMBOGE (HUE) 639

Handled with extreme ease when well diluted but was a little heavy going in thicker applications. Seemed to be over bound somewhat. Lightfast pigments.

PY3 ARYLIDE YELLOW 10G ASTM II (37) PY42 MARS YELLOW ASTM I (43)		
PIGMENT DETAIL ON LABEL YES	ASTM II L'FAST	RATING ★ ★★

DA VINCI PAINTS — SCUOLA 2ND RANGE

PERMANENT GAMBOGE W7

The term 'Permanent' does not exactly tell us that this is an imitation. Lightfast and brushed with ease.

PY97 ARYLIDE YELLOW FGL ASTM II (46) PY153 NICKEL DIOXINE YELLOW ASTM II (50)		
PIGMENT DETAIL ON LABEL YES	ASTM II L'FAST	

ART SPECTRUM — ARTISTS' WATER COLOUR

GAMBOGE 265 GENUINE

WINSOR & NEWTON

ARTISTS' WATER COLOUR

This substance will fade rather quickly. Our sample was heavy and unpleasant to use, unless as a thin wash.

Most unreliable. Transparent. Was previously called simply 'Gamboge'.

NY24 GAMBOGE WG V (40)

PIGMENT DETAIL ON LABEL	WG	RATING
YES	V L'FAST	★

GAMBOGE NEW 267

WINSOR & NEWTON

ARTISTS' WATER COLOUR

Neither pigment is reliable. Both have tested out poorly. Our sample did likewise. Brushed out rather well. Semi-transparent.

Reformulated>

PR3 TOLUIDINE RED WG V (115)
PY1 ARYLIDE YELLOW G
ASTM V (37)

PIGMENT DETAIL ON LABEL	ASTM	RATING
YES	V L'FAST	★

NEW GAMBOGE 267

WINSOR & NEWTON

ARTISTS' WATER COLOUR

Reliable enough pigment, a great improvement on the previous formulation but a rather gummy paint.

Was difficult to apply unless dilute.

PY153 NICKEL DIOXINE YELLOW
ASTM II (50)

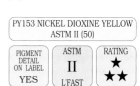

PIGMENT DETAIL ON LABEL	ASTM	RATING
YES	II L'FAST	★ ★★

GAMBOGE HUE 266 (314)

WINSOR & NEWTON

COTMAN WATER COLOURS 2ND RANGE

Sample was particularly gummy making all but very thin washes difficult. Neither pigment can tolerate light. Unreliable. Transparent.

Reformulated>

PY1 ARYLIDE YELLOW G
ASTM V (37)
PR3 TOLUIDINE RED WG V (115)

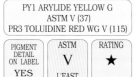

PIGMENT DETAIL ON LABEL	ASTM	RATING
YES	V L'FAST	★

GAMBOGE HUE 266

WINSOR & NEWTON

COTMAN WATER COLOURS 2ND RANGE

Has to be well worked on the palette with a wet brush before applying in other than a medium to thin wash.

Appeared to be over bound with gum.

PY153 NICKEL DIOXINE YELLOW
ASTM II (50)

PIGMENT DETAIL ON LABEL	ASTM	RATING
YES	II L'FAST	★ ★★

NEW GAMBOGE 5738

HUNTS

SPEEDBALL PROFESSIONAL WATERCOLOURS

The description given, 'Hansa Yellow Pigment', is quite meaningless.

Although our sample faded I will not offer a rating without further information.

Discontinued

HANSA YELLOW PIGMENT

PIGMENT DETAIL ON LABEL	ASTM	RATING
NO	L'FAST	

GAMBOGE (HUE) W077

GRUMBACHER

FINEST ARTISTS' WATER COLOR

Washes out adequately. The previous description on the tube, 'Hansa Yellow Base' was meaningless. Now correctly labelled Semi-opaque.

PY42 MARS YELLOW ASTM I (43)
PY3 ARYLIDE YELLOW 10G
ASTM II (37)

PIGMENT DETAIL ON LABEL	ASTM	RATING
YES	II L'FAST	★ ★★

GAMBOGE HUE A077

GRUMBACHER

ACADEMY ARTISTS' WATERCOLOR 2ND RANGE

Now reformulated with reliable ingredients. Earlier version was made unreliable by the inclusion of Pigment Orange 1. Handles well. Transparent.

PY65 ARYLIDE YELLOW RN ASTM II (44)
PY138 QUINOPHTHALONE YELLOW
ASTM II (48)
PO62 BENZIMIDAZOLONE ORANGE H5G
ASTM II (97)

PIGMENT DETAIL ON LABEL	ASTM	
YES	II L'FAST	

GAMBOGE LAKE EXTRA 124

OLD HOLLAND

CLASSIC WATERCOLOURS

Fine for very thin washes only. The sample was an appalling substance best described as coloured gum. Dried to a lovely shine though.

PY153 NICKEL DIOXINE YELLOW
ASTM II (50)
PY3 ARYLIDE YELLOW 10G
ASTM II (37)

PIGMENT DETAIL ON LABEL	ASTM	RATING
CHEMICAL MAKE UP ONLY	II L'FAST	★

GAMBOGE (HUE) 640

DALER ROWNEY

ARTISTS' WATER COLOUR

Reliable pigments have been employed in this version of 'Gamboge'. Handles very well giving a good range of values. Semi-transparent.

PY153 NICKEL DIOXINE YELLOW
ASTM II (50)
PY3 ARYLIDE YELLOW 10G
ASTM II (37)

PIGMENT DETAIL ON LABEL	ASTM	
YES	II L'FAST	

GAMBOGE HUE

DALER ROWNEY

GEORGIAN WATER COLOUR 2ND RANGE

PY1, the pigment used in this version of 'Gamboge' bleached out when tested. Most unreliable. Transparent.

Reformulated>

PY1 ARYLIDE YELLOW G
ASTM V (37)

PIGMENT DETAIL ON LABEL	ASTM	RATING
NO	V L'FAST	★

GAMBOGE HUE

DALER ROWNEY

GEORGIAN WATER COLOUR 2ND RANGE

It is well known that PY1:1 has failed formal testing as a watercolour. There is no reason why 'student' or 2nd range colours should be unreliable. There will be many an early piece of work worth saving.

PY1:1 ARYLIDE YELLOW G
ASTM III (37)
PY3 ARYLIDE YELLOW 10G
ASTM II (37)

PIGMENT DETAIL ON LABEL	ASTM	RATING
NO	III L'FAST	★★

NEW GAMBOGE 060

DANIEL SMITH

EXTRA-FINE WATERCOLORS

A transparent staining colour which washed out very well, giving a series of very smooth tints. Heavier applications equally easy to apply. First class. The word 'New' does not make it clear that this is not Gamboge.

| PY153 NICKEL DIOXINE YELLOW ASTM II (50) |

| PIGMENT DETAIL ON LABEL YES | ASTM II L'FAST | |

GAMBOGE 105

M.GRAHAM & CO.

ARTISTS' WATERCOLOR

As this is an imitation Gamboge I feel that it should be described as such to remove any confusion. It should also employ lightfast pigments for the sake of the customer.

| PY110 ISOINDOLINONE YELLOW R ASTM III (47) |

| PIGMENT DETAIL ON LABEL YES | ASTM III L'FAST | RATING ★★ |

GAMBOGE 049

AMERICAN JOURNEY

PROFESSIONAL ARTISTS' WATER COLOR

Yet another imitation sold under a misleading name. It is not that any knowledgeable artist would seek out genuine Gamboge, more to remove confusion. Reliable and washed out well.

| PY3 ARYLIDE YELLOW 10G ASTM II (37) PY42 MARS YELLOW ASTM I (43) |

| PIGMENT DETAIL ON LABEL YES | ASTM II L'FAST | 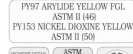 |

GAMBOGE 124

PÈBÈO

FRAGONARD ARTISTS' WATER COLOUR

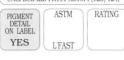

The pigment information below was taken from the tube. The company tell us not to take too much notice of this as the literature might be different and the labels are to be modified. Cont. >

| PY138 QUINOPHTHALONE YELLOW ASTM II (48) *UNSPECIFIED PR101 ASTM I (123/124)* |

| PIGMENT DETAIL ON LABEL YES | ASTM L'FAST | RATING |

GAMBOGE 124

PÈBÈO

FRAGONARD ARTISTS' WATER COLOUR

The pigments below are from the printed matter supplied. I will not offer assessments as I cannot be really sure just what was in the tube supplied. Older stock with the correct label or new without?

| PY74LF ARYLIDE YELLOW 5GX ASTM III (44) PY42 MARS YELLOW ASTM I (43) *UNSPECIFIED PR101 ASTM I (123/124)* |

| PIGMENT DETAIL ON LABEL YES | ASTM L'FAST | RATING |

GAMBOGE (SUBST) 152

LEFRANC & BOURGEOIS

LINEL EXTRA-FINE ARTISTS' WATERCOLOUR

If this rather outdated name must be retained then at least reliable pigments such as these should be used. Semi-transparent.

| PY97 ARYLIDE YELLOW FGL ASTM II (46) PY153 NICKEL DIOXINE YELLOW ASTM II (50) |

| PIGMENT DETAIL ON LABEL CHEMICAL MAKE UP ONLY | ASTM II L'FAST | |

GAMBOGE 238

TALENS

REMBRANDT ARTISTS' QUALITY EXTRA FINE

Slightly gummy which made for uneven washes over a full range of values. A reliable pigment has been used. Semi-transparent.

Reformulated >

| PY97 ARYLIDE YELLOW FGL ASTM II (46) |

| PIGMENT DETAIL ON LABEL YES | ASTM II L'FAST | RATING ★ ★★ |

GAMBOGE 238

TALENS

REMBRANDT ARTISTS' QUALITY EXTRA FINE

The sample supplied was, to my mind, not a paint at all but a heavy coloured gum.

But at least it is lightfast gum.

| PY150 NICKEL AZO YELLOW ASTM I (49) PO48 QUINACRIDONE GOLD ASTM II (97) |

| PIGMENT DETAIL ON LABEL YES | ASTM II L'FAST | RATING ★ |

GAMBOGE GUM MODERN 210

SCHMINCKE

HORADAM FINEST ARTISTS' WATER COLOURS

The sample provided was a little gummy but handled particularly well in thin washes, giving smooth clear tints. Transparent, lightfast. Was previously called 'Gamboge Hue 209.

| PY108 ANTHRAPYRIMIDINE YELLOW WG II (46) |

| PIGMENT DETAIL ON LABEL YES | WG II L'FAST | RATING ★ ★★ |

GAMBOGE 238

TALENS

WATER COLOUR 2ND RANGE

A lightfast pigment has been employed. Second range, or 'Student' colours need not be unreliable. Washes well. Semi-transparent.

Range discontinued

| PY97 ARYLIDE YELLOW FGL ASTM II (46) |

| PIGMENT DETAIL ON LABEL YES | ASTM II L'FAST | |

GAMBOGE 238

TALENS

VAN GOGH 2ND RANGE

Gave a very good series of light washes but did not handle too well when heavier.

Reliable pigments have been used.

| PY154 BENZIMIDAZOLONE YELLOW H3G ASTM I (50) *UNSPECIFIED PR101 ASTM I (123/124)* |

| PIGMENT DETAIL ON LABEL YES | ASTM I L'FAST | RATING ★ ★★ |

GAMBOGE NOVA 48

HOLBEIN

ARTISTS' WATER COLOR

A newly introduced colour from this manufacturer. Transparent, giving rather clear washes. Handled better when thinned. Staining and easy to lift.

| PY153 NICKEL DIOXINE YELLOW ASTM II (50) PY154 BENZIMIDAZOLONE YELLOW H3G ASTM I (50) |

| PIGMENT DETAIL ON LABEL YES | ASTM II L'FAST | RATING ★ ★★ |

GAMBOGE (HUE) 521

MAIMERI

Predictably our sample bleached out and became very blotchy in a short time. PY17 is most unreliable. Semi-opaque.

Range discontinued

PY17 DIARYLIDE YELLOW AO WG V (39)		
PIGMENT DETAIL ON LABEL **NO**	WG **V** L'FAST	RATING ★

ARTISTI EXTRA-FINE WATERCOLOURS

GAMBOGE 2H

DR.Ph. MARTINS

I cannot comment on the reliability of this product without knowing the actual pigments/dyes that might have been used.

NO PIGMENT DETAIL ON THE PRODUCT OR IN THE LITERATURE SUPPLIED		
PIGMENT DETAIL ON LABEL **NO**	ASTM L'FAST	RATING

HYDRUS FINE ART WATERCOLOR

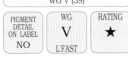
Indian Yellow

Indian Yellow has a rather bizarre background.

As the name suggests, it was originally produced in India. Cows were fed a diet of mango leaves and then denied water. Their concentrated urine was collected and mixed with mud. This was later purified into a very clear yellow.

Generally leans towards orange, although green-yellows are available.

Once the bias, or leaning of the particular colour you have has been decided, it is possible to plan colour mixing in advance.

If the yellow leans towards orange the mixing complementary will be a blue violet, if it is a green-yellow select a red violet as the mixing partner. Complementary colours will darken each other very successfully.

INDIAN YELLOW 045

DANIEL SMITH

A typical 'Indian Yellow'. The name is too old to require the term 'Hue'. Handled well. A semi transparent staining colour. Reliable.

PY108 ANTHRAPYRIMIDINE YELLOW WG II (46)		
PIGMENT DETAIL ON LABEL **YES**	WG **II** L'FAST	

EXTRA-FINE WATERCOLORS

PERMANENT INDIAN YELLOW W8

ART SPECTRUM

A transparent yellow which gave very smooth, even, clear washes.

A reliable, well made product.

PY153 NICKEL DIOXINE YELLOW ASTM II (50)		
PIGMENT DETAIL ON LABEL **YES**	ASTM **II** L'FAST	

ARTISTS' WATER COLOUR

INDIAN YELLOW 098

MAIMERI

Previously 'Indian Yellow (Hue) 520 in Artisti range, with unreliable pigments. Now lightfast and handles very well. Recommended.

PY139 ISOINDOLINE YELLOW WG II (48) PV49 COBALT AMMONIUM VIOLET PHOSPHATE WG II (187)		
PIGMENT DETAIL ON LABEL **YES**	WG **II** L'FAST	

MAIMERIBLU SUPERIOR WATERCOLOURS

INDIAN YELLOW 098

MAIMERI

Reliable pigments have been used to imitate this ancient colour.

A rating of I or II will ensure that your work is protected.

PY139 ISOINDOLINE YELLOW ASTM I (48) PV49 COBALT AMMONIUM VIOLET PHOSPHATE WG II (187)		
PIGMENT DETAIL ON LABEL **YES**	WG **II** L'FAST	

VENEZIA EXTRAFINE WATERCOLOURS

INDIAN YELLOW 1024

LUKAS

Handles particularly well, giving smooth, gradated washes. Reliable pigment which will resist light. Transparent. The description 'org. monoazo pigment' on the tube is less than helpful.

PY3 ARYLIDE YELLOW 10G ASTM II (37)		
PIGMENT DETAIL ON LABEL CHEMICAL MAKE UP ONLY	ASTM **II** L'FAST	

ARTISTS' WATER COLOUR

INDIAN YELLOW 44

HOLBEIN

I have insufficient information on PY95 to offer assessments. The sample paint handled very well.

Semi-transparent, non staining.

PY83HR70 DIARYLIDE YELLOW HR70 WG II (45) PY95 DISAZO YELLOW R LF NOT OFFERED (45)		
PIGMENT DETAIL ON LABEL **YES**	ASTM L'FAST	RATING

ARTISTS' WATER COLOR

INDIAN YELLOW 248

DA VINCI PAINTS

A semi-transparent combination which washed out well. Tends to granulate on heavier papers. As always with this company, reliable pigments have been used.

PERMANENT ARTISTS' WATER COLOR

PO62 BENZIMIDAZOLONE ORANGE H5G ASTM II (97)
PY97 ARYLIDE YELLOW FGL ASTM II (46)

PIGMENT DETAIL ON LABEL	ASTM	
YES	II L'FAST	

INDIAN YELLOW (SUBST) 182

LEFRANC & BOURGEOIS

A reliable pigment has been employed.

Brushed out very well, giving even washes over the full range. Semi-transparent. Clear pigment information on the label would be helpful.

LINEL EXTRA-FINE ARTISTS' WATERCOLOUR

PY153 NICKEL DIOXINE YELLOW ASTM II (50)

PIGMENT DETAIL ON LABEL CHEMICAL MAKE UP ONLY	ASTM
	II L'FAST

INDIAN YELLOW 517

SENNELIER

Now reformulated using excellent ingredients. (The earlier version was unreliable due to the inclusion of PY83). Check ingredients if purchasing. Transparent to semi-transparent

EXTRA-FINE WATERCOLOUR

PY153 NICKEL DIOXINE YELLOW ASTM II (50)

PIGMENT DETAIL ON LABEL	ASTM	
YES	II L'FAST	

INDIAN YELLOW 244

TALENS

Sample was very gummy, giving poor washes unless very thin. Will gradually fade on exposure. Semi-transparent.

Reformulated>

PY110 ISOINDOLINONE YELLOW R ASTM III (47)

REMBRANDT ARTISTS' QUALITY EXTRA FINE

PIGMENT DETAIL ON LABEL	ASTM	RATING
YES	III L'FAST	★

INDIAN YELLOW 224

TALENS

Reliable pigments used but the paint is rather on the gummy side, making application less than easy unless well diluted.

PY154 BENZIMIDAZOLONE YELLOW H3G ASTM I (50)
PO48 QUINACRIDONE GOLD ASTM II (97)

REMBRANDT ARTISTS' QUALITY EXTRA FINE

PIGMENT DETAIL ON LABEL	ASTM	RATING
YES	II L'FAST	★ ★★

INDIAN YELLOW HUE W111

GRUMBACHER

Reformulated some time ago using excellent pigments. (The earlier version employed very unreliable ingredients). Check contents if purchasing. Handles very well. Transparent.

PY97 ARYLIDE YELLOW FGL ASTM II (46)
PO62 BENZIMIDAZOLONE ORANGE H5G ASTM II (97)

FINEST ARTISTS' WATER COLOR

PIGMENT DETAIL ON LABEL	ASTM	
YES	II L'FAST	

INDIAN YELLOW HUE A111

GRUMBACHER

The pigment used is fast to light. I cannot offer an assessment as a sample was not provided.

Reformulated? >

PY65 ARYLIDE YELLOW RN ASTM II (44)

ACADEMY ARTISTS' WATERCOLOR 2ND RANGE

PIGMENT DETAIL ON LABEL	ASTM	RATING
YES	II L'FAST	

INDIAN YELLOW HUE A111

GRUMBACHER

Sample was not provided. I have no idea of the present ingredients. Urgent facsimiles not answered. Do they want you to know? Previously PY65. Might still be. Assessments and colour guide not offered.

ACADEMY ARTISTS' WATERCOLOR 2ND RANGE

PIGMENT DETAIL ON LABEL	ASTM	RATING
YES	L'FAST	

INDIAN YELLOW 129

UTRECHT

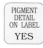

Sample supplied was rather over bound. Handled very well as a wash but heavier applications tended to be uneven.

Reliable pigments have been used.

PROFESSIONAL ARTISTS' WATER COLOR

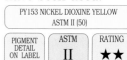
PY153 NICKEL DIOXINE YELLOW ASTM II (50)

PIGMENT DETAIL ON LABEL	ASTM	RATING
YES	II L'FAST	★★

INDIAN YELLOW 319

WINSOR & NEWTON

Sample was rather gummy and dried to a shine unless very thin. Will gradually fade on exposure to light. Semi-transparent.

Reformulated >

PY1:1 ARYLIDE YELLOW G ASTM III (37)

ARTISTS' WATER COLOUR

PIGMENT DETAIL ON LABEL	ASTM	RATING
YES	III L'FAST	★

INDIAN YELLOW 319

WINSOR & NEWTON

Sample had to be worked with a wet brush before the paint could be applied in any other than thin washes.

PY153 NICKEL DIOXINE YELLOW ASTM II (50)
PO62 BENZIMIDAZOLONE ORANGE H5G ASTM II (97)

ARTISTS' WATER COLOUR

PIGMENT DETAIL ON LABEL	ASTM	RATING
YES	II L'FAST	★ ★★

INDIAN YELLOW 061

AMERICAN JOURNEY

Pigments which will withstand light, protecting your valuable work.

Sample handled very well. Reliable.

PROFESSIONAL ARTISTS' WATER COLOR

PO62 BENZIMIDAZOLONE ORANGE H5G ASTM II (97)
PY97 ARYLIDE YELLOW FGL ASTM II (46)

PIGMENT DETAIL ON LABEL	ASTM	
YES	II L'FAST	

INDIAN YELLOW 643

DALER ROWNEY

The pigments used in this watercolour are both unreliable, the yellow in particular. As expected, our sample bleached white. Transparent.

Reformulated>

PY100 TARTRAZINE LAKE ASTM V (46)
PR83:1 ALIZARIN CRIMSON ASTM IV (122)

ARTISTS' WATER COLOUR

PIGMENT DETAIL ON LABEL	ASTM	RATING
NO	V L'FAST	★

INDIAN YELLOW 105

DALER ROWNEY

When brushing out a watercolour paint I look for smooth, very even washes at all intensities. Also very thin washes which do not 'break up'. This paint satisfies all of those criteria.

PY153 NICKEL DIOXINE YELLOW ASTM II (50)

ARTISTS' WATER COLOUR

PIGMENT DETAIL ON LABEL	ASTM	
YES	II L'FAST	

INDIAN YELLOW-GREEN LAKE EXTRA 118

OLD HOLLAND

Washed out poorly at all intensities due to an excess of gum. I have insufficient information on PY129 to offer assessments.

PY153 NICKEL DIOXINE YELLOW ASTM II (50)
PY129 AZOMETHINE YELLOW 5GT
LF NOT OFFERED (48)

CLASSIC WATERCOLOURS

PIGMENT DETAIL ON LABEL	ASTM	RATING
CHEMICAL MAKE UP ONLY	L'FAST	

INDIAN YELLOW BROWN LAKE EXTRA 130

OLD HOLLAND

Unlike so many examples from this company the sample was not spoiled by an excess of gum. Reliable pigments, an excellent product.

PY153 NICKEL DIOXINE YELLOW ASTM II (50)
PY42 MARS YELLOW ASTM I (43)

CLASSIC WATERCOLOURS

PIGMENT DETAIL ON LABEL	ASTM	
CHEMICAL MAKE UP ONLY	II L'FAST	

INDIAN YELLOW-ORANGE LAKE EXTRA 127

OLD HOLLAND

I cannot offer assessments as insufficient is known about PR260. Apart from the fact that it has not been officially tested as an art material.

PY153 NICKEL DIOXINE YELLOW ASTM II (50)
PR260 COMMON NAME N/K
LF NOT OFFERED (137)

CLASSIC WATERCOLOURS

PIGMENT DETAIL ON LABEL	ASTM	RATING
CHEMICAL MAKE UP ONLY	L'FAST	

INDIAN YELLOW 220

SCHMINCKE

Unreliable. The inclusion of PY110 (which has been tested under ASTM conditions), lowered the lightfast rating. Tints in particular are liable to fade. Semi-opaque.

PY110 ISOINDOLINONE YELLOW R ASTM III (47)
PY154 BENZIMIDAZOLONE YELLOW H3G ASTM I (50)

HORADAM FINEST ARTISTS' WATER COLOURS

PIGMENT DETAIL ON LABEL	ASTM	RATING
YES	III L'FAST	★★

Lemon Yellow

A general term in use for a pale green yellow, rather than the name for a particular ingredient.

Various yellow pigments are employed, the most common being PY3, which is reliable. Transparency varies, usually semi-transparent.

In mixing, this green-yellow will give semi-opaque bright greens when combined with an opaque green-blue such as Cerulean Blue.

Clearer bright greens result when mixed with a transparent green-blue such as Phthalocyanine Blue.

Dull oranges will be created when Lemon Yellow is combined with any red.

Mixing complementary is a red violet. These two colours will darken each other without destroying the character of their partner.

LEMON YELLOW 346

WINSOR & NEWTON

Brushes out well to give good medium to thin layers. Lacks body for heavier application. Reliable ingredients. Semi-transparent.

Reformulated>

PY3 ARYLIDE YELLOW 10G ASTM II (37)

COTMAN WATER COLOURS 2ND RANGE

PIGMENT DETAIL ON LABEL	ASTM	RATING
YES	II L'FAST	★ ★★

LEMON YELLOW HUE 346

WINSOR & NEWTON

Slightly gummy and handled better in the thinner ranges.

A reliable, lightfast pigment.

PY175 BENZIMIDAZOLONE YELLOW H6G WG II (51)

COTMAN WATER COLOURS 2ND RANGE

PIGMENT DETAIL ON LABEL	WG	RATING
YES	II L'FAST	★ ★★

LEMON YELLOW HUE (NICKEL TITANATE) (USA ONLY) 347

WINSOR & NEWTON

Moderately transparent with reasonable covering power.

The sample tested for the first edition resisted fading but did darken very slightly in heavy application.

PY53 NICKEL TITANATE YELLOW ASTM I (43)

COTMAN WATER COLOURS 2ND RANGE

PIGMENT DETAIL ON LABEL	ASTM	
YES	I L'FAST	

LEMON YELLOW 347 (NICKEL TITANATE)

WINSOR & NEWTON

ARTISTS' WATER COLOUR

Due to the nature of the pigment, not manufacture, a rather dull, weak, Lemon Yellow which will not contribute well when mixing bright greens.

Lightfast pigment. Semi-opaque. Was previously called 'Lemon Yellow Hue 347'.

PY53 NICKEL TITANATE YELLOW ASTM I (43)

PIGMENT DETAIL ON LABEL	ASTM	
YES	I L'FAST	

WINSOR LEMON 722

WINSOR & NEWTON

ARTISTS' WATER COLOUR

The sample supplied was rather sticky and appeared to be heavy with gum.

The final result was fine but took some working towards.

PY175 BENZIMIDAZOLONE YELLOW H6G WG II (51)

PIGMENT DETAIL ON LABEL	WG	RATING
YES	II L'FAST	★ ★★

LEMON YELLOW W118

GRUMBACHER

FINEST ARTISTS' WATER COLOR

Well packed with pigment. A strong watercolour which washes out very well at any strength. Dependable. Semi-transparent.

Previously called 'Lemon Yellow (Hansa Yellow)'.

PY3 ARYLIDE YELLOW 10G ASTM II (37)

PIGMENT DETAIL ON LABEL	ASTM	
YES	II L'FAST	

LEMON YELLOW A118

GRUMBACHER

ACADEMY ARTISTS' WATERCOLOR 2ND RANGE

The ingredients are given clearly and accurately on the tube. Washes out particularly well over a good range of values. Semi-transparent. Previously called 'Lemon Yellow (Hansa Yellow)'.

PY3 ARYLIDE YELLOW 10G ASTM II (37)

PIGMENT DETAIL ON LABEL	ASTM	
YES	II L'FAST	

PERMANENT LEMON YELLOW 238

PÈBÈO

FRAGONARD ARTISTS' WATER COLOUR

A reasonably transparent, bright green yellow. Our sample handled particularly well giving good washes.

Dependable ingredients. Company incorrectly claim ASTM I.

PY138 QUINOPHTHALONE YELLOW ASTM II (48)

PIGMENT DETAIL ON LABEL	ASTM	
YES	II L'FAST	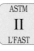

LEMON YELLOW 651

DALER ROWNEY

ARTISTS' WATER COLOUR

A reliable pigment has been used. This watercolour paint will resist light very well.

Brushed out very smoothly. Semi-transparent.

PY3 ARYLIDE YELLOW 10G ASTM II (37)

PIGMENT DETAIL ON LABEL	ASTM	
YES	II L'FAST	

LEMON YELLOW

DALER ROWNEY

GEORGIAN WATER COLOUR 2ND RANGE

Earlier examples were rather cloudy and dull due to the inclusion of white pigment. This has now been removed. Reliable ingredients. Semi-transparent. Excellent.

Pigment details on the tube would be helpful.

PY3 ARYLIDE YELLOW 10G ASTM II (37)

PIGMENT DETAIL ON LABEL	ASTM	
NO	II L'FAST	

PERMANENT LEMON YELLOW 254

TALENS

VAN GOGH 2ND RANGE

I cannot offer assessment as I have insufficient information about the pigment employed.

Sample handled very well indeed.

PY184 BISMUTH VANADATE YELLOW LF NOT OFFERED (51)

PIGMENT DETAIL ON LABEL	ASTM	RATING
YES	L'FAST	

PERMANENT LEMON YELLOW 254

TALENS

REMBRANDT ARTISTS' QUALITY EXTRA FINE

A very well produced, well balanced watercolour paint. Flows from the brush onto wet paper with ease. I am afraid assessments cannot be offered because too little is known about the pigment.

PY184 BISMUTH VANADATE YELLOW LF NOT OFFERED (51)

PIGMENT DETAIL ON LABEL	ASTM	RATING
YES	L'FAST	

TALENS YELLOW LEMON 246

TALENS

REMBRANDT ARTISTS' QUALITY EXTRA FINE

Gives good even washes. Reasonably bright despite the use of a white pigment. Dependable ingredients. Semi-opaque.

Discontinued

PY3 ARYLIDE YELLOW 10G ASTM II (37)
PW4 ZINC WHITE ASTM I (384)

PIGMENT DETAIL ON LABEL	ASTM	
YES	II L'FAST	

LEMON YELLOW 501

SENNELIER

EXTRA-FINE WATERCOLOUR

PY1, a fugitive pigment, which once led to fading, has now been removed. Check ingredients if purchasing to ensure new stock. Now excellent. Semi-transparent to transparent.

PY3 ARYLIDE YELLOW 10G ASTM II (37)

PIGMENT DETAIL ON LABEL	ASTM	
YES	II L'FAST	

LEMON YELLOW 33

HOLBEIN

ARTISTS' WATER COLOR

Colour is slightly clouded by the use of white in the make up. This must be intended and can be taken into account when selecting.

Reliable pigments. Handles very well. Semi-transparent, non staining and easy to lift.

PY3 ARYLIDE YELLOW 10G ASTM II (37)
PW6 TITANIUM WHITE ASTM I (385)

PIGMENT DETAIL ON LABEL	ASTM	
YES	II L'FAST	

PERMANENT YELLOW LEMON 35

HOLBEIN

Transparent to semi-transparent. Very reliable ingredients giving a smooth, non staining colour which lifts with ease. Excellent.

ARTISTS' WATER COLOR

PY3 ARYLIDE YELLOW 10G ASTM II (37)
PY53 NICKEL TITANATE YELLOW ASTM I (43)

PIGMENT DETAIL ON LABEL	ASTM	
YES	II L'FAST	

LEMON YELLOW 608

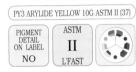

MAIMERI

Well ground paint giving smooth, even washes. A practical, lightfast pigment. Good value. Semi-transparent.

Discontinued

STUDIO FINE WATER COLOR 2ND RANGE

PY3 ARYLIDE YELLOW 10G ASTM II (37)

PIGMENT DETAIL ON LABEL	ASTM	
NO	II L'FAST	

PERMANENT YELLOW LEMON 112

MAIMERI

A very well made watercolour paint which washes out beautifully.

Reliable. Being semi opaque it covers reasonably well but there are slight limitations in clarity to the thin washes.

MAIMERIBLU SUPERIOR WATERCOLOURS

PY175 BENZIMIDAZOLONE YELLOW H6G WG II (51)

PIGMENT DETAIL ON LABEL	WG	
YES	II L'FAST	

CARAN D'ACHE

LEMON YELLOW 240

PY3 Makes an ideal 'Lemon Yellow'. It has a leaning towards green, is semi transparent and will resist fading. This is a well made example. Lifted very well.

FINEST WATERCOLOURS

PY3 ARYLIDE YELLOW 10G ASTM II (37)

PIGMENT DETAIL ON LABEL	ASTM	
YES	II L'FAST	

PERMANENT YELLOW LEMON 112

MAIMERI

A series of values moving from full strength to very light were provided by this well made watercolour paint.

VENEZIA EXTRAFINE WATERCOLOURS

PY175 BENZIMIDAZOLONE YELLOW H6G WG II (51)

PIGMENT DETAIL ON LABEL	WG	
YES	II L'FAST	

LEMON YELLOW W1

ART SPECTRUM

This is a very reliable yellow with a definite bias towards green. As such it will give relatively bright greens with Cerulean Blue and extremely bright, clear greens with Phalo Blue. The sample contained an excess of gum making heavier applications difficult.

ARTISTS' WATER COLOUR

PY3 ARYLIDE YELLOW 10G ASTM II (37)

PIGMENT DETAIL ON LABEL	ASTM	RATING
YES	II L'FAST	★★

UTRECHT

LEMON YELLOW 122

Having worked with various green yellows I have come to the opinion that PY3 makes the ideal 'Lemon Yellow'. This is a very well made example.

PROFESSIONAL ARTISTS' WATER COLOR

PY3 ARYLIDE YELLOW 10G ASTM II (37)

PIGMENT DETAIL ON LABEL	ASTM	
YES	II L'FAST	

LEMON YELLOW 5710

HUNTS

The earlier description offered in the literature, 'Hansa Yellow Pigment' was meaningless. Now that the pigment has been properly identified I can assess this as a reliable and most valuable colour.

SPEEDBALL PROFESSIONAL WATERCOLOURS

PY3 ARYLIDE YELLOW 10G ASTM II (37)

PIGMENT DETAIL ON LABEL	ASTM	
NO	II L'FAST	

LEMON YELLOW 215

SCHMINCKE

Reasonably transparent. Washes out to give even, gradated washes. Reliable pigment which will resist fading.

An excellent semi transparent watercolour which was previously called 'Permanent Yellow Light 215'.

HORADAM FINEST ARTISTS' WATER COLOURS

PY3 ARYLIDE YELLOW 10G ASTM II (37)

PIGMENT DETAIL ON LABEL	ASTM	
YES	II L'FAST	

LEMON YELLOW NO 1

PENTEL

As these colours are described as being for the use of artists, they have found a place in this book. As they are described as being 'fade resistant' we should expect some indication of the pigments used, either in the literature or on the product.

WATER COLORS

PIGMENT DETAILS NOT GIVEN

PIGMENT DETAIL ON LABEL	ASTM	RATING
NO	L'FAST	

LEMON YELLOW No 01

PENTEL (POLY TUBE)

I cannot offer assessments as I have no idea as to the ingredients. As this range is described as being suitable for 'artists and designers' and 'won't fade' they are featured in these pages.

PIGMENT DETAILS NOT GIVEN

PIGMENT DETAIL ON LABEL	ASTM	RATING
NO	L'FAST	

Cadmium Lemon Yellow

Well made examples brush out smoothly, are opaque but strong enough to give a clear wash.

Absolutely lightfast.

MIR
(JAURENA S.A)

ACUARELA

CADMIUM YELLOW LEMON 513

A bright, well made yellow which brushed out smoothly.

As with all of your watercolours, it is worth seeking out those made with quality pigments.

PY35 CADMIUM YELLOW LIGHT ASTM I (41)

| PIGMENT DETAIL ON LABEL | ASTM | |
| YES | I L'FAST | |

MIR
(JAURENA S.A)

ACUARELA

CADMIUM YELLOW LEMON HUE 505

The very slight difference between this and the colour to the left would not make me consider purchasing the two from the same range.

As they are both reliable I would go on price.

PY3 ARYLIDE YELLOW 10G ASTM II (37)

| PIGMENT DETAIL ON LABEL | ASTM | |
| YES | II L'FAST | |

PÈBÈO

FRAGONARD
ARTISTS'
WATER
COLOUR

LEMON CADMIUM YELLOW 331

Absolutely lightfast. The use of this excellent pigment ensures a quality watercolour which will retain its hue. Opaque.

PY35 CADMIUM YELLOW LIGHT ASTM I (41)

| PIGMENT DETAIL ON LABEL | ASTM | |
| YES | I L'FAST | |

OLD
HOLLAND

CLASSIC
WATERCOLOURS

CADMIUM YELLOW LEMON 9

A well made watercolour which handles very smoothly.

Bright, strong, good covering power, an excellent product. Opaque. Previously PY37.

PY35 CADMIUM YELLOW LIGHT ASTM I (41)

| PIGMENT DETAIL ON LABEL CHEMICAL MAKE UP ONLY | ASTM | |
| | I L'FAST | |

LEFRANC &
BOURGEOIS

LINEL
EXTRA-FINE
ARTISTS'
WATERCOLOUR

CADMIUM YELLOW LEMON 156

An absolutely lightfast pigment. Strong, bright, opaque and with good covering power.

Brushes out well. A description of the chemical make up will mean little to other than chemists who paint.

PY35 CADMIUM YELLOW LIGHT ASTM I (41)

| PIGMENT DETAIL ON LABEL CHEMICAL MAKE UP ONLY | ASTM | |
| | I L'FAST | |

HOLBEIN

ARTISTS'
WATER COLOR

CADMIUM YELLOW LEMON 40

Washes out smoothly across the range of values. An excellent pigment used. Absolutely lightfast, transparent and non staining. Opaque.

PY37 CADMIUM YELLOW MEDIUM OR DEEP ASTM I (42)

| PIGMENT DETAIL ON LABEL | ASTM | |
| YES | I L'FAST | |

MAIMERI

MAIMERIBLU
SUPERIOR
WATERCOLOURS

CADMIUM YELLOW LEMON 082

PY35 is strong enough to give reasonably transparent washes when well diluted. An excellent all round watercolour which will serve you well. Opaque.

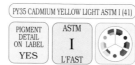

PY35 CADMIUM YELLOW LIGHT ASTM I (41)

| PIGMENT DETAIL ON LABEL | ASTM | |
| YES | I L'FAST | |

SENNELIER

EXTRA-FINE
WATERCOLOUR

CADMIUM YELLOW LEMON 535

An excellent all round watercolour. Powerful yet able to give delicate, quite transparent washes. Absolutely lightfast. Opaque.

PY35 CADMIUM YELLOW LIGHT ASTM I (41)

| PIGMENT DETAIL ON LABEL | ASTM | |
| YES | I L'FAST | |

WINSOR
& NEWTON

ARTISTS'
WATER COLOUR

CADMIUM LEMON 086

Strong and bright. Opaque yet giving reasonably clear washes due to its strength. PY35 is an excellent all round pigment. Recommended.

PY35 CADMIUM YELLOW LIGHT ASTM I (41)

| PIGMENT DETAIL ON LABEL | ASTM | |
| YES | I L'FAST | |

CARAN
D'ACHE

FINEST
WATERCOLOURS

LEMON CADMIUM YELLOW 500

A pan colour which lifts well without an excess of glycerine (or similar) to attract moisture.

Reliable and paints out well, what more could you ask for?

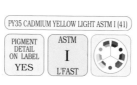

PY35 CADMIUM YELLOW LIGHT ASTM I (41)

| PIGMENT DETAIL ON LABEL | ASTM | |
| YES | I L'FAST | |

DA VINCI
PAINTS

PERMANENT
ARTISTS'
WATER COLOR

CADMIUM YELLOW LEMON 218

A new colour from this company. The sample gave very even washes and handled well at all strengths. Lightfast, opaque and staining. An excellent product.

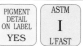

PY35 CADMIUM YELLOW LIGHT ASTM I (41)

| PIGMENT DETAIL ON LABEL | ASTM | |
| YES | I L'FAST | |

CADMIUM YELLOW LEMON W032

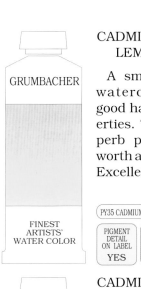

GRUMBACHER

A smooth, strong watercolour with good handling properties. This is a superb pigment, well worth any extra cost. Excellent.

FINEST ARTISTS' WATER COLOR

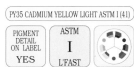

PY35 CADMIUM YELLOW LIGHT ASTM I (41)		
PIGMENT DETAIL ON LABEL **YES**	ASTM **I** L'FAST	

CADMIUM YELLOW LEMON 5708

HUNTS

An excellent paint, strong, bright and covers well. Should be less expensive than the chemically pure Cadmiums. Opaque.

Discontinued

SPEEDBALL PROFESSIONAL WATERCOLOURS

CADMIUM SULPHIDE COPRECIPITATED WITH BARIUM SULPHATE		
PIGMENT DETAIL ON LABEL **NO**	ASTM **I** L'FAST	

CADMIUM YELLOW LEMON 223

SCHMINCKE

A strong bright colour which was well made and handled smoothly across a useful range of values. A superb pigment and an excellent product. Opaque.

HORADAM FINEST ARTISTS' WATER COLOURS

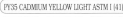

PY35 CADMIUM YELLOW LIGHT ASTM I (41)		
PIGMENT DETAIL ON LABEL **YES**	ASTM **I** L'FAST	

CADMIUM YELLOW LEMON 207

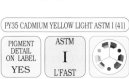

TALENS

Previously contained PW5, which dulled the colour. Now a strong, bright intense hue.

Our sample brushed out very smoothly over a useful range of values. Opaque.

REMBRANDT ARTISTS' QUALITY EXTRA FINE

PY35 CADMIUM YELLOW LIGHT ASTM I (41)		
PIGMENT DETAIL ON LABEL **YES**	ASTM **I** L'FAST	

CADMIUM YELLOW (AZO) 212

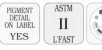

TALENS

Lightfast pigments used. Second range or Student colours need not be unreliable. Semi-transparent. Although discontinued, many will still have the colour.

Range discontinued

WATER COLOUR 2ND RANGE

PW4 ZINC WHITE ASTM I (384)		
PY3 ARYLIDE YELLOW 10G ASTM II (37)		
PIGMENT DETAIL ON LABEL **YES**	ASTM **II** L'FAST	

ST. PETERSBURG

ARTISTS' WATERCOLOURS

CADMIUM LEMON 001

This line of watercolours has enjoyed considerable sales success. Yet it would appear that not one purchaser has the first idea of the pigments used or their durability. Amazing.

DETAILS OF THE PIGMENTS USED ARE DELIBERATELY KEPT FROM THE ARTIST, FOR WHATEVER REASON		
PIGMENT DETAIL ON LABEL **NO**	ASTM L'FAST	RATING

Mars Yellow

Basically a synthetic version of Yellow Ochre, (a natural occurring pigment).

Strangely, many colours described as Yellow Ochre are Mars Yellow and the only watercolour actually called Mars Yellow is Yellow Ochre.

A neutralised orange-yellow for mixing purposes.

MARS YELLOW 054

DANIEL SMITH

A well made watercolour produced from a reliable pigment.

PY42, Mars Yellow can be considered as a synthetic alternative to Yellow Ochre.

Reasonably clear washes.

EXTRA-FINE WATERCOLORS

PY42 MARS YELLOW ASTM I (43)		
PIGMENT DETAIL ON LABEL **YES**	ASTM **I** L'FAST	

MARS YELLOW 319

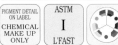

OLD HOLLAND

A reliable pigment has been used to give a smooth paint which handles exceptionally well.

A quality product in all respects.

CLASSIC WATERCOLOURS

PY42 MARS YELLOW ASTM I (43)		
PIGMENT DETAIL ON LABEL CHEMICAL MAKE UP ONLY	ASTM **I** L'FAST	

MARS YELLOW 28

HOLBEIN

This is not Mars Yellow, it is Zinc Iron Yellow. The word 'Hue' or 'Imitation' would clarify the situation. This is important if we are to choose watercolours on their handling characteristics as well as their reliability .

ARTISTS' WATER COLOR

PY119 ZINC IRON YELLOW WG II (47)		
PIGMENT DETAIL ON LABEL **YES**	WG **II** L'FAST	RATING ★ ★★

MARS YELLOW 505

SENNELIER

It seems odd that Yellow Ochre (with an addition), is marketed under the name of its synthetic cousin.

A well made paint employing reliable pigments. Semi-transparent.

Reformulated>

EXTRA-FINE WATERCOLOUR

| PY3 ARYLIDE YELLOW 10G ASTM II (37) | | |
| PY43 YELLOW OCHRE ASTM I (43) | | |

| PIGMENT DETAIL ON LABEL **YES** | ASTM **II** L'FAST | |

MARS YELLOW 505

SENNELIER

The fact that this is an imitation Mars Yellow should be reflected in its title with the word 'Hue' or 'imitation'.

A reliable enough watercolour and well made.

EXTRA-FINE WATERCOLOUR

| *UNSPECIFIED PBr7 (309/310)* | | |
| PO49 QUINACRIDONE DEEP GOLD WG II (97) | | |

| PIGMENT DETAIL ON LABEL **YES** | WG **II** L'FAST | |

I have decided not to lower my assessment if a paint has been incorrectly named.

Instead I have concentrated on the qualities of the paint, leaving the reader to decide whether the product, however named, is suitable for the purpose intended.

Naples Yellow

Originally a lead based pigment suitable only for oil paints.

The name has become more of a colour description than a pigment title.

Commonly a blend of Cadmium Yellow and white, but nowadays the range of pigments used has widened.

When used in mixing, treat as a neutralised orange-yellow. An orange yellow because that is the usual base colour and neutralised, (dulled), by the white. Will give cool, subtle greens and soft neutral oranges. Complementary, a blue-violet.

NAPLES YELLOW

MAIMERI

Sample stood up very well to our lightfast testing.

A well made product, washing out very smoothly. Semi-transparent.

Range discontinued

ARTISTI EXTRA-FINE WATERCOLOURS

PY83HR70 DIARYLIDE YELLOW HR70 WG II (45)		
PY37 CADMIUM YELLOW MEDIUM OR DEEP ASTM I (42)		
PY53 NICKEL TITANATE YELLOW ASTM I (43)		

| PIGMENT DETAIL ON LABEL **NO** | WG **II** L'FAST | |

NAPLES YELLOW LIGHT 105

MAIMERI

A slightly gummy version of this popular colour. Handled better in thin washes. Dependable pigments have been used.

MAIMERIBLU SUPERIOR WATERCOLOURS

PW4 ZINC WHITE ASTM I (384)		
PY97 ARYLIDE YELLOW FGL ASTM II (46)		
PY42 MARS YELLOW ASTM I (43)		

| PIGMENT DETAIL ON LABEL **YES** | ASTM **II** L'FAST | RATING ★★ |

NAPLES YELLOW REDDISH 106

MAIMERI

Very even smooth washes, as one would expect from this combination of pigments.

A reliable, well produced paint.

MAIMERIBLU SUPERIOR WATERCOLOURS

| PW6 TITANIUM WHITE ASTM I (385) | | |
| PY42 MARS YELLOW ASTM I (43) | | |

| PIGMENT DETAIL ON LABEL **YES** | ASTM **I** L'FAST | |

NAPLES YELLOW 076

AMERICAN JOURNEY

Judging by the colour, this seems to be mainly Yellow Ochre with just a touch of the Cadmium Yellow Light. Reliable ingredients. Slight staining, semi-opaque.

PROFESSIONAL ARTISTS' WATER COLOR

| PY35 CADMIUM YELLOW LIGHT ASTM I (41) | | |
| PY43 YELLOW OCHRE ASTM I (43) | | |

| PIGMENT DETAIL ON LABEL **YES** | ASTM **I** L'FAST | |

NAPLES YELLOW 30

HOLBEIN

The labelling of this range has improved considerably since the last edition. Superb ingredients. Our sample brushed out very well. Opaque and non staining. An excellent product.

ARTISTS' WATER COLOR

PY37 CADMIUM YELLOW MEDIUM OR DEEP ASTM I (42)		
PY42 MARS YELLOW ASTM I (43)		
PW6 TITANIUM WHITE ASTM I (385)		

| PIGMENT DETAIL ON LABEL **YES** | ASTM **I** L'FAST | |

NAPLES YELLOW IMITATION 191

LEFRANC & BOURGEOIS

All pigments are absolutely lightfast. The resulting paint brushes out beautifully.

Correctly named. The words 'Hue' and 'Imitation' having the same meaning in this context.

LINEL EXTRA-FINE ARTISTS' WATERCOLOUR

PY42 MARS YELLOW ASTM I (43)		
PY35 CADMIUM YELLOW LIGHT ASTM I (41)		
PW5 LITHOPONE WG I (384)		

| PIGMENT DETAIL ON LABEL CHEMICAL MAKE UP ONLY | ASTM **I** L'FAST | |

NAPLES YELLOW LIGHT 2180

UMTON BARVY

ARTISTIC WATER COLOR

If kept dry, this watercolour paint could sit under the blazing sun for many years without changing. A very well made example of this colour type.

| PW4 ZINC WHITE ASTM I (384) |
| PY37 CADMIUM YELLOW MEDIUM OR DEEP ASTM I (42) |
| PY43 YELLOW OCHRE ASTM I (43) |

PIGMENT DETAIL ON LABEL	ASTM	
NO	I L'FAST	

NAPLES YELLOW 422

WINSOR & NEWTON

ARTISTS' WATER COLOUR

Sample brushed out smoothly. All ingredients are absolutely lightfast. A useful convenience colour, very well made. Semi-opaque.

| PR101 MARS RED ASTM I (124) |
| PW4 ZINC WHITE ASTM I (384) |
| PY35 CADMIUM YELLOW LIGHT ASTM I (41) |

PIGMENT DETAIL ON LABEL	ASTM	
YES	I L'FAST	

NAPLES YELLOW DEEP 425

WINSOR & NEWTON

ARTISTS' WATER COLOUR

Gave very smooth washes over a useful range of values, varying from a neutralised orange yellow to reasonably clear washes.

I would advice caution as PBr24 has not been proven to be reliable.

| PBr24 CHROME ANTIMONY TITANIUM BUFF RUTILE WG III (312) |

PIGMENT DETAIL ON LABEL	WG	RATING
YES	III L'FAST	★★

NAPLES YELLOW W44

ART SPECTRUM

ARTISTS' WATER COLOUR

A little over bound but handled quite well.

As with all versions of Naples Yellow', it is an easily mixed convenience colour.

| PW4 ZINC WHITE ASTM I (384) |
| PY42 MARS YELLOW ASTM I (43) |

PIGMENT DETAIL ON LABEL	ASTM	RATING
YES	I L'FAST	★ ★★

NAPLES YELLOW REDDISH W45

ART SPECTRUM

ARTISTS' WATER COLOUR

It is difficult to see what would take this colour towards red given the stated ingredients, which are the same as for the colour to the left. I will not therefore offer a rating in this edition.

| PW4 ZINC WHITE ASTM I (384) |
| PY42 MARS YELLOW ASTM I (43) |

PIGMENT DETAIL ON LABEL	ASTM	RATING
YES	L'FAST	

NAPLES YELLOW 126

PÈBÈO

FRAGONARD ARTISTS' WATER COLOUR

The inclusion of PY74LF reduces the overall permanence of this colour. Company dispute this but seem to be using the wrong ASTM list. Becomes slightly duller on exposure, especially tints.

| PR101 MARS RED ASTM I (124) |
| PW6 TITANIUM WHITE ASTM I (385) |
| PY74LF ARYLIDE YELLOW 5GX ASTM III (44) |
| PY42 MARS YELLOW ASTM I (43) |

PIGMENT DETAIL ON LABEL	ASTM	RATING
YES	III L'FAST	★★

NAPLES YELLOW EXTRA 313

OLD HOLLAND

CLASSIC WATERCOLOURS

The sample was rather over bound. As with all watercolours which contain an excess of gum, only thin washes were possible.

| PW4 ZINC WHITE ASTM I (384) |
| PW6 TITANIUM WHITE ASTM I (385) |
| PY42 MARS YELLOW ASTM I (43) |

PIGMENT DETAIL ON LABEL	ASTM	RATING
CHEMICAL MAKE UP ONLY	I L'FAST	★★

NAPLES YELLOW DEEP EXTRA 316

OLD HOLLAND

CLASSIC WATERCOLOURS

Yellow Deep Extra during use but I suspect Yellow Light Extra after exposure.

Although unreliable, the sample was well made and gave good washes.

| PBr24 CHROME ANTIMONY TITANIUM BUFF RUTILE WG III (312) |

PIGMENT DETAIL ON LABEL	WG	RATING
CHEMICAL MAKE UP ONLY	III L'FAST	★★

NAPLES YELLOW REDDISH EXTRA 112

OLD HOLLAND

CLASSIC WATERCOLOURS

A rather complex formula. Handled very well. I am afraid that I cannot offer assessments as I have insufficient information on PR260.

| PW4 ZINC WHITE ASTM I (384) |
| PW6 TITANIUM WHITE ASTM I (385) |
| PY53 NICKEL TITANATE YELLOW ASTM I (43) |
| PO43 PERINONE ORANGE WG II (96) |
| PR260 COMMON NAME N/K LF NOT OFFERED (137) |

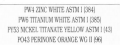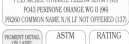

PIGMENT DETAIL ON LABEL	ASTM	RATING
CHEMICAL MAKE UP ONLY	L'FAST	

NAPLES YELLOW 634

DALER ROWNEY

ARTISTS' WATER COLOUR

Thoroughly reliable ingredients. A useful convenient colour. Good handling characteristics imparted by each pigment. Opaque.

Reformulated >

| PW6 TITANIUM WHITE ASTM I (385) |
| PY37 CADMIUM YELLOW MEDIUM OR DEEP ASTM I (42) |
| PO20 CADMIUM ORANGE ASTM I (94) |

PIGMENT DETAIL ON LABEL	ASTM	
YES	I L'FAST	

NAPLES YELLOW 634

DALER ROWNEY

ARTISTS' WATER COLOUR

A shift in ingredients to give another version of this popular convenience colour. Thoroughly reliable.

| PY35 CADMIUM YELLOW LIGHT ASTM I (41) |
| PR108 CADMIUM RED LIGHT, MEDIUM OR DEEP ASTM I (126) |
| PW6 TITANIUM WHITE ASTM I (385) |

PIGMENT DETAIL ON LABEL	ASTM	
YES	I L'FAST	

NAPLES YELLOW 567

SENNELIER

EXTRA-FINE WATERCOLOUR

Excellent pigments, particularly fast to light. Sample was slightly over bound but gave very good washes. Reformulated few years ago, PY37 changed to PY35. PW6 added. Opaque.

| PW4 ZINC WHITE ASTM I (384) |
| PY35 CADMIUM YELLOW LIGHT ASTM I (41) |
| PW6 TITANIUM WHITE ASTM I (385) |

PIGMENT DETAIL ON LABEL	ASTM	RATING
YES	I L'FAST	★ ★★

NAPLES YELLOW 058

When the watercolour purists tell me that they would never use white, it turns out that most are happy to use colours such as this, which contain white. This is a well made example.

EXTRA-FINE WATERCOLORS

| PW4 ZINC WHITE ASTM I (384) |
| PY35 CADMIUM YELLOW LIGHT ASTM I (41) |
| *UNSPECIFIED PR101 ASTM I (123/124)* |

PIGMENT DETAIL ON LABEL **YES** | ASTM **I** L'FAST

NAPLES YELLOW RED 224

TALENS

A convenience colour easily mixed from the stated ingredients, (as are all Naples Yellows). Quality pigments making an excellent watercolour.

Reformulated >

REMBRANDT ARTISTS' QUALITY EXTRA FINE

| PO20 CADMIUM ORANGE ASTM I (94) |
| PY35 CADMIUM YELLOW LIGHT ASTM I (41) |
| PW4 ZINC WHITE ASTM I (384) |

PIGMENT DETAIL ON LABEL **YES** | ASTM **I** L'FAST

NAPLES YELLOW RED (on tube) REDDISH (in lit.) 224

TALENS

After having washed out so many heavy going, gummy paints for the compilation this book, it is a pleasure to come across colours such as this, which handle as a watercolour paint should handle.

REMBRANDT ARTISTS' QUALITY EXTRA FINE

| PY42 MARS YELLOW ASTM I (43) |
| PO43 PERINONE ORANGE WG II (96) |
| PW4 ZINC WHITE ASTM I (384) |

PIGMENT DETAIL ON LABEL **YES** | WG **II** L'FAST

NAPLES YELLOW LIGHT 222

TALENS

As with all colours containing Cadmium Yellow, avoid exposing to light in a humid atmosphere. Brushed out extremely well, a quality product. Opaque.

Discontinued

REMBRANDT ARTISTS' QUALITY EXTRA FINE

| PW4 ZINC WHITE ASTM I (384) |
| PY35 CADMIUM YELLOW LIGHT ASTM I (41) |

PIGMENT DETAIL ON LABEL **YES** | ASTM **I** L'FAST

NAPLES YELLOW RED 224

TALENS

Such colours as this might be convenient but they are very easy to mix.

Lightfast and well produced.

VAN GOGH 2ND RANGE

| PY42 MARS YELLOW ASTM I (43) |
| PO43 PERINONE ORANGE WG II (96) |

PIGMENT DETAIL ON LABEL **YES** | WG **II** L'FAST

NAPLES YELLOW DEEP 223

TALENS

Without the addition of PBr24, a pigment which has not been subjected to recognised testing as an art material, this would have been a colour that I could have recommended.

REMBRANDT ARTISTS' QUALITY EXTRA FINE

| PBr24 CHROME ANTIMONY TITANIUM BUFF RUTILE WG III (312) |
| PY53 NICKEL TITANATE YELLOW ASTM I (43) |
| PW4 ZINC WHITE ASTM I (384) |

PIGMENT DETAIL ON LABEL **YES** | WG **III** L'FAST | RATING ★★

NAPLES YELLOW REDDISH 230

SCHMINCKE

A soft, brownish opaque yellow produced from a range of very reliable ingredients. The sample provided gave very even washes over the full range.

HORADAM FINEST ARTISTS' WATER COLOURS

| PY42 MARS YELLOW ASTM I (43) |
| PR251 COMMON NAME N/K WG II (136) |
| PW4 ZINC WHITE ASTM I (384) |
| PW6 TITANIUM WHITE ASTM I (385) |

PIGMENT DETAIL ON LABEL **YES** | WG **II** L'FAST

NAPLES YELLOW 229

SCHMINCKE

The PBr24 content must be at an absolute minimum as our sample was unaffected by light. Brushed out well, if a little over bound. Semi-opaque.

HORADAM FINEST ARTISTS' WATER COLOURS

| PBr24 CHROME ANTIMONY TITANIUM BUFF RUTILE WG III (312) |
| PW6 TITANIUM WHITE ASTM I (385) |
| PY53 NICKEL TITANATE YELLOW ASTM I (43) |

PIGMENT DETAIL ON LABEL **YES** | WG **III** L'FAST | RATING ★★

NAPLES YELLOW (HUE) W146

GRUMBACHER

As with all paints containing Cadmium Yellow, tends to fade in a humid atmosphere. Excellent pigments used. Opaque.

FINEST ARTISTS' WATER COLOR

| PBr7 BURNT SIENNA ASTM I (310) |
| PR108 CADMIUM RED LIGHT, MEDIUM OR DEEP ASTM I (126) |
| PY35:1 CADMIUM BARIUM YELLOW ASTM I (41) |

PIGMENT DETAIL ON LABEL **YES** | ASTM L'FAST

NAPLES YELLOW HUE A146

GRUMBACHER

The only unreliable pigment is the PR49:1. On exposure the colour gradually becomes lighter and yellower.

Reformulated >

ACADEMY ARTISTS' WATERCOLOR 2ND RANGE

| PBr7 BURNT SIENNA ASTM I (310) |
| PY3 ARYLIDE YELLOW 10G ASTM II (37) |
| PR49:1 LITHOL RED WG IV (119) |
| PW6 TITANIUM WHITE ASTM I (385) |

PIGMENT DETAIL ON LABEL **YES** | WG **IV** L'FAST | RATING ★

NAPLES YELLOW HUE A146

GRUMBACHER

The addition of white is necessary to dull and cool the other colours. The watercolourist who avoids the use of white is denied a wide range of unique tints. This is a well made product.

ACADEMY ARTISTS' WATERCOLOR 2ND RANGE

| PY3 ARYLIDE YELLOW 10G ASTM II (37) |
| *UNSPECIFIED PBr7 (309/310)* |
| PR178 PERYLENE RED ASTM II (131) |
| PW6 TITANIUM WHITE ASTM I (385) |

PIGMENT DETAIL ON LABEL **YES** | ASTM **II** L'FAST

NAPLES YELLOW 259

DA VINCI PAINTS

A little brighter and less 'cloudy' than the 'traditional' Naples Yellow. This is due, presumably to the absence of white. A well made paint which is light resistant.

PERMANENT ARTISTS' WATER COLOR

| PY35 CADMIUM YELLOW LIGHT ASTM I (41) |
| PY43 YELLOW OCHRE ASTM I (43) |

PIGMENT DETAIL ON LABEL **YES** | ASTM **I** L'FAST

NAPLES YELLOW 1034

LUKAS

There can be little of the impermanent PBr24 involved (need there be any?), as our sample stood up very well during exposure tests. Brushed out very smoothly.

ARTISTS' WATER COLOUR

PY53 NICKEL TITANATE YELLOW ASTM I (43) PBr24 CHROME ANTIMONY TITANIUM BUFF RUTILE WG III (312)		
PIGMENT DETAIL ON LABEL CHEMICAL MAKE UP ONLY	WG III L'FAST	RATING ★★

NAPLES YELLOW REDDISH 1036

LUKAS

The sample provided did not stand up very well to our exposure testing. A pity, as it handled very well in washes. Such colours are very easy to match with reliable pigments.

ARTISTS' WATER COLOUR

PBr24 CHROME ANTIMONY TITANIUM BUFF RUTILE WG III (312)		
PIGMENT DETAIL ON LABEL CHEMICAL MAKE UP ONLY	WG III L'FAST	RATING ★★

Any 'Naples Yellow' containing Cadmium Yellow will tend to fade on exposure to light in a humid atmosphere.

Miscellaneous Yellows

I am always very wary of colours sold under either trade or fancy names. We now have a range of valuable yellows which could be sold openly under their own titles.

Be very careful of purchasing paints which are not fully and accurately labelled.

When mixing with any of the following, it pays to establish the bias or leaning of the colour.

Do you have a green or an orange yellow to work with?

ANTIQUE AMBER 032

HOLBEIN

Reliable pigments have been used to produce a watercolour paint which was a pleasure to wash out. An excellent product.

IRODORI ANTIQUE WATERCOLOR

PBr11 MANGANESE FERRITE WG II (311) PY83HR70 DIARYLIDE YELLOW HR70 WG II (45)		
PIGMENT DETAIL ON LABEL YES	WG II L'FAST	

ANTIQUE BRIGHT YELLOW 031

HOLBEIN

Lightfast pigments to give, despite its title, a rather subdued greenish yellow. Washed out very well, a quality product.

IRODORI ANTIQUE WATERCOLOR

PY53 NICKEL TITANATE YELLOW ASTM I (43) PY43 YELLOW OCHRE ASTM I (43)		
PIGMENT DETAIL ON LABEL YES	ASTM I L'FAST	

ANTIQUE DANDELION 030

HOLBEIN

A fairly strong bright yellow which painted out very well to give smooth layers at all strengths. As you can see by the lightfast rating below, this is a reliable watercolour.

IRODORI ANTIQUE WATERCOLOR

PY3 ARYLIDE YELLOW 10G ASTM II (37) PY42 MARS YELLOW ASTM I (43)		
PIGMENT DETAIL ON LABEL YES	ASTM II L'FAST	

ANTIQUE GOLD 048

HOLBEIN

Titanated Mica is an absolutely lightfast material giving a colour which varies depending on the angle of vision. One moment a greyed brown, the next a rather (to my eyes) garish 'gold'.

Very difficult to apply in a light, even wash.

IRODORI ANTIQUE WATERCOLOR

TITANATED MICA		
PIGMENT DETAIL ON LABEL YES	WG I L'FAST	RATING ★★

ANTIQUE LEMON 007

HOLBEIN

PY3 Arylide or Hansa Yellow is an extremely useful green yellow. Semi transparent and resistant to light.

This example was well made.

IRODORI ANTIQUE WATERCOLOR

PY3 ARYLIDE YELLOW 10G ASTM II (37)		
PIGMENT DETAIL ON LABEL YES	ASTM II L'FAST	

ANTIQUE SUN YELLOW 006

HOLBEIN

I suppose that 'Sun Yellow' is quite a good name. For a while that is.

As the PY1 fades, as fade it must on exposure, the colour will move towards the orange bias of the PY83. Why do they do it?

IRODORI ANTIQUE WATERCOLOR

PY1 ARYLIDE YELLOW G ASTM V (37) PY83HR70 DIARYLIDE YELLOW HR70 WG II (45)		
PIGMENT DETAIL ON LABEL YES	ASTM V L'FAST	RATING ★

ARYLIDE YELLOW FGL 203

DA VINCI PAINTS

A bright yellow leaning towards green. Strong in mixes, it gives very smooth even washes over a useful range of values. A lightfast, semi-transparent, staining colour.

PERMANENT ARTISTS' WATER COLOR

PY97 ARYLIDE YELLOW FGL ASTM II (46)		
PIGMENT DETAIL ON LABEL **YES**	ASTM **II** L'FAST	

ANTIQUE ORANGE YELLOW 029

HOLBEIN

The washes from this watercolour can be taken to extremely thin applications without breaking down. This is due not only to the transparent nature of the pigment but also to an absence of filler.

IRODORI ANTIQUE WATERCOLOR

PY83HR70 DIARYLIDE YELLOW HR70 WG II (45)		
PIGMENT DETAIL ON LABEL **YES**	WG **II** L'FAST	

AURORA YELLOW 017

WINSOR & NEWTON

Why Cadmium Yellow, an excellent pigment in its own right, is sold under this name is a mystery to me. Opaque.

Discontinued, Company says is similar to Cadmium Yellow Pale.

ARTISTS' WATER COLOUR

PY35 CADMIUM YELLOW LIGHT ASTM I (41)		
PIGMENT DETAIL ON LABEL **YES**	ASTM **I** L'FAST	

AZO YELLOW LIGHT 268

TALENS

Bright and fairly strong tinctorially.

A semi opaque pigment which is strong enough, when the paint is as well made as this, to give reasonably clear washes.

REMBRANDT ARTISTS' QUALITY EXTRA FINE

PY154 BENZIMIDAZOLONE YELLOW H3G ASTM II (50)		
PIGMENT DETAIL ON LABEL **YES**	ASTM **II** L'FAST	

AZO YELLOW LIGHT 268

TALENS

Although containing the same ingredients as the 'Artist Quality' version in this make, our sample was rather over bound. It can be practice to use less of an expensive pigment and replace it with gum.

VAN GOGH 2ND RANGE

PY154 BENZIMIDAZOLONE YELLOW H3G ASTM II (50)		
PIGMENT DETAIL ON LABEL **YES**	ASTM **II** L'FAST	RATING ★★

AZO YELLOW MEDIUM 269

TALENS

PY152 is, given its well known reputation, an irresponsible pigment to use in any media, let alone watercolours.

REMBRANDT ARTISTS' QUALITY EXTRA FINE

PY152 DIARYLIDE YELLOW YR WG V (49) PO62 BENZIMIDAZOLONE ORANGE H5G ASTM II (97)		
PIGMENT DETAIL ON LABEL **YES**	WG **V** L'FAST	RATING ★

AZO YELLOW MIDDLE 269

TALENS

A fairly strong yellow which gives bright, attractive washes when well diluted. Rather duller in mass tone. Well made and reliable.

VAN GOGH 2ND RANGE

PY154 BENZIMIDAZOLONE YELLOW H3G ASTM II (50) PO62 BENZIMIDAZOLONE ORANGE H5G ASTM II (97)		
PIGMENT DETAIL ON LABEL **YES**	ASTM **II** L'FAST	

AZO YELLOW DEEP 270

TALENS

PO43 has an excellent reputation and is considered by many to be second only to Cadmium Orange. Used generously in this excellent product.

REMBRANDT ARTISTS' QUALITY EXTRA FINE

PY154 BENZIMIDAZOLONE YELLOW H3G ASTM II (50) PO43 PERINONE ORANGE WG II (96)		
PIGMENT DETAIL ON LABEL **YES**	ASTM **II** L'FAST	

AZO YELLOW DEEP 270

TALENS

A very well produced watercolour paint employing reliable pigments.

Gave very good, even washes.

VAN GOGH 2ND RANGE

PY154 BENZIMIDAZOLONE YELLOW H3G ASTM II (50) PO43 PERINONE ORANGE WG II (96)		
PIGMENT DETAIL ON LABEL **YES**	ASTM **II** L'FAST	

AZO YELLOW 018

M. GRAHAM & CO.

Some yellows tend to wash out almost in bands between values. This example is quite different. Handled beautifully giving a 'seamless' wash from full strength to the thinnest wash.

ARTISTS' WATERCOLOR

PY151 BENZIMIDAZOLONE YELLOW H4G WG II (49)		
PIGMENT DETAIL ON LABEL **YES**	WG **II** L'FAST	

BRILLIANT YELLOW LIGHT 221

SCHMINCKE

This used to be a mix of Cadmium Yellow and White. The unfortunate addition of the PBr24 lowers the lightfastness rating. Opaque.

Reformulated >

HORADAM FINEST ARTISTS' WATER COLOURS

PW6 TITANIUM WHITE ASTM I (385) PY154 BENZIMIDAZOLONE YELLOW H3G ASTM II (50) PBr24 CHROME ANTIMONY TITANIUM BUFF RUTILE WG III (312)		
PIGMENT DETAIL ON LABEL **YES**	WG **III** L'FAST	RATING ★★

BRILLIANT YELLOW LIGHT 221

SCHMINCKE

There is confusion here. A sample of this colour was not provided but all the indications are that 'Brilliant Yellow Dark', which *was* provided *but is not* listed, is one and the same.

HORADAM FINEST ARTISTS' WATER COLOURS

PW6 TITANIUM WHITE ASTM I (385) PY53 !NICKEL TITANATE YELLOW ASTM I (43) PBr24 CHROME ANTIMONY TITANIUM BUFF RUTILE WG III (312)		
PIGMENT DETAIL ON LABEL **YES**	WG **III** L'FAST	RATING

BRILLIANT YELLOW 1

SCHMINCKE

Reliable ingredients. This colour is very easily reproduced on the palette. Our sample brushed out well. Transparent.

Discontinued

HORADAM FINEST ARTISTS' WATER COLOURS

| PW5 LITHOPONE WG I (384) |
| PY3 ARYLIDE YELLOW 10G ASTM II (37) |

PIGMENT DETAIL ON LABEL	ASTM	
YES	II L'FAST	

BRILLIANT YELLOW DARK 221

SCHMINCKE

Given the ingredients, this was never going to be a brilliant yellow, light or dark. Very smooth, even washes. Let down by the unreliable PBr24.

HORADAM FINEST ARTISTS' WATER COLOURS

| PW6 TITANIUM WHITE ASTM I (385) |
| PY53 NICKEL TITANATE YELLOW ASTM I (43) |
| PBr24 CHROME ANTIMONY TITANIUM BUFF RUTILE WG III (312) |

PIGMENT DETAIL ON LABEL	WG	RATING
YES	III L'FAST	★★

BRILLIANT YELLOW LIGHT 103

OLD HOLLAND

Not a great deal seems to be known about the relatively new PO69. You might take a chance and use it, I cannot take a chance and assess it.

CLASSIC WATERCOLOURS

| PW4 ZINC WHITE ASTM I (384) |
| PW6 TITANIUM WHITE ASTM I (385) |
| PY83HR70 DIARYLIDE YELLOW HR70 WG II (45) |
| PO69 COMMON NAME N/K LF NOT OFFERED (98) |

PIGMENT DETAIL ON LABEL	ASTM	RATING
CHEMICAL MAKE UP ONLY	L'FAST	

BRILLIANT YELLOW 106

OLD HOLLAND

Once again I cannot offer an assessment until more is known about PO69.

CLASSIC WATERCOLOURS

| PW4 ZINC WHITE ASTM I (384) |
| PW6 TITANIUM WHITE ASTM I (385) |
| PY53 NICKEL TITANATE YELLOW ASTM I (43) |
| PO69 COMMON NAME N/K LF NOT OFFERED (98) |

PIGMENT DETAIL ON LABEL	ASTM	RATING
CHEMICAL MAKE UP ONLY	L'FAST	

BRILLIANT YELLOW REDDISH 109

OLD HOLLAND

PO69 again. Perhaps the company will put my mind to rest and offer proof of its value as an ingredient in a paint intended for artistic use.

CLASSIC WATERCOLOURS

| PW4 ZINC WHITE ASTM I (384) |
| PW6 TITANIUM WHITE ASTM I (385) |
| PY53 NICKEL TITANATE YELLOW ASTM I (43) |
| PO69 COMMON NAME N/K LF NOT OFFERED (98) |
| PO43 PERINONE ORANGE WG II (96) |

PIGMENT DETAIL ON LABEL	ASTM	RATING
CHEMICAL MAKE UP ONLY	L'FAST	

BRILLIANT YELLOW 513

MAIMERI

The addition of a white pigment will always dull and cool any colour. This yellow would have been a little more 'brilliant' without it. Semi-transparent.

Discontinued

VENEZIA EXTRAFINE WATERCOLOURS

| PW6 TITANIUM WHITE ASTM I (385) |
| PY83HR70 DIARYLIDE YELLOW HR70 WG II (45) |

PIGMENT DETAIL ON LABEL	WG	RATING
YES	II L'FAST	★★

BUMBLEBEE YELLOW 013

AMERICAN JOURNEY

I suppose that this name hardly adds anything to the confusion which exists surrounding the naming of artists colours. Hopefully you will select more on the pigments used. Nevertheless, this is a quality product.

PROFESSIONAL ARTISTS' WATER COLOR

| PY97 ARYLIDE YELLOW FGL ASTM II (46) |

PIGMENT DETAIL ON LABEL	ASTM	
YES	II L'FAST	

BISMUTH YELLOW 629

DALER ROWNEY

Although PY184 rated as ASTM I when made up into an acrylic paint, it could prove to be I, II or III as a watercolour. Until more is known I will not offer an assessment.

ARTISTS' WATER COLOUR

| PY184 BISMUTH VANADATE YELLOW LF NOT OFFERED (51) |

PIGMENT DETAIL ON LABEL	ASTM	RATING
NO	L'FAST	

BISMUTH YELLOW 025

WINSOR & NEWTON

Washed out extremely well from heavier layers to the thinnest. Gave very even, clear washes.

I am afraid that I cannot offer assessments as I have insufficient information about PY184.

ARTISTS' WATER COLOUR

| PY184 BISMUTH VANADATE YELLOW LF NOT OFFERED (51) |

PIGMENT DETAIL ON LABEL	ASTM	RATING
YES	L'FAST	

DEEP YELLOW 610

MAIMERI

Will gradually fade on exposure. It will also become more orange as the PO43 will resist the light. Most unreliable. Transparent.

Range discontinued

STUDIO FINE WATERCOLOURS

| PY1 ARYLIDE YELLOW G ASTM V (37) |
| PO43 PERINONE ORANGE WG II (96) |

PIGMENT DETAIL ON LABEL	ASTM	RATING
YES	V L'FAST	★

FLANDERS YELLOW 178

LEFRANC & BOURGEOIS

A reliable, transparent watercolour which washes out rather well.

The label gives the colorant as 'Azo Pigment'. Which Azo?

LINEL EXTRA-FINE ARTISTS' WATERCOLOUR

| PY3 ARYLIDE YELLOW 10G ASTM II (37) |

PIGMENT DETAIL ON LABEL	ASTM	RATING
CHEMICAL MAKE UP ONLY	II L'FAST	★ ★★

GOLD YELLOW 176

LEFRANC & BOURGEOIS

It is no secret that Chrome Yellow Lemon can darken considerably on exposure. Even marketed under a fancy name. Our sample certainly did. Semi-opaque.

Discontinued

LINEL EXTRA-FINE ARTISTS' WATERCOLOUR

| PY34 CHROME YELLOW LEMON LF NOT OFFERED (41) |

PIGMENT DETAIL ON LABEL	ASTM	RATING
CHEMICAL MAKE UP ONLY	L'FAST	

GALLSTONE 208

LEFRANC & BOURGEOIS

The pigment PY153 is normally reliable and proved so in other paints. Our Gallstone sample darkened. No assessments offered. Semi-transparent.

Reformulated >

PY153 NICKEL DIOXINE YELLOW
ASTM II (50)

LINEL EXTRA-FINE ARTISTS' WATERCOLOUR

PIGMENT DETAIL ON LABEL CHEMICAL MAKE UP ONLY	ASTM L'FAST	RATING

GALLSTONE 208

LEFRANC & BOURGEOIS

Originally produced from gallstones taken from animal carcasses. This imitation would have been a lot less messy to produce. A top quality product.

PY153 NICKEL DIOXINE YELLOW
ASTM II (50)
UNSPECIFIED PR101 ASTM I (123/124)

LINEL EXTRA-FINE ARTISTS' WATERCOLOUR

PIGMENT DETAIL ON LABEL CHEMICAL MAKE UP ONLY	ASTM II L'FAST	

GREENISH YELLOW 46

HOLBEIN

At full strength is a very dull green-yellow. Washes into a much brighter tint. Settles out when heavy and can be difficult to lift. Transparent and non staining.

PY177 IRGAZIN YELLOW 4GT
WG II (51)

ARTISTS' WATER COLOR

PIGMENT DETAIL ON LABEL YES	WG II L'FAST	

GOLDEN YELLOW A081

GRUMBACHER

Neither pigment takes kindly to the light. Second range colours need not be fugitive. Most unreliable. Transparent.

Reformulated>

PY1 ARYLIDE YELLOW G ASTM V (37)
PO1 HANSA ORANGE WG V (94)

ACADEMY ARTISTS' WATERCOLOR 2ND RANGE

PIGMENT DETAIL ON LABEL YES	ASTM V L'FAST	RATING ★

GOLDEN YELLOW A081

GRUMBACHER

A fairly bright yellow which gave perfectly even gradated washes at all strengths.

A quality product employing quality pigments.

PY3 ARYLIDE YELLOW 10G ASTM II (37)
PY65 ARYLIDE YELLOW RN ASTM II (44)

ACADEMY ARTISTS' WATERCOLOR 2ND RANGE

PIGMENT DETAIL ON LABEL YES	ASTM II L'FAST	

GOLDEN LAKE 128

MAIMERI

I have double checked the label and it definitely states that the pigment is PV49. Whatever it is, the sample was more of a heavy coloured gum than a watercolour paint.

PV49 COBALT AMMONIUM
VIOLET PHOSPHATE WG II (187)

MAIMERIBLU SUPERIOR WATERCOLOURS

PIGMENT DETAIL ON LABEL YES	WG II L'FAST	RATING ★

GOLD 893

SCHMINCKE

It is obviously not my role to comment on taste but I do wonder what this trend towards the use of metallic paints in watercolour is all about. As with all other examples that I have tried, this paints out with the greatest of difficulty.

COATED MICA TITANIUM
DIOXIDE & IRON OXIDE

HORADAM FINEST ARTISTS' WATER COLOURS

PIGMENT DETAIL ON LABEL YES	WG I L'FAST	RATING ★

GREEN PINK 665

SCHMINCKE

Late notification on the use of PY129 makes it impossible to offer assessments. Sample over bound and lacking in body.

Discontinued

PY42 MARS YELLOW ASTM I (43)
PY129 AZOMETHINE YELLOW 5GT
LF NOT OFFERED (48)

HORADAM FINEST ARTISTS' WATER COLOURS

PIGMENT DETAIL ON LABEL YES	ASTM L'FAST	RATING

GREEN YELLOW

SCHMINCKE

The sample provided by the company was so heavy with gum that it was most unpleasant to use. Heavier layers dried like a well varnished oil paint.

PY150 NICKEL AZO YELLOW
ASTM I (49)
PBk7 CARBON BLACK ASTM I (370)

HORADAM FINEST ARTISTS' WATER COLOURS

PIGMENT DETAIL ON LABEL YES	ASTM I L'FAST	RATING ★

GOLD 90

HOLBEIN

As with other 'golds', this substance (I cannot bring myself to call it a watercolour paint), was very difficult to apply.

It moved in easy steps from a heavy streaky layer to a thin streaky layer.

PW20 MICA WG I (386)

ARTISTS' WATER COLOR

PIGMENT DETAIL ON LABEL YES	WG I L'FAST	RATING ★

GOLD 1012

LUKAS

Another metallic 'gold' paint. The pigment will be absolutely lightfast but the paint will be difficult to apply unless in very thin washes.

Metallic finishes used to be confined to automobiles. Nostalgia isn't what it used to be.

PERLGLANZPIGMENT
NACREOUS PIGMENT

ARTISTS' WATER COLOUR

PIGMENT DETAIL ON LABEL CHEMICAL MAKE UP ONLY	WG I L'FAST	RATING ★

HANSA YELLOW DEEP 123

UTRECHT

A rich orange yellow which handled very well. A semi transparent colour which will resist damage from the light.

PY65 ARYLIDE YELLOW RN
ASTM II (44)

PROFESSIONAL ARTISTS' WATER COLOR

PIGMENT DETAIL ON LABEL YES	ASTM II L'FAST	

HANSA YELLOW LIGHT 041

DANIEL SMITH

This pigment forms the basis for many a green yellow. It gives a paint which, when as well made as this is, paints out smoothly and is resistant to light.

EXTRA-FINE WATERCOLORS

PY3 ARYLIDE YELLOW 10G ASTM II (37)		
PIGMENT DETAIL ON LABEL YES	ASTM II L'FAST	

HANSA YELLOW MEDIUM 039

DANIEL SMITH

PY97 leads to a strong semi transparent watercolour when well produced. Will give bright greens with any of the green blues. An excellent product.

EXTRA-FINE WATERCOLORS

PY97 ARYLIDE YELLOW FGL ASTM II (46)		
PIGMENT DETAIL ON LABEL YES	ASTM II L'FAST	

HANSA YELLOW DEEP 040

DANIEL SMITH

A bright semi transparent orange yellow which gives a very useful range of values.

A reliable, well made watercolour.

EXTRA-FINE WATERCOLORS

PY65 ARYLIDE YELLOW RN ASTM II (44)		
PIGMENT DETAIL ON LABEL YES	ASTM II L'FAST	

HANSA YELLOW LIGHT 1H

DR.Ph. MARTINS

I have been asked by many artists to include this range of liquid watercolours.

I am afraid that I cannot offer more than the colour sample.

HYDRUS FINE ART WATERCOLOR

PIGMENT INFORMATION NOT FOUND ON THE PRODUCT OR IN THE SUPPLIED LITERATURE		
PIGMENT DETAIL ON LABEL NO	ASTM L'FAST	RATING

HANSA DEEP YELLOW 13H

DR.Ph. MARTINS

Very many artists have used this product in their work. Perhaps they have been able to ascertain the pigments used.

HYDRUS FINE ART WATERCOLOR

PIGMENT INFORMATION NOT FOUND ON THE PRODUCT OR IN THE SUPPLIED LITERATURE		
PIGMENT DETAIL ON LABEL NO	ASTM L'FAST	RATING

HELIOS YELLOW 180

LEFRANC & BOURGEOIS

A strong, semi transparent green-yellow, giving a useful range of values. Reliable and handles well. Semi-transparent. Label gives the pigment as 'Azo Yellow', which is quite meaningless.

LINEL EXTRA-FINE ARTISTS' WATERCOLOUR

PY97 ARYLIDE YELLOW FGL ASTM II (46)		
PIGMENT DETAIL ON LABEL CHEMICAL MAKE UP ONLY	ASTM II L'FAST	

HELIO GENUINE YELLOW LIGHT 1045

LUKAS

Brushes out very well giving good washes.

It is a pity that the actual colour will depart rapidly. Transparent.

ARTISTS' WATER COLOUR

PY1 ARYLIDE YELLOW G ASTM V (37)		
PIGMENT DETAIL ON LABEL CHEMICAL MAKE UP ONLY	ASTM V L'FAST	RATING ★

HELIO GENUINE YELLOW DEEP 1047

LUKAS

As with its lighter cousin to the left, the use of PY1 will ensure a brief life after exposure. Transparent.

ARTISTS' WATER COLOUR

PY1 ARYLIDE YELLOW G ASTM V (37)		
PIGMENT DETAIL ON LABEL CHEMICAL MAKE UP ONLY	ASTM V L'FAST	RATING ★

HELIO GEN. YELLOW LEMON 1044

LUKAS

Will resist exposure to light. A well produced paint which gives smooth, even washes over a range of values. Semi transparent.

ARTISTS' WATER COLOUR

PY3 ARYLIDE YELLOW 10G ASTM II (37)		
PIGMENT DETAIL ON LABEL CHEMICAL MAKE UP ONLY	ASTM II L'FAST	

HANSA YELLOW LIGHT (LEMON) 242

DA VINCI PAINTS

Well labelled, giving full information on the ingredients. Reasonably transparent when applied thinly. Washes out very smoothly. Excellent.

PERMANENT ARTISTS' WATER COLOR

PY3 ARYLIDE YELLOW 10G ASTM II (37)		
PIGMENT DETAIL ON LABEL YES	ASTM II L'FAST	

HANSA YELLOW LIGHT (LEMON) 642

DA VINCI PAINTS

The sample tube supplied was under considerable pressure. This suggests an imbalance in the make up of the paint. Reliable pigment used.

SCUOLA 2ND RANGE

PY3 ARYLIDE YELLOW 10G ASTM II (37)		
PIGMENT DETAIL ON LABEL YES	ASTM II L'FAST	RATING ★★

IRON OXIDE YELLOW 181

UTRECHT

Literature states that the pigment is PY42, the tube is labelled as PY43.

Both are similar in many ways. The tints are often slightly brighter in Mars Yellow than those given by a Yellow Ochre due to the absence of clay.

PROFESSIONAL ARTISTS' WATER COLOR

PY42 MARS YELLOW ASTM I (43) OR PY43 YELLOW OCHRE ASTM I (43)		
PIGMENT DETAIL ON LABEL YES	ASTM I L'FAST	

TRANSLUCENT YELLOW 209

SCHMINCKE

This colour used to be called Brilliant Yellow 2. Then Lasurgelb 902. It has been reformulated and now brushes out very well. A green-yellow. Transparent.

HORADAM FINEST ARTISTS' WATER COLOURS

| PY150 NICKEL AZO YELLOW ASTM I (49) |
| PY37:1 CADMIUM-BARIUM MEDIUM OR DEEP ASTM I (42) |
| PY153 NICKEL DIOXINE YELLOW ASTM II (50) |

| PIGMENT DETAIL ON LABEL YES | ASTM II L'FAST | |

NICKEL TITANATE YELLOW 109

MAIMERI

Rather weak in tinting strength, this yellow will have limited applications in colour mixing. A subdued green yellow produced using a reliable pigment.

MAIMERIBLU SUPERIOR WATERCOLOURS

| PY53 NICKEL TITANATE YELLOW ASTM I (43) |

| PIGMENT DETAIL ON LABEL YES | ASTM I L'FAST | |

NICKEL TITANIUM YELLOW 121

OLD HOLLAND

Although this is a green yellow it will not give particularly bright greens with any of the green blues as it is rather on the dull side. Lightfast. Well made.

CLASSIC WATERCOLORS

| PY53 NICKEL TITANATE YELLOW ASTM I (43) |

| PIGMENT DETAIL ON LABEL CHEMICAL MAKE UP ONLY | ASTM I L'FAST | |

NICKEL AZO YELLOW 061

DANIEL SMITH

The sample was rather unpleasant to use. This was due, it would seem, to an excess of binder. Transparent and lightfast.

EXTRA-FINE WATERCOLORS

| PY150 NICKEL AZO YELLOW ASTM I (49) |

| PIGMENT DETAIL ON LABEL YES | ASTM I L'FAST | RATING ★★ |

NICKEL TITANATE YELLOW 062

DANIEL SMITH

Due to the nature of the pigment, this is a rather weak, dull green yellow.

However, it is lightfast, the sample was well made and it will suit many a palette.

EXTRA-FINE WATERCOLORS

| PY53 NICKEL TITANATE YELLOW ASTM I (43) |

| PIGMENT DETAIL ON LABEL YES | ASTM I L'FAST | |

NICKEL TITANIUM YELLOW 431

WINSOR & NEWTON

Rather sticky as it comes from the tube.

Medium to thinner washes are fine but any heavier and the paint has to be pre-worked with a wet brush for ease of application.

ARTISTS' WATER COLOUR

| PY53 NICKEL TITANATE YELLOW ASTM I (43) |

| PIGMENT DETAIL ON LABEL YES | ASTM I L'FAST | RATING ★★ |

NICKEL TITANATE YELLOW 637

DALER ROWNEY

Judging by the number of companies now using this pigment it seems to be gaining in popularity. `A reliable well made watercolour.

ARTISTS' WATER COLOUR

| PY53 NICKEL TITANATE YELLOW ASTM I (43) |

| PIGMENT DETAIL ON LABEL YES | ASTM I L'FAST | |

OLD HOLLAND YELLOW LIGHT

OLD HOLLAND

Excellent ingredients, but sample difficult to use as over half of the tube was pure gum, rest over bound.

Reformulated >

CLASSIC WATERCOLOURS

| PW4 ZINC WHITE ASTM I (384) |
| PY37 CADMIUM YELLOW MEDIUM OR DEEP ASTM I (42) |

| PIGMENT DETAIL ON LABEL CHEMICAL MAKE UP ONLY | ASTM I L'FAST | RATING ★ |

OLD HOLLAND YELLOW LIGHT

OLD HOLLAND

Extremely good pigments used to make a lightly coloured gum.

CLASSIC WATERCOLOURS

| PW4 ZINC WHITE ASTM I (384) |
| PW6 TITANIUM WHITE ASTM I (385) |
| PY43 YELLOW OCHRE ASTM I (43) |

| PIGMENT DETAIL ON LABEL CHEMICAL MAKE UP ONLY | ASTM I L'FAST | RATING ★ |

OLD HOLLAND YELLOW MEDIUM

OLD HOLLAND

Sample excessively gummy. Dried with a beautiful shine. Only a very weak wash was possible.

Reformulated >

CLASSIC WATERCOLOURS

| PW4 ZINC WHITE ASTM I (384) |
| PY37 CADMIUM YELLOW MEDIUM OR DEEP ASTM I (42) |

| PIGMENT DETAIL ON LABEL CHEMICAL MAKE UP ONLY | ASTM I L'FAST | RATING ★ |

OLD HOLLAND YELLOW MED 7

OLD HOLLAND

A rather gum laden paint which I could only paint out in very thin washes.

CLASSIC WATERCOLOURS

| PW4 ZINC WHITE ASTM I (384) |
| PW6 TITANIUM WHITE ASTM I (385) |
| PY43 YELLOW OCHRE ASTM I (43) |
| PY3 ARYLIDE YELLOW 10G ASTM II (37) |

| PIGMENT DETAIL ON LABEL CHEMICAL MAKE UP ONLY | ASTM II L'FAST | RATING ★ |

OLD HOLLAND YELLOW DEEP 405

OLD HOLLAND

Sample was over-bound and was not possible to use unless in a very thin wash.

Reformulated >

CLASSIC WATERCOLOURS

| PW4 ZINC WHITE ASTM I (384) |
| PY37 CADMIUM YELLOW MEDIUM OR DEEP ASTM I (42) |

| PIGMENT DETAIL ON LABEL CHEMICAL MAKE UP ONLY | ASTM I L'FAST | RATING ★ |

OLD HOLLAND YELLOW DEEP 8

OLD HOLLAND

As the components are all lightfast this paint will resist the light very well.

Sample rather over bound.

| PW4 ZINC WHITE ASTM I (384) |
| PW6 TITANIUM WHITE ASTM I (385) |
| PY43 YELLOW OCHRE ASTM I (43) |
| PY151 BENZIMIDAZOLONE YELLOW H4G WG II (49) |

| PIGMENT DETAIL ON LABEL CHEMICAL MAKE UP ONLY | WG II L'FAST | RATING ★★ ★★ |

CLASSIC WATERCOLOURS

PERMANENT YELLOW DEEP 217

SCHMINCKE

The use of PY110 will ensure that this paint will fade gradually on exposure to light. Thin washes particularly vulnerable.

Discontinued

| PY154 BENZIMIDAZOLONE YELLOW H3G ASTM II (50) |
| PY110 ISOINDOLINONE YELLOW R ASTM III (47) |

| PIGMENT DETAIL ON LABEL YES | ASTM III L'FAST | RATING ★★ |

HORADAM FINEST ARTISTS' WATER COLOURS

PERMANENT YELLOW MIDDLE 216

SCHMINCKE

The fugitive PY1 has now been replaced by a reliable pigment. Sample washed out very smoothly. A much improved colour.

Discontinued

| PY154 BENZIMIDAZOLONE YELLOW H3G ASTM II (50) |
| PW5 LITHOPONE WG I (384) |

| PIGMENT DETAIL ON LABEL YES | ASTM II L'FAST | |

HORADAM FINEST ARTISTS' WATER COLOURS

PURE YELLOW 216

SCHMINCKE

This is another example of the use of a strong semi-opaque pigment.

The paint covers well but due to its strength will wash out to give thin clear layers.

| PY154 BENZIMIDAZOLONE YELLOW H3G ASTM II (50) |

| PIGMENT DETAIL ON LABEL YES | ASTM II L'FAST | |

HORADAM FINEST ARTISTS' WATER COLOURS

PERMANENT YELLOW DEEP 114

MAIMERI

A strong orange yellow which handled well.

Reliable pigments making up into a sound paint.

| PY139 ISOINDOLINE YELLOW ASTM I (48) |

| PIGMENT DETAIL ON LABEL YES | ASTM I L'FAST | |

MAIMERIBLU SUPERIOR WATERCOLOURS

PERMANENT YELLOW DEEP 114

MAIMERI

I could find very little difference between this colour and its artist quality equivalent to the left. Same pigments and same excellent handling qualities.

| PY139 ISOINDOLINE YELLOW ASTM I (48) |

| PIGMENT DETAIL ON LABEL YES | ASTM I L'FAST | |

VENEZIA EXTRAFINE WATERCOLOURS

PERMANENT YELLOW

PENTEL (POLY TUBE)

If a watercolour is offered for the use of the artist it will find its way into this book.

Impossible to offer any guidance.

| PIGMENT DETAIL COULD NOT BE FOUND ON THE PRODUCT OR IN THE LITERATURE |

| PIGMENT DETAIL ON LABEL NO | ASTM L'FAST | RATING |

ARTISTS' WATER COLOUR

PERMANENT YELLOW 664

DALER ROWNEY

'Permanent Yellow' seems a strange name when one considers the fugitive pigment employed. Most unreliable. Transparent.

Reformulated >

| PY1 ARYLIDE YELLOW G ASTM V (37) |

| PIGMENT DETAIL ON LABEL YES | ASTM V L'FAST | RATING ★ |

ARTISTS' WATER COLOUR

PERMANENT YELLOW 664

DALER ROWNEY

A bright yellow of reasonable transparency.

Leaning towards orange in mass tone (heavier layer), it takes on a slight green bias when applied thinly.

| PY138 QUINOPHTHALONE YELLOW ASTM II (48) |

| PIGMENT DETAIL ON LABEL YES | ASTM II L'FAST | |

ARTISTS' WATER COLOUR

PERMANENT YELLOW LIGHT 36

HOLBEIN

Our sample faded dramatically (as was expected). The inclusion of PY55, a fugitive pigment, ensures limited life. I am surprised that this particular company would use a fugitive colorant.

| PY55 DIARYLIDE YELLOW PT WG IV (44) |
| PY53 NICKEL TITANATE YELLOW ASTM I (43) |

| PIGMENT DETAIL ON LABEL YES | WG IV L'FAST | RATING ★ |

ARTISTS' WATER COLOR

PERMANENT YELLOW DEEP 37

HOLBEIN

Previously a reliable watercolour. For whatever reason the fugitive PY55 has now been added. Gives very even washes over the full range. Transparent to semi-transparent.

| PY55 DIARYLIDE YELLOW PT WG IV (44) |
| PY53 NICKEL TITANATE YELLOW ASTM I (43) |

| PIGMENT DETAIL ON LABEL YES | WG IV L'FAST | RATING ★ |

ARTISTS' WATER COLOR

PERMANENT LIGHT YELLOW 239

PÈBÈO

An unreliable pigment which will fade readily. Company claim is ASTM 1 but they seem to be using the oils/acrylics list (where it is I) as a copy of such was sent to verify their stance.

| PY74LF ARYLIDE YELLOW 5GX ASTM III (44) |

| PIGMENT DETAIL ON LABEL YES | ASTM III L'FAST | RATING ★★ |

FRAGONARD ARTISTS' WATER COLOUR

PERMANENT DARK YELLOW 240

PÈBÈO

FRAGONARD
ARTISTS'
WATER
COLOUR

This is an example of a 'permanent' yellow which would appear to be reliable under normal conditions. Washes well. Semi-transparent.

PY65 ARYLIDE YELLOW RN ASTM II (44)		
PIGMENT DETAIL ON LABEL **YES**	ASTM **II** L'FAST	

SPECTRUM YELLOW W3

ART SPECTRUM

ARTISTS'
WATER COLOUR

A strong, smooth yellow with a definite bias towards orange. Semi transparent it gave fairly clear washes when well diluted. An excellent product.

PY97 ARYLIDE YELLOW FGL ASTM II (46) PY83HR70 DIARYLIDE YELLOW HR70 WG II (45)		
PIGMENT DETAIL ON LABEL **YES**	ASTM **II** L'FAST	

PRIMARY YELLOW 517

MAIMERI

ARTISTI EXTRA
FINE
WATERCOLOURS

PY1, an ingredient in this watercolour, is very easily damaged by light. Brushed out well but impermanent. Transparent.

Range discontinued

PY1 ARYLIDE YELLOW G ASTM V (37) PY3 ARYLIDE YELLOW 10G ASTM II (37)		
PIGMENT DETAIL ON LABEL **YES**	ASTM **V** L'FAST	RATING ★

PRIMARY YELLOW 116

MAIMERI

MAIMERIBLU
SUPERIOR
WATER COLOR

When purchasing any paint intended for artistic use, it always pays to look for the pigment and the ASTM rating.

This is a fine, reliable watercolour.

PY97 ARYLIDE YELLOW FGL ASTM II (46)		
PIGMENT DETAIL ON LABEL **NO**	ASTM **II** L'FAST	

PRIMARY YELLOW 609

MAIMERI

STUDIO
FINE
WATER COLOR
2ND RANGE

As with the Artist quality version of this colour, rapid fading on exposure is assured by the use of PY1. Transparent.

Range discontinued

PY1 ARYLIDE YELLOW G ASTM V (37)		
PIGMENT DETAIL ON LABEL **NO**	ASTM **V** L'FAST	RATING ★

PRIMARY YELLOW 116

MAIMERI

VENEZIA
EXTRAFINE
WATERCOLOURS

This is a fairly bright greenish yellow which gives a useful range of values at different strengths.

Well made, employing proven pigments.

PY97 ARYLIDE YELLOW FGL ASTM II (46)		
PIGMENT DETAIL ON LABEL **YES**	ASTM **II** L'FAST	

PRIMARY YELLOW 1021

LUKAS

ARTISTS'
WATER COLOUR

The pigment description provided on the label tells us very little as there are a range of Monoazo pigments available. Some are excellent, others not so.

Assessments cannot be offered.

MONOAZO PIGMENT		
PIGMENT DETAIL ON LABEL **CHEMICAL MAKE UP ONLY**	ASTM L'FAST	RATING

PURE YELLOW

SCHMINCKE

HORADAM
FINEST
ARTISTS'
WATER COLOURS

Sample gave a nice, even flow of colour throughout the range of values. Semi opaque but strong enough to provide very thin washes. A quality product.

PY154 BENZIMIDAZOLONE YELLOW H3G ASTM II (50)		
PIGMENT DETAIL ON LABEL **YES**	ASTM **II** L'FAST	

QUINACRIDONE GOLD 445

SENNELIER

EXTRA-FINE
WATERCOLOUR

As I have outlined elsewhere in this book, there seems to be a definite trend towards producing over bound watercolour paints. They handle poorly unless very dilute. This example is no exception.

PO49 QUINACRIDONE DEEP GOLD WG II (97) PG7 PHTHALOCYANINE GREEN ASTM I (259)		
PIGMENT DETAIL ON LABEL **YES**	WG **II** L'FAST	RATING ★★

BROWN PINK 445

SENNELIER

EXTRA-FINE
WATERCOLOUR

Previously faded as a tint and darkened in mass tone. Now reformulated using reliable pigments. An excellent watercolour paint. Semi-opaque.

Discontinued

PO49 QUINACRIDONE DEEP GOLD WG II (97) PG7 PHTHALOCYANINE GREEN ASTM I (259) PW21 BLANC FIXE WG 1 (386)		
PIGMENT DETAIL ON LABEL **YES**	WG **II** L'FAST	

QUINACRIDONE GOLD 547

WINSOR & NEWTON

ARTISTS'
WATER COLOUR

The trend today seems to be to use less (expensive) pigment and to make up the difference with binder and thickeners.

I cannot say that this is the case here but the sample bore all the hallmarks. Gum laden and streaky without plenty of water.

PO49 QUINACRIDONE DEEP GOLD WG II (97)		
PIGMENT DETAIL ON LABEL **YES**	WG **II** L'FAST	RATING ★★

ROYAL YELLOW 508

MIR (JAURENA S.A)

ACUARELA

A greater awareness on the part of the artist as to the performance of the pigments employed, will oblige manufacturers to supply quality products such as this.

PY3 ARYLIDE YELLOW 10G ASTM II (37) PY83HR70 DIARYLIDE YELLOW HR70 WG II (45)		
PIGMENT DETAIL ON LABEL **YES**	ASTM **II** L'FAST	

SCHEVENINGEN YELLOW LEMON 10

OLD HOLLAND

PY3 gives an excellent green yellow, often described as a 'Lemon Yellow'. It is a pigment to look for.

This paint has very good lightfastness, is semi transparent and washes very well.

CLASSIC WATERCOLOURS

PY3 ARYLIDE YELLOW 10G ASTM II (37)		
PIGMENT DETAIL ON LABEL CHEMICAL MAKE UP ONLY	ASTM **II** L'FAST	

SCHEVENINGEN YELLOW MEDIUM 14

OLD HOLLAND

I can only hope that the company has more information on this pigment than I could find. Assessments cannot be offered.

CLASSIC WATERCOLOURS

PY120 BENZIMIDAZOLONE YELLOW H2G LF NOT OFFERED (47)		
PIGMENT DETAIL ON LABEL CHEMICAL MAKE UP ONLY	ASTM L'FAST	RATING

SCHEVENINGEN YELLOW DEEP 15

OLD HOLLAND

To my mind, giving the chemical make up of the pigments in use on the label can only add confusion. It uses less printing ink to describe them by Colour Index Name. Sample reliable but gum laden.

CLASSIC WATERCOLOURS

PY83HR70 DIARYLIDE YELLOW HR70 WG II (45)		
PIGMENT DETAIL ON LABEL CHEMICAL MAKE UP ONLY	WG **II** L'FAST	RATING ★★

SCHEVENINGEN YELLOW LIGHT 12

OLD HOLLAND

This pigment rated highly in ASTM in other media and has a good reputation.

The made up paint gave very good washes.

CLASSIC WATERCOLOURS

PY151 BENZIMIDAZOLONE YELLOW H4G WG II (49)		
PIGMENT DETAIL ON LABEL CHEMICAL MAKE UP ONLY	WG **II** L'FAST	

SENNELIER YELLOW LIGHT 578

SENNELIER

Semi-opaque but strong enough to give fairly transparent washes when well diluted. Very well produced. Brushes out very smoothly.

EXTRA-FINE WATERCOLOUR

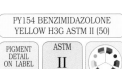

PY154 BENZIMIDAZOLONE YELLOW H3G ASTM II (50)		
PIGMENT DETAIL ON LABEL YES	ASTM **II** L'FAST	

SENNELIER YELLOW DEEP 579

SENNELIER

A deep orange-yellow which washes out beautifully. Reliable ingredients used. It is encouraging to see that the majority of newly introduced colours are lightfast.

EXTRA-FINE WATERCOLOUR

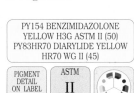

PY154 BENZIMIDAZOLONE YELLOW H3G ASTM II (50) PY83HR70 DIARYLIDE YELLOW HR70 WG II (45)		
PIGMENT DETAIL ON LABEL YES	ASTM **II** L'FAST	

SOUR LEMON (HANSA) 133

AMERICAN JOURNEY

Solid, steadfast, PY3 again. This is a pigment worth looking for when you require a reliable yellow-green.

A well produced paint which washed out smoothly.

PROFESSIONAL ARTISTS' WATER COLOR

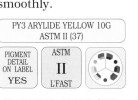

PY3 ARYLIDE YELLOW 10G ASTM II (37)		
PIGMENT DETAIL ON LABEL YES	ASTM **II** L'FAST	

SAHARA YELLOW 194

LEFRANC & BOURGEOIS

Washes out very well. Semi-transparent. Label states 'Azo pigment'. This is quite meaningless as there are a range of 'Azo pigments, from excellent to poor.

LINEL EXTRA-FINE ARTISTS' WATERCOLOUR

PY65 ARYLIDE YELLOW RN ASTM II (44)		
PIGMENT DETAIL ON LABEL CHEMICAL MAKE UP ONLY	ASTM **II** L'FAST	

STIL DE GRAIN 618

MAIMERI

Becomes greener and paler as the yellow content gradually fades. Not to be relied on if you value your work. Transparent.

Range discontinued

STUDIO FINE WATER COLOR 2ND RANGE

PG10 GREEN GOLD WG II (260) PY1 ARYLIDE YELLOW G ASTM V (37)		
PIGMENT DETAIL ON LABEL NO	ASTM **V** L'FAST	RATING ★

TALENS YELLOW 248

TALENS

Despite requests we were not informed of the type of PY74. The best it could be would be ASTM III. Unreliable. Semi-transparent.

Discontinued

REMBRANDT ARTISTS' QUALITY EXTRA FINE

PY74LF ARYLIDE YELLOW 5GX ASTM III (44)		
PIGMENT DETAIL ON LABEL YES	ASTM **III** L'FAST	RATING ★★

TRANSPARENT YELLOW 653

WINSOR & NEWTON

A rather sticky watercolour paint which only handled well in thinner applications.

This does seem to be the trend nowadays with several companies.

ARTISTS' WATER COLOUR

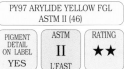

PY97 ARYLIDE YELLOW FGL ASTM II (46)		
PIGMENT DETAIL ON LABEL YES	ASTM **II** L'FAST	RATING ★★

TALENS YELLOW DEEP 249

TALENS

Our sample faded badly suggesting the type of PY74 to be H.S. (High Strength). This version is particularly unreliable.

Discontinued

VAN GOGH 2ND RANGE

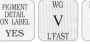

PY74LF ARYLIDE YELLOW 5GX ASTM III (44) PR4 CHLORINATED PARA RED WG V (115)		
PIGMENT DETAIL ON LABEL YES	WG **V** L'FAST	RATING ★

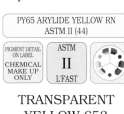
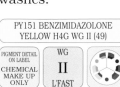

TALENS YELLOW LIGHT 247

TALENS

REMBRANDT ARTISTS' QUALITY EXTRA FINE

A well made yellow which handled with ease. Unfortunately it is let down by the inclusion of the unreliable PY74.

Discontinued

| PW4 ZINC WHITE ASTM I (384) |
| PY3 ARYLIDE YELLOW 10G ASTM II (37) |
| PY74 ARYLIDE YELLOW 5GX ASTM III (44) |

| PIGMENT DETAIL ON LABEL YES | ASTM III L'FAST | RATING ★★ |

TITANIUM YELLOW LIGHT 206

SCHMINCKE

HORADAM FINEST ARTISTS' WATER COLOURS

An opaque, green yellow which washes out very well. The only drawback to this excellent pigment is that it is weak in tinting strength. A limitation when mixing.

Was previously called 'Titan Yellow Light 210'.

| PY53 NICKEL TITANATE YELLOW ASTM I (43) |

| PIGMENT DETAIL ON LABEL YES | ASTM I L'FAST | |

VANADIUM

SCHMINCKE

HORADAM FINEST ARTISTS' WATER COLOURS

I am afraid that I have insufficient information on this pigment to offer any guidance. I do know that it has not been subjected to ASTM testing as a watercolour.

| PY184 BISMUTH VANADATE YELLOW LF NOT OFFERED (51) |

| PIGMENT DETAIL ON LABEL CHEMICAL MAKE UP ONLY | ASTM L'FAST | RATING |

WINSOR YELLOW 730 (058)

WINSOR & NEWTON

ARTISTS' WATER COLOUR

Despite earlier confirmation from the manufacturer, the incorrect pigment was given in the first edition. Reliable PY3 is used, not the unreliable PY1. Transparent.

Reformulated >

| PY3 ARYLIDE YELLOW 10G ASTM II (37) |

| PIGMENT DETAIL ON LABEL YES | ASTM II L'FAST | |

WINSOR YELLOW 730

WINSOR & NEWTON

ARTISTS' WATER COLOUR

At one time a well made watercolour paint would burst into life as soon as a laden brush touched wet paper.

Too many, as with this example, now have to be broken down first with water on the palette. Due to a gummy consistency only for thinner washes.

| PY154 BENZIMIDAZOLONE YELLOW H3G ASTM II (50) |

| PIGMENT DETAIL ON LABEL YES | ASTM II L'FAST | RATING ★★ |

WINSOR YELLOW DEEP 731

WINSOR & NEWTON

ARTISTS' WATER COLOUR

Slightly over bound. Thin to medium washes fine, but not quite so easy to handle when at all heavier.

Reliable pigment used.

| PY65 ARYLIDE YELLOW RN ASTM II (44) |

| PIGMENT DETAIL ON LABEL YES | ASTM II L'FAST | RATING ★ ★★ |

YELLOW STIL DE GRAIN 537

MAIMERI

ARTISTI EXTRA-FINE WATERCOLOUR

It is a pity that the fugitive PY1 should have been used as reliable alternatives are available.

Range discontinued

| PB29 ULTRAMARINE BLUE ASTM I (215) |
| PY1 ARYLIDE YELLOW G ASTM V (37) |

| PIGMENT DETAIL ON LABEL YES | ASTM V L'FAST | RATING ★ |

YELLOW LAKE 561

SENNELIER

EXTRA-FINE WATERCOLOUR

The less than reliable PY83 has been replaced by lightfast pigments. Sample was slightly over bound but handled very well as a wash. Transparent to semi-transparent.

| PO49 QUINACRIDONE DEEP GOLD WG II (97) |
| PY153 NICKEL DIOXINE YELLOW ASTM II (50) |

| PIGMENT DETAIL ON LABEL YES | ASTM II L'FAST | RATING ★ ★★ |

YELLOW No.12

PENTEL (POLY TUBE)

WATER COLOUR

All watercolours offered for artistic use should identify the pigments employed.

Perhaps in the next edition?

| PIGMENT DETAIL NOT OFFERED ON THE PRODUCT OR IN THE LITERATURE PROVIDED |

| PIGMENT DETAIL ON LABEL NO | ASTM L'FAST | RATING |

My approach to colour mixing is based on understanding 'colour type' rather than taking note of the colour name. For accurate and controlled mixing, it is important to be able to decide whether a particular yellow leans towards green or orange.

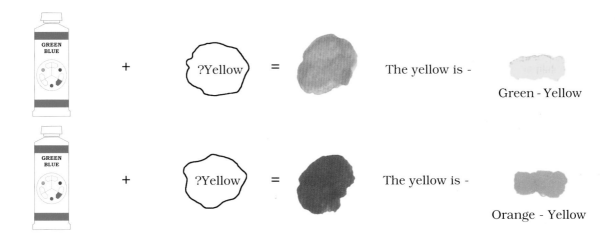

GREEN BLUE + ?Yellow = The yellow is - Green - Yellow

GREEN BLUE + ?Yellow = The yellow is - Orange - Yellow

It is usually possible to decide between the various yellows by eye. However, a simple test will quickly confirm the colour type,

Mix the yellow with a GREEN - blue, such as Cerulean Blue.

If the yellow happens to be a green-yellow, the result of mixing it with the green - blue will be a right green, as you would expect: green - yellow and green - blue make a bright green.

On the other hand, if the result is a dull, slightly grey green, then the yellow is clearly identified as an orange - yellow. Orange - yellow and green - blue make a mid green.

See appendix at end of book for further information on colour mixing.

Only the Artist can bring about change

Apart from a few, art material manufacturers are more interested in the bottom line than they are in the work of the artist.

Although regrettable, it is perhaps understandable, as businesses face increased competition and ever rising prices.

An additional factor is that the marketing, accountancy and management side of the larger companies often become distanced from their own chemists and others in the laboratory.

The frequent 'changing of hands' of certain companies has not helped, as the more experienced staff are often laid off by the new owners.

With this background, you can be fairly certain that the onus lies with the purchasing artist if further change is to come about.

If you make it clear through your buying habits that you will not accept inferior pigments or poorly made products, improvements *will* be made. Market forces will see to that.

By selecting only those watercolour paints which contain ASTM I or II pigments, and returning poorly manufactured goods, you will be offered better in the future.

Oranges

Brief history of orange pigments

Although artists have traditionally favoured mixed oranges they have turned to orange pigments when a particularly 'clean', bright hue was required.

The early Egyptians used coloured earths and pre-mixed oranges. Some of their colour work is outstanding.

Realgar, an arsenic based orange, was a real danger to the user and probably helped many to an early grave.

Cadmium Orange, a bright, strong, opaque hue, would have been the envy of earlier artists.

One of the earliest orange pigments was Realgar, an orange - red used by many ancient civilizations and available until the late 19th Century. >

Realgar was replaced by Cadmium Orange.

When well produced, Cadmium Orange has proved itself to be the most reliable of the

bright orange pigments available today. It is unsurpassed in clarity of hue by any mix of red and yellow.

Within the range offered by modern colourmen are several unreliable products, and a variety of pre-mixed oranges.

Choose carefully when purchasing a ready produced orange, it might be a simple mix or prove to be unreliable.

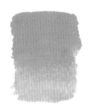

With a strong, reliable orange red and an orange yellow, all but the very brightest oranges can be mixed on the palette.

Modern Orange Pigments

PO1	HANSA ORANGE	94
PO13	PYRAZOLONE ORANGE	94
PO20	CADMIUM ORANGE	94
PO20:1	CADMIUM-BARIUM ORANGE	95
PO34	DIARYLIDE ORANGE	95
PO36	BENZIMIDAZOLONE ORANGE HL	95
PO37	DIARYLIDE ORANGE	96
PO43	PERINONE ORANGE	96
PO46	RED LAKE C	96
PO48	QUINACRIDONE GOLD	97
PO49	QUINACRIDONE DEEP GOLD	97
PO62	BENZIMIDAZOLONE ORANGE H5G	97
PO65	COMMON NAME NOT KNOWN	98
PO69	COMMON NAME NOT KNOWN	98
PO73	COMMON NAME NOT KNOWN	98

PO1 HANSA ORANGE

PO1 is a bright yellow-orange of reasonable strength and transparency. Unfortunately it fades rather readily and has failed all of the tests for which I have results. Our sample had changed noticeably after only a short exposure. By the end of the test the tint was almost bleached out and the mass tone was duller.

This is another example of a colorant better suited to industrial rather than artistic use. A pigment with a poor reputation for lightfastness.

It is surely better to pay the extra for a reliable (and similar) orange such as Cadmium Orange.

Also called Fanchon Orange.

PO13 PYRAZOLONE ORANGE

A strong semi-opaque reddish-orange. Introduced in 1910. PO13 has had plenty of time to establish a reputation as a thoroughly unreliable orange. During ASTM testing the samples quickly bleached and were removed from exposure, it is not listed.

The sample shown here had deteriorated to this stage within a short time. A thoroughly worthless substance of no value to the artist. Bear in mind that you will be buying the colour on the right.

If you are looking for an orange which starts to fade as it is applied, this is for you.

Quite unsuitable for artistic expression.

PO20 CADMIUM ORANGE

When well produced, Cadmium Orange is one of the most reliable and versatile of the bright oranges available to todays' artist. Mixtures of reds and yellows do not quite compare for clarity of hue.

Opaque, with good covering power, it is strong enough to give reasonable washes when well diluted. Given a rating of I following ASTM testing as a watercolour. Similar chemically to PY37 (Cadmium Yellow) and PR108 (Cadmium Red). An excellent pigment.

Unaffected by light, this pigment is on the ASTM recommended list for watercolours. Surely it is worth the extra cost to purchase materials of such excellence.

PO20:1 CADMIUM-BARIUM ORANGE

Cadmium Barium Orange is usually as bright and certainly as permanent as the chemically pure Cadmium Orange (PO20). When well produced it brushes out very smoothly across the range of values.

A fine, strong, bright orange with excellent handling characteristics. Absolutely lightfast, it passed ASTM testing effortlessly.

Rated ASTM I as a watercolour.

PO34 DIARYLIDE ORANGE

Several versions of this pigment are manufactured. In hue it is a very bright orange to reddish-orange. Opaque to semi-opaque but allows reasonably clear washes when very dilute. So far only tested under ASTM conditions as a gouache. It failed the testing with a rating of V and III. There are two versions of this pigment, the more opaque is redder, coarser and possibly a little more lightfast than the other.

Introduced in 1936, it has a poor reputation in Industry. Most unreliable. Rated WG V pending further tests. Also called Benzidine Orange.

PO36 BENZIMIDAZOLONE ORANGE HL

PO36 is a moderately bright reddish-orange. In hue it is close to Vermilion.

During ASTM lightfast testing, this pigment stood up very well when made up into an oil paint and an acrylic and has since tested ASTM I as a watercolour. Semi-opaque.

This would appear to be a very trustworthy pigment.

It stood up well under ASTM conditions and in our own trials.

PO37

The Colour Index name PO37 has been discontinued and all information transferred to PO34.

Wherever you come across reference to this pigment in an artists paint you will either have a rather old colorant, or the manufacturer has not kept up to date with the changes that have been made in the naming of pigments.

Please see page 94 for detail of PO34.

PO43 PERINONE ORANGE

A brilliant, reliable orange pigment. In hue it varies from mid-orange to red-orange.

PO 43 is found in many artists paints apart from watercolours. As an orange it is second only to Cadmium Orange, PO20. This is understandable as it is very fast to light, transparent and bright.

Rated as I in ASTM testing as an oil paint and acrylic. Not yet tested as a watercolour, but has an excellent reputation.

Our sample did not show any sign of change after exposure. This, together with the excellent results of testing in other media, suggests a reliable watercolour.

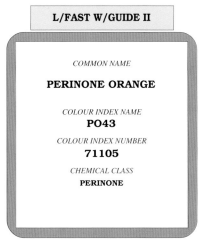

L/FAST W/GUIDE II

COMMON NAME

PERINONE ORANGE

COLOUR INDEX NAME
PO43

COLOUR INDEX NUMBER
71105

CHEMICAL CLASS
PERINONE

PO46 RED LAKE C

Also called BON Arylide Orange, PO46 is an inexpensive (that's the word), transparent orange with poor alkali resistance and very poor lightfastness.

Not yet tested under ASTM conditions I have rated it as

W/Guide V for the purposes of this book based on its poor reputation.

L/FAST W/GUIDE V

COMMON NAME

RED LAKE C

COLOUR INDEX NAME
PO46

COLOUR INDEX NUMBER
15602

CHEMICAL CLASS
MONOAZO: 2-NAPHTHOL

PO48 QUINACRIDONE GOLD

A transparent orange which leans towards yellow.

Quinacridone Gold has stood up very well to ASTM testing in a variety of paint types.

As an oil paint and when made up into an acrylic paint it was placed into category I, excellent. When made into a watercolour, without the protection of the binder, it also recorded ASTM I.

Also called Cinquasia Gold, Monastral Deep Gold and

Monastral Fast Gold. Used in metallic finishes for automobiles in shades of copper and gold.

L/FAST ASTM I
COMMON NAME
QUINACRIDONE GOLD
COLOUR INDEX NAME
PO48
COLOUR INDEX NUMBER
73900 & 73920
CHEMICAL CLASS
INDIGOID: QUINACRIDONE

PO49 QUINACRIDONE DEEP GOLD

At the time of writing this pigment has not been tested as a water colour.

The results of ASTM testing in both oils and acrylics are very encouraging. It was given a rating of I in both media. An orange-yellow, low in chroma and semi-opaque.

One example of its use in watercolours is as an ingredient in Sap Green, where its qualities of hue are secondary.

Mass tone is similar to much cheaper iron oxides. Our tests suggest that is reliable and I will give it the benefits of the doubt when assessing its use.

L/FAST W/GUIDE II
COMMON NAME
QUINACRIDONE DEEP GOLD
COLOUR INDEX NAME
PO49
COLOUR INDEX NUMBER
N.A.
CHEMICAL CLASS
QUINACRIDONE

PO62 BENZIMIDAZOLONE ORANGE H5G

PO62 is a reasonably bright yellowish orange.

Benzimidazolone oranges in general have a very good reputation for reliability. This pigment has been tested under ASTM conditions as a watercolour.

It stood up extremely well and was given a rating of II. Semi-opaque, it is strong enough to give a reasonably clear wash. A wash moreover, which will not start to disappear as soon as the brush is laid down.

Our sample exhibited no sign of change. An excellent pigment with an ASTM rating of II. On the list of approved pigments.

L/FAST ASTM II
COMMON NAME
BENZIMIDAZOLONE ORANGE H5G
COLOUR INDEX NAME
PO62
COLOUR INDEX NUMBER
11775
CHEMICAL CLASS
BENZIMIDAZOLONE DERIVED PIGMENT MONOAZO: ACETOACTYL

PO65 COMMON NAME UNKNOWN

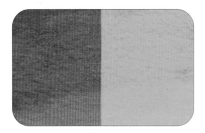

PO65 has not been mentioned in the Colour Index since 1982 and appears to be obsolete. The company listing it as an ingredient must have either kept a large stock or have labelled incorrectly.

As they did not answer our questions I cannot tell which is the case.

It was mainly used in rubber products and occasionally in printing inks. Not tested under ASTM conditions it has been listed as 'fair' lightfastness in the Colour Index. However, the Colour Index also lists as 'fair' pigments which have been given a rating of ASTM V when tested in artists' paints. Almost certainly unreliable. Alternatively called Irgazin Orange 3GL.

PO69 COMMON NAME UNKNOWN

I have very little information on this material apart from the fact that a pigment manufacturer has said that its lightfastness is good but that it fails to meet stringent use requirements and that full shades fade. What does that all mean? This relatively new pigment has not been ASTM tested in any art material.

If I have scoured the records, with the help of experts, and can find out no more than the above, I feel sure that the manufacturers will have little else to go on before using it in the production of 'artists' quality' paints. Remember this if deciding on a purchase.

PO73 COMMON NAME UNKNOWN

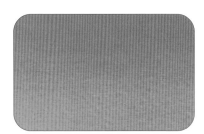

I have very little information on this pigment apart from the fact that it is a bright transparent orange with an ASTM rating of II as a gouache.

Until more information becomes available I feel unable to offer a lightfastness rating. It might well prove to be reliable given the testing which has taken place so far.

Time for a change of direction?

I have to say that I am very surprised by the speed with which certain watercolour manufacturers take up new and untried pigments.

In certain cases the ratings shown on the tube can only have come either from 'in the office window' testing or from the imagination.

Properly controlled testing is expensive and is not normally carried out by companies on an individual basis.

Of concern also is the readiness of many to use pigments which have *failed* all controlled testing.

It is for reasons such as these that I am calling in this book for a complete change of direction.

Manufacturers have, at their disposal, more than enough ASTM tested and approved pigments to produce all the individual and mixed colours that are currently on offer. If requested, we can help them in the area of colour mixing.

There is absolutely no reason to use other than lightfast colorants.

If new pigments come onto the scene, they should not, of course, be ignored. Neither should older, untested pigments of interest.

But instead of simply using them in your watercolour paints they should be tested under the conditions set by the ASTM subcommittee.

This would mean that the tests would have to be paid for and manufacturers have made it very clear that they do not wish to do this.

It is because of this reluctance to finance the operation that formal testing stopped quite some time ago.

The majority of manufacturers are only really interested in the bottom line. The chemists and others in the laboratory are over ridden by the accountants and sales people.

Hit them in the pocket and they *will* change, I can assure you.

The next edition of this book could show that pigments rated as ASTM I or II are the *only* ones in use.

It is entirely up to you, the purchasing artist. I feel that your trust has been abused for too long. But it's how you feel that will change things or otherwise.

A wide range of lightfast oranges can be mixed from a few reliable colours.
Reproduced from our Home Study Course ' Practical Colour Mixing'

Mid intensity colours

A range of soft, warm, semi-opaque to opaque oranges emerge from thais mixing pair when compared to the previous exercise. This is particularly so at the red-orange end of the range where the opaque Cadmium Red Light has a major influence.

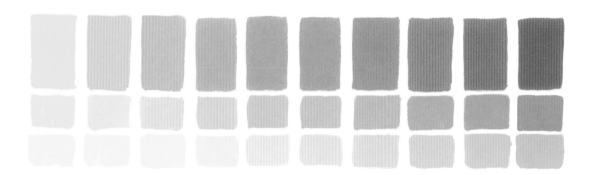

Mid intensity oranges will result as only one of the contributing colours, the orange-red, carries any significant amount of orange.

Use the colour illustration shown here as no more than a general guide as there will be differences between the colours that you mix and those printed here.

Conventional colour printing is severely limited, particularly in the area of orange.

This is because the red used in printing is a violet red (magenta). As the 'colour-type' name suggests, a violet-red carries a small amount of orange.

Only mid oranges can result when it is mixed with a yellow.

If the yellow used by the printer happens to be a *green*-yellow the oranges will be even duller than if an orange-yellow had been employed.

Orange Watercolours

Cadmium Orange ... 102
Chrome Orange ... 105
Miscellaneous Orange .. 106

Cadmium Orange

A well produced Cadmium Orange is reasonably strong and rather bright.

An opaque colour, it is however, strong enough to give reasonably clear washes when applied thinly.

Be wary of paints described as Cadmium Orange but which have cheaper, inferior ingredients. The word 'Hue' following the name is clear identification of an imitation. Pigments described here as Cadmium Orange (PO 20) from information supplied, might well be a blend of Cadmium Yellow and Cadmium Red.

For mixing purposes, varies between yellow-orange (complementary, a violet-blue) to red-orange (complementary a green-blue).

Ultramarine is the only practical violet blue. Cerulean Blue, Prussian Blue and Phthalocyanine Blue are typical green - blues.

PURE CADMIUM ORANGE 133

UTRECHT

A strong, bright 'clean' orange watercolour which brushed out very well over a range of values. Lightfast.

Although opaque it gave reasonably clear thin washes. Excellent.

PROFESSIONAL ARTISTS' WATER COLOR

PO20 CADMIUM ORANGE ASTM I (94)		
PIGMENT DETAIL ON LABEL **YES**	ASTM **I** L'FAST	

CADMIUM DEEP ORANGE 2121

UMTON BARVY

A bright, strong, opaque orange with a bias towards red, which lifted well from the pan.

Ideal pigment making up into an ideal watercolour paint.

ARTISTIC WATER COLOR

PO20 CADMIUM ORANGE ASTM I (94)		
PIGMENT DETAIL ON LABEL **NO**	ASTM **I** L'FAST	

CADMIUM ORANGE LIGHT 2120

UMTON BARVY

More a mid orange than the redder colour to the left. Washed out very well.

Bright, strong and reliable. A description that I have never been given.

ARTISTIC WATER COLOR

PY35 CADMIUM YELLOW LIGHT ASTM I (41)		
PIGMENT DETAIL ON LABEL **NO**	ASTM **I** L'FAST	

CADMIUM ORANGE W9

ART SPECTRUM

I believe that there is some confusion with the pigment. On the tube it is given as PO37 Cadmium Sulphoselenide, ASTM I. The name PO37 is no longer used and has a different chemical description. Perhaps they mean PY37?

Assessments not offered.

ARTISTS' WATER COLOUR

PIGMENT DETAIL ON LABEL **YES**	ASTM L'FAST	RATING

CADMIUM ORANGE W025

GRUMBACHER

A slightly dull orange red. Excellent ingredients which are particularly fast to light. Flows very well in a wash. Opaque.

FINEST ARTISTS' WATER COLOR

PR108:1 CADMIUM-BARIUM RED LIGHT, MEDIUM OR DEEP ASTM I (126) PO20 CADMIUM ORANGE ASTM I (94)		
PIGMENT DETAIL ON LABEL **YES**	ASTM **I** L'FAST	

CADMIUM ORANGE HUE A025

GRUMBACHER

Previously unreliable, this colour has been reformulated using lightfast pigments. Handled well.

ACADEMY ARTISTS' WATERCOLOR 2ND RANGE

PY65 ARYLIDE YELLOW RN ASTM II (44) PY138 QUINOPHTHALONE YELLOW ASTM II (48) PO62 BENZIMIDAZOLONE ORANGE H5G ASTM II (97) PR188 NAPHTHOL AS ASTM II (132)		
PIGMENT DETAIL ON LABEL **YES**	ASTM **II** L'FAST	

CADMIUM ORANGE 022

AMERICAN JOURNEY

An opaque, staining colour with many admirable qualities. It is lightfast, ultra smooth in application, covers well but still gives fairly clear washes when well diluted.

PROFESSIONAL ARTISTS' WATER COLOR

PO20 CADMIUM ORANGE ASTM I (94)		
PIGMENT DETAIL ON LABEL **YES**	ASTM **I**	

CADMIUM ORANGE 208

DA VINCI PAINTS

Superb. A rich, strong orange. Full information on ingredients on tube, plus comprehensive potential hazard warning. Opaque and staining. Slight tendency to granulate.

PERMANENT ARTISTS' WATER COLOR

PO20 CADMIUM ORANGE ASTM I (94)		
PIGMENT DETAIL ON LABEL **YES**	ASTM **I** L'FAST	

CADMIUM ORANGE (HUE) 608

DA VINCI PAINTS

Tube contents under slight pressure. This does not cause a problem unless you waste paint but suggests an imbalance between pigment and binder.

Otherwise an excellent product.

SCUOLA 2ND RANGE

PO62 BENZIMIDAZOLONE ORANGE H5G ASTM II (97)		
PIGMENT DETAIL ON LABEL **YES**	ASTM **II** L'FAST	RATING ★ ★★

ORANGE CADMIUM YELLOW 334

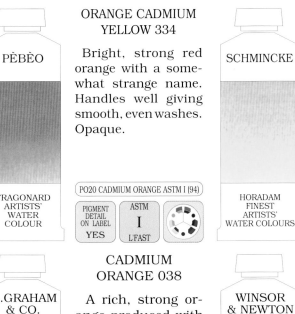

PÈBÉO

Bright, strong red orange with a somewhat strange name. Handles well giving smooth, even washes. Opaque.

FRAGONARD ARTISTS' WATER COLOUR

PO20 CADMIUM ORANGE ASTM I (94)

PIGMENT DETAIL ON LABEL YES	ASTM I L'FAST	

CADMIUM ORANGE LIGHT 227

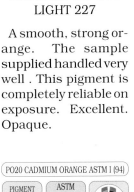

SCHMINCKE

A smooth, strong orange. The sample supplied handled very well. This pigment is completely reliable on exposure. Excellent. Opaque.

HORADAM FINEST ARTISTS' WATER COLOURS

PO20 CADMIUM ORANGE ASTM I (94)

PIGMENT DETAIL ON LABEL YES	ASTM I L'FAST	

CADMIUM ORANGE DEEP 228

SCHMINCKE

Gives good, even washes. Reliable pigment used which will be unaffected by exposure to light. An excellent product which brushed out very well. Opaque.

HORADAM FINEST ARTISTS' WATER COLOURS

PO20 CADMIUM ORANGE ASTM I (94)

PIGMENT DETAIL ON LABEL YES	ASTM I L'FAST	

CADMIUM ORANGE 038

M.GRAHAM & CO.

A rich, strong orange produced with the genuine pigment. The sample provided washed out very well indeed. An excellent product.

ARTISTS' WATERCOLOR

PO20 CADMIUM ORANGE ASTM I (94)

PIGMENT DETAIL ON LABEL YES	ASTM I L'FAST	

CADMIUM ORANGE 089

WINSOR & NEWTON

A mixed orange which is easily duplicated on the palette. Should be described as a 'Hue'. Very good ingredients however. Paint flows smoothly. Opaque.

ARTISTS' WATER COLOUR

PY35 CADMIUM YELLOW LIGHT ASTM I (41)
PR108 CADMIUM RED LIGHT, MEDIUM OR DEEP ASTM I (126)

PIGMENT DETAIL ON LABEL YES	ASTM I L'FAST	

CADMIUM ORANGE (USA ONLY) 089

WINSOR & NEWTON

Label gives full information.

Ingredients are superb, particularly in a 'second range' paint. Opaque.

COTMAN WATER COLOURS 2ND RANGE

PY35 CADMIUM YELLOW LIGHT ASTM I (41)
PR108 CADMIUM RED LIGHT, MEDIUM OR DEEP ASTM I (126)

PIGMENT DETAIL ON LABEL YES	ASTM I L'FAST	

CADMIUM ORANGE 090

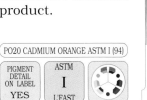

WINSOR & NEWTON

Neither pigment is reliable. This colour will fade rapidly when exposed to light. Semi-opaque.

Reformulated

COTMAN WATER COLOURS 2ND RANGE

PY1 ARYLIDE YELLOW G ASTM V (37)
PO13 PYRAZOLONE ORANGE ASTM V (94)

PIGMENT DETAIL ON LABEL YES	ASTM V L'FAST	RATING ★

CADMIUM ORANGE HUE 090

 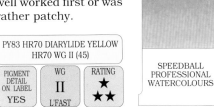

WINSOR & NEWTON

Medium and thinner washes handled very well but I experienced some difficulty in heavier applications.

The paint had to be well worked first or was rather patchy.

COTMAN WATER COLOURS 2ND RANGE

PY83 HR70 DIARYLIDE YELLOW HR70 WG II (45)

PIGMENT DETAIL ON LABEL YES	WG II L'FAST	RATING ★ ★★

CADMIUM ORANGE 5704

HUNTS

Reliable ingredients. Paint flowed well. It is a pity the company would not cooperate with the supply of information. Opaque.

Discontinued

SPEEDBALL PROFESSIONAL WATERCOLOURS

CADMIUM SULPHOSELENIDE COPRECIPITATED WITH BARIUM SULPHATE

PIGMENT DETAIL ON LABEL NO	ASTM I L'FAST	

CADMIUM YELLOW ORANGE 161

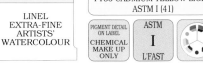

LEFRANC & BOURGEOIS

A superb all round watercolour. Excellent ingredients. Strong bright and handles very well. Opaque.

LINEL EXTRA-FINE ARTISTS' WATERCOLOUR

PO20 CADMIUM ORANGE ASTM I (94)
PY35 CADMIUM YELLOW LIGHT ASTM I (41)

PIGMENT DETAIL ON LABEL CHEMICAL MAKE UP ONLY	ASTM I L'FAST	

CADMIUM YELLOW ORANGE 44

 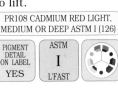

HOLBEIN

Bright, rather strong, smooth flowing and absolutely lightfast. The packaging has been much improved and full pigment details are now on the label. Opaque, non staining and easy to lift.

ARTISTS' WATER COLOR

PR108 CADMIUM RED LIGHT, MEDIUM OR DEEP ASTM I (126)

PIGMENT DETAIL ON LABEL YES	ASTM I L'FAST	

CADMIUM RED ORANGE 16

 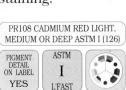

HOLBEIN

An excellent all round watercolour. Smooth flowing, bright, strong and completely reliable. Opaque and semi staining.

ARTISTS' WATER COLOR

PR108 CADMIUM RED LIGHT, MEDIUM OR DEEP ASTM I (126)

PIGMENT DETAIL ON LABEL YES	ASTM I L'FAST	

CADMIUM ORANGE 518

MIR
(JAURENA S.A)

ACUARELA

Leaning very much towards red, this is a strong, bright orange with good handling characteristics.

PO20 CADMIUM ORANGE ASTM I (94)

PIGMENT DETAIL ON LABEL	ASTM	
YES	I L'FAST	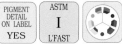

CADMIUM ORANGE 532

CARAN D'ACHE

FINEST WATERCOLOURS

This watercolour appears more like PO20 Cadmium Orange than Cadmium Red. Either way it will be most reliable. Brushed out well.

PR108 CADMIUM RED LIGHT, MEDIUM OR DEEP ASTM I (126)

PIGMENT DETAIL ON LABEL	ASTM	
YES	I L'FAST	

CADMIUM RED ORANGE 534

CARAN D'ACHE

FINEST WATERCOLOURS

A strong, reliable pigment has been used to produce a first class pan colour. The paint softened readily without the scrubbing required with some makes.

PR108 CADMIUM RED LIGHT, MEDIUM OR DEEP ASTM I (126)

PIGMENT DETAIL ON LABEL	ASTM	
YES	I L'FAST	

DARK CADMIUM ORANGE 533

CARAN D'ACHE

FINEST WATERCOLOURS

The paint softened readily without needing the excess of additive to make it a 'semi moist' pan.

Very smooth, even, bright washes over a useful range.

PO20 CADMIUM ORANGE ASTM I (94)

PIGMENT DETAIL ON LABEL	ASTM	
YES	I L'FAST	

CADMIUM ORANGE (AZO) 216

TALENS

WATER COLOUR 2ND RANGE

On exposure the red will fade followed soon after by the yellow. I would suggest fine for temporary work only. Semi-opaque.

Discontinued

PY74LF ARYLIDE YELLOW 5GX ASTM III (44)
PR4 CHLORINATED PARA RED WG V (115)

PIGMENT DETAIL ON LABEL	WG	RATING
YES	V L'FAST	★

CADMIUM ORANGE 211

TALENS

REMBRANDT ARTISTS' QUALITY EXTRA FINE

An excellent watercolour. Particularly good ingredients. Flows smoothly over a wide range of values. Opaque.

PO20 CADMIUM ORANGE ASTM I (94)
PY35 CADMIUM YELLOW LIGHT ASTM I (41)

PIGMENT DETAIL ON LABEL	ASTM	
YES	I L'FAST	

CADMIUM ORANGE 006

St. PETERSBURG

ARTISTS' WATERCOLOURS

The colour lifted well and brushed out smoothly, whatever it is made of.

INFORMATION ON THE PIGMENTS USED IN THIS WATERCOLOUR WERE REFUSED BY THE MANUFACTURER

PIGMENT DETAIL ON LABEL	ASTM	RATING
NO	L'FAST	

CADMIUM YELLOW ORANGE 537

SENNELIER

EXTRA-FINE WATERCOLOUR

Two very reliable pigments with excellent handling qualities. Brushes very well. Semi-opaque.

This is a quality product.

PO20 CADMIUM ORANGE ASTM I (94)
PY35 CADMIUM YELLOW LIGHT ASTM I (41)

PIGMENT DETAIL ON LABEL	ASTM	
YES	I L'FAST	

CADMIUM RED ORANGE 609

SENNELIER

EXTRA-FINE WATERCOLOUR

A first rate watercolour. Rich, velvety dark red-orange. Unaffected by light. Smoothly ground. Opaque.

PR108 CADMIUM RED LIGHT, MEDIUM OR DEEP ASTM I (126)

PIGMENT DETAIL ON LABEL	ASTM	
YES	I L'FAST	

CADMIUM ORANGE 013

DANIEL SMITH

EXTRA-FINE WATERCOLORS

An excellent watercolour which handled very well. Gave good covering when at all heavy and reasonably clear washes when thinned.

PO20 CADMIUM ORANGE ASTM I (94)

PIGMENT DETAIL ON LABEL	ASTM	
YES	I L'FAST	

CADMIUM ORANGE 410

OLD HOLLAND

CLASSIC WATERCOLOURS

No assessments offered. There must be more than the PY37 in this red-orange. The company did not or would not confirm the ingredients.

Reformulated >

PY37 CADMIUM YELLOW MEDIUM OR DEEP ASTM I (42)

PIGMENT DETAIL ON LABEL		
CHEMICAL MAKE UP ONLY		

CADMIUM ORANGE 17

OLD HOLLAND

CLASSIC WATERCOLOURS

The sample provided brushed very well over a useful range of values. As the correct pigment was used it is a pity that the user only has the chemical make up to go by on the tube label.

PO20 CADMIUM ORANGE ASTM I (94)

PIGMENT DETAIL ON LABEL	ASTM	
CHEMICAL MAKE UP ONLY	L'FAST	

CADMIUM ORANGE 615

DALER ROWNEY

ARTISTS' WATER COLOUR

An excellent all-round watercolour.

Produced from superb ingredients. Strong, vibrant colour. Handles well. PY35 replaces previous PY37. Opaque.

PO20 CADMIUM ORANGE ASTM I (94)
PY35 CADMIUM YELLOW LIGHT ASTM I (41)

PIGMENT DETAIL ON LABEL	ASTM	
YES	I L'FAST	

CADMIUM ORANGE (HUE) 619

DALER ROWNEY

ARTISTS' WATER COLOUR

Although this is an imitation, and correctly labelled as such, the colour is close to genuine Cadmium Orange. Reliable.

PO62 BENZIMIDAZOLONE ORANGE H5G ASTM II (97)
PY65 ARYLIDE YELLOW RN ASTM II (44)

PIGMENT DETAIL ON LABEL	ASTM	
YES	II L'FAST	

CADMIUM ORANGE 054

MAIMERI

MAIMERIBLU SUPERIOR WATERCOLOURS

Bright, strong, well prepared watercolour. Superb ingredients. Will not change in hue on exposure. Opaque.

PO20 CADMIUM ORANGE ASTM I (94)

PIGMENT DETAIL ON LABEL	ASTM	
YES	I L'FAST	

CADMIUM ORANGE (HUE) 619

DALER ROWNEY

GEORGIAN WATER COLOUR 2ND RANGE

Fine for temporary sketch work only as the colour will fade rapidly, as the company know. Semi-opaque.

Reformulated

PR4 CHLORINATED PARA RED WG V (115)
PO13 PYRAZOLONE ORANGE ASTM V (94)
PW6 TITANIUM WHITE ASTM I (385)

PIGMENT DETAIL ON LABEL	ASTM	RATING
NO	V L'FAST	★

CADMIUM ORANGE HUE

DALER ROWNEY

GEORGIAN WATER COLOUR 2ND RANGE

Given the low quality (as far as permanence is concerned) pigments used this will be a short lived colour. Perhaps keep finished work under your bed, away from the light.

PR4 CHLORINATED PARA RED WG V (115)
PO13 PYRAZOLONE ORANGE ASTM V (94)

PIGMENT DETAIL ON LABEL	ASTM	RATING
NO	V L'FAST	★

PO20, Cadmium Orange, appears to be slightly brighter than a mix of Cadmium Red and Cadmium Yellow. All three are chemically related.

Chrome Orange

In practise, this is either an unreliable mix of Chrome Yellow Lemon and Chrome Orange, or a concoction of almost anything else.

Varies between yellow and red orange. Best left alone.

CHROME ORANGE, NO LEAD 214

SCHMINCKE

HORADAM FINEST ARTISTS' WATER COLOURS

Fast to light. Despite the first part of the name, fortunately has nothing to do with Chrome Orange. Previously called 'Chrome Orange Hue 214'.

PO62 BENZIMIDAZOLONE ASTM II (97)

PIGMENT DETAIL ON LABEL	ASTM	
YES	II L'FAST	

CHROME ORANGE 160

WINSOR & NEWTON

ARTISTS' WATER COLOUR

On exposure our sample changed from a reasonably bright red-orange to a deep brown. Semi-opaque.

Discontinued

PY34 CHROME YELLOW LEMON LF NOT OFFERED (41)
PR104 CHROME ORANGE LF NOT OFFERED (125)

PIGMENT DETAIL ON LABEL	ASTM	RATING
YES	L'FAST	

CHROME ORANGE 624

DALER ROWNEY

ARTISTS' WATER COLOUR

If exposed to light you will soon be left with a pale dull yellow as PY1 and PO13 are both fugitive. Semi-opaque.

Discontinued

PY1 ARYLIDE YELLOW G ASTM V (37)
PY42 MARS YELLOW ASTM I (43)
PO13 PYRAZOLONE ORANGE ASTM V (94)

PIGMENT DETAIL ON LABEL	ASTM	RATING
NO	V L'FAST	★

CHROME ORANGE DEEP 625

DALER ROWNEY

ARTISTS' WATER COLOUR

Sample became a deep, dull brown during exposure to light and the atmosphere. Semi-opaque.

Discontinued

PY34 CHROME YELLOW LEMON LF NOT OFFERED (41)
PR104 CHROME ORANGE LF NOT OFFERED (125)

PIGMENT DETAIL ON LABEL	ASTM	RATING
NO	L'FAST	

Miscellaneous Oranges

Many pre-mixed oranges are of dubious value. If you have control of colour mixing and reliable orange reds and orange-yellows, you will be able to produce ranges equal to any of the following.

PO43 and PO62 are worth considering, but little else.

When mixing, first decide on the bias or leaning of the colour. Mixing complementary of a red-orange is a green-blue such as Cerulean or Phthalocyanine Blue, that of yellow orange, a violet-blue. Ultramarine is the only practical violet-blue.

ANTIQUE ORANGE 004

HOLBEIN

IRODORI ANTIQUE WATERCOLOR

The use of two pigments which are known by all manufacturers to be most unreliable, spoil this colour. Use only if you are happy that it will move towards white.

PO34 DIARYLIDE ORANGE WG V (95)
PY1 ARYLIDE YELLOW G ASTM V (37)

PIGMENT DETAIL ON LABEL: YES | ASTM V L'FAST | RATING ★

ANTIQUE RED ORANGE 005

HOLBEIN

IRODORI ANTIQUE WATERCOLOR

The use of two pigments which are known to be unreliable makes this a poor buy, unless you are not concerned about the future of your work. Unreliable.

PR48:1 PERMANENT RED 2B (BARIUM) WG V (118)
PR112 NAPHTHOL AS-D ASTM III (127)

PIGMENT DETAIL ON LABEL: YES | WG V L'FAST | RATING ★

ANTIQUE JAUNE BRILLIANT 028

HOLBEIN

IRODORI ANTIQUE WATERCOLOR

A pale orange very easily produced on the palette. Reliable ingredients used and the paint is well made.

PO36 BENZIMIDAZOLONE ORANGE HL ASTM I (95)
PW6 TITANIUM WHITE ASTM I (385)

PIGMENT DETAIL ON LABEL: YES | ASTM I L'FAST |

ANTIQUE CORAL RED 027

HOLBEIN

IRODORI ANTIQUE WATERCOLOR

An easily mixed pale reddish orange. Reliable pigments gave a paint which will resist light extremely well. Brushed out very smoothly.

PO36 BENZIMIDAZOLONE ORANGE HL ASTM I (95)
PW6 TITANIUM WHITE ASTM I (385)

PIGMENT DETAIL ON LABEL: YES | ASTM I L'FAST |

AVIGNON ORANGE 053

MAIMERI

MAIMERIBLU SUPERIOR WATERCOLOURS

Sample gave rather streaky layers when applied at all heavily.

Worked fine when painted out in thinner washes. Reliable

PR206 QUINACRIDONE BURNT ORANGE WG II (133)

PIGMENT DETAIL ON LABEL: YES | WG II L'FAST | RATING ★ ★★

ALIZARIN ORANGE A005

GRUMBACHER

ACADEMY ARTISTS' WATERCOLOR 2ND RANGE

A strong reddish orange which handled very well. The ingredients are all lightfast. An easily mixed convenience colour.

PY150 NICKEL AZO YELLOW ASTM I (49)
PR209 QUINACRIDONE RED Y ASTM II (134)
PY65 ARYLIDE YELLOW RN ASTM II (44)

PIGMENT DETAIL ON LABEL: YES | ASTM II L'FAST |

AUSTRALIAN RED GOLD W49

ART SPECTRUM

ARTISTS' WATER COLOUR

Quite a large amount of dark foreign matter, which would not dissolve into the paint, spoilt the wash at all strengths.

PY83HR70 DIARYLIDE YELLOW HR70 WG II (45)
UNSPECIFIED PR101 ASTM I (123/124)
PV19 QUINACRIDONE VIOLET ASTM I (185)

PIGMENT DETAIL ON LABEL: YES | ASTM II L'FAST | RATING ★

BENZIMIDA ORANGE 204

DA VINCI PAINTS

PERMANENT ARTISTS' WATER COLOR

A reasonably bright, 'clean' mid-orange. Semi-transparent and easily lifted from the paper. An excellent all round watercolour.

PO62 BENZIMIDAZOLONE ORANGE H5G ASTM II (97)

PIGMENT DETAIL ON LABEL: YES | ASTM II L'FAST |

BRILLIANT ORANGE 1 903

SCHMINCKE

HORADAM FINEST ARTISTS' WATER COLOURS

Smooth, even flowing in a wash. Both ingredients are lightfast. Not particularly brilliant, rather dull in fact.

Discontinued

PO20 CADMIUM ORANGE ASTM I (94)
PO62 BENZIMIDAZOLONE ORANGE H5G ASTM II (97)

PIGMENT DETAIL ON LABEL: YES | ASTM II L'FAST |

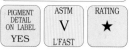

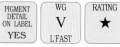

106

BRILLIANT ORANGE W247

HOLBEIN

As there is not a great deal known about PO73, apart from the fact that it has not been officially tested in artists materials, I am afraid that I cannot offer assessments.

ARTISTS' WATER COLOR

| PO73 COMMON NAME N/K |
| LF NOT OFFERED (99) |
| PO62 BENZIMIDAZOLONE |
| ORANGE H5G ASTM II (97) |

PIGMENT DETAIL ON LABEL	ASTM	RATING
YES	L'FAST	

BRILLIANT ORANGE 504

MAIMERI

A reliable pigment used giving a reasonably bright orange.

Makes an excellent all round watercolour. Transparent.

Discontinued

ARTISTI EXTRA-FINE WATERCOLOURS

| PO43 PERINONE ORANGE WG II (96) |

PIGMENT DETAIL ON LABEL	WG	
NO	II L'FAST	

CADMIUM YELLOW RED 162

LEFRANC & BOURGEOIS

A rich, bright, strong orange which flows very well in a wash. Excellent pigments used. Absolutely lightfast. Opaque.

LINEL EXTRA-FINE ARTISTS' WATERCOLOUR

| PO20 CADMIUM ORANGE ASTM I (94) |

PIGMENT DETAIL ON LABEL	ASTM	
CHEMICAL MAKE UP ONLY	I L'FAST	

CADMIUM YELLOW ORANGE 142

OLD HOLLAND

Washed out with ease giving a smooth range of easily gradated washes.

An excellent, lightfast Pigment.

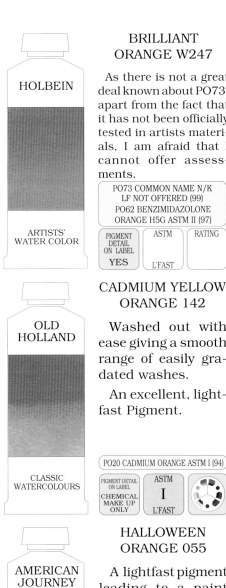

CLASSIC WATERCOLOURS

| PO20 CADMIUM ORANGE ASTM I (94) |

PIGMENT DETAIL ON LABEL	ASTM	
CHEMICAL MAKE UP ONLY	I L'FAST	

CORAL ORANGE 145

OLD HOLLAND

I discovered the use of PO67 in the closing stages of this book and have little information on it. Had the actual pigment used been made clear on the tube it would have been a different matter.

It has not been ASTM tested in any art material.

CLASSIC WATERCOLOURS

| PO67 |

PIGMENT DETAIL ON LABEL	WG	RATING
CHEMICAL MAKE UP ONLY	L'FAST	

CHINESE ORANGE 645

SENNELIER

Completely reformulated several years ago using lightfast pigments. Check product when purchasing as colour used to be unreliable. Semi-transparent. Excellent.

EXTRA-FINE ARTISTS' WATER COLOURS

| PO49 QUINACRIDONE DEEP GOLD |
| WG II (97) |
| PR209 QUINACRIDONE RED Y |
| ASTM II (134) |

PIGMENT DETAIL ON LABEL	ASTM	
yes	II L'FAST	

HALLOWEEN ORANGE 055

AMERICAN JOURNEY

A lightfast pigment leading to a paint which brushed out very smoothly indeed. A most reliable product. Non staining and semi-transparent.

PROFESSIONAL ARTISTS' WATER COLOR

| PO62 BENZIMIDAZOLONE |
| ORANGE H5G ASTM II (97) |

PIGMENT DETAIL ON LABEL	ASTM	
YES	II L'FAST	

HELIO GENUINE ORANGE 1048

LUKAS

Completely lightfast. A superb, well prepared watercolour. Bright, reliable oranges are available. First rate. Semi-opaque.

ARTISTS' WATER COLOUR

| PO62 BENZIMIDAZOLONE |
| ORANGE H5G ASTM II (97) |

PIGMENT DETAIL ON LABEL	ASTM	
CHEMICAL MAKE UP ONLY	II L'FAST	

JUANE BRILLIANT N°.1 31

HOLBEIN

Reformulated some time ago to give a very smooth convenience colour. The previous ingredients also gave a lightfast product.

ARTISTS' WATER COLOR

| PO20 CADMIUM ORANGE ASTM I (94) |
| PY37 CADMIUM YELLOW MEDIUM OR |
| DEEP ASTM I (42) |
| PW6 TITANIUM WHITE ASTM I (385) |

PIGMENT DETAIL ON LABEL	ASTM	
YES	I L'FAST	

JUANE BRILLIANT N°2 32

HOLBEIN

All pigments particularly lightfast. A convenience colour, which is very easily mixed. Opaque and non staining.

ARTISTS' WATER COLOR

| PR108 CADMIUM RED LIGHT, |
| MEDIUM OR DEEP ASTM I (126) |
| PW6 TITANIUM WHITE ASTM I (385) |
| PO20 CADMIUM ORANGE ASTM I (94) |

PIGMENT DETAIL ON LABEL	ASTM	
YES	I L'FAST	

LASUR ORANGE 2 904

SCHMINCKE

This colour used to be named Brilliant Orange 2. Insufficient information about the pigment now used makes it impossible to offer an assessment. Transparent.

Discontinued

HORADAM FINEST ARTISTS' WATER COLOURS

| |

PIGMENT DETAIL ON LABEL	ASTM	RATING
YES	L'FAST	

LEAD RED 621

SENNELIER

Particularly unreliable. The colour fades due to the high yellow content. The darkening effect of the Red Lead is minimal suggesting little is present.

Discontinued

EXTRA-FINE WATERCOLOUR

| PR105 RED LEAD WG V (125) |
| PY1:1 ARYLIDE YELLOW G |
| ASTM III (37) |

PIGMENT DETAIL ON LABEL	WG	RATING
YES	V L'FAST	★

MARS ORANGE 307

Despite the stated use of absolutely lightfast pigments, our sample darkened slightly in mass tone.

An additional ingredient perhaps? Semi-transparent.

Reformulated >

LINEL EXTRA-FINE ARTISTS' WATERCOLOUR

PR101 MARS RED ASTM I (124) PY42 MARS YELLOW ASTM I (43)		

| PIGMENT DETAIL ON LABEL CHEMICAL MAKE UP ONLY | ASTM I L'FAST | RATING ★ ★★ |

MARS ORANGE 307

LEFRANC & BOURGEOIS

The sample was choked with gum and very difficult to work with.

Lightfast but a very poor watercolour paint.

LINEL EXTRA-FINE ARTISTS' WATERCOLOUR

| PY42 MARS YELLOW ASTM I (43) | | |

| PIGMENT DETAIL ON LABEL CHEMICAL MAKE UP ONLY | ASTM I L'FAST | RATING ★★ |

ORANGE 601

MAIMERI

Gradually becomes lighter and redder as the yellow fades. Brushes out very smoothly giving even washes. Semi-transparent.

Range discontinued

| PY83HR70 DIARYLIDE YELLOW HR70 WG II (45) PR9 NAPHTHOL AS-OL ASTM III (117) | | |

| PIGMENT DETAIL ON LABEL YES | ASTM III L'FAST | RATING ★★ |

STUDIO FINE WATER COLOURS 2ND RANGE

ORANGE LAKE 125

MAIMERI

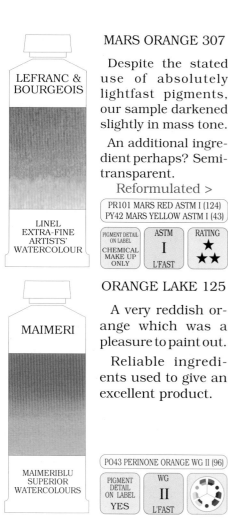

A very reddish orange which was a pleasure to paint out.

Reliable ingredients used to give an excellent product.

MAIMERIBLU SUPERIOR WATERCOLOURS

| PO43 PERINONE ORANGE WG II (96) | | |

| PIGMENT DETAIL ON LABEL YES | WG II L'FAST | |

ORANGE N°.3

PENTEL

I can tell you very little about this watercolour apart from the fact that it is offered for artistic work.

WATERCOLOURS

| NO INDICATION ON THE PIGMENTS USED ON THE PRODUCT OR IN THE LITERATURE WHICH WAS SUPPLIED. | | |

| PIGMENT DETAIL ON LABEL NO | ASTM L'FAST | RATING |

PEACHY KEEN 088

AMERICAN JOURNEY

Quite a concoction but at least all pigments are reliable. Sample handled well. Non staining. The white brings some opacity and clouds the colour, which was obviously the intention.

| PY97 ARYLIDE YELLOW FGL ASTM II (46) PO62 BENZIMIDAZOLONE ORANGE H5G ASTM II (97) PW6 TITANIUM WHITE ASTM I (385) PR188 NAPHTHOL AS ASTM II (132) | | |

| PIGMENT DETAIL ON LABEL YES | ASTM II L'FAST | |

PROFESSIONAL ARTISTS' WATER COLOR

PERINONE ORANGE 066

DANIEL SMITH

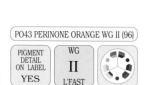

A reliable pigment which gave an orange with a definite leaning towards red. Brushed very well.

EXTRA-FINE WATERCOLORS

| PO43 PERINONE ORANGE WG II (96) | | |

| PIGMENT DETAIL ON LABEL YES | WG II L'FAST | |

PERINONE ORANGE 000

UTRECHT

A reliable red orange which remained bright at all strengths. Although such colours are easily mixed, they can be a convenience if you use a lot of the colour type.

PROFESSIONAL ARTISTS' WATER COLOR

| PO43 PERINONE ORANGE WG II (96) | | |

| PIGMENT DETAIL ON LABEL YES | WG II L'FAST | |

PERMANENT ORANGE 5703

HUNTS

The company description 'Azoic Pigment' is about as specific as calling a cat an animal. I cannot offer more information. No assessments given.

Discontinued

| AZOIC PIGMENT | | |

| PIGMENT DETAIL ON LABEL NO | ASTM L'FAST | RATING |

SPEEDBALL PROFESSIONAL WATERCOLOURS

PERMANENT YELLOW ORANGE W238

HOLBEIN

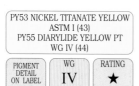

A strong, bright colour which handled very well. It is a pity that it will alter rapidly in light. Opaque and easy to lift.

ARTISTS' WATER COLOR

| PY53 NICKEL TITANATE YELLOW ASTM I (43) PY55 DIARYLIDE YELLOW PT WG IV (44) | | |

| PIGMENT DETAIL ON LABEL YES | WG IV L'FAST | RATING ★ |

PERMANENT ORANGE 110

MAIMERI

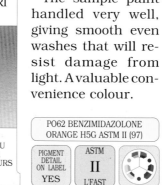

The sample paint handled very well, giving smooth even washes that will resist damage from light. A valuable convenience colour.

MAIMERIBLU SUPERIOR WATERCOLOURS

| PO62 BENZIMIDAZOLONE ORANGE H5G ASTM II (97) | | |

| PIGMENT DETAIL ON LABEL YES | ASTM II L'FAST | |

PERMANENT ORANGE 062

MAIMERI

Absolutely lightfast. The sample provided was slightly gummy. It handled very well when thinned but was a little heavy going when applied at all heavily.

VENEZIA EXTRAFINE WATERCOLOURS

| PO36 BENZIMIDAZOLONE ORANGE HL ASTM I (95) | | |

| PIGMENT DETAIL ON LABEL YES | ASTM I L'FAST | RATING ★ ★★ |

PERMANENT ORANGE 242

PÈBÈO

FRAGONARD ARTISTS' WATER COLOUR

A watercolour that handles well, giving even washes. Semi-transparent. Company claim ASTM I but appear to be using the oils/acrylics list as guidance where PR9 is ASTM I.

| PY65 ARYLIDE YELLOW RN ASTM II (44) | | |
| PR9 NAPHTHOL AS-OL ASTM III (117) | | |

PIGMENT DETAIL ON LABEL	ASTM	RATING
YES	III	★★
	L'FAST	

PERMANENT ORANGE 266

TALENS

REMBRANDT ARTISTS' QUALITY EXTRA FINE

Hopefully the manu-facturer has been able to find out more on PO73 and its history that I have. Assess-ments cannot be of-fered.

| PY154 BENZIMIDAZOLONE YELLOW H3G ASTM II (50) | | |
| PO73 COMMON NAME N/K LF NOT OFFERED (99) | | |

PIGMENT DETAIL ON LABEL	ASTM	RATING
YES		
	L'FAST	

PERMANENT ORANGE 266

TALENS

VAN GOGH 2ND RANGE

Rather over bound and difficult to apply. I can-not offer assessments as I have little information on PO73, apart from the fact that it has not been ASTM tested as an art material.

| PY154 BENZIMIDAZOLONE YELLOW H3G ASTM II (50) | | |
| PO73 COMMON NAME N/K LF NOT OFFERED (99) | | |

PIGMENT DETAIL ON LABEL	ASTM	RATING
YES		
	L'FAST	

PERMANENT ORANGE 071

DANIEL SMITH

EXTRA-FINE WATERCOLORS

A reasonably bright orange. PO62 gives a very useful range of values and the colour remains fairly bright at all strengths.

| PO62 BENZIMIDAZOLONE ORANGE H5G ASTM II (97) | | |

PIGMENT DETAIL ON LABEL	ASTM	
YES	II	
	L'FAST	

PERMANENT ORANGE W10

ART SPECTRUM

ARTISTS' WATER COLOUR

A reliable orange which gave smooth even transparent washes.

If you do use such convenience colours at least make sure that they are lightfast.

| PO62 BENZIMIDAZOLONE ORANGE H5G ASTM II (97) | | |

PIGMENT DETAIL ON LABEL	ASTM	
YES	II	
	L'FAST	

PERMANENT ORANGE 218

SCHMINCKE

HORADAM FINEST ARTISTS' WATER COLOURS

PO69 has not been tested under ASTM con-ditions in any art media. I cannot find sufficient in-formation to offer a lightfastness rating. Transparent.

Discontinued

| PY153 NICKEL DIOXINE YELLOW ASTM II (50) | | |
| PO69 COMMON NAME N/K LF NOT OFFERED (98) | | |

PIGMENT DETAIL ON LABEL	ASTM	RATING
YES		
	L'FAST	

TRANSLUCENT ORANGE 218

SCHMINCKE

HORADAM FINEST ARTISTS' WATER COLOURS

Heavier use leads to initial streaking. But this can be worked in quite easily. Medium and lighter washes are excellent.

Assessments not of-fered as insufficient is known about PO71.

| PO71 COMMON NAME N/K LF NOT OFFERED (98) | | |

PIGMENT DETAIL ON LABEL	ASTM	RATING
YES		
	L'FAST	

QUINACRIDONE BURNT ORANGE 086

DANIEL SMITH

EXTRA-FINE WATERCOLORS

The sample was slightly over bound. Thinner washes were fine but the paint was not so easy to handle in heavier applica-tions. Lightfast.

| PO48 QUINACRIDONE GOLD ASTM II (97) | | |

PIGMENT DETAIL ON LABEL	ASTM	RATING
YES	II	★ ★★
	L'FAST	

QUINACRIDONE RED ORANGE 655

SENNELIER

EXTRA-FINE WATERCOLOUR

A fairly bright, trans-parent red-orange. The sample painted out very well over a good range of values. Absolutely lightfast. Excellent.

| PR209 QUINACRIDONE RED Y ASTM II (134) | | |

PIGMENT DETAIL ON LABEL	ASTM	
YES	II	
	L'FAST	

RED ORANGE 640

SENNELIER

EXTRA-FINE WATERCOLOUR

A well produced mid or-ange which brushed out particularly well, giving some very subtle light washes. I have insuffi-cient information about PO69 to offer assess-ments.

Reformulated

| PO69 COMMON NAME N/K LF NOT OFFERED (98) | | |
| PY83HR70 DIARYLIDE YELLOW HR70 WG II (45) | | |

PIGMENT DETAIL ON LABEL	ASTM	RATING
YES		
	L'FAST	

RED ORANGE 640

SENNELIER

EXTRA-FINE WATERCOLOUR

A bright, strong orange.

An excellent water-colour paint which washed out beauti-fully. Will resist light.

| PO43 PERINONE ORANGE WG II (96) | | |
| PY83HR70 DIARYLIDE YELLOW HR70 WG II (45) | | |

PIGMENT DETAIL ON LABEL	WG	
YES	II	
	L'FAST	

ROWNEY ORANGE

DALER ROWNEY

GEORGIAN WATER COLOUR 2ND RANGE

Introduced just a few years ago, a rela-tively new colour em-ploying pigments which are known to fade, the PY1 in par-ticular. Surely a backward step!

| PR9 NAPHTHOL AS-OL ASTM III (117) | | |
| PY1 ARYLIDE YELLOW G ASTM V (37) | | |

PIGMENT DETAIL ON LABEL	ASTM	RATING
NO	V	★
	L'FAST	

SCHEVENINGEN ORANGE 18

OLD HOLLAND

CLASSIC WATERCOLOURS

A bright orange which brushed out very well indeed.

I cannot offer assessments for the reasons described on page 98 under PO69.

PO69 COMMON NAME N/K LF
NOT OFFERED (98)

PIGMENT DETAIL ON LABEL	ASTM	RATING
CHEMICAL MAKE UP ONLY	L'FAST	

TALENS ORANGE 250

TALENS

REMBRANDT ARTISTS' QUALITY EXTRA FINE

As expected, our sample faded severely in a short time. Most unreliable pigments. Semi-transparent.

Discontinued

PY74LF ARYLIDE YELLOW 5GX
ASTM III (44)
PR4 CHLORINATED PARA RED
WG V (115)

PIGMENT DETAIL ON LABEL	WG	RATING
YES	V	★
	L'FAST	

WARM ORANGE 633

DALER ROWNEY

ARTISTS' WATER COLOUR

A reddish orange, thinner applications moving slightly towards yellow.

As insufficient information is available on this pigment I can only assume that the manufacturer has sound reasons for using it.

PO73 COMMON NAME N/K
LF NOT OFFERED (99)

PIGMENT DETAIL ON LABEL	ASTM	RATING
YES	L'FAST	

WINSOR ORANGE 724

WINSOR & NEWTON

ARTISTS' WATER COLOUR

Rather gummy consistency.

This caused some hesitation in the washes. As soon as the paint was worked in it behaved well.

PO62 BENZIMIDAZOLONE
ORANGE H5G ASTM II (97)

PIGMENT DETAIL ON LABEL	ASTM	RATING
YES	II	★ ★★
	L'FAST	

Colour mixing

The complementaries, orange and blue, will successfully darken each other and give a range of greys when their intensities are equally combined.

The mixing complementary of a yellow-orange is a violet-blue, that of red-orange a green-blue such as Cerulean Blue or Phthalocyanine Blue.

A mid-orange can be combined with either type of blue for varied results.

In this example, a mid-orange (neither yellow or red) has been mixed with a violet-blue, (Ultramarine).

Why buy greys when they are so easy to mix? Any of the colours shown here will soften into a wide range of tints,

Reds

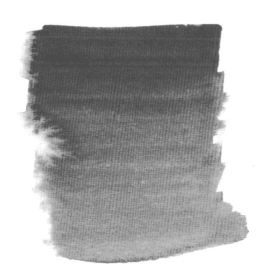

History of red pigments

The raw materials for the making of red pigments abound in nature. Amongst the substances used have been flowers, woods, resins, roots, seeds, insects, clays and rocks.

In the constant search for durable red pigments, the artist and chemist refined these materials to a high degree, and in very many cases produced them synthetically. The story is really one of the replacement of one red or group of reds by superior products.

One of the earliest red pigments was Cinnabar, produced from a hard red rock, varying from a liver colour to a scarlet. It was the only bright red of the ancient world. Such strongly coloured minerals were highly valued and became articles of >

Cinnabar, the first bright red of antiquity.

commerce. Although many minerals are rich in colour, relatively few make useful pigments, ground ruby for example, becomes a white dust when powdered, as do many other stones.>

Vermilion, synthetic Cinnabar, was once an important orange-red.

Vermilion, a synthetically produced version of Cinnabar was an important red for many centuries. Vermilion has always suffered the defect of darkening on exposure to the atmosphere.

Minium was valued by book illustrators for its relative brightness.

Minium, an orange red, similar to today's red lead, was widely used for book illumination and panel painting during the Middle Ages.

It owed its popularity to the fact that Cinnabar and Vermilion were difficult to obtain and expensive. It was the closest that many artists could get to a bright red.

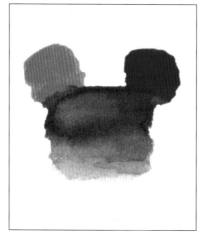

Vermilion was of little value when mixing for bright violets.

The inclination of Vermilion towards orange meant that artists could not mix clear violets because with any of the blues Vermilion will give only dull neutral colours. This factor, together with a requirement for rich transparent reds, led to the manufacture of 'Red Lake' pigments from various vegetable and animal dyes.

Brazil, a red produced from a particular bark, was highly prized.

During the Middle Ages a variety of dyes were produced from resins, insects and woods. The most important of them being Lac, Grain and Brazil. These reds were highly esteemed. This is illustrated by the fact that the discovery of a new source of one of them led to the naming of the country Brazil.

Unfortunately, many of these lake colours were very fugitive, certainly by today's standards.

Under favourable conditions, where light and moisture have been excluded, such as the illumination on the pages of a book, they have stood up remarkably well.

Folium, a vegetable dye which varied in colour depending on its acidity, was also of some importance during Medieval times.

These ancient pigments, together with other red lakes, such as Carmine and Madder have been replaced, almost >

Madder was at one time of vital importance in European trade.

exclusively by Alizarin. Once extracted from the root of the Madder plant, Alizarin, now produced synthetically, has >

Synthetic Alizarin, an unreliable substance, is overdue for retirement.

become one of the major reds, this, despite its very poor fastness to light as a tint.

We are indeed fortunate to have the Cadmium Reds, excellent pigments worth any additional cost.

Many reliable, modern reds are marketed under ancient and now meaningless names.

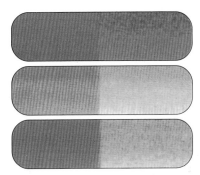

Very many of the reds in use today are quite worthless to the artist.

The modern artist is well served by a limited number of very reliable reds. Reds which would have been worth a fortune to earlier painters had they been able to obtain them. A King's ransom would have been paid for the Cadmium Reds and other reliable pigments. We are indeed fortunate.

In recent years a limited range of lightfast, synthetic red pigments have become available. Strangely the names of many of the earlier unreliable reds

have been retained to describe these modern and reliable pigments. Therefore, regrettably, making many of the superb modern colour names seem meaningless. This not only adds to the confusion but does not allow the true names of these pigments to emerge and become known.

Today the artist had a greater variety of permanent red pigments available than at any time in history.

Against this background it has to be said that we also

have the most extensive range of utterly useless reds that have ever been in use. The vast majority of both orange and violet reds offered as watercolours are unsuitable for artistic use.

Most fade when applied thinly, others fade at any strength, still others darken or become discoloured.

Awareness, coupled with clear identification of these poor substances will hopefully drive them from the paint rack

Modern Red Pigments

PR2	NAPTHOL RED FR	115
PR3	TOLUIDINE RED	115
PR4	CHLORINATED PARA RED	115
NR4	CARMINE	116
PR5	NAPTHOL 1TR	116
PR6	PARACHLOR RED	116
PR7	NAPHTHOL AS-TR	117
PR9	NAPHTHOL AS-OL	117
NR9	NATURAL ROSE MADDER	117
PR19	ARYLIDE MAROON DARK	118
PR23	NAPHTHOL RED LF	118
PR48:1	PERMANENT RED 2B (BARIUM)	118
PR48:2	PERMANENT RED 2B (CALCIUM)	119
PR48:4	PERMANENT RED 2B (MANGANESE)	119
PR49:1	LITHOL RED	119
PR53:1	BARIUM RED LAKE C	120
PR57	LITHOL RUBINE (SODIUM)	120
PR57:1	LITHOL RUBINE (CALCIUM)	120
PR60	SCARLET LAKE (SODIUM)	121
PR81	RHODAMINE Y	121
PY82	RHODAMINE YELLOW SHADE	121
PR83	ROSE MADDER ALIZARIN	122
PR83:1	ALIZARIN CRIMSON	122
PR88MRS	THIOINDIGOID VIOLET,	122
PR90	PHIOXINE RED	123
PR101	MARS VIOLET	123
PR101	INDIAN RED	123
PR101	MARS RED	124
PR101	LIGHT OR ENGLISH RED OXIDE	124
PR101	VENETIAN RED	124
PR102	LIGHT RED	125
PR104	CHROME ORANGE	125
PR105	RED LEAD	125
PR106	VERMILION	126
PR108	CADMIUM RED LIGHT, MEDIUM OR DEEP	126
PR108:1	CADMIUM-BARIUM RED LIGHT, MEDIUM OR DEEP	126
PR112	NAPHTHOL AS-D	127
PR122	QUINACRIDONE MAGENTA	127
PR144	DISAZO RED	114
PR146	NAPHTHOL RED	127
PR149	PERYLENE RED BL	128
PR 166	DISAZO SCARLET	128
PR168	BROMINATED ANTHRANTHRONE	128
PR170	F3RK-70 NAPHTHOL RED	129
PR171	BENZIMIDAZOLONE BORDEAUX	129
PR173	RHODAMINE B	129
PR175	BENZIMIDAZOLONE MAROON	130
PR176	BENZIMIDAZOLONE CARMINE HF3C	130
PR177	ANTHRAQUINOID RED	130
PR178	PERYLENE RED	131
PR179	PERYLENE MAROON	131
PR181	THIOINDIGOID MAGENTA	131
PR187	NAPHTHOL RED HF4B	132
PR188	NAPHTHOL AS	132
PR192	QUINACRIDONE RED	132
PR202	QUINACRIDONE MAGENTA B	133
PR206	QUINACRIDONE BURNT ORANGE	133
PR207	QUINACRIDONE SCARLET	133
PR209	QUINACRIDONE RED Y	134
PR210	PERMANENT RED F6RK	134
PR214	COMMON NAME N/K	134
PR216	PYRANTHRONE RED	135
PR233	CHROME TIN PINK SPHENE	135
PR242	SANDORIN SCARLET 4RF	135
PR251	COMMON NAME N/K	136
PR254	PYRROLE RED	136
PR255	PYRROLE SCARLET	136
PR257	COMMON NAME N/K	137
PR260	COMMON NAME N/K	137
PR264	COMMON NAME N/K	137

PR144 DISAZO RED

Late of the use of this pigment notification places the description on this page.

A strong, semi-opaque violet red which, surprise surprise is in use without being officially tested in any art material.

Does not have a particularly good reputation and will be not be assessed for the purposes of this book.

We will not know how it behaves on exposure to light until the industry which offers artists' paints pay for properly controlled and verifiable testing.

I do not have a colour sample of this pigment.

L/FAST NOT OFFERED

COMMON NAME
DISAZO RED

COLOUR INDEX NAME
PR144

COLOUR INDEX NUMBER
12510

CHEMICAL CLASS
MONOAZO: BENZIMIDAZOLONE

PR2 NAPHTHOL RED FRR

A reasonably bright violet - red , which to my mind has no place amongst artists' paints. This pigment failed all tests of which I have records, and failed dismally. During our own trials the sample had faded noticeably after only a very short exposure. Testing was discontinued soon after. Why are such thoroughly unreliable pigments offered to the artist? Could it be something to do with profit margins?

With time you will end up with the colour on the right. It will also spoil any colours which result from a mix.

COMMON NAME

NAPHTHOL RED FRR

COLOUR INDEX NAME
PR2

COLOUR INDEX NUMBER
12310

CHEMICAL CLASS
MONAZO

Also called Flash Red.

PR3 TOLUIDINE RED

Toluidine reds have many industrial applications and are available in light, medium and dark shades. Printers, one of the principal users, regard them as pigments which print out poorly, are dull, weak and fade quickly. So why are they also found in artists' paints when reliable reds, similar in hue, are available?

The PR3 that we found was dull, semi-opaque and faded rapidly. It has failed all ASTM testing.

In our sample the tint bleached out quickly and the mass tone became even duller. Not worth considering if you place any value on your work.

COMMON NAME

TOLUIDINE RED

COLOUR INDEX NAME
PR3

COLOUR INDEX NUMBER
12120

CHEMICAL CLASS
**NON-METALISED AZO
RED TOLUIDINE**

Also called Helio Red.

PR4 CHLORINATED PARA RED

A bright, rather intense orange red, for a while! Developed in 1907, it is semi-opaque with a high tinting strength.

There are many industrial applications for this pigment, where reliability is often a secondary consideration.

PR4 has failed all ASTM testing to date. Such substances should not, I feel, be even offered to the artist.

Surely even the absolute beginner would not want their work to deteriorate to such an extent.

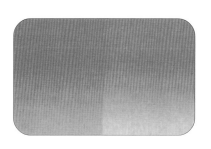

Our sample bleached rapidly when applied as a tint. The mass tone became darker and considerably duller. It also bled into subsequent paint layers. Not recommended.

COMMON NAME

CHLORINATED PARA RED

COLOUR INDEX NAME
PR4

COLOUR INDEX NUMBER
12085

CHEMICAL CLASS
NON METALISED AZO PIGMENT

Has many other names.

NR4 CARMINE

Carmine is produced from the dried bodies of a tiny beetle native to Central America. It is also sold as a food colorant under the name Cochineal. In use for many centuries, it is a transparent violet-red with good tinting strength.

Highly fugitive, it will fade rapidly as a tint and move towards brown in mass tone. Although it is entirely unsuitable as an artist's pigment, it is retained because of 'demand'.

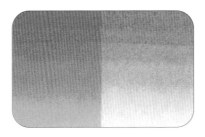

Carmine has failed all ASTM lightfast testing. Our sample changed as above within a very short time.

L/FAST ASTM V

COMMON NAME

CARMINE

COLOUR INDEX NAME
NATURAL RED 4

COLOUR INDEX NUMBER
75470

CHEMICAL CLASS
NATURAL PIGMENT MADE FROM COCHINEAL INSECT

PR5 NAPHTHOL 1TR

PR5 is a reasonably bright violet - red. A strong pigment with quite good covering power. It gives reasonably clear washes when very dilute.

When offered the protection of the binder it fared well in ASTM testing with a rating of II as an oil paint or acrylic. Without such protection it is more vulnerable and was rated as ASTM III in recent tests.

As a tint our sample started to show definite fading.

The mass tone remained unchanged. It will be better to treat this pigment with caution.

It has many other names.

L/FAST ASTM III

COMMON NAME

NAPHTHOL 1TR

COLOUR INDEX NAME
PR5

COLOUR INDEX NUMBER
12490

CHEMICAL CLASS
NAPTHOL 1TR

PR6 PARACHLOR RED

Parachlor starts life as a bright orange - red, valued for a brilliance which soon fades. Semiopaque. Exposure to light quickly fades the tint and dulls the mass tone. This pigment did poorly in every test for which I have results. In our own testing it quickly proved itself to be yet another of the quite unsuitable reds offered to the artist. There are reliable reds available for the discerning artist.

Pending further testing this pigment will be regarded as unreliable in my assessments. PR6 is also called

Parachloronitraniline red.

L/FAST W/GUIDE III

COMMON NAME

PARACHLOR RED

COLOUR INDEX NAME
PR6

COLOUR INDEX NUMBER
12090

CHEMICAL CLASS
MONAZO

PR7 NAPHTHOL AS -TR

This is another good example of the protection offered by certain binders. When made up into either an oil paint or acrylic this pigment received a rating of I during ASTM testing. As a watercolour it only rated III.

A rather bright violet red which gives reasonably transparent washes when well diluted.

This pigment should be regarded as unsatisfactory for use in artists' watercolours and is worth avoiding.

Found to be unsuitable as a watercolour during ASTM testing. Our sample faded quickly as a tint and became duller in mass tone.

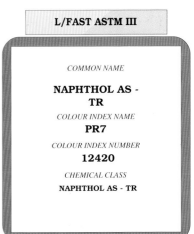

L/FAST ASTM III

COMMON NAME

NAPHTHOL AS - TR

COLOUR INDEX NAME

PR7

COLOUR INDEX NUMBER

12420

CHEMICAL CLASS

NAPHTHOL AS - TR

PR9 NAPHTHOL AS - OL

A very bright orange - red, semi-opaque. PR9 has not been tested under ASTM conditions at the time of writing. As an acrylic it rated very well (II) and gouache, also II. It must be borne in mind however, that the pigment is at its most vulnerable when made up into a watercolour paint, as such it rated only III.

A borderline case, especially when applied as a thin wash.

Our sample faded as a tint, but showed no change in mass tone.

I would suggest some caution in its use as you will be taking a chance with your work.

PR9 is also called Naphthol Bright Red.

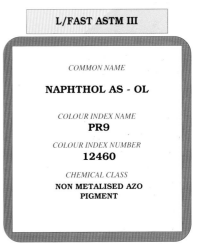

L/FAST ASTM III

COMMON NAME

NAPHTHOL AS - OL

COLOUR INDEX NAME

PR9

COLOUR INDEX NUMBER

12460

CHEMICAL CLASS

NON METALISED AZO PIGMENT

NR9 NATURAL ROSE MADDER

For many centuries a range of dyes have been produced from the root of the madder plant. Such dyes can be utilised in the manufacture of transparent pigments, varying in hue.

Rose Madder, a clear violet red, is still with us as a watercolour. It is, unfortunately, particularly fugitive and failed ASTM testing as a watercolour. To retain this pigment for the sake of tradition is rather pointless to my way of thinking, although 'tradition' and 'romance' sells well. Maybe that's it.

Rated well as an oil paint (II) but failed ASTM testing as a watercolour. The tint in our sample faded quickly and the mass tone became duller. The colour can be matched by other means.

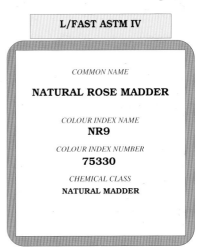

L/FAST ASTM IV

COMMON NAME

NATURAL ROSE MADDER

COLOUR INDEX NAME

NR9

COLOUR INDEX NUMBER

75330

CHEMICAL CLASS

NATURAL MADDER

PR19 ARYLIDE MAROON DARK

This pigment appears to be virtually obsolete. The only colourmen still using it are working through their present stock.

A dark brownish red. I have little information on reliability or characteristics. The colour sample shown is an approximation only.

The only colour in which this is used resisted light very well. No lightfast rating offered.

COMMON NAME

ARYLIDE MAROON DARK

COLOUR INDEX NAME

PR19

COLOUR INDEX NUMBER

12400

CHEMICAL CLASS

MONOAZO

PR23 NAPHTHOL RED

This is a disastrous substance to employ as an artist's pigment. It is no secret that it bleaches out rapidly. All test results that I have seen show that it is most unreliable. It is an unfortunate fact that the majority of red pigments that have found their way into artists' watercolours are either fugitive or less than reliable.

There are, however, reliable alternatives available. PR23 is a definite violet-red.

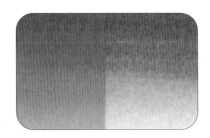

Our sample bleached white as a tint in a very short time and lost its vibrancy in mass tone. Also called Imperse Red.

L/FAST W/GUIDE V

COMMON NAME

NAPHTHOL RED

COLOUR INDEX NAME

PR23

COLOUR INDEX NUMBER

12355

CHEMICAL CLASS

MONAZO

PR48:1 PERMANENT RED 2B (BARIUM)

A very bright orange - red. Semi-opaque but gives a reasonable range of values. Strong, with particularly good tinting strength. The common name is very misleading as it is certainly not a permanent pigment. I have no knowledge of any formal testing having been carried out. Discovered in the 1920's. Poor alkaline resistance. Will only be used by an irresponsible and uncaring manufacturer.

By reputation and the results of our own exposure testing rated WG V.

Also called Barium Red 2B.

L/FAST W/GUIDE V

COMMON NAME

PERMANENT RED 2B (BARIUM)

COLOUR INDEX NAME

PR48 : 1

COLOUR INDEX NUMBER

15865 : 1

CHEMICAL CLASS

MONOAZO - BARIUM SALT

PR48:2 PERMANENT RED 2B (CALCIUM)

PR48 : 2 is a brilliant, semi-opaque violet red which has failed all tests of which I have knowledge.

With an ASTM rating of IV as a watercolour, it is clearly unsuitable for use as an artist's paint.

Or so you would think. In our own sample, the tint faded rapidly and the mass tone became noticeably duller. I can think of no reason to use such inferior colorants apart from their relatively low cost as raw pigment.

As in other recorded tests, our sample faded dramatically as a tint and became duller in heavier application. Does not quite live up to its name.

Also called Calcium Red 2B.

PR48:4 PERMANENT RED 2B (MANGANESE)

A bright violet - red, fairly opaque.

Not yet tested as a watercolour under ASTM conditions. It contains between 9 - 15% manganese which improves lightfastness. Our own lightfast testing suggested that a certain amount of caution is required when using paints made up with this pigment.

Thin washes faded at a steady rate while the colour remained stable in mass tone.

Pending the results of further testing I will give a rating of WG II to III.
Also called Manganese Red 2B.

PR49:1 LITHOL RED

A semi-opaque, medium red. Particularly fugitive, it performed poorly in all tests that I have knowledge of. A low cost pigment with relatively high tinting strength. This might make it suitable for certain industrial applications, but its susceptibility to light should eliminate it from artists' paints. Fortunately, I only found one example of its use as a watercolour, and that in a blend.

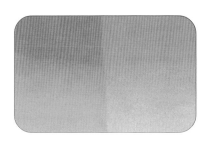

A fugitive pigment which has no place amongst artists' water colours.

Also called Barium Lithol Red.

PR53:1 RED LAKE C (BARIUM)

Very bright orange - red. Possesses quite good tinting strength. Known in industry for its low cost, brilliance and tinting strength. The fact that it fades rapidly is often less of a concern. It is a different matter altogether with artists' paints, especially watercolours. We should be able to expect better. Poor alkaline resistance.

Tested ASTM V as an oil paint, this with the protection of the binder. It has even less resistance when made up into a watercolour.

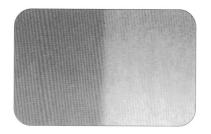

Has bleached out in all tests for which I have records, also in our own. Rated WG V. Also called Barium Red Lake C.

PR57 LITHOL RUBINE (SODIUM)

This pigment has wide industrial application, where, presumably lightfastness cannot be such a consideration. PR57 has a poor reputation, this was backed up by our own observations.

We have no reports of other independent testing. Amongst its many uses it is employed as a food colorant. As such it probably has a longer life than it does as an artist's paint.

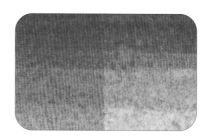

Unsuitable for artistic use and sold only to the unwary or uncaring. Rated WG V.

PR57:1 LITHOL RUBINE (CALCIUM)

Lithol Rubine is popular in the printing industry, often being employed as the standard process magenta. Valued for its strength, covering power and low cost. It gives a strong, bright print tone where lightfastness does not matter, (in the production of weekly magazines for example).

Fugitive, it is quite unsuitable for use in artists' watercolours. A semi-opaque, violet - red. Failed all testing of which I have knowledge.

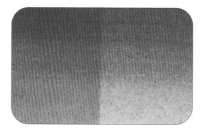

Our sample bleached out very quickly. Its strength and covering power might be valued by industry, but they are short lived. Most unsuitable. Also called Rubine 4G.

PR60 SCARLET LAKE (SODIUM)

This is yet another violet red which starts life as a bright transparent hue but quickly deteriorates after application. PR60 has performed poorly in all tests for which I have results.

Our own sample faded badly as a tint and darkened considerably in mass tone. Why are such inferior materials offered to the artist when lightfast reds with desirable qualities are available? Could it be anything to do with the cost of the raw material?

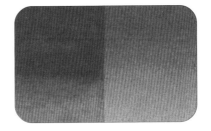

Sample deteriorated badly. The tint faded and moved towards violet and the mass tone darkened and also changed in hue.

Unsuitable for artistic use.

COMMON NAME
SCARLET LAKE (SO-DIUM)

COLOUR INDEX NAME
PR60

COLOUR INDEX NUMBER
16105

CHEMICAL CLASS
MONAZO. SODIUM SALT

PR81 RHODAMINE Y

Rhodamine Y is a brilliant, transparent violet red with high tinting strength. Employed also as a printing ink, it is a mobile disaster area as an artist's watercolour.

All of the Rhodamines are noted both for their brilliancy and their rate of deterioration. Known as 'daylight' fluorescent colours, they are able not only to fade on exposure but also to discolour. Such bright hues cannot yet be obtained in reliable, quality artists' watercolours.

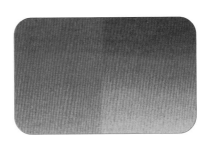

If you need the colour on the right, this is for you. Sample faded and discoloured as a tint and moved rapidly towards a dull brown in mass tone.

Also called PTMA Pink.

COMMON NAME
RHODAMINE Y

COLOUR INDEX NAME
PR81

COLOUR INDEX NUMBER
45160 : 1

CHEMICAL CLASS
XANTHENE. PTMA

PR82 RHODAMINE YELLOW SHADE

PR82 is a particularly bright reddish - violet, especially when applied as a medium wash. Like the Rhodamines it sacrifices permanence for temporary brilliance and discolours on exposure.

Transparent, it gives very clear washes. This type of bright fluorescent colour would probably be attractive to a floral artist. It is most unfortunate that they would very soon end up with the opposite effect, dull or faded areas in the work.

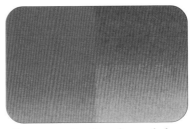

Our sample discoloured dramatically within a very short time in mass tone. The tint faded equally fast. Absolutely unsuitable for artistic use. Employed only by uncaring manufacturers.

COMMON NAME
RHODAMINE YELLOW SHADE

COLOUR INDEX NAME
PR82

COLOUR INDEX NUMBER
45150 : 1

CHEMICAL CLASS
XANTHENE. PTMA

PR83 ROSE MADDER, ALIZARIN

The principal dye of the madder root was known in Asia Minor as 'Uzari' or 'Alizari' which gave the modern name Alizarin. A synthetic version of this dye has been available since 1868. Rose Madder Alizarin is a dilute form of this dye when compared to Alizarin Crimson.

Despite its popularity it is unreliable, fading quite quickly as a tint. More reliable when applied heavily but as such is prone to cracking. A transparent violet red. Failed ASTM testing as a watercolour.

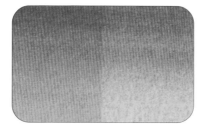

Sample faded quite quickly in both light and medium washes. There are lightfast transparent violet - reds available which are suitable for artistic expression. Definitely worth avoiding.

L/FAST ASTM IV
COMMON NAME
ROSE MADDER, ALIZARIN
COLOUR INDEX NAME
PR83
COLOUR INDEX NUMBER
58000
CHEMICAL CLASS
1.2 DIHYDROXY ANTHRAQUINONE ON ALUMINA BASE

PR83:1 ALIZARIN CRIMSON

A reasonably bright violet red, sometimes leaning towards brown. Valued for its transparency.

Now synthesised, the basic colorant is some 3,000 years old. When applied as a thick layer it takes on a blackish appearance. In that form it has reasonable fastness to light, but tends to crack.

The true beauty of this colour is only revealed when it is applied as a tint. Mixed with white or when diluted it is disastrous, fading quickly.

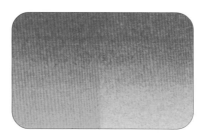

Rated IV as a watercolour in ASTM tests. A very popular pigment, it is found in most watercolour ranges and paint boxes. This material is entirely unsuitable for artistic use.

Help to make it obsolete.

L/FAST ASTM IV
COMMON NAME
ALIZARIN CRIMSON
COLOUR INDEX NAME
PR83 : 1
COLOUR INDEX NUMBER
58000 : 1
CHEMICAL CLASS
1, 2 DINYDROXY ANTHRAQUINONE

PR88 MRS THIOINDIGOID VIOLET

PR88 MRS is more a red-violet than a violet red. Thioindigoids (sounds more like a medical condition than a pigment) vary in their fastness to light. The Colour Index Name PR88 MRS identifies this as a version possessing quite good resistance to light.

When made into an acrylic and oil paint it did very well in ASTM testing, with a rating of I. Without protection from the binder it does slightly less well as a watercolour.

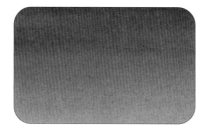

I rated it as W/Guide II in the last edition of this book. Subsequent testing has produced an ASTM rating of II, which is still very good.

L/FAST ASTM II
COMMON NAME
THIOINDIGOID VIOLET
COLOUR INDEX NAME
PR88 MRS
COLOUR INDEX NUMBER
73312
CHEMICAL CLASS
THIOINDIGOID

PR90 PHIOXINE RED

A brilliant transparent red, with a soft pink undercolour. Unfortunately the colour is only temporary as it departs rapidly at the first sign of light. The main use of this pigment is in the manufacture of printing inks, coloured pencils and crayons. None of the Xanthene pigments are suitable for artists' paints. How many lovingly produced paintings have been spoiled by this disastrous material? Another reason for artists to become familiar with their pigments.

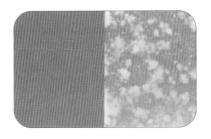

The colour deteriorates rapidly. As a tint it bleached out completely and the mass tone became very blotchy. Most unsuitable.

Also called Eosine.

PR101 MARS VIOLET

Mars Violet is an absolutely lightfast synthetic iron oxide. A subdued brownish violet it is generally opaque, but fairly transparent varieties are available. Possesses very good covering power, yet will also give reasonable washes when well diluted.

Extremely lightfast, it was given a rating of I following the exacting test methods of the ASTM. Mars Violet offers a useful range of values to the watercolourist, from deep, sullen violets to subtle tints.

A most reliable pigment, compatible with others, inert and absolutely lightfast. Mars Violet is on the ASTM list of approved pigments. Highly recommended. Also called Violet Iron Oxide.

PR101 INDIAN RED

Indian Red is a neutralised or dulled red. As is mentioned in the description of Light or English Red Oxide, the term 'Indian Red' is little more than an indication of the basic colour type.

One of a range of very reliable synthetic iron oxides. When making a selection from this range, consider the tint or undercolour as well as the mass tone. Indian Red possesses good covering power, but usually washes out to give reasonably clear tints.

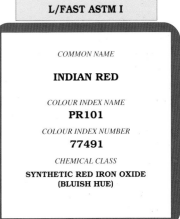

Absolutely lightfast. Rated I following ASTM testing as a watercolour. On the list of approved pigments.

PR101 MARS RED

A synthetic red iron oxide, Mars

Red is similar in hue to its naturally occurring counterpart, Burnt Sienna. The range of Mars colours are really artificial versions of native earth colours.

Being manufactured, rather than mined, the quality and hue tends to remain rather more constant, although the colour can be a little harsh when compared with the natural pigment. Opaque and reasonably transparent versions are available.

A well made Mars Red is a fiery neutralised orange, offering a useful range of values. An excellent pigment all round. Rated I in ASTM lightfast testing and on the list of approved pigments. Unaffected by light even as a very thin wash.

L/FAST ASTM I

COMMON NAME

MARS RED

COLOUR INDEX NAME
PR101

COLOUR INDEX NUMBER
77491

CHEMICAL CLASS
SYNTHETIC RED IRON OXIDE

PR101 LIGHT OR ENGLISH RED OXIDE

The distinctions between the various synthetic iron oxides which come under the colour Index Name pigment Red101, are difficult to determine.

Of basically the same make up, they are generally separated by the leaning of the hue, bluish, yellowish, etc. The various manufacturers might well group them differently.

Like Light or English Red Oxide, they are all absolutely lightfast, vary in transparency and have good covering power. They are all excellent pigments.

Rated I following ASTM testing as a watercolour. Compatible with all pigments. A most reliable dulled orange.

L/FAST ASTM I

COMMON NAME

LIGHT OR ENGLISH RED OXIDE

COLOUR INDEX NAME
PR101

COLOUR INDEX NUMBER
77491

CHEMICAL CLASS
SYNTHETIC RED IRON OXIDE (YELLOWISH HUE)

PR101 VENETIAN RED

An excellent pigment. Venetian Red, one of the synthetic iron oxides, is highly stable, compatible with all other pigments, inexpensive and absolutely lightfast. With a rating of I following ASTM lightfast testing, you can be certain that the colour will remain as you apply it.

A dull reddish orange with a useful range of values. Usually opaque but some grades will give a reasonably transparent wash. A highly recommended pigment.

Absolutely lightfast. This pigment will not be at all affected by light. Rated ASTM I and on the list of approved pigments.

L/FAST ASTM I

COMMON NAME

VENETIAN RED

COLOUR INDEX NAME
PR101

COLOUR INDEX NUMBER
77491

CHEMICAL CLASS
SYNTHETIC IRON OXIDE (YELLOWISH HUE)

PR102 LIGHT RED

A neutralised orange. Light Red is produced by heating the naturally occurring Yellow Ochre. When the relevant ASTM standard on artists' pigments was being written, the manufacturers involved agreed that calcined natural Yellow Ochre, rather than a synthetic iron oxide, would be called Light Red.

Other companies might well have different ideas. You will know exactly where you are if you choose products with ASTM approved labelling.

Covers well and is reasonably transparent in washes, Absolutely lightfast. Rated ASTM I in watercolour and on the list of approved pigments. The colour might well vary from the sample shown.

PR104 CHROME ORANGE

A mid orange which can become very dark on exposure to light and the atmosphere. Similar chemically to PY34 Chrome Yellow Lemon. As with PY34 it was given as ASTM rating of I as a watercolour.

In our own testing the colour darkened considerably, as did every colour which contained it. During ASTM testing one of the newer encapsulated varieties might have been used. Alternatively, our exposure of the samples to the atmosphere

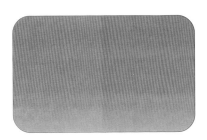

could have caused the damage. Pending further testing or information, I will not offer an assessment. This is an unusual step as I otherwise always use the ASTM findings.

PR105 RED LEAD

A dull orange-red. Opaque, with good covering power. Red Lead is well known as a primer for use on metals. Also well known is the fact that it blackens on exposure to the Hydrogen Sulphide of the atmosphere.

It is of little consequence if the undercoat on a bridge gradually darkens, but artists' watercolours are another matter. It is astonishing that the latter use is even considered.

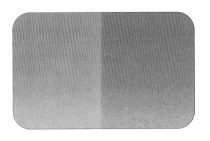

This substance will definitely darken on exposure to the atmosphere, especially in cities and industrial areas. Well worth avoiding.

PR106 VERMILION

Usually a brilliant orange-red. PR106 is fairly high in tinting strength and opaque. Being a heavy pigment, it tends to settle out in a wash, forming pockets of colour. An artificial inorganic pigment, Vermilion contains mercury and should be handled with care.

Unfortunately, it darkens on exposure to light, particularly when high levels of ultraviolet are present. Once an important pigment, it is now more than adequately replaced by the reliable and less expensive Cadmium Red Light.

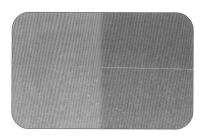

As a watercolour it was rated III under ASTM testing. An unreliable colour which can become very dark on exposure. Our experience would suggest a rating of V.

L/FAST ASTM III

COMMON NAME

VERMILION

COLOUR INDEX NAME

PR106

COLOUR INDEX NUMBER

77766

CHEMICAL CLASS

MERCURIC SULPHIDE

PR108 CADMIUM RED - LIGHT, MEDIUM OR DEEP

A first rate pigment with very desirable qualities. It varies in hue from a bright orange-red to a deeper violet-red. Opaque, with good hiding power, it is nevertheless strong enough to give reasonably clear washes. It will not bleed into other colours and resists light, heat, Hydrogen Sulphide and alkalis. There have been moves to ban this excellent pigment. If they are successful we will lose one of the few reliable orange-reds presently available.

Absolutely lightfast. Rated ASTM I as a watercolour. Possesses an excellent range of qualities. An outstanding pigment well worth the cost.

L/FAST ASTM I

COMMON NAME

CADMIUM RED LIGHT, MEDIUM OR DEEP C.P.

COLOUR INDEX NAME

PR108

COLOUR INDEX NUMBER

77202

CHEMICAL CLASS

CONCENTRATED CADMIUM-SELENO SULPHIDE (CC)

PR108:1 CADMIUM BARIUM RED - LIGHT, MEDIUM OR DEEP

An alternative to the chemically pure Cadmium Red Light, Medium or Deep PR108. Usually less expensive, it possesses many of the admirable qualities of PR108 although it is somewhat weaker in tinting strength.

Opaque, but is strong enough to give a reasonably clear wash when well diluted. Such tints will be quite safe as this is a most reliable pigment. Absolutely lightfast.

Rated I as a watercolour following testing under ASTM conditions. Ranges in hue from an orange-red to a deeper violet-red. It is also called Cadmium Lithopone.

L/FAST ASTM I

COMMON NAME

CADMIUM-BARIUM RED LIGHT, MEDIUM OR DEEP

COLOUR INDEX NAME

PR108 : 1

COLOUR INDEX NUMBER

77202 : 1

CHEMICAL CLASS

CADMIUM SELENO-SULPHIDE COPRECIPITATED WITH BARIUM SULPHATE

PR112 NAPHTHOL AS-D

PR112 is a reasonably bright orange red. Semi-opaque, it still gives reasonable washes as far as transparency is concerned. An opaque version is available.

Not as lightfast as some of the other Naphthol pigments, it rated only III as a watercolour during testing under ASTM conditions. Not really suitable for artistic use where fastness to light is a consideration. It is produced under a wide variety of names.

Our sample faded as a tint but remained unchanged in mass tone. Unsuitable for lasting work. Also called Permanent Red FGR.

PR122 QUINACRIDONE MAGENTA

A bright red, leaning very definitely towards violet. Valued for its transparency. Unaffected by heat, acids or alkalis. Given an ASTM rating of III following testing as a watercolour. It does seem that this pigment resists light very well initially but will eventually fade. In soft light the colour should have a reasonably long life, perhaps many years. Possesses medium tinting strength. Rated ASTM III as a watercolour.

Certain companies disagree with this rating following their own experience.

They should, I feel, present their information to the ASTM subcommittee to see if retesting might be called for. Or, more to the point, be prepared to finance such re-testing.

PR146 NAPHTHOL RED

This is yet another of the many violet-reds employed as an artists' watercolour which can be relied on to deteriorate. Failed ASTM testing with a rating of III in both oils and acrylics.

Without the protection of the binder a watercolour will tend to fade much quicker. Not as

disastrous as some red pigments,

but still unsuitable for use in artistic expression, unless lightfastness is not a consideration.

The tint in our sample faded to a marked extent, but the mass tone was only slightly affected.

PR149 PERYLENE RED BL

A transparent red, giving reasonably clear washes when well diluted. A fairly bright pigment with excellent tinting strength. PR149 was the first of the perylene pigments, introduced by Hoechst in 1957. Unfortunately it has not been subjected to any formal testing to my knowledge.

Perylene pigments, however, do have an excellent reputation for lightfastness.

Sample stood up particularly well to our testing, darkening slightly in mass tone. Rated WG II pending further testing.

PR166 DISAZO SCARLET

PR166 is a bright orange-red. Semi-opaque, but washes out to give fairly clear tints. A reasonably strong pigment with good tinting strength, it will quickly influence many other colours in a mix.

This pigment stood up quite well in previous testing of which I have knowledge. Not yet trialed under the more exacting conditions of the ASTM. Pending further testing I will rate it as II for the purposes of this book.

Sample fared very well when subjected to light. This will hopefully prove to be a reliable orange-red.

PR168 BROMINATED ANTHRANTHRONE

PR168 is a fairly bright, transparent orange-red low in tinting strength. This limits its use in colour mixing.

When diluted it gives rather dull tints.

Not yet subjected to ASTM testing as a watercolour paint. However, it rated particularly well in other media. Category I in acrylics and II in oils.

Rated WG II for this edition pending further testing. It is also called Vat Orange.

PR170 F3RK-70 NAPHTHOL RED

There are two types of PR170: PR170 F5RK and PR170 F3RK. In addition there is a '70' version of PR170 F3RK. (Apologies for all the numbers). Varieties often exist within a pigment group but the 'family members' are not all equally lightfast.

Unless the pigment is fully specified treat it with caution. In this case it is a bright, fairly strong red which tested ASTM II in oil and I in acrylics. A medium performance, moderately priced organic red.

In the absence of an ASTM finding I rated it W/Guide II in previous editions of this book. It has now been tested and rated ASTM II.

PR171 BENZIMIDAZOLONE BORDEAUX

PR171 is a rather dark violet-red, the type of colour often referred to as a Maroon.

When made into a watercolour it gives transparent washes.

Although rated ASTM I as an Acrylic I have no record of its performance as a watercolour. Although it might well be lightfast in this media I will not give it a rating for the purposes of this book.

Other pigments with a high rating as an acrylic have performed poorly as a watercolour.

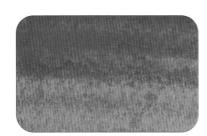

It really is the responsibility of the paint manufacturers to ensure that the pigments that they use in your paints are properly tested.

But that means money and would affect the bottom line.

PR173 RHODAMINE B

A transparent red. The Rhodamines are brilliant but very short lived. Such colours have a certain appeal as they are so bright. That appeal would be diminished if the purchaser realised the rate at which the colour deteriorates. Based on the parent dye Basic Violet 10.

This is the dye used in the equally fugitive PV 1. The only other use I could find for this colorant was in the manufacture of cosmetics.

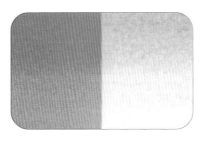

Not ASTM tested in any media.

Fugitive. Only used by the irresponsible, uncaring or uninformed manufacturer.

PR175 BENZIMIDAZOLONE MAROON

PR175 is a rather dark red which becomes slightly orange in tints.

A transparent colour which is slightly soluble in some organic solvents.

It tested very well when made up into an acrylic with an ASTM lightfast rating of I. It was also rated I as an oil paint. Although not tested as a watercolour I will give it a rating of W/Guide II for the purposes of this book

as an earlier sample that I tested withstood light very well.

Also known as Benzimidazolone Red HFT and PV Fast Red HFT.

PR176 BENZIMIDAZOLONE CARMINE HF3C

Also called Permanent Carmine HF 36, PR176 is a reasonably bright violet-red. When unadulterated it gives particularly clear, even washes.

Being transparent the light tends to sink into heavily applied layers, causing them to take on a very dark appearance. As far as I am aware this pigment has not been subjected to any formal lightfast testing.

Judging by the performance of the pigment during our own testing rated WG II pending ASTM testing.

Such testing, as I have said elsewhere, should be paid for by the manufacturers who make their profit selling you paints made up with these very pigments.

PR177 ANTHRAQUINOID RED

PR177 is a mid red of high tinting power. Due to its strength it will quickly influence many other colours in a mix.

It is reasonably transparent in thin washes.

Prior to ASTM testing I had rated it as W/Guide II to III as it has a reasonable reputation for lightfastness and had fared well in my own tests.

It has now tested as ASTM II.

Mainly used in the automotive industry for the production of clean bright reds.

PR178 PERYLENE RED

PR178 leans slightly towards violet. Introduced in 1966, it is semi-transparent to semi-opaque with reasonable covering power. This is one of the very few reliable violet-reds at our disposal. Following the stringent testing procedures of the ASTM, it was given a rating of II. This pigment has also performed well in other tests that have been carried out.

It is one of the few reliable alternatives to impermanent violet-reds such as Alizarin Crimson.

Our sample exhibited only the faintest change to the tint following exposure.

An excellent pigment, lightfast and reasonably transparent. Superior to Alizarin Crimson.

PR179 PERYLENE MAROON

Two types of red are available under this description, a 'clean' red which leans towards orange and a duller violet-red.

Both versions are transparent. Following ASTM testing this pigment was found to be particularly reliable, testing ASTM I in acrylics, oils and, of interest to us, watercolours. In previous editions, prior to the ASTM tests I had rated it as

W/Guide II as it had been given a I in oils and acrylics and

had performed well in my own tests.

Also called Paliogen Red L and Perrindo Maroon R.

PR181 THIOINDIGOID MAGENTA

PR181 leans slightly towards violet. A rather weak pigment with an almost washed out appearance. Poor covering power and reasonably transparent. At the time of writing it has not been tested under ASTM conditions as a watercolour.

It has been tested as an oil paint however, but rated only III despite the protection offered by the binder. Without such protection it will be even more vulnerable as a watercolour.

With a poor rating as an oil paint, it will tend to fade even faster as a watercolour. Our sample deteriorated rapidly. Unreliable.

PR 187 NAPHTHOL RED HF4B

A reasonably bright semi-transparent violet-red.

There are no independent test results available to us apart from our own. This pigment also has industrial applications where it is used in bicycle coatings.

Look out for faded (or otherwise), red bicycles before deciding on the use of this pigment in your work.

As our own sample stood up very well to exposure, I will give a rating of WG II pending further testing.

Let us hope that the responsibility for financing such testing is provided by those companies using this pigment in their watercolours.

PR188 NAPHTHOL AS

Napthol As is a rather bright orange-red which is reasonably strong tinctorially. It is semi-opaque but gives clear tints when applied as a wash.

It rated very well, (I) when tested both as an oil and an acrylic paint under ASTM test conditions, for this reason as well as my own observations I rated it as W/Guide II in previous editions.

It has, happily, now been given

the full ASTM test and has been given a rating of II, very good, in watercolours.

PR192 QUINACRIDONE RED

Quinacridone Red is one of the few violet reds which have stood up well to the rigours of ASTM lightfast testing.

As both an oil paint and an acrylic it received a rating of I. This does not, of course, mean that it will do equally well as a watercolour.

Our sample, however, indicated that this will probably prove to be a reliable pigment when further tested.

A bright violet-red giving clear washes.

Sample hardly changed during exposure. Pending further testing I will rate it as lightfast II for the purposes of this book. Reliable.

PR202 QUINACRIDONE MAGENTA B

Quinacridone Magenta B is a transparent violet-red. It is similar to, but duller than PR122 Quinacridone Magenta.

Not yet subjected to ASTM testing as a watercolour but it stood up well when tested as a watercolour with a rating of I, excellent. It is used in the automobile industry when lightfastness is an important factor.

This pigment does have a good reputation and rated well in other

lightfast tests. For these reasons I will give it a rating of W/Guide II pending possible ASTM testing as a watercolour.

PR206 QUINACRIDONE BURNT ORANGE

Quinacridone Burnt Orange is the type of violet-red often described as a maroon.

It is transparent and lacks brightness.

PR206 has yet to be tested as a watercolour under ASTM condition. This is due to the reluctance of the manufacturers of your paints to properly finance the testing of the pigments that they use.

It rated ASTM I as when made up into an acrylic paint and resisted fading in our own tests.

Pending further examination I will rate it W/Guide II for the purposes of this book. Amongst other names it is also called Quinacridone Maroon and Monastral Maroon.

PR207 QUINACRIDONE SCARLET

Quinacridone Scarlet is a bright orange - red. Transparent, it brushes out into delicate pinks when well diluted.

With an ASTM rating of I when made up into both oil and acrylic paints, it promises to do well when further tested as a watercolour.

Without the protection of the binder one cannot be sure how it will stand up. Our own observations, together with the ASTM results in other media, indicate a reliable pigment.

Our own sample altered imperceptibly during exposure to light. All the evidence indicates a thoroughly reliable pigment. Rated as II for the purposes of this book.

PR209 QUINACRIDONE RED Y

The majority of red pigments employed in watercolours are unsuitable for artistic use. There are materials of excellence available however. PR209 is a reasonably bright, transparent orange-red. With an ASTM rating of II as a watercolour, it has proven reliability. Without an awareness of the meaning and significance of Colour Index Names and Numbers, the artist cannot expect to be able to choose wisely. A most reliable orange - red of great value to the watercolourist.

Our sample was unaffected by light in any way. A first rate pigment with a useful range of qualities. Highly recommended.

PR210 PERMANENT RED F6RK

I have become very wary of paints and pigments with the word 'permanent' in their title, as it usually indicates quite the opposite.

This pigment is no exception as it has a poor reputation for lightfastness, fading with 30 hours under some test conditions.

It has not been tested for lightfastness in an artists' paint as far as I am aware.

Given its very poor reputation I will rate it as W/Guide for this

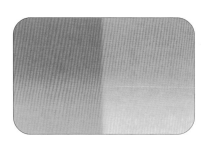

publication. A semi-opaque violet-red it is mainly used in printing inks, where it is probably better employed.

PR214 COMMON NAME UNKNOWN

Although I do not have a single common name, PR214 is known under a variety of descriptions.

Amongst these are Fastogen Super Red 2R, Sandosperse Red E-BN, Foscolor Red 214 and Vynamon Red.

PR216 PYRANTHRONE RED

Pigment Red 216 is best described as a neutralised, or dulled, orange-red. A good range of values are available, from a deep, rich, red-brown to soft, dull, orange tints.

Semi-opaque, but gives reasonably clear washes when well diluted. Not yet tested under ASTM conditions but has stood up well to other exposure tests. I am surprised that it is so little used in artists' watercolours.

By reputation and our testing rated WG II pending further examination.

Also called Paliogen Red L.

PR233 CHROME TIN PINK SPHENE

PR233 is a rather dull red which leans somewhat towards violet.

Although it has not been tested in any art material, it should prove to be reliable as mixed oxides are usually very lightfast.

A high temperature calcination of a mixture of oxides of calcium, tin, silicon and chromium. It seems that its main use is in powder form for use in ceramics.

Given the reputation of such

combinations I will give a rating of W\Guide II pending possible ASTM testing.

PR242 SANDORIN SCARLET 4RF

Sandorin Scarlet 4RF is a bright orange-red. This would appear to be one of the few reliable orange-reds yet tested under ASTM conditions.

It has a good reputation in industry, where it is used in the production of high performance inks and exterior paints.

Our sample certainly stood up extremely well to light exposure tests showing only the slightest change. I will give it a rating of II for the purposes of this book.

Pending further testing this would appear to be an excellent orange-red.

PR251 COMMON NAME UNKNOWN

A bright orange-red with good covering power which has not yet been subjected to ASTM testing in any artists' paint.

Also in use in house and acrylic emulsion paints this pigment has a very good reputation as far as its ability to withstand light is concerned.

Reported as having excellent lightfastness I will give a rating of W/Guide II for the purposes of this publication pending possible ASTM testing.

Hopefully this will come about if manufacturers spend some of the money they use on promoting their products on actually testing them properly.

PR254 PYRROLE RED

Also called Irgazin DPP Red BO, PR254 is a bright transparent red.

This pigment has not been tested to ASTM standards when made up into a watercolour paint.

However, it has been tested as an acrylic paint where it rated particularly well, ASTM I.

More commonly used in automobile paints where lightfastness is a concern.

Given its result as an acrylic together with its reputation I will give a rating of W/Guide II in this edition.

PR255 PYRROLE SCARLET

Also called Irgazin DPP Red 5G, PR255 is a bright transparent orange-red closely related to PR254.

Tested under ASTM conditions with excellent results, ASTM I.

This is a relatively new pigment and I have little additional information on it at this stage.

PR257 COMMON NAME UNKNOWN

PR257, also known as Sandorin Red Violet 3RL, varies from a violet-red to a reddish-violet.

When made up into a paint it has good covering power, being opaque.

Not yet subjected to ASTM testing in any art media. As it has been reported to possess good lightfastness in tints, better in fact than PR88 (ASTM II), I will give it a rating of

W/Guide II until it is properly tested. I have to say that I am not comfortable about having to give ratings to so many pigments. It is surely the responsibility of water-colour manufacturers to ensure that the paints that they rave about are correctly tested. But that means money!

PR260 COMMON NAME UNKNOWN

A rather dull orange-red, PR260 is also known as Paliogen Red.

The coarse particles lend opacity to the final paint.

As it has not been tested in any art material I have little more to go on than the fact that it is used in the automobile industry.

Their standards are high but I have seen many a faded car, in fact I have owned a few.

Given the lack of information I cannot offer a lightfastness rating.

PR264 COMMON NAME UNKNOWN

Although the common name is not known via general use, this pigment is sometimes described as Irgazin DPP Rubine.

A transparent red which has not been ASTM tested in any art material.

Having seen some of the 'in the office window' lightfast testing carried out by companies who should know otherwise, I have to say that it is about time the art materials industry got its act together for the sake of its customers. You are probably one of them.

Correctly conducted lightfast testing is expensive but it only has to be done once for each untried pigment.

Two reds plus their complimentaries will provide a vast range of reliable reds.
Reproduced from our Home Study Course ' Practical Colour Mixing'

Blending the mixing primaries

Exercise 39 The reds

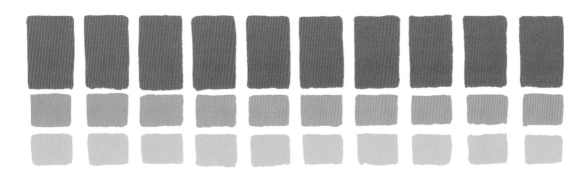

Whereas we have three blues, there are only two reds in our range. These are considered to be more than sufficient as they vary both in colour type and in transparency.

When the range above is combined with the many reds that you have already produced, you will have a vast series of reds to work with, particularly when the tints are taken into account.

Too many painters add unnecessary colours to their paint boxes because of the usual frustration experienced when trying to follow the established way of working.

Such additions not only add to the expense of painting, which is high enough as it is, but many are unreliable.

Genuine Alizarin Crimson, for example, will always fade when applied thinly or when mixed with white.

Genuine Vermilion can become very dark on exposure to light. There are many such examples in both student and artist quality paints.

I suggest that you work with as few colours as possible and make sure that they are lightfast and well made. Always check the pigments that have been used.

Red Watercolours

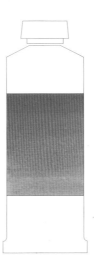

Contents

Alizarin Crimson .. 141

Cadmium Red Light.. 143

Cadmium Red .. 145

Cadmium Red Deep... 148

Carmine ... 150

Crimson Lake .. 153

Madders ... 155

Quinacridone .. 159

Scarlet .. 161

Vermilion .. 163

Miscellaneous Reds ... 166

Alizarin is the principle dye of the madder root. It was synthesised in 1868 and was the first of the natural dye stuffs to be made artificially.

When applied heavily it resists light well, it also takes on a very blackish, heavy appearance and tends to crack.

When applied lightly, or mixed with white, it fades at a steady rate.

This unreliable substance, very popular with the colourmen, is long past its time. Lightfast alternatives are available. When mixing it is a definite violet red. The complementary is a yellow green.

ALIZARIN CRIMSON 147

UTRECHT

The sample was slightly over bound but painted out well in thinner applications. Will resist light well when heavy but fades when applied thinly or mixed with white. Unreliable.

PROFESSIONAL ARTISTS' WATER COLOR

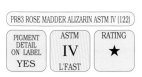
PR83 ROSE MADDER ALIZARIN ASTM IV (122)

PIGMENT DETAIL ON LABEL	ASTM	RATING
YES	IV L'FAST	★

ALIZARIN CRIMSON 004

DANIEL SMITH

The use of this most unreliable pigment continues despite the fact that it has failed ASTM testing as a watercolour. Best avoided if you value your work.

EXTRA-FINE WATERCOLORS

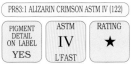
PR83:1 ALIZARIN CRIMSON ASTM IV (122)

PIGMENT DETAIL ON LABEL	ASTM	RATING
YES	IV L'FAST	★

ALIZARIN CRIMSON 010

M.GRAHAM & CO.

I am surprised that this company still offer genuine Rose Madder Alizarin after the ASTM tests have been fully recorded and are known to all manufacturers.

Most unreliable.

ARTISTS' WATERCOLOR

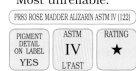
PR83 ROSE MADDER ALIZARIN ASTM IV (122)

PIGMENT DETAIL ON LABEL	ASTM	RATING
YES	IV L'FAST	★

ALIZARIN CRIMSON 326

TALENS

An appalling substance which should have become part of history by now. All manufacturers using this pigment are fully aware of its drawbacks.

REMBRANDT ARTISTS' QUALITY EXTRA FINE

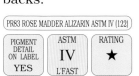
PR83 ROSE MADDER ALIZARIN ASTM IV (122)

PIGMENT DETAIL ON LABEL	ASTM	RATING
YES	IV L'FAST	★

PERMANENT ALIZARIN CRIMSON W209

HOLBEIN

I could not find a description of the pigments either on the tube or in the literature, therefore I cannot offer any sort of rating. Described as being transparent and staining.

ARTISTS' WATER COLOR

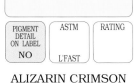

PIGMENT DETAIL ON LABEL	ASTM	RATING
NO	L'FAST	

ALIZARIN CRIMSON 001

AMERICAN JOURNEY

The sample provided was slightly gummy which led to rather uneven washes in heavier applications. A reliable pigment. Staining and transparent.

PROFESSIONAL ARTISTS' WATER COLOR

PV19 QUINACRIDONE VIOLET ASTM II (185)

PIGMENT DETAIL ON LABEL	ASTM	RATING
YES	II L'FAST	★ ★★

ALIZARIN CRIMSON (QUINACRIDONE) 202

DA VINCI PAINTS

A superb, strong, lightfast colour. Reformulated several years ago and very much improved. Previously contained the unreliable PR83:1 Crimson Alizarin. Transparent and staining.

PERMANENT ARTISTS' WATER COLOR

PV19 QUINACRIDONE VIOLET ASTM II (185)

PIGMENT DETAIL ON LABEL	ASTM	RATING
YES	II L'FAST	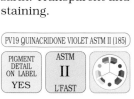

ALIZARIN CRIMSON (QUINACRIDONE) 602

DA VINCI PAINTS

The sample supplied was rather gummy and painted out awkwardly unless thinned.

Reliable pigment used. One of a new range of 'student' colours from this company.

SCUOLA 2ND RANGE

PV19 QUINACRIDONE VIOLET ASTM II (185)

PIGMENT DETAIL ON LABEL	ASTM	RATING
YES	II L'FAST	★★

ALIZARIN CRIMSON 20H

DR.Ph. MARTINS

Without a description of the pigments in either the literature provided or on the product label I cannot offer an assessment. Use with absolute caution.

HYDRUS FINE ART WATERCOLOR

PIGMENT DETAIL ON LABEL	ASTM	RATING
NO	L'FAST	

ALIZARIN CRIMSON 004

WINSOR & NEWTON

Brushes out very well into series of washes. Pigment is unreliable and tends to fade quickly as a wash. Transparent and staining.

ARTISTS' WATER COLOUR

PR83:1 ALIZARIN CRIMSON ASTM IV (122)

PIGMENT DETAIL ON LABEL	ASTM	RATING
YES	IV L'FAST	★

PERMANENT ALIZARIN CRIMSON 466

WINSOR & NEWTON

Sample handled very well indeed, giving smooth, even washes.

Although the name will linger on for a long time, it is encouraging to see the gradual change from genuine Alizarin Crimson to reliable alternatives.

ARTISTS' WATER COLOUR

 PR206 QUINACRIDONE BURNT ORANGE WG II (133)

PIGMENT DETAIL ON LABEL	WG	
YES	II L'FAST	

ALIZARIN CRIMSON 004

WINSOR & NEWTON

Washes out reasonably well but is as fragile on exposure as its 'Artist' quality cousin. Transparent.

Reformulated>

COTMAN WATER COLOURS 2ND RANGE

PR83:1 ALIZARIN CRIMSON ASTM IV (122)

PIGMENT DETAIL ON LABEL	ASTM	RATING
YES	IV L'FAST	★

ALIZARIN CRIMSON HUE 003

WINSOR & NEWTON

Correctly described as a 'Hue' being an imitation Alizarin Crimson. The artists' quality should also be described this way.

Washed out well and is reliable.

COTMAN WATER COLOUR

PR206 QUINACRIDONE BURNT ORANGE WG II (133)

PIGMENT DETAIL ON LABEL	WG	
YES	II L'FAST	

ALIZARIN CRIMSON 515

DALER ROWNEY

As with most watercolours, thinner washes are the norm. When so applied will fade quickly on exposure. Transparent.

ARTISTS' WATER COLOUR

PR83:1 ALIZARIN CRIMSON ASTM IV (122)

PIGMENT DETAIL ON LABEL	ASTM	RATING
YES	IV L'FAST	★

ALIZARIN CRIMSON (HUE) 525

DALER ROWNEY

A far superior product to its genuine counterpart.

As more artists come to realise that Crimson Alizarin has ruined countless paintings, they will ask why it was offered for so long. And why some still offer it.

ARTISTS' WATER COLOUR

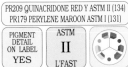
PR209 QUINACRIDONE RED Y ASTM II (134)
PR179 PERYLENE MAROON ASTM I (131)

PIGMENT DETAIL ON LABEL	ASTM	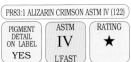
YES	II L'FAST	

CRIMSON ALIZARIN

DALER ROWNEY

Sample was particularly unpleasant to use and it was impossible to get an even, gradated wash. Unreliable. Transparent.

GEORGIAN WATER COLOUR 2ND RANGE

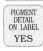
PR83:1 ALIZARIN CRIMSON ASTM IV (122)

PIGMENT DETAIL ON LABEL	ASTM	RATING
NO	IV L'FAST	★

ALIZARIN CRIMSON LAKE EXTRA 163

OLD HOLLAND

Sample painted out poorly as it was rather over bound. The Rose Madder Alizarin will alter the colour as it fades. Unreliable.

CLASSIC WATERCOLOURS

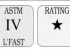
PV19 QUINACRIDONE RED ASTM II (185)
PV19 QUINACRIDONE VIOLET ASTM II (185)
PR83 ROSE MADDER ALIZARIN ASTM IV (122)

PIGMENT DETAIL ON LABEL	ASTM	RATING
CHEMICAL MAKE UP ONLY	IV L'FAST	★

ALIZARIN CRIMSON 357

SCHMINCKE

It is very well known to all art material manufacturers that PR83:I, Alizarin Crimson, is most unreliable and will ruin an artists work for no good reason. Lightfast alternatives are available and have been for a long time.

HORADAM FINEST ARTISTS' WATER COLOURS

PR83:1 ALIZARIN CRIMSON ASTM IV (122)

PIGMENT DETAIL ON LABEL	ASTM	RATING
YES	IV L'FAST	★

ALIZARIN CRIMSON 689

SENNELIER

The name was changed several years ago from 'Madder lake Deep'.

This colour will fade as all paints which are produced from Alizarin Crimson will fade. Transparent.

EXTRA-FINE WATERCOLOUR

PR83:1 ALIZARIN CRIMSON ASTM IV (122)

PIGMENT DETAIL ON LABEL	ASTM	RATING
YES	IV L'FAST	★

ALIZARIN CRIMSON W001

GRUMBACHER

Reasonable resistance to light is offered when applied heavily, but thinner washes (which is the most common practice of the watercolourist), will fade rather quickly. Transparent.

FINEST ARTISTS' WATER COLOR

PR83 ROSE MADDER ALIZARIN ASTM IV (122)

PIGMENT DETAIL ON LABEL	ASTM	RATING
YES	IV L'FAST	★

ALIZARIN CRIMSON A001

GRUMBACHER

Like other Alizarin Crimsons it will fade quickly on exposure to light. This is especially so when it is thinly applied. Transparent.

ACADEMY ARTISTS' WATERCOLOR 2ND RANGE

PR83 ROSE MADDER ALIZARIN ASTM IV (122)

PIGMENT DETAIL ON LABEL	ASTM	RATING
YES	IV L'FAST	★

ALIZARIN CRIMSON GOLDEN W002

GRUMBACHER

FINEST ARTISTS' WATER COLOR

As I have said in the previous two editions, 'Sample not supplied. Assessment made on the stated pigment used'.

The same situation still prevails. This company show only half hearted interest in what are, after all, your interests.

PR83 ROSE MADDER ALIZARIN ASTM IV (122)

PIGMENT DETAIL ON LABEL	ASTM	RATING
YES	IV L'FAST	★

ALIZARIN CRIMSON 5700

HUNTS

SPEEDBALL PROFESSIONAL WATERCOLOURS

Unreliable ingredients, PR83 will cause rapid fading on exposure. Brushes well. Transparent.

PR83 ROSE MADDER ALIZARIN ASTM IV (122)

PIGMENT DETAIL ON LABEL	ASTM	RATING
YES	IV L'FAST	★

Cadmium Red Light

To my mind this is the ideal orange red. It is bright, washes well and is absolutely lightfast. Being opaque it covers well with a thin layer. Being strong it will give quite transparent washes when diluted.

Cadmium Red Light has, to a large extent, replaced the troublesome Vermilion. A definite orange-red, it is very versatile in mixes.

In order to darken without destroying character, add the complementary blue-green. A superb colour, well worth any extra cost

CADMIUM RED LIGHT 1072

LUKAS

ARTISTS' WATER COLOUR

A fine orange-red. Densely packed pigment gives a watercolour with a wide range of values. Excellent. Opaque.

PR108 CADMIUM RED LIGHT, MEDIUM OR DEEP ASTM I (126)

PIGMENT DETAIL ON LABEL	ASTM	
CHEMICAL MAKE UP ONLY	I L'FAST	

CADMIUM RED PALE 506

DALER ROWNEY

ARTISTS' WATER COLOUR

Beautiful, smooth, even washes from this superb watercolour paint.

Strong, bright and opaque, a pleasure to work with.

PR108 CADMIUM RED LIGHT, MEDIUM OR DEEP ASTM I (126)

PIGMENT DETAIL ON LABEL	ASTM	
YES	I L'FAST	

CADMIUM RED PALE (HUE) 526

PO73 has proven to be reliable when made up into a gouache.

Although it will more than likely prove to be lightfast when made up into a watercolour paint, I cannot take chances and offer assessments.

DALER ROWNEY

ARTISTS' WATER COLOUR

PR254 PYRROLE RED WG II (136)
PO73 COMMON NAME N/K LF NOT OFFERED (98)

PIGMENT DETAIL ON LABEL	ASTM	RATING
YES	L'FAST	

CADMIUM RED LIGHT 212

DA VINCI PAINTS

PERMANENT ARTISTS' WATER COLOR

Very well labelled product. Carries pigment and extensive health information. Recently reformulated to improve handling. Opaque.

PR108 CADMIUM RED LIGHT, MEDIUM OR DEEP ASTM I (126)

PIGMENT DETAIL ON LABEL	ASTM	
YES	I L'FAST	

CADMIUM RED LIGHT (HUE) 612

DA VINCI PAINTS

SCUOLA 2ND RANGE

A rather difficult paint to work with due to its consistency.

Reliable enough pigments have been used.

PR188 NAPHTHOL AS ASTM II (132)
PO62 BENZIMIDAZOLONE ORANGE H5G ASTM II (97)

PIGMENT DETAIL ON LABEL	ASTM	RATING
YES	II L'FAST	★ ★★

CADMIUM RED LIGHT 143

UTRECHT

PROFESSIONAL ARTISTS' WATER COLOR

Rich, velvety orange reds when fully saturated to smooth, reasonably clear washes at the other end of the scale.

PR108 CADMIUM RED LIGHT, MEDIUM OR DEEP ASTM I (126)

PIGMENT DETAIL ON LABEL	ASTM	
YES	I L'FAST	

CARAN D'ACHE

LIGHT CADMIUM RED 560

The damp brush quickly filled with paint from the surface of the pan and washed out very well.

A quality product using the correct pigment.

FINEST WATERCOLOURS

PR108 CADMIUM RED LIGHT, MEDIUM OR DEEP ASTM I (126)

| PIGMENT DETAIL ON LABEL YES | ASTM I L'FAST | |

MAIMERI

CADMIUM RED LIGHT 226

A bright, rich orange red. A very well made watercolour which handles superbly. An excellent paint. Opaque.

MAIMERIBLU SUPERIOR WATERCOLOURS

PR108 CADMIUM RED LIGHT, MEDIUM OR DEEP ASTM I (126)

| PIGMENT DETAIL ON LABEL YES | ASTM I L'FAST | |

M.GRAHAM & CO.

CADMIUM RED LIGHT 050

A very well made watercolour paint which handles very smoothly over a wide range of values.

A quality product.

ARTISTS' WATERCOLOR

PR108 CADMIUM RED LIGHT, MEDIUM OR DEEP ASTM I (126)

| PIGMENT DETAIL ON LABEL YES | ASTM I L'FAST | |

HOLBEIN

CADMIUM RED LIGHT W214

Brushes out beautifully. A superb, opaque, non staining paint. When well made this pigment gives a watercolour which is seen by many to be the ideal orange red.

ARTISTS' WATER COLOR

PR108 CADMIUM RED LIGHT, MEDIUM OR DEEP ASTM I (126)

| PIGMENT DETAIL ON LABEL YES | ASTM I L'FAST | |

UMTON BARVY

CADMIUM RED LIGHT 2270

A bright, strong orange red which gave smooth washes with ease.

Pigment information on the product label at some time in the future will be a great help.

ARTISTIC WATER COLOR

PR108 CADMIUM RED LIGHT, MEDIUM OR DEEP ASTM I (126)

| PIGMENT DETAIL ON LABEL NO | ASTM L'FAST | |

MIR (JAURENA S.A)

CADMIUM RED LIGHT 523

More of a medium to deep version of the colour rather than the usual definite orange bias. One would expect this from the pigment used. A well made product.

ACUARELA

PR108 CADMIUM RED LIGHT, MEDIUM OR DEEP ASTM I (126)

| PIGMENT DETAIL ON LABEL YES | ASTM I L'FAST | |

GRUMBACHER

CADMIUM RED LIGHT W027

As soon as the loaded brush touched the damp paper the resulting wash was well on its way.

This is what I would expect from a well produced watercolour paint. Excellent.

FINEST ARTISTS' WATER COLOR

PR108 CADMIUM RED LIGHT, MEDIUM OR DEEP ASTM I (126)

| PIGMENT DETAIL ON LABEL YES | ASTM I L'FAST | |

GRUMBACHER

CADMIUM RED LIGHT 027

A fine collection of unreliable pigments.

I would suggest for temporary student work only. Semi-opaque.

Reformulated>

ACADEMY ARTISTS' WATERCOLOR 2ND RANGE

PR112 NAPHTHOL AS-D ASTM III (127)
PY1 ARYLIDE YELLOW G ASTM V (37)
PO1 HANSA ORANGE WG V (94)

| PIGMENT DETAIL ON LABEL YES | ASTM V L'FAST | RATING ★ |

GRUMBACHER

CADMIUM RED LIGHT HUE A207

With certain colours, such as this, it is always worth the extra cost to purchase the better quality. No substitute can match genuine Cadmium Red.

ACADEMY ARTISTS' WATERCOLOR 2ND RANGE

PY97 ARYLIDE YELLOW FGL ASTM II (46)
PY65 ARYLIDE YELLOW RN ASTM II (44)
PR178 PERYLENE RED ASTM II (131)
PR188 NAPHTHOL AS ASTM II (132)

| PIGMENT DETAIL ON LABEL YES | ASTM II L'FAST | |

SENNELIER

CADMIUM RED LIGHT 605

An excellent, well made watercolour with many admirable qualities. Well worth any extra cost over inferior orange-reds. Opaque.

EXTRA-FINE WATERCOLOUR

PR108 CADMIUM RED LIGHT, MEDIUM OR DEEP ASTM I (126)

| PIGMENT DETAIL ON LABEL YES | ASTM I L'FAST | |

OLD HOLLAND

CADMIUM RED LIGHT 21

The previous colour No was 411. More a violet-red than the usual orange-red. This should be noted when mixing. An excellent watercolour. Opaque.

CLASSIC WATERCOLOURS

PR108 CADMIUM RED LIGHT, MEDIUM OR DEEP ASTM I (126)

| PIGMENT DETAIL ON LABEL CHEMICAL MAKE UP ONLY | ASTM I L'FAST | |

SCHMINCKE

CADMIUM RED LIGHT 349

A change of ingredient from the norm. Nevertheless a fine, strong paint which works well. Opaque.

HORADAM FINEST ARTISTS' WATER COLOURS

PO20 CADMIUM ORANGE ASTM I (94)

| PIGMENT DETAIL ON LABEL YES | ASTM I L'FAST | |

CADMIUM RED LIGHT 303

TALENS

A rich, velvety orange red. Absolutely lightfast and possesses excellent handling qualities. This was previously called 'Cadmium Red Pale' and did not then contain the PR108. Should correctly be called a 'Hue.

REMBRANDT ARTISTS' QUALITY EXTRA FINE

PO20 CADMIUM ORANGE ASTM I (94)
PR108 CADMIUM RED LIGHT, MEDIUM OR DEEP ASTM I (126)

PIGMENT DETAIL ON LABEL	ASTM	
YES	I L'FAST	

CADMIUM RED LIGHT (AZO) 304

TALENS

Fine for temporary sketch work, particularly if kept away from the light. Handles well, but unreliable. Semi-opaque.

Range discontinued

WATERCOLOUR 2ND RANGE

PY74LF ARYLIDE YELLOW 5GX ASTM III (44)
PR4 CHLORINATED PARA RED WG V (115)

PIGMENT DETAIL ON LABEL	WG	RATING
YES	V L'FAST	★

CADMIUM RED 100 (USA ONLY)

WINSOR & NEWTON

Would be judged a superb paint in any range. Pigment and health details on tube. Excellent. Opaque.

Why is this higher quality 2nd range colour available only in the USA?

COTMAN WATER COLOURS 2ND RANGE

PR108 CADMIUM RED LIGHT, MEDIUM OR DEEP ASTM I (126)

PIGMENT DETAIL ON LABEL	ASTM	
YES	I L'FAST	

CADMIUM RED PALE (AZO) 103

WINSOR & NEWTON

The tint becomes paler and the mass tone darker when exposed to light.

Fugitive. Suitable for temporary work. Semi-opaque.
Reformulated>

COTMAN WATER COLOURS 2ND RANGE

PY1 ARYLIDE YELLOW G ASTM V (37)
PR4 CHLORINATED PARA RED WG V (115)

PIGMENT DETAIL ON LABEL	ASTM	RATING
YES	V L'FAST	★

CADMIUM RED PALE HUE 103

WINSOR & NEWTON

Genuine Cadmium Red is possibly the ideal orange red.

As such, it always pays to purchase the artists' quality over imitations such as this.

COTMAN WATER COLOURS 2ND RANGE

PY65 ARYLIDE YELLOW RN ASTM II (44)
PR255 COMMON NAME N/K ASTM I (136)

PIGMENT DETAIL ON LABEL	ASTM	
YES	II L'FAST	

Cadmium Red

Deeper in hue than Cadmium Red Light. Possesses the same admirable qualities: brushes well, reasonably bright and absolutely lightfast.

Colour varies between manufacturers so choose carefully.

A superb colour when well made. For mixing purposes it is nearly always an orange-red. (Violet-red versions are available).

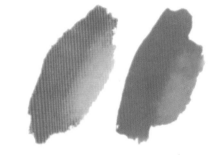

The complementary partner is a blue-green.

CADMIUM RED MEDIUM 211

DA VINCI PAINTS

A dense, strong, opaque mid red. The sample provided washed out smoothly over a very useful range of values. Excellent.

PERMANENT ARTISTS' WATER COLOR

PR108 CADMIUM RED LIGHT, MEDIUM OR DEEP ASTM I (126)

PIGMENT DETAIL ON LABEL	ASTM	
YES	I L'FAST	

CADMIUM RED 335

PÈBÈO

Previously contained PR9, which had lowered its lightfast rating. Much improved without it. Well produced. A strong, reasonably bright, orange red, giving good even washes. Opaque.

FRAGONARD ARTISTS' WATER COLOUR

PR108 CADMIUM RED LIGHT, MEDIUM OR DEEP ASTM I (126)

PIGMENT DETAIL ON LABEL	ASTM	
YES	I L'FAST	

BRILLIANT CAD RED 3H

DR.Ph. MARTINS

Surely this companies' sales would increase if they made clear to the more knowledgeable and caring artist just what pigments they used.

HYDRUS FINE ART WATERCOLOR

INFORMATION ON THE PIGMENT/S USED IS NOT PROVIDED

PIGMENT DETAIL ON LABEL	ASTM	RATING
NO	L'FAST	

CADMIUM RED 094

WINSOR & NEWTON

A rich, deep colour. The paint washes out very well over the full range of values. Opaque. Granulates quite readily.

ARTISTS' WATER COLOUR

PR108 CADMIUM RED LIGHT, MEDIUM OR DEEP ASTM I (126)

PIGMENT DETAIL ON LABEL	ASTM	
YES	I L'FAST	

CADMIUM RED HUE 095

WINSOR & NEWTON

Neither ingredient is reliable. Perhaps for temporary work. The colour will be temporary anyway on exposure to light. Semi-opaque.

Reformulated>

COTMAN WATER COLOURS 2ND RANGE

PR3 TOLUIDINE RED WG V (115)
PR4 CHLORINATED PARA RED WG V (115)

PIGMENT DETAIL ON LABEL	WG	RATING
YES	V L'FAST	★

CADMIUM RED HUE 095

WINSOR & NEWTON

A fairly bright red, somewhat lacking in body. Washed out well.

Correctly named as an imitation Cadmium Red.

COTMAN WATER COLOURS 2ND RANGE

PR149 PERYLENE RED BL WG II (128)
PR255 COMMON NAME N/K ASTM I (136)

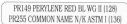

PIGMENT DETAIL ON LABEL	WG	RATING
YES	II L'FAST	★ ★★

CADMIUM RED 094 (USA ONLY)

WINSOR & NEWTON

Full information on tube. Dense pigment, the made up paint washes out very well but the colour is a little dull. Opaque.

COTMAN WATER COLOURS 2ND RANGE

PR108 CADMIUM RED LIGHT, MEDIUM OR DEEP ASTM I (126)

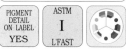

PIGMENT DETAIL ON LABEL	ASTM	
YES	I L'FAST	

CADMIUM RED MEDIUM 314

TALENS

Previously called 'Cadmium Red 305'. Superb pigment, densely packed.

A well produced watercolour which washes out very well. Opaque.

REMBRANDT ARTISTS' QUALITY EXTRA FINE

PR108 CADMIUM RED LIGHT, MEDIUM OR DEEP ASTM I (126)

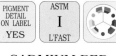

PIGMENT DETAIL ON LABEL	ASTM	
YES	I L'FAST	

CADMIUM RED MIDDLE 2230

UMTON BARVY

Bright, strong, opaque but reasonably clear washes.

Lifted from the pan with ease, gave very smooth washes. Correct pigment. What more could you ask for?

ARTISTIC WATER COLOR

PR108 CADMIUM RED LIGHT, MEDIUM OR DEEP ASTM I (126)

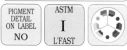

PIGMENT DETAIL ON LABEL	ASTM	
NO	I L'FAST	

CADMIUM RED 040

M.GRAHAM & CO.

An excellent example of this colour. A well balanced watercolour paint which gave up a series of smooth, easily laid washes. Absolutely lightfast if kept away from moisture.

ARTISTS' WATERCOLOR

PR108 CADMIUM RED LIGHT, MEDIUM OR DEEP ASTM I (126)

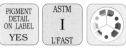

PIGMENT DETAIL ON LABEL	ASTM	
YES	I L'FAST	

CADMIUM RED MEDIUM 014

DANIEL SMITH

Described by the company as being semi transparent, where the pigment is opaque, this is a comparatively weak example of Cadmium Red. Washed well.

EXTRA-FINE WATERCOLORS

PR108 CADMIUM RED LIGHT, MEDIUM OR DEEP ASTM I (126)

PIGMENT DETAIL ON LABEL	ASTM	RATING
YES	I L'FAST	★ ★★

CADMIUM RED SCARLET 20

OLD HOLLAND

Has a strong leaning towards orange, as one would expect from the pigment used.

Handled quite well after a little working with a damp brush.

CLASSIC WATERCOLOURS

PO20 CADMIUM ORANGE ASTM I (94)

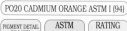

PIGMENT DETAIL ON LABEL	ASTM	RATING
CHEMICAL MAKE UP ONLY	I L'FAST	★ ★★

CADMIUM RED 501

DALER ROWNEY

A particularly well made watercolour. Brushed out very well over a good range of values. Opaque. Highly recommended.

ARTISTS' WATER COLOUR

PR108 CADMIUM RED LIGHT, MEDIUM OR DEEP ASTM I (126)

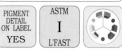

PIGMENT DETAIL ON LABEL	ASTM	
YES	I L'FAST	

CADMIUM RED (HUE) 503

DALER ROWNEY

The idea of deciding the suitability of a pigment for artistic use, via ASTM approved testing, is to ensure that pigments such as PY74LF do not find their way into artists' quality paint.

ARTISTS' WATER COLOUR

PR254 PYRROLE RED WG II (136)
PY74LF ARYLIDE YELLOW 5GX ASTM III (44)

PIGMENT DETAIL ON LABEL	ASTM	RATING
YES	III L'FAST	★★

CADMIUM RED (HUE) 503

DALER ROWNEY

The pigment used is prone to fading, especially as a tint.

I find this disappointing in a colour introduced not so very long ago, whether for students work or not.

GEORGIAN WATER COLOUR 2ND RANGE

PR9 NAPHTHOL AS-OL ASTM III (117)

PIGMENT DETAIL ON LABEL	ASTM	RATING
NO	III L'FAST	★★

CADMIUM RED W13

ART SPECTRUM

ARTISTS' WATER COLOUR

A smooth, dense, well made watercolour paint which handled beautifully across a very useful range of values.

Will not let you down.

PR108 CADMIUM RED LIGHT, MEDIUM OR DEEP ASTM I (126)

PIGMENT DETAIL ON LABEL	ASTM	
YES	I L'FAST	

CADMIUM RED MEDIUM 144

UTRECHT

PROFESSIONAL ARTISTS' WATER COLOR

A well made example of this colour.

If you have to make savings it is better to make them in the earth colours etc. It always pays to purchase genuine Cadmium Red.

PR108 CADMIUM RED LIGHT, MEDIUM OR DEEP ASTM I (126)

PIGMENT DETAIL ON LABEL	ASTM	
YES	I L'FAST	

CADMIUM RED SCARLET 012

DANIEL SMITH

EXTRA-FINE WATERCOLORS

Bright, strong in tinting strength, covers well yet gives reasonably clear, very thin washes.

A well made example.

PR108 CADMIUM RED LIGHT, MEDIUM OR DEEP ASTM I (126)

PIGMENT DETAIL ON LABEL	ASTM	
YES	I L'FAST	

CADMIUM RED MEDIUM W029

GRUMBACHER

FINEST ARTISTS' WATER COLOR

A particularly dull, 'heavy' violet-red.

The bias should be taken into account when colour mixing. Lightfast. Opaque.

PR108 CADMIUM RED LIGHT, MEDIUM OR DEEP ASTM I (126)

PIGMENT DETAIL ON LABEL	ASTM	
YES	I L'FAST	

CADMIUM RED MEDIUM HUE A029

GRUMBACHER

ACADEMY ARTISTS' WATERCOLOR 2ND RANGE

The lightfast rating of I given on the sample tube supplied is incorrect. The pigments are all fugitive which causes the colour to fade and discolour at an alarming rate.

Reformulated

PO1 HANSA ORANGE WG V (94)
PR4 CHLORINATED PARA RED WG V (115)
PR49:1 LITHOL RED WG IV (119)
PR3 TOLUIDINE RED WG V (115)

PIGMENT DETAIL ON LABEL	WG	RATING
YES	V L'FAST	★

CADMIUM RED MEDIUM HUE A029

GRUMBACHER

ACADEMY ARTISTS' WATERCOLOR 2ND RANGE

A 'harder' colour than genuine Cadmium Red.

When it comes to selecting your palette it pays to obtain the best and make savings in other areas. Imitation Cadmium Reds are never the best.

PR149 PERYLENE RED BL WG II (128)
PR178 PERYLENE RED ASTM II (131)
PR 166 DISAZO SCARLET WG II (128)

PIGMENT DETAIL ON LABEL	ASTM	RATING
YES	II L'FAST	★★

CADMIUM RED ORANGE

SCHMINCKE

HORADAM FINEST ARTISTS' WATER COLOURS

A bright, strong colour.

Brushes out well into even gradated washes. Absolutely impervious to light. Opaque.

PO20 CADMIUM ORANGE ASTM I (94)

PIGMENT DETAIL ON LABEL	ASTM	
YES	I L'FAST	

CADMIUM RED MIDDLE 347

SCHMINCKE

HORADAM FINEST ARTISTS' WATER COLOURS

A strong, very well produced colour which handled beautifully.

The strength allowed for reasonably clear washes even though the pigment is opaque.

PR108:1 CADMIUM-BARIUM RED LIGHT, MEDIUM OR DEEP ASTM I (126)

PIGMENT DETAIL ON LABEL	ASTM	
YES	I L'FAST	

CADMIUM RED MEDIUM (VERMILIONED) 154

OLD HOLLAND

CLASSIC WATERCOLOURS

A little over bound, which is a shame as the paint washed out perfectly after a little working with a damp brush.

A most reliable pigment has been used.

PR108 CADMIUM RED LIGHT, MEDIUM OR DEEP ASTM I (126)

PIGMENT DETAIL ON LABEL CHEMICAL MAKE UP ONLY	ASTM	RATING
	I L'FAST	★ ★★

CADMIUM RED (HUE) 616

MAIMERI

STUDIO FINE WATER COLOR 2ND RANGE

Similar in hue to genuine Cadmium Red Medium. Unfortunately it is affected by light when applied thinly. Suitable for student work perhaps. Semi-transparent.

Range discontinued

PR112 NAPHTHOL AS-D ASTM III (127)

HEALTH	ASTM	RATING
✕ INFO	III L'FAST	★★

CADMIUM RED 025

AMERICAN JOURNEY

PROFESSIONAL ARTISTS' WATER COLOR

A bright, vibrant orange red.

For full colour mixing an orange red is essential. Of those on offer Cadmium Red (Light or Medium) is, I believe, the very best.

PR108 CADMIUM RED LIGHT, MEDIUM OR DEEP ASTM I (126)

PIGMENT DETAIL ON LABEL	ASTM	
YES	I L'FAST	

Equally reliable and with similar qualities to the other Cadmium Reds.

This is the least versatile and can be duplicated by adding a touch of the mixing complementary to Cadmium Red Medium.

For mixing purposes it varies in hue between a rather heavy violet red to a deep orange-red.

Mixing complementaries are: For a violet-red, yellow-green and for the orange-red version, blue-green.

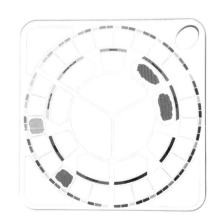

CADMIUM RED DEEP 502

DALER ROWNEY

A dull, rather 'heavy' violet red. The sample washed out very smoothly. An excellent all round deep red.

Absolutely lightfast unless also exposed to moisture.

ARTISTS' WATER COLOUR

PR108 CADMIUM RED LIGHT, MEDIUM OR DEEP ASTM I (126)		
PIGMENT DETAIL ON LABEL **YES**	ASTM **I** L'FAST	

CADMIUM RED DEEP (HUE) 504

DALER ROWNEY

I am afraid that too little is known to us about PR264 to be able to offer an assessment. Hopefully the company have other records. Not ASTM tested.

ARTISTS' WATER COLOUR

PR264 COMMON NAME N/K LF NOT OFFERED (137) PR254 PYRROLE RED WG II (136)		
PIGMENT DETAIL ON LABEL **YES**	ASTM — L'FAST	RATING

CADMIUM RED DEEP 528

MIR (JAURENA S.A)

A very reliable pigment which passed ASTM testing as a watercolour with top marks. Sample washed out very smoothly. Recommended.

ACUARELA

PR108 CADMIUM RED LIGHT, MEDIUM OR DEEP ASTM I (126)		
PIGMENT DETAIL ON LABEL **YES**	ASTM **I** L'FAST	

CADMIUM RED DEEP 350

SCHMINCKE

A dull violet-red. The pigment is resistant to just about everything. Washes well at any value. Opaque. Recent pigment change from PR108:1 (page 126) to PR108, same page. Excellent.

HORADAM FINEST ARTISTS' WATER COLOURS

PR108 CADMIUM RED LIGHT, MEDIUM OR DEEP ASTM I (126)		
PIGMENT DETAIL ON LABEL **YES**	ASTM **I** L'FAST	

CADMIUM RED DEEP 145

UTRECHT

Our sample handled very well and gave a useful range of values.

Being fairly strong it does allow for reasonably clear washes when well diluted.

PROFESSIONAL ARTISTS' WATER COLOR

PR108 CADMIUM RED LIGHT, MEDIUM OR DEEP ASTM I (126)		
PIGMENT DETAIL ON LABEL **YES**	ASTM **I** L'FAST	

CADMIUM RED DEEP 5709

HUNTS

See page 126 for details of PR108:1 Cadmium-Barium Red. Handles well over the full range. Opaque.

Discontinued

SPEEDBALL PROFESSIONAL WATERCOLOURS

CADMIUM SULFOSELENIDE COPRECIPITATED WITH BARIUM SULPHATE		
PIGMENT DETAIL ON LABEL **YES**	ASTM **I** L'FAST	

CADMIUM RED DEEP 097)

WINSOR & NEWTON

A rich, velvety deep red. Well produced watercolour giving a range of very smooth washes. Opaque and tends to granulate in thin rather wet washes.

ARTISTS' WATER COLOUR

PR108 CADMIUM RED LIGHT, MEDIUM OR DEEP ASTM I (126)		
PIGMENT DETAIL ON LABEL **YES**	ASTM **I** L'FAST	

CADMIUM RED DEEP 098 HUE

WINSOR & NEWTON

Personally I would rather see colours described under their own name rather than impersonating another. A poor imitation. Semi-opaque.

Reformulated >

COTMAN WATER COLOURS 2ND RANGE

PR112 NAPHTHOL AS-D ASTM III (127)		
PIGMENT DETAIL ON LABEL **YES**	ASTM **III** L'FAST	RATING **★★**

CADMIUM RED DEEP (HUE) 098

WINSOR & NEWTON

Not as dark in hue as genuine Cadmium Red Deep, but then this is an imitation. Very well made using quality lightfast pigments. Brushed out smoothly. Transparent and staining.

COTMAN WATER COLOURS 2ND RANGE

PR254 PYRROLE RED WG II (136) PR188 NAPHTHOL AS ASTM II (132)		
PIGMENT DETAIL ON LABEL **YES**	ASTM **II** L'FAST	

148

CADMIUM RED DEEP W026

GRUMBACHER

FINEST ARTISTS' WATER COLOR

A very densely packed paint. Has good hiding power. Difficult to get a good gradated wash. Reliable. Opaque.

PR108 CADMIUM RED LIGHT, MEDIUM OR DEEP ASTM I (126)		
PIGMENT DETAIL ON LABEL **YES**	ASTM **I** L'FAST	RATING ★ ★★

CADMIUM BARIUM RED DEEP 026

GRUMBACHER

ACADEMY ARTISTS' WATERCOLOR 2ND RANGE

The earlier formulation of PR108:1 seems to have been changed to the pigments given here. Rather a pity as the PR49:1 (with its poor reputation), lowers the lightfast rating dramatically.

Discontinued

PR49:1 LITHOL RED WG IV (119) PY42 MARS YELLOW ASTM I (43)		
PIGMENT DETAIL ON LABEL **YES**	WG **IV** L'FAST	RATING ★

CADMIUM RED DEEP HUE A026

GRUMBACHER

ACADEMY ARTISTS' WATERCOLOR 2ND RANGE

Reliable quality pigments making up into a very smooth paint. Handled beautifully.

PR170 F3RK-70 NAPHTHOL RED ASTM II (129) *UNSPECIFIED PR101 ASTM I (123/124)* PY42 MARS YELLOW ASTM I (43)		
PIGMENT DETAIL ON LABEL **YES**	ASTM **II** L'FAST	

CADMIUM RED DEEP 23

OLD HOLLAND

CLASSIC WATERCOLOURS

A rather 'heavily' dull, red, definitely on the violet side. Gives very even washes over the full range. Opaque and lightfast.

PR108 CADMIUM RED LIGHT, MEDIUM OR DEEP ASTM I (126)		
PIGMENT DETAIL ON LABEL **CHEMICAL MAKE UP ONLY**	ASTM **I** L'FAST	

CADMIUM RED DEEP 306

TALENS

REMBRANDT ARTISTS' QUALITY EXTRA FINE

Strong enough to give fairly clear washes when well diluted. A very good watercolour, well produced. Opaque.

PR108 CADMIUM RED LIGHT, MEDIUM OR DEEP ASTM I (126)		
PIGMENT DETAIL ON LABEL **YES**	ASTM **I** L'FAST	

CADMIUM RED DEEP (AZO) 307

TALENS

WATER COLOUR 2ND RANGE

The ingredients are not worthy of the title. Not everybody will realise just what they are buying. Semi-opaque.

Discontinued

PR4 CHLORINATED PARA RED WG V (115) PR23 NAPHTHOL RED LF NOT OFFERED (118)		
PIGMENT DETAIL ON LABEL **YES**	WG **V** L'FAST	RATING ★

CADMIUM RED DEEP 1074

LUKAS

ARTISTS' WATER COLOUR

Slightly violet-red. Absolutely lightfast pigment. It really is worth being aware of such ingredients. It is a pity that the pigment detail on the label is unclear to most. First class watercolour. Opaque.

PR108 CADMIUM RED LIGHT, MEDIUM OR DEEP ASTM I (126)		
PIGMENT DETAIL ON LABEL **CHEMICAL MAKE UP ONLY**	ASTM **I** L'FAST	

CADMIUM RED DEEP 232

MAIMERI

MAIMERIBLU SUPERIOR WATERCOLOURS

Strong colour which handles very well.

Powerful enough to give reasonably thin washes when well diluted. Opaque.

PR108 CADMIUM RED LIGHT, MEDIUM OR DEEP ASTM I (126)		
PIGMENT DETAIL ON LABEL **YES**	ASTM **I** L'FAST	

CADMIUM RED DEEP 015

DANIEL SMITH

EXTRA-FINE WATERCOLORS

Gave very smooth transition from heavier applications to very thin.

An excellent watercolour employing a superb pigment.

PR108 CADMIUM RED LIGHT, MEDIUM OR DEEP ASTM I (126)		
PIGMENT DETAIL ON LABEL **YES**	ASTM **I** L'FAST	

CADMIUM RED DEEP 2228

UMTON BARVY

ARTISTIC WATER COLOR

A very well made product. If anything, it is harder to produce a workable paint in pan form than in a tube.

Too hard and the paint will not lift, too soft and it is tacky. This is very well balanced.

PR108 CADMIUM RED LIGHT, MEDIUM OR DEEP ASTM I (126)		
PIGMENT DETAIL ON LABEL **NO**	ASTM **I** L'FAST	

CADMIUM RED DEEP W215

HOLBEIN

ARTISTS' WATER COLOR

A little brighter and closer to orange in mass tone than other examples of this colour. Washes out very well. Opaque and non staining. Reliable.

PR108 CADMIUM RED LIGHT, MEDIUM OR DEEP ASTM I (126)		
PIGMENT DETAIL ON LABEL **YES**	ASTM **I** L'FAST	

CADMIUM RED DEEP W15

ART SPECTRUM

A smooth, dense watercolour which brushed out very well over a good range of values. Gave surprisingly clear thin washes. An excellent product.

ARTISTS' WATER COLOUR

PR108 CADMIUM RED LIGHT, MEDIUM OR DEEP ASTM I (126)		
PIGMENT DETAIL ON LABEL **YES**	ASTM **I** L'FAST	

CADMIUM RED DEEP 210

DA VINCI PAINTS

A dense red, biased towards violet.

Although an opaque paint, it's strength allows for reasonably clear washes when diluted. Weaker colours often tend to granulate.

PERMANENT ARTISTS' WATER COLOR

PR108 CADMIUM RED LIGHT, MEDIUM OR DEEP ASTM I (126)		
PIGMENT DETAIL ON LABEL **YES**	ASTM **I** L'FAST	

Carmine

This is another name from the past which is used to sell a variety of violet - reds, often of dubious value.

Genuine Carmine is obtained from the dried bodies of beetles native to South America.

The European use of the pigment dates from the mid 1500's.

A cool transparent violet-red, genuine Carmine is fugitive and unsuitable for most artistic use.

For mixing purposes treat as a violet-red. Complementary is a yellow-green.

ALIZARIN CARMINE 002

WINSOR & NEWTON

It is well known that this pigment is unreliable unless applied thickly or kept in the dark. Transparent.

Discontinued

ARTISTS' WATER COLOUR

PR83:1 ALIZARIN CRIMSON ASTM IV (122)		
PIGMENT DETAIL ON LABEL **YES**	ASTM **IV** L'FAST	RATING **★**

CARMINE 127 (094)

WINSOR & NEWTON

The pigment used, genuine Carmine, is a fugitive substance long past its time.

The colour is easily matched with reliable materials. Transparent.

Discontinued

ARTISTS' WATER COLOUR

NR4 CARMINE ASTM V (116)		
PIGMENT DETAIL ON LABEL **YES**	ASTM **V** L'FAST	RATING **★**

PERMANENT CARMINE 479

WINSOR & NEWTON

Without an exact description of the pigment used, its Colour Index Name, I do not wish to offer an assessment. Transparent and staining.

ARTISTS' WATER COLOUR

QUINACRIDONE PYRROLIDONE		
PIGMENT DETAIL ON LABEL **YES**	ASTM L'FAST	RATING

CARMINE 020

DANIEL SMITH

A semi-transparent staining colour which handled very well.

Reliable ingredients used. A quality product.

EXTRA-FINE WATERCOLORS

PR176 BENZIMIDAZOLONE CARMINE HF3C WG II (130)		
PIGMENT DETAIL ON LABEL **YES**	WG **II** L'FAST	

PERMANENT CARMINE 233

PÈBÈO

Exposure to light will gradually fade the tint and cause the mass tone to become duller. Use with caution. Semi-transparent.

Company claim ASTM II but seem to be using the wrong ASTM lists.

FRAGONARD ARTISTS' WATER COLOUR

PR5 NAPTHOL 1TR ASTM III (116)		
PIGMENT DETAIL ON LABEL **YES**	ASTM **III** L'FAST	RATING **★★**

CARMINE 525

MIR (JAURENA S.A)

A close imitation of the genuine (and disastrous) substance.

Unfortunately it will fade at a steady rate. Not worth considering if you value your work.

ACUARELA

PR5 NAPTHOL 1TR ASTM III (116)		
PIGMENT DETAIL ON LABEL **YES**	ASTM **III** L'FAST	RATING **★★**

CARMINE GENUINE 637

SENNELIER

A paint produced using one of the most inferior pigments available - genuine Carmine. Previously called 'Carmine Extra Fine Quality' Transp.

EXTRA-FINE WATERCOLOUR

NR4 CARMINE ASTM V (116)		
PIGMENT DETAIL ON LABEL **YES**	ASTM **V** L'FAST	RATING ★

CARMINE 635

SENNELIER

Whatever name it is sold under, PR83:1, (Alizarin Crimson) is as unreliable as ever. Fades, as a tint . Transparent.

Reformulated >

EXTRA-FINE WATERCOLOUR

PR83:1 ALIZARIN CRIMSON ASTM IV (122)		
PIGMENT DETAIL ON LABEL **YES**	ASTM **IV** L'FAST	RATING ★

CARMINE 635

SENNELIER

This is a rather pointless reformulation if resistance to light was ever a consideration.

EXTRA-FINE WATERCOLOUR

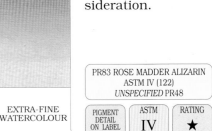

PR83 ROSE MADDER ALIZARIN ASTM IV (122) *UNSPECIFIED PR48*		
PIGMENT DETAIL ON LABEL **YES**	ASTM **IV** L'FAST	RATING ★

CARMINE RED 355

SCHMINCKE

Gives very smooth, even washes and stood up particularly well to our lightfast testing.

Now reformulated, the suspect PR48:4 being replaced by the superb PV19.

Discontinued

HORADAM FINEST ARTISTS' WATER COLOURS

PV19 QUINACRIDONE VIOLET ASTM II (185)		
PIGMENT DETAIL ON LABEL **YES**	ASTM **II** L'FAST	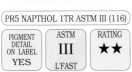

PERMANENT CARMINE 353

SCHMINCKE

Our sample tested very well. Reformulated several years ago (you might still hold an earlier example), the unreliable PR48:4 once added has now been removed. An excellent paint employing a superb pigment. Transparent.

HORADAM FINEST ARTISTS' WATER COLOURS

PV19 QUINACRIDONE VIOLET ASTM II (185)		
PIGMENT DETAIL ON LABEL **YES**	ASTM **II** L'FAST	

CARMINE (QUINACRIDONE) 225

DA VINCI PAINTS

Lightfast pigment giving a paint which was slightly over bound. Our sample washed out very well in thin applications but not so when all heavier.

PERMANENT ARTISTS' WATER COLOR

PV19 QUINACRIDONE VIOLET ASTM II (185)		
PIGMENT DETAIL ON LABEL **YES**	ASTM **II** L'FAST	RATING ★ ★★

CARMINE 509

DALER ROWNEY

Washes out reasonably well but settles out poorly, giving uneven washes. Failed ASTM lightfast testing as a watercolour. Use with caution, if at all. Transparent.

Reformulated >

ARTISTS' WATER COLOUR

PR5 NAPTHOL 1TR ASTM III (116)		
PIGMENT DETAIL ON LABEL **YES**	ASTM **III** L'FAST	RATING ★★

CARMINE 509

DALER ROWNEY

Sample was a little over bound, giving a rather shiny appearance when applied at all heavily.

A reliable replacement and a definite step in the right direction.

ARTISTS' WATER COLOUR

PR170 F3RK-70 NAPHTHOL RED ASTM II (129)		
PIGMENT DETAIL ON LABEL **YES**	ASTM **II** L'FAST	RATING ★ ★★

CARMINE HUE A038

GRUMBACHER

A good imitation of genuine Carmine. Reformulated several years ago and very much improved. The fugitive PR48:2 being replaced by the excellent PV19. Check if you have old paints. Lightfast.

ACADEMY ARTISTS' WATERCOLOR 2ND RANGE

PV19 QUINACRIDONE VIOLET ASTM II (185)		
PIGMENT DETAIL ON LABEL **YES**	ASTM **II** L'FAST	

CARMINE LAKE EXTRA 160

OLD HOLLAND

A combination of pigments let down by the inclusion of the unreliable PR83.

CLASSIC WATERCOLOURS

PV19 QUINACRIDONE VIOLET ASTM II (185) PR88 MRS THIOINDIGOID VIOLET ASTM II (122) PR83 ROSE MADDER, ALIZARIN ASTM IV (122)		
PIGMENT DETAIL ON LABEL **CHEMICAL MAKE UP ONLY**	ASTM **IV** L'FAST	RATING ★

CARMINE 318

TALENS

A rosy red. Washes out well. The PR112 content will tend to fade on exposure making the colour paler and rather more violet. Semi-transparent.

Reformulated >

REMBRANDT ARTISTS' QUALITY EXTRA FINE

PV19 QUINACRIDONE VIOLET ASTM II (185) PR112 NAPHTHOL AS-D ASTM III (127)		
PIGMENT DETAIL ON LABEL **YES**	ASTM **III** L'FAST	RATING ★★

CARMINE 318

TALENS

I have insufficient information on PR264 to offer assessment for this colour. Not a great deal is known about it.

REMBRANDT ARTISTS' QUALITY EXTRA FINE

PR264 COMMON NAME N/K LF NOT OFFERED (137) PV19 QUINACRIDONE VIOLET ASTM II (185)		
PIGMENT DETAIL ON LABEL **YES**	ASTM L'FAST	RATING

CARMINE 606

MAIMERI

Both pigments let this colour down as they fade at a steady rate on exposure. Brushes out very smoothly. Semi-opaque.

STUDIO FINE WATERCOLOURS

Range discontinued

PR146 NAPHTHOL RED WG IV (127) PR9 NAPHTHOL AS-OL ASTM III (117)		
PIGMENT DETAIL ON LABEL YES	WG IV L'FAST	RATING ★

ALIZARIN CARMINE 510

MAIMERI

This pigment is very popular with the manufacturers for some reason. Not suitable for normal artistic expression. Transparent.

ARTISTI EXTRAFINE WATERCOLOURS

Range discontinued

PR83:1 ALIZARIN CRIMSON ASTM IV (122)		
PIGMENT DETAIL ON LABEL YES	ASTM IV L'FAST	RATING ★

CARMINE W211

HOLBEIN

The almost worthless Crimson Alizarin is sold under a variety of names. Unsuitable for normal artistic use. Transparent and staining.

ARTISTS' WATER COLOR

PR83 ROSE MADDER ALIZARIN ASTM IV (122)		
PIGMENT DETAIL ON LABEL YES	ASTM IV L'FAST	RATING ★

CADMIUM RED CARMINE 365

LEFRANC & BOURGEOIS

A case of a superb pigment whose name has been linked to a worthless colorant from the past. Excellent. Opaque.

LINEL EXTRA-FINE ARTISTS' WATERCOLOUR

PR108 CADMIUM RED LIGHT, MEDIUM OR DEEP ASTM I (126)		
PIGMENT DETAIL ON LABEL CHEMICAL MAKE UP ONLY	ASTM I L'FAST	

MADDER CARMINE 329

LEFRANC & BOURGEOIS

Rose Madder Alizarin sold under yet another name. As unreliable as ever. Transparent.

LINEL EXTRA-FINE ARTISTS' WATERCOLOUR

PR83 ROSE MADDER ALIZARIN ASTM IV (122)		
PIGMENT DETAIL ON LABEL CHEMICAL MAKE UP ONLY	ASTM IV L'FAST	RATING ★

CARMINE PERMANENT 331

LEFRANC & BOURGEOIS

Now we are getting somewhere. Reliable violet-reds are available.

This is an excellent all round watercolour. Transparent.

LINEL EXTRA-FINE ARTISTS' WATERCOLOUR

PV19 QUINACRIDONE VIOLET ASTM II (185)		
PIGMENT DETAIL ON LABEL CHEMICAL MAKE UP ONLY	ASTM II L'FAST	

CARMINE RED 1061

LUKAS

PR9 is prone to fading as a wash. A well produced colour which handled smoothly. The pigment details on the tube 'Alizarin Krapplack, org. Monoazo pigment', will not mean very much to many artists.

ARTISTS' WATER COLOUR

PR9 NAPHTHOL AS-OL ASTM III (117) PR176 BENZIMIDAZOLONE CARMINE HF3C WG II (130)		
PIGMENT DETAIL ON LABEL CHEMICAL MAKE UP ONLY	ASTM III L'FAST	RATING ★★

CARAN D'ACHE

FINEST WATERCOLOURS

CARMINE 80

It is not a secret that PR5 makes for an unreliable watercolour. All manufacturers are, or certainly should be, aware of this fact.

PR5 NAPTHOL 1TR ASTM III (116)		
PIGMENT DETAIL ON LABEL YES	ASTM III L'FAST	RATING ★★

ST. PETERSBURG

ARTISTS' WATERCOLOURS

CARMINE 106

Brushed out well but what on earth is it?

The manufacturers do not wish you (or their distributors in the USA and the UK) to have the first idea. Obviously I cannot offer assessments.

INFORMATION ON THE PIGMENTS USED DELIBERATELY WITHHELD FROM THE ARTIST		
PIGMENT DETAIL ON LABEL NO	ASTM L'FAST	RATING

MADDER CARMINE

SCHMINCKE

First rate watercolour paint.

Slightly violet-red. Washes smoothly. Far superior to the usual PR83, Crimson Alizarin found in such colours. Semi-transparent.

HORADAM FINEST ARTISTS' WATER COLOURS

Discontinued

PR178 PERYLENE RED ASTM II (131)		
PIGMENT DETAIL ON LABEL YES	ASTM II L'FAST	

A term used since ancient times to describe a clear violet-red of either animal or vegetable origin.

Nowadays it is used to market similar hues, often regardless of quality. As you will notice, it is yet another way to sell the almost worthless Alizarin Crimson.

A violet - red, mixing complementary is a yellow-green.

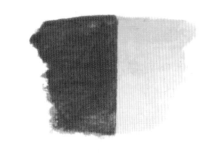

Unless you select with care you could end up with the colour on the right.

CRIMSON LAKE 514

DALER ROWNEY

ARTISTS' WATER COLOUR

Washes well when very thin but difficult to apply when heavy. It will unfortunately also fade rapidly when thin. Transparent.

Discontinued

| PR83:1 ALIZARIN CRIMSON ASTM IV (122) |
| PR88 MRS THIOINDIGOID VIOLET ASTM II (122) |

| PIGMENT DETAIL ON LABEL | ASTM | RATING |
| YES | IV L'FAST | ★ |

CRIMSON LAKE 265

DALER ROWNEY

GEORGIAN WATER COLOUR 2ND RANGE

The pigment used is unreliable.

Our sample faded dramatically. Not suitable for normal artistic use.

Reformulated >

| PR57 LITHOL RUBINE (SODIUM) WG V (120) |

| PIGMENT DETAIL ON LABEL | WG | RATING |
| NO | V L'FAST | ★ |

CRIMSON LAKE 265

DALER ROWNEY

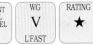

GEORGIAN WATER COLOUR 2ND RANGE

Given the poor reputation of PR210 this would seem to be a pointless reformulation, if resistance to light was ever a consideration.

| PR88 MRS THIOINDIGOID VIOLET ASTM II (122) |
| PR210 PERMANENT RED F6RK WG V (134) |

| PIGMENT DETAIL ON LABEL | WG | RATING |
| NO | V L'FAST | ★ |

CRIMSON LAKE 341

LEFRANC & BOURGEOIS

LINEL EXTRA-FINE ARTISTS' WATERCOLOUR

It would be better to see an excellent pigment like Quinacridone Violet sold under its own name, instead of an obscure title from the past. Transparent.

| PV19 QUINACRIDONE RED ASTM II (185) |

| PIGMENT DETAIL ON LABEL | ASTM | |
| CHEMICAL MAKE UP ONLY | II L'FAST | |

THALO CRIMSON W204

GRUMBACHER

FINEST ARTISTS' WATER COLOR

Rather over bound which made heavier applications difficult. Excellent pigment used. Transparent.

| PV19 QUINACRIDONE RED ASTM II (185) |

| PIGMENT DETAIL ON LABEL | ASTM | RATING |
| YES | II L'FAST | ★★ |

THALO CRIMSON A204

GRUMBACHER

ACADEMY ARTISTS' WATERCOLOR 2ND RANGE

Not all 'student' or second range colours need be temporary. Handles well. Superb pigment. Excellent all round watercolour in any range. Transparent.

| PV19 QUINACRIDONE VIOLET ASTM II (185) |

| PIGMENT DETAIL ON LABEL | ASTM | |
| YES | II L'FAST | |

CRIMSON LAKE 205 (017)

WINSOR & NEWTON

ARTISTS' WATER COLOUR

PR83:1, Alizarin Crimson is sold under one name after another. Fades rapidly as a thin wash. Not suitable for most artistic uses. Transparent.

Discontinued

| PR83:1 ALIZARIN CRIMSON ASTM IV (122) |

| PIGMENT DETAIL ON LABEL | ASTM | RATING |
| YES | IV L'FAST | ★ |

PERMANENT CRIMSON (ALIZARIN HUE) W17

ART SPECTRUM

ARTISTS' WATER COLOUR

Reliable ingredients used to give a well made watercolour which washed out giving clear even washes. Transparent, staining.

| PR176 BENZIMIDAZOLONE CARMINE HF3C WG II (130) |
| *UNSPECIFIED PR101* ASTM I (123/124) |

| PIGMENT DETAIL ON LABEL | WG | |
| YES | II L'FAST | |

SPECTRUM CRIMSON (ALIZARIN HUE) W16

ART SPECTRUM

ARTISTS' WATER COLOUR

Strong, very transparent and lightfast. A well made violet red with many desirable qualities. A staining colour.

| PV19 QUINACRIDONE VIOLET ASTM II (185) |
| PV19 QUINACRIDONE RED ASTM II (185) |

| PIGMENT DETAIL ON LABEL | ASTM | |
| YES | II L'FAST | |

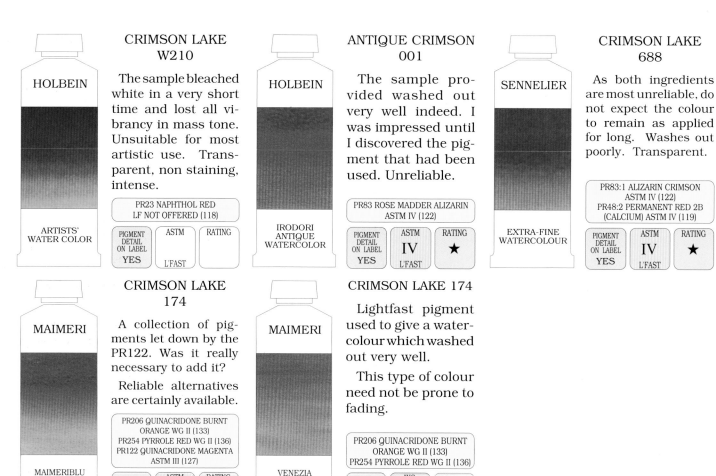

CRIMSON LAKE
W210

HOLBEIN

ARTISTS'
WATER COLOR

The sample bleached white in a very short time and lost all vibrancy in mass tone. Unsuitable for most artistic use. Transparent, non staining, intense.

PR23 NAPHTHOL RED LF NOT OFFERED (118)		
PIGMENT DETAIL ON LABEL **YES**	ASTM L'FAST	RATING

ANTIQUE CRIMSON
001

HOLBEIN

IRODORI
ANTIQUE
WATERCOLOR

The sample provided washed out very well indeed. I was impressed until I discovered the pigment that had been used. Unreliable.

PR83 ROSE MADDER ALIZARIN ASTM IV (122)		
PIGMENT DETAIL ON LABEL **YES**	ASTM **IV** L'FAST	RATING ★

CRIMSON LAKE
688

SENNELIER

EXTRA-FINE
WATERCOLOUR

As both ingredients are most unreliable, do not expect the colour to remain as applied for long. Washes out poorly. Transparent.

PR83:1 ALIZARIN CRIMSON ASTM IV (122) PR48:2 PERMANENT RED 2B (CALCIUM) ASTM IV (119)		
PIGMENT DETAIL ON LABEL **YES**	ASTM **IV** L'FAST	RATING ★

CRIMSON LAKE
174

MAIMERI

MAIMERIBLU
SUPERIOR
WATERCOLOURS

A collection of pigments let down by the PR122. Was it really necessary to add it?

Reliable alternatives are certainly available.

PR206 QUINACRIDONE BURNT ORANGE WG II (133) PR254 PYRROLE RED WG II (136) PR122 QUINACRIDONE MAGENTA ASTM III (127)		
PIGMENT DETAIL ON LABEL **YES**	ASTM **III** L'FAST	RATING ★★

CRIMSON LAKE 174

MAIMERI

VENEZIA
EXTRAFINE
WATERCOLOURS

Lightfast pigment used to give a watercolour which washed out very well.

This type of colour need not be prone to fading.

PR206 QUINACRIDONE BURNT ORANGE WG II (133) PR254 PYRROLE RED WG II (136)		
PIGMENT DETAIL ON LABEL **YES**	WG **II** L'FAST	

Many quite worthless pigments are offered to the artist because of 'demand'. (I have already given my views on why such a demand might exist).

What is disturbing, is that excellent, modern pigments such as PV19 are seldom offered, and then not often under their own name. This presumably is because they 'are not in demand'.

How can the artist create demand when, for example, PV19 is marketed under a meaningless Medieval name, alongside all manner of substances?

A range of clear dyes can be produced from the root of the Madder plant, varying from a rose colour through browns to purple.

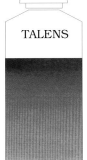

The colouring matter is found between the outer skin and the woody core.

Together with other colorants, Alizarin has been extracted and used as a dye since the time of the ancient Egyptians. It is now produced synthetically and is, unfortunately, in wide use.

For colour mixing purposes Madders are violet reds, usually transparent. Mixing complementary is yellow-green.

SCHMINCKE

HORADAM
FINEST
ARTISTS'
WATER COLOURS

MADDER RED DARK 354

Lightfast pigments. Washed out smoothly. Was previously named 'Madder Lake Deep', (this was unreliable), then 'Madder Lake, (these pigments) now renamed as above. Transparent.

| PV42 QUINACRIDONE MAROON B WG II (187) |
| PR254 PYRROLE RED WG II (136) |

PIGMENT DETAIL ON LABEL	WG	
YES	II L'FAST	

Madder Lake

Modern Alizarin Crimson is a synthetic Madder Lake colour. The term 'Lake' refers to any inert, chalk like, pigment which has been coloured with a dye.

Madder lake is a name under which a variety of violet-reds are marketed.

TALENS

REMBRANDT
ARTISTS'
QUALITY
EXTRA FINE

MADDER LAKE LIGHT 327

Rather over bound sample, only possible in thin washes. Excellent pigment, better sold under its own name rather than an obscure title. Transparent.

Discontinued

| PV19 QUINACRIDONE VIOLET ASTM II (185) |

PIGMENT DETAIL ON LABEL	ASTM	RATING
YES	II L'FAST	★★

TALENS

REMBRANDT
ARTISTS'
QUALITY
EXTRA FINE

PERM MADDER LAKE LT. 321

Reliable pigments. The sample was very over bound, more like a heavy coloured gum than a watercolour paint. Thin washes possible.

| PR254 PYRROLE RED WG II (136) |
| PV19 QUINACRIDONE VIOLET ASTM II (185) |

PIGMENT DETAIL ON LABEL	ASTM	RATING
YES	II L'FAST	★

TALENS

VAN GOGH
2ND RANGE

MADDER LAKE LIGHT 327

The inclusion of PR177, a pigment which failed ASTM testing as a watercolour, lets this product down. An unnecessary inclusion as reliable alternatives are readily available.

| PR177 ANTHRAQUINOID RED ASTM III (130) |
| PV19 QUINACRIDONE VIOLET ASTM II (185) |

PIGMENT DETAIL ON LABEL	ASTM	RATING
YES	III L'FAST	★★

TALENS

REMBRANDT
ARTISTS'
QUALITY
EXTRA FINE

PERM. MADDER LAKE 336

As insufficient is known about PR264 as far as its use in art materials is concerned, I cannot offer assessments.

| PR264 COMMON NAME N/K LF NOT OFFERED (137) |
| PV19 QUINACRIDONE VIOLET ASTM II (185) |

PIGMENT DETAIL ON LABEL	ASTM	RATING
YES	L'FAST	

TALENS

REMBRANDT
ARTISTS'
QUALITY
EXTRA FINE

MADDER LAKE DEEP 331

Good old Alizarin Crimson again. Apply it heavily and it will crack, apply lightly and it will fade. Transparent.

| PR83:1 ALIZARIN CRIMSON ASTM IV (122) |

PIGMENT DETAIL ON LABEL	ASTM	RATING
YES	IV L'FAST	★

TALENS

WATER COLOUR
2ND RANGE

MADDER LAKE DEEP 331

Sample was difficult to use unless in thin washes (very gummy). Unreliable Alizarin Crimson. Transparent.

Range discontinued

| PR83:1 ALIZARIN CRIMSON ASTM IV (122) |

PIGMENT DETAIL ON LABEL	ASTM	RATING
YES	IV L'FAST	★

TALENS

VAN GOGH
2ND RANGE

MADDER LAKE DEEP 331

Yet another pigment in use which has failed ASTM testing as a watercolour. As often mentioned, lightfast alternatives are readily available.

| PR177 ANTHRAQUINOID RED ASTM III (130) |

PIGMENT DETAIL ON LABEL	ASTM	RATING
YES	III L'FAST	★★

St. PETERSBURG

ARTISTS'
WATERCOLOURS

MADDER LAKE 105

The manufacturers have stated, in so many words, that they do not wish you to know what pigments have been used in this paint. Clearly I cannot offer assessments.

| INFORMATION ON THE PIGMENTS USED DELIBERATELY WITHHELD FROM THE ARTIST |

PIGMENT DETAIL ON LABEL	ASTM	RATING
NO	L'FAST	

MADDER ALIZARIN LAKE 523

MAIMERI

It is a pity that the unreliable PR83, Rose Madder Alizarin, was added. Name changed several years ago from 'Rose Madder Alizarin Light'. Transparent.

Range discontinued

PR83 ROSE MADDER ALIZARIN ASTM IV (122) PV19 QUINACRIDONE VIOLET ASTM II (185)		
PIGMENT DETAIL ON LABEL **YES**	ASTM **IV** L'FAST	RATING ★

ARTISTI EXTRAFINE WATERCOLOURS

MADDER LAKE DEEP 358

SCHMINCKE

It is claimed that the PR177 has improved lightfastness. Even if this is the case it will not help matters as the PR83:1 will do most of the damage as it fades.

PR83:1 ALIZARIN CRIMSON ASTM IV (122) PR177 ANTHRAQUINOID RED ASTM III (130)		
PIGMENT DETAIL ON LABEL **YES**	ASTM **IV** L'FAST	RATING ★

HORADAM FINEST ARTISTS' WATER COLOURS

MADDER LAKE LIGHT DEEP 413

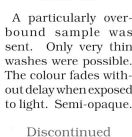

OLD HOLLAND

A particularly over-bound sample was sent. Only very thin washes were possible. The colour fades without delay when exposed to light. Semi-opaque.

Discontinued

PR48:2 PERMANENT RED 2B (CALCIUM) ASTM IV (119)		
PIGMENT DETAIL ON LABEL CHEMICAL MAKE UP ONLY	ASTM **IV** L'FAST	RATING ★

CLASSIC WATERCOLOURS

MADDER (GERANIUM) LAKE LIGHT EXTRA 27

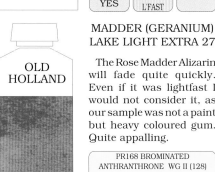

OLD HOLLAND

The Rose Madder Alizarin will fade quite quickly. Even if it was lightfast I would not consider it, as our sample was not a paint but heavy coloured gum. Quite appalling.

PR168 BROMINATED ANTHRANTHRONE WG II (128) PR175 BENZIMIDAZOLONE MAROON WG II (130) PR83 ROSE MADDER ALIZARIN ASTM IV (122)		
PIGMENT DETAIL ON LABEL CHEMICAL MAKE UP ONLY	ASTM **IV** L'FAST	RATING ★

CLASSIC WATERCOLOURS

MADDER LAKE DEEP 414

OLD HOLLAND

The company failed to confirm ingredients. Paint faded at the same rate as Alizarin Crimson. No assessments offered.

Discontinued

PIGMENT DETAIL ON LABEL CHEMICAL MAKE UP ONLY	ASTM L'FAST	RATING

CLASSIC WATERCOLOURS

MADDER (CRIMSON) LAKE DEEP EXTRA 28

OLD HOLLAND

Sample slightly over bound but painted out quite well. The PR83 is unreliable and will spoil the colour.

PV19 QUINACRIDONE VIOLET ASTM II (185) PR83 ROSE MADDER ALIZARIN ASTM IV (122)		
PIGMENT DETAIL ON LABEL CHEMICAL MAKE UP ONLY	ASTM **IV** L'FAST	RATING ★

CLASSIC WATERCOLOURS

ROSE MADDER LAKE 690

SENNELIER

PR83 makes a rather poor watercolour paint. Gives thin washes only. Poor resistance to light. Transparent.

PR83 ROSE MADDER ALIZARIN ASTM IV (122)		
PIGMENT DETAIL ON LABEL **YES**	ASTM **IV** L'FAST	RATING ★

EXTRA-FINE WATERCOLOUR

ROSE DORE MADDER LAKE 691

SENNELIER

May also be called Rose Madder Dore. Under either name it will change dramatically on exposure to light. Fades and discolours. Transparent.

PY13 DIARYLIDE YELLOW AAMX WG IV (38) PR83 ROSE MADDER ALIZARIN ASTM IV (122)		
PIGMENT DETAIL ON LABEL **YES**	ASTM **IV** L'FAST	RATING ★

EXTRA-FINE WATERCOLOUR

DEEP MADDER 346

LEFRANC & BOURGEOIS

Brushes out well but fades even better. Transparent.

PR83 ROSE MADDER ALIZARIN ASTM IV (122)		
PIGMENT DETAIL ON LABEL CHEMICAL MAKE UP ONLY	ASTM **IV** L'FAST	RATING ★

LINEL EXTRA-FINE ARTISTS' WATERCOLOUR

ALIZARIN MADDER LAKE LIGHT 1064

LUKAS

Each of the various pigments is almost equally unsuitable. For temporary work only. Transparent.

PR83 ROSE MADDER ALIZARIN ASTM IV (122) PY12 DIARYLIDE YELLOW AAA WG IV (38) PR3 TOLUIDINE RED WG V (115)		
PIGMENT DETAIL ON LABEL CHEMICAL MAKE UP ONLY	ASTM **IV** L'FAST	RATING ★

ARTISTS' WATER COLOUR

RUBY MADDER 236

PÈBÈO

PR122 stands up to light very well for quite some time but will then start to fade. It has failed ASTM testing as a watercolour. Transparent.

PR122 QUINACRIDONE MAGENTA ASTM III (127)		
PIGMENT DETAIL ON LABEL **YES**	ASTM **III** L'FAST	RATING ★★

FRAGONARD ARTISTS' WATER COLOUR

ALIZARIN MADDER LAKE DEEP 1066

LUKAS

Over bound and unpleasant to use, as earlier samples had been. Unreliable pigments used. Not worth considering.

PR83 ROSE MADDER ALIZARIN ASTM IV (122) PR176 BENZIMIDAZOLONE CARMINE HF3C WG II (130) PV23BS DIOXAZINE PURPLE ASTM III-IV (186)		
PIGMENT DETAIL ON LABEL CHEMICAL MAKE UP ONLY	ASTM **IV** L'FAST	RATING ★

ARTISTS' WATER COLOUR

PINK MADDER 235

PÈBÈO

FRAGONARD
ARTISTS'
WATER
COLOUR

At last the use of a reliable pigment. A well produced, bright pink watercolour. Washes out very well and is dependable. Transparent.

Reformulated >

PR207 QUINACRIDONE SCARLET
WG II (133)

PIGMENT DETAIL ON LABEL	WG	
YES	II L'FAST	

PINK MADDER 235

PÈBÈO

Colour cannot be shown as the new make up of this paint was not provided.

FRAGONARD
ARTISTS'
WATER
COLOUR

I am informed that the pigment make up described below now applies to this colour. Unfortunately the sample provided was made up of PR207, the previous colour.

PR209 QUINACRIDONE RED Y
ASTM II (134)
PY65 ARYLIDE YELLOW RN
ASTM II (44)

PIGMENT DETAIL ON LABEL		RATING
YES		

MADDER LAKE DEEP 2320

UMTON BARVY

ARTISTIC
WATER COLOR

A rather weak violet red produced with an unreliable pigment.

If you use it in your finished work you can expect eventual damage from the light.

PR177 ANTHRAQUINOID RED
ASTM III (130)

PIGMENT DETAIL ON LABEL	ASTM	RATING
NO	III L'FAST	★★

Rose Madder

The yellow flowering madder plant was once extensively cultivated in Europe for the dyes which could be extracted from its roots.

Genuine Rose Madder is a weak form of one of the colouring agents from the root.

Preparing genuine Rose Madder requires a great deal of skill and knowledge on the part of the colourman.

But is it really worth it? A most unreliable colour, easily matched by modern lightfast alternatives.

To my mind it makes little sense to use a colour which will fade quickly, for the sake of a romantic name and a varied history.

The name is mainly used to sell other red pigments, invariably fugitive.

ROSE MADDER 347

LEFRANC & BOURGEOIS

LINEL
EXTRA-FINE
ARTISTS'
WATERCOLOUR

The usual problem when this pigment is employed. Thin, weak paint, rather gummy and tends to deteriorate in colour quickly. Transparent.

Discontinued

PR83 ROSE MADDER ALIZARIN
ASTM IV (122)

PIGMENT DETAIL ON LABEL	ASTM	RATING
CHEMICAL MAKE UP ONLY	IV L'FAST	★

ROSE MADDER QUINACRIDONE 275

DA VINCI PAINTS

PERMANENT
ARTISTS'
WATER COLOR

A violet-red which gives very clear, 'clean' washes due to the clarity of the pigments. Gives bright violets when mixed with Ultramarine Blue. Lightfast.

PV19 QUINACRIDONE VIOLET
ASTM II (185)
PR88 MRS THIOINDIGOID VIOLET
ASTM II (122)

PIGMENT DETAIL ON LABEL	ASTM	
YES	II L'FAST	

ROSE MADDER W212

HOLBEIN

ARTISTS'
WATER COLOR

PR83 is a weaker version of Alizarin Crimson, with all the failings of that pigment. Most unreliable. Washes well. Transparent, semi staining and hard to lift.

PR83 ROSE MADDER ALIZARIN
ASTM IV (122)

PIGMENT DETAIL ON LABEL	ASTM	RATING
YES	IV L'FAST	★

ROSE MADDER ALIZARIN DEEP 524

MAIMERI

ARTISTI
EXTRAFINE
WATERCOLOURS

The unreliable Alizarin Crimson previously included has been replaced by the superb PV 19. Now an excellent paint. Transparent.

Range discontinued

PV19 QUINACRIDONE VIOLET
ASTM II (185)
PO43 PERINONE ORANGE
WG II (96)

PIGMENT DETAIL ON LABEL	ASTM	
YES	II L'FAST	

ROSE MADDER (ALIZARIN) DEEP 525

MAIMERI

ARTISTI
EXTRAFINE
WATERCOLOURS

There would seem to be little Ultramarine Blue involved. The paint faded almost back to white paper after short exposure. Transparent.

Range discontinued

PR83:1 ALIZARIN CRIMSON
ASTM IV (122)
PB29 ULTRAMARINE BLUE A
ASTM I (215)

PIGMENT DETAIL ON LABEL	ASTM	RATING
YES	IV L'FAST	★

ROSE MADDER (ALIZARIN) DEEP 611

MAIMERI

STUDIO FINE
WATERCOLOURS
2ND RANGE

Suitable for temporary sketch work perhaps as it fades on exposure.

Transparent.

Range discontinued

PR83:1 ALIZARIN CRIMSON
ASTM IV (122)
PV23 DIOXAZINE PURPLE
ASTM III-IV (186)

PIGMENT DETAIL ON LABEL	ASTM	RATING
YES	IV L'FAST	★

ROSE MADDER GENUINE 100

DANIEL SMITH

EXTRA-FINE WATERCOLORS

This is an extremely bright violet red, for a while that is. This pigment failed ASTM testing, and with a very poor rating.

NR9 NATURAL ROSE MADDER ASTM IV (117)

PIGMENT DETAIL ON LABEL	ASTM	RATING
YES	IV L'FAST	★

ROSE MADDER (QUINACRIDONE) 121

AMERICAN JOURNEY

PROFESSIONAL ARTISTS' WATER COLOR

Sample was rather over bound and more suited to thinner applications.

Reliable pigments have been used.

PV19 QUINACRIDONE VIOLET ASTM II (185)
PR88 MRS THIOINDIGOID VIOLET ASTM II (122)

PIGMENT DETAIL ON LABEL	ASTM	RATING
YES	II L'FAST	★★

ROSE MADDER GENUINE 587

WINSOR & NEWTON

ARTISTS' WATER COLOUR

Sample was very thin and gummy. Only of use as a light wash. An unreliable pigment prone to rapid fading and discoloration. Transparent.

NR9 NATURAL ROSE MADDER ASTM IV (117)

PIGMENT DETAIL ON LABEL	ASTM	RATING
YES	IV L'FAST	★

ROSE MADDER ALIZARIN 581

WINSOR & NEWTON

ARTISTS' WATER COLOUR

Washes out well but fades at a rapid rate. As the company knows full well it will.

Transparent.

Discontinued

PR83:1 ALIZARIN CRIMSON ASTM IV (122)

PIGMENT DETAIL ON LABEL	ASTM	RATING
YES	IV L'FAST	★

ROSE MADDER (ALIZARIN LAKE) 580

WINSOR & NEWTON

COTMAN WATER COLOURS 2ND RANGE

Unpleasant to use unless in very thin washes. Suitable for temporary sketch work perhaps. The colour will be temporary anyway. Transparent.

Reformulated >

PR83:1 ALIZARIN CRIMSON ASTM IV (122)

PIGMENT DETAIL ON LABEL	ASTM	RATING
YES	IV L'FAST	★

ROSE MADDER HUE 580

WINSOR & NEWTON

COTMAN WATER COLOURS 2ND RANGE

A rather weak colour which washed out well in thin applications but difficult to apply any heavier, even in medium layers.

PR206 QUINACRIDONE BURNT ORANGE WG II (133)

PIGMENT DETAIL ON LABEL	WG	RATING
YES	II L'FAST	★★

ROSE MADDER W182

GRUMBACHER

FINEST ARTISTS' WATER COLOR

Sample was rather over bound. Painted out well in thin washes only. This would not concern me as I would not even consider a material which is known to fade rapidly.

PR83 ROSE MADDER ALIZARIN ASTM IV (122)

PIGMENT DETAIL ON LABEL	ASTM	RATING
YES	IV L'FAST	★

ROSE MADDER A182

GRUMBACHER

ACADEMY ARTISTS' WATERCOLOR 2ND RANGE

A weak colour which fades rapidly when applied thinly. Heavier applications tend to crack. Transparent.

PR83 ROSE MADDER ALIZARIN ASTM IV (122)

PIGMENT DETAIL ON LABEL	ASTM	RATING
YES	IV L'FAST	★

MADDER LAKE LIGHT 356

SCHMINCKE

HORADAM FINEST ARTISTS' WATER COLOURS

Sample was particularly gummy and impossible to use unless very thinly applied. Faded without prompting. Semi-opaque.

Seems to be called 'Rose Madder 356' in catalogue.

PR83:1 ALIZARIN CRIMSON ASTM IV (122)
PR48:4 PERMANENT RED 2B (MANGANESE) WG II-III (119)

PIGMENT DETAIL ON LABEL	ASTM	RATING
YES	IV L'FAST	★

ROSE MADDER 329

TALENS

REMBRANDT ARTISTS' QUALITY EXTRA FINE

An excellent pigment. Sample was rather over bound. Ideal replacement for the usual inferior pigments sold under this name. It can be done. Transparent.

Discontinued

PV19 QUINACRIDONE VIOLET ASTM II (185)

PIGMENT DETAIL ON LABEL	ASTM	RATING
YES	II L'FAST	★ ★★

ROSE MADDER W18

ART SPECTRUM

ARTISTS' WATER COLOUR

Sample was over bound and washed out with difficulty in all but thin washes. Transparent and staining. Pigment is reliable.

PV19 QUINACRIDONE VIOLET ASTM II (185)

PIGMENT DETAIL ON LABEL	ASTM	RATING
YES	II L'FAST	★★

ROSE MADDER HUE 346

SCHMINCKE

HORADAM FINEST ARTISTS' WATER COLOURS

Previously known as 'Permanent Rose'. Brushes very well giving smooth gradated washes. The pigment used is very reliable. Transparent.

Discontinued

PV19 QUINACRIDONE VIOLET ASTM II (185)

PIGMENT DETAIL ON LABEL	ASTM	
YES	II L'FAST	

ROSE MADDER (HUE) 563

DALER ROWNEY

Unpleasant to handle unless in extremely thin washes. But why worry, the colour will disappear unless you live down a coal mine.

Reformulated >

| PR83:1 ALIZARIN CRIMSON ASTM IV (122) |
| PR81 RHODAMINE Y WG V (121) |

PIGMENT DETAIL ON LABEL	WG	RATING
NO	IV L'FAST	★

GEORGIAN WATER COLOUR 2ND RANGE

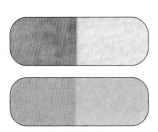

Earlier artists were only too pleased to drop unreliable pigments in favour of more lightfast products. Do not be taken in by the marketing of 'tradition'.

ROSE MADDER HUE

DALER ROWNEY

Reformulated but hardly worth the effort as the colour will still fade rapidly, thanks to the continued inclusion of PR83:1.

| PR83:1 ALIZARIN CRIMSON ASTM IV (122) |
| PV19 QUINACRIDONE VIOLET ASTM II (185) |

PIGMENT DETAIL ON LABEL	ASTM	RATING
NO	IV L'FAST	★

GEORGIAN WATER COLOUR 2ND RANGE

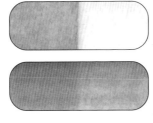

Some very poor pigments are sold as 'Madders'. The name and most of the products should pass gracefully into history.

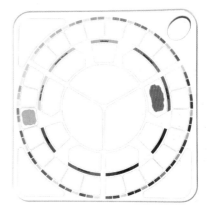

If using any of the Madders, treat them as violet-reds for mixing purposes.

The complementary, both visually and when mixing, is a yellow-green.

It makes little difference if the yellow-green is bright, of mid intensity or is dull. In each case it will absorb part of the violet red light in a mix, dulling and darkening that colour. Please contact us at the School of Colour if you need any help with your colour mixing.

The Quinacridones

For very many years the standard violet-red has been Alizarin Crimson. As I have mentioned elsewhere, it is a disastrous substance which is unfit for serious artistic use.

To my mind the ideal replacement is Quinacridone violet with Quinacridone red being a close follow up.

In previous editions I have called on manufacturers to use the actual name of the colorant instead of disguising it behind a fancy or trade name.

Once artists become familiar with the correct name of a quality pigment they will start to look for it.

It is encouraging to see that this is starting to happen with this particular colorant.

What we have to watch out for however, is that in time, fugitive pigments such as the dreaded Alizarin Crimson are not sneaked in under this name.

If you think that I am too suspicious and this is not liable to happen, you have only just opened the book at this page.

It will be a long time before the fugitive reds are driven out due to commercial pressures from the artist, but it is starting to happen.

QUINACRIDONE ROSE 092

DANIEL SMITH

PV19 Quinacridone Violet is a pigment worth looking out for. When well made, the resulting paint is bright, transparent and lightfast.

This is a very good example.

| PV19 QUINACRIDONE VIOLET ASTM II (185) |

PIGMENT DETAIL ON LABEL	ASTM	
YES	II L'FAST	

EXTRA-FINE WATERCOLORS

QUINACRIDONE RED 091

DANIEL SMITH

A very reliable violet red pigment which makes up into a superb transparent paint. Handled extremely well. Recommended.

| PV19 QUINACRIDONE VIOLET ASTM II (185) |

PIGMENT DETAIL ON LABEL	ASTM	
YES	II L'FAST	

EXTRA-FINE WATERCOLORS

QUINACRIDONE PINK 095

DANIEL SMITH

The sample provided washed out very well in mid to thin applications but dried to a slight shine in heavier layers. A reliable, transparent, staining violet red.

| PV42 QUINACRIDONE MAROON B WG II (187) |

PIGMENT DETAIL ON LABEL	WG	RATING
YES	I L'FAST	★ ★★

EXTRA-FINE WATERCOLORS

QUINACRIDONE ROSE 554

MAIMERI

Washes out particularly well over the full range. A bright, clear violet-red. Dependable. Transparent.

Range discontinued

PV19 QUINACRIDONE VIOLET
ASTM II (185)

ARTISTI
EXTRAFINE
WATERCOLOURS

| PIGMENT DETAIL ON LABEL **YES** | ASTM **II** L'FAST | |

QUINACRIDONE ROSE 336

TALENS

A lightfast pigment has been employed but this does not make it a quality paint. Rather over bound, our sample was unpleasant to use when at all heavy.

PV19 QUINACRIDONE VIOLET
ASTM II (185)

REMBRANDT
ARTISTS'
QUALITY
EXTRA FINE

| PIGMENT DETAIL ON LABEL **YES** | ASTM **II** L'FAST | RATING ★★ |

QUINACRIDONE ROSE 336

TALENS

A first class ingredient. It is encouraging to see this pigment in greater use. It is certainly far superior to Alizarin Crimson, the material that it seems to be replacing.

PV19 QUINACRIDONE VIOLET
ASTM II (185)

VAN GOGH
2ND RANGE

| PIGMENT DETAIL ON LABEL **YES** | ASTM **II** L'FAST | |

QUINACRIDONE RED 528

DALER ROWNEY

Smooth, fairly clear washes are obtainable from this watercolour. A quality product employing a first rate pigment. Reliable.

Discontinued

PR209 QUINACRIDONE RED Y
ASTM II (134)

ARTISTS'
WATER COLOUR

| PIGMENT DETAIL ON LABEL **YES** | ASTM **II** L'FAST | |

QUINACRIDONE RED 155

M.GRAHAM & CO.

Handled very well at all strengths. A reliable pigment employed to make a quality paint.

PR209 QUINACRIDONE RED Y
ASTM II (134)

ARTISTS'
WATERCOLOR

| PIGMENT DETAIL ON LABEL **YES** | ASTM **II** L'FAST | |

QUINACRIDONE ROSE 156

M.GRAHAM & CO.

A strong, transparent violet red. It will give bright violets with Ultramarine Blue and darkens beautifully with Phthalocyanine Green or Viridian. A first class, well made product.

PV19 QUINACRIDONE VIOLET
ASTM II (185)

ARTISTS'
WATERCOLOR

| PIGMENT DETAIL ON LABEL **YES** | ASTM **II** L'FAST | |

QUINACRIDONE CORAL 088

DANIEL SMITH

A good balance of binder and pigment, our sampled handled beautifully.

An excellent violet red. Transparent and dependable.

PR209 QUINACRIDONE RED Y
ASTM II (134)

EXTRA-FINE
WATERCOLORS

| PIGMENT DETAIL ON LABEL **YES** | ASTM **II** L'FAST | |

QUINACRIDONE RED 002

UTRECHT

A bright 'clean' violet red which gave very clear washes. A first class product. Has passed ASTM testing as a watercolour.

PR209 QUINACRIDONE RED Y
ASTM II (134)

PROFESSIONAL
ARTISTS'
WATER COLOR

| PIGMENT DETAIL ON LABEL **YES** | ASTM **II** L'FAST | |

QUINACRIDONE RED 548

WINSOR & NEWTON

One of the recently introduced colours. The pigment employed is lightfast and gave a watercolour which was most pleasant to handle.

PR209 QUINACRIDONE RED Y
ASTM II (134)

ARTISTS'
WATER COLOUR

| PIGMENT DETAIL ON LABEL **YES** | ASTM **II** L'FAST | |

Scarlet

The term Scarlet has come to be no more than yet another name under which to sell more red paint. It does not seem to matter whether it is transparent or opaque or whether it is lightfast or fugitive.

Choose carefully and purchase the pigment used rather than the colour name or brand.

This name (plus certain others), could well be dropped to lessen the confusion of colour descriptions.

When mixing, first decide on the type of red.

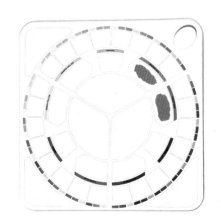

SCARLET 274

MAIMERI — VENEZIA EXTRAFINE WATERCOLOURS

PR254 has a good reputation as far as its resistance to light is concerned. A reasonably bright red which gave smooth, even washes.

PR254 PYRROLE RED WG II (136)		
PIGMENT DETAIL ON LABEL **YES**	WG **II** L'FAST	

PERMANENT SCARLET 234

PÈBÈO — FRAGONARD ARTISTS' WATER COLOUR

Label claims an ASTM lightfast rating of I. Neither pigment has been given this rating as a watercolour. Both appearing on the list of 'unapproved' watercolour pigments. Sample faded as expected. Semi-opaque.

PR9 NAPHTHOL AS-OL ASTM III (117) PR5 NAPTHOL 1TR ASTM III (116)		
PIGMENT DETAIL ON LABEL **YES**	ASTM **III** L'FAST	RATING ★★

SCARLET LAKE W222

HOLBEIN — ARTISTS' WATER COLOR

PR48:1 gives a reasonable range of values but is very prone to fading on exposure. Sample deteriorated quickly. Semi-opaque.

PR48:1 PERMANENT RED 2B (BARIUM) WG V (118)		
PIGMENT DETAIL ON LABEL **YES**	WG **V** L'FAST	RATING ★

SCARLET - ALIZARIN 569

DALER ROWNEY — ARTISTS' WATER COLOUR

Our sample faded dramatically. This was to be expected as such inferior ingredients were used. Transparent.

Discontinued

PR83:1 ALIZARIN CRIMSON ASTM IV (122) PR4 CHLORINATED PARA RED WG V (115)		
PIGMENT DETAIL ON LABEL **YES**	ASTM **IV** L'FAST	RATING ★

SCARLET - LAKE 571

DALER ROWNEY — ARTISTS' WATER COLOUR

The failings of PR3, Toluidine Red are well known. It is discouraging to see it used by such a respected company. Semi-opaque.

Discontinued

PR3 TOLUIDINE RED WG V (115)		
PIGMENT DETAIL ON LABEL **YES**	WG **V** L'FAST	RATING ★

SCARLET LAKE 571

DALER ROWNEY — GEORGIAN WATER COLOUR 2ND RANGE

Once painted out and exposed to light, it will be a race to see which pigment self destructs first. Semi-opaque.

PR83:1 ALIZARIN CRIMSON ASTM IV (122) PR3 TOLUIDINE RED WG V (115)		
PIGMENT DETAIL ON LABEL **NO**	ASTM **IV** L'FAST	RATING ★

SCARLET-LAKE 363

SCHMINCKE — HORADAM FINEST ARTISTS' WATER COLOURS

Pr254 has not yet been tested under ASTM conditions as a watercolour. However, it rated very well in oils and acrylics. Sample washed out smoothly. A superb paint. According to the catalogue this might be well be called 'Scarlet Red'.

PR254 PYRROLE RED WG II (136)		
PIGMENT DETAIL ON LABEL **YES**	WG **II** L'FAST	

SCARLET - LAKE 603 (044)

WINSOR & NEWTON — ARTISTS' WATER COLOUR

A fine, vibrant orange red which is reasonably strong tinctorially.

Quite transparent in thin washes. Excellent all round watercolour. Semi-opaque.

PR188 NAPHTHOL AS ASTM II (132)		
PIGMENT DETAIL ON LABEL **YES**	ASTM **II** L'FAST	

CADMIUM - SCARLET 106

WINSOR & NEWTON — ARTISTS' WATER COLOUR

A first rate watercolour paint. Very bright, vibrant orange-red. Handled beautifully over full range of values. Excellent. Opaque.

PR108 CADMIUM RED LIGHT, MEDIUM OR DEEP ASTM I (126)		
PIGMENT DETAIL ON LABEL **YES**	ASTM **I** L'FAST	

CADMIUM - SCARLET 5707

HUNTS

Without cooperation from the company I did not have a sample to examine. A pity as ingredients are first class.

Discontinued

CADMIUM SULFOSELENIDE COPRECIPITATED WITH BARIUM SULFATE		
PIGMENT DETAIL ON LABEL **NO**	ASTM **L'FAST**	RATING

SPEEDBALL PROFESSIONAL WATERCOLOURS

SCARLET LAKE A189

GRUMBACHER

This colour was reformulated a few years ago and much improved. Check ingredients if purchasing old stock. Semi-transparent. Now reliable.

PO36 BENZIMIDAZOLONE ORANGE HL ASTM I (95) PR170 F3RK-70 NAPHTHOL RED ASTM II (129)		
PIGMENT DETAIL ON LABEL **YES**	ASTM **II** **L'FAST**	

ACADEMY ARTISTS' WATERCOLOR 2ND RANGE

SCARLET LAKE EXTRA 157

OLD HOLLAND

Rather gummy, our sample handled fairly well as a thin wash but was otherwise difficult to work. Reliable ingredients.

PR168 BROMINATED ANTHRANTHRONE WG II (128) PR209 QUINACRIDONE RED Y ASTM II (134)		
PIGMENT DETAIL ON LABEL CHEMICAL MAKE UP ONLY	ASTM **II** **L'FAST**	RATING **★★**

CLASSIC WATERCOLOURS

QUINACRIDONE BURNT SCARLET 087

DANIEL SMITH

A neutralised, or dulled red. A reliable pigment has been used which gives rise to an excellent watercolour paint. Transparent and staining.

PR206 QUINACRIDONE BURNT ORANGE WG II (133)		
PIGMENT DETAIL ON LABEL **YES**	WG **II** **L'FAST**	

EXTRA-FINE WATERCOLORS

DEEP SCARLET 033

DANIEL SMITH

The pigment used in this paint has a very good reputation. Gave very even, semi-transparent washes.

PR175 BENZIMIDAZOLONE MAROON WG II (130)		
PIGMENT DETAIL ON LABEL **YES**	WG **II** **L'FAST**	

EXTRA-FINE WATERCOLORS

PERYLENE SCARLET 076

DANIEL SMITH

Although many of the red watercolours on the market tend to fade or darken, there are many examples, such as this, of reds which are reliable. Handled very smoothly. A quality product.

PR149 PERYLENE RED BL WG II (128)		
PIGMENT DETAIL ON LABEL **YES**	WG **II** **L'FAST**	

EXTRA-FINE WATERCOLORS

CADMIUM SCARLET 213

DA VINCI PAINTS

A newly introduced colour. If you have the Cadmium Red Light from this company you will not really need this. Same pigment and virtually the same colour.

PR108 CADMIUM RED LIGHT, MEDIUM OR DEEP ASTM I (126)		
PIGMENT DETAIL ON LABEL **YES**	ASTM **I** **L'FAST**	

PERMANENT ARTISTS' WATER COLOR

CADMIUM SCARLET 028

AMERICAN JOURNEY

Cadmium Red Light under another name. The sample handled very well. This pigment, in a well made paint, will cover well and also give fairly clear washes.

PR108 CADMIUM RED LIGHT, MEDIUM OR DEEP ASTM I (126)		
PIGMENT DETAIL ON LABEL **YES**	ASTM **I** **L'FAST**	

PROFESSIONAL ARTISTS' WATER COLOR

SCARLET 104

ST. PETERSBURG

ARTISTS' WATERCOLOURS

Literature published by the UK and USA distributors describe this range as being of 'Artists' quality and throw a lot of hype our way.

But they, like all of us, do not have a clue as to the ingredients.

THE COMPANY DELIBERATELY KEEP DETAILS OF THE PIGMENT OR PIGMENTS USED AWAY FROM THE ARTIST.		
PIGMENT DETAIL ON LABEL **NO**	ASTM **L'FAST**	RATING

Vermilion

Exactly where and when Vermilion was discovered is uncertain. The first definite reference is contained in an 8th Century Greek manuscript.

A combination of mercury and sulphur, it has played an important part in the history of painting.

Genuine Vermilion is unpredict-able and can become very dark, almost black, when exposed to light and the atmosphere.

Now more than adequately replaced by the trouble free Cadmium Red Light.

An orange-red, mixing complementary is a blue-green.

VERMILION 520

The failings of this pigment during ASTM testing should be known to all artist paint manufacturers. A bright red, but this is temporary. Unreliable.

MIR (JAURENA S.A)

ACUARELA

PR112 NAPHTHOL AS-D ASTM III (127)		
PIGMENT DETAIL ON LABEL YES	ASTM **III** L'FAST	RATING ★★

VERMILION NO 10

Although this range is described as being for the use of artists, I can find no reference of the pigments used in the literature supplied or on the label. Take a chance if you

PENTEL

WATER COLORS

PIGMENT INFORMATION NOT GIVEN ON THE PRODUCT LABEL OR IN THE LITERATURE SUPPLIED.		
PIGMENT DETAIL ON LABEL NO	ASTM L'FAST	RATING

VERMILION No 10

A bright orange-red which washed out well. What it is I haven't a clue as the company do not seem to publish any details of the pigments employed in its production.

PENTEL (POLY TUBE)

PIGMENT INFORMATION NOT GIVEN ON THE PRODUCT LABEL OR IN THE LITERATURE SUPPLIED.		
PIGMENT DETAIL ON LABEL NO	ASTM L'FAST	RATING

VERMILION 5706

PR112 has failed ASTM testing as a watercolour.

Surely all art material manufacturers know this, or they certainly should. Unreliable.

HUNTS

SPEEDBALL PROFESSIONAL WATERCOLOURS

PR112 NAPHTHOL AS-D ASTM III (127)		
PIGMENT DETAIL ON LABEL YES	ASTM **III** L'FAST	RATING ★★

VERMILION EXTRA 148

The sample tube supplied was under considerable pressure and part emptied itself on opening. This suggests an incompatibility between the pigment and the binder. Little is known about the pigment. Assessments not offered.

OLD HOLLAND

CLASSIC WATERCOLOURS

PR260 COMMON NAME N/K LF NOT OFFERED (137)		
PIGMENT DETAIL ON LABEL CHEMICAL MAKE UP ONLY	ASTM L'FAST	RATING

VERMILION RED 243

The claimed ASTM lightfast rating of I would appear to be incorrect. As an acrylic, PR9 would be ASTM I, as an oil ASTM II, but watercolours can be another matter altogether. Semi-opaque. Unreliable.

PÈBÈO

FRAGONARD ARTISTS' WATER COLOUR

PY65 ARYLIDE YELLOW RN ASTM II (44) PR9 NAPHTHOL AS-OL ASTM III (117)		
PIGMENT DETAIL ON LABEL YES	ASTM **III** L'FAST	RATING ★★

VERMILION LIGHT HUE W228

PR112 has failed ASTM lightfast testing as a watercolour and is on the 'unapproved' list.

I know it, they know it and so do you.

GRUMBACHER

FINEST ARTISTS' WATER COLOR

PR112 NAPHTHOL AS-D ASTM III (127) PY3 ARYLIDE YELLOW 10G ASTM II (37)		
PIGMENT DETAIL ON LABEL YES	ASTM **III** L'FAST	RATING ★★

VERMILION DEEP HUE W226

The inferior PR112 once used has been replaced by reliable pigments. Check ingredients if purchasing to ensure new stock. Excellent.

GRUMBACHER

FINEST ARTISTS' WATER COLOR

PR188 NAPHTHOL AS ASTM II (132) PR170 F3RK-70 NAPHTHOL RED ASTM II (129) PR209 QUINACRIDONE RED Y ASTM II (134) PY3 ARYLIDE YELLOW 10G ASTM II (37)		
PIGMENT DETAIL ON LABEL YES	ASTM **II** L'FAST	

VERMILION A224 HUE

Both pigments are reliable, having passed the stringent test requirements of the ASTM. Painted out well and gave extremely smooth, even washes. Excellent.

GRUMBACHER

ACADEMY ARTISTS' WATERCOLOR 2ND RANGE

PR188 NAPHTHOL AS ASTM II (132) PY65 ARYLIDE YELLOW RN ASTM II (44)		
PIGMENT DETAIL ON LABEL YES	ASTM **II** L'FAST	

ORGANIC VERMILION 064

DANIEL SMITH

A semi-transparent staining colour. A reliable watercolour which you will find brushes out with ease into a series of fairly clear, even washes.

EXTRA-FINE WATERCOLORS

PR188 NAPHTHOL AS ASTM II (132)

| PIGMENT DETAIL ON LABEL YES | ASTM II L'FAST | |

VERMILION HUE W219

HOLBEIN

Our sample faded dramatically. This is to be expected given the nature of the pigments. Why offer them?

ARTISTS' WATER COLOR

PR48:1 PERMANENT RED 2B (BARIUM) WG V (118)
PY81 DIARYLIDE YELLOW H10G LF NOT OFFERED (45)
PR112 NAPHTHOL AS-D ASTM III (127)

| PIGMENT DETAIL ON LABEL YES | WG V L'FAST | RATING ★ |

VERMILION W218

HOLBEIN

This is more like it. A bright, vibrant orange red. Excellent pigment used and it shows in the finished paint. I suppose that it is not described as a 'Hue', as it should be, or there would be two colours with the same name in the range. Opaque.

ARTISTS' WATER COLOR

PR108 CADMIUM RED LIGHT, MEDIUM OR DEEP ASTM I (126)

| PIGMENT DETAIL ON LABEL YES | ASTM I L'FAST | |

VERMILION LIGHT 548

MAIMERI

If you are looking for a dull, greyed brown, paint out first with this bright orange red and expose to light and the atmosphere. Opaque.

Range discontinued

ARTISTI EXTRAFINE WATERCOLOURS

PR106 VERMILION ASTM III (126)

| | ASTM III L'FAST | RATING ★★ |

VERMILION DEEP 549

MAIMERI

It has been known since antiquity that genuine Vermilion darkens on exposure. More so than the ASTM rating would indicate. Opaque.

Range discontinued

ARTISTI EXTRAFINE WATERCOLOURS

PR106 VERMILION ASTM III (126)

| | ASTM III L'FAST | RATING ★★ |

VERMILION (HUE) 629

MAIMERI

A bright pink. Handles very well giving smooth gradated washes. Reformulated few years ago (was PR3, page 115) but still very unreliable. A step in the right direction? Semi-opaque.

Range discontinued

STUDIO FINE WATERCOLOR 2ND RANGE

PR112 NAPHTHOL AS-D ASTM III (127)
PY1 ARYLIDE YELLOW G ASTM V (37)

| | ASTM V L'FAST | RATING ★ |

VERMILION (HUE) 289

DA VINCI PAINTS

An imitation Vermilion, as indicated by the word 'Hue' in the title. Not as orange as traditional Vermilion. Semi-opaque but gives reasonably clear tints. Lightfast.

PERMANENT ARTISTS' WATER COLOR

PR188 NAPHTHOL AS ASTM II (132)
PO62 BENZIMIDAZOLONE ORANGE H5G ASTM II (97)

| PIGMENT DETAIL ON LABEL YES | ASTM II L'FAST | |

VERMILION 365

SCHMINCKE

PR255 has now been tested under ASTM conditions and found to be lightfast.

An excellent all round watercolour.

HORADAM FINEST ARTISTS' WATER COLOURS

PR255 COMMON NAME N/K ASTM I (136)

| PIGMENT DETAIL ON LABEL YES | ASTM I L'FAST | |

FRENCH VERMILION 675

SENNELIER

Reformulated several years ago and much improved. Check pgts. if purchasing to ensure new stock. An excellent opaque orange red, far superior to genuine Vermilion.

EXTRA-FINE WATERCOLOUR

PR242 SANDORIN SCARLET 4RF WG II (135)

| PIGMENT DETAIL ON LABEL YES | WG II L'FAST | |

VERMILION 311

TALENS

Neither pigment is reliable. Our sample faded as a tint and became darker and duller in mass tone. Semi-opaque.

Reformulated >

REMBRANDT ARTISTS' QUALITY EXTRA FINE

PR4 CHLORINATED PARA RED WG V (115)
PY74LF ARYLIDE YELLOW 5GX ASTM III (44)

| PIGMENT DETAIL ON LABEL YES | WG V L'FAST | RATING ★ |

VERMILION 311

TALENS

Much improved over the earlier version, (please see left). Lightfast pigments giving a paint which is a pleasure to use.

REMBRANDT ARTISTS' QUALITY EXTRA FINE

PR255 COMMON NAME N/K ASTM I (136)
PY154 BENZIMIDAZOLONE YELLOW H3G ASTM II (50)

| PIGMENT DETAIL ON LABEL YES | ASTM II L'FAST | |

VERMILION 310

TALENS

Good, smooth even washes. A second range (often called 'Students' quality), paint which is lightfast and handles very well.

VAN GOGH 2ND RANGE

PR255 COMMON NAME N/K ASTM I (136)
PY154 BENZIMIDAZOLONE YELLOW H3G ASTM II (50)

| PIGMENT DETAIL ON LABEL YES | ASTM II L'FAST | |

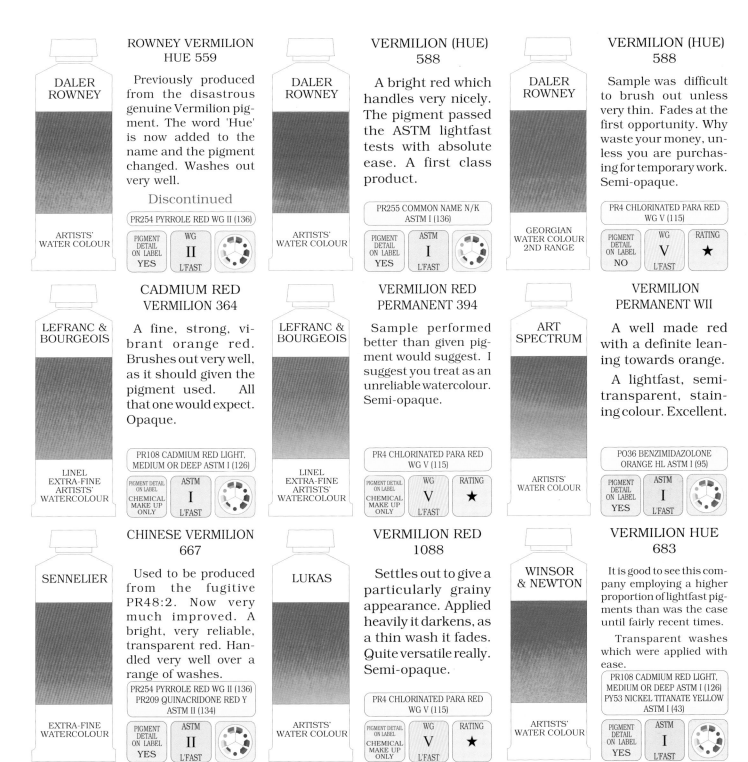

ROWNEY VERMILION HUE 559

DALER ROWNEY

Previously produced from the disastrous genuine Vermilion pigment. The word 'Hue' is now added to the name and the pigment changed. Washes out very well.

Discontinued

PR254 PYRROLE RED WG II (136)

ARTISTS' WATER COLOUR

PIGMENT DETAIL ON LABEL	WG	
YES	II L'FAST	

VERMILION (HUE) 588

DALER ROWNEY

A bright red which handles very nicely. The pigment passed the ASTM lightfast tests with absolute ease. A first class product.

PR255 COMMON NAME N/K ASTM I (136)

ARTISTS' WATER COLOUR

PIGMENT DETAIL ON LABEL	ASTM	
YES	I L'FAST	

VERMILION (HUE) 588

DALER ROWNEY

Sample was difficult to brush out unless very thin. Fades at the first opportunity. Why waste your money, unless you are purchasing for temporary work. Semi-opaque.

PR4 CHLORINATED PARA RED WG V (115)

GEORGIAN WATER COLOUR 2ND RANGE

PIGMENT DETAIL ON LABEL	WG	RATING
NO	V L'FAST	★

CADMIUM RED VERMILION 364

LEFRANC & BOURGEOIS

A fine, strong, vibrant orange red. Brushes out very well, as it should given the pigment used. All that one would expect. Opaque.

PR108 CADMIUM RED LIGHT, MEDIUM OR DEEP ASTM I (126)

LINEL EXTRA-FINE ARTISTS' WATERCOLOUR

PIGMENT DETAIL ON LABEL CHEMICAL MAKE UP ONLY	ASTM	
	I L'FAST	

VERMILION RED PERMANENT 394

LEFRANC & BOURGEOIS

Sample performed better than given pigment would suggest. I suggest you treat as an unreliable watercolour. Semi-opaque.

PR4 CHLORINATED PARA RED WG V (115)

LINEL EXTRA-FINE ARTISTS' WATERCOLOUR

PIGMENT DETAIL ON LABEL CHEMICAL MAKE UP ONLY	WG	RATING
	V L'FAST	★

VERMILION PERMANENT WII

ART SPECTRUM

A well made red with a definite leaning towards orange.

A lightfast, semi-transparent, staining colour. Excellent.

PO36 BENZIMIDAZOLONE ORANGE HL ASTM I (95)

ARTISTS' WATER COLOUR

PIGMENT DETAIL ON LABEL	ASTM	
YES	I L'FAST	

CHINESE VERMILION 667

SENNELIER

Used to be produced from the fugitive PR48:2. Now very much improved. A bright, very reliable, transparent red. Handled very well over a range of washes.

PR254 PYRROLE RED WG II (136)
PR209 QUINACRIDONE RED Y ASTM II (134)

EXTRA-FINE WATERCOLOUR

PIGMENT DETAIL ON LABEL	ASTM	
YES	II L'FAST	

VERMILION RED 1088

LUKAS

Settles out to give a particularly grainy appearance. Applied heavily it darkens, as a thin wash it fades. Quite versatile really. Semi-opaque.

PR4 CHLORINATED PARA RED WG V (115)

ARTISTS' WATER COLOUR

PIGMENT DETAIL ON LABEL CHEMICAL MAKE UP ONLY	WG	RATING
	V L'FAST	★

VERMILION HUE 683

WINSOR & NEWTON

It is good to see this company employing a higher proportion of lightfast pigments than was the case until fairly recent times.

Transparent washes which were applied with ease.

PR108 CADMIUM RED LIGHT, MEDIUM OR DEEP ASTM I (126)
PY53 NICKEL TITANATE YELLOW ASTM I (43)

ARTISTS' WATER COLOUR

PIGMENT DETAIL ON LABEL	ASTM	
YES	I L'FAST	

There are definite signs that the use of genuine Vermilion is on the decrease. Winsor & Newton have discontinued their Vermilion 680 and Scarlet Vermilion 605. Daler Rowney have dropped Scarlet Vermilion 573.

The name might become more of a title to describe an orange red, particularly as more companies realise the damage that genuine Vermilion can cause to an artist's work.

Better still if the description merged into history and pigments were correctly identified by name. The knowledgeable artist could then choose with confidence. Perhaps market pressure will bring this about.

Genuine Vermilion can cause immense damage to a painting. Some of the imitations are not a lot better, they usually fade to the same extent that Vermilion can darken.

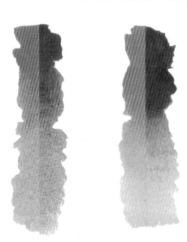

You will already have an indication of the number of red pigments in general use today. As you will see, few of them are suitable for artistic use.

The next few pages will give an indication of the colour names used to market many of these reds.

It is little wonder that most caring artists are confused about what to buy and use.

Select for pigment rather colour name or make. If the pigment is not clearly identified I would suggest that you do not select at all.

As a basis I would suggest a good quality Cadmium Red Light for the orange-red and a violet-red based on PV19 or PR192, both Quinacridone Reds.

With basic colour mixing skill (we can always help you here), these colours, plus their mixing complementaries, will give a vast range of reds.

Additional, carefully selected reds can then be added if required.

ANTIQUE PINK 003

HOLBEIN

IRODORI ANTIQUE WATERCOLOR

This paint will start to deteriorate not long after your finished work is exposed to the light, which one assumes it will be. PR48:2 not only has a poor reputation but has been proven to be unreliable.

| PV19 QUINACRIDONE VIOLET ASTM II (185) |
| PR48:2 PERMANENT RED 2B (CALCIUM) ASTM IV (119) |

PIGMENT DETAIL ON LABEL	ASTM	RATING
YES	IV L'FAST	★

ANTIQUE DEEP RED 025

HOLBEIN

IRODORI ANTIQUE WATERCOLOR

A watercolour containing PR112 is fine if you do not care about the longevity of your work. It is well known that this pigment is unreliable.

| PR112 NAPHTHOL AS-D ASTM III (127) |

PIGMENT DETAIL ON LABEL	ASTM	RATING
YES	III L'FAST	★★

ANTIQUE PURPLE RED 002

HOLBEIN

IRODORI ANTIQUE WATERCOLOR

Colour Number on the tube is 002 and in the literature as 001. Only a small point but it might help you to choose correctly. A reliable red giving very even washes.

| PR170 F3RK-70 NAPHTHOL RED ASTM II (129) |

PIGMENT DETAIL ON LABEL	ASTM	
YES	II L'FAST	

ANTIQUE ROSE 026

HOLBEIN

IRODORI ANTIQUE WATERCOLOR

This colour is let down by the use of PR112. I do not understand why manufacturers continue to use unreliable pigments when lightfast alternatives are readily available.

| PR112 NAPHTHOL AS-D ASTM III (127) |
| PW6 TITANIUM WHITE ASTM I (385) |

PIGMENT DETAIL ON LABEL	ASTM	RATING
YES	III L'FAST	★★

ANGELICO RED 357

LEFRANC & BOURGEOIS

LINEL EXTRA-FINE ARTISTS' WATERCOLOUR

An intense orange red. Gives reasonably clear washes when well diluted. Reliable pigment used. Semi-opaque.

| PR 166 DISAZO SCARLET WG II (128) |

PIGMENT DETAIL ON LABEL	WG	
CHEMICAL MAKE UP ONLY	II L'FAST	

ANGELICO RED

LEFRANC & BOURGEOIS

LINEL EXTRA-FINE ARTISTS' WATERCOLOUR

As PR144 has not been subjected to controlled, independent testing as an art material, let alone a watercolour paint, I cannot offer assessments.

| PR144 DISAZO RED L/F NOT OFFERED (308) |
| PR 166 DISAZO SCARLET WG II (128) |

PIGMENT DETAIL ON LABEL	ASTM	RATING
CHEMICAL MAKE UP ONLY	L'FAST	

ANTHRAQUINOID RED 005

DANIEL SMITH

EXTRA-FINE WATERCOLORS

Good, clear washes are available from this paint. Unfortunately, given the pigment which has been used, they will start to fade on exposure to the light.

| PR177 ANTHRAQUINOID RED ASTM III (130) |

PIGMENT DETAIL ON LABEL	ASTM	RATING
YES	III L'FAST	★★

BURGUNDY WINE RED 166

OLD HOLLAND

CLASSIC WATERCOLOURS

PR177 has failed ASTM testing as a watercolour. It is on the list of 'unapproved' pigments. If you care more than the manufacturer about your work you will avoid it.

| PR177 ANTHRAQUINOID RED ASTM III (130) |

PIGMENT DETAIL ON LABEL	ASTM	RATING
CHEMICAL MAKE UP ONLY	III L'FAST	★★

BREUGHEL RED 359

LEFRANC & BOURGEOIS

LINEL EXTRA-FINE ARTISTS' WATERCOLOUR

Both pigments are particularly fugitive. If you use this paint and your work later deteriorates, try to look as unconcerned as the manufacturer would be. Semi-opaque.

| PO13 PYRAZOLONE ORANGE ASTM V (94) |
| PR4 CHLORINATED PARA RED WG V (115) |

PIGMENT DETAIL ON LABEL	ASTM	RATING
CHEMICAL MAKE UP ONLY	V L'FAST	★

BORDEAUX 008

DANIEL SMITH

EXTRA-FINE WATERCOLORS

A deep, red violet staining colour which brushed out very well.

Claimed by the company to be lightfast II (their rating, not ASTM). I have little information on PV32 apart from the fact that it has not been given an ASTM rating in any media. Not assessed.

PV32		
PIGMENT DETAIL ON LABEL **YES**	ASTM L'FAST	RATING

BRILLIANT PINK 175

OLD HOLLAND

CLASSIC WATERCOLOURS

Sample rather over bound. Gave thinner washes without a problem but heavier applications difficult to work. Reliable pigments giving a dull pink.

| PW4 ZINC WHITE ASTM I (384) |
| PW6 TITANIUM WHITE ASTM I (385) |
| PR188 NAPHTHOL AS ASTM II (132) |

PIGMENT DETAIL ON LABEL CHEMICAL MAKE UP ONLY	ASTM **II** L'FAST	RATING ★★

BRILLIANT RED W14

ART SPECTRUM

ARTISTS' WATER COLOUR

A semi-transparent, reasonably bright red. Reliable pigment gives a watercolour that will resist damage from light. Handled very well.

| PR170 F3RK-70 NAPHTHOL RED ASTM II (129) |

PIGMENT DETAIL ON LABEL **YES**	ASTM **II** L'FAST	

BRIGHT ROSE (LUMINOUS) W370

HOLBEIN

ARTISTS' WATER COLOR

I have been unable to trace the colorants used. By their description they would appear to be dyes.

Given the company lightfast rating of * from a possible *** this would appear to be a fugitive colour worth avoiding.

BV11:1 AND AB83		
PIGMENT DETAIL ON LABEL **YES**	ASTM L'FAST	RATING

BRIGHT RED 619

SENNELIER

EXTRA-FINE WATERCOLOUR

Was once known as 'Helios Red' and produced from the disastrous PR3. (pg. 115). Check earlier examples if you have them. Now very much improved. Both pigments are lightfast. Excellent.

| PO43 PERINONE ORANGE WG II (96) |
| PR254 PYRROLE RED WG II (136) |

PIGMENT DETAIL ON LABEL **YES**	WG **II** L'FAST	

BRIGHT RED 396

LEFRANC & BOURGEOIS

LINEL EXTRA-FINE ARTISTS' WATERCOLOUR

A clear, vivid red. Strong colour with excellent tinting strength. Handled well.

Heavier applications darken slightly on exposure. Transparent.

| PR149 PERYLENE RED BL WG II (128) |

PIGMENT DETAIL ON LABEL CHEMICAL MAKE UP ONLY	WG **II** L'FAST	

BRIGHT RED 042

WINSOR & NEWTON

ARTISTS' WATER COLOUR

Sample paint so stiff was difficult to remove from tube. Tint fades, heavier applications darken dramatically. Semi-opaque.

Reformulated >

| PR4 CHLORINATED PARA RED WG V (115) |
| PY1 ARYLIDE YELLOW G ASTM V (37) |

PIGMENT DETAIL ON LABEL **YES**	ASTM **V** L'FAST	RATING ★

BRIGHT RED 042

WINSOR & NEWTON

ARTISTS' WATER COLOUR

This is more like it. The question is, why were such poor pigments as employed in the predecessor to this colour used in the first place? An opaque, staining colour.

| PR188 NAPHTHOL AS ASTM II (132) |
| PY65 ARYLIDE YELLOW RN ASTM II (44) |

PIGMENT DETAIL ON LABEL **YES**	ASTM **II** L'FAST	

BRILLIANT PINK W225

HOLBEIN

ARTISTS' WATER COLOR

An opaque, non staining colour which is relatively easy to lift from the paper after application. Reliable pigments.

| PR209 QUINACRIDONE RED Y ASTM II (134) |
| PW6 TITANIUM WHITE ASTM I (385) |

PIGMENT DETAIL ON LABEL **YES**	ASTM **II** L'FAST	

CARTHAMUS ROSE 352

LEFRANC & BOURGEOIS

LINEL EXTRA-FINE ARTISTS' WATERCOLOUR

Our sample underwent an amazing transformation on exposure. Light washes disappeared and heavier applications changed to white splashes on a red background. Transparent.

| PR90 PHIOXINE RED WG V (123) |

PIGMENT DETAIL ON LABEL CHEMICAL MAKE UP ONLY	WG **V** L'FAST	RATING ★

CHERRY RED (QUINACRIDONE RED) W224

HOLBEIN

ARTISTS' WATER COLOR

A transparent staining colour, very hard to lift. Reliable pigments used. Handled very well, a good buy if you need this colour type.

| PR209 QUINACRIDONE RED Y ASTM II (134) |

PIGMENT DETAIL ON LABEL **YES**	ASTM **II** L'FAST	

CORAL

ART SPECTRUM

ARTISTS' WATER COLOUR

The company claim that this is lightfast, and it might well be. Not tested as a watercolour under ASTM conditions. I am unable to offer assessments. Paint was so stiff it was almost impossible to squeeze out.

| PY192 COMMON NAME N/K LF NOT OFFERED (52) |
| PY83HR70 DIARYLIDE YELLOW HR70 WG II (45) |

PIGMENT DETAIL ON LABEL **YES**	ASTM L'FAST	RATING

DEEP RED 366

SCHMINCKE

HORADAM FINEST ARTISTS' WATER COLOURS

Previously called Cadmium Red Deep Hue, same ingredients. A strong red leaning towards violet. Now ASTM tested as a watercolour and rated I excellent. Very transparent, washed out smoothly. Semi-opaque.

PR179 PERYLENE MAROON ASTM I (131)		
PIGMENT DETAIL ON LABEL **YES**	ASTM **I** L'FAST	

DEEP RED ROSE 4H

DR.Ph. MARTINS

HYDRUS FINE ART WATERCOLOR

As these colorants are used by many artists, information of the ingredients would be rather helpful. I can glean nothing from the literature and the label only assures me that the colour is lightfast, produced from permanent pigments. Actually I am not assured, only told.

NO INFORMATION AVAILABLE		
PIGMENT DETAIL ON LABEL **NO**	ASTM L'FAST	RATING

ENGLISH RED

ST. PETERSBURG

ARTISTS' WATERCOLOURS

Whatever this substance is, it washed out very poorly unless well diluted.

Might be worth considering if you are an habitual gambler.

INFORMATION ON PIGMENTS DELIBERATELY WITHHELD FROM THE END USER		
PIGMENT DETAIL ON LABEL **NO**	ASTM L'FAST	RATING

FLESH COLOUR 2190

UMTON BARVY

ARTISTIC WATER COLOR

As the unreliable PR177 fades on exposure to light, as it almost certainly will, the colour will move towards a very pale yellow. Easily mixed.

PW4 ZINC WHITE ASTM I (384)
PR177 ANTHRAQUINOID RED ASTM III (130)
PY43 YELLOW OCHRE ASTM I (43)

PIGMENT DETAIL ON LABEL **NO**	ASTM **III** L'FAST	RATING ★★

FLESH TINT 115

OLD HOLLAND

CLASSIC WATERCOLOURS

I cannot offer assessments as I have insufficient information on PR214. Apart from the fact that it is yet another pigment which has not been subjected to controlled testing as an art material.

PW4 ZINC WHITE ASTM I (384)
PW6 TITANIUM WHITE ASTM I (385)
PY119 ZINC IRON YELLOW WG II (47)
PR214 COMMON NAME N/K LF NOT OFFERED (134)

PIGMENT DETAIL ON LABEL **CHEMICAL MAKE UP ONLY**	ASTM L'FAST	RATING

FLESH TINT 068

MAIMERI

VENEZIA EXTRAFINE WATERCOLOURS

Lightfast colours which have been made up into a watercolour which is most unpleasant to use. An over enthusiastic use of gum.

PW4 ZINC WHITE ASTM I (384)
PY42 MARS YELLOW ASTM I (43)

PIGMENT DETAIL ON LABEL **YES**	ASTM **I** L'FAST	RATING ★★

FLESH TINT 511

MAIMERI

ARTISTI EXTRA-FINE WATERCOLOURS

Reliable ingredients. Gives very even, smooth washes. I suppose that there must be somebody who looks as unusual as this colour. Opaque.

Range discontinued

PW6 TITANIUM WHITE ASTM I (385)
PY37 CADMIUM YELLOW MEDIUM OR DEEP ASTM I (42)
PV19 QUINACRIDONE VIOLET ASTM II (185)
PO43 PERINONE ORANGE WG II (96)

PIGMENT DETAIL ON LABEL **YES**	ASTM **II** L'FAST	

FIRE ENGINE RED 046

AMERICAN JOURNEY

PROFESSIONAL ARTISTS' WATER COLOR

A semi-transparent staining colour. A mid red which handles well enough.

Ingredients are reliable.

PR188 NAPHTHOL AS ASTM II (132)
PV19 QUINACRIDONE VIOLET ASTM II (185)

PIGMENT DETAIL ON LABEL **YES**	ASTM **II** L'FAST	

GARNET LAKE 181

MAIMERI

MAIMERIBLU SUPERIOR WATERCOLOURS

Our sample was difficult to handle unless in thin washes.

A reliable pigment used which will resist the light, protecting your valuable work.

PR88 MRS THIOINDIGOID VIOLET ASTM II (122)

PIGMENT DETAIL ON LABEL **YES**	ASTM **II** L'FAST	RATING ★★

GERANIUM LAKE 526

MAIMERI

ARTISTI EXTRA-FINE WATERCOLOURS

Sample over bound, making for difficult handling other than thin washes. As expected it faded readily to a marked extent. Transparent.

Discontinued

PR81 RHODAMINE Y WG V (121)

PIGMENT DETAIL ON LABEL **YES**	WG **V** L'FAST	RATING ★

GERANIUM LAKE A078

GRUMBACHER

ACADEMY ARTISTS' WATERCOLOR 2ND RANGE

Suitable for temporary work only. Handles well in a wash. Fades readily on exposure to light. Semi-opaque.

Reformulated >

PR3 TOLUIDINE RED WG V (115)

PIGMENT DETAIL ON LABEL **YES**	WG **V** L'FAST	RATING ★

GERANIUM RED

GRUMBACHER

ACADEMY ARTISTS' WATERCOLOR 2ND RANGE

A bit of a concoction to give an unremarkable mid red. The pigments employed are all reliable and will not let you down.

PR149 PERYLENE RED BL WG II (128)
PR 166 DISAZO SCARLET WG II (128)
PR170 F3RK-70 NAPHTHOL RED ASTM II (129)

PIGMENT DETAIL ON LABEL **YES**	ASTM **II** L'FAST	

GERANIUM LAKE BLUISH 1081

LUKAS

ARTISTS' WATER COLOUR

PR 122 resists light very well for a considerable time but will eventually fade. Use with caution, if at all.

PR122 QUINACRIDONE MAGENTA ASTM III (127)

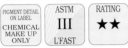
PIGMENT DETAIL ON LABEL CHEMICAL MAKE UP ONLY | ASTM III L'FAST | RATING ★★

GERANIUM ROSE 1092

LUKAS

ARTISTS' WATER COLOUR

A rather bright violet pink. Handles well giving very even washes. Fragile on exposure to light. Semi-transparent.

PR5 NAPTHOL 1TR ASTM III (116)
PR122 QUINACRIDONE MAGENTA ASTM III (127)

PIGMENT DETAIL ON LABEL CHEMICAL MAKE UP ONLY | ASTM III L'FAST | RATING ★★

GOLDEN BAROK RED 136

OLD HOLLAND

CLASSIC WATERCOLOURS

As with so many of the colours in this range the sample was over bound. A gummy 'paint' which handled poorly unless very dilute. Personally I would not worry about this as I would not purchase such an unreliable substance.

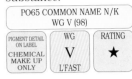
PO65 COMMON NAME N/K WG V (98)

PIGMENT DETAIL ON LABEL CHEMICAL MAKE UP ONLY | WG V L'FAST | RATING ★

GRUMBACHER RED W095

GRUMBACHER

FINEST ARTISTS' WATER COLOR

In the last edition I had written 'Reformulated, the unreliable PR112 has thankfully been removed and replaced by lightfast pigments.'

Reformulated >

PR170 F3RK-70 NAPHTHOL RED ASTM II (129)
PR188 NAPHTHOL AS ASTM II (132)

PIGMENT DETAIL ON LABEL YES | ASTM II L'FAST |

GRUMBACHER RED W095

GRUMBACHER

FINEST ARTISTS' WATER COLOR

Story continued from colour to the left.

It seems as if the PR112 is back again. If so it is a definite step backwards.

I can never be sure as this company are most unhelpful and do not respond to questions.

PR112 NAPHTHOL AS-D ASTM III (127)

PIGMENT DETAIL ON LABEL YES | ASTM III L'FAST | RATING ★★

GRUMBACHER RED A095

GRUMBACHER

ACADEMY ARTISTS' WATERCOLOR 2ND RANGE

It would seem that the 2nd range (often called 'Students Quality') is more lightfast that the Artists' quality. Reliable and handled very well.

PR170 F3RK-70 NAPHTHOL RED ASTM II (129)
PR188 NAPHTHOL AS ASTM II (132)

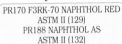
PIGMENT DETAIL ON LABEL YES | ASTM II L'FAST |

HELVETIC RED 561

CARAN D'ACHE

FINEST WATERCOLOURS

An unreliable colour which will fade at a steady rate on exposure to light. Well produced, giving smooth even washes. Lifted well from the pan. Use if you like taking chances.

PR9 NAPHTHOL AS-OL ASTM III (117)

PIGMENT DETAIL ON LABEL YES | ASTM III L'FAST | RATING ★★

MALMAISON ROSE 353

LEFRANC & BOURGEOIS

LINEL EXTRA-FINE ARTISTS' WATERCOLOUR

A particularly bright violet-red, high in tinting strength. Unfortunately is very fugitive. Unsuitable for most artistic use. Transparent.

Reformulated >

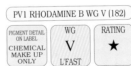
PV1 RHODAMINE B WG V (182)

PIGMENT DETAIL ON LABEL CHEMICAL MAKE UP ONLY | WG V L'FAST | RATING ★

MALMAISON ROSE

LEFRANC & BOURGEOIS

LINEL EXTRA-FINE ARTISTS' WATERCOLOUR

If, as appears to be the case, this actually is a reformulation of the colour to the left, I do not think much of it. The PR173 is known to be unreliable.

PR173 RHODAMINE B WG V (129)
PV19 QUINACRIDONE VIOLET ASTM II (185)

PIGMENT DETAIL ON LABEL CHEMICAL MAKE UP ONLY | WG V L'FAST | RATING ★

MARS ORANGE-RED 337

OLD HOLLAND

CLASSIC WATERCOLOURS

A well made watercolour without the excessive gum that I have come to associate with this make. Lightfast ingredients. Handled very well.

PY42 MARS YELLOW ASTM I (43)
UNSPECIFIED PR101 ASTM I (123/124)

PIGMENT DETAIL ON LABEL CHEMICAL MAKE UP ONLY | ASTM I L'FAST |

NAPHTHAMIDE MAROON 059

DANIEL SMITH

EXTRA-FINE WATERCOLORS

I do not have sufficient information on PR171 to offer assessments. What I do know is that it has not been officially tested as an art material. Sample handled very well.

PR171 BENZIMIDAZOLONE BORDEAUX LF NOT OFFERED (129)

PIGMENT DETAIL ON LABEL YES | ASTM L'FAST | RATING

NAPHTHOL RED 120

M. GRAHAM & CO.

ARTISTS' WATERCOLOR

Any watercolour produced using PR112 starts life as a bright mid red.

Unfortunately it starts to deteriorate at a steady pace on exposure to the light.

PR112 NAPHTHOL AS-D ASTM III (127)

PIGMENT DETAIL ON LABEL YES | ASTM III L'FAST | RATING ★★

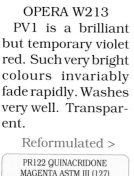

OPERA W213

HOLBEIN

PV1 is a brilliant but temporary violet red. Such very bright colours invariably fade rapidly. Washes very well. Transparent.

Reformulated >

| PR122 QUINACRIDONE MAGENTA ASTM III (127) | | |
| PV1 RHODAMINE B WG V (182) | | |

PIGMENT DETAIL ON LABEL	WG	RATING
YES	V L'FAST	★

ARTISTS' WATER COLOR

OPERA W213

HOLBEIN

I have insufficient information on the addition BV10 (replacing previous PV1), to offer an assessment. It would seem to be a dye. If so it will almost certainly be unreliable. More so than the PR122. Company rate it * from a possible ***.

PR122 QUINACRIDONE MAGENTA ASTM III (127) BV10		

PIGMENT DETAIL ON LABEL	ASTM	RATING
YES	L'FAST	

ARTISTS' WATER COLOR

OLD HOLLAND BRIGHT RED 151

OLD HOLLAND

Low in tinting strength. A reasonably bright orange red when at full strength, the tints are rather dull. Lightfast and well made.

PR168 BROMINATED ANTHRANTHRONE WG II (128)		

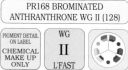

PIGMENT DETAIL ON LABEL	WG	RATING
CHEMICAL MAKE UP ONLY	II L'FAST	

CLASSIC WATERCOLOURS

OLD HOLLAND RED GOLD LAKE 133

OLD HOLLAND

The sample provided was not a paint but a heavy coloured gum. Appalling.

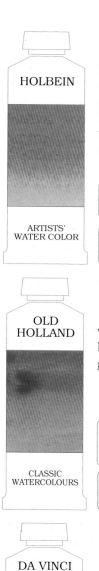

| PY153 NICKEL DIOXINE YELLOW ASTM II (50) | | |
| PV19 QUINACRIDONE RED ASTM II (185) | | |

PIGMENT DETAIL ON LABEL	ASTM	RATING
CHEMICAL MAKE UP ONLY	II L'FAST	★

CLASSIC WATERCOLOURS

PERMANENT ROSE QUINACRIDONE 264

DA VINCI PAINTS

PV19, Quinacridone Violet is a superb pigment. Bright, transparent and far more reliable than Crimson Alizarin. This is an excellent paint.

PV19 QUINACRIDONE VIOLET ASTM II (185)		

PIGMENT DETAIL ON LABEL	ASTM	RATING
YES	II L'FAST	

PERMANENT ARTISTS' WATER COLOR

PERMANENT RED 265

DA VINCI PAINTS

Reasonably strong tinctorially, this colour will play its part in mixing. Semi opaque but reasonably clear washes.

Well labelled. An excellent paint.

PR188 NAPHTHOL AS ASTM II (132)		

PIGMENT DETAIL ON LABEL	ASTM	RATING
YES	II L'FAST	

PERMANENT ARTISTS' WATER COLOR

PERMANENT RED 665

DA VINCI PAINTS

The sample was rather gum laden and painted out with some difficulty as a medium wash. Fine well diluted.

Lightfast pigment.

PR188 NAPHTHOL AS ASTM II (132)		

PIGMENT DETAIL ON LABEL	ASTM	RATING
YES	II L'FAST	★★

SCUOLA 2ND RANGE

PERMANENT RED 072

DANIEL SMITH

A fairly dull violet red with proven resistance to light.

The sample was very well made and handled beautifully at all strengths.

PR170 F3RK-70 NAPHTHOL RED ASTM II (129)		

PIGMENT DETAIL ON LABEL	ASTM	RATING
YES	II L'FAST	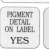

EXTRA-FINE WATERCOLORS

PERMANENT RED DEEP 069

DANIEL SMITH

Employing the same pigment, and as well made, this is a little deeper than the red to the left from the same company.

Not sufficiently different, however, to tempt me to purchase both.

PR170 F3RK-70 NAPHTHOL RED ASTM II (129)		

PIGMENT DETAIL ON LABEL	ASTM	RATING
YES	II L'FAST	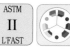

EXTRA-FINE WATERCOLORS

PERMANENT RED LIGHT 1099

LUKAS

The inclusion of PV23BS brings the overall lightfast rating right down. By appearance and effect there can be very little involved as sample did reasonably well under test. Semi-opaque.

| PR5 NAPTHOL 1TR ASTM III (116) | | |
| PV23BS DIOXAZINE PURPLE ASTM III-IV (186) | | |

PIGMENT DETAIL ON LABEL	ASTM	RATING
CHEMICAL MAKE UP ONLY	III-IV L'FAST	★★

ARTISTS' WATER COLOUR

PERMANENT RED DEEP 1097

LUKAS

PR9 is on the list of pigments found to be unsuitable for artistic use.

In this paint it faded considerably. Semi-opaque.

PR9 NAPHTHOL AS-OL ASTM III (117)		

PIGMENT DETAIL ON LABEL	ASTM	RATING
CHEMICAL MAKE UP ONLY	III L'FAST	★★

ARTISTS' WATER COLOUR

PERMANENT ROSE 5720

HUNTS

Referring to the ingredients given I can only say, 'which Quinacridone pigment'? They vary in many ways. Sample not supplied. No assessments offered.

Discontinued

LINEAR QUINACRIDONE PIGMENT		

PIGMENT DETAIL ON LABEL	ASTM	RATING
YES	L'FAST	

SPEEDBALL PROFESSIONAL WATERCOLOURS

PERMANENT RED LIGHT 251

MAIMERI

MAIMERIBLU
SUPERIOR
WATERCOLOURS

Watercolours produced with this pigment are fairly bright when heavily applied but become duller in thinner washes. Low in tinting strength.

A well produced and reliable orange red.

PR168 BROMINATED
ANTHRANTHRONE WG II (128)

PIGMENT DETAIL ON LABEL	WG	
YES	II L'FAST	

PERMANENT RED LIGHT 251

MAIMERI

VENEZIA
EXTRAFINE
WATERCOLOURS

A little over bound, our sample washed out well in light applications but not so when heavier.

A reliable orange red.

PR168 BROMINATED
ANTHRANTHRONE WG II (128)

PIGMENT DETAIL ON LABEL	WG	RATING
YES	II L'FAST	★★

PERMANENT RED DEEP 253

MAIMERI

MAIMERIBLU
SUPERIOR
WATERCOLOURS

As this pigment failed ASTM testing as a watercolour it will, hopefully, be less used in the future. Cannot be depended on.

PR177 ANTHRAQUINOID RED
ASTM III (130)

PIGMENT DETAIL ON LABEL	ASTM	RATING
YES	III L'FAST	★★

PERMANENT RED DEEP 253

MAIMERI

VENEZIA
EXTRAFINE
WATERCOLOURS

There are sufficient lightfast reds on the market to be able to offer a wide range of choices.

PR177 is not one of them.

PR177 ANTHRAQUINOID RED
ASTM III (130)

PIGMENT DETAIL ON LABEL	ASTM	RATING
YES	III L'FAST	★★

PERMANENT ROSE W19

ART SPECTRUM

ARTISTS'
WATER COLOUR

A reliable pigment which usually gives brighter washes than our sample provided. Slightly over bound it did not paint out well in medium to heavy layers.

PV19 QUINACRIDONE VIOLET
ASTM II (185)

PIGMENT DETAIL ON LABEL	ASTM	RATING
YES	II L'FAST	★★

PERMANENT RED 15H

DR.Ph. MARTINS

HYDRUS FINE
ART
WATERCOLOR

If you are one of the many artists who have used this product, did you have more information than I have been provided with, or did you simply take a chance?

INFORMATION ON THE
PIGMENT/S USED NOT GIVEN
ON THE PRODUCT OR IN THE
LITERATURE PROVIDED

PIGMENT DETAIL ON LABEL	ASTM	RATING
NO	L'FAST	

PERMANENT ROSE 502

WINSOR & NEWTON

ARTISTS'
WATER COLOUR

Gives clear, even washes across the range. The colour has recently been strengthened. Reasonably bright red giving violet pink undertones. Reliable pigment. Transparent and staining.

PV19 QUINACRIDONE RED
ASTM II (185)

PIGMENT DETAIL ON LABEL	ASTM	
YES	II L'FAST	

PERMANENT ROSE 502

WINSOR & NEWTON

COTMAN
WATER COLOURS
2ND RANGE

Sample a little over-bound, making full strength washes difficult. Excellent pigments, bright, strong and dependable. Transparent and staining.

PV19 QUINACRIDONE RED
ASTM II (185)

PIGMENT DETAIL ON LABEL	ASTM	
YES	II L'FAST	

PERMANENT ROSE (QUIN) 094

AMERICAN JOURNEY

PROFESSIONAL
ARTISTS'
WATER COLOR

A fine, reliable pigment. Mix with a quality Ultramarine Blue for bright, transparent violets. A well made and dependable paint.

PV19 QUINACRIDONE VIOLET
ASTM II (185)

PIGMENT DETAIL ON LABEL	ASTM	
YES	II L'FAST	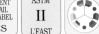

PERMANENT RED W221

HOLBEIN

ARTISTS'
WATER COLOR

Gives reasonably transparent washes and handles quite well.

Unfortunately, prone to fading. Semi-opaque, staining and quite intense.

PR112 NAPHTHOL AS-D
ASTM III (127)

PIGMENT DETAIL ON LABEL	ASTM	RATING
YES	III L'FAST	★★

PERMANENT ROSE W220

HOLBEIN

ARTISTS'
WATER COLOR

PR60 is an unreliable pigment. Sample faded as a tint and discoloured in mass tone, becoming more violet.

PR60 SCARLET LAKE (SODIUM)
WG V (121)

PIGMENT DETAIL ON LABEL	WG	RATING
YES	V L'FAST	★

PERMANENT RED 61

CARAN D'ACHE

FINEST
WATERCOLOURS

A well made watercolour which lifted and washed out with ease.

It is a pity that a pigment with such a poor reputation has been used. Why? They must know.

PR4 CHLORINATED PARA RED
WG V (115)

PIGMENT DETAIL ON LABEL	WG	RATING
YES	V L'FAST	★

PERMANENT RED ORANGE 360

SCHMINCKE

A bright orange-red which washes out beautifully. The PO69 previously used has been replaced by the equally reliable PO62. A well made product.

HORADAM
FINEST
ARTISTS'
WATER COLOURS

PR251 COMMON NAME N/K
WG II (136)
PO62 BENZIMIDAZOLONE
ORANGE H5G ASTM II (97)

PIGMENT DETAIL ON LABEL	ASTM	
YES	II L'FAST	

PERMANENT RED 361

SCHMINCKE

The unreliable PR6 (page 116) has been replaced by PR251, a colorant with a very good reputation. Earlier ingredients are given as many will have retained paints purchased some time ago. This is now a quality product.

HORADAM
FINEST
ARTISTS'
WATER COLOURS

PR251 COMMON NAME N/K
WG II (136)

PIGMENT DETAIL ON LABEL	WG	
YES	II L'FAST	

PERMANENT RED 3 362

SCHMINCKE

The pigment has not been ASTM tested as a watercolour but rated very well in oils and acrylics. A bright, transparent orange-red, low in tinting strength. Brushes very well.

Discontinued

HORADAM
FINEST
ARTISTS'
WATER COLOURS

PR168 BROMINATED
ANTHRANTHRONE WG II (128)

PIGMENT DETAIL ON LABEL	WG	
YES	II L'FAST	

PERMANENT RED DEEP 345

SCHMINCKE

According to the catalogue, this might be called 'Dark Red'.

Reasonably bright, strong violet-red. Gives very even washes over the full range of values.

HORADAM
FINEST
ARTISTS'
WATER COLOURS

PR170 F3RK-70 NAPHTHOL RED
ASTM II (129)

PIGMENT DETAIL ON LABEL	ASTM	
YES	II L'FAST	

PERMANENT RED LIGHT 370

TALENS

An orange red which brushed out very well when dilute but was a little heavy going in thicker applications. Lightfast pigments.

REMBRANDT
ARTISTS'
QUALITY
EXTRA FINE

PY154 BENZIMIDAZOLONE
YELLOW H3G ASTM II (50)
PR255 COMMON NAME N/K
ASTM II (136)

PIGMENT DETAIL ON LABEL	ASTM	RATING
YES	II L'FAST	★ ★★

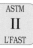

PERMANENT RED LIGHT 370

TALENS

A bright, reasonably transparent orange red. PR255 is a relatively new pigment which passed ASTM testing with flying colours (or should that be 'as a flying colour'?)

Excellent product.

VAN GOGH
2ND RANGE

PR255 COMMON NAME N/K
ASTM I (136)

PIGMENT DETAIL ON LABEL	ASTM	
YES	I L'FAST	

PERMANENT RED MEDIUM 377

TALENS

A little confusion here, the catalogue gives the ingredient as PR255 but the label states that the pigment used is PR254. As both are reliable and the sample was well made I will rate it accordingly.

REMBRANDT
ARTISTS'
QUALITY
EXTRA FINE

PR254 PYRROLE RED WG II (136)

PIGMENT DETAIL ON LABEL	WG	
YES	II L'FAST	

PERMANENT RED DEEP 371

TALENS

A deep, rather intense velvety red. The pigment rated well as an acrylic but has yet to be tested as a watercolour.

Sample gave reasonably clear washes. Excellent product.

REMBRANDT
ARTISTS'
QUALITY
EXTRA FINE

PR254 PYRROLE RED WG II (136)

PIGMENT DETAIL ON LABEL	WG	
YES	II L'FAST	

PERMANENT RED DEEP 371

TALENS

Rather similar in hue to their artists' quality (shown left), I do not think that I would ever be tempted to purchase both. A high quality product.

VAN GOGH
2ND RANGE

PR254 PYRROLE RED WG II (136)
PV19 QUINACRIDONE VIOLET
ASTM II (185)

PIGMENT DETAIL ON LABEL	ASTM	
YES	II L'FAST	

PERMANENT ROSE 537

DALER ROWNEY

Smooth, even washes from this well produced watercolour.

Quinacridone Red is a reliable pigment under normal conditions. Transparent.

ARTISTS'
WATER COLOUR

PV19 QUINACRIDONE RED
ASTM II (185)

PIGMENT DETAIL ON LABEL	ASTM	
YES	II L'FAST	

PERMANENT ROSE 537

DALER ROWNEY

Resists light initially but will eventually fade on prolonged exposure. This is unfortunate as it can eventually spoil you work. Medium tinting strength.

Reformulated >

GEORGIAN
WATER COLOUR
2ND RANGE

PR122 QUINACRIDONE MAGENTA
ASTM III (127)

PIGMENT DETAIL ON LABEL	ASTM	RATING
NO	III L'FAST	★★

PERMANENT ROSE

DALER ROWNEY

This version is not as bright as the pigment would suggest it should be.

Perhaps, as in many 'student' colours, additives have replaced more of the pigment than they ideally should have.

GEORGIAN
WATER COLOUR
2ND RANGE

PV19 QUINACRIDONE VIOLET
ASTM II (185)

PIGMENT DETAIL ON LABEL	ASTM	RATING
NO	II L'FAST	★ ★★

PERMANENT RED 535

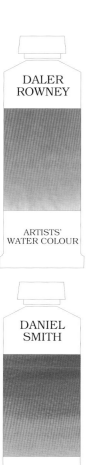

DALER ROWNEY

ARTISTS' WATER COLOUR

A fine, strong, bright red initially.

Soon affected by light however, the tint becomes lighter and the mass tone darker and duller. Semi-opaque.

Reformulated >

PR4 CHLORINATED PARA RED WG V (115)

PIGMENT DETAIL ON LABEL	WG	RATING
YES	V L'FAST	★

PERMANENT RED

DALER ROWNEY

ARTISTS' WATER COLOUR

I am afraid that I have insufficient information on PO73 to offer a lightfast rating or comment on the paint itself. Perhaps the manufacturers will supply me the information that they used when making their decision.

PR254 PYRROLE RED WG II (136) PO73 COMMON NAME N/K LF NOT OFFERED (98)

PIGMENT DETAIL ON LABEL	ASTM	RATING
YES	L'FAST	

PERYLENE MAROON 421

DALER ROWNEY

ARTISTS' WATER COLOUR

This is a rather dull violet-red which gave fairly transparent washes. The pigment stood up very well to the rigours of ASTM lightfast testing.

A quality product.

PR179 PERYLENE MAROON ASTM I (131)

PIGMENT DETAIL ON LABEL	ASTM	
YES	I L'FAST	

PERYLENE RED 075

DANIEL SMITH

EXTRA-FINE WATERCOLORS

A semi transparent staining colour which brushed out beautifully over a useful range of values.

A first class product.

PR178 PERYLENE RED ASTM II (131)

PIGMENT DETAIL ON LABEL	ASTM	
YES	II L'FAST	

PERYLENE RED 529

DALER ROWNEY

ARTISTS' WATER COLOUR

A very dull, rather 'heavy' violet red. The pigment is most reliable and will not spoil you work by future deterioration. All pigments used in artists watercolours should rate either ASTM I or II.

PR179 PERYLENE MAROON ASTM I (131)

PIGMENT DETAIL ON LABEL	ASTM	
YES	I L'FAST	

PINK No 15

PENTEL

WATER COLORS

I cannot tell you anything about this colour, other than that many would describe it as rather garish, annoyingly bright pink. I wouldn't do so because I do not make such comments.

PIGMENT INFORMATION NOT PROVIDED IN ANY FORM

PIGMENT DETAIL ON LABEL	ASTM	RATING
NO	L'FAST	

PILBARA RED W63

ART SPECTRUM

ARTISTS' WATER COLOUR

A transparent lightfast product very similar in hue to Burnt Sienna.

Handled well in all applications.

UNSPECIFIED PR101 ASTM I (123/124) PV19 QUINACRIDONE VIOLET ASTM II (185)

PIGMENT DETAIL ON LABEL	ASTM	
YES	II L'FAST	

PERYLENE MAROON 074

DANIEL SMITH

EXTRA-FINE WATERCOLORS

A semi-transparent, semi-staining paint which gave very even washes. Although such colours can be mixed with ease, they can be rather convenient if in frequent use.

PR179 PERYLENE MAROON ASTM I (131)

PIGMENT DETAIL ON LABEL	ASTM	
YES	I L'FAST	

PINK COLOUR 081

DANIEL SMITH

EXTRA-FINE WATERCOLORS

The sample tube provided did not contain paint but a very heavy, coloured gum. Quite impossible to use. I am surprised that this company would have manufactured it.

PR233 CHROME TIN PINK SPHENE WG II (135)

PIGMENT DETAIL ON LABEL	WG	RATING
YES	II L'FAST	★

PYRROL SCARLET 085

DANIEL SMITH

EXTRA-FINE WATERCOLORS

A bright orange-red which gave a series of very smooth even washes. Being quite transparent, extremely thin washes were possible. A well made watercolour.

PR255 COMMON NAME N/K ASTM I (136)

PIGMENT DETAIL ON LABEL	ASTM	
YES	I L'FAST	

PYRROL RED 084

DANIEL SMITH

EXTRA-FINE WATERCOLORS

PR254 gives a medium strength fairly transparent red.

The sample handled very well at all strengths.

PR254 PYRROLE RED WG II (136)

PIGMENT DETAIL ON LABEL	WG	
YES	II L'FAST	

PERYLENE MAROON A163

GRUMBACHER

ACADEMY ARTISTS' WATERCOLOR 2ND RANGE

Reliable ingredients giving a dull rather 'heavy' violet red.

Handled well in all applications.

PR179 PERYLENE MAROON ASTM I (131)

PIGMENT DETAIL ON LABEL	ASTM	
YES	I L'FAST	

PRIMARY RED 1051

LUKAS

A reliable pigment lightfast, bright and transparent.

Thinner washes handled very well but sample was a little difficult to work in heavier applications.

ARTISTS' WATER COLOUR

PV19 QUINACRIDONE VIOLET ASTM II (185)		
PIGMENT DETAIL ON LABEL CHEMICAL MAKE UP ONLY	ASTM **II** L'FAST	RATING ★ ★★

ROSE DORE 576

WINSOR & NEWTON

A rather weak colour, difficult to use unless thin. Then washes out very well. Dependable pigments used. Transparent.

Reformulated >

ARTISTS' WATER COLOUR

PV19 QUINACRIDONE VIOLET ASTM II (185) PY3 ARYLIDE YELLOW 10G ASTM II (37)		
PIGMENT DETAIL ON LABEL YES	ASTM **II** L'FAST	RATING ★★

ROSE DORE 576

WINSOR & NEWTON

This pigment combination gives a watercolour paint which is transparent and staining. Despite the strength of the pigments, this replacement is also rather weak. (See left).

ARTISTS' WATER COLOUR

PV19 QUINACRIDONE VIOLET ASTM II (185) PY97 ARYLIDE YELLOW FGL ASTM II (46)		
PIGMENT DETAIL ON LABEL YES	ASTM **II** L'FAST	RATING ★ ★★

ROSE LAKE 182

MAIMERI

To my mind PV19 Quinacridone Violet is the ideal violet-red.

It is high in tinting strength, very transparent and lightfast.

This example is very well made and washed out with ease.

MAIMERIBLU SUPERIOR WATERCOLOURS

PV19 QUINACRIDONE VIOLET ASTM II (185)		
PIGMENT DETAIL ON LABEL YES	ASTM **II** L'FAST	

ROSE LAKE 182

MAIMERI

Lightfast coloured gum which was almost impossible to brush out.

VENEZIA EXTRAFINE WATERCOLOURS

PV19 QUINACRIDONE VIOLET ASTM II (185)		
PIGMENT DETAIL ON LABEL YES	ASTM **II** L'FAST	RATING ★

ROSE DORE MADDER LAKE ANTIQUE EXTRA 172

OLD HOLLAND

Despite the grand title, the sample supplied was little more than coloured gum.

Most disappointing. Would have been even more so had I purchased the colour for use.

CLASSIC WATERCOLOURS

PR175 BENZIMIDAZOLONE MAROON WG II (130) PR168 BROMINATED ANTHRANTHRONE WG II (128) PR83 ROSE MADDER ALIZARIN ASTM IV (122)		
PIGMENT DETAIL ON LABEL CHEMICAL MAKE UP ONLY	ASTM **IV** L'FAST	RATING ★

ROSE DORE (QUINACRIDONE) 272

DA VINCI PAINTS

Sample gave very smooth washes when well diluted but did not handle so well when applied at all heavy. Most reliable pigments have been used.

PERMANENT ARTISTS' WATER COLOR

PV19 QUINACRIDONE VIOLET ASTM II (185) PR188 NAPHTHOL AS ASTM II (132)		
PIGMENT DETAIL ON LABEL YES	ASTM **II** L'FAST	RATING ★ ★★

ROSE CARTHAME 574

WINSOR & NEWTON

Sample darkened slightly in mass tone when applied as a medium wash. Reliable. Semi-opaque.

Discontinued

ARTISTS' WATER COLOUR

PR188 NAPHTHOL AS ASTM II (132)		
PIGMENT DETAIL ON LABEL YES	ASTM **II** L'FAST	RATING ★ ★★

ROSE DORE (ALIZARIN)

DALER ROWNEY

These two pigments give an orange-red with a short life. Semi-transparent.

Discontinued

ARTISTS' WATER COLOUR

PR83:1 ALIZARIN CRIMSON ASTM IV (122) PR4 CHLORINATED PARA RED WG V (115)		
PIGMENT DETAIL ON LABEL YES	ASTM **IV** L'FAST	RATING ★

ROSE PINK 655

SENNELIER

Most unreliable. Sample faded dramatically.

The pigment is more suited to industrial use. Semi-opaque.

Discontinued

EXTRA-FINE WATERCOLOUR

PR53:1 BARIUM RED LAKE C WG V (120)		
PIGMENT DETAIL ON LABEL YES	WG **V** L'FAST	RATING ★

TYRIEN ROSE 659

SENNELIER

Pigment Violet 1 is a disastrous substance to use in an artist's watercolour. Starts life as a brilliant red-violet. On exposure soon disappears altogether. The company is aware of this. Transparent.

EXTRA-FINE WATERCOLOUR

PV1 RHODAMINE B WG V (182)		
PIGMENT DETAIL ON LABEL YES	WG **V** L'FAST	RATING ★

RUBY RED 388

LEFRANC & BOURGEOIS

A fine, bright violet red. Washes out particularly well. PV19 is an excellent pigment, dependable and far superior to Alizarin Crimson. Transparent.

LINEL EXTRA-FINE ARTISTS' WATERCOLOUR

PV19 QUINACRIDONE RED ASTM II (185)		
PIGMENT DETAIL ON LABEL CHEMICAL MAKE UP ONLY	ASTM **II** L'FAST	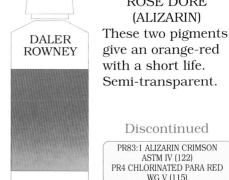

RUBY LAKE 178

OLD HOLLAND

As I have found with the majority of samples from this company, the paint was rather gummy.

Handles fairly well in thin washes but hard going in heavier layers.

CLASSIC WATERCOLOURS

PR209 QUINACRIDONE RED Y
ASTM II (134)
PR168 BROMINATED
ANTHRANTHRONE WG II (128)

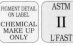

| PIGMENT DETAIL ON LABEL CHEMICAL MAKE UP ONLY | ASTM II L'FAST | RATING ★★ |

RUBY RED 351

SCHMINCKE

Previously known as 'Ruby Red 905', before that as 'Brilliant Red 1'. Used to be less than reliable, this is now an excellent violet red. Lightfast and transparent. Recommended.

HORADAM FINEST ARTISTS' WATER COLOURS

PV19 QUINACRIDONE VIOLET
ASTM II (185)

| PIGMENT DETAIL ON LABEL YES | ASTM II L'FAST | |

REMBRANDT ROSE 368

TALENS

Faded as suggested by the ASTM rating. A clear violet-red. Only relatively thin washes possible. Transparent.

Discontinued

REMBRANDT ARTISTS' QUALITY EXTRA FINE

PR122 QUINACRIDONE MAGENTA
ASTM III (127)

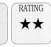

| PIGMENT DETAIL ON LABEL YES | ASTM III L'FAST | RATING ★★ |

RED ROSE DEEP (QUINACRIDONE) 276

DA VINCI PAINTS

PV19 is similar in hue to Alizarin Crimson but brighter and more reliable.

This is another excellent example of its qualities. Transparent.

PERMANENT ARTISTS' WATER COLOR

PV19 QUINACRIDONE VIOLET
ASTM II (185)

| PIGMENT DETAIL ON LABEL YES | ASTM II L'FAST | |

RED ROSE DEEP (QUINAC) 676

DA VINCI PAINTS

As with many other examples from this new range of colours, the sample was rather weak and had a gummy consistency. Excellent pigment behind it however.

SCUOLA 2ND RANGE

PV19 QUINACRIDONE VIOLET
ASTM II (185)

| PIGMENT DETAIL ON LABEL YES | ASTM II L'FAST | RATING ★ ★★ |

RED No 11

PENTEL (POLY TUBE)

This particular range is covered because it is our policy to cover as many colours offered 'for artistic use' as possible.

Assessments not possible. Maybe next time?

NO INFORMATION ON THE PIGMENTS USED AVAILABLE ON THE PRODUCT OR IN THE LITERATURE PROVIDED

| PIGMENT DETAIL ON LABEL NO | ASTM L'FAST | RATING |

RED No 11

PENTEL

I cannot offer any guidance because I do not have the first idea of the pigments which have been used.

WATER COLORS

NO INFORMATION ON THE PIGMENTS USED AVAILABLE ON THE PRODUCT OR IN THE LITERATURE PROVIDED

| PIGMENT DETAIL ON LABEL NO | ASTM L'FAST | RATING |

RAMBLING ROSE (QUIN) 109

AMERICAN JOURNEY

The longer we hold back from calling this colour Quinacridone Violet, the longer it will be before artists ask for it by name.

I do realise that commercial considerations will always prevail. Maybe one day? An excellent product however.

PROFESSIONAL ARTISTS' WATER COLOR

PV19 QUINACRIDONE VIOLET
ASTM II (185)

| PIGMENT DETAIL ON LABEL YES | ASTM II L'FAST | |

RED HOT MOMMA 118

AMERICAN JOURNEY

Following my remarks with the colour to the left - I give up! There will always be those who choose colours by name over ingredients. Despite the rather silly title this is a well made product.

PROFESSIONAL ARTISTS' WATER COLOR

PR188 NAPHTHOL AS
ASTM II (132)

| PIGMENT DETAIL ON LABEL YES | ASTM II L'FAST | |

SCHEVENINGEN RED SCARLET 19

OLD HOLLAND

An intense, very well made watercolour paint which handled with absolute ease. Until further information on PR260 is available I cannot offer an assessment.

CLASSIC WATERCOLOURS

PO43 PERINONE ORANGE
WG II (96)
PR260 COMMON NAME N/K
LF NOT OFFERED (137)

| PIGMENT DETAIL ON LABEL CHEMICAL MAKE UP ONLY | ASTM L'FAST | RATING |

SCHEVENINGEN ROSE DEEP 29

OLD HOLLAND

A well produced example of a watercolour employing this reliable pigment.

Washed out very smoothly over a good range of values.

CLASSIC WATERCOLOURS

PV19 QUINACRIDONE RED
ASTM II (185)

| PIGMENT DETAIL ON LABEL CHEMICAL MAKE UP ONLY | ASTM II L'FAST | |

SCHEVENINGEN RED MEDIUM 169

OLD HOLLAND

A fairly strong colour which will quickly influence many other in a mix. Semi opaque but washed out quite thinly without breaking up.

CLASSIC WATERCOLOURS

PR188 NAPHTHOL AS
ASTM II (132)

| PIGMENT DETAIL ON LABEL CHEMICAL MAKE UP ONLY | ASTM II L'FAST | |

SCHEVENINGEN RED LIGHT 22

OLD HOLLAND

CLASSIC WATERCOLOURS

A bright red which does not lean strongly towards either orange or violet. Semi opaque and reliable.

It is a pity that the ingredients are not made clear on the label to other than chemists.

PR188 NAPHTHOL AS ASTM II (132)		
PIGMENT DETAIL ON LABEL CHEMICAL MAKE UP ONLY	ASTM **II** L'FAST	

SCHEVENINGEN RED DEEP 24

OLD HOLLAND

CLASSIC WATERCOLOURS

I can offer little in the way of guidance as a sample was not provided for examination and insufficient is known about the pigment.

PR214 COMMON NAME N/K LF NOT OFFERED (134)		
PIGMENT DETAIL ON LABEL CHEMICAL MAKE UP ONLY	ASTM L'FAST	RATING

SANDAL RED 263

MAIMERI

MAIMERIBLU SUPERIOR WATERCOLOURS

This is becoming a popular pigment and understandably so. Bright, transparent and stood up well to the rigours of ASTM testing made up as a watercolour.

This is a well made product.

PR254 PYRROLE RED WG II (136)		
PIGMENT DETAIL ON LABEL YES	WG **II** L'FAST	

SPECTRUM RED W12

ART SPECTRUM

ARTISTS' WATER COLOUR

PR251, when well made up, as this example has been, gives a strong, bright orange red which washes out very smoothly. Pigment has an excellent reputation.

PR251 COMMON NAME N/K WG II (136)		
PIGMENT DETAIL ON LABEL YES	WG **II** L'FAST	

SHELL PINK W226

HOLBEIN

ARTISTS' WATER COLOR

A rather mediocre pink easily reproduced by mixing an orange red such as Cadmium Red Light, with white. Opaque, non staining and easy to lift.

Without sufficient information on PO73 I cannot give an assessment.

PO73 COMMON NAME N/K LF NOT OFFERED (99) PW6 TITANIUM WHITE ASTM I (385)		
PIGMENT DETAIL ON LABEL YES	ASTM L'FAST	RATING

SPEEDBALL RED 5705

HUNTS

SPEEDBALL PROFESSIONAL WATERCOLOURS

PR112 failed ASTM lightfast tests when made up into a watercolour paint.

PR112 NAPHTHOL AS-D ASTM III (127)		
PIGMENT DETAIL ON LABEL YES	ASTM **III** L'FAST	RATING ★★

SENNELIER RED 636

SENNELIER

EXTRA-FINE WATERCOLOUR

Bright, transparent and lightfast. The sample provided gave very even, clear washes.

PR254 PYRROLE RED WG II (136)		
PIGMENT DETAIL ON LABEL YES	WG **II** L'FAST	

THALO CRIMSON

GRUMBACHER

FINEST ARTISTS' WATER COLOR

A very well produced watercolour employing an excellent pigment.

High in tinting strength, very transparent and lightfast.

PV19 QUINACRIDONE VIOLET ASTM II (185)		
PIGMENT DETAIL ON LABEL YES	ASTM **II** L'FAST	

THALO CRIMSON

GRUMBACHER

ACADEMY ARTISTS' WATERCOLOR 2ND RANGE

The paint in our sample was under pressure, indicating an imbalance between the binder and the pigment.

A most trustworthy pigment used with admirable qualities.

PV19 QUINACRIDONE VIOLET ASTM II (185)		
PIGMENT DETAIL ON LABEL YES	ASTM **I** L'FAST	RATING ★ ★★

THALO RED W207

GRUMBACHER

FINEST ARTISTS' WATER COLOR

A vibrant strong red with a violet-pink undertone. Washes out very smoothly. Reliable pigment used. Far superior to Alizarin Crimson. Transparent.

PV19 QUINACRIDONE RED ASTM II (185)		
PIGMENT DETAIL ON LABEL YES	ASTM **II** L'FAST	

THALO RED A207

GRUMBACHER

ACADEMY ARTISTS' WATERCOLOR 2ND RANGE

Pigment Violet 19 is far superior to violet reds such as Alizarin Crimson.

This watercolour would be the envy of many an Artists' quality range.

PV19 QUINACRIDONE VIOLET ASTM II (185)		
PIGMENT DETAIL ON LABEL YES	ASTM **II** L'FAST	

TIZIANO RED 261

MAIMERI

MAIMERIBLU SUPERIOR WATERCOLOURS

Sample was over bound. Very thin washes were possible but otherwise was basically a coloured gum.

Disappointing from this company.

PR209 QUINACRIDONE RED Y ASTM II (134)		
PIGMENT DETAIL ON LABEL YES	ASTM **II** L'FAST	RATING ★

TYRIAN ROSE 354

LEFRANC & BOURGEOIS

A brilliant violet pink which soon becomes brilliant white paper.

Most unsuitable for normal artistic use. Transparent.

Reformulated >

LINEL EXTRA-FINE ARTISTS' WATERCOLOUR

PV1 RHODAMINE B WG V (182)		
PIGMENT DETAIL ON LABEL CHEMICAL MAKE UP ONLY	WG **V** L'FAST	RATING ★

TYRIAN ROSE 354

LEFRANC & BOURGEOIS

Why reformulate a colour using an equally unreliable pigment?

If this was not enough the sample provided was most unpleasant to use, being little more than a coloured gum.

LINEL EXTRA-FINE ARTISTS' WATERCOLOUR

PR173 RHODAMINE B WG V (129)		
PIGMENT DETAIL ON LABEL CHEMICAL MAKE UP ONLY	WG **V** L'FAST	RATING ★

TALENS RED LIGHT 364

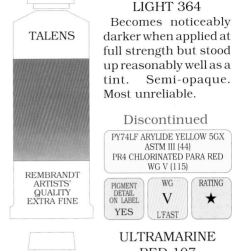

TALENS

Becomes noticeably darker when applied at full strength but stood up reasonably well as a tint. Semi-opaque. Most unreliable.

Discontinued

REMBRANDT ARTISTS' QUALITY EXTRA FINE

PY74LF ARYLIDE YELLOW 5GX ASTM III (44) PR4 CHLORINATED PARA RED WG V (115)		
PIGMENT DETAIL ON LABEL YES	WG **V** L'FAST	RATING ★

TALENS RED DEEP 365

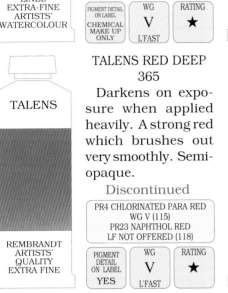

TALENS

Darkens on exposure when applied heavily. A strong red which brushes out very smoothly. Semi-opaque.

Discontinued

REMBRANDT ARTISTS' QUALITY EXTRA FINE

PR4 CHLORINATED PARA RED WG V (115) PR23 NAPHTHOL RED LF NOT OFFERED (118)		
PIGMENT DETAIL ON LABEL YES	WG **V** L'FAST	RATING ★

TRANSPARENT MARS RED 250

MAIMERI

The sample provided was a thick, sticky, coloured gum.

But at least it was lightfast coloured gum.

MAIMERIBLU SUPERIOR WATERCOLOURS

UNSPECIFIED PR101 ASTM I (123/124)		
PIGMENT DETAIL ON LABEL YES	ASTM **I** L'FAST	RATING ★

ULTRAMARINE RED 107

DANIEL SMITH

This pigment normally gives bright reddish violets.

For whatever reason, our sample was very weak, rather dull and suitable for thin washes only.

EXTRA-FINE WATERCOLORS

PV15 ULTRAMARINE VIOLET ASTM I (184)		
PIGMENT DETAIL ON LABEL YES	ASTM **I** L'FAST	RATING ★★

ULTRAMARINE RED-PINK 187

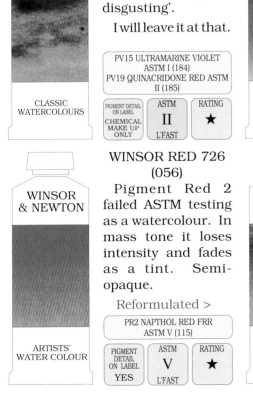

OLD HOLLAND

The note that I made whilst testing reads 'coloured gum, disgusting'.

I will leave it at that.

CLASSIC WATERCOLOURS

PV15 ULTRAMARINE VIOLET ASTM I (184) PV19 QUINACRIDONE RED ASTM II (185)		
PIGMENT DETAIL ON LABEL CHEMICAL MAKE UP ONLY	ASTM **II** L'FAST	RATING ★

UCCELLO RED 391

LEFRANC & BOURGEOIS

Please see my notes concerning this pigment which are to be found at the top of page 98.

I have tried without success in the past to obtain clarification from the company.

LINEL EXTRA-FINE ARTISTS' WATERCOLOUR

PO65 COMMON NAME N/K WG V (98)		
PIGMENT DETAIL ON LABEL CHEMICAL MAKE UP ONLY	WG **V** L'FAST	RATING ★

WILD FUSCHIA 145

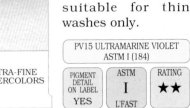

AMERICAN JOURNEY

The literature states 'colour can fade'. It would be more accurate to say 'colour *will* fade'.

If you like to take chances with your work you might like to know that it is non-staining and semi-transparent.

PROFESSIONAL ARTISTS' WATER COLOR

PR122 QUINACRIDONE MAGENTA ASTM III (127)		
PIGMENT DETAIL ON LABEL YES	ASTM **III** L'FAST	RATING ★★

WINSOR RED 726 (056)

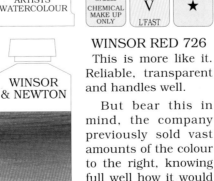

WINSOR & NEWTON

Pigment Red 2 failed ASTM testing as a watercolour. In mass tone it loses intensity and fades as a tint. Semi-opaque.

Reformulated >

ARTISTS' WATER COLOUR

PR2 NAPTHOL RED FRR ASTM V (115)		
PIGMENT DETAIL ON LABEL YES	ASTM **V** L'FAST	RATING ★

WINSOR RED 726

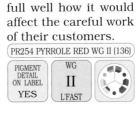

WINSOR & NEWTON

This is more like it. Reliable, transparent and handles well.

But bear this in mind, the company previously sold vast amounts of the colour to the right, knowing full well how it would affect the careful work of their customers.

ARTISTS' WATER COLOUR

PR254 PYRROLE RED WG II (136)		
PIGMENT DETAIL ON LABEL YES	WG **II** L'FAST	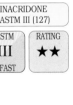

As already mentioned, my approach to colour mixing is based firmly on identifying and using colours according to type. Is a red an orange - red or a violet - red etc.

It is, of course, essential that you are able to identify colours according to their make-up. The various reds available are, for most people difficult to decide upon.

 + = The Red is - Orange - Red

 + = The Red is - Violet - Red

Once you have settled down to a limited palette and have come to associate colour-name with colour - type, (Cadmium Red Light, for example, is an orange-red) it will be smooth sailing until you decide to introduce further colours.

There is a very simple test to decide between the various reds. Take the red in question and mix it with a known VIOLET-blue, such as Ultramarine Blue.

If the resulting mix is a rather dull, greyed, slightly violet hue, you can be sure that the red in question is an orange - red.

Alternatively, if the result is a bright violet, then, without a doubt, the red has identified itself as being a violet-red.

The results are always as dramatic as these examples. It is a simple test which is foolproof.

Violets

The first unmixed violet was Tyrian purple a clear reddish violet in use until about the 10th Century.

Produced from a certain species of whelk, it has probably been the most exclusive and expensive colouring matter in history. Mainly used in Mediterranean countries, it also enjoyed some popularity in England, where a local shellfish was used.

A clear substance was extracted from a gland in the whelks' body. On exposure to light this became a bright violet. Vast numbers were required. It takes over 12,000 whelks to produce under 1 1/2 grammes of dye.

Archil and Folium, vegetable dyes, which were similar in colour to Tyrian Purple, then became the standard pure purples.

The majority of artists in the Middle Ages preferred to mix their violets, either on the palette or as glazes.

Mauve, discovered by William Perkin in 1856 was the first of the 'coal tar' colours. Many more were introduced. They were produced from chemicals obtained by distilling coal tar and were usually fugitive.

 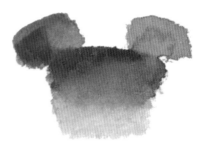

Despite the quality materials which are readily available we are still offered pigments of dubious quality and permanency.

We now have a range of particularly bright violet pigments, a range which would be the envy of earlier painters.

Many of todays' artists also prefer to mix their violets, valuing the more muted effects that are obtainable.

Modern Violet Pigments

PV1 RHODAMINE B 182

PV2 RHODAMINE 3B LAKE 182

PV3 METHYL VIOLET 182

PV4 MAGENTA .. 183

PV5AL ALIZARIN MAROON 183

PV13 COMMON NAME NOT KNOWN 183

PV14 COBALT VIOLET 184

PV15 ULTRAMARINE RED 184

PV15 ULTRAMARINE VIOLET 184

PV16 MANGANESE VIOLET 185

PV19 QUINACRIDONE VIOLET 185

PV19 QUINACRIDONE RED 185

PV23BS or RS DIOXAZINE PURPLE 186

PV37 COMMON NAME NOT KNOWN 186

PV39 CRYSTAL VIOLET 186

PV42 QUINACRIDONE MAROON B 187

PV46 GRAPHTOL VIOLET CI-4RL.............. 187

PV49 COBALT AMMONIUM VIOLET PHOSPHATE 187

PV88 DOES NOT EXIST 188

PV1 RHODAMINE B

As with the Rhodamine Reds, this is a brilliant but short lived colour. It is, temporarily, a bright, reddish-violet.

Being transparent, it washes out into very clear tints. High in tinting strength, it will quickly influence most other colours in a mix. Valued by the printing industry for its strength and brilliance, it is the standard printing ink, Magenta. With a dismal record as far as permanence is concerned, it is surprising to find it used in artists' paint.

The tint of our sample faded quickly and the mass tone discoloured. Not worth considering unless you wish your work to change similarly. Parent dye: Basic Violet 10.

PV2 RHODAMINE 3B LAKE

A dye, as such, cannot be used to make a watercolour. If it is utilised to dye an inert, colourless powder, the resulting coloured pigment has the necessary qualities to be made into a workable paint. Such pigments are known as 'Lake' colours. They augment the range of pigments which come naturally in powder form. Basic Violet II, is such a Lake colour. It is a transparent reddish-violet. All Xanthene pigments fade badly.

This version fared no better with a lightfastness rating of ASTM IV in watercolours. Also known as Vivid Magenta 6B.

PV3 METHYL VIOLET

PV3 is a rather bright, transparent bluish-violet. For a while that is. Particularly fugitive, it will deteriorate quickly from the moment it sees the light of day. It also has poor resistance to alkalis, this will probably not be a problem as the colour will usually have departed beforehand.

For the technically minded the PTMA in the chemical description stands for Phosphotungstomolybic Acid Salt. So now you know.

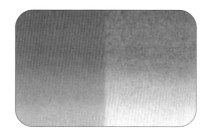

The poor reputation of this pigment was verified by the rapid deterioration of our sample. The tint virtually disappeared and the mass tone faded and discoloured.

Parent dye : Basic Violet 1.

PV4 MAGENTA

PV4, Magenta, is a bright red-dish-violet which would seem to be going out of use. Transparent, it gives clear washes when well diluted.

The only colourmen that had been using it, have now switched to another pigment. Mentioned here as you might come across it in older paints that you might still be using.

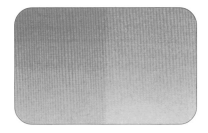

By reputation and our own testing rated WG V.

Also called Fuchsine.

PV5AL ALIZARIN MAROON

Alizarin Maroon is a bright red-dish violet. Transparent, it gives good clear washes. In previous editions of this book I gave a rating of W/Guide IV as it has a very poor reputation as far as lightfast is concerned and it had altered rapidly during our own lightfast testing. The mass tone had discoloured. Now tested under ASTM conditions it has been given a rating of V. This pigment is even less resistant to light than PR83, Alizarin Crimson, which only rated IV following

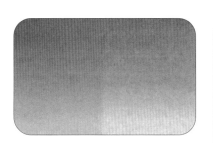

ASTM testing. Can any manufacturer using this pigment to produce watercolours for the artist, really care?

PV13 COMMON NAME NOT KNOWN

PV13 has not been tested in any art material and has a very poor reputation as far as fastness to light is concerned.

Although not found in the colours covered within this book, I have come across it in earlier watercolours. Such paints might still be in use and are worth checking.

PV14 COBALT VIOLET

Cobalt Violet first appeared in the early 1800's and was produced from a natural ore. Nowadays it is manufactured chemically.

A transparent violet which varies from a red-violet to a bluer version. There are two basic types, both of which are rated ASTM I. A rather weak pigment with little body.

In my opinion it makes a very poor watercolour as the result is more of a coloured gum than a paint.

Absolutely lightfast with an ASTM rating of I.

L/FAST ASTM I

COMMON NAME

COBALT VIOLET

COLOUR INDEX NAME

PV14

COLOUR INDEX NUMBER

77362 or 77360

CHEMICAL CLASS

COBALT AMMONIUM PHOSPHATE OR COBALT PHOSPHATE

PV15 ULTRAMARINE RED

PV15 Ultramarine Red is a brilliant reddish violet obtained by heating PV15 Ultramarine Violet in the presence of gaseous acids. Both versions share the same Colour Index Number. Absolutely lightfast with a rating of ASTM I following testing when made into a watercolour.

As there are reliable violet pigments such as this available, why is it that many very inferior violets are offered to the artist.

Could it be anything to do with profit margins and a lack of concern?

PV15 is highly recommended.

L/FAST ASTM I

COMMON NAME

ULTRAMARINE RED

COLOUR INDEX NAME

PV15

COLOUR INDEX NUMBER

77007

CHEMICAL CLASS

COMPLEX SILICATE OF SODIUM AND ALUMINUM WITH SULPHUR

PV15 ULTRAMARINE VIOLET

Ultramarine Violet is obtained by heating Ultramarine Blue with certain chemicals until the desired hue is obtained. Ultramarine Blue and both versions of PV15 have the Colour Index Number 77007 A brilliant, lightfast violet.

Both versions of PV15 are absolutely lightfast. They rated ASTM I following lightfast testing as watercolours. Highly recommended.

L/FAST ASTM I

COMMON NAME

ULTRAMARINE VIOLET

COLOUR INDEX NAME

PV15

COLOUR INDEX NUMBER

77007

CHEMICAL CLASS

COMPLEX SILICATE OF SODIUM AND ALUMINUM WITH SULPHUR

PV16 MANGANESE VIOLET

PV16 is a rather dull, reddish to mid violet. Opaque to semi-opaque with good covering power it does not give particularly clear tints. Extremely resistant to light, it rated I under ASTM testing as a watercolour. It is a heat sensitive pigment with many industrial uses in temperature indicating paints and crayons.

A colour change takes place at a certain temperature. A solid, reliable pigment which will retain its colour in all normal use.

Our sample did not change in the slightest during exposure to light.

A most reliable pigment.

PV19 QUINACRIDONE VIOLET

Quinacridone Violet is a bright, violet-red with many admirable qualities. Made up into both an oil paint and an acrylic, it rated ASTM I, absolutely lightfast. Without the protection of the binder it rated II as a watercolour, which is still very good.

Transparent, it gives very clear washes. (An opaque version is available). As a watercolour it brushes well and has a useful range of values. An excellent violet-red. PV19 is an ideal replacement for Crimson Alizarin.

It is far more reliable, brighter, brushes out better and makes cleaner and far brighter violets in mixes Ultramarine Blue. Thoroughly recommended.

PV19 QUINACRIDONE RED

Quinacridone Y form is transparent, giving clear washes. (An opaque version is available). The Colour Index number was changed some years ago from 46500 to 73900. You might come across this earlier number as several manufacturers retain it. Not yet ASTM tested as a watercolour, but it rated I in both oils and acrylics.

The Quinacridones are a little more expensive than the Naphthol pigments but more reliable. Vastly superior to Alizarin Crimson.

There is every indication that this colorant will be very reliable. Pending further testing it will be rated II for the purposes of this book.

PV23BS or RS DIOXAZINE PURPLE

Dioxazine Purple is available in two distinct versions. PV23RS (Red Shade) and PV23BS (Blue Shade).

The distinction is important as there is a definite lightfastness difference between the two. The Red Shade being more lightfast than the Blue Shade. The results of ASTM lightfast testing give a good indication of the protection offered by certain binders. The Red Shade tested I in oil, II in acrylic and III in watercolour.

The Blue Shade rated even worse with a finding of ASTM IV as a watercolour.

PV37 COMMON NAME NOT KNOWN

A transparent bluish violet which is also called Cromophtal Violet B or Micolith Violet B-K.

This pigment has not been tested in any art material as far as the ASTM standards are concerned.

Redder than PV23 but has weaker tinting strength. I am advised that it should have the same lightfastness as PV23, which is no recommendation as that pigment rates at only ASTM III to IV.

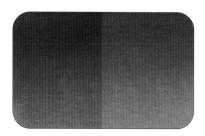

Accordingly I will give a rating of W/Guide III to IV prior to the art material industry paying for correct and reliable lightfast tests to be carried out. We may have a long wait.

PV39 CRYSTAL VIOLET

This is a disastrous substance, which to my mind has no place whatsoever amongst artists' watercolours.

As a thin wash it will start to fade quickly and dramatically. In mass tone it will darken and discolour. The failings of this pigment are not a secret and will (or should) be known by every manufacturer using it.

It starts life as a bright blue violet of good transparency. The parent dye is C.I. Basic Violet 3.

Our sample deteriorated as you see above, in a very short time.

Not suitable for artistic expression and offered for reasons best known to the manufacturer.

PV42 QUINACRIDONE MAROON B

A dull, transparent violet with a leaning towards red.

Not yet subjected to ASTM testing in any media. However, it does have a good reputation for lightfastness in other areas and withstood twelve months exposure to the sun before starting to fade.

Pending further testing I will rate it W/Guide II for the purposes of this book, based on its reputation and make up.

Also called Cinquasia Maroon, Cinquasia Transparent Red B and Manoastral Maroon.

PV46 GRAPHTOL VIOLET CI-4RL

A dull, reddish violet. Reasonably transparent, it gives quite clear tints when applied as a thin wash and takes on a blackish appearance when applied heavily. At the time of writing, this pigment had not been tested under ASTM procedures. However, it does have a good reputation for lightfastness.

As our sample only changed by the slightest degree during exposure, I will give it a provisional rating of II for the purpose of this publication.

On reputation and the performance of our sample I would suggest that this pigment be regarded as reliable pending further testing.

PV49 COBALT AMMONIUM VIOLET PHOSPHATE

A semi-opaque, reddish-violet related to PV14 Cobalt Violet.

Some care should be taken when using as the pigment contains soluble cobalt. As with all colours it is not a good practice to point brushes in the mouth. Better to get somebody else to do it for you (I'm only kidding - before the letters start) Gives a limited range of values, and is more useful when applied thinly. Poor resistance to acid and alkali, which is another reason to use neutral Ph watercolour paper.

Based on our own testing rated WG II pending further trials. The question is, when will such tests take place? The pigment has been is use for a long time.

PV88

There is no such pigment as PV88. Reference is made only because it is given as an ingredient in one of the watercolours covered in this book. The highest violet number in any reference is PV50. It could be that there has been a confusion between PV88 and PR88MRS.

Many basic violets are easily pre-mixed from lightfast colours.
Reproduced from our Home Study Course 'Practical Colour Mixing'

Bright violets

If you are using an alternative violet-red to Quinacridone Violet, I suggest that you make certain that the colour is lightfast and is a good 'carrier' of violet.

The most commonly used violet-red world wide is Alizarin Crimson.

Genuine Alizarin Crimson will fade quite rapidly when applied in thin layers or when mixed with white and is a poor 'carrier' of violet.

When mixed with the same violet-blue as above it will, at best, give mixes similar to the mid-intensity violets that are covered later.

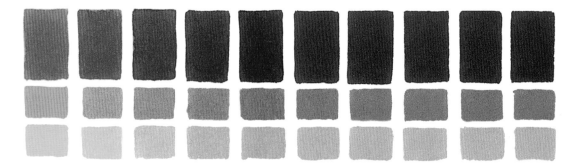

From Box 2 onwards, the violet-blue is progressively added and the violet-red gradually phased out until eventually pure violet-blue emerges in the final box.

Around the mid point is a violet leaning neither towards the blue nor the red. Each colour has been progressively lightened to show two tints.

As we have found, violet-red (Quinacridone Violet) and violet-blue (Ultramarine Blue), give a bright violet - the brightest of all mixed violets in fact.

The aim of this and the following exercises is to give a basic range of the colours which will emerge from the contributing hues.

As I am sure you will appreciate, many more colours could be mixed between those shown and a far greater range of tints are available - as you will discover when you start to put this approach into practice.

The exercises should be treated as an *indication* of the available range of mixes from each pair.

Violet Watercolours

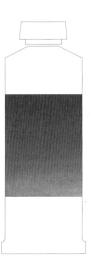

Cobalt Violet 190

Magenta .. 193

Mauves .. 195

Purples .. 197

Miscellaneous 199

Every time that I have used Cobalt Violet I have found it difficult to handle.

Having now had the opportunity to examine a wide range, covering all of the major brands, I have come to the conclusion that PV 14, Cobalt Violet, makes a very poor watercolour pigment.

It appears to have little body and The paint is so over bound due to the nature of the pigment that it is a little like trying to work with a thick coloured gum. Very thin washes are fine but heavier applications are very difficult.

Absolutely lightfast with an ASTM rating of I as a watercolour. Cobalt Violet has been in use since the early 1800's.

In hue is usually a reddish violet. Mixing complementary a green-yellow.

COBALT VIOLET LIGHT 177

UTRECHT

Although the pigment has little 'body' and the resulting watercolour is invariably rather gummy, this is going a little too far. Sample no more than thick coloured gum.

PROFESSIONAL ARTISTS' WATER COLOR

PV49 COBALT AMMONIUM VIOLET PHOSPHATE WG II (187)		
PIGMENT DETAIL ON LABEL YES	WG II L'FAST	RATING ★

COBALT VIOLET DEEP 176

UTRECHT

Following the notes to the left, this is going even more overboard. Gum with a tiny amount of pigment, an appalling substance.

PROFESSIONAL ARTISTS' WATER COLOR

PV14 COBALT VIOLET ASTM I (184)		
PIGMENT DETAIL ON LABEL YES	ASTM I L'FAST	RATING ★

COBALT VIOLET 539

TALENS

According to the stated ingredients, should be lightfast. Our sample faded and discoloured. No assessment offered. Transparent.

REMBRANDT ARTISTS' QUALITY EXTRA FINE

PV14 COBALT VIOLET ASTM I (184)		
PIGMENT DETAIL ON LABEL YES	ASTM L'FAST	RATING

COBALT VIOLET 236

DA VINCI PAINTS

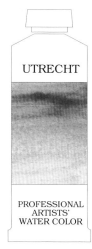

Weak, difficult to brush out, little 'body'.

How did Cobalt Violet ever establish itself as a watercolour? Transparent.

PERMANENT ARTISTS' WATER COLOR

PV14 COBALT VIOLET ASTM I (184)		
PIGMENT DETAIL ON LABEL YES	ASTM I L'FAST	RATING ★

COBALT VIOLET DEEP 237

DA VINCI PAINTS

A relatively new colour. Given the known qualities of PV14 I wonder why it was ever included.

Sample was very unpleasant to use at all weights.

PERMANENT ARTISTS' WATER COLOR

PV14 COBALT VIOLET ASTM I (184) PB28 COBALT BLUE ASTM I (215)		
PIGMENT DETAIL ON LABEL YES	ASTM I L'FAST	RATING ★

COBALT VIOLET W053

GRUMBACHER

As seems to be the case when this pigment is employed, the paint was of a gummy consistency and painted out very poorly.

FINEST ARTISTS' WATER COLOR

PV14 COBALT VIOLET ASTM I (184)		
PIGMENT DETAIL ON LABEL YES	ASTM I L'FAST	RATING ★

COBALT VIOLET LIGHT W310

HOLBEIN

Reliable as far as resistance to light is concerned but difficult to use unless applied very thinly. Transparent, non staining and easy to lift.

ARTISTS' WATER COLOR

PV14 COBALT VIOLET ASTM I (184)		
PIGMENT DETAIL ON LABEL YES	ASTM I L'FAST	RATING ★

COBALT VIOLET 338

PÈBÈO

Suffers the usual problem of Cobalt Violet watercolours, weak, gummy and difficult to use. Transparent.

FRAGONARD ARTISTS' WATER COLOUR

PV14 COBALT VIOLET ASTM I (184)		
PIGMENT DETAIL ON LABEL YES	ASTM I L'FAST	RATING ★

COBALT VIOLET DEEP 1127

LUKAS

As literature was not supplied as requested, I cannot give more that the chemical description from the tube label. I will not attempt to interpret this and will not therefore offer assessments.

ARTISTS' WATER COLOUR

SILICATE OF SODIUM AND ALUMINIUM WITH SULFUR		
PIGMENT DETAIL ON LABEL CHEMICAL MAKE UP ONLY	ASTM L'FAST	RATING

COBALT BLUE VIOLET 115

A simple mix sold under a name which should have passed into history many years ago.

Will be judged as a reliable, well made watercolour paint despite the name.

PV19 QUINACRIDONE VIOLET ASTM II (185)
PB28 COBALT BLUE ASTM I (215)

PIGMENT DETAIL ON LABEL	ASTM	
YES	II L'FAST	

COBALT VIOLET 030

Given the nature of the pigment I expected a very gum laden, weak paint.

My expectations were more than fulfilled. An appalling substance.

PV49 COBALT AMMONIUM VIOLET PHOSPHATE WG II (187)

PIGMENT DETAIL ON LABEL	WG	RATING
YES	II L'FAST	★

COBALT VIOLET DEEP 031

Weak and of a poor consistency but handled better than most examples of this material.

PV14 COBALT VIOLET ASTM I (184)

PIGMENT DETAIL ON LABEL	ASTM	RATING
YES	I L'FAST	★★

COBALT VIOLET 449

The name is misleading and does not represent the ingredients. (Fortunately for the user). Good range of values. Brushes out well. Transparent.

Range discontinued

PV19 QUINACRIDONE VIOLET ASTM II (185)
PB28 COBALT BLUE ASTM I (215)

PIGMENT DETAIL ON LABEL	ASTM	
YES	II L'FAST	

COBALT VIOLET 449

A Cobalt Violet, employing the genuine pigment, which washed out well across a useful range of values.

This is either a break through in the use of this pigment or there are additions. I will not offer assessments until I have analysed the paint.

PV14 COBALT VIOLET ASTM I (184)

PIGMENT DETAIL ON LABEL	ASTM	RATING
YES	I L'FAST	

COBALT VIOLET 9H

There are obviously very many painters who either work in ignorance, don't care or have more information than I have been provided with for the compilation of this book.

ESSENTIAL INFORMATION ON THE COLORANTS EMPLOYED IN THIS WATERCOLOUR ARE NOT GIVEN ON THE PRODUCT LABEL OR IN THE MATERIAL PROVIDED

PIGMENT DETAIL ON LABEL	ASTM	RATING
	L'FAST	

COBALT VIOLET 620

Whether in tube or pan form, the usual problems associated with the employment of this useless pigment always prevail. Weak, gummy and hard to paint out.

PV14 COBALT VIOLET ASTM I (184)

PIGMENT DETAIL ON LABEL	ASTM	RATING
YES	I L'FAST	★

COBALT VIOLET ROSE 653

Previously called 'Cobalt Rose 653'.

The sample provided washed out very well, giving clear, even tints. I suspect the addition of other pigment/s. But that's me. Not assessed until analysed.

PV14 COBALT VIOLET ASTM I (184)
PW4 ZINC WHITE ASTM I (384)

PIGMENT DETAIL ON LABEL	ASTM	RATING
YES	I L'FAST	

COBALT VIOLET LIGHT HUE 911

A paint which gave very smooth, even washes.

Unfortunately it is let down by the inclusion of the less than reliable PR122.

PR122 QUINACRIDONE MAGENTA ASTM III (127)
PV16 MANGANESE VIOLET ASTM I (185)
PW6 TITANIUM WHITE ASTM I (385)

PIGMENT DETAIL ON LABEL	ASTM	RATING
YES	III L'FAST	★★

COBALT VIOLET DEEP HUE 913

In the previous edition I had written 'An absolutely lightfast mid-violet. An excellent all round watercolour paint'.

Since then PV23BR or RS has been added. Depending on the type of PV23 the colour will now deteriorate fairly fast or fast. Clever thinking.

PV16 MANGANESE VIOLET ASTM I (185)
PV23BS or RS ASTM III - IV (186)

PIGMENT DETAIL ON LABEL	ASTM	RATING
YES	III-IV L'FAST	★

 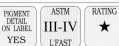

COBALT VIOLET PALE GENUINE 907

To me this seems a misleading name to sell Manganese Violet under. Especially the 'Genuine' part. Still, this is the art material industry.

Discontinued

PV16 MANGANESE VIOLET ASTM I (185)

PIGMENT DETAIL ON LABEL	ASTM	RATING
YES	I L'FAST	★ ★★

COBALT VIOLET DEEP GENUINE 909

The usual failings associated with PV14. A weak gum laden paint. Transparent.

Discontinued

PV14 COBALT VIOLET ASTM I (184)

PIGMENT DETAIL ON LABEL	ASTM	RATING
YES	I L'FAST	★

COBALT VIOLET 192

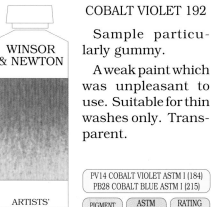

WINSOR & NEWTON

ARTISTS' WATER COLOUR

Sample particularly gummy.

A weak paint which was unpleasant to use. Suitable for thin washes only. Transparent.

PV14 COBALT VIOLET ASTM I (184)
PB28 COBALT BLUE ASTM I (215)

PIGMENT DETAIL ON LABEL	ASTM	RATING
YES	I L'FAST	★★

COBALT VIOLET (USA ONLY) 192

WINSOR & NEWTON

COTMAN WATER COLOURS 2ND RANGE

A weak paint with very little body.

Difficult to use unless in very thin washes. Transparent.

PV14 COBALT VIOLET ASTM I (184)

PIGMENT DETAIL ON LABEL	ASTM	RATING
YES	I L'FAST	★★

COBALT VIOLET W21

ART SPECTRUM

ARTISTS' WATER COLOUR

The usual dismally poor watercolour paint associated with this pigment. Weak and dominated by the binder.

Why is this pigment still around? Is it that 'traditional' that it has to stay regardless?

PV14 COBALT VIOLET ASTM I (184)

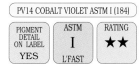

PIGMENT DETAIL ON LABEL	ASTM	RATING
YES	I L'FAST	★★

COBALT VIOLET LIGHT 415

OLD HOLLAND

CLASSIC WATERCOLOURS

Sample was particularly gummy. Impossible to use unless as an extremely thin wash. Lightfast and transparent.

Reformulated >

PV14 COBALT VIOLET ASTM I (184)

PIGMENT DETAIL ON LABEL	ASTM	RATING
CHEMICAL MAKE UP ONLY	I L'FAST	★★

COBALT VIOLET LIGHT 31

OLD HOLLAND

CLASSIC WATERCOLOURS

The substance that crept out of the tube was not paint at all but thick coloured gum. Appalling.

Lightfast, but I would want it to fade.

PV49 COBALT AMMONIUM VIOLET PHOSPHATE WG II (187)

PIGMENT DETAIL ON LABEL	WG	RATING
CHEMICAL MAKE UP ONLY	II L'FAST	★

COBALT VIOLET DARK 32

OLD HOLLAND

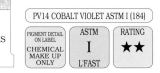

CLASSIC WATERCOLOURS

Previously 'Cobalt Violet Deep 416'.

Sample was very gummy. Paint difficult to wash and rather grainy. How surprising. Lightfast. Transparent.

PV14 COBALT VIOLET ASTM I (184)

PIGMENT DETAIL ON LABEL	ASTM	RATING
CHEMICAL MAKE UP ONLY	I L'FAST	★★

COBALT VIOLET 043

AMERICAN JOURNEY

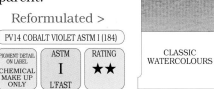

PROFESSIONAL ARTISTS' WATER COLOR

Non staining, transparent, coloured gum.

But it is lightfast.

PV14 COBALT VIOLET ASTM I (184)

PIGMENT DETAIL ON LABEL	ASTM	RATING
YES	I L'FAST	★

COBALT VIOLET HUE 533

MIR (JAURENA S.A)

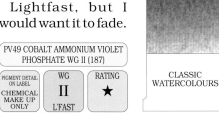

ACUARELA

It must be well known throughout the art materials industry that this pigment is either unreliable or very unreliable.

You and I care about your painstaking work. Do many others?

PV23BS/RS DIOXAZINE PURPLE ASTM III-IV (186)

PIGMENT DETAIL ON LABEL	ASTM	RATING
YES	III-IV L'FAST	★

COBALT VIOLET LIGHT 2510

UMTON BARVY

ARTISTIC WATER COLOR

Whether in pan or tube form the use of PV14 leads towards a very poor watercolour.

This is no exception. Difficult to lift, thin, weak and hard to get a decent wash.

PV14 COBALT VIOLET ASTM I (184)

PIGMENT DETAIL ON LABEL	ASTM	RATING
NO	I L'FAST	★

CADMIUM ORANGE 013

UMTON BARVY

ARTISTIC WATER COLOR

Difficult to lift from the pan. Thinner applications just about possible.

A poor watercolour paint thanks to the use of PV14.

PV14 COBALT VIOLET ASTM I (184)

PIGMENT DETAIL ON LABEL	ASTM	RATING
NO	I L'FAST	★

The term Magenta is widely used in the printing industry to describe the standard red used in the 'four colour' printing process.

It is loosely used in relation to artists materials to describe a violet red.

When mixing, add Ultramarine (violet-blue) for a range of bright violets. Mixing complementary is a yellow green. Each will darken the other without destroying the character of their partner.

ANTIQUE MAGENTA 022

HOLBEIN

IRODORI ANTIQUE WATERCOLOR

An interesting line up of pigments. It will be a race to see which of them fades the quickest. My money will be on the PV23.

It is not just me going on, or hearsay, these pigments have been proven to be unreliable.

| PR122 QUINACRIDONE MAGENTA ASTM III (127) |
| PV23BS/RS DIOXAZINE PURPLE ASTM III-IV (186) |

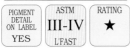

| PIGMENT DETAIL ON LABEL | ASTM | RATING |
| YES | III-IV L'FAST | ★ |

PERMANENT MAGENTA W64

ART SPECTRUM

ARTISTS' WATER COLOUR

A series of very smooth, even washes are obtainable. As the sample is duller and cloudier than this pigment alone would suggest, I will withhold assessments until I have more information.

| PV19 QUINACRIDONE VIOLET ASTM II (185) |

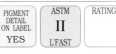

| PIGMENT DETAIL ON LABEL | ASTM | RATING |
| YES | II L'FAST | |

OLD HOLLAND MAGENTA 181

OLD HOLLAND

CLASSIC WATERCOLOURS

PR122 has been shown, by testing procedures arrived at in conjunction with the art materials industry, to be unreliable when exposed to light.

| PR122 QUINACRIDONE MAGENTA ASTM III (127) |

| PIGMENT DETAIL ON LABEL | ASTM | RATING |
| CHEMICAL MAKE UP ONLY | III L'FAST | ★★ |

PERMANENT MAGENTA 5725

HUNTS

SPEEDBALL PROFESSIONAL WATERCOLOURS

Exact information on ingredients not provided. No assessment offered.

Discontinued

| LINEAR QUINACRIDONE PIGMENT |

| PIGMENT DETAIL ON LABEL | ASTM | RATING |
| NO | L'FAST | |

PERMANENT MAGENTA 241

PÈBÉO

FRAGONARD ARTISTS' WATER COLOUR

An excellent watercolour paint. The ingredients give a dependable red violet which handles very well. Transparent.

| PV19 QUINACRIDONE VIOLET ASTM II (185) |

| PIGMENT DETAIL ON LABEL | ASTM | |
| YES | II L'FAST | |

PRIMARY RED MAGENTA 256

MAIMERI

MAIMERIBLU SUPERIOR WATERCOLOURS

A recent change of pigment from the unreliable PR122 to the superb PV19. Colour number also changed from 518. Transparent and washes very well.

| PV19 QUINACRIDONE VIOLET ASTM II (185) |

| PIGMENT DETAIL ON LABEL | ASTM | |
| YES | II L'FAST | |

PRIMARY RED MAGENTA 256

MAIMERI

VENEZIA EXTRAFINE WATERCOLOURS

Previously produced from the unreliable PR81. Now reformulated using an excellent pigment.

Strong, bright and transparent.

| PV19 QUINACRIDONE VIOLET ASTM II (185) |

| PIGMENT DETAIL ON LABEL | ASTM | |
| YES | II L'FAST | |

PERMANENT MAGENTA 091

AMERICAN JOURNEY

PROFESSIONAL ARTISTS' WATER COLOR

I would have expected a slightly brighter result from these two pigments. Both are very good 'carriers' of violet. Brushed out very well.

| PV19 QUINACRIDONE VIOLET ASTM II (185) |
| PB29 ULTRAMARINE BLUE ASTM I (215) |

| PIGMENT DETAIL ON LABEL | ASTM | RATING |
| YES | II L'FAST | ★★ |

PERMANENT MAGENTA 680

SENNELIER

EXTRA-FINE WATERCOLOUR

Previously included the unreliable PR122 which rated only III under ASTM lightfast test conditions. Check old paints that you might have.

Now that this has been removed the paint is far more reliable.

| PV19 QUINACRIDONE VIOLET ASTM II (185) |

| PIGMENT DETAIL ON LABEL | ASTM | |
| YES | II L'FAST | |

PERMANENT MAGENTA 489

WINSOR & NEWTON

This colour has been strengthened over the previous version. PV19 is an excellent pigment worth looking out for. A reliable red-violet which handles very well. Transparent.

ARTISTS' WATER COLOUR

PV19 QUINACRIDONE VIOLET ASTM II (185)		
PIGMENT DETAIL ON LABEL **YES**	ASTM **II** L'FAST	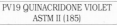

PERMANENT MAGENTA 262 (QUINACRIDONE)

DA VINCI PAINTS

Superb ingredients giving a first rate, all round, watercolour paint. Very dark at full strength, it washes out to give a range of very subtle tints.

PERMANENT ARTISTS' WATER COLOR

PV19 QUINACRIDONE VIOLET ASTM II (185) PB29 ULTRAMARINE BLUE ASTM I (215)		
PIGMENT DETAIL ON LABEL **YES**	ASTM **II** L'FAST	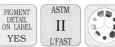

PERMANENT MAGENTA 409

DALER ROWNEY

The BS (Blue Shade) of PV23 is even more unreliable than the RS (Red Shade). Will gradually deteriorate on exposure. Semi-transparent.

Reformulated >

ARTISTS' WATER COLOUR

PV23BS DIOXAZINE PURPLE ASTM III-IV (186) PR122 QUINACRIDONE MAGENTA ASTM III (127)		
PIGMENT DETAIL ON LABEL **NO**	ASTM **III-IV** L'FAST	RATING ★

PERMANENT MAGENTA 409

DALER ROWNEY

This is a lot more like it. Reformulated to give a lightfast version under the same colour name.

Bear in mind that the unreliability of the previously used pigment did not come as a surprise to the manufacturer.

ARTISTS' WATER COLOUR

PV19 QUINACRIDONE VIOLET ASTM II (185)		
PIGMENT DETAIL ON LABEL **YES**	ASTM **II** L'FAST	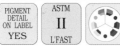

QUINACRIDONE MAGENTA 414

DALER ROWNEY

I suppose that some time before the next issue of this guide, this manufacturer is going to say, 'Oh no, has PR122 really failed ASTM testing? And we have been selling it to artists'. Avoid.

ARTISTS' WATER COLOUR

PR122 QUINACRIDONE MAGENTA ASTM III (127)		
PIGMENT DETAIL ON LABEL **YES**	ASTM **III** L'FAST	RATING ★★

COBALT MAGENTA 417

DALER ROWNEY

Before opening the tube I knew what to expect. The use of PV14 guaranteed that the paint would be weak, have little 'body', be swamped by the binder and be almost impossible to wash out smoothly.

ARTISTS' WATER COLOUR

PV14 COBALT VIOLET ASTM I (184)		
PIGMENT DETAIL ON LABEL **NO**	ASTM **I** L'FAST	RATING ★★

QUINACRIDONE MAGENTA 414

DR.Ph. MARTINS

A manufacturer providing samples and technical information for inclusion in this publication must surely know my approach when vital information is denied the artist.

HYDRUS FINE ART WATERCOLOR

PIGMENT INFORMATION NOT GIVEN ON THE PRODUCT OR IN THE LITERATURE PROVIDED		
PIGMENT DETAIL ON LABEL **NO**	ASTM L'FAST	RATING

QUINACRIDONE MAGENTA 414

UTRECHT

Pigments such as PR122, which have been proven to be unreliable, will only depart the scene when artists use their considerable purchasing power to bring about change.

PROFESSIONAL ARTISTS' WATER COLOR

PR122 QUINACRIDONE MAGENTA ASTM III (127)		
PIGMENT DETAIL ON LABEL **YES**	ASTM **III** L'FAST	RATING ★★

MAGENTA 352

SCHMINCKE

This used to be called 'Brilliant Red 2', then 'Magenta 906', now the above.

PV42 has not yet been ASTM tested but has a very good reputation for lightfastness. Sample gave very clear washes. Transparent.

HORADAM FINEST ARTISTS' WATER COLOURS

PV42 QUINACRIDONE MAROON B WG II (187)		
PIGMENT DETAIL ON LABEL **YES**	WG **II** L'FAST	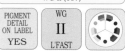

MAGENTA 1141

LUKAS

Fades rapidly as a tint and moves towards a dull, greyed, red-violet in mass tone. PR5 is another pigment to drive out of use.

Semi-transparent.

ARTISTS' WATER COLOUR

PR5 NAPTHOL 1TR ASTM III (116)		
PIGMENT DETAIL ON LABEL **CHEMICAL MAKE UP ONLY**	ASTM **III** L'FAST	RATING ★★

QUINACRIDONE MAGENTA 090

DANIEL SMITH

A reliable, rather dull (not that this is a bad thing), violet red which gave very smooth, even washes. A well made, quality product. Transparent.

EXTRA-FINE WATERCOLORS

PR202 QUINACRIDONE MAGENTA B WG II (133)		
PIGMENT DETAIL ON LABEL **YES**	WG **II** L'FAST	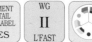

PERMANENT MAGENTA W314

HOLBEIN

Brushes out very smoothly. Excellent pigment used. Bright, transparent and gives a wide range of values. Transparent.

ARTISTS' WATER COLOR

PV19 QUINACRIDONE VIOLET ASTM II (185)		
PIGMENT DETAIL ON LABEL **YES**	ASTM **II** L'FAST	

Mauves

The name was originally used for the colour discovered by William Perkin in 1856. Mauve was the first of many thousands of coal tar dyes, most of which proved particularly fugitive.

The term is now used somewhat carelessly to describe violets varying from red to blue. Blue violets being the most common.

Mauve is usually considered to be a blue-violet but red-violets are also sold under the title.

The mixing complementary of a blue-violet is an orange-yellow such as Cadmium Yellow Light.

If you are working with a Mauve biased towards red, select a green-yellow (Lemon Yellow).

PERMANENT MAUVE 413

As the ASTM rating suggests, the use of PV23 will cause a gradual deterioration of the colour. Reliable if kept in the dark, as artists have been for a very long time. Semi-transparent.

DALER ROWNEY
ARTISTS' WATER COLOUR

PV23 RS DIOXAZINE PURPLE ASTM III-IV (186)		
PIGMENT DETAIL ON LABEL YES	ASTM III-IV L'FAST	RATING ★

MAUVE 413

A sensitive colour which will quickly change from a bright violet to a very pale grey-violet. Transparent.

Reformulated >

DALER ROWNEY
GEORGIAN WATER COLOUR 2ND RANGE

PV3 METHYL VIOLET WG V (182) PR81 RHODAMINE Y WG V (121) PB15 PHTHALOCYANINE BLUE ASTM II (213)		
PIGMENT DETAIL ON LABEL YES	WG V L'FAST	RATING ★

MAUVE 319

I am advised that BV10 and BR2 might well be fugitive dyes

But why worry? The irresponsible use of PV3 is going to ruin the colour anyway.

DALER ROWNEY
GEORGIAN WATER COLOUR 2ND RANGE

PV3 METHYL VIOLET WG V (182) PB60 INDANTHRONE BLUE WG II (216) BV10 AND BR2		
PIGMENT DETAIL ON LABEL NO	WG V L'FAST	RATING ★

MAUVE A139

Will resist light quite well for some time but will eventually fade to a marked extent.

Why use a material which is proven to be unreliable? I am sure it is nothing to do with profit margins.

GRUMBACHER
ACADEMY ARTISTS' WATERCOLOR 2ND RANGE

PV23 BS DIOXAZINE PURPLE ASTM III-IV (186)		
PIGMENT DETAIL ON LABEL YES	ASTM III-IV L'FAST	RATING ★

MAUVE 532

It is a pity that the unreliable PV23BS was added to the excellent PV19.

Brushed out well. Semi-transparent.

Reformulated >

TALENS
REMBRANDT ARTISTS' QUALITY EXTRA FINE

PV19 QUINACRIDONE VIOLET ASTM II (185) PV23 BS DIOXAZINE PURPLE ASTM III-IV (186)		
PIGMENT DETAIL ON LABEL YES	ASTM III-IV L'FAST	RATING ★

MAUVE 320

A reliable combination to replace the previous disaster area. So it can be done.

Handled very well and is lightfast.

TALENS
REMBRANDT ARTISTS' QUALITY EXTRA FINE

PB15 PHTHALOCYANINE BLUE ASTM II (213) PV19 QUINACRIDONE VIOLET ASTM II (185)		
PIGMENT DETAIL ON LABEL YES	ASTM II L'FAST	

MAUVE 476

Several manufacturers dispute the ASTM rating of IV. Our own tests tended to support the low rating. It might be that the version used here is more reliable. Pending further testing I have to give a low rating.

SCHMINCKE
HORADAM FINEST ARTISTS' WATER COLOURS

PV23 DIOXAZINE PURPLE ASTM III-IV (186)		
PIGMENT DETAIL ON LABEL YES	ASTM III-IV L'FAST	RATING ★

MAUVE 499

The use of PV39, will ensure that the tint will fade and the mass tone discolour. Transparent. The name has recently been changed from 'Magenta' 490.

Discontinued

SCHMINCKE
HORADAM FINEST ARTISTS' WATER COLOURS

PR122 QUINACRIDONE MAGENTA ASTM III (127) PV39 CRYSTAL VIOLET WG V (186) PV19 QUINACRIDONE VIOLET ASTM II (185)		
PIGMENT DETAIL ON LABEL YES	WG V L'FAST	RATING ★

MAUVE 398 (030)

It would appear that the violet component is less than reliable. Sample quickly faded and discoloured. It became a green-blue due to the remaining PB15. Semi-transparent.

Discontinued

WINSOR & NEWTON
ARTISTS' WATER COLOUR

ALUMINA LAKE OF BASIC VIOLETS 1.10 AND 14 PB15 PHTHALOCYANINE BLUE ASTM II (213)		
PIGMENT DETAIL ON LABEL YES	ASTM L'FAST	RATING ★

MAUVE 256

DA VINCI PAINTS

PERMANENT ARTISTS' WATER COLOR

A blue-violet which handles well. Very clear washes are available over a wide range of values. A 'clean' colour produced from excellent pigments.

PV19 QUINACRIDONE VIOLET ASTM II (185)
PB29 ULTRAMARINE BLUE ASTM I (215)

PIGMENT DETAIL ON LABEL	ASTM	
YES	II L'FAST	

MAUVE 656

DA VINCI PAINTS

SCUOLA 2ND RANGE

Reliable ingredients but the physical nature of the paint needs to be adjusted, as I am sure it will be. Paint under considerable pressure and washed out with difficulty unless thin.

PB29 ULTRAMARINE BLUE ASTM I (215)
PV19 QUINACRIDONE VIOLET ASTM II (185)

PIGMENT DETAIL ON LABEL	ASTM	RATING
YES	II L'FAST	★★

PERMANENT MAUVE W23

ART SPECTRUM

ARTISTS' WATER COLOUR

Sample washed out very well in this easily mixed convenience colour. Excellent pigments used. A well made watercolour paint.

Transparent and semi staining.

PB29 ULTRAMARINE BLUE ASTM I (215)
PV19 QUINACRIDONE VIOLET ASTM II (185)

PIGMENT DETAIL ON LABEL	ASTM	
YES	II L'FAST	

MAUVE 398

WINSOR & NEWTON

COTMAN WATER COLOURS 2ND RANGE

On exposure to light the colour moves from a bright red-violet to a very dull mid-violet. Most unreliable. Transparent.

Reformulated >

PV2 RHODAMINE 3B LAKE ASTM IV (182)
PB15 PHTHALOCYANINE BLUE ASTM II (213)

PIGMENT DETAIL ON LABEL	ASTM	RATING
YES	IV L'FAST	★

MAUVE 398

WINSOR & NEWTON

COTMAN WATER COLOURS 2ND RANGE

From one very irresponsible combination to another. Hard to believe isn't it?

'2nd Range' or 'Student' colours need not be fugitive.

PR122 QUINACRIDONE MAGENTA ASTM III (127)
PV23 DIOXAZINE PURPLE ASTM III-IV (186)

PIGMENT DETAIL ON LABEL	ASTM	RATING
YES	III-IV L'FAST	★

PERMANENT MAUVE 491

WINSOR & NEWTON

ARTISTS' WATER COLOUR

Absolutely lightfast. A rather weak colour but handles well. Does not give very clear washes when thin. Granulates.

PV16 MANGANESE VIOLET ASTM I (185)

PIGMENT DETAIL ON LABEL	ASTM	
YES	I L'FAST	

DIOXAZINE MAUVE 202

OLD HOLLAND

CLASSIC WATERCOLOURS

Rather over bound causing poor washes unless heavy. But it will fade nicely.

PV23:1 RS DIOXAZINE PURPLE ASTM III-IV (186)

PIGMENT DETAIL ON LABEL	ASTM	RATING
CHEMICAL MAKE UP ONLY	III-IV L'FAST	★

MAUVE 1142

LUKAS

ARTISTS' WATER COLOUR

Our sample faded as a tint and moved towards blue in mass tone. Washed out smoothly. Semi-transparent. It is entirely up to the buying artist whether or not such materials remain in use.

PV23 RS DIOXAZINE PURPLE ASTM III-IV (186)
PR5 NAPTHOL 1TR ASTM III (116)

PIGMENT DETAIL ON LABEL	ASTM	RATING
CHEMICAL MAKE UP ONLY	III-IV L'FAST	★

Purples

Whereas mauves are usually blue violets, purples are generally red violets.

Many are fugitive and all but the brightest can be duplicated on the palette, using reliable ingredients.

The brighter manufactured colours tend to fade rapidly.

Purple is normally a red-violet. Its mixing complementary is yellow green. Violets, in the next section, will vary from red to blue in bias. When selecting for any of them, first decide on the leaning of the colour, place it into the palette and look directly opposite for its mixing partner.

DIOXAZINE PURPLE 008

UTRECHT

PROFESSIONAL ARTISTS' WATER COLOR

An over bound watercolour paint which is set to have a limited life once painted out. Not impressed.

PV23 RS DIOXAZINE PURPLE ASTM III-IV (186)		
PIGMENT DETAIL ON LABEL YES	ASTM III-IV L'FAST	RATING ★

PURPLE LAKE 437

DALER ROWNEY

ARTISTS' WATER COLOUR

Why add an inferior substance such as PR83:1 to an excellent pigment like PV19? Fades and discolours. Transparent.

Discontinued

| PR83:1 ALIZARIN CRIMSON ASTM IV (122) | | |
PV19 QUINACRIDONE VIOLET ASTM II (185)		
PIGMENT DETAIL ON LABEL NO	ASTM IV L'FAST	RATING ★

PURPLE MADDER (ALIZARIN) 439

DALER ROWNEY

ARTISTS' WATER COLOUR

That this watercolour will move towards a dull blackish red is predictable. The red fades, the black stays. Semi-opaque.

Discontinued

| PR83:1 ALIZARIN CRIMSON ASTM IV (122) | | |
PBk6 LAMP BLACK ASTM I (370)		
PIGMENT DETAIL ON LABEL NO	ASTM IV L'FAST	RATING ★

PURPLE

DALER ROWNEY

GEORGIAN WATER COLOUR 2ND RANGE

A rather beautiful, bright red-violet which becomes a very pale, discoloured, red-grey on exposure to light. Transparent.

Reformulated>

| PR81 RHODAMINE Y WG V (121) | | |
PB15 PHTHALOCYANINE BLUE ASTM II (213)		
PIGMENT DETAIL ON LABEL NO	WG V L'FAST	RATING ★

PURPLE

DALER ROWNEY

GEORGIAN WATER COLOUR 2ND RANGE

I am advised that BV10 and BR2 are probably fugitive dyes. But why worry? The PV3 will ruin the colour anyway.

| PV3 METHYL VIOLET WG V (182) | | |
| PB60 INDANTHRONE BLUE WG II (216) | | |
BV10 AND BR2		
PIGMENT DETAIL ON LABEL NO	WG V L'FAST	RATING ★

PURPLE MAGENTA 367

SCHMINCKE

HORADAM FINEST ARTISTS' WATER COLOURS

The fugitive PV1, see page 182, previously added has been removed. The lightfast rating has improved from WGV to ASTM III. A step in the right direction, but a very small step. Previously 'Brilliant Purple 1 907'.

PR122 QUINACRIDONE MAGENTA ASTM III (127)		
PIGMENT DETAIL ON LABEL YES	ASTM III L'FAST	RATING ★★

BRILLIANT PURPLE 2 908

SCHMINCKE

HORADAM FINEST ARTISTS' WATER COLOURS

Quickly spoils on exposure due to the use of the fugitive PV1.

A most unreliable pigment. Transparent. This colour has now been discontinued.

Discontinued

| PR48:4 PERMANENT RED 2B (MANGANESE) WG II-III (119) | | |
PV1 RHODAMINE B WG V (182)		
PIGMENT DETAIL ON LABEL YES	WG V L'FAST	RATING ★

BRILLIANT PURPLE 930

SCHMINCKE

HORADAM FINEST ARTISTS' WATER COLOURS

This is utterly irresponsible. The manufacturers cannot be under any illusion that this colour will be other than very short lived (pse. see notes page 182). What goes on in this industry? Do they only care when artists change buying habits? If so I will continue to encourage such change.

PV1 RHODAMINE B WG V (182)		
PIGMENT DETAIL ON LABEL YES	WG V L'FAST	RATING ★

PASSIONATE PURPLE 082

AMERICAN JOURNEY

PROFESSIONAL ARTISTS' WATER COLOR

A red violet produced from pigments which have actually proved their worth. It can be done. Washed out very well. A quality product.

| PR88 MRS THIOINDIGOID VIOLET ASTM II (122) | | |
PV19 QUINACRIDONE VIOLET ASTM II (185)		
PIGMENT DETAIL ON LABEL YES	ASTM II L'FAST	

CADMIUM RED PURPLE 611

SENNELIER

The pigment selected gives a very reliable, dense watercolour. Unaffected by light or heat. An excellent product. Opaque.

EXTRA-FINE WATERCOLOUR

PR108 CADMIUM RED LIGHT, MEDIUM OR DEEP ASTM I (126)		
PIGMENT DETAIL ON LABEL **YES**	ASTM **I** L'FAST	

QUINACRIDONE PURPLE 671

SENNELIER

Sample resisted light very well for some time but eventually gave in. Treat with caution. Transparent. The name changed several years ago from 'Helios Purple'.

EXTRA-FINE WATERCOLOUR

PR122 QUINACRIDONE MAGENTA ASTM III (127)		
PIGMENT DETAIL ON LABEL **YES**	ASTM **III** L'FAST	RATING ★★

PURPLE No13

PENTEL

It might well be that this range and its associated product in the poly tubes is not meant for artistic use.

If so, the wording in the product literature should be amended.

WATER COLORS

PIGMENT INFORMATION NOT PROVIDED IN ANY FORM		
PIGMENT DETAIL ON LABEL **NO**	ASTM L'FAST	RATING

LIGHT PURPLE 91

CARAN D'ACHE

Washed out with ease and lifted from the pan likewise.

Before we get excited it should be born in mind that the results of ASTM testing of PR122 are well known. As are the eventual results when used in a piece of work.

FINEST WATER COLOUR

PW4 ZINC WHITE ASTM I (384) PR122 QUINACRIDONE MAGENTA ASTM III (127)		
PIGMENT DETAIL ON LABEL **YES**	ASTM **III** L'FAST	RATING ★★

SCHEVENINGEN PURPLE BROWN 26

OLD HOLLAND

There must be an abundance of gum Arabic in The Netherlands, judging by the amount put into the watercolours produced there.

CLASSIC WATERCOLOURS

PR175 BENZIMIDAZOLONE MAROON WG II (130)		
PIGMENT DETAIL ON LABEL CHEMICAL MAKE UP ONLY	WG **II** L'FAST	RATING ★★

CADMIUM RED PURPLE 25

OLD HOLLAND

A well made, well balanced watercolour paint which washed out evenly. This version of PR108, *if there are no additions*, is very much on the violet side. I will accept the description but will analyse the paint.

CLASSIC WATERCOLOURS

PR108 CADMIUM RED LIGHT, MEDIUM OR DEEP ASTM I (126)		
PIGMENT DETAIL ON LABEL CHEMICAL MAKE UP ONLY	ASTM **I** L'FAST	

ROYAL PURPLE LAKE 184

OLD HOLLAND

Coloured gum.

CLASSIC WATERCOLOURS

PV19 QUINACRIDONE VIOLET ASTM II (185)		
PIGMENT DETAIL ON LABEL CHEMICAL MAKE UP ONLY	ASTM **II** L'FAST	RATING ★

CADMIUM PURPLE 2229

UMTON BARVY

Reliable pigment used. I cannot offer an assessment as a sample was not supplied.

ARTISTIC WATER COLOR

PR108 CADMIUM RED LIGHT, MEDIUM OR DEEP ASTM I (126)		
PIGMENT DETAIL ON LABEL **NO**	ASTM L'FAST	RATING

PERMANENT MADDER LAKE PURPLE 325

TALENS

A well produced watercolour paint which gave smooth, even washes. I am afraid that I have insufficient information on PR264 to offer assessments.

REMBRANDT ARTISTS' QUALITY EXTRA FINE

PR264 COMMON NAME N/K LF NOT OFFERED (137) PV19 QUINACRIDONE VIOLET ASTM II (185)		
PIGMENT DETAIL ON LABEL **YES**	ASTM L'FAST	RATING

CADMIUM RED PURPLE 17

HOLBEIN

An excellent pigment giving a superb watercolour. Strong enough to give reasonably transparent washes. Opaque.

ARTISTS' WATER COLOR

PR108 CADMIUM RED LIGHT, MEDIUM OR DEEP ASTM I (126)		
PIGMENT DETAIL ON LABEL **YES**	ASTM **I** L'FAST	

ANTIQUE TYRIAN PURPLE 045

HOLBEIN

Please see my notes on page 186 concerning PV37. Nice name though.

IRODORI ANTIQUE WATERCOLOR

PV37 COMMON NAME N/K WG III-IV (186) PR88 MRS THIOINDIGOID VIOLET ASTM II (122)		
PIGMENT DETAIL ON LABEL **YES**	WG **III-IV** L'FAST	RATING ★

DIOXAZINE PURPLE 100

M.GRAHAM & CO.

An appallingly bad pigment to produce a watercolour which took all day to dry out, in even medium applications.

ARTISTS' WATERCOLOR

PV23BS/RS DIOXAZINE PURPLE ASTM III-IV (186)		
PIGMENT DETAIL ON LABEL **YES**	ASTM **III-IV** L'FAST	RATING ★

PURPLE LAKE 544

WINSOR & NEWTON

The use of PV2 guarantees fading and severe discoloration on exposure to light. Temporary work only. Transparent.

Reformulated >

COTMAN WATER COLOURS 2ND RANGE

| PV2 RHODAMINE 3B LAKE ASTM IV (182) |
| PB15 PHTHALOCYANINE BLUE ASTM II (213) |

PIGMENT DETAIL ON LABEL	ASTM	RATING
YES	IV L'FAST	★

PURPLE LAKE 544

WINSOR & NEWTON

An appalling, gummy mess emerged from the tube.

The company has reformulated many colours, discontinued others and introduced new, but I have to say the quality seems to me to have dropped somewhat during this exercise.

COTMAN WATER COLOURS 2ND RANGE

| PR88 MRS THIOINDIGOID VIOLET ASTM II (122) |

PIGMENT DETAIL ON LABEL	ASTM	
YES	II L'FAST	

PURPLE LAKE 544 (038)

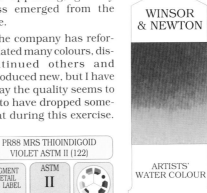

WINSOR & NEWTON

Rapidly disintegrates on exposure to light. Thin tints disappear. Becomes discoloured in heavier applications. Most unreliable. Transparent.

Discontinued

ARTISTS' WATER COLOUR

| PR83:1 ALIZARIN CRIMSON ASTM IV (122) |
| PV23BS DIOXAZINE PURPLE ASTM III-IV (186) |

PIGMENT DETAIL ON LABEL	ASTM	RATING
YES	IV L'FAST	★

PURPLE MADDER (ALIZARIN) 546

WINSOR & NEWTON

A race to decide which pigment will leave the scene first. Now discontinued, but do not forget that reputations and fortunes have been made supplying such substances to the unwary artist.

Discontinued

ARTISTS' WATER COLOUR

| PV23 RS DIOXAZINE PURPLE ASTM III-IV (186) |
| PR83:1 ALIZARIN CRIMSON ASTM IV (122) |

PIGMENT DETAIL ON LABEL	ASTM	RATING
YES	IV L'FAST	★

PURPLE MADDER (ALIZARIN) 335

TALENS

Gives good even washes but the colour will be short lived. Very dark when applied heavily. Transparent.

Discontinued, and about time

REMBRANDT ARTISTS' QUALITY EXTRA FINE

| PR83:1 ALIZARIN CRIMSON ASTM IV (122) |
| PR122 QUINACRIDONE MAGENTA ASTM III (127) |

PIGMENT DETAIL ON LABEL	ASTM	RATING
YES	IV L'FAST	★

THALO PURPLE W206

GRUMBACHER

The irresponsible inclusion of the unreliable PV23BS will cause the colour to spoil on exposure. Semi-transparent.

FINEST ARTISTS' WATER COLOR

| PV23BS DIOXAZINE PURPLE ASTM III-IV (186) |
| PB15 PHTHALOCYANINE BLUE ASTM II (213) |

PIGMENT DETAIL ON LABEL	ASTM	RATING
YES	III-IV L'FAST	★

Miscellaneous Violets

The term violet is used to describe any pigment or combination of pigments giving either a red, blue or mid violet colour. I believe the wide range of violets that are available reflect the difficulty that most painters find in mixing this particular hue. These difficulties have come about because of the widespread belief in the 'Three Primary System'. It is a method of working which will always fail us.

When the artist sets about mixing a violet with the belief that blue and red will combine to give the colour, chaos usually results.

My book 'Blue and Yellow Don't Make Green' could equally well be titled 'Blue and Red Don't Make Violet'. When blue and red are mixed in equal intensity the two colours destroy each other, leaving the amount of violet that they each contain.

With basic colour mixing skills, a wide range of violets can be produced from just four colours. Two reds and two blues. Bring in the two yellows to desaturate and you have a vast range.

All but the very brightest can be produced on the palette. Bright manufactured violets are invariably fugitive anyway.

ALIZARINE VIOLET LAKE 940

SENNELIER

PV5:1 is a most unfortunate substance to use in an artist's watercolour. Fades as a wash and severely discolours in mass tone. Transparent.

Reformulated >

EXTRA-FINE WATERCOLOUR

| PV5:1 AL ALIZARIN MAROON ASTM V (183) |

PIGMENT DETAIL ON LABEL	ASTM	RATING
YES	V L'FAST	★

ALIZARINE VIOLET LAKE 940

SENNELIER

I find this hard to believe. One appalling substance changed for another. If you want this industry to change you will have to hit them in the pocket. Not much else seems to matter. Your work certainly doesn't.

EXTRA-FINE WATERCOLOUR

| PR83 ROSE MADDER ALIZARIN ASTM IV (122) |

PIGMENT DETAIL ON LABEL	ASTM	RATING
YES	IV L'FAST	★

ANTIQUE VIOLET 021

HOLBEIN

The pigment description below says it all.

IRODORI ANTIQUE WATERCOLOR

| PV23BS/RS DIOXAZINE PURPLE ASTM III-IV (186) |

PIGMENT DETAIL ON LABEL	ASTM	RATING
YES	III-IV L'FAST	★

ANTIQUE VIOLET BLUE 044

HOLBEIN

A soft, pale violet which will become softer and paler on exposure to the light.

IRODORI ANTIQUE WATERCOLOR

| PV23BS/RS DIOXAZINE PURPLE ASTM III-IV (186) |
| PW6 TITANIUM WHITE ASTM I (385) |

| PIGMENT DETAIL ON LABEL **YES** | ASTM **III-IV** L'FAST | RATING ★ |

BRILLIANT VIOLET 909

SCHMINCKE

Once a disastrous colour due to inferior ingredients.

Now reformulated to give a superb, lightfast paint. Transparent

Discontinued

HORADAM FINEST ARTISTS' WATER COLOURS

| PV15 ULTRAMARINE VIOLET ASTM I (184) |
| PV16 MANGANESE VIOLET ASTM I (185) |

| PIGMENT DETAIL ON LABEL **YES** | ASTM **I** L'FAST | |

BLUE VIOLET 903

SENNELIER

A paint which washed out extremely well but will tend to darken on exposure to light. Described as 'fugitive' in the literature. So why offer it?

EXTRA-FINE WATERCOLOUR

| PV39 CRYSTAL VIOLET WG V (186) |

| PIGMENT DETAIL ON LABEL **YES** | WG **V** L'FAST | RATING ★ |

BAYEUX VIOLET 603

LEFRANC & BOURGEOIS

Reliable red-violets do exist and the pigments are easily obtained. This is an excellent all round watercolour. Semi-opaque.

Reformulated >

LINEL EXTRA-FINE ARTISTS' WATERCOLOUR

| PV46 GRAPTHOL VIOLET CI-4RL WG II (187) |

| PIGMENT DETAIL ON LABEL CHEMICAL MAKE UP ONLY | WG **II** L'FAST | |

BAYEUX VIOLET 603

LEFRANC & BOURGEOIS

Painted out evenly and will gradually fade in the same way.

LINEL EXTRA-FINE ARTISTS' WATERCOLOUR

| PR122 QUINACRIDONE MAGENTA ASTM III (127) |
| PV23BS DIOXAZINE PURPLE ASTM III-IV (186) |

| PIGMENT DETAIL ON LABEL CHEMICAL MAKE UP ONLY | ASTM **IV** L'FAST | RATING ★ |

BRIGHT VIOLET (LUMINOUS) W375

HOLBEIN

From what I can gather, BV7 and BV15 are probably dyes with a very short life. The vividness of the colour would seem to bear this out. No assessments possible until I have more information.

ARTISTS' WATER COLOR

| BV7 AND BV15 |

| PIGMENT DETAIL ON LABEL **YES** | ASTM L'FAST | RATING |

BRILLIANT VIOLET 2 910

SCHMINCKE

Exposure to light will cause the tint to fade and heavier applications to discolour dramatically. A temporary brilliance. Transparent becoming disappeared.

Reformulated>

HORADAM FINEST ARTISTS' WATER COLOURS

| PV39 CRYSTAL VIOLET WG V (186) |

| PIGMENT DETAIL ON LABEL **YES** | WG **V** L'FAST | RATING ★ |

BRILLIANT BLUE VIOLET 910

SCHMINCKE

I cannot offer a colour guide as a sample was not provided.

Literature says is for the special use of graphic and design. It is certainly unsuitable for work to be exposed to the light.

HORADAM FINEST ARTISTS' WATER COLOURS

| PV3 METHYL VIOLET WG V (182) |

| PIGMENT DETAIL ON LABEL **YES** | WG **V** L'FAST | RATING ★ |

BRILLIANT RED VIOLET 940

SCHMINCKE

Brilliant red violet and then brilliant white paper, or at best a pale, dull, red violet.

It is irresponsible to offer such materials for artistic use without printing a large warning on the product label.

HORADAM FINEST ARTISTS' WATER COLOURS

| PV1 RHODAMINE B WG V (182) |

| PIGMENT DETAIL ON LABEL **YES** | WG **V** L'FAST | RATING ★ |

CÔTE D'AZUR VIOLET 032

DANIEL SMITH

I was about to research the pigment when I tried to paint the sample out.

No more than thick coloured gum. An absolutely appalling substance.

EXTRA-FINE WATERCOLORS

| NATURAL LIGHT CAPUT MORTUUM |

| PIGMENT DETAIL ON LABEL **YES** | ASTM L'FAST | RATING |

CARBAZOLE VIOLET 019

DANIEL SMITH

The sample was very well made and washed out beautifully.

It is a pity that it will fade on exposure to light. As this is well known, why offer it?

EXTRA-FINE WATERCOLORS

| PV23BS/RS DIOXAZINE PURPLE ASTM III-IV (186) |

| PIGMENT DETAIL ON LABEL **YES** | ASTM **III-IV** L'FAST | RATING ★ |

DIOXAZINE VIOLET 231

WINSOR & NEWTON

After initially resisting light quite well our sample faded.

Use with caution and keep finished work away from direct light. In fact from any light. Semi-transparent then later, almost totally.

COTMAN WATER COLOURS 2ND RANGE

| PV23 RS DIOXAZINE PURPLE ASTM III-IV (186) |

| PIGMENT DETAIL ON LABEL **YES** | ASTM **III-IV** L'FAST | RATING ★ |

CAPUT MORTUUM VIOLET 125

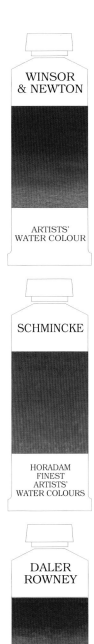

WINSOR & NEWTON

A rather gum laden watercolour paint.

Fortunately the nature of the pigment helps to give reasonable washes after being worked with a wet brush.

ARTISTS' WATER COLOUR

UNSPECIFIED PR101
ASTM I (123/124)

| PIGMENT DETAIL ON LABEL YES | ASTM I L'FAST | RATING ★★ |

EGYPT VIOLET 610

LEFRANC & BOURGEOIS

PV 23 RS takes light very well for some time but then fades rather quickly. A well produced paint which washes out very smoothly. Semi-transparent.

LINEL EXTRA-FINE ARTISTS' WATERCOLOUR

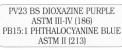
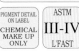
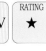

PV23 BS DIOXAZINE PURPLE
ASTM III-IV (186)
PB15:1 PHTHALOCYANINE BLUE
ASTM II (213)

| PIGMENT DETAIL ON LABEL CHEMICAL MAKE UP ONLY | ASTM III-IV L'FAST | RATING ★ |

GLOWING VIOLET 497

SCHMINCKE

A very much improved colour. Once fugitive, now reformulated into a superb, lightfast watercolour paint. Transparent.

Discontinued

HORADAM FINEST ARTISTS' WATER COLOURS

PV15 ULTRAMARINE VIOLET
ASTM I (184)
PV16 MANGANESE VIOLET
ASTM I (185)

| PIGMENT DETAIL ON LABEL YES | ASTM I L'FAST | |

MANGANESE VIOLET 474

SCHMINCKE

Previous colour No was 908. A semi-transparent violet which handles very well over a range of washes.

Very reliable ingredients.

HORADAM FINEST ARTISTS' WATER COLOURS

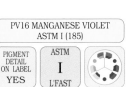

PV16 MANGANESE VIOLET
ASTM I (185)

| PIGMENT DETAIL ON LABEL YES | ASTM I L'FAST | |

MARS VIOLET W313

HOLBEIN

The unspecified Pigment Brown 7 and Pigment Red 101 will be reliable. Unfortunately the Pigment Violet 23 will cause a loss of colour. Most unreliable.

ARTISTS' WATER COLOR

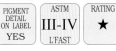

UNSPECIFIED PR101 ASTM I (123/124)
UNSPECIFIED PBr7 (309/310)
PV23BS/RS DIOXAZINE PURPLE
ASTM III-IV (186)

| PIGMENT DETAIL ON LABEL YES | ASTM III-IV L'FAST | RATING ★ |

MARS VIOLET W25

ART SPECTRUM

Sample brushed out beautifully, giving smooth even washes.

A well made watercolour paint employing a lightfast pigment.

ARTISTS' WATER COLOUR

UNSPECIFIED PR101
ASTM I (123/124)

| PIGMENT DETAIL ON LABEL YES | ASTM I L'FAST | |

MARS VIOLET 411

DALER ROWNEY

A very well produced watercolour paint which handled beautifully.

PR101 lends itself to the production of dense, smooth paints. Lightfast.

ARTISTS' WATER COLOUR

UNSPECIFIED PR101
ASTM I (123/124)

| PIGMENT DETAIL ON LABEL YES | ASTM I L'FAST | |

MARS VIOLET 052

DANIEL SMITH

Handles beautifully over a wide range of values. With the PR101s it pays to look for the delicate under tones which emerge in the thinner washes.

Absolutely lightfast.

EXTRA-FINE WATERCOLORS

PR101 MARS VIOLET ASTM I (123)

| PIGMENT DETAIL ON LABEL YES | ASTM I L'FAST | |

MANGANESE VIOLET 112

CARAN D'ACHE

Difficult to lift paint from the pan. Washed out fairly well when thin but not so when at all heavy. Unpleasant to use.

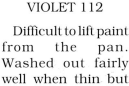

PV16 MANGANESE VIOLET
ASTM I (185)

| PIGMENT DETAIL ON LABEL YES | ASTM I L'FAST | RATING ★★ |

MANGANESE VIOLET-BLUENESS 196

OLD HOLLAND

A material that this company seem to be getting better at producing. Thick, coloured gum. An appalling substance.

CLASSIC WATERCOLOURS

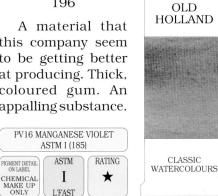

PV16 MANGANESE VIOLET
ASTM I (185)

| PIGMENT DETAIL ON LABEL CHEMICAL MAKE UP ONLY | ASTM I L'FAST | RATING ★ |

MANGANESE VIOLET-REDDISH 190

OLD HOLLAND

A redder coloured gum to the sample on the left. Completely unworkable.

But it did come in a nice wooden box.

CLASSIC WATERCOLOURS

PV16 MANGANESE VIOLET
ASTM I (185)

| PIGMENT DETAIL ON LABEL CHEMICAL MAKE UP ONLY | ASTM I L'FAST | RATING ★ |

MANGANESE VIOLET 2500

UMTON BARVY

Sample handled very well indeed in washes and lifted easily from the pan.

A reliable watercolour paint.

ARTISTIC WATER COLOR

PV16 MANGANESE VIOLET
ASTM I (185)

| PIGMENT DETAIL ON LABEL NO | ASTM I L'FAST | |

MANGANESE VIOLET 052

DANIEL SMITH

EXTRA-FINE WATERCOLORS

Washed out well in thin applications, poorly in heavier.

Due to the nature of the pigment the tints are not particularly clear. Lightfast.

PV16 MANGANESE VIOLET
ASTM I (185)

PIGMENT DETAIL ON LABEL	ASTM	RATING
YES	I L'FAST	★★

MANGANESE VIOLET 254

DA VINCI PAINTS

PERMANENT ARTISTS' WATER COLOR

A well produced mid violet. Semi-opaque with good covering power.

Handles well over a wide range of values. Absolutely lightfast.

PV16 MANGANESE VIOLET
ASTM I (185)

PIGMENT DETAIL ON LABEL	ASTM	
YES	I L'FAST	

MINERAL VIOLET W312

HOLBEIN

ARTISTS' WATER COLOR

Absolutely lightfast. Flows very well in a wash. Non staining with low tinting strength.

PV15 ULTRAMARINE VIOLET
ASTM I (184)

PIGMENT DETAIL ON LABEL	ASTM	
YES	I L'FAST	

MINERAL VIOLET 460

MAIMERI

MAIMERIBLU SUPERIOR WATERCOLOURS

Due to the nature of the pigment, this is a rather dull reddish violet with reasonable covering power. A reliable watercolour paint.

PV16 MANGANESE VIOLET
ASTM I (185)

PIGMENT DETAIL ON LABEL	ASTM	
YES	I L'FAST	

MINERAL VIOLET (FLINDERS BLUE) W24

ART SPECTRUM

ARTISTS' WATER COLOUR

Sample was a little over bound and handled better in thinner washes than heavier. A reliable semi opaque watercolour paint.

PV16 MANGANESE VIOLET
ASTM I (185)

PIGMENT DETAIL ON LABEL	ASTM	RATING
YES	I L'FAST	★ ★★

MANGANESE VIOLET 915

SENNELIER

EXTRA-FINE WATERCOLOUR

PV16 is particularly resistant to light. The sample handled well. Thin washes are less than transparent. Semi-opaque. Name recently changed from 'Mineral Violet'.

PV16 MANGANESE VIOLET
ASTM I (185)

PIGMENT DETAIL ON LABEL	ASTM	
YES	I L'FAST	

OLD HOLLAND BLUE VIOLET 205

OLD HOLLAND

CLASSIC WATERCOLOURS

Washed out beautifully. Moved from one value to another beautifully and will change colour beautifully as the PV23 fades.

PB15 PHTHALOCYANINE BLUE
ASTM II (213)
PV23 RS DIOXAZINE PURPLE
ASTM III-IV (186)

PIGMENT DETAIL ON LABEL	ASTM	RATING
CHEMICAL MAKE UP ONLY	III-IV L'FAST	★

OLD HOLLAND BRIGHT VIOLET 193

OLD HOLLAND

CLASSIC WATERCOLOURS

The same remarks apply as for the colour to the left.

PV15 ULTRAMARINE VIOLET ASTM I (184)
PV23 RS DIOXAZINE PURPLE ASTM III-IV (186)
PV19 QUINACRIDONE RED ASTM II (185)

PIGMENT DETAIL ON LABEL	ASTM	RATING
CHEMICAL MAKE UP ONLY	III-IV L'FAST	★

OLD VIOLET 478

SCHMINCKE

HORADAM FINEST ARTISTS' WATER COLOURS

The pigment has now been tested under ASTM conditions as a watercolour paint with very good results.

A well made paint.

Discontinued

PR257 COMMON NAME N/K
ASTM II (137)

PIGMENT DETAIL ON LABEL	ASTM	
YES	II L'FAST	

PERMANENT VIOLET 073

DANIEL SMITH

EXTRA-FINE WATERCOLORS

A semi transparent reddish violet which handled with absolute ease. A well produced, reliable watercolour paint.

PR88 MRS THIOINDIGOID
VIOLET ASTM II (122)

PIGMENT DETAIL ON LABEL	ASTM	
YES	II L'FAST	

PERMANENT VIOLET BLUEISH 463

MAIMERI

MAIMERIBLU SUPERIOR WATERCOLOURS

An intense colour on the way to self destruction. It is no secret in the art materials industry that this pigment is unstable.

PV23BS/RS DIOXAZINE PURPLE
ASTM III-IV (186)

PIGMENT DETAIL ON LABEL	ASTM	RATING
YES	III-IV L'FAST	★

PERMANENT VIOLET BLUEISH 463

MAIMERI

VENEZIA EXTRAFINE WATERCOLOURS

This might be a popular pigment but all manufacturers using it know that your work will spoil if you also use it.

PV23BS/RS DIOXAZINE PURPLE
ASTM III-IV (186)

PIGMENT DETAIL ON LABEL	ASTM	RATING
YES	III-IV L'FAST	★

PERMANENT VIOLET REDDISH 465

MAIMERI

Avoid the nonsense of colours which the manufacturers know will ruin your work.

These colours are so easy to mix from reliable paints it isn't true.

PR122 QUINACRIDONE MAGENTA ASTM III (127)
PV23BS/RS DIOXAZINE PURPLE ASTM III-IV (186)

PIGMENT DETAIL ON LABEL	ASTM	RATING
YES	III-IV L'FAST	★

MAIMERIBLU SUPERIOR WATERCOLOURS

PERMANENT VIOLET REDDISH 465

MAIMERI

More of the same, please see left.

PR122 QUINACRIDONE MAGENTA ASTM III (127)
PV23BS/RS DIOXAZINE PURPLE ASTM III-IV (186)

PIGMENT DETAIL ON LABEL	ASTM	RATING
YES	III-IV L'FAST	★

VENEZIA EXTRAFINE WATERCOLOURS

PERMANENT VIOLET W315

HOLBEIN

Will gradually deteriorate on exposure to light, particularly when applied as a thin wash. Semi-transparent gradually becoming exceedingly transparent.

PV23 DIOXAZINE PURPLE ASTM III-IV (186)

PIGMENT DETAIL ON LABEL	ASTM	RATING
YES	III-IV L'FAST	★

ARTISTS' WATER COLOR

PERMANENT VIOLET 172

UTRECHT

As the manufacturer must know, this colour will alter, moving towards a dull bluer violet as the PV23 fades.

PB29 ULTRAMARINE BLUE ASTM I (215)
PV23/RS DIOXAZINE PURPLE ASTM III-IV (186)

PIGMENT DETAIL ON LABEL	ASTM	RATING
YES	III-IV L'FAST	★

PROFESSIONAL ARTISTS' WATER COLOR

PERMANENT BLUE VIOLET 568

TALENS

At last, a manufactured violet which will not alter and spoil your work. It can be done and is easy to do so.

PV19 QUINACRIDONE VIOLET ASTM II (185)
PB15 PHTHALOCYANINE BLUE ASTM II (213)

PIGMENT DETAIL ON LABEL	ASTM	
YES	II L'FAST	

REMBRANDT ARTISTS' QUALITY EXTRA FINE

PERMANENT BLUE VIOLET 568

TALENS

Easily mixed on the palette.

Strong, transparent and can be trusted.

PV19 QUINACRIDONE VIOLET ASTM II (185)
PB15 PHTHALOCYANINE BLUE ASTM II (213)

PIGMENT DETAIL ON LABEL	ASTM	
YES	II L'FAST	

VAN GOGH 2ND RANGE

PERMANENT RED VIOLET 567

TALENS

Before considering a purchase, it is best to make sure that you do not already have this standard colorant amongst your other paints. Lightfast and transparent.

PV19 QUINACRIDONE VIOLET ASTM II (185)

PIGMENT DETAIL ON LABEL	ASTM	
YES	II L'FAST	

REMBRANDT ARTISTS' QUALITY EXTRA FINE

PERMANENT RED VIOLET 567

TALENS

It is most encouraging to see PV19 taking over from the very unreliable Alizarin Crimson in so many colours.

A bright, lightfast reddish violet which handles very well.

PV19 QUINACRIDONE VIOLET ASTM II (185)

PIGMENT DETAIL ON LABEL	ASTM	
YES	II L'FAST	

VAN GOGH 2ND RANGE

PERMANENT VIOLET 530

MIR (JAURENA S.A)

The old 'Permanent Violet' using impermanent pigments trick.

It never fails. But this colour will.

PR122 QUINACRIDONE MAGENTA ASTM III (127)
PV23BS/RS DIOXAZINE PURPLE ASTM III-IV (186)

PIGMENT DETAIL ON LABEL	ASTM	RATING
YES	III-IV L'FAST	★

ACUARELA

PERMANENT VIOLET 483

SCHMINCKE

Not particularly well named. Fades and discolours readily on exposure. Unsuitable for artistic use. Transparent.
Discontinued

PV23 BS DIOXAZINE PURPLE ASTM III-IV (186)
PV1 RHODAMINE B WG V (182)

PIGMENT DETAIL ON LABEL	ASTM	RATING
YES	III-IV L'FAST	★

HORADAM FINEST ARTISTS' WATER COLOURS

PERMANENT VIOLET 248

PÈBÈO

Pigment Violet 23 fades quickly after initially resisting light quite well. A smooth watercolour which handles well. Semi-transparent. Claimed to be ASTM II by the company but they have it wrong as they are using the incorrect ASTM list.

PV23 RS DIOXAZINE PURPLE ASTM III-IV (186)

PIGMENT DETAIL ON LABEL	ASTM	RATING
YES	III-IV L'FAST	★

FRAGONARD ARTISTS' WATER COLOUR

PERMANENT VIOLET 631

LEFRANC & BOURGEOIS

On exposure, will fade as a tint and discolour in heavier applications. Not a lot of use really unless this is what you are looking for.

Brushed out well over the range of values.

PR122 QUINACRIDONE MAGENTA ASTM III (127)

PIGMENT DETAIL ON LABEL	ASTM	RATING
CHEMICAL MAKE UP ONLY	III L'FAST	★★

LINEL EXTRA-FINE ARTISTS' WATERCOLOUR

PURPLE MADDER 543

WINSOR & NEWTON

An over bound watercolour paint which initially globulates on the surface in heavier layers and dries with a light shine. Transparent and staining.

PR177 ANTHRAQUINOID RED
ASTM III (130)
PR122 QUINACRIDONE MAGENTA
ASTM III (127)

ARTISTS' WATER COLOUR

PIGMENT DETAIL ON LABEL	ASTM	RATING
YES	III L'FAST	★★

PURPLE VIOLET 493

SCHMINCKE

PR202 has a particularly good reputation for lightfastness. The sample provided gave very clear, easily managed washes. A first class watercolour paint.

Discontinued

PR202 QUINACRIDONE
MAGENTA B WG II (133)

HORADAM FINEST ARTISTS' WATER COLOURS

PIGMENT DETAIL ON LABEL	WG	
YES	II L'FAST	

QUINACRIDONE VIOLET 094

DANIEL SMITH

Washed out very well. An excellent, reliable product.

Transparent and strong tinctorially.

PV19 QUINACRIDONE VIOLET
ASTM II (185)

EXTRA-FINE WATERCOLORS

PIGMENT DETAIL ON LABEL	ASTM	
YES	II L'FAST	

QUINACRIDONE VIOLET 004

UTRECHT

Quinacridone Violet is a first class pigment. Tested and tried it will give you bright violets mixed with Ultramarine Blue and very red violets alone. Darken with a yellow green.

PROFESSIONAL ARTISTS' WATER COLOR

PV19 QUINACRIDONE VIOLET
ASTM II (185)

PIGMENT DETAIL ON LABEL	ASTM	
YES	II L'FAST	

QUINACRIDONE MAGENTA 545

WINSOR & NEWTON

I have met representatives from this company. They know full well that this pigment has failed ASTM testing, yet they still offer it to you. Fades at a steady, even and predictable rate.

ARTISTS' WATER COLOUR

PR122 QUINACRIDONE MAGENTA
ASTM III (127)

PIGMENT DETAIL ON LABEL	ASTM	RATING
YES	III L'FAST	★★

QUINACRIDONE VIOLET 158

M. GRAHAM & CO.

A very smooth series of washes from this excellent product.

This plus Ultramarine Blue and you have a wide range of bright violets. Add yellows and it is vast.

PV19 QUINACRIDONE VIOLET
ASTM II (185)

ARTISTS' WATERCOLOR

PIGMENT DETAIL ON LABEL	ASTM	
YES	II L'FAST	

QUINACRIDONE VIOLET 368

SCHMINCKE

PV19 is a superb, all round pigment. Strong, transparent and bright. It is encouraging to see the use of this pigment becoming more widespread. This is an excellent watercolour.

PV19 QUINACRIDONE VIOLET
ASTM II (185)

HORADAM FINEST ARTISTS' WATER COLOURS

PIGMENT DETAIL ON LABEL	ASTM	
YES	II L'FAST	

QUINACRIDONE VIOLET 559

MAIMERI

PR 122 takes the light very well initially but will eventually fade. Use with caution (if at all) and keep any work in a soft light. Unsuitable for serious artistic endeavour.

Discontinued

PR122 QUINACRIDONE MAGENTA
ASTM III (127)

ARTISTI EXTRA-FINE WATERCOLOURS

PIGMENT DETAIL ON LABEL	ASTM	RATING
NO	III L'FAST	★★

QUINACRIDONE VIOLET 106

AMERICAN JOURNEY

A little gum laden but handled very well nevertheless, particularly when well diluted. A most reliable pigment with admirable qualities.

PV19 QUINACRIDONE VIOLET
ASTM II (185)

PROFESSIONAL ARTISTS' WATER COLOR

PIGMENT DETAIL ON LABEL	ASTM	RATING
YES	II L'FAST	★ ★★

RED VIOLET 905

SENNELIER

Very heavy applications turn to a pale dull red, medium and light washes go grey and then vanish altogether. Disastrous and irresponsible. Transparent.

Reformulated >

PV1 RHODAMINE B WG V (182)
PV3 METHYL VIOLET WG V (182)

EXTRA-FINE WATERCOLOUR

PIGMENT DETAIL ON LABEL	WG	RATING
YES	V L'FAST	★

RED VIOLET 905

SENNELIER

What a move forward. From two disastrous pigments to two disastrous pigments.

If you trust your work to the integrity of the average artists' paint manufacturer you can have little regard for it.

PV1 RHODAMINE B WG V (182)
PV39 CRYSTAL VIOLET WG V (186)

EXTRA-FINE WATERCOLOUR

PIGMENT DETAIL ON LABEL	WG	RATING
YES	V L'FAST	★

RED VIOLET 545

TALENS

It is a pity that the pigment is less than reliable as it would have made a useful violet-red. Thin washes in particular will tend to fade quickly. Should not be offered.

Discontinued

PR122 QUINACRIDONE MAGENTA
ASTM III (127)

WATER COLOUR 2ND RANGE

PIGMENT DETAIL ON LABEL	ASTM	RATING
YES	III L'FAST	★★

ROSE VIOLET (QUINACRIDONE MAGENTA) W318

HOLBEIN

Temporary brightness from a paint employing a pigment known throughout the trade to be unworthy of use in an artist watercolour.

ARTISTS' WATER COLOR

PR122 QUINACRIDONE MAGENTA
ASTM III (127)

PIGMENT DETAIL ON LABEL	ASTM	RATING
YES	III L'FAST	★★

RAW UMBER VIOLET 098

DANIEL SMITH

An unusual combination giving a colour similar to a mix of Cerulean Blue and Cadmium Red Light (Another way to produce a dull greyed violet). Washed well,

EXTRA-FINE WATERCOLORS

UNSPECIFIED PBr7 (309/310)
PV19 QUINACRIDONE VIOLET
ASTM II (185)

PIGMENT DETAIL ON LABEL	ASTM	
YES	II L'FAST	

SPEEDBALL VIOLET 5715

HUNTS

On subjecting PV23RS to the exacting lightfast tests set down by the ASTM, it was found to be unreliable. So why is in such widespread use?

SPEEDBALL PROFESSIONAL WATERCOLOURS

PV23RS DIOXAZINE PURPLE
ASTM III-IV (186)

PIGMENT DETAIL ON LABEL	ASTM	RATING
NO	III-IV L'FAST	★

SCHEVENINGEN VIOLET 30

OLD HOLLAND

Sample was very pleasant to use, giving excellent, smooth washes with ease.

A worthy pigment employed in the production of a quality product.

CLASSIC WATERCOLOURS

PR88 MRS THIOINDIGOID VIOLET
ASTM II (122)

PIGMENT DETAIL ON LABEL	ASTM	
CHEMICAL MAKE UP ONLY	II L'FAST	

THIO VIOLET W211

GRUMBACHER

Transparent, reasonably bright, good range of values and resistant to light.

A reliable and well produced watercolour.

FINEST ARTISTS' WATER COLOR

PR88 MRS THIOINDIGOID VIOLET
ASTM II (122)

PIGMENT DETAIL ON LABEL	ASTM	
YES	II L'FAST	

THIO VIOLET A211

GRUMBACHER

Gives a good range of values and even gradated washes. Reasonably transparent when thinly applied. Reliable.

ACADEMY ARTISTS' WATERCOLOR 2ND RANGE

PR88 MRS THIOINDIGOID VIOLET
ASTM II (122)

PIGMENT DETAIL ON LABEL	ASTM	
YES	II L'FAST	

THIO VIOLET W20

ART SPECTRUM

Handles better in thin applications than heavier.

I cannot offer assessments as it seems that the pigment given on the tube does not exist.

ARTISTS' WATER COLOUR

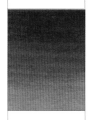
PV88 DOES NOT EXIST (188)

PIGMENT DETAIL ON LABEL	ASTM	RATING
YES	L'FAST	

THIOINDIGO VIOLET 640

WINSOR & NEWTON

A reliable transparent pigment used for this newly introduced colour.

Washed out reasonably well despite being somewhat over bound.

ARTISTS' WATER COLOUR

PR88 MRS THIOINDIGOID VIOLET
ASTM II (122)

PIGMENT DETAIL ON LABEL	ASTM	
YES	II L'FAST	

THIOINDIGO VIOLET 280

DA VINCI PAINTS

A reddish-violet which washes out very smoothly.

Excellent pigments giving a reliable, well produced colour.

PERMANENT ARTISTS' WATER COLOR

PV19 QUINACRIDONE VIOLET
ASTM II (185)
PR88 MRS THIOINDIGOID VIOLET
ASTM II (122)

PIGMENT DETAIL ON LABEL	ASTM	
YES	II L'FAST	

ULTRAMARINE VIOLET 199

OLD HOLLAND

A very reliable pigment made up into a watercolour paint which is particularly difficult to work. Very thin washes are fine. But that's it.

CLASSIC WATERCOLOURS

PV15 ULTRAMARINE VIOLET
ASTM I (184)

PIGMENT DETAIL ON LABEL	ASTM	RATING
CHEMICAL MAKE UP ONLY	I L'FAST	★★

ULTRAMARINE VIOLET W22

ART SPECTRUM

PV15 often has an unusual odour. A little like a gas works. Not that this makes any difference to the paint. An excellent product which gave effortless washes.

ARTISTS' WATER COLOUR

PV15 ULTRAMARINE VIOLET
ASTM I (184)

PIGMENT DETAIL ON LABEL	ASTM	
YES	I L'FAST	

ULTRAMARINE VIOLET 440

MAIMERI

Sample was slightly over bound and gave better dilute washes than heavier.

First class pigment used which will resist damage from the light.

MAIMERIBLU SUPERIOR WATERCOLOURS

PV15 ULTRAMARINE VIOLET
ASTM I (184)

PIGMENT DETAIL ON LABEL	ASTM	RATING
YES	I L'FAST	★★

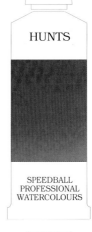

CARAN D'ACHE

FINEST WATERCOLOURS

ULTRAMARINE VIOLET 630

Very difficult to lift the paint from the pan, which is unusual in this make.

Washes were difficult to apply unless very thin. Thumbs down on this one I'm afraid.

PV15 ULTRAMARINE VIOLET ASTM I (184)

| PIGMENT DETAIL ON LABEL YES | ASTM I L'FAST | RATING ★★ |

TALENS

REMBRANDT ARTISTS' QUALITY EXTRA FINE

ULTRAMARINE VIOLET 507

A weak coloured gum. Due in part to the nature of the pigment, but it didn't have to be chosen.

Anyway, it's lightfast if you want a paint which is unpleasant to handle.

PV15 ULTRAMARINE VIOLET ASTM I (184)

| PIGMENT DETAIL ON LABEL YES | ASTM I L'FAST | RATING ★★ |

DALER ROWNEY

ARTISTS' WATER COLOUR

ULTRAMARINE VIOLET 419

Due, it would seem to the behaviour of this pigment when combined with gum, the resulting paint has a rather gummy consistency and washes poorly unless thin.

PV15 ULTRAMARINE VIOLET ASTM I (184)

| PIGMENT DETAIL ON LABEL NO | ASTM I L'FAST | RATING ★★ |

DANIEL SMITH

EXTRA-FINE WATERCOLORS

ULTRAMARINE VIOLET 108

Washed out very satisfactorily when thin but not so when at all heavy.

As with Cobalt Violet, this pigment seems to be unsuited for use in watercolour paints. That will not diminish its use however. But you could.

PV15 ULTRAMARINE VIOLET ASTM I (184)

| PIGMENT DETAIL ON LABEL YES | ASTM I L'FAST | RATING ★★ |

WINSOR & NEWTON

ARTISTS' WATER COLOUR

ULTRAMARINE VIOLET 672

Assessments cannot be offered or a colour guide given as a sample was not provided.

PV15 ULTRAMARINE VIOLET ASTM I (184)

| PIGMENT DETAIL ON LABEL YES | ASTM I L'FAST | RATING |

SCHMINCKE

HORADAM FINEST ARTISTS' WATER COLOURS

ULTRAMARINE VIOLET 495

PV15 has a very strange odour which remains with the paint film.

Absolutely lightfast. Difficult in heavier applications and seems unsuited to watercolours. Semi-opaque.

PV15 ULTRAMARINE RED ASTM I (184)

| PIGMENT DETAIL ON LABEL YES | ASTM I L'FAST | RATING ★★ |

ULTRAMARINE RED 2260

Sample handled very well indeed for the application of thin washes. Lacked 'body' for heavier layers.

A lightfast pigment used.

PV15 ULTRAMARINE VIOLET ASTM I (184)

| PIGMENT DETAIL ON LABEL NO | ASTM I L'FAST | RATING ★★ |

LUKAS

ARTISTS' WATER COLOUR

ULTRAMARINE RED 1094

The pigment has a strong odour, almost like coal gas.

This latest sample, like all previous, lacked body and was rather chalky. Semi-opaque.

PV15 ULTRAMARINE VIOLET ASTM I (184)

| PIGMENT DETAIL ON LABEL CHEMICAL MAKE UP ONLY | ASTM I L'FAST | RATING ★★ |

GRUMBACHER

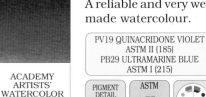

ACADEMY ARTISTS' WATERCOLOR 2ND RANGE

VIOLET 229

The unreliable PV23 once used has been replaced with a lightfast pigment. A step in the right direction, without a doubt. A reliable and very well made watercolour.

PV19 QUINACRIDONE VIOLET ASTM II (185)
PB29 ULTRAMARINE BLUE ASTM I (215)

| PIGMENT DETAIL ON LABEL YES | ASTM II L'FAST | |

TALENS

VAN GOGH 2ND RANGE

VIOLET 536

PV 23 will unfortunately fade to a considerable extent on exposure to light.

Thinner washes are most susceptible to damage. Semi-transparent.

Discontinued

PV23 DIOXAZINE PURPLE ASTM III-IV (186)

| PIGMENT DETAIL ON LABEL YES | ASTM III-IV L'FAST | RATING ★ |

TALENS

REMBRANDT ARTISTS' QUALITY EXTRA FINE

VIOLET 536

Will fade after initially resisting the light. This is a pity as the colour is quite strong and the paint handles very well. Treat with caution. Better still, don't use it. Semi-transparent.

Discontinued

PV23BS DIOXAZINE PURPLE ASTM III-IV (186)

| PIGMENT DETAIL ON LABEL YES | ASTM III-IV L'FAST | RATING ★ |

ST. PETERSBURG

ARTISTS' WATERCOLOURS

VIOLET

I sometimes wonder if the tremendous effort required to put these books together is really worth it.

Financially it never will be. But if I can alert concerned artists to what actually goes on, it will have been worth it all.

INFORMATION ON THE PIGMENTS USED HAS BEEN DELIBERATELY DENIED TO THE ARTIST

| PIGMENT DETAIL ON LABEL NO | ASTM L'FAST | |

VIOLET 630

MAIMERI

Reformulated several years ago, but without any real improvement to the lightfastness.

The pigment is prone to fairly rapid fading. Semi-trans.

Discontinued

PV23BS/RS DIOXAZINE PURPLE ASTM III-IV (186)

MAIMERIBLU SUPERIOR WATERCOLOURS

PIGMENT DETAIL ON LABEL	ASTM	RATING
YES	III-IV L'FAST	★

VIOLET CARMINE 690 (091)

WINSOR & NEWTON

It would appear that the lake of basic violets is unreliable. Our sample rapidly changed from a reasonably bright violet to a light, dull grey. Disastrous.

Discontinued

ALUMINA LAKE OF BASIC VIOLETS 1.10 AND 14.
PB15 PHTHALOCYANINE BLUE ASTM II (213)
PBk6 LAMP BLACK ASTM I (370)

ARTISTS' WATER COLOUR

PIGMENT DETAIL ON LABEL	ASTM
YES	L'FAST

VIOLET ALIZARIN 453

DALER ROWNEY

Washes out very well into a useful range of values. Unfortunately will tend to fade and change colour due to the PV23 content.

Discontinued

PV23BS/RS DIOXAZINE PURPLE ASTM III-IV (186)
PBk6 LAMP BLACK ASTM I (370)
PV19 QUINACRIDONE VIOLET ASTM II (185)

ARTISTS' WATER COLOUR

PIGMENT DETAIL ON LABEL	ASTM	RATING
YES	III-IV L'FAST	★

VIOLET LAKE 1128

LUKAS

On exposure will tend to gradually become paler and bluer as the PV23 content fades. This will be most noticeable in thin washes. Don't get caught.

PV23 RS DIOXAZINE PURPLE ASTM III-IV (186)
PB15 PHTHALOCYANINE BLUE ASTM II (213)

ARTISTS' WATER COLOUR

PIGMENT DETAIL ON LABEL	ASTM	RATING
CHEMICAL MAKE UP ONLY	III-IV L'FAST	★

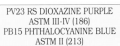 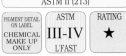

VIOLET LAKE 527

MAIMERI

Washed out very smoothly over the full range. Unreliable due to the Pigment Violet 23 content. As the violet fades the colour will become bluer. Keep any work in very soft light.

Discontinued

PB29 ULTRAMARINE BLUE ASTM I (215)
PV23BS/RS DIOXAZINE PURPLE ASTM III-IV (186)

ARTISTI EXTRA-FINE WATERCOLOURS

PIGMENT DETAIL ON LABEL	ASTM	RATING
NO	III-IV L'FAST	★

VIOLET GREY W354

HOLBEIN

Reliable pigments. Rather chalky in appearance due to the use of the white. Handled reasonably well. Non staining and easy to lift.

PR88 MRS THIOINDIGOID VIOLET ASTM II (122)
PW6 TITANIUM WHITE ASTM I (385)

ARTISTS' WATER COLOR

PIGMENT DETAIL ON LABEL	ASTM	
YES	II L'FAST	

VIOLET EXTRA LIGHT 611

LEFRANC & BOURGEOIS

PV3 is a most unsuitable substance for use in the preparation of artists materials. Fades and discolours alarmingly. Transparent.

Reformulated >

PV3 METHYL VIOLET WG V (182)

LINEL EXTRA-FINE ARTISTS' WATERCOLOUR

PIGMENT DETAIL ON LABEL	WG	RATING
CHEMICAL MAKE UP ONLY	V L'FAST	★

VIOLET EXTRA LIGHT 611

LEFRANC & BOURGEOIS

Reformulated, but look at the panel below to see what they used.

Does any of it make sense? Or am I writing this too late at night?

PR122 QUINACRIDONE MAGENTA ASTM III (127)
PV23BS/RS DIOXAZINE PURPLE ASTM III-IV (186)

LINEL EXTRA-FINE ARTISTS' WATERCOLOUR

PIGMENT DETAIL ON LABEL	ASTM	RATING
CHEMICAL MAKE UP ONLY	III-IV L'FAST	★

VERZINO VIOLET 473

MAIMERI

This is becoming very tedious. Once again the favourite and inexpensive PR122.

Everyone who needs to know, does know, that it is unsuitable for use in watercolours prepared for the artist.

PR122 QUINACRIDONE MAGENTA ASTM III (127)

MAIMERIBLU SUPERIOR WATERCOLOURS

PIGMENT DETAIL ON LABEL	ASTM	RATING
YES	III L'FAST	★

WINSOR VIOLET 728

WINSOR & NEWTON

Resists the light very well at first but the Pigment Violet 23 content will eventually fade causing a colour change and loss of chroma.

Discontinued

PV23 DIOXAZINE PURPLE ASTM III-IV (186)
PV19 QUINACRIDONE RED ASTM II (185)

ARTISTS' WATER COLOUR

PIGMENT DETAIL ON LABEL	ASTM	RATING
YES	III-IV L'FAST	★

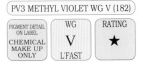 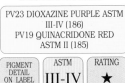

WINDSOR VIOLET DIOXAZINE 733

WINSOR & NEWTON

It appears that the previous colour (to the left) has been dropped and this one introduced. If this is the case we are no further ahead. Ask yourself, does this company really care about your work?

Gum laden and sticky.

PV23BS/RS DIOXAZINE PURPLE ASTM III-IV (186)

ARTISTS' WATER COLOUR

PIGMENT DETAIL ON LABEL	ASTM	RATING
YES	III-IV L'FAST	★

LAVENDER W316

HOLBEIN

Reliable pigments giving rise to a chalky blue with a touch of violet.

Washed out well but do not expect clear tints due to the white content.

PV15 ULTRAMARINE VIOLET ASTM I (184)
PB29 ULTRAMARINE BLUE ASTM I (215)
PW6 TITANIUM WHITE ASTM I (385)

ARTISTS' WATER COLOR

PIGMENT DETAIL ON LABEL	ASTM	
YES	I L'FAST	

LILAC W317

HOLBEIN

ARTISTS'
WATER COLOR

If you took away the PR122 and the PV23 you would have a reliable colour that would not fade and ruin your careful work. But you might have white anyway.

An irresponsible collection.

PR122 QUINACRIDONE MAGENTA ASTM III (127)
PV23BS/RS DIOXAZINE PURPLE
ASTM III-IV (186)
PW6 TITANIUM WHITE ASTM I (385)

PIGMENT DETAIL ON LABEL	ASTM	RATING
YES	III-IV L'FAST	★

MOONGLOW 057

DANIEL SMITH

EXTRA-FINE
WATERCOLORS

It is a pity that the unreliable PR177 had to be included as it has lowered the lightfast rating of this paint. In fact it didn't have to be as there are many reliable alternatives.

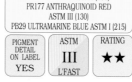

PG18 VIRIDIAN ASTM I (261)
PR177 ANTHRAQUINOID RED
ASTM III (130)
PB29 ULTRAMARINE BLUE ASTM I (215)

PIGMENT DETAIL ON LABEL	ASTM	RATING
YES	III L'FAST	★★

PHTHALO BLUE RED 583

TALENS

REMBRANDT
ARTISTS'
QUALITY
EXTRA FINE

This is simply Phthalocyanine Blue. You probably have it already under another name.

Reliable of course, transparent, strong and worthwhile.

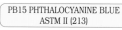

PB15 PHTHALOCYANINE BLUE
ASTM II (213)

PIGMENT DETAIL ON LABEL	ASTM	
YES	II L'FAST	

QUINACRIDONE ROSE 156

M.GRAHAM
& CO.

ARTISTS'
WATERCOLOR

Sample was a little over bound. This made for difficult washes unless well worked with a damp brush on the palette.

Reliable pigment.

PV19 QUINACRIDONE VIOLET
ASTM II (185)

PIGMENT DETAIL ON LABEL	ASTM	RATING
YES	II L'FAST	

ROSE OF ULTRAMARINE 101

DANIEL SMITH

EXTRA-FINE
WATERCOLORS

Ultramarine Blue and Quinacridone Violet make, I believe, the ideal violet. Bright, strong, transparent and lightfast. This version it to the red

PB29 ULTRAMARINE BLUE
ASTM I (215)
PV19 QUINACRIDONE VIOLET
ASTM II (185)

PIGMENT DETAIL ON LABEL	ASTM	
YES	II L'FAST	

ULTRAMARINE PINK 83

CARAN D'ACHE

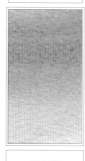

FINEST
WATERCOLOURS

An extremely weak colour which was hard to lift from the pan.

It does seem that this pigment, together with PV14, Cobalt Violet and PG23, Green Earth is unsuitable when a workable paint is sought.

PV15 ULTRAMARINE VIOLET
ASTM I (184)

PIGMENT DETAIL ON LABEL	ASTM	RATING
YES	I L'FAST	★★

Blues

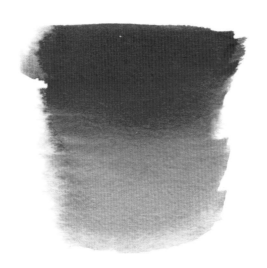

The modern artist is fortunate in having a good selection of bright and reliable blues.

Until fairly recent times the painter had to make do with a restrictive range of blue pigments, which were often very costly.

Egyptian Blue Frit was probably the first artificial pigment ever produced.

Used by the early Egyptians from about 3,000 BC it was made form a specially manufactured blue glass which was then ground into a powder.

Egyptian Blue Frit was a sophisticated pigment which required great skill in its production.

A wide variety of blue coloured petals have been used to produce bright but short lived dyes.

Genuine Ultramarine was produced from the semi-precious stone Lapis Lasuli. It was extremely expensive.

Extracting the colour from the stone was a long and laborious process and required considerable skill.

The French invention of an artificial Ultramarine was a major break-through in the history of artists' materials.

Azurite, prepared from a blue mineral was known and used in ancient Egypt, China and Japan, it became important in European art from the 15th to the middle of the 17th Century. The open, coarse particles were said to have sparkled like miniature sapphires.

The medieval artist preferred to use Ultramarine over Azurite for the more important work, where it could be afforded.

Genuine Ultramarine, made by processing ground Lapis Lazuli, a semi precious stone, was the most expensive and treasured artists pigment from the middle ages to the 1800's.

The invention of an artificial Ultramarine, and its production from 1830 was a major breakthrough.

Indigo, a deep violet blue was highly prized by artists and became a valuable article of commerce until it was replaced by a synthetic version around 1897.

The Indigo trade was of vital importance to the East India Company. Vast amounts of the colorant was imported by Great Britain each year, prior to the introduction of a synthetic version.

The first artificially prepared pigment with a fully recorded history was Prussian Blue. Available after 1724, it became a very important artists' colour.

The introduction of Phthalocyanine Blue in recent times was welcomed by many as an alternative to Prussian Blue.

Both are similar in hue and handling but Phthalocyanine Blue did not tend to take on a bronze sheen as can Prussian Blue.

Bright, clean and very transparent, Cobalt Blue has, since its introduction become the standard blue of many artists.

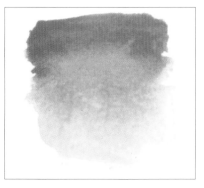

Cerulean Blue, possessing a greater opacity than the other

blues is favoured by many, both for its colour and hiding power. Fairly expensive, it is sometimes substituted by the relatively inferior Manganese Blue.

We now have a good range of reliable blue pigments at our disposal. Despite this we are still offered blues which will fade quickly and otherwise deteriorate. To add to the situation a range of meaningless, fancy names are employed to describe basic blues such as Phthalocyanine.

Modern Blue Pigments

PB1 VICTORIA BLUE ... 213

PB15 PHTHALOCYANINE BLUE 213

PB16 PHTHALOCYANINE BLUE 213

PB17 PHTHALOCYANINE BLUE 214

PB24 FUGITIVE PEACOCK BLUE 214

PB27 PRUSSIAN BLUE ... 214

PB28 COBALT BLUE ... 215

PB29 ULTRAMARINE BLUE 215

PB33 MANGANESE BLUE .. 215

PB35 CERULEAN BLUE .. 216

PB36 CERULEAN BLUE, CHROMIUM 216

PB60 INDANTHRONE BLUE 216

PB66 INDIGO BLUE ... 217

PB72 COBALT ZINC ALUMINATE 217

PB74 COBALT ZINC SILICATE.................................. 217

PB73 COBALT SILICATE BLUE OLIVINE 218

PB1 VICTORIA BLUE

PB1 has many applications in the printing industry. It is valued by printers for its high tinting strength, brightness and transparency. The fact that it has poor lightfastness is a secondary consideration.

The blue used in, say, a weekly magazine or an advertising leaflet does not have to be particularly permanent. I feel that is quite a different matter with works of art. This bright violet blue is unsuitable for artistic use.

Our sample deteriorated rapidly, the tint faded and it became darker and duller in mass tone.

Also called Sicilian Blue.

PB15 PHTHALOCYANINE BLUE

A bright, powerful green-blue. Valued by artists for its transparency, it gives very clear washes when well diluted. PB15 is divided into distinctive commercial types. PB15:1, PB15:2, PB15:3 etc. There is little difference between them in chemical make up and all are equally lightfast.

The colour varies slightly between commercial types, some being greener than others. A powerful pigment, PB15 has to be handled with some care and

will quickly influence most other colours in a mix. Rated II as a watercolour following ASTM testing. An excellent all round pigment.

PB16 PHTHALOCYANINE BLUE

As with PB15 this is a bright, powerful blue with a pronounced green bias. It has not been tested as a watercolour under ASTM conditions but it rated I, excellent, as both an acrylic and an oil paint.

I have found the pigment in use in only one colour, Old Holland Caribbean Blue. The question is where did the pigment itself come from?

It is not listed in any reference from 1973 onward and it appears to have gone out of pro-

duction around that time. It would seem that the company has either kept a supply for almost 30 years or has made a mistake in the pigment description.

PB17 PHTHALOCYANINE BLUE

74200 is the Colour Index Number of the dye Direct Blue 87. The pigment produced from this dye is PB17.

PB17 as such is used in the manufacture of a further pigment PB17:1. Our only reference of its use gives it as PB17 only. I do not have any test results to refer to.

Its reputation places it as less lightfast than the other Phthalocyanines.

As our sample faded somewhat, I will class it as WG III

pending further testing.

As our sample faded on exposure it moved towards green in mass tone. Use with caution.

PB24 FUGITIVE PEACOCK BLUE

This pigment, without any doubt, takes my vote as the most unsuitable substance for artistic use that I have ever come across.

The colour leaves the tube or pan as a very bright greenish blue. Within a short time it turns a green-grey and then gradually disappears altogether. Has certain industrial applications where its low cost overcomes its inherent weaknesses. Reasonably transparent, but this factor quickly becomes irrelevant.

Parent dye is Acid Blue 9. It would be cheaper to leave the paper white. Also called Erioglaucine Lake.

PB27 PRUSSIAN BLUE

Available since the early 1700's, PB27 has been an important pigment. A bright, transparent and very powerful green-blue. Several variations, (PB27 :1 etc.) are available.

They vary slightly in hue and strength. Rated as ASTM I, excellent, as a watercolour. This is a pigment with a varied history, being alternatively praised and condemned. It has been reported to darken under certain conditions. Applied heavily, it tends to bronze over, which can be disconcerting.

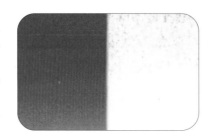

Bronzing (a metallic sheen) can be a problem.

Phthalocyanine Blue is preferred by many artists. Similar in hue, transparency strength and price, but less controversial.

PB28 COBALT BLUE

Absolutely lightfast, with an ASTM rating of I in watercolour.

Often erroneously described as a pure 'primary' blue, it does in fact reflect fair amounts of green and violet as well as blue. The hue usually leans more towards green. Low in tinting strength with moderate covering power.

In use since the early 1800's, it is a thoroughly reliable pigment with an excellent range of qualities.

The colour is often imitated in manufactured watercolours by a mixture of Phthalocyanine Blue and white or Ultramarine Blue and white.

PB29 ULTRAMARINE BLUE

An excellent all round pigment, it is absolutely lightfast with an ASTM rating of I as a watercolour.

Possesses a high tinting strength with moderate covering power. Valued for its transparency, it gives very clear washes. In hue it leans very definitely towards violet.

It is the only violet blue really worth considering. Fast to alkali but very easily damaged by even very weak acids. (Acid resistant versions are available).

Manufactured since 1830, it has more than proven its worth. A superb pigment, lightfast, transparent and with a useful range of values.

PB33 MANGANESE BLUE

PB33 is a moderately transparent greenish blue. Possessing reasonably high tinting strength, it will quickly affect certain other colours in a mix.

Manganese Blue is often seen as a cheaper alternative to Cerulean Blue being similar in hue, although normally a little greener. However, it does not have the body of Cerulean. Modern Manganese Blue watercolours invariably have a gummy texture, Chemically inert, it is resistant to light, heat, acids and alkalis.

As a watercolour it has been given a rating of I following ASTM controlled lightfast testing. The manufacture of this pigment seems to have stopped altogether but some companies have stocks.

PB35 CERULEAN BLUE

An 'atmospheric' greenish blue much valued by the landscape painter. It possesses a greater opacity than other blues, which gives it very good covering power.

Although dark blues will cover well, they rely on their depth of colour rather than their 'body'. Tends to 'settle' out into pockets of colour in a wash. Low in tinting strength. In use since the early 1800's. The name is derived from the Latin 'Caeruleum' meaning 'sky blue pigment'.

Absolutely lightfast, with an ASTM rating of I as a watercolour. Cheaper imitations are easily duplicated on the palette and are no match for the genuine article.

L/FAST ASTM I
COMMON NAME
CERULEAN BLUE
COLOUR INDEX NAME
PB35
COLOUR INDEX NUMBER
77368
CHEMICAL CLASS
OXIDES OF COBALT AND TIN

PB36 CERULEAN BLUE, CHROMIUM

PB36 is a close cousin of PB35, Cerulean Blue.

The chemical make up varies from oxides of Cobalt and Tin in Cerulean Blue, to oxides of Cobalt and Chromium in this pigment. Generally rather brighter and with greater tinting strength than PB35. Both are similar in hue, being blues with a definite bias towards green.

Being particularly opaque it has very good covering power.

Absolutely lightfast, it gained an ASTM rating of I during lightfast testing as a watercolour. A most reliable pigment with many useful qualities.

L/FAST ASTM I
COMMON NAME
CERULEAN BLUE, CHROMIUM
COLOUR INDEX NAME
PB36
COLOUR INDEX NUMBER
77343
CHEMICAL CLASS
OXIDES OF COBALT AND CHROMIUM

PB60 INDANTHRONE BLUE

Indanthrone Blue is a slightly dull blue, leaning a little towards violet. Semi-opaque, it has poor covering power unless applied rather heavily.

When washed out into a tint it is lower in chroma (colour) than other blues in this hue range. PB60 rated as ASTM I as both an oil and an acrylic. Without the protection offered by the binder it might not rate as highly in watercolours. Parent dye is Vat Blue 4.

Excellent results in both oils and acrylics, plus a good reputation for lightfastness. Pending further testing, rated II for the purposes of this book. Also called Anthraquinoid Blue.

L/FAST W/GUIDE II
COMMON NAME
INDANTHRONE BLUE
COLOUR INDEX NAME
PB60
COLOUR INDEX NUMBER
69800
CHEMICAL CLASS
ANTHRAQUINONE

PB66 INDIGO BLUE

Genuine Indigo, now obsolete in artists' paints, has a long and varied history.

A valuable article of commerce, it played an important part in the history of the East India Company. The importation into Europe virtually ceased after 1897 on the introduction of a synthetic version.

Modern Indigo has a poor reputation for lightfastness. A dull blackish blue, reasonably transparent. Now tested under ASTM conditions as a watercolour, it rated a poor IV.

Within a short time our sample had deteriorated badly, fading in all values. An unreliable pigment.

Also called CI Vat Blue 1 Dye.

PB72 COBALT ZINC ALUMINATE

A bright blue, PB72 is also called Cobalt Zinc Aluminate Blue Spinel.

I have very little information about this pigment other than the fact that it has not been tested in any art material. It is used in ceramic glazes, porcelain enamels and high temperature coatings.

Given its make up of mixed oxides which have been taken to a high temperature, it will

almost certainly be very lightfast. For the purposes of this book I will give it a rating of W/Guide II.

PB74 COBALT ZINC SILICATE

An opaque pigment often described as 'Navy Blue' in colour.

Again I have very little information about this pigment other than the fact that it has not been tested in any art material. It is used in high performance paints, plastics and ceramic products.

As with PB72, given its make up of mixed oxides which have been taken to a high temperature, it will almost certainly be

lightfast. For the purposes of this publication I will give it a rating of W/Guide II pending possible ASTM testing.

PB73 COBALT SILICATE BLUE OLIVINE

Again I have very little information about this pigment other than the fact that it has not been tested in any art material.

It is used in high performance coatings, ceramic glazes and porcelain enamels.

As with PB72 and PB74, with its make up of mixed oxides, which have been taken to a high temperature, it will almost certainly be lightfast.

However, until actually tested an art material its performance

should not be taken for granted cannot be.

For the purposes of this publication I will give it a rating of W/Guide II pending possible ASTM testing.

L/FAST W/GUIDE II

COMMON NAME

COBALT SILICATE BLUE OLIVINE

COLOUR INDEX NAME

PB73

COLOUR INDEX NUMBER

77364

CHEMICAL CLASS

HIGH TEMPERATURE CALCINATION OF MIXED OXIDES

A vast range of reliable blues of varying transparency are easily mixed from a few standards
Reproduced from our Home Study Course ' Practical Colour Mixing'

Blending the mixing primaries

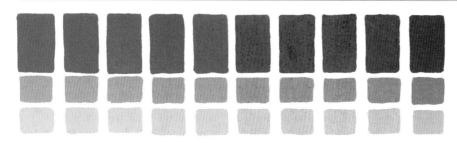

Your colour range can be extended considerably by blending each of the principal mixing pairs, the blues, reds and yellows. In the above exercise, Cerulean Blue (an opaque green-blue, has been mixed with Ultramarine Blue (a transparent violet-blue) to produce a useful range of hues, varying in transparency.

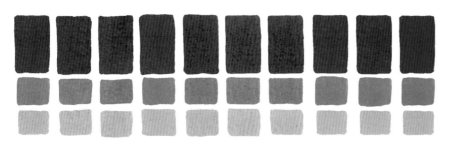

By changing the type of green-blue from the opaque Cerulean Blue to the transparent Phthalocyanine Blue the range can be extended even further.

In the above exercise, the transparency and 'extra' greenness of the Phthalocyanine Blue plays a very definite role, particularly in the tints.

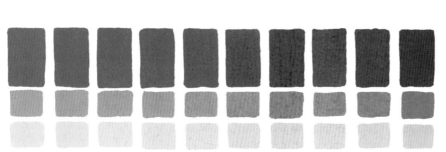

The two green-blues are now combined to give an ever widening range. As you will see, the varying opacity and varying green content of this pair will produce some very useful hues, particularly when it comes to selecting 'sky' colours. You do not need to go out and buy every blue paint in sight. The above, plus the other blues that you have produced should be more than enough for most pieces of work.

Blue Watercolours

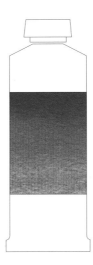

Contents

Cerulean Blue.....................................221

Cobalt Blue.......................................225

Indigo..229

Manganese Blue....................................232

Pthalocyanine Blue................................234

Prussian Blue.....................................236

Turquoise...239

Ultramarine.......................................241

Miscellaneous.....................................246

Cerulean Blue

A clean, bright, strong greenish blue. As with other pigments produced at high temperature it is very fast to light.

Cerulean Blue has greater opacity than other blues. Although dark blues will cover well, they rely on their depth of colour rather than their 'body'.

Imitations do not compare in hue, handling or value for money.

For mixing purposes treat as a green-blue. Complementary is a red-orange.

CERULEAN BLUE GENUINE 229

DA VINCI PAINTS

PERMANENT ARTISTS' WATER COLOR

Absolutely lightfast and with good covering power. A well produced colour which brushed out very smoothly.

PB36 CERULEAN BLUE, CHROMIUM ASTM I (216)		
PIGMENT DETAIL ON LABEL **YES**	ASTM **I** L'FAST	

CERULEAN BLUE (HUE) 230

DA VINCI PAINTS

PERMANENT ARTISTS' WATER COLOR

Correctly labelled to indicate an imitation Cerulean Blue. Washed out well. Semi-transparent.

PB15 PHTHALOCYANINE BLUE ASTM II (213) PW6 TITANIUM WHITE ASTM I (385)		
PIGMENT DETAIL ON LABEL **YES**	ASTM **II** L'FAST	

CERULEAN BLUE (HUE) 630

DA VINCI PAINTS

SCUOLA 2ND RANGE

Handled better in thin washes than in heavier applications due to the slightly gummy consistency of the paint.

PB15 PHTHALOCYANINE BLUE ASTM II (213) PW6 TITANIUM WHITE ASTM I (385)		
PIGMENT DETAIL ON LABEL **YES**	ASTM **II** L'FAST	RATING ★★

CERULEAN BLUE 2520

UMTON BARVY

ARTISTIC WATER COLOR

Paint was rather difficult to lift from the pan, which is unusual with this make. Gave smooth, even washes. A most reliable pigment.

PB35 CERULEAN BLUE ASTM I (216)		
PIGMENT DETAIL ON LABEL **NO**	ASTM **I** L'FAST	RATING ★ ★★

CERULEAN BLUE, CHROMIUM 157

UTRECHT

PROFESSIONAL ARTISTS' WATER COLOR

Genuine ingredient in a well produced watercolour paint which handled with ease. Opaque.

PB36 CERULEAN BLUE, CHROMIUM ASTM I (216)		
PIGMENT DETAIL ON LABEL **YES**	ASTM **I** L'FAST	

CERULEAN BLUE 012

UTRECHT

PROFESSIONAL ARTISTS' WATER COLOR

High quality pigment but the paint has, unfortunately, been spoiled by an over enthusiastic use of gum. Almost unworkable.

PB35 CERULEAN BLUE ASTM I (216)		
PIGMENT DETAIL ON LABEL **YES**	ASTM **I** L'FAST	RATING ★

CERULEAN BLUE 039

GRUMBACHER

FINEST ARTISTS' WATER COLOR

We finally have a sample for the third edition of this book. Unfortunately is has been poorly made and suffers from an excess of binder.

PB35 CERULEAN BLUE ASTM I (216)		
PIGMENT DETAIL ON LABEL **NO**	ASTM **I** L'FAST	RATING ★★

CERULEAN BLUE 039

GRUMBACHER

ACADEMY ARTISTS' WATERCOLOR 2ND RANGE

Tube well labelled apart from the colour name. The addition of the word 'Hue' would be helpful. Semi-transparent.

Reformulated >

PB15 PHTHALOCYANINE BLUE ASTM II (213) PW6 TITANIUM WHITE ASTM I (385)		
PIGMENT DETAIL ON LABEL **YES**	ASTM **II** L'FAST	RATING ★ ★★

CERULEAN BLUE HUE A039

GRUMBACHER

ACADEMY ARTISTS' WATERCOLOR 2ND RANGE

An extremely complex recipe to imitate a colour that at least is described as a 'Hue'. Washed out well and is reliable.

PB15:4 PHTHALOCYANINE BLUE ASTM II (213) PB29 ULTRAMARINE BLUE ASTM I (215) PBk9 IVORY BLACK ASTM I (371) PW4 ZINC WHITE ASTM I (384)		
PIGMENT DETAIL ON LABEL **YES**	ASTM **II** L'FAST	

COERULEUM 111

DALER ROWNEY

A smooth, well produced watercolour. Genuine ingredients have been used to provide a first class product. Opaque.

ARTISTS' WATER COLOUR

PB35 CERULEAN BLUE ASTM I (216)		
PIGMENT DETAIL ON LABEL **YES**	ASTM **I** L'FAST	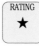

COERULEUM (HUE) 112

DALER ROWNEY

By adding the PB24, a fugitive pigment, the colour has been given a limited future. Fades readily. Semi-transparent.

Reformulated >

GEORGIAN WATER COLOUR 2ND RANGE

PB29 ULTRAMARINE BLUE ASTM I (215) PW6 TITANIUM WHITE ASTM I (385) PB24 FUGITIVE PEACOCK BLUE WG V (214)		
PIGMENT DETAIL ON LABEL **NO**	WG **V** L'FAST	RATING ★

COERULEUM HUE

DALER ROWNEY

I have insufficient information available on FB2:1 Blue Lake to offer assessments.

Sample washed out well.

GEORGIAN WATER COLOUR 2ND RANGE

PB29 ULTRAMARINE BLUE ASTM I (215) PW6 TITANIUM WHITE ASTM I (385) FB2:1 BLUE LAKE		
PIGMENT DETAIL ON LABEL **NO**	ASTM **I** L'FAST	RATING

CERULEAN BLUE 5712

HUNTS

This is not Cerulean Blue at all but a simple mix of Phthalocyanine Blue and Titanium White. Semi-opaque.

Discontinued

SPEEDBALL PROFESSIONAL WATERCOLOURS

COPPER PHTHALOCYANINE AND TITANIUM DIOXIDE		
PIGMENT DETAIL ON LABEL **NO**	ASTM **I** L'FAST	RATING ★ ★★

CERULEAN BLUE W34

ART SPECTRUM

Genuine Cerulean Blue tends to granulate readily in well diluted washes, a feature many artists seek.

This is a slightly over bound example which handled better when thin.

ARTISTS' WATER COLOUR

PB35 CERULEAN BLUE ASTM I (216)		
PIGMENT DETAIL ON LABEL **YES**	ASTM **I** L'FAST	RATING ★ ★★

CERULEAN BLUE 080

M.GRAHAM & CO.

PB36 is a little brighter and stronger than its cousin PB35. Both have excellent fastness to light.

Well made and washed out with ease.

ARTISTS' WATERCOLOR

PB36 CERULEAN BLUE, CHROMIUM ASTM I (216)		
PIGMENT DETAIL ON LABEL **YES**	ASTM **I** L'FAST	

CERULEAN 368

MAIMERI

An excellent watercolour, smoothly ground, dense pigment.

Gives a good range of values and is absolutely lightfast. Opaque.

MAIMERIBLU SUPERIOR WATERCOLOURS

PB36 CERULEAN BLUE, CHROMIUM ASTM I (216)		
PIGMENT DETAIL ON LABEL **YES**	ASTM **I** L'FAST	

CERULEAN 607

MAIMERI

Closer in hue to a 'turquoise' than Cerulean Blue. Easily duplicated on the palette. Reliable. Transparent. Incorrectly labelled.

Discontinued

STUDIO FINE WATERCOLOURS

PG7 PHTHALOCYANINE GREEN ASTM I (259) PB15:3 PHTHALOCYANINE BLUE ASTM II (213)		
PIGMENT DETAIL ON LABEL **YES**	ASTM **II** L'FAST	RATING ★ ★★

CERULEAN 416

MAIMERI

This is an imitation Cerulean Blue which many will purchase believing it to be genuine. Such practices give a price advantage to the manufacturer.

Gave an even wash, reliable.

VENEZIA EXTRAFINE WATERCOLOURS

PW4 ZINC WHITE ASTM I (384) PB15:1 PHTHALOCYANINE BLUE ASTM II (213)		
PIGMENT DETAIL ON LABEL **YES**	ASTM **II** L'FAST	RATING ★ ★★

CERULEAN BLUE 329

PÈBÈO

Brushed out very smoothly, especially in medium to thin washes. Correct ingredients used. Absolutely lightfast. Opaque.

Reformulated >

FRAGONARD ARTISTS' WATER COLOUR

PB35 CERULEAN BLUE ASTM I (216)		
PIGMENT DETAIL ON LABEL **YES**	ASTM **I** L'FAST	

CERULEAN BLUE

PÈBÈO

The sample had a very gummy consistency which made washes of all strengths difficult to apply. Falsely labelled.

FRAGONARD ARTISTS' WATER COLOUR

PB28 COBALT BLUE ASTM I (215) PG18 VIRIDIAN ASTM I (261)		
PIGMENT DETAIL ON LABEL **YES**	ASTM **I** L'FAST	RATING ★★

CERULEAN BLUE 305

SENNELIER

Was previously an inexpensive mix masquerading under the name. The ingredients have now been changed to the genuine pigment. Opaque.

EXTRA-FINE WATERCOLOUR

PB35 CERULEAN BLUE ASTM I (216)		
PIGMENT DETAIL ON LABEL **YES**	ASTM **I** L'FAST	

CERULEAN BLUE 137

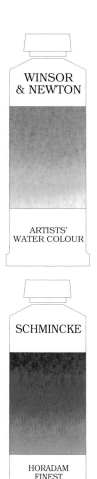

WINSOR & NEWTON

A particularly well made Cerulean Blue. The labels for this range now, at last, carry pigment information. Opaque and granulating.

ARTISTS' WATER COLOUR

PB35 CERULEAN BLUE ASTM I (216)

| PIGMENT DETAIL ON LABEL YES | ASTM I L'FAST | |

CERULEAN BLUE HUE 139

WINSOR & NEWTON

Correctly labelled to indicate that this is an Imitation Cerulean Blue. Brushes out very well. Reliable.

COTMAN WATER COLOURS 2ND RANGE

PB15 PHTHALOCYANINE BLUE ASTM II (213)

| PIGMENT DETAIL ON LABEL YES | ASTM II L'FAST | |

CERULEAN BLUE 137 (USA ONLY)

WINSOR & NEWTON

Genuine Cerulean Blue in a 'second range' colour.

A surprising and very encouraging development, when will it be offered outside of the USA? Opaque.

COTMAN WATER COLOURS 2ND RANGE

PB35 CERULEAN BLUE ASTM I (216)

| PIGMENT DETAIL ON LABEL YES | ASTM I L'FAST | |

CERULEAN BLUE HUE 481

SCHMINCKE

Renamed several years ago, the word 'Hue' has been added to indicate that the colour is an imitation 'Cerulean Blue'. Reliable ingredients. Semi-opaque.

HORADAM FINEST ARTISTS' WATER COLOURS

PW4 ZINC WHITE ASTM I (384)
PB15 PHTHALOCYANINE BLUE ASTM II (213)

| PIGMENT DETAIL ON LABEL YES | ASTM II L'FAST | |

COBALT CERULEAN 499

SCHMINCKE

Previously called 'Cerulean Blue 482'

The 'Chromium' version of Cerulean Blue is slightly brighter than PB35. Both are equally lightfast. An invaluable, opaque colour.

HORADAM FINEST ARTISTS' WATER COLOURS

PB36 CERULEAN BLUE, CHROMIUM ASTM I (216)

| PIGMENT DETAIL ON LABEL YES | ASTM I L'FAST | |

CERULEAN BLUE 662

UMTON BARVY

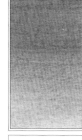

ARTISTIC WATER COLOR

A rather weak example which did not lift easily from the pan and gave poor washes unless well diluted.

PB35 CERULEAN BLUE ASTM I (216)

| PIGMENT DETAIL ON LABEL NO | ASTM I L'FAST | RATING ★★ |

CERULEAN BLUE 1121

LUKAS

ARTISTS' WATER COLOUR

Quality ingredients giving a quality paint. Smooth and free flowing, a well produced watercolour paint. Opaque.

PB36 CERULEAN BLUE, CHROMIUM ASTM I (216)

| PIGMENT DETAIL ON LABEL CHEMICAL MAKE UP ONLY | ASTM I L'FAST | |

CERULEAN BLUE 021

DANIEL SMITH

EXTRA-FINE WATERCOLORS

Sample handled with ease giving smooth gradated washes. A quality product.

PB36 CERULEAN BLUE, CHROMIUM ASTM I (216)

| PIGMENT DETAIL ON LABEL YES | ASTM I L'FAST | |

CERULEAN BLUE W292

HOLBEIN

ARTISTS' WATER COLOR

First class ingredients give a watercolour which washes out well and is absolutely dependable. Non staining and easy to lift.

PB35 CERULEAN BLUE ASTM I (216)

| PIGMENT DETAIL ON LABEL YES | ASTM I L'FAST | |

CERULEAN BLUE 535

MIR (JAURENA S.A)

ACUARELA

An imitation of the genuine article which should be correctly labelled. When making price comparisons a would be purchaser can easily be mislead.

Rather streaky washes.

PB15 PHTHALOCYANINE BLUE ASTM II (213)
PW4 ZINC WHITE ASTM I (384)

| PIGMENT DETAIL ON LABEL YES | ASTM II L'FAST | RATING ★ ★★ |

CERULEAN BLUE 027

LEFRANC & BOURGEOIS

LINEL EXTRA-FINE ARTISTS' WATERCOLOUR

Unfortunately, the sample was so over-bound that I had difficulty in working it at any strength. Genuine ingredients.

PB35 CERULEAN BLUE ASTM I (216)

| PIGMENT DETAIL ON LABEL CHEMICAL MAKE UP ONLY | ASTM I L'FAST | RATING ★ |

CERULEAN BLUE 037

AMERICAN JOURNEY

PROFESSIONAL ARTISTS' WATER COLOR

Non staining, opaque and fast to light. This is a well produced example using genuine pigments. Washed out very well.

PB36 CERULEAN BLUE, CHROMIUM ASTM I (216)

| PIGMENT DETAIL ON LABEL YES | ASTM I L'FAST | |

CERULEAN BLUE 534

TALENS

Excellent pigment used. At least nowadays the pigments are given on this label as well as with most other makes. Handled very well over full range. Opaque.

REMBRANDT ARTISTS' QUALITY EXTRA FINE

PB35 CERULEAN BLUE ASTM I (216)

| PIGMENT DETAIL ON LABEL YES | ASTM I L'FAST | |

CERULEAN BLUE (PHTHALO) 535

TALENS

The use of the work 'Phthalo' indicates an imitation Cerulean Blue. Reliable ingredients. Semi-transparent.

WATER COLOUR 2ND RANGE

Range discontinued

PB15 PHTHALOCYANINE BLUE ASTM II (213)
PW6 TITANIUM WHITE ASTM I (385)

| PIGMENT DETAIL ON LABEL YES | ASTM II L'FAST | |

CERULEAN BLUE PHTHALO 535

TALENS

Such imitations never quite match the genuine article for hue and opacity. Reliable. Semi-transparent.

REMBRANDT ARTISTS' QUALITY EXTRA FINE

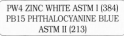

PW4 ZINC WHITE ASTM I (384)
PB15 PHTHALOCYANINE BLUE ASTM II (213)

| PIGMENT DETAIL ON LABEL YES | ASTM II L'FAST | |

CERULEAN BLUE (PHTHALO) 535

TALENS

Cerulean Blue is usually imitated by either Ultramarine Blue and white or this combination. Washed out well but does not have the 'body' of genuine Cerulean Blue.

VAN GOGH 2ND RANGE

PB15 PHTHALOCYANINE BLUE ASTM II (213)
PW4 ZINC WHITE ASTM I (384)

| PIGMENT DETAIL ON LABEL YES | ASTM II L'FAST | RATING |

CERULEAN BLUE DEEP 235

OLD HOLLAND

A well made watercolour which brushed out with ease, giving a series of smooth washes. High quality pigments used.

CLASSIC WATERCOLOURS

PB36 CERULEAN BLUE, CHROMIUM ASTM I (216)

| PIGMENT DETAIL ON LABEL CHEMICAL MAKE UP ONLY | ASTM I L'FAST | |

CERULEAN BLUE LIGHT 238

OLD HOLLAND

The substance that emerged from the tube was a combination of some 70% heavy dark gum and blue coloured gum. Roughly mixed. I have to query why the gum should be so dark when the binder for watercolours is a lot clearer.

CLASSIC WATERCOLOURS

PB35 CERULEAN BLUE ASTM I (216)

| PIGMENT DETAIL ON LABEL CHEMICAL MAKE UP ONLY | ASTM I L'FAST | RATING ★ |

CERULEAN BLUE

OLD HOLLAND

Quality ingredients make into a very reliable green-blue. Gave good, even washes. Opaque.

Reformulated >

CLASSIC WATERCOLOURS

PB36 CERULEAN BLUE, CHROMIUM ASTM I (216)

| PIGMENT DETAIL ON LABEL CHEMICAL MAKE UP ONLY | ASTM I L'FAST | |

CERULEAN BLUE 39

OLD HOLLAND

This is quite amazing. Before changing from one type of Cerulean Blue to another, this was a quality product. If our sample is anything to go by, it is now mainly heavy, sticky dark brown gum with a small amount of gum laden blue. Appalling.

PB35 CERULEAN BLUE ASTM I (216)

| PIGMENT DETAIL ON LABEL CHEMICAL MAKE UP ONLY | ASTM I L'FAST | RATING ★ |

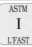

Cobalt Blue

The standard blue for many artists, bright, clean and with moderate covering power.

Because of its relatively high price it is often subjected to adulteration and imitation. I would suggest that you purchase the best quality, genuine Cobalt Blue if it a colour that you require, no substitute can match the true pigment.

For mixing purposes Cobalt Blue usually leans towards green. Variations biased towards violet are available, but these invariably contain Ultramarine Blue. Mixing complementary is a red orange.

COBALT BLUE LIGHT 487

Thoroughly reliable pigment used. Sample brushed out beautifully giving smooth even washes. Absolutely lightfast.

SCHMINCKE
HORADAM FINEST ARTISTS' WATER COLOURS

PB28 COBALT BLUE ASTM I (215)

PIGMENT DETAIL ON LABEL	ASTM	
YES	I L'FAST	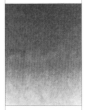

COBALT BLUE DEEP 488

Previously made without the PB74. An excellent watercolour giving smooth, even washes over a useful range of values. Lightfast pigments have been employed.

SCHMINCKE
HORADAM FINEST ARTISTS' WATER COLOURS

PB28 COBALT BLUE ASTM I (215)
PB74 COBALT ZINC SILICATE WG II (217)

PIGMENT DETAIL ON LABEL	WG	
YES	II L'FAST	

COBALT BLUE DEEP 488

I cannot offer a colour reference or assessments as a sample was not provided.

A reliable pigment has been used.

SCHMINCKE
HORADAM FINEST ARTISTS' WATER COLOURS

PB74 COBALT ZINC SILICATE WG II (217)

PIGMENT DETAIL ON LABEL	WG	RATING
YES	II L'FAST	

COBALT BLUE TONE

Previously called 'Cobalt Blue Imitation 486' when it was clearly described as a replica.

It lacks the distinctive hue of the genuine article. Semi-transparent.

SCHMINCKE
HORADAM FINEST ARTISTS' WATER COLOURS

PW4 ZINC WHITE ASTM I (384)
PB29 ULTRAMARINE BLUE ASTM I (215)

PIGMENT DETAIL ON LABEL	ASTM	RATING
YES	I L'FAST	★ ★★

AZURE COBALT 024

A mix of Cobalt Blue and Viridian, easily duplicated on the palette. Both pigments absolutely lightfast.

Discontinued as company say it can be mixed by the artist. Where do they get it from?

WINSOR & NEWTON
ARTISTS' WATER COLOUR

PB28 COBALT BLUE ASTM I (215)
PG18 VIRIDIAN ASTM I (261)

PIGMENT DETAIL ON LABEL	ASTM	
YES	I L'FAST	

COBALT BLUE 178

Genuine ingredients give an excellent watercolour. Brushes out very well, particularly in thin to medium washes. Absolutely lightfast and tends to granulate.

WINSOR & NEWTON
ARTISTS' WATER COLOUR

PB28 COBALT BLUE ASTM I (215)

PIGMENT DETAIL ON LABEL	ASTM	
YES	I L'FAST	

COBALT BLUE HUE 179

Brushes out well. A reliable 'second range' colour. On the violet side when compared to genuine Cobalt Blue.

WINSOR & NEWTON
COTMAN WATER COLOURS 2ND RANGE

PW5 LITHOPONE WG I (384)
PB29 ULTRAMARINE BLUE ASTM I (215)

PIGMENT DETAIL ON LABEL	ASTM	
YES	I L'FAST	

COBALT BLUE DEEP 180

Has a gummy consistency making it unpleasant to use unless very dilute.

Pigment is yet another which has not been officially tested as an art material.

WINSOR & NEWTON
ARTISTS' WATER COLOUR

PB73 COBALT SILICATE BLUE OLIVINE WG II (218)

PIGMENT DETAIL ON LABEL	WG	RATING
YES	II L'FAST	★★

COBALT BLUE 178 (USA ONLY)

Excellent ingredients, particularly for a 'second range' colour. We look forward to this being available in other countries.

The paint brushed out smoothly into gradated washes. Reasonably bright. Transparent.

WINSOR & NEWTON
COTMAN WATER COLOURS 2ND RANGE

PB28 COBALT BLUE ASTM I (215)

PIGMENT DETAIL ON LABEL	ASTM	
YES	I L'FAST	

COBALT BLUE 040

AMERICAN JOURNEY

A staining, semi transparent watercolour which suffered from a little too much gum. Handled very well unless heavier applications were sought. First class pigment.

PROFESSIONAL ARTISTS' WATER COLOR

PB28 COBALT BLUE ASTM I (215)		
PIGMENT DETAIL ON LABEL **YES**	ASTM **I** L'FAST	RATING ★ ★★

COBALT BLUE 030

LEFRANC & BOURGEOIS

Brighter in hue than most other examples.

A smooth, even colour which brushed out very well. Transparent.

LINEL EXTRA-FINE ARTISTS' WATERCOLOUR

PB28 COBALT BLUE ASTM I (215)	
PIGMENT DETAIL ON LABEL **CHEMICAL MAKE UP ONLY**	ASTM **I** L'FAST

COBALT BLUE 049

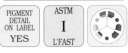

GRUMBACHER

Rather stronger in colour and tinting strength than is usual.

Sample gave good series of even washes. Semi-transparent.

FINEST ARTISTS' WATER COLOR

PB28 COBALT BLUE ASTM I (215)	
PIGMENT DETAIL ON LABEL **YES**	ASTM **I** L'FAST

COBALT BLUE HUE A049

GRUMBACHER

Be aware that this is a poor imitation. At least the word 'Hue' has now been added. Reliable. Transparent.

ACADEMY ARTISTS' WATERCOLOR 2ND RANGE

PB29 ULTRAMARINE BLUE ASTM I (215)		
PIGMENT DETAIL ON LABEL **YES**	ASTM **I** L'FAST	RATING ★ ★★

COBALT BLUE W26

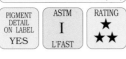

ART SPECTRUM

Semi-transparent and without a doubt, absolutely lightfast. Sample washed out very well, particularly in thinner applications.

ARTISTS' WATER COLOUR

PB28 COBALT BLUE ASTM I (215)	
PIGMENT DETAIL ON LABEL **YES**	ASTM **I** L'FAST

COBALT BLUE 109

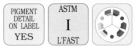

DALER ROWNEY

Genuine ingredients give a clear blue which brushed out particularly well. Correct ingredients are always worth seeking out. Transparent.

ARTISTS' WATER COLOUR

PB28 COBALT BLUE ASTM I (215)	
PIGMENT DETAIL ON LABEL **YES**	ASTM **I** L'FAST

COBALT BLUE (HUE) 110

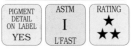

DALER ROWNEY

Correctly described, the word 'Hue' identifying it as an imitation. I do not lower my assessments on properly identified imitations.

Lightfast ingredients, semi-transparent.

GEORGIAN WATER COLOUR 2ND RANGE

PB29 ULTRAMARINE BLUE ASTM I (215)		
PW6 TITANIUM WHITE ASTM I (385)		
PIGMENT DETAIL ON LABEL **NO**	ASTM **I** L'FAST	

COBALT BLUE DEEP 116

DALER ROWNEY

This watercolour paint washes out very well, giving smooth even layers. A well made product.

ARTISTS' WATER COLOUR

PB72 COBALT ZINC ALUMINATE WG II (217)		
PIGMENT DETAIL ON LABEL **YES**	WG **II** L'FAST	

COBALT BLUE 538

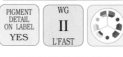

MIR (JAURENA S.A)

Cerulean Blue masquerading as Cobalt Blue. A poor imitation, which would benefit from the word 'Hue'. Handles better when thinned.

ACUARELA

PB36 CERULEAN BLUE, CHROMIUM ASTM I (216)		
PIGMENT DETAIL ON LABEL **YES**	ASTM **I** L'FAST	RATING ★ ★★

COBALT BLUE LIGHT 2530

UMTON BARVY

Picked up easily from the pan and washed out with ease.

An excellent watercolour paint which should be labelled as a 'Hue', being an imitation Cobalt Blue.

ARTISTIC WATER COLOR

PB36 CERULEAN BLUE, CHROMIUM ASTM I (216)		
PIGMENT DETAIL ON LABEL **NO**	ASTM **I** L'FAST	RATING ★ ★★

COBALT BLUE DEEP 2540

UMTON BARVY

A series of very smooth washes are available from this well made watercolour paint.

Lifted with ease from the pan.

ARTISTIC WATER COLOR

PB28 COBALT BLUE ASTM I (215)	
PIGMENT DETAIL ON LABEL **NO**	ASTM **I** L'FAST

COBALT BLUE 090

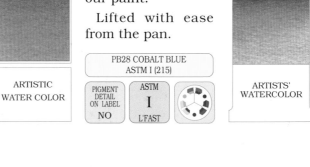

M.GRAHAM & CO.

A very well made product which handled beautifully.

Good, even washes from this absolutely lightfast watercolour.

ARTISTS' WATERCOLOR

PB28 COBALT BLUE ASTM I (215)	
PIGMENT DETAIL ON LABEL **YES**	ASTM **I** L'FAST

COBALT BLUE
No. 23

PENTEL

I would have thought that, given the nature of this book, the company would have ensured that relevant information on the pigments that they use was provided before they sent samples.

PIGMENTATION DETAIL NOT ON PRODUCT OR IN LITERATURE SUPPLIED

WATER COLORS

PIGMENT DETAIL ON LABEL	ASTM	RATING
NO	L'FAST	

COBALT BLUE
No. 23

PENTEL (POLY TUBE)

Please see remarks with colour to the left.

PIGMENTATION DETAIL NOT ON PRODUCT OR IN LITERATURE SUPPLIED

WATER COLORS

PIGMENT DETAIL ON LABEL	ASTM	RATING
NO	L'FAST	

COBALT BLUE 307

SENNELIER

A definite green blue which is slightly 'chalky' in appearance. Handled well over a useful range of washes. Semi-transparent.

EXTRA-FINE WATERCOLOUR

PB28 COBALT BLUE
ASTM I (215)

PIGMENT DETAIL ON LABEL	ASTM	
YES	I L'FAST	

COBALT BLUE 234

DA VINCI PAINTS

As with all Da Vinci paints this is well labelled, giving full information.

A well produced watercolour. Dependable and reasonably transparent.

PERMANENT ARTISTS' WATER COLOR

PB28 COBALT BLUE
ASTM I (215)

PIGMENT DETAIL ON LABEL	ASTM	
YES	I L'FAST	

COBALT BLUE
(HUE) 634

DA VINCI PAINTS

A correctly described imitation. Handled well over the range of values.

SCUOLA 2ND RANGE

PB15 PHTHALOCYANINE BLUE ASTM II (213)
PW6 TITANIUM WHITE ASTM I (385)

PIGMENT DETAIL ON LABEL	ASTM	
YES	II L'FAST	

COBALT BLUE 16H

DR.Ph. MARTINS

If, like many, you use this product in your work, you either have information which was not supplied to me or you are one of lifes' risk takers.

HYDRUS FINE ART WATERCOLOR

PIGMENTATION DETAIL NOT ON PRODUCT OR IN LITERATURE SUPPLIED

PIGMENT DETAIL ON LABEL	ASTM	RATING
NO	L'FAST	

COBALT BLUE 155

UTRECHT

Sample provided washed out very well. A quality pigment used to make a quality watercolour paint.

PROFESSIONAL ARTISTS' WATER COLOR

PB28 COBALT BLUE
ASTM I (215)

PIGMENT DETAIL ON LABEL	ASTM	
YES	I L'FAST	

COBALT TEAL 166

UTRECHT

Low in tinting strength, this colour will not have a great impact on others when mixing.

If you are aware of this is does not diminish it as a useful paint.

A reliable, well made product.

PROFESSIONAL ARTISTS' WATER COLOR

PG50 LIGHT GREEN OXIDE
WG II (263)

PIGMENT DETAIL ON LABEL	WG	
YES	II L'FAST	

COBALT BLUE 511

TALENS

A well produced watercolour paint. Smooth even washes over a good range of values. Lightfast and quite transparent.

REMBRANDT ARTISTS' QUALITY EXTRA FINE

PB28 COBALT BLUE
ASTM I (215)

PIGMENT DETAIL ON LABEL	ASTM	
YES	I L'FAST	

COBALT BLUE
(ULTRAM) 512

TALENS

A reliable imitation but lacks the subtly of hue of genuine Cobalt Blue. Easily duplicated. Semi-transparent.

REMBRANDT ARTISTS' QUALITY EXTRA FINE

PB29 ULTRAMARINE BLUE
ASTM I (215)
PW4 ZINC WHITE ASTM I (384)

PIGMENT DETAIL ON LABEL	ASTM	
YES	I L'FAST	

COBALT BLUE
ULTRAM 512

TALENS

The difference in hue between this paint and Ultramarine Blue is hardly noticeable. Reliable.

Range discontinued

WATER COLOUR 2ND RANGE

PB29 ULTRAMARINE BLUE
ASTM I (215)
PW4 ZINC WHITE ASTM I (384)

PIGMENT DETAIL ON LABEL	ASTM	
YES	I L'FAST	

COBALT BLUE 512
ULTRAMARINE

TALENS

An imitation which could, I feel, benefit from the word 'Hue' in the title, as many will feel it to be a type of Cobalt Blue. Over bound and handled poorly.

VAN GOGH 2ND RANGE

PB29 ULTRAMARINE BLUE
ASTM I (215)
PW4 ZINC WHITE ASTM I (384)

PIGMENT DETAIL ON LABEL	ASTM	RATING
YES	I L'FAST	★★

COBALT BLUE 330

An excellent water-colour, clear, bright and washes out very well. Genuine ingredients are absolutely lightfast. Transparent.

PÈBÈO

FRAGONARD ARTISTS' WATER COLOUR

PB28 COBALT BLUE ASTM I (215)

| PIGMENT DETAIL ON LABEL YES | ASTM I L'FAST | |

COBALT BLUE HUE 5714

Ultramarine Blue, Phthalocyanine Blue and Titanium White. Rather harsh in hue compared to genuine article. Semi-transparent.

HUNTS

SPEEDBALL PROFESSIONAL WATERCOLOURS

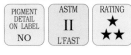

PB29 ULTRAMARINE BLUE ASTM I (215)
PW6 TITANIUM WHITE ASTM I (385)
PB15 PHTHALOCYANINE BLUE ASTM II (213)

| PIGMENT DETAIL ON LABEL NO | ASTM II L'FAST | RATING ★ ★★ |

MIDDLE COBALT BLUE 660

An extremely weak paint, for whatever reason, possibly an excess of gum (which is difficult to detect in a pan colour).

Suitable only for very thin washes.

CARAN D'ACHE

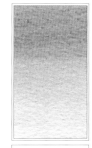

FINEST WATERCOLOURS

PB28 COBALT BLUE ASTM I (215)

| PIGMENT DETAIL ON LABEL YES | ASTM I L'FAST | RATING ★★ |

COBALT BLUE 025

Washed out very nicely, smooth, even and effortless. A very well made product. Semi transparent and slightly staining.

DANIEL SMITH

EXTRA-FINE WATERCOLORS

PB28 COBALT BLUE ASTM I (215)

| PIGMENT DETAIL ON LABEL YES | ASTM I L'FAST | |

COBALT BLUE W290

Smooth, well produced watercolour, employing genuine ingredients.

Washed out very well at all strengths. Absolutely lightfast and quite transparent.

HOLBEIN

ARTISTS' WATER COLOR

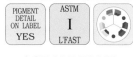

PB28 COBALT BLUE ASTM I (215)

| PIGMENT DETAIL ON LABEL YES | ASTM I L'FAST | |

COBALT BLUE HUE W291

As the company also produce genuine Cobalt Blue I should by-pass this one. Does not compare. Transparent.

HOLBEIN

ARTISTS' WATER COLOR

PB29 ULTRAMARINE BLUE ASTM I (215)
PB15 PHTHALOCYANINE BLUE ASTM II (213)

| PIGMENT DETAIL ON LABEL YES | ASTM II L'FAST | RATING ★ ★★ |

COBALT BLUE DEEP 1125

Brushes out beautifully, a very well produced watercolour paint.

A clear, bright blue leaning towards green. Transparent.

LUKAS

ARTISTS' WATER COLOUR

PB28 COBALT BLUE ASTM I (215)

| PIGMENT DETAIL ON LABEL CHEMICAL MAKE UP ONLY | ASTM I L'FAST | |

COBALT BLUE IMITATION 1126

Clearly labelled as an imitation Cobalt Blue.

More on the violet side due to the ingredients. Absolutely lightfast. Transparent.

LUKAS

ARTISTS' WATER COLOUR

PB29 ULTRAMARINE BLUE ASTM I (215)

| PIGMENT DETAIL ON LABEL CHEMICAL MAKE UP ONLY | ASTM I L'FAST | |

COBALT BLUE LIGHT 373

Genuine Cobalt Blue (as this is) cannot be matched by substitute mixtures.

Washed out very well. Most reliable. Transparent.

MAIMERI

MAIMERIBLU SUPERIOR WATERCOLOURS

PB28 COBALT BLUE ASTM I (215)

| PIGMENT DETAIL ON LABEL YES | ASTM I L'FAST | |

COBALT BLUE DEEP 374

It is always worth choosing a Cobalt Blue produced with genuine ingredients.

Imitations are always a poor second best. An excellent product.

MAIMERI

MAIMERIBLU SUPERIOR WATERCOLOURS

PB28 COBALT BLUE ASTM I (215)

| PIGMENT DETAIL ON LABEL YES | ASTM I L'FAST | |

COBALT BLUE (HUE) 603

Phthalocyanine Blue with a little white will give the same colour. A reasonable imitation, closer than Ultramarine and White mixes.
Discontinued

MAIMERI

STUDIO FINE WATERCOLOURS

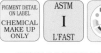

PB15:1 PHTHALOCYANINE BLUE ASTM II (213)
PB15:3 PHTHALOCYANINE BLUE ASTM II (213)
PW6 TITANIUM WHITE ASTM I (385)

| PIGMENT DETAIL ON LABEL YES | ASTM II L'FAST | |

COBALT BLUE 250

Reliable ingredients gave a sample paint which handled well. Lightfast, genuine pigment used.

OLD HOLLAND

CLASSIC WATERCOLOURS

PB28 COBALT BLUE ASTM I (215)

| PIGMENT DETAIL ON LABEL CHEMICAL MAKE UP ONLY | ASTM I L'FAST | |

COBALT BLUE TURQUOISE 42

OLD HOLLAND

Washed out fairly well. As this is Cerulean Blue rather than Cobalt this should be recorded in the title. Lightfast.

CLASSIC WATERCOLOURS

PB36 CERULEAN BLUE, CHROMIUM ASTM I (216)		
PIGMENT DETAIL ON LABEL CHEMICAL MAKE UP ONLY	ASTM I L'FAST	RATING ★ ★★

COBALT BLUE DEEP 38

OLD HOLLAND

Most of the sample tube was a heavy dark brown gum followed by a small amount of blue coloured gum.

But it did come in a nice presentation box.

CLASSIC WATERCOLOURS

PB74 COBALT ZINC SILICATE WG II (217)		
PIGMENT DETAIL ON LABEL CHEMICAL MAKE UP ONLY	WG II L'FAST	RATING ★

COBALT TEAL BLUE 028

DANIEL SMITH

A semi-transparent green blue which is rather low in tinting strength. As such it will not play much of a part in colour mixing.

If you are happy with these factors it is a well made paint.

EXTRA-FINE WATERCOLORS

PG50 LIGHT GREEN OXIDE WG II (263)		
PIGMENT DETAIL ON LABEL YES	WG II L'FAST	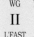

COBALT BLUE 203

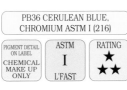

ST. PETERSBURG

Given the situation outlined below, it says as much about the painters who purchase and use this product as it says about the company and its distributors.

ARTISTS' WATERCOLOURS

COMPANY POLICY DICTATES THAT THE ARTIST IS NOT TO BE TRUSTED WITH INFORMATION CONCERNING THE PIGMENTS USED IN THIS WATERCOLOUR.		
PIGMENT DETAIL ON LABEL NO	ASTM L'FAST	RATING

Indigo

Originally imported from India, genuine Indigo has had a varied and eventful history.

It was produced from the leaves of the plant Indigofera Tinctoria. Widely used in Asia, Indigo was first imported into Europe in 1516.

A valuable article of commerce, Indigo played an important part in the British takeover of India.

Synthetic Indigo, with a poor reputation for reliability, is usually duplicated by various blue/black mixes.

Easily mixed on the palette, but the use of black might cause dullness.

For this type of colour I would always mix Ultramarine Blue with Burnt Sienna.

Being complementaries, the orange (Burnt Sienna) will darken the blue. As they are both transparent the light will sink in, making the colour very dark.

Such a mix is far livelier than any blue/black combination.

INDIGO 1122

LUKAS

Reliable, convenience colour easily duplicated on the palette.

Washes out very well and is semi-transparent.

ARTISTS' WATER COLOUR

PB15 PHTHALOCYANINE BLUE ASTM II (213) PR176 BENZIMIDAZOLONE CARMINE HF3C WG II (130) PBk7 CARBON BLACK ASTM I (370)		
PIGMENT DETAIL ON LABEL CHEMICAL MAKE UP ONLY	ASTM II L'FAST	

INDIGO 249

DA VINCI PAINTS

A strong, very transparent blue which leans slightly towards green.

Brushes out very smoothly from a very dark hue to a subtle tint.

PERMANENT ARTISTS' WATER COLOR

PB27 PRUSSIAN BLUE ASTM I (214) PV19 QUINACRIDONE VIOLET ASTM II (185)		
PIGMENT DETAIL ON LABEL YES	ASTM II L'FAST	

INDIGO W298

HOLBEIN

A reliable convenience colour, simple to mix.

Brushes out well over a wide range of values. Semi-transparent and staining.

ARTISTS' WATER COLOR

PB27 PRUSSIAN BLUE ASTM I (214) PBk6 LAMP BLACK ASTM I (370)		
PIGMENT DETAIL ON LABEL YES	ASTM I L'FAST	

INDIGO 553

MIR (JAURENA S.A)

Instead of adding black to Ultramarine Blue to produce this type of colour, try adding a little Burnt Sienna. The result will have much more 'life' about it.

Sample did not wash out evenly. Lightfast.

ACUARELA

| PB29 ULTRAMARINE BLUE ASTM I (215) |
| PBk7 CARBON BLACK ASTM I (370) |

| PIGMENT DETAIL ON LABEL **YES** | ASTM **I** L'FAST | RATING ★ ★★ |

INDIGO 522

MAIMERI

Will become paler and bluer as the Alizarin Crimson fades. This will be particularly noticeable in the thinner washes. Semi-transparent.

Discontinued

| PR83:1 ALIZARIN CRIMSON ASTM IV (122) |
| PBk7 CARBON BLACK ASTM I (370) |
| PB27 PRUSSIAN BLUE ASTM I (214) |

ARTISTI EXTRA FINE WATERCOLOURS

| PIGMENT DETAIL ON LABEL **YES** | ASTM **IV** L'FAST | RATING ★ |

INDIGO 422

MAIMERI

Some will find this, a typical 'Indigo' to be a convenience colour. Personally I would find it more convenient simply to mix it rather than open a tube.

Sample handled better in thin layers than heavy.

MAIMERIBLU SUPERIOR WATERCOLOURS

| PB27 PRUSSIAN BLUE ASTM I (214) |
| PBk7 CARBON BLACK ASTM I (370) |

| PIGMENT DETAIL ON LABEL **YES** | ASTM **I** L'FAST | RATING ★ ★★ |

INDIGO 064

AMERICAN JOURNEY

Reliable pigments giving yet another version of this easily mixed colour type.

Sample handled very well over the range of values. Quite transparent.

PROFESSIONAL ARTISTS' WATER COLOR

| PB27 PRUSSIAN BLUE ASTM I (214) |
| PV19 QUINACRIDONE VIOLET ASTM II (185) |

| PIGMENT DETAIL ON LABEL **YES** | ASTM **II** L'FAST | |

INDIGO 046

DANIEL SMITH

As you will see, there are a variety of ways to produce this rather dull, dark blue.

Dependable ingredients used in this case. Washed out well.

EXTRA-FINE WATERCOLORS

| PB60 INDANTHRONE BLUE WG II (216) |
| PBk6 LAMP BLACK ASTM I (370) |

| PIGMENT DETAIL ON LABEL **YES** | WG **II** L'FAST | |

PERMANENT INDIGO 053

LEFRANC & BOURGEOIS

Very dark, almost black when heavily applied, washes down into the usual grey-blue. Reliable ingredients. Semi-transparent.

LINEL EXTRA-FINE ARTISTS' WATERCOLOUR

| PB60 INDANTHRONE BLUE WG II (216) |
| PBk7 CARBON BLACK ASTM I (370) |

| PIGMENT DETAIL ON LABEL CHEMICAL MAKE UP ONLY | WG **II** L'FAST | |

INDIGO W112

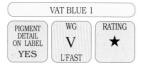

GRUMBACHER

Vat Blue 1 is the dye used in PB66 (page 217). Grumbacher use a special form of this dye in their Indigo. Sample lost its red sheen and became very black in mass tone. Tint faded.

FINEST ARTISTS' WATER COLOR

| VAT BLUE 1 |

| PIGMENT DETAIL ON LABEL **YES** | WG **V** L'FAST | RATING ★ |

INDIGO A112

GRUMBACHER

Sample not provided, previously or for this edition

PB66 Indigo Blue has a very poor reputation for lightfastness. It is unfortunate to see a colour introduced just a few years ago which will deteriorate on exposure to light.

Reformulated >

| PB66 INDIGO BLUE ASTM IV (217) |

ACADEMY ARTISTS' WATERCOLOR 2ND RANGE

| PIGMENT DETAIL ON LABEL **YES** | ASTM **IV** L'FAST | RATING |

INDIGO

GRUMBACHER

If you wish to avoid black in your work and seek livelier dark blues than this, try adding a touch of Burnt Sienna to Ultramarine Blue.

Sample washed out very well. Reliable.

ACADEMY ARTISTS' WATERCOLOR 2ND RANGE

| PB29 ULTRAMARINE BLUE ASTM I (215) |
| PV19 QUINACRIDONE VIOLET ASTM II (185) |
| PBk7 CARBON BLACK ASTM I (370) |

| PIGMENT DETAIL ON LABEL **YES** | ASTM **II** L'FAST | |

INDIGO 322

WINSOR & NEWTON

Washed out very well, reliable ingredients, but easily mixed from standard colours. Semi-transparent.

COTMAN WATER COLOURS 2ND RANGE

| PBk7 CARBON BLACK ASTM I (370) |
| PB29 ULTRAMARINE BLUE ASTM I (215) |
| PB15 PHTHALOCYANINE BLUE ASTM II (213) |

| PIGMENT DETAIL ON LABEL **YES** | ASTM **II** L'FAST | |

INDIGO 322

WINSOR & NEWTON

Like most Indigos it is almost black in mass tone and washes out into a dull blue-grey. Reliable.

ARTISTS' WATER COLOUR

| PBk6 LAMP BLACK ASTM I (370) |
| PV19 QUINACRIDONE VIOLET ASTM II (185) |
| *UNSPECIFIED PV15 ASTM I (184)* |

| PIGMENT DETAIL ON LABEL **YES** | ASTM **II** L'FAST | |

CARAN D'ACHE

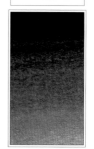

FINEST WATERCOLOURS

INDIGO BLUE 139

The colour lifted very well from the pan and gave smooth, very even washes.

Most reliable.

| PB15 PHTHALOCYANINE BLUE ASTM II (213) |
| PBk7 CARBON BLACK ASTM I (370) |

| PIGMENT DETAIL ON LABEL **YES** | ASTM **II** L'FAST | |

INDIGO 308

SENNELIER

Almost black in mass tone. Washes out to give a very wide range of values.

A convenience colour which is easily mixed. Lightfast.

EXTRA-FINE WATERCOLOUR

| PBk7 CARBON BLACK ASTM I (370) |
| PB15:1 PHTHALOCYANINE BLUE ASTM II (213) |

| PIGMENT DETAIL ON LABEL **YES** | ASTM **II** L'FAST | |

INDIGO BLUE W30

ART SPECTRUM

Rather gum laden, our sample did not provide satisfactory washes unless very thin.

ARTISTS' WATER COLOUR

| PB29 ULTRAMARINE BLUE ASTM I (215) |
| PBk6 LAMP BLACK ASTM I (370) |

| PIGMENT DETAIL ON LABEL **YES** | ASTM **I** L'FAST | RATING ★★ |

INDIGO MODERN 533

TALENS

Lightfast pigments giving the usual blue black. Sample washed out well. Semi-transparent.

Reformulated >

REMBRANDT ARTISTS' QUALITY EXTRA FINE

| PB15 PHTHALOCYANINE BLUE ASTM II (213) |
| PBk7 CARBON BLACK ASTM I (370) |
| PV19 QUINACRIDONE VIOLET ASTM II (185) |

| PIGMENT DETAIL ON LABEL **YES** | ASTM **II** L'FAST | |

INDIGO 533

TALENS

Has been reformulated to give a smooth, reliable dark blue which provides smooth washes.

REMBRANDT ARTISTS' QUALITY EXTRA FINE

| PB15 PHTHALOCYANINE BLUE ASTM II (213) |
| PBk6 LAMP BLACK ASTM I (370) |

| PIGMENT DETAIL ON LABEL **YES** | ASTM **II** L'FAST | |

INDIGO MODERN 533

TALENS

A wide range of values available, from a colour close to black to a light blue-grey. Semi-transparent.

Discontinued

WATER COLOUR 2ND RANGE

| PB15 PHTHALOCYANINE BLUE ASTM II (213) |
| PBk7 CARBON BLACK ASTM I (370) |
| PV19 QUINACRIDONE VIOLET ASTM II (185) |

| PIGMENT DETAIL ON LABEL **YES** | ASTM **II** L'FAST | |

INDIGO 533

TALENS

A very easy paint to wash out. A wide range of values are available, from a deep blackish blue to very thin pale blue washes. Reliable.

VAN GOGH 2ND RANGE

| PB15 PHTHALOCYANINE BLUE ASTM II (213) |
| PBk6 LAMP BLACK ASTM I (370) |

| PIGMENT DETAIL ON LABEL **YES** | ASTM **II** L'FAST | |

INDIGO 125

PÈBÈO

Almost black at full strength but washes out into a reasonably transparent green blue. Lightfast. Semi-transparent.

FRAGONARD ARTISTS' WATER COLOUR

| PB15 PHTHALOCYANINE BLUE ASTM II (213) |
| PG7 PHTHALOCYANINE GREEN ASTM I (259) |
| PR88 MRS THIOINDIGOID VIOLET ASTM II (122) |

| PIGMENT DETAIL ON LABEL **YES** | ASTM **II** L'FAST | |

INDIGO 485

SCHMINCKE

PB66 has a poor reputation for reliability. It will cause deterioration in such mixes. Becomes bluer on fading. Semi-transparent.

HORADAM FINEST ARTISTS' WATER COLOURS

| PB15:1 PHTHALOCYANINE BLUE ASTM II (213) |
| PB66 INDIGO BLUE ASTM IV (217) |

| PIGMENT DETAIL ON LABEL **YES** | ASTM **IV** L'FAST | RATING ★ |

DARK BLUE INDIGO 498

SCHMINCKE

Previously called 'Indigo Hue' 479'.

PB60 is a slightly dull blue leaning towards violet. It has a good reputation for lightfastness. The sample washed out very smoothly. Semi-transparent.

HORADAM FINEST ARTISTS' WATER COLOURS

| PB60 INDANTHRONE BLUE WG II (216) |

| PIGMENT DETAIL ON LABEL **YES** | WG **II** L'FAST | |

INDIGO EXTRA

OLD HOLLAND

Comparatively little black can have been added as the hue is a definite green-blue. Lightfast ingredients used. Semi-transparent.

Reformulated >

CLASSIC WATERCOLOURS

| PB15 PHTHALOCYANINE BLUE ASTM II (213) |
| PBk9 IVORY BLACK ASTM I (371) |

| PIGMENT DETAIL ON LABEL CHEMICAL MAKE UP ONLY | ASTM **II** L'FAST | |

INDIGO EXTRA 33

OLD HOLLAND

This appears to be mainly PB15 with a touch of black.

Washed reasonably well. Reliable pigments.

CLASSIC WATERCOLOURS

| PV19 QUINACRIDONE REDASTM II (185) |
| PBk7 CARBON BLACK ASTM I (370) |
| PB15 PHTHALOCYANINE BLUE ASTM II (213) |

| PIGMENT DETAIL ON LABEL CHEMICAL MAKE UP ONLY | ASTM **II** L'FAST | |

INDIGO 127

DALER ROWNEY

Very little Alizarin Crimson can be involved as our sample did not change when tested. Semi-opaque.

Reformulated >

ARTISTS' WATER COLOUR

| PR83:1 ALIZARIN CRIMSON ASTM IV (122) |
| PB15 PHTHALOCYANINE BLUE ASTM II (213) |
| PBk7 CARBON BLACK ASTM I (370) |
| PB29 ULTRAMARINE BLUE ASTM I (215) |

| PIGMENT DETAIL ON LABEL **YES** | ASTM **IV** L'FAST | RATING ★ |

INDIGO

DALER ROWNEY

Very easily produced on the palette. Reliable ingredients used to give a reliable watercolour paint. Washes out very well.

PB15 PHTHALOCYANINE BLUE ASTM II (213)
PV19 QUINACRIDONE VIOLET ASTM II (185)
PBk7 CARBON BLACK ASTM I (370)

ARTISTS' WATER COLOUR

PIGMENT DETAIL ON LABEL	ASTM	
YES	II L'FAST	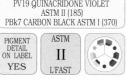

INDIGO 127

DALER ROWNEY

Fortunately little of the Alizarin Crimson seems to have been added, the colour change on exposure was slight. Semi-transparent.

Reformulated >

PR83:1 ALIZARIN CRIMSON ASTM IV (122)
PB15 PHTHALOCYANINE BLUE ASTM II (213)
PBk7 CARBON BLACK ASTM I (370)
PB29 ULTRAMARINE BLUE ASTM I (215)

GEORGIAN WATER COLOUR 2ND RANGE

PIGMENT DETAIL ON LABEL	ASTM	RATING
NO	IV L'FAST	★★

INDIGO

DALER ROWNEY

A touch of Burnt Sienna into Ultramarine Blue and you will have not one dark violet-blue but an easily varied series.

This product is very well made.

PB15 PHTHALOCYANINE BLUE ASTM II (213)
PBk7 CARBON BLACK ASTM I (370)
PR88 MRS THIOINDIGOID VIOLET ASTM II (122)

GEORGIAN WATER COLOUR 2ND RANGE

PIGMENT DETAIL ON LABEL	ASTM	RATING
NO	II L'FAST	

Manganese Blue

Often thought of as a cheaper alternative to Cerulean Blue. It is much more transparent and lacks 'body'.

It became very noticeable, when the various versions were compared, that Manganese Blue does not make up into a successful watercolour paint. Its lack of body made for paints which were often no more than coloured gum.

Personally I would always select genuine Cerulean Blue, even if it were ten times the price. Mixing complementary is red orange. Use as a semi-transparent green-blue.

As the pigment, to my knowledge, is no longer produced, (unless commenced again), the genuine product will only come from those manufactures who have retained stock from the past.

MANGANESE AZURE BLUE 093

LEFRANC & BOURGEOIS

PB33 does not make into a particularly useful watercolour. It might be lightfast but is unpleasant to use unless thin. Semi-transparent.

Reformulated>

PB33 MANGANESE BLUE ASTM I (215)

LINEL EXTRA-FINE ARTISTS' WATERCOLOUR

PIGMENT DETAIL ON LABEL	ASTM	RATING
CHEMICAL MAKE UP ONLY	I L'FAST	★★

MANGANESE AZURE BLUE

LEFRANC & BOURGEOIS

If you already have Phthalocyanine Blue, or the pigment under another name, you will not need yet another one. The word 'Hue' should be in the title. A faultless colour otherwise.

PB15:3 PHTHALOCYANINE BLUE ASTM II (213)

LINEL EXTRA-FINE ARTISTS' WATERCOLOUR

PIGMENT DETAIL ON LABEL	ASTM	
CHEMICAL MAKE UP ONLY	II L'FAST	

MANGANESE BLUE 073

The hue would suggest that this colour is heavily dependant on the PB15 content.

That it is unpleasant to use due to its lack of body and gummy consistency is probably to do with the PB33.

AMERICAN JOURNEY

PB33 MANGANESE BLUE ASTM I (215)
PB15 PHTHALOCYANINE BLUE ASTM II (213)

PROFESSIONAL ARTISTS' WATER COLOR

PIGMENT DETAIL ON LABEL	ASTM	RATING
YES	II L'FAST	★★

MANGANESE BLUE 1119

LUKAS

Weak in 'body' and unpleasant to use. Excessively gummy due to physical nature of pigment. Semi-transparent.

PB33 MANGANESE BLUE ASTM I (215)

ARTISTS' WATER COLOUR

PIGMENT DETAIL ON LABEL	ASTM	RATING
CHEMICAL MAKE UP ONLY	I L'FAST	★★

MANGANESE BLUE 552

MAIMERI

A rather gummy, weak watercolour which washes reasonably well when applied thinly. Lightfast and semi-transparent.

Discontinued

PB33 MANGANESE BLUE ASTM I (215)

ARTISTI EXTRAFINE WATERCOLOURS

PIGMENT DETAIL ON LABEL	ASTM	RATING
YES	I L'FAST	★★

MANGANESE BLUE HUE 013

UTRECHT

The catalogue gives PW4 as an ingredient but this is not mentioned on the tube label. The hue would suggest that the label is correct. Reliable and handled with ease.

PB15 PHTHALOCYANINE BLUE ASTM II (213)
PW4 ZINC WHITE ASTM I (384)

PROFESSIONAL ARTISTS' WATER COLOR

PIGMENT DETAIL ON LABEL	ASTM	
YES	II L'FAST	

MANGANESE BLUE NOVA W305

HOLBEIN

The pigment had previously been PB35. I had said then 'Possesses little body giving a rather gum laden paint. Brushes out with difficulty.'

Now reformulated and brushed out again, my remarks remain the same.

ARTISTS' WATER COLOR

PB15 PHTHALOCYANINE BLUE ASTM II (213)		
PIGMENT DETAIL ON LABEL **YES**	ASTM **II** L'FAST	RATING ★★

MANGANESE BLUE 108

DALER ROWNEY

Gummy and difficult to work with unless washed out very thin. Reasonable tinting strength. Semi-transparent.

Discontinued

ARTISTS' WATER COLOUR

PB33 MANGANESE BLUE ASTM I (215)		
PIGMENT DETAIL ON LABEL **YES**	ASTM **I** L'FAST	RATING ★★

MANGANESE BLUE (HUE) 121

DALER ROWNEY

Phthalocyanine Blue with a touch of white. Not difficult to mix.

Sample handled well and is reliable should you baulk at the challenge of mixing it.

ARTISTS' WATER COLOUR

PB15:3 PHTHALOCYANINE BLUE ASTM II (213) PW5 LITHOPONE WG I (384)		
PIGMENT DETAIL ON LABEL **YES**	ASTM **II** L'FAST	

MANGANESE BLUE 382 (071)

WINSOR & NEWTON

Like other examples of Manganese Blue it was unpleasant to use unless in very thin washes. Over bound. Semi-transparent.

Discontinued

ARTISTS' WATER COLOUR

PB33 MANGANESE BLUE ASTM I (215)		
PIGMENT DETAIL ON LABEL **YES**	ASTM **I** L'FAST	RATING ★★

MANGANESE BLUE HUE 379

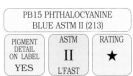

WINSOR & NEWTON

The founders of the company would spin in their graves if they knew of the sample that we received.

The consistency of liquid honey, quite impossible to use.

ARTISTS' WATER COLOUR

PB15 PHTHALOCYANINE BLUE ASTM II (213)		
PIGMENT DETAIL ON LABEL **YES**	ASTM **II** L'FAST	RATING ★

MANGANESE BLUE (MIXTURE) 253

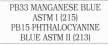
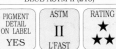

DA VINCI PAINTS

Sample was slightly gummy at full strength. This is probably due to the PB33 content. Washed out very smoothly however. A lightfast green-blue.

PERMANENT ARTISTS' WATER COLOR

PB33 MANGANESE BLUE ASTM I (215) PB15 PHTHALOCYANINE BLUE ASTM II (213)		
PIGMENT DETAIL ON LABEL **YES**	ASTM **II** L'FAST	RATING ★ ★★

MANGANESE BLUE HUE 051

DANIEL SMITH

A rather gum laden example which washed out poorly unless very thin.

In this respect it resembles the colour it is imitating. Transparent and staining.

EXTRA-FINE WATERCOLORS

PB15 PHTHALOCYANINE BLUE ASTM II (213)		
PIGMENT DETAIL ON LABEL **YES**	ASTM **II** L'FAST	RATING ★★

MANGANESE BLUE 131

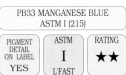

GRUMBACHER

Sample was rather gummy. Washed out reasonably well as a thin wash, but heavier applications need a trowel. Semi-transparent.

Discontinued

FINEST ARTISTS' WATER COLOR

PB33 MANGANESE BLUE ASTM I (215)		
PIGMENT DETAIL ON LABEL **YES**	ASTM **I** L'FAST	RATING ★★

MANGANESE BLUE 131

GRUMBACHER

In whatever quality, the pigment itself causes the paint to be little more than a coloured gum. Semi-transparent.

Discontinued

ACADEMY ARTISTS' WATERCOLOR 2ND RANGE

PB33 MANGANESE BLUE ASTM I (215)		
PIGMENT DETAIL ON LABEL **YES**	ASTM **I** L'FAST	RATING ★★

MANGANESE BLUE 41

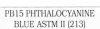
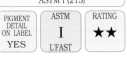
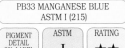

OLD HOLLAND

Sample was particularly over bound. A greenish blue possessing reasonable tinting strength but little body. Semi-opaque.

CLASSIC WATERCOLOURS

PB33 MANGANESE BLUE ASTM I (215)		
PIGMENT DETAIL ON LABEL CHEMICAL MAKE UP ONLY	ASTM **I** L'FAST	RATING ★★

MANGANESE BLUE DEEP 241

OLD HOLLAND

Unworkable coloured gum. If you have made a purchase, and it is as our sample, you could always stick things together with it. Better still, take it back for a full refund.

CLASSIC WATERCOLOURS

PB33 MANGANESE BLUE ASTM I (215) PV16 MANGANESE VIOLET ASTM I (185)		
PIGMENT DETAIL ON LABEL CHEMICAL MAKE UP ONLY	ASTM **I** L'FAST	RATING ★

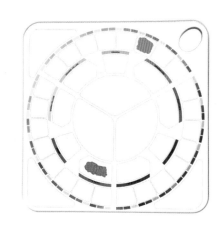

Phthalocyanine Blue was discovered by accident when the lining of a dye vat cracked.

A vibrant, deep greenish blue. Valued for its transparency, it gives very clear washes when diluted. Strong tinctorially, it will soon influence other colours in a mix and can also dominate a painting quickly.

Sold under its own title as well as fancy or trade names. A very important, inexpensive transparent green blue.

Gives very clear blue greens when mixed with Phthalocyanine Green or Viridian.

Mixing complementary is a red orange.

PHTHALO BLUE 74

DR.Ph. MARTINS

HYDRUS FINE ART WATERCOLOR

Either I am missing something or this company has been able to get away with the supply of colorants described as for artistic use without actually declaring the contents.

PIGMENT INFORMATION NOT PROVIDED ON THE PRODUCT LABEL OR IN THE LITERATURE

PIGMENT DETAIL ON LABEL	ASTM	RATING
NO	L'FAST	

PHTHALO BLUE W32

ART SPECTRUM

ARTISTS' WATER COLOUR

A series of beautifully smooth, effortless washes are available from this quality product.

PB15:3 PHTHALOCYANINE BLUE ASTM II (213)

PIGMENT DETAIL ON LABEL	ASTM II	
YES	L'FAST	

PHTHALO BLUE 077

DANIEL SMITH

EXTRA-FINE WATERCOLORS

A rich green blue giving exceedingly clear washes. A strong staining colour with many admirable qualities. This is a quality product.

PB15:3 PHTHALOCYANINE BLUE ASTM II (213)

PIGMENT DETAIL ON LABEL	ASTM II	
YES	L'FAST	

PHTHALOCYANINE BLUE 551

MAIMERI

ARTIST FINE WATERCOLOURS

A powerful green blue. Dense pigment in a well produced watercolour paint. Handles particularly well. Transparent.

Range discontinued

PB15 PHTHALOCYANINE BLUE ASTM II (213)

PIGMENT DETAIL ON LABEL	ASTM II	
YES	L'FAST	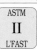

PHTHALO BLUE GREEN 576

TALENS

REMBRANDT ARTISTS' QUALITY EXTRA FINE

A very rich, deep green blue at full strength washing down to clear bright tints.

An excellent product.

PB15 PHTHALOCYANINE BLUE ASTM II (213)

PIGMENT DETAIL ON LABEL	ASTM II	
YES	L'FAST	

PHTHALO BLUE 570

TALENS

WATER COLOUR 2ND RANGE

Gives very clear, bright green blue washes. Being transparent, it becomes dark when heavily applied.

Range discontinued

PB15 PHTHALOCYANINE BLUE ASTM II (213)

PIGMENT DETAIL ON LABEL	ASTM II	
YES	L'FAST	

PHTHALO BLUE 570

TALENS

VAN GOGH 2ND RANGE

A well made example of this colour. Very bright, strong, transparent and lightfast.

Will give very bright, clear greens with a green yellow, (Lemon Yellow).

PB15 PHTHALOCYANINE BLUE ASTM II (213)

PIGMENT DETAIL ON LABEL	ASTM II	
YES	L'FAST	

PHTHALO BLUE RED 583

TALENS

REMBRANDT ARTISTS' QUALITY EXTRA FINE

There is only a very slight difference in hue between this and the colour to the left. If you use this make and wish to make savings you will find the Van Gogh version to be equally reliable.

UNSPECIFIED PV15 ASTM I (184)

PIGMENT DETAIL ON LABEL	ASTM I	
YES	L'FAST	

PHTHALO BLUE 154

UTRECHT

PROFESSIONAL ARTISTS' WATER COLOR

A rich velvety deep green blue at full saturation. Washes out into very clear tints. A quality product.

PB15 PHTHALOCYANINE BLUE ASTM II (213)

PIGMENT DETAIL ON LABEL	ASTM II	
YES	L'FAST	

CARAN D'ACHE — PHTHALOCYANINE BLUE 162

FINEST WATERCOLOURS

The paint lifted readily from the pan. Not always the case with pan colours.

A strong paint which washed out very well.

PB15:3 PHTHALOCYANINE BLUE ASTM II (213)

PIGMENT DETAIL ON LABEL **YES** | ASTM **II** L'FAST

M.GRAHAM & CO. — PHTHALOCYANINE BLUE 140

ARTISTS' WATERCOLOR

A very rich, velvety green blue at full strength leading to extremely clear bright tints when well diluted.

An excellent paint.

PB15:3 PHTHALOCYANINE BLUE ASTM II (213)

PIGMENT DETAIL ON LABEL **YES** | ASTM **II** L'FAST

SCHMINCKE — PHTHALO BLUE 484

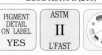

HORADAM FINEST ARTISTS' WATER COLOURS

Bright and powerful, PB15 should be handled with some care due to its strength. Well produced. Transparent.

PB15:1 PHTHALOCYANINE BLUE ASTM II (213)

PIGMENT DETAIL ON LABEL **YES** | ASTM **II** L'FAST

DALER ROWNEY — PHTHALO BLUE (RS) 139

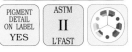

ARTISTS' WATER COLOUR

The RS stands for 'Red Shade' in other words a green blue with a touch of violet.

Handles very well, a reliable product.

PB15 PHTHALOCYANINE BLUE ASTM II (213)

PIGMENT DETAIL ON LABEL **YES** | ASTM **II** L'FAST

DALER ROWNEY — PHTHALO BLUE (GS) 140

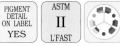

ARTISTS' WATER COLOUR

GS or 'Green Shade' denotes a phthalo blue which leans more than others towards green.

Reliable and washes out with ease.

PB15:3 PHTHALOCYANINE BLUE ASTM II (213)

PIGMENT DETAIL ON LABEL **YES** | ASTM **II** L'FAST

SENNELIER — PHTHALO BLUE 326

EXTRA-FINE WATERCOLOUR

A very intense green blue which has many admirable qualities but should be used with some caution due to its strength.

This is a well made example.

PB15:3 PHTHALOCYANINE BLUE ASTM II (213)

PIGMENT DETAIL ON LABEL **YES** | ASTM **II** L'FAST

DA VINCI PAINTS — PHTHALO BLUE 267

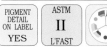

PERMANENT ARTISTS' WATER COLOR

All with of the various Phthalocyanine Blues, it will quickly stamp their mark on a painting. Powerful, use with care. Transparent.

PB15 PHTHALOCYANINE BLUE ASTM II (213)

PIGMENT DETAIL ON LABEL **YES** | ASTM **II** L'FAST

DA VINCI PAINTS — PHTHALO BLUE 667

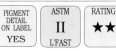

SCUOLA 2ND RANGE

Sample tube was under considerable pressure and the washes were difficult to apply due to the consistency of the paint.

I feel sure that the 'teething problems' in this new range will quickly be rectified.

PB15 PHTHALOCYANINE BLUE ASTM II (213)

PIGMENT DETAIL ON LABEL **YES** | ASTM **II** L'FAST | RATING ★★

GRUMBACHER — THALO BLUE 203

FINEST PROFESSIONAL WATER COLOR

A bright, powerful green blue, valued for its transparency. Washes out into very clear tints. Lightfast.

PB15 PHTHALOCYANINE BLUE ASTM II (213)

PIGMENT DETAIL ON LABEL **YES** | ASTM **II** L'FAST

GRUMBACHER — THALO BLUE A203

ACADEMY ARTISTS' WATERCOLOR 2ND RANGE

A densely packed, smoothly ground watercolour, in a well labelled tube.

Bright and clear. What more could you ask for?

PB15 PHTHALOCYANINE BLUE ASTM II (213)

PIGMENT DETAIL ON LABEL **YES** | ASTM **II** L'FAST

Prussian Blue

The discovery of Prussian Blue in the early 1700's is considered to be the beginning of the era of modern pigments.

An intense green-blue of great tinctorial power.

Because of unreliably in the past and a tendency to 'bronze' over, artists welcomed the introduction of Phthalocyanine Blue as an alternative.

Both share similarities of hue, strength and handling characteristics.

Personally I would always choose Phthalocyanine Blue as the bronzing with Prussian Blue can be disconcerting.

Mixing complementary is a red orange.

PRUSSIAN BLUE 046

Valued for its transparency, this bright green-blue gives a wide range of values.

Most reliable.

LEFRANC & BOURGEOIS

LINEL EXTRA-FINE ARTISTS' WATERCOLOUR

PB27 PRUSSIAN BLUE ASTM I (214)

PIGMENT DETAIL ON LABEL — CHEMICAL MAKE UP ONLY | ASTM I L'FAST

PRUSSIAN BLUE 271

Strong, bright and powerful. Use with care in mixing due to its high tinting strength.

A well made watercolour. Transparent.

DA VINCI PAINTS

PERMANENT ARTISTS' WATER COLOR

PB27 PRUSSIAN BLUE ASTM I (214)

PIGMENT DETAIL ON LABEL YES | ASTM I L'FAST

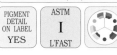
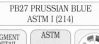

PRUSSIAN BLUE 671

Painted out very smoothly, particularly in thinner applications.

An absolutely lightfast watercolour.

DA VINCI PAINTS

SCUOLA 2ND RANGE

PB27 PRUSSIAN BLUE ASTM I (214)

PIGMENT DETAIL ON LABEL YES | ASTM I L'FAST

PRUSSIAN BLUE 538

Gives very clear washes. A vibrant green-blue offering a wide range of values. Absolutely lightfast. Transparent and staining.

WINSOR & NEWTON

ARTISTS' WATER COLOUR

PB27 PRUSSIAN BLUE ASTM I (214)

PIGMENT DETAIL ON LABEL YES | ASTM I L'FAST

PRUSSIAN BLUE 538

Virtually identical to the 'Artists' Quality' Prussian Blue in this make.

Bright, strong, staining and transparent.

WINSOR & NEWTON

COTMAN WATER COLOURS 2ND RANGE

PB27 PRUSSIAN BLUE ASTM I (214)

PIGMENT DETAIL ON LABEL YES | ASTM I L'FAST
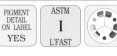

PRUSSIAN BLUE 153

A very well made watercolour paint. Rich, strong colour at full saturation moving to bright, very transparent washes when well diluted.

M.GRAHAM & CO.

ARTISTS' WATERCOLOR

PB27 PRUSSIAN BLUE ASTM I (214)

PIGMENT DETAIL ON LABEL YES | ASTM I L'FAST

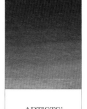

PRUSSIAN BLUE W168

Several variations of PB27 exist. The pigment used in this watercolour, PB27:1 is very closely related. An excellent product.

GRUMBACHER

FINEST PROFESSIONAL WATER COLOR

PB27:1 PRUSSIAN BLUE ASTM I (214)

PIGMENT DETAIL ON LABEL YES | ASTM I L'FAST

PRUSSIAN BLUE A168

Better labelled than most 'Artist Quality' paints. Also well produced. Smooth, bright and transparent.

GRUMBACHER

ACADEMY ARTISTS' WATERCOLOR 2ND RANGE

PB27 PRUSSIAN BLUE ASTM I (214)

PIGMENT DETAIL ON LABEL YES | ASTM I L'FAST

PRUSSIAN BLUE W297

A powerful, very intense blue which will quickly influence other colours in a mix.

Valued for its transparency. Absolutely lightfast.

HOLBEIN

ARTISTS' WATER COLOR

PB27 PRUSSIAN BLUE ASTM I (214)

PIGMENT DETAIL ON LABEL YES | ASTM I L'FAST

PRUSSIAN BLUE
135

DALER ROWNEY

ARTISTS' WATER COLOUR

Being very transparent it takes on a particularly dark appearance when applied heavily. The light sinks in deeply and little escapes. An excellent watercolour.

PB27 PRUSSIAN BLUE
ASTM I (214)

PIGMENT DETAIL ON LABEL	ASTM	
YES	I L'FAST	

PRUSSIAN BLUE

DALER ROWNEY

GEORGIAN WATER COLOUR 2ND RANGE

Definitely a green blue, this should be born in mind when mixing.

The strength of this colour must be kept under control. Well produced watercolour. Transparent.

PB27 PRUSSIAN BLUE
ASTM I (214)

PIGMENT DETAIL ON LABEL	ASTM	
NO	I L'FAST	

PRUSSIAN BLUE
082

DANIEL SMITH

EXTRA-FINE WATERCOLORS

Most definitely a staining colour. Once applied it wants to stay there. As with other staining colours, this should not be seen as a drawback.

This is a high quality, well made example.

PB27 PRUSSIAN BLUE
ASTM I (214)

PIGMENT DETAIL ON LABEL	ASTM	
YES	I L'FAST	

PRUSSIAN BLUE
097

AMERICAN JOURNEY

PROFESSIONAL ARTISTS' WATER COLOR

At full saturation this is a very rich, velvety, deep green blue.

When washed out a series of clear bright tints emerge. A well made product.

PB27 PRUSSIAN BLUE
ASTM I (214)

PIGMENT DETAIL ON LABEL	ASTM	
YES	I L'FAST	

CARAN D'ACHE

FINEST WATERCOLOURS

PRUSSIAN BLUE
159

The paint lifted well from the pan, without the endless, brush damaging scrubbing associated with some makes.

A quality product.

PB27 PRUSSIAN BLUE
ASTM I (214)

PIGMENT DETAIL ON LABEL	ASTM	
YES	I L'FAST	

PRUSSIAN BLUE
W33

ART SPECTRUM

ARTISTS' WATER COLOUR

A very well produced watercolour which handled smoothly at all values.

Most reliable.

PB27 PRUSSIAN BLUE
ASTM I (214)

PIGMENT DETAIL ON LABEL	ASTM	
YES	I L'FAST	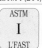

PRUSSIAN BLUE
No 24

PENTEL (POLY TUBE)

WATER COLORS

This looks as if it might be Prussian Blue, but I have no way of knowing.

PIGMENT INFORMATION DOES NOT APPEAR ON THE PRODUCT LABEL OR IN THE LITERATURE SUPPLIED

PIGMENT DETAIL ON LABEL	ASTM	RATING
NO	L'FAST	

PRUSSIAN BLUE
No 24

PENTEL

WATER COLORS

The remarks to the left also apply here.

PIGMENT INFORMATION DOES NOT APPEAR ON THE PRODUCT LABEL OR IN THE LITERATURE SUPPLIED

PIGMENT DETAIL ON LABEL	ASTM	RATING
NO	L'FAST	

PRUSSIAN BLUE
1134

LUKAS

ARTISTS' WATER COLOUR

Bright when applied thinly, also exceedingly transparent.

A powerful green blue, very well made.

PB27 PRUSSIAN BLUE
ASTM I (214)
PG7 PHTHALOCYANINE GREEN
ASTM I (259)

PIGMENT DETAIL ON LABEL	ASTM	
CHEMICAL MAKE UP ONLY	I L'FAST	

PRUSSIAN BLUE
402

MAIMERI

MAIMERIBLU SUPERIOR WATERCOLOURS

Very well produced watercolour possessing admirable handling qualities.

Absolutely lightfast. Transparent.

PB27 PRUSSIAN BLUE
ASTM I (214)

PIGMENT DETAIL ON LABEL	ASTM	
YES	I L'FAST	

PRUSSIAN BLUE
402

MAIMERI

VENEZIA EXTRAFINE WATERCOLOURS

A well produced watercolour. Washes out very smoothly into a wide range of values.

Completely resistant to light, most reliable. Transparent.

PB27 PRUSSIAN BLUE
ASTM I (214)

PIGMENT DETAIL ON LABEL	ASTM	
YES	I L'FAST	

PRUSSIAN BLUE
HUE 543

MIR (JAURENA S.A)

ACUARELA

A little difficult to wash out in heavier applications. Handled extremely well in medium to light washes.

A reliable product.

PB15 PHTHALOCYANINE BLUE ASTM II (213)

PIGMENT DETAIL ON LABEL	ASTM	RATING
YES	II L'FAST	★ ★★

PRUSSIAN BLUE
158

UTRECHT

PROFESSIONAL
ARTISTS'
WATER COLOR

Sample handled very well giving even washes over a wide range of values, from a rich fully saturated deep blue to the thinnest light washes.

PB27 PRUSSIAN BLUE
ASTM I (214)

PIGMENT DETAIL ON LABEL YES	ASTM I L'FAST	

PRUSSIAN BLUE
492

SCHMINCKE

HORADAM
FINEST
ARTISTS'
WATER COLOURS

Exceedingly strong. Brushes out particularly well into a series of smooth gradated washes. Lightfast and transparent.

PB27 PRUSSIAN BLUE
ASTM I (214)

PIGMENT DETAIL ON LABEL YES	ASTM I L'FAST	

PRUSSIAN BLUE
318

SENNELIER

EXTRA-FINE
WATERCOLOUR

As with other Prussian Blues, heavier applications can take on a definite bronzed appearance. This example is very well made. Transparent.

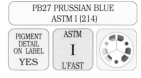

PB27 PRUSSIAN BLUE
ASTM I (214)

PIGMENT DETAIL ON LABEL YES	ASTM I L'FAST	

PRUSSIAN BLUE IMITATION 120

The Pigment Violet 23 content will let the colour down. It resists light for some time but will then fade. Other pigments reliable. The company claim of ASTM II is incorrect. But why an imitation?

PÈBÈO

FRAGONARD
ARTISTS'
WATER
COLOUR

PB15 PHTHALOCYANINE BLUE ASTM II (213)
PV23RS DIOXAZINE PURPLE
ASTM III (186)
PG7 PHTHALOCYANINE GREEN ASTM I (259)

PIGMENT DETAIL ON LABEL YES	ASTM III L'FAST	RATING ★

PRUSSIAN BLUE
508

TALENS

REMBRANDT
ARTISTS'
QUALITY
EXTRA FINE

Well produced and smoothly milled, giving very clear washes. The strength of Prussian Blue will quickly dominate in a mix. Transparent.

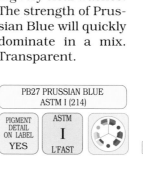

PB27 PRUSSIAN BLUE
ASTM I (214)

PIGMENT DETAIL ON LABEL YES	ASTM I L'FAST	

PRUSSIAN BLUE
508

TALENS

WATER COLOUR
2ND RANGE

This 'Second Range' or 'Student colour' is virtually identical to the 'Artists Quality'. Very well produced. Transparent.

Discontinued

PB27 PRUSSIAN BLUE
ASTM I (214)

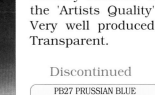

PIGMENT DETAIL ON LABEL YES	ASTM I L'FAST	

PRUSSIAN BLUE
508

TALENS

VAN GOGH
2ND RANGE

A powerful hue which can quickly influence others in a mix.

Sample painted out very well into a wide series of values.

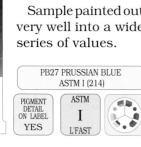

PB27 PRUSSIAN BLUE
ASTM I (214)

PIGMENT DETAIL ON LABEL YES	ASTM I L'FAST	

More a colour description than anything else. The name is used to describe a green-blue, usually produced from a mix of Phthalocyanine Blue and Phthalocyanine Green.

With the same ingredients you can mix the identical colour on the palette.

The mixing complementary is a red-orange.

If the red-orange is also reasonably transparent the resulting mixes will be very dark when applied heavily, particularly when mixed into greys.

Transparent paints absorb the light. In heavier layers, it sinks in and much is unable to escape, causing the colour to appear blackish.

ANDREWS' TURQUOISE 004

AMERICAN JOURNEY

PROFESSIONAL ARTISTS' WATER COLOR

Reliable pigments giving a reliable, simple to do yourself, mix. Never mind the two types of Phthalo Green. One or the other plus white will approx. this colour. Washed well.

| PG7 PHTHALOCYANINE GREEN ASTM I (259) |
| PG36 PHTHALOCYANINE GREEN ASTM I (262) |
| PW6 TITANIUM WHITE ASTM I (385) |

PIGMENT DETAIL ON LABEL	ASTM	
YES	I L'FAST	

COBALT BLUE TURQUOISE LIGHT 262

OLD HOLLAND

CLASSIC WATERCOLOURS

This company certainly get through a lot of gum Arabic, or whatever it is they use. Another unworkable substance.

| PG50 LIGHT GREEN OXIDE WG II (263) |

PIGMENT DETAIL ON LABEL	WG	RATING
CHEMICAL MAKE UP ONLY	II L'FAST	★

TURQUOISE BLUE DEEP 265

OLD HOLLAND

CLASSIC WATERCOLOURS

Two whites and two Phthalocyanines. The built in subtlety which must be there is lost when you try to paint it out in other than very thin washes.

| PW4 ZINC WHITE ASTM I (384) |
| PW6 TITANIUM WHITE ASTM I (385) |
| PB15 PHTHALOCYANINE BLUE ASTM II (213) |
| PG7 PHTHALOCYANINE GREEN ASTM I (259) |

PIGMENT DETAIL ON LABEL	ASTM	RATING
CHEMICAL MAKE UP ONLY	II L'FAST	★★

AUSTRALIAN TURQUOISE W62

ART SPECTRUM

ARTISTS' WATER COLOUR

The paint was so stiff that I almost had to stand on the tube.

A rather weak, granulating colour that gave reasonable light washes.

| PG50 LIGHT GREEN OXIDE WG II (263) |

PIGMENT DETAIL ON LABEL	WG	RATING
YES	II L'FAST	★★

ANTIQUE TURQUOISE 019

HOLBEIN

IRODORI ANTIQUE WATERCOLOR

If you have PB17 Phthalocyanine Blue in your collection you also have 'Antique Turquoise'.

By reputation this pigment will be prone to fading.

| PB17 PHTHALOCYANINE BLUE WG III (214) |

PIGMENT DETAIL ON LABEL	WG	RATING
YES	III L'FAST	★★

COBALT TURQUOISE 190

WINSOR & NEWTON

ARTISTS' WATER COLOUR

Very definitely on the green side. A reliable paint which handles well at all strengths.

Cerulean Blue in disguise.

| PB36 CERULEAN BLUE, CHROMIUM ASTM I (216) |

PIGMENT DETAIL ON LABEL	ASTM	
YES	I L'FAST	

TURQUOISE A213

GRUMBACHER

ACADEMY ARTISTS' WATERCOLOR 2ND RANGE

If you expose this disastrous substance to light, the colour will disappear entirely in a relatively short time. Transparent and then very transparent.

| PB24 FUGITIVE PEACOCK BLUE WG V (214) |

PIGMENT DETAIL ON LABEL	WG	RATING
YES	V L'FAST	★

TURQUOISE BLUE W299

HOLBEIN

ARTISTS' WATER COLOUR

PB17, a less reliable variety of Phthalo. Blue, will cause a certain amount of fading and move heavier applications towards green. Semi-transp.

| PB17 PHTHALOCYANINE BLUE WG III (214) |
| PG7 PHTHALOCYANINE GREEN ASTM I (259) |
| PY3 ARYLIDE YELLOW 10G ASTM II (37) |
| PW6 TITANIUM WHITE ASTM I (385) |

PIGMENT DETAIL ON LABEL	WG	RATING
YES	III L'FAST	★★

COBALT TURQUOISE LIGHT W306

HOLBEIN

ARTISTS' WATER COLOUR

An opaque, non staining colour which is easy to lift from the surface of most papers.

Lightfast and covers well.

| PB28 COBALT BLUE ASTM I (215) |

PIGMENT DETAIL ON LABEL	ASTM	
YES	I L'FAST	

PÈBÈO

FRAGONARD ARTISTS' WATER COLOUR

TURQUOISE BLUE 121

A particularly bright, transparent blue green. A good range of values are on offer. Company claim ASTM I but seem to be using the Acrylics list.

| PB15 PHTHALOCYANINE BLUE ASTM II (213) |
| PG7 PHTHALOCYANINE GREEN ASTM I (259) |

| PIGMENT DETAIL ON LABEL YES | ASTM II L'FAST | |

UMTON BARVY

ARTISTIC WATER COLOR

COBALT TURQUOISE 2760

Straightforward Cerulean Blue which would benefit from the word 'Hue' to avoid confusion.

Lifted and handled with ease. A quality product.

| PB36 CERULEAN BLUE, CHROMIUM ASTM I (216) |

| PIGMENT DETAIL ON LABEL YES | ASTM I L'FAST | |

WINSOR & NEWTON

COTMAN WATER COLOURS 2ND RANGE

TURQUOISE 654

Brushes well into very clear washes. A strong combination which will quickly influence other colours in a mix. Transparent although described as being opaque.

| PB15 PHTHALOCYANINE BLUE ASTM II (213) |
| PG7 PHTHALOCYANINE GREEN ASTM I (259) |

| PIGMENT DETAIL ON LABEL YES | ASTM II L'FAST | |

DA VINCI PAINTS

PERMANENT ARTISTS' WATER COLOR

COBALT TURQUOISE 238

Cerulean Blue described as Cobalt Turquoise. A case of cross naming.

If you have the former do you need the latter? Washes well and is lightfast.

| PB36 CERULEAN BLUE, CHROMIUM ASTM I (216) |

| PIGMENT DETAIL ON LABEL YES | ASTM I L'FAST | |

WINSOR & NEWTON

ARTISTS' WATER COLOUR

COBALT TURQUOISE LIGHT 191

Sample washed out reasonably well despite having a rather gum laden consistency.

| PG50 LIGHT GREEN OXIDE WG II (263) |

| PIGMENT DETAIL ON LABEL YES | WG II L'FAST | RATING ★ ★★ | |

TALENS

REMBRANDT ARTISTS' QUALITY EXTRA FINE

TURQUOISE BLUE 522

Handles well and is pleasant to use, particularly in thinner washes. A simple mix of reliable pigments. Transparent.

| PB15 PHTHALOCYANINE BLUE ASTM II (213) |
| PG7 PHTHALOCYANINE GREEN ASTM I (259) |

| PIGMENT DETAIL ON LABEL YES | ASTM II L'FAST | |

TALENS

WATER COLOUR

TURQUOISE BLUE 522

A common 'Turquoise' mix. The 'Phthalos' Blue and Green. Bright, strong and transparent.

Range discontinued

| PB15 PHTHALOCYANINE BLUE ASTM II (213) |
| PG7 PHTHALOCYANINE GREEN ASTM I (259) |

| PIGMENT DETAIL ON LABEL YES | ASTM II L'FAST | |

SCHMINCKE

HORADAM FINEST ARTISTS' WATER COLOURS

HELIO TURQUOISE 1 475

This colour was reformulated several years ago and was then called 'Brilliant Turquoise'. Present sample gave very smooth washes. Transparent.

| PB16 PHTHALOCYANINE BLUE WG II (213) |

| PIGMENT DETAIL ON LABEL YES | WG II L'FAST | |

SCHMINCKE

HORADAM FINEST ARTISTS' WATER COLOURS

COBALT TURQUOISE 509

Previously called 'Brilliant Turquoise 914'. Handles better in thin washes than in heavier applications. Low in tinting strength due to the pigment. Lightfast pigment. Semi-opaque.

| PG50 LIGHT GREEN OXIDE WG II (263) |

| PIGMENT DETAIL ON LABEL YES | WG II L'FAST | RATING ★ ★★ | |

SCHMINCKE

HORADAM FINEST ARTISTS' WATER COLOURS

COBALT GREEN TURQUOISE 510

Previously 'Blue Turquoise 915'.

A very well made paint which washed out beautifully over a wide range of values. An excellent all round colour. Semi-opaque and fast to light.

| PB36 CERULEAN BLUE, CHROMIUM ASTM I (216) |

| PIGMENT DETAIL ON LABEL YES | ASTM I L'FAST | |

DANIEL SMITH

EXTRA-FINE WATERCOLORS

COBALT TURQUOISE 029

This is simply Cerulean Blue, although the sample did not have the appearance of an unadulterated Cerulean Blue. Dull and lifeless.

| PB36 CERULEAN BLUE, CHROMIUM ASTM I (216) |

| PIGMENT DETAIL ON LABEL YES | ASTM I L'FAST | RATING ★ ★★ | |

DANIEL SMITH

EXTRA-FINE WATERCOLORS

PHTHALO TURQUOISE 029

If you have the previous colour (to the left) add a touch of Phthalocyanine Blue and you will have this. Washed out well and is reliable.

| PB36 CERULEAN BLUE, CHROMIUM ASTM I (216) |
| PB15:3 PHTHALOCYANINE BLUE ASTM II (213) |

| PIGMENT DETAIL ON LABEL YES | ASTM II L'FAST | |

ULTRAMARINE TURQUOISE 105

DANIEL SMITH

EXTRA-FINE WATERCOLORS

Many will have these standard colours in their collection. As with all of the 'Turquoises' this is easy to mix.

Sample handled very well and is most reliable.

PB29 ULTRAMARINE BLUE ASTM I (215) PG7 PHTHALOCYANINE GREEN ASTM I (259)

PIGMENT DETAIL ON LABEL YES	ASTM I L'FAST	

COBALT TURQUOISE (RS) 155

DALER ROWNEY

ARTISTS' WATER COLOUR

Cerulean Blue again. The RS stands for 'Red Shade', indicating a leaning towards violet. Well made, brushed out effortlessly and is reliable.

PB36 CERULEAN BLUE, CHROMIUM ASTM I (216)

PIGMENT DETAIL ON LABEL YES	ASTM I L'FAST	

COBALT TURQUOISE (GS) 156

DALER ROWNEY

ARTISTS' WATER COLOUR

This variety of Cerulean leans a little towards green, GS standing for 'Green Shade'. Reliable and well produced.

PB36 CERULEAN BLUE, CHROMIUM ASTM I (216)

PIGMENT DETAIL ON LABEL YES	ASTM I L'FAST	

TRANSPARENT TURQUOISE

DALER ROWNEY

ARTISTS' WATER COLOUR

If, like many, you have these two Phthalos in your paint box, simply mix this colour yourself.

Otherwise is well produced and lightfast.

PG7 PHTHALOCYANINE GREEN ASTM I (259) PB15:3 PHTHALOCYANINE BLUE ASTM II (213)

PIGMENT DETAIL ON LABEL YES	ASTM II L'FAST	

Ultramarine

The only definite violet-blue of the palette. Originally produced from the semiprecious stone Lapis Lazuli, it was extremely expensive.

Manufactured synthetically from 1830. Much is owed to the inventor, a Frenchman named J.B. Guimet. (Hence the commonly used name, French Ultramarine).

A pure, durable colour, high in tinting strength and particularly transparent.

An invaluable hue when mixing, will produce bright violets with a good violet-red, dull greens with an orange-yellow and deep greys to blacks with Burnt Sienna. Mixing complementary is a yellow-orange.

ULTRAMARINE BLUE 139

AMERICAN JOURNEY

PROFESSIONAL ARTISTS' WATER COLOR

A very well produced version of this essential violet-blue.

Sample washed with absolute ease. Lightfast and non staining.

PB29 ULTRAMARINE BLUE ASTM I (215)

PIGMENT DETAIL ON LABEL YES	ASTM I L'FAST	

FRENCH ULTRAMARINE 263

WINSOR & NEWTON

ARTISTS' WATER COLOUR

A well produced watercolour paint. Ultramarine is valued for its transparency, strength and the fact that it is the only worthwhile violet blue.

PB29 ULTRAMARINE BLUE ASTM I (215)

PIGMENT DETAIL ON LABEL YES	ASTM I L'FAST	

ULTRA MARINE 660

WINSOR & NEWTON

COTMAN WATER COLOURS 2ND RANGE

Sample was rather over bound making heavier applications difficult.

Thinner washes very bright and transparent.

PB29 ULTRAMARINE BLUE ASTM I (215)

PIGMENT DETAIL ON LABEL YES	ASTM I L'FAST	RATING ★ ★★

WINSOR & NEWTON

ARTISTS' WATER COLOUR

ULTRAMARINE GREEN SHADE 667

Prussian Blue masquerading as Ultramarine Blue, (whatever the shade) without being declared by the simple word 'Hue'.

Sample thick, sticky coloured gum which was impossible to use.

PB27 PRUSSIAN BLUE ASTM I (214)		
PIGMENT DETAIL ON LABEL **YES**	ASTM **I** L'FAST	RATING ★

ART SPECTRUM

ARTISTS' WATER COLOUR

ULTRAMARINE BLUE W27

A strong transparent violet blue which washed out with ease. A quality product.

PB29 ULTRAMARINE BLUE ASTM I (215)		
PIGMENT DETAIL ON LABEL **YES**	ASTM **I** L'FAST	

ART SPECTRUM

ARTISTS' WATER COLOUR

FRENCH ULTRAMARINE W28

Ultramarine Blue is very sensitive to even very weak acids. If you wish to prevent bleaching it pays to use acid free paper and acid free framing materials.

This sample was excellent. Handled well.

PB29 ULTRAMARINE BLUE ASTM I (215)		
PIGMENT DETAIL ON LABEL **YES**	ASTM **I** L'FAST	

UMTON BARVY

ARTISTIC WATER COLOR

ULTRAMARINE DEEP 2330

To increase the depth of any Ultramarine Blue, add a touch of Burnt Sienna. You can take the mix all the way to black.

This is a well made watercolour paint.

PB29 ULTRAMARINE BLUE ASTM I (215)		
PIGMENT DETAIL ON LABEL **NO**	ASTM **I** L'FAST	

CARAN D'ACHE

FINEST WATERCOLOURS

DARK ULTRAMARINE 640

Sample lifted with ease from the pan and washed out very well. An excellent product.

PB29 ULTRAMARINE BLUE ASTM I (215)		
PIGMENT DETAIL ON LABEL **YES**	ASTM **I** L'FAST	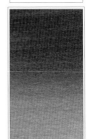

CARAN D'ACHE

FINEST WATERCOLOURS

ULTRAMARINE 140

Slightly brighter that the 'Dark Ultramarine' in this range (see left).

A tiny touch of Burnt Sienna into this colour and you will also have the dark version.

PB29 ULTRAMARINE BLUE ASTM I (215)		
PIGMENT DETAIL ON LABEL **YES**	ASTM **I** L'FAST	

M.GRAHAM & CO.

ARTISTS' WATERCOLOR

ULTRAMARINE BLUE 190

One of the richer versions of this colour. A deep velvety violet blue.

An excellent product, one of the best.

PB29 ULTRAMARINE BLUE ASTM I (215)		
PIGMENT DETAIL ON LABEL **YES**	ASTM **I** L'FAST	

GRUMBACHER

FINEST ARTISTS' WATER COLOR

ULTRAMARINE BLUE W219

There is little, if any difference between this and the next colour. If you have one, the other will be superfluous. Transparent.

PB29 ULTRAMARINE BLUE ASTM I (215)		
PIGMENT DETAIL ON LABEL **YES**	ASTM **I** L'FAST	

GRUMBACHER

FINEST ARTISTS' WATER COLOR

FRENCH ULTRAMARINE BLUE W076

Bright, strong, absolutely lightfast and very transparent.

All that you would expect from a quality Ultramarine.

PB29 ULTRAMARINE BLUE ASTM I (215)		
PIGMENT DETAIL ON LABEL **YES**	ASTM **I** L'FAST	

GRUMBACHER

ACADEMY ARTISTS' WATERCOLOR 2ND RANGE

ULTRAMARINE BLUE A219

Brushed out very well. Almost identical to the 'Artists Quality' version and certainly as lightfast. Transparent.

PB29 ULTRAMARINE BLUE ASTM I (215)		
PIGMENT DETAIL ON LABEL **YES**	ASTM **I** L'FAST	

HOLBEIN

ARTISTS' WATER COLOR

ULTRAMARINE LIGHT W293

A well produced watercolour. High in tinting strength, clear in washes and strong in hue. Absolutely lightfast, non staining and easy to lift.

PB29 ULTRAMARINE BLUE ASTM I (215)		
PIGMENT DETAIL ON LABEL **YES**	ASTM **I** L'FAST	

HOLBEIN

ARTISTS' WATER COLOR

ULTRAMARINE DEEP W294

Bright, clear and strong. Sample washed out well but was slightly overbound. Transparent, easy to lift from the paper once applied.

PB29 ULTRAMARINE BLUE ASTM I (215)		
PIGMENT DETAIL ON LABEL **YES**	ASTM **I** L'FAST	RATING ★ ★★

ANTIQUE ULTRAMARINE 018

HOLBEIN

A rather cloudy, softer version of this colour. Such diminished intensity can come about by the addition of white or an excess of filler.

IRODORI ANTIQUE WATERCOLOR

PB29 ULTRAMARINE BLUE
ASTM I (215)

| PIGMENT DETAIL ON LABEL YES | ASTM I L'FAST | RATING ★ ★★ |

ULTRAMARINE LIGHT 505

TALENS

Sample was slightly over bound, making heavier applications difficult. Washed out well over rest of range. Transparent.

Discontinued

REMBRANDT ARTISTS' QUALITY EXTRA FINE

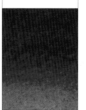

PB29 ULTRAMARINE BLUE
ASTM I (215)

| PIGMENT DETAIL ON LABEL YES | ASTM I L'FAST | RATING ★ ★★ |

ULTRAMARINE DEEP 506

TALENS

A well produced watercolour paint. Strong, bright and washed out well into a useful range of values. Transparent.

REMBRANDT ARTISTS' QUALITY EXTRA FINE

PB29 ULTRAMARINE BLUE
ASTM I (215)

| PIGMENT DETAIL ON LABEL YES | ASTM I L'FAST | |

ULTRAMARINE DEEP 506

TALENS

Smooth, very even washes from this well made watercolour. Handled very easily. Transparent.

Range discontinued

WATER COLOUR 2ND RANGE

PB29 ULTRAMARINE BLUE
ASTM I (215)

| PIGMENT DETAIL ON LABEL YES | ASTM I L'FAST | 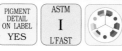 |

ULTRAMARINE DEEP 506

TALENS

Sample was a little over bound but the paint broke down quite easily with a damp brush.

A reliable pigment.

VAN GOGH 2ND RANGE

PB29 ULTRAMARINE BLUE
ASTM I (215)

| PIGMENT DETAIL ON LABEL YES | ASTM I L'FAST | RATING ★ ★★ |

FRENCH ULTRAMARINE 503

TALENS

More of a coloured gum when at all heavy. Washed out well only when well diluted.

REMBRANDT ARTISTS' QUALITY EXTRA FINE

PB29 ULTRAMARINE BLUE
ASTM I (215)

| PIGMENT DETAIL ON LABEL YES | ASTM I L'FAST | RATING ★★ |

ULTRAMARINE BLUE 106

DANIEL SMITH

An intense rich velvety violet blue at full saturation, washing down to extremely thin, clear washes. An excellent product.

EXTRA-FINE WATERCOLORS

PB29 ULTRAMARINE BLUE
ASTM I (215)

| PIGMENT DETAIL ON LABEL YES | ASTM I L'FAST | |

FRENCH ULTRAMARINE 034

DANIEL SMITH

To my eye this is a little less intense than the 'Ultramarine Blue' in this range. You would need to be a bit of an 'Ultra' freak to need both.

Well produced.

EXTRA-FINE WATERCOLORS

PB29 ULTRAMARINE BLUE
ASTM I (215)

| PIGMENT DETAIL ON LABEL YES | ASTM I L'FAST | |

FRENCH ULTRAMARINE LIGHT EXTRA 37

OLD HOLLAND

There has to be one. Sample was no more than heavy coloured gum.

Unworkable.

CLASSIC WATERCOLOURS

PB29 ULTRAMARINE BLUE
ASTM I (215)
PB28 COBALT BLUE
ASTM I (215)

| PIGMENT DETAIL ON LABEL CHEMICAL MAKE UP ONLY | ASTM I L'FAST | RATING ★ |

ULTRAMARINE BLUE 419

OLD HOLLAND

A very well produced watercolour. Brushed out smoothly into a series of bright, clear washes. Transparent.

CLASSIC WATERCOLOURS

PB29 ULTRAMARINE BLUE
ASTM I (215)

| PIGMENT DETAIL ON LABEL CHEMICAL MAKE UP ONLY | ASTM I L'FAST | 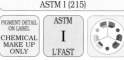 |

ULTRAMARINE BLUE DEEP 244

OLD HOLLAND

Sample rather over bound. Washed fine when dilute but heavy going in other applications.

CLASSIC WATERCOLOURS

PB29 ULTRAMARINE BLUE
ASTM I (215)

| PIGMENT DETAIL ON LABEL CHEMICAL MAKE UP ONLY | ASTM I L'FAST | RATING ★★ |

ULTRAMARINE BLUE 284

DA VINCI PAINTS

A smooth paint which handles very well over a range of values. Particularly transparent washes are available.

PERMANENT ARTISTS' WATER COLOR

PB29 ULTRAMARINE BLUE
ASTM I (215)

| PIGMENT DETAIL ON LABEL YES | ASTM I L'FAST | |

ULTRAMARINE BLUE 684

DA VINCI PAINTS

Sample tube was under considerable pressure.

Washed out well when dilute but not so evenly in heavier applications.

SCUOLA 2ND RANGE

PB29 ULTRAMARINE BLUE
ASTM I (215)

PIGMENT DETAIL ON LABEL	ASTM	RATING
YES	I L'FAST	★ ★★

ULTRA BLUE 5733

HUNTS

Reliable ingredients. Handled very well and gave bright clear washes.

SPEEDBALL PROFESSIONAL WATERCOLOURS

PB29 ULTRAMARINE BLUE
ASTM I (215)

PIGMENT DETAIL ON LABEL	ASTM	
NO	I L'FAST	

ULTRAMARINE LIGHT 391

MAIMERI

Rather poorly made. Sample was over bound and difficult to work with.

MAIMERIBLU SUPERIOR WATERCOLOURS

PB29 ULTRAMARINE BLUE
ASTM I (215)

PIGMENT DETAIL ON LABEL	ASTM	RATING
YES	I L'FAST	★★

ULTRAMARINE DEEP 392

MAIMERI

Not only should acid free paper be used to prevent damage to this colour, but the mount/matt board *and the backboard* should also be acid free.

This is a very well made example of this colour.

MAIMERIBLU SUPERIOR WATERCOLOURS

PB29 ULTRAMARINE BLUE
ASTM I (215)

PIGMENT DETAIL ON LABEL	ASTM	
YES	I L'FAST	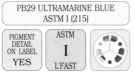

SKY BLUE ULTRAMARINE 428

MAIMERI

'Sky Blue Ultramarine' is a rather weak, cloudy colour, or rather, our sample was.

Such cloudiness can come about through the addition of white or filler.

VENEZIA EXTRAFINE WATERCOLOURS

PB29 ULTRAMARINE BLUE
ASTM I (215)

PIGMENT DETAIL ON LABEL	ASTM	RATING
YES	I L'FAST	★ ★★

ULTRAMARINE DEEP 392

MAIMERI

Little different from everyday Ultramarine. To really deepen this colour add a touch of Burnt Sienna. It will darken the blue whilst retaining transparency.

Washed out very well.

VENEZIA EXTRAFINE WATERCOLOURS

PB29 ULTRAMARINE BLUE
ASTM I (215)

PIGMENT DETAIL ON LABEL	ASTM	
YES	I L'FAST	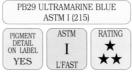

ULTRAMARINE 615

MAIMERI

There is very little difference between this and the 'Artists Quality' of the same make. Absolutely lightfast. Transparent.

Range discontinued

STUDIO FINE WATER COLOR 2ND RANGE

PB29 ULTRAMARINE BLUE
ASTM I (215)

PIGMENT DETAIL ON LABEL	ASTM	
NO	I L'FAST	

ULTRAMARINE

MAIMERI

An intense violet blue. Well produced, it gives very smooth washes over the full range of values. Transparent.

Range discontinued

ARTISTI EXTRA-FINE WATERCOLOURS

PB29 ULTRAMARINE BLUE
ASTM I (215)

PIGMENT DETAIL ON LABEL	ASTM	
NO	I L'FAST	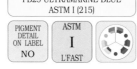

FRENCH ULTRAMARINE BLUE 159

UTRECHT

A rather gum laden paint which washed out well only when very dilute.

Many beginners erroneously blame themselves if they cannot get a good wash from over bound watercolours.

PROFESSIONAL ARTISTS' WATER COLOR

PB29 ULTRAMARINE BLUE
ASTM I (215)

PIGMENT DETAIL ON LABEL	ASTM	RATING
YES	I L'FAST	★★

ULTRAMARINE BLUE 151

UTRECHT

Rather over bound. Gave reasonable washes when thinned but not so when at all heavy.

PROFESSIONAL ARTISTS' WATER COLOR

PB29 ULTRAMARINE BLUE
ASTM I (215)

PIGMENT DETAIL ON LABEL	ASTM	RATING
YES	I L'FAST	★★

ULTRAMARINE 8H

The label states: 'Hydrus fine art watercolour is made from the finest artist pigments which have been chosen for extreme lightfastness and brilliance.'

So what are these pigments? If given in other literature, it would have made sense to let me know.

DR.Ph. MARTINS

HYDRUS FINE ART WATERCOLOR

PIGMENT INFORMATION NOT GIVEN

PIGMENT DETAIL ON LABEL	ASTM	RATING
NO	L'FAST	

ULTRAMARINE FINEST 494

SCHMINCKE

A bright, strong Ultramarine. Well produced, it washes into a series of very transparent layers. Absolutely lightfast.

HORADAM FINEST ARTISTS' WATER COLOURS

PB29 ULTRAMARINE BLUE
ASTM I (215)

PIGMENT DETAIL ON LABEL	ASTM	
YES	I L'FAST	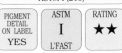

ULTRAMARINE BLUE 496

SCHMINCKE

HORADAM FINEST ARTISTS' WATER COLOURS

The addition of Phthalocyanine Blue, a definite green-blue, is not sufficient to move the colour away from being on the violet side. Where is the word 'Hue'?

PB15:1 PHTHALOCYANINE BLUE ASTM II (213)
PB29 ULTRAMARINE BLUE ASTM I (215)

PIGMENT DETAIL ON LABEL	ASTM L'FAST	RATING
YES	II	★★

ULTRAMARINE 202

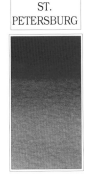

ST. PETERSBURG

ARTISTS' WATERCOLOURS

'And so cheap for artists' quality'. I have heard that many a time. But are they artists' quality or are they more suited to the use of children? I have no way of knowing, do you?

DETAILS OF THE PIGMENTS USED IN THIS RANGE ARE KEPT FROM THE ARTIST AS A MATTER OF COMPANY POLICY

PIGMENT DETAIL ON LABEL	ASTM L'FAST	RATING
NO		

FRENCH ULTRAMARINE 123

DALER ROWNEY

ARTISTS' WATER COLOUR

Handles well over the full range of values. As with all transparent colours takes on a very dark appearance when applied heavily.

PB29 ULTRAMARINE BLUE ASTM I (215)

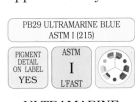

PIGMENT DETAIL ON LABEL	ASTM L'FAST
YES	I

ULTRAMARINE

DALER ROWNEY

GEORGIAN WATER COLOUR 2ND RANGE

If you need to make savings, this is virtually as bright and transparent as the 'Artists Quality' version.

PB29 ULTRAMARINE BLUE ASTM I (215)

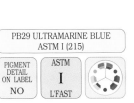

PIGMENT DETAIL ON LABEL	ASTM L'FAST
NO	I

ULTRAMARINE 232

PÈBÈO

FRAGONARD ARTISTS' WATER COLOUR

As with previous samples, heavier washes were difficult as the paint was over bound. Medium to thin washes very smooth and transparent.

PB29 ULTRAMARINE BLUE ASTM I (215)

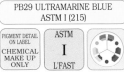

PIGMENT DETAIL ON LABEL	ASTM L'FAST	RATING
YES	I	★★

ULTRAMARINE LIGHT 312

SENNELIER

EXTRA-FINE WATERCOLOUR

Brushed out well. This colour was reformulated several years ago to give a very much improved product. Absolutely lightfast, brushed out with ease.

PB29 ULTRAMARINE BLUE ASTM I (215)

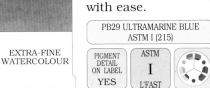

PIGMENT DETAIL ON LABEL	ASTM L'FAST
YES	I

ULTRAMARINE DEEP 315

SENNELIER

EXTRA-FINE WATERCOLOUR

Very well produced. A much improved colour, earlier version was slightly cloudy. Not dramatically different from their Ultramarine Light. Transparent.

PB29 ULTRAMARINE BLUE ASTM I (215)

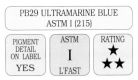

PIGMENT DETAIL ON LABEL	ASTM L'FAST
YES	I

ULTRAMARINE LIGHT 056

LEFRANC & BOURGEOIS

LINEL EXTRA-FINE ARTISTS' WATERCOLOUR

An intense, vibrant violet-blue. Brushes out beautifully, especially in thin washes where its transparency can be of great value.

PB29 ULTRAMARINE BLUE ASTM I (215)

PIGMENT DETAIL ON LABEL	ASTM L'FAST
CHEMICAL MAKE UP ONLY	I

ULTRAMARINE DEEP 055

LEFRANC & BOURGEOIS

LINEL EXTRA-FINE ARTISTS' WATERCOLOUR

Previous samples had been slightly overbound. This latest is much improved.

The lighter washes were bright and transparent.

PB29 ULTRAMARINE BLUE ASTM I (215)

PIGMENT DETAIL ON LABEL	ASTM L'FAST
CHEMICAL MAKE UP ONLY	I

ULTRAMARINE FINEST 1135

LUKAS

ARTISTS' WATER COLOUR

Colour very slightly clouded. Otherwise an excellent watercolour which handled well over the full range. Transparent.

PB29 ULTRAMARINE BLUE ASTM I (215)

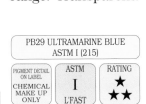

PIGMENT DETAIL ON LABEL	ASTM L'FAST	RATING
CHEMICAL MAKE UP ONLY	I	★★

ULTRAMARINE DEEP 540

MIR (JAURENA S.A)

ACUARELA

Unfortunately, a sample was not provided so I cannot offer assessments or a colour guide.

PB29 ULTRAMARINE BLUE ASTM I (215)

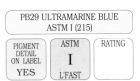

PIGMENT DETAIL ON LABEL	ASTM L'FAST	RATING
YES	I	

Ultramarine Blue is very easily damaged by even weak acids. In the example on the right, dilute lemon juice was dropped onto the dried paint film. It bleached white within seconds.

Cheap, acid laden watercolour paper can cause deterioration over time, the more expensive acid free papers are always worth the extra money.

Poor quality framing can also cause considerable, if gradual, damage to Ultramarine Blue.

Acid in the mount/matt board will slowly migrate to the paper. Darkening it around the edges at first and also causing the Ultramarine Blue to fade.

Often overlooked is the fact that backing board will be acidic unless an acid free version is specified.

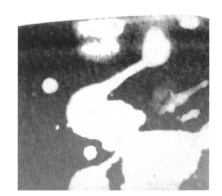

Miscellaneous Blues

As you will see, most colours falling into this category are based on the standard blues of the palette.

All can be obtained or mixed without the expense of further purchase.

When artists come to realise that the paint ranges to take seriously will have a limited number of reliable, well described colours, things will change for the better.

Most of the following colour descriptions are more to do with marketing than with real value to the artist.

The mixing complementary of a green-blue is a red-orange, that of a violet-blue, yellow-orange.

HOLBEIN
IRODORI ANTIQUE WATERCOLOR
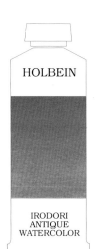

ANTIQUE POMPADOUR 042

The same basic mix as the colour to the left. Just juggle with the white content and you will have a range of such mixes.

A well made product.

PB29 ULTRAMARINE BLUE ASTM I (215)
PW6 TITANIUM WHITE ASTM I (385)

PIGMENT DETAIL ON LABEL	ASTM	
YES	I L'FAST	

HOLBEIN
IRODORI ANTIQUE WATERCOLOR

ANTIQUE PEACOCK BLUE 043

If you work with the limited palette that I suggest elsewhere, you will already have these two basic mixing colours.

A well made watercolour. Smooth washes.

PB15 PHTHALOCYANINE BLUE ASTM II (213)
PY3 ARYLIDE YELLOW 10G ASTM II (37)

PIGMENT DETAIL ON LABEL	ASTM	
YES	II L'FAST	

HOLBEIN
IRODORI ANTIQUE WATERCOLOR

ANTIQUE SKY BLUE 041

Another very easily mixed (convenience?) colour.

Pigments both very resistant to damage from the light. A quality product.

PB15 PHTHALOCYANINE BLUE ASTM II (213)
PW6 TITANIUM WHITE ASTM I (385)

PIGMENT DETAIL ON LABEL	ASTM	
YES	II L'FAST	

HOLBEIN
IRODORI ANTIQUE WATERCOLOR

ANTIQUE BRONZE BLUE 020

Phthalocyanine Blue certainly comes in for a hammering when it comes to name changing.

The sample was very well made and gave excellent washes.

PB15:02 PHTHALOCYANINE BLUE ASTM II (213)

PIGMENT DETAIL ON LABEL	ASTM	
YES	II L'FAST	

HOLBEIN
IRODORI ANTIQUE WATERCOLOR

ANTIQUE PALE BLUE 017

Add white to Ultramarine Blue and you have this colour. Why have someone else do your basic colour mixing?

A well produced paint which washed out well.

PB29 ULTRAMARINE BLUE ASTM I (215)
PW6 TITANIUM WHITE ASTM I (385)

PIGMENT DETAIL ON LABEL	ASTM	
YES	I L'FAST	

ANTWERP BLUE 010

WINSOR & NEWTON

The name Antwerp Blue was once used to describe Prussian Blue to which a lot of filler had been added. Reliable. Transparent.

ARTISTS' WATER COLOUR

PB27 PRUSSIAN BLUE ASTM I (214)		
PIGMENT DETAIL ON LABEL **YES**	ASTM **I** L'FAST	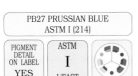

ANTWERP BLUE W31

ART SPECTRUM

Prussian Blue again, under yet another name.

Sample washed out better in thin layers than when heavier. Reliable pigment used.

ARTISTS' WATER COLOUR

PB27 PRUSSIAN BLUE ASTM I (214)		
PIGMENT DETAIL ON LABEL **YES**	ASTM **I** L'FAST	RATING ★ ★★

AZURITE 035

DANIEL SMITH

Genuine, quality Azurite is rather expensive. Until I am able to analyse the pigment I will accept it as being genuine.

The finished 'paint' is another matter. Best described as unworkable coloured gum.

EXTRA-FINE WATERCOLORS

GENUINE AZURITE		
PIGMENT DETAIL ON LABEL **YES**	ASTM L'FAST	RATING ★

BLUE LAKE 229

OLD HOLLAND

Being somewhat on the gum laden side, the sample only performed well when applied as a very dilute wash.

CLASSIC WATERCOLOURS

PB15 PHTHALOCYANINE BLUE ASTM II (213)		
PIGMENT DETAIL ON LABEL CHEMICAL MAKE UP ONLY	ASTM **II** L'FAST	RATING ★★

BRILLIANT BLUE 2 912

SCHMINCKE

If using this brand and you already have their Phthalocyanine Blue, this will be superfluous. Transparent.

Discontinued

HORADAM FINEST ARTISTS' WATER COLOURS

PB15 PHTHALOCYANINE BLUE ASTM II (213)	
PIGMENT DETAIL ON LABEL **YES**	ASTM **II** L'FAST

BERLIN BLUE 359

MAIMERI

The extra helping of gum in the sample allowed for excellent thin washes but less satisfactory heavier applications.

The latter dried to a lovely shine.

MAIMERIBLU SUPERIOR WATERCOLOURS

PB15:1 PHTHALOCYANINE BLUE ASTM II (213)		
PIGMENT DETAIL ON LABEL **YES**	ASTM **II** L'FAST	RATING ★★

BLUE 260

CARAN D'ACHE

Paint lifted from the pan with ease. And this without the need for an over dose of glycerine, or similar, to create a 'semi moist' paint.

A quality product.

WATER COLOURS

PB15 PHTHALOCYANINE BLUE ASTM II (213)		
PIGMENT DETAIL ON LABEL **YES**	ASTM **II** L'FAST	

BLUE VERDITER (IMITATION) 052

LEFRANC & BOURGEOIS

An ancient name for what was an incompatible, poisonous blue. Bears no relation to this unimportant mix. Semi-transparent and lightfast.

LINEL EXTRA-FINE ARTISTS' WATERCOLOUR

PB28 COBALT BLUE ASTM I (215)		
PB35 CERULEAN BLUE ASTM I (216)		
PW4 ZINC WHITE ASTM I (384)		
PIGMENT DETAIL ON LABEL CHEMICAL MAKE UP ONLY	ASTM **I** L'FAST	

BLUE GREY W350

HOLBEIN

A Phthalocyanine Blue without the addition of white would have been more useful in the range. Semi-opaque, slight staining.

ARTISTS' WATER COLOR

PB15 PHTHALOCYANINE BLUE ASTM II (213)		
PW6 TITANIUM WHITE ASTM I (385)		
PIGMENT DETAIL ON LABEL **YES**	ASTM **II** L'FAST	

CARIBBEAN BLUE 232

OLD HOLLAND

An over bound paint, which handled well only when dilute.

It appears that PB16 went out of production about 30 years ago. Please see notes page 213.

CLASSIC WATERCOLOURS

PB16 PHTHALOCYANINE BLUE WG II (213)		
PIGMENT DETAIL ON LABEL CHEMICAL MAKE UP ONLY	WG **II** L'FAST	RATING ★★

CYANIN BLUE 231

PÈBÈO

The name was once used to describe a mix of Prussian and Cobalt Blue.

In this case it is another name for Phthalocyanine Blue. Transparent.

FRAGONARD ARTISTS' WATER COLOUR

PB15 PHTHALOCYANINE BLUE ASTM II (213)		
PIGMENT DETAIL ON LABEL **YES**	ASTM **II** L'FAST	

CINEREOUS BLUE 344

SENNELIER

The name relates to the weak leftovers from the production of genuine Ultramarine. This, on the other hand, is a simple mix. Semi-opaque.

EXTRA-FINE WATERCOLOUR

PB15 PHTHALOCYANINE BLUE ASTM II (213)		
PW6 TITANIUM WHITE ASTM I (385)		
PIGMENT DETAIL ON LABEL **YES**	ASTM **II** L'FAST	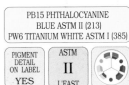

CYANINE BLUE 209 (018)

WINSOR & NEWTON

ARTISTS' WATER COLOUR

Cobalt and Prussian Blue are the traditional mix for this description. Simple to duplicate. Transparent.

Discontinued

 PB28 COBALT BLUE ASTM I (215)
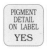 PB27 PRUSSIAN BLUE ASTM I (214)

PIGMENT DETAIL ON LABEL	ASTM	
YES	**I** L'FAST	

COMPOSE BLUE W296

HOLBEIN

ARTISTS' WATER COLOR

A simple mix of Phthalocyanine Blue and white. Easily duplicated on the palette.

Semi-transparent, slight staining.

 PW6 TITANIUM WHITE ASTM I (385)
PB15 PHTHALOCYANINE BLUE ASTM II (213)

PIGMENT DETAIL ON LABEL	ASTM	
YES	**II** L'FAST	

DELFT BLUE 1 482

SCHMINCKE

HORADAM FINEST ARTISTS' WATER COLOURS

Previously called 'Brilliant Blue' and employed PB1, a most unreliable pigment. (Check your old paints).

Replaced several years ago by the far superior PB60 and renamed as above. Well produced. Transparent.

 PB60 INDANTHRONE BLUE WG II (216)

PIGMENT DETAIL ON LABEL	WG	
YES	**II** L'FAST	

FAIENCE BLUE 377

MAIMERI

MAIMERIBLU SUPERIOR WATERCOLOURS

A rather dull blue with a slight bias towards violet. Semi opaque but needs to be fairly heavy to cover.

A well made watercolours paint which gave excellent washes.

 PB60 INDANTHRONE BLUE WG II (216)

PIGMENT DETAIL ON LABEL	WG	
YES	**II** L'FAST	

GREEN BLUE 409

MAIMERI

MAIMERIBLU SUPERIOR WATERCOLOURS

Phthalocyanine Blue and Phthalocyanine Green will give a series of bright, transparent, powerful green blues. This is just one of them.

A reliable, well made paint. Superb washes.

 PG7 PHTHALOCYANINE GREEN ASTM I (259)
PB15:3 PHTHALOCYANINE BLUE ASTM II (213)

PIGMENT DETAIL ON LABEL	ASTM	
YES	**II** L'FAST	

HOGGAR BLUE 036

LEFRANC & BOURGEOIS

LINEL EXTRA-FINE ARTISTS' WATERCOLOUR

If you already have Phthalocyanine Blue you will not need to buy it again under this fancy title.

 PB15:1 PHTHALOCYANINE BLUE ASTM II (213)

PIGMENT DETAIL ON LABEL CHEMICAL MAKE UP ONLY	ASTM	
	II L'FAST	

HELIO BLUE 1198

LUKAS

ARTISTS' WATER COLOUR

Phthalocyanine Blue is sold under a variety of fancy names, this is one of them. Transparent.

 PB15 PHTHALOCYANINE BLUE ASTM II (213)

PIGMENT DETAIL ON LABEL CHEMICAL MAKE UP ONLY	ASTM	
	II L'FAST	

HORTENSIA BLUE 038

LEFRANC & BOURGEOIS

LINEL EXTRA-FINE ARTISTS' WATERCOLOUR

Phthalocyanine Blue yet again. Strong, bright and very transparent. It does have its own name however.

 PB15:1 PHTHALOCYANINE BLUE ASTM II (213)

PIGMENT DETAIL ON LABEL CHEMICAL MAKE UP ONLY	ASTM	
	II L'FAST	

HELIO CERULEAN 479

SCHMINCKE

HORADAM FINEST ARTISTS' WATER COLOURS

Phthalocyanine Blue certainly comes in for a few name changes here and there. Fine if you like collecting fancy names but many will buy the same colour several times. Well produced.

 PB15:3 PHTHALOCYANINE BLUE ASTM II (213)

PIGMENT DETAIL ON LABEL	ASTM	
YES	**II** L'FAST	

HELIO BLUE REDDISH 478

SCHMINCKE

HORADAM FINEST ARTISTS' WATER COLOURS

A well produced Phthalocyanine Blue, whatever name it might be sold under.

Washed out very evenly across the range.

 PB15:6 PHTHALOCYANINE BLUE ASTM II (213)

PIGMENT DETAIL ON LABEL	ASTM	
YES	**II** L'FAST	

HORIZON BLUE W304

HOLBEIN

ARTISTS' WATER COLOR

As already mentioned, Phthalocyanine Blue and Phthalocyanine Green will give a series of bright, transparent, powerful green blues. Add white to one of them and you will have this colour.

PB15 PHTHALOCYANINE BLUE ASTM II (213)
PG7 PHTHALOCYANINE GREEN ASTM I (259)
PW6 TITANIUM WHITE ASTM I (385)

PIGMENT DETAIL ON LABEL	ASTM	
YES	**II** L'FAST	

INDANTHRENE BLUE 107

DALER ROWNEY

ARTISTS' WATER COLOUR

PB60 gives a watercolour which is rather dull and has a slight leaning towards violet. A reliable, well made paint.

 PB60 INDANTHRONE BLUE WG II (216)

PIGMENT DETAIL ON LABEL	WG	
YES	**II** L'FAST	

INDANTHRENE BLUE 321

WINSOR & NEWTON

ARTISTS' WATER COLOUR

A newly introduced colour which gave extremely good results.

Beautiful, smooth washes with flowed with ease. Resistant to light.

PB60 INDANTHRONE BLUE WG II (216)

PIGMENT DETAIL ON LABEL	WG	
YES	II L'FAST	

INDANTHRENE BLUE 585

TALENS

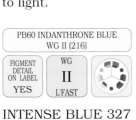

REMBRANDT ARTISTS' QUALITY EXTRA FINE

Semi opaque but needs a fairly heavy layer to cover well. Due to the nature of the pigment, a rather dull, slightly violet blue. Reliable.

PB60 INDANTHRONE BLUE WG II (216)

PIGMENT DETAIL ON LABEL	WG	
YES	II L'FAST	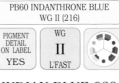

INDANTHRONE BLUE 043

DANIEL SMITH

EXTRA-FINE WATERCOLORS

Much brighter and redder than all other examples that I have seen of watercolour paints made up using this pigment.

I will not offer an assessment in this addition.

PB60 INDANTHRONE BLUE WG II (216)

PIGMENT DETAIL ON LABEL	WG	RATING
YES	II L'FAST	

INTENSE BLUE 327

WINSOR & NEWTON

COTMAN WATER COLOURS 2ND RANGE

Phthalocyanine Blue is intense. It is also transparent and powerful. Yet another name used to market this standard colour.

PB15 PHTHALOCYANINE BLUE ASTM II (213)

PIGMENT DETAIL ON LABEL	ASTM	
YES	II L'FAST	

INDIAN BLUE 039

LEFRANC & BOURGEOIS

LINEL EXTRA-FINE ARTISTS' WATERCOLOUR

A dull, slightly violet blue. Rather weak, with poor covering power due to the nature of the pigments. Such characteristics do not detract from the quality of the paint as we all look for different things. Stands up well to light. Semi-opaque.

PB60 INDANTHRONE BLUE WG II (216)

PIGMENT DETAIL ON LABEL	WG	
CHEMICAL MAKE UP ONLY	II L'FAST	

ICE BLUE 185

CARAN D'ACHE

FINEST WATERCOLOURS

It would seem that this pigment went out of production some 30 years ago as it has not been listed in any reference since 1973. A bit of a mystery which I shall try and clear up for the next edition. A well made paint by the way.

PB16 PHTHALOCYANINE BLUE WG II (213)

PIGMENT DETAIL ON LABEL	WG	
YES	II L'FAST	

JOE'S BLUE (PHTHALO) 067

AMERICAN JOURNEY

PROFESSIONAL ARTISTS' WATER COLOR

As the title suggests, the favourite for fancy names, good old Phthalocyanine Blue.

Lightfast, transparent and washes very well.

PB15 PHTHALOCYANINE BLUE ASTM II (213)

PIGMENT DETAIL ON LABEL	ASTM	
YES	II L'FAST	

KING'S BLUE LIGHT 256

OLD HOLLAND

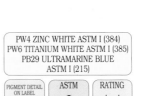

CLASSIC WATERCOLOURS

Reliable ingredients giving a pale 'washed out' over bound blue.

PW4 ZINC WHITE ASTM I (384)
PW6 TITANIUM WHITE ASTM I (385)
PB29 ULTRAMARINE BLUE ASTM I (215)

PIGMENT DETAIL ON LABEL	ASTM	RATING
CHEMICAL MAKE UP ONLY	I L'FAST	★★

KING'S BLUE DEEP 253

OLD HOLLAND

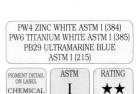

CLASSIC WATERCOLOURS

Please see remarks with colour to the left.

PW4 ZINC WHITE ASTM I (384)
PW6 TITANIUM WHITE ASTM I (385)
PB29 ULTRAMARINE BLUE ASTM I (215)

PIGMENT DETAIL ON LABEL	ASTM	RATING
CHEMICAL MAKE UP ONLY	I L'FAST	★★

LAPIS LAZULI 036

DANIEL SMITH

EXTRA-FINE WATERCOLORS

My eyes lit up when I saw the pigment description. They lit down rapidly when I saw the paint.

Genuine Lapis Lazuli, (not the grey rock in which it is found?) is the precursor to Ultramarine Blue, a rich, vibrant, violet blue. This 'paint' is dull, grey coloured gum. A distortion of history.

GENUINE LAPIS LAZULI

PIGMENT DETAIL ON LABEL	ASTM	RATING
YES	L'FAST	

MOUNTAIN BLUE 480

SCHMINCKE

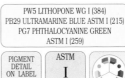

HORADAM FINEST ARTISTS' WATER COLOURS

A colour which is easily blended from Ultramarine Blue, Phthalo Green and White. Reformulated recently. Handles well. Semi-transparent.

PW5 LITHOPONE WG I (384)
PB29 ULTRAMARINE BLUE ASTM I (215)
PG7 PHTHALOCYANINE GREEN ASTM I (259)

PIGMENT DETAIL ON LABEL	ASTM	
YES	I L'FAST	

MONESTIAL BLUE 136

DALER ROWNEY

GEORGIAN WATER COLOUR 2ND RANGE

A superb transparent green-blue which gives particularly clear washes. The pigment is most reliable. An excellent colour.

PB15:3 PHTHALOCYANINE BLUE ASTM II (213)

PIGMENT DETAIL ON LABEL	ASTM	
NO	II L'FAST	

DALER ROWNEY

ARTISTS' WATER COLOUR

MONESTIAL BLUE (PHTHALO) 136

PB15 was first offered in 1935 under the name Monastral Blue. A variation of this name is retained by Rowney. Transparent.

Discontinued

PB15 PHTHALOCYANINE BLUE ASTM II (213)		
PIGMENT DETAIL ON LABEL YES	ASTM **II** L'FAST	

LEFRANC & BOURGEOIS

LINEL EXTRA-FINE ARTISTS' WATERCOLOUR

MINERAL BLUE PERMANENT 060

Previously called 'Antwerp Blue'. A simple mix of standard colours that are available in most paint boxes. Transparent and reliable.

PB15:1 PHTHALOCYANINE BLUE ASTM II (213) PG7 PHTHALOCYANINE GREEN ASTM I (259)		
PIGMENT DETAIL ON LABEL CHEMICAL MAKE UP ONLY	ASTM **II** L'FAST	

HOLBEIN

ARTISTS' WATER COLOR

MARINE BLUE W302

A very intense, transparent green blue which washed out very smoothly.

PB16 PHTHALOCYANINE BLUE WG II (213)		
PIGMENT DETAIL ON LABEL YES	WG **II** L'FAST	

CARAN D'ACHE

FINEST WATERCOLOURS

NIGHT BLUE 149

A rather dull blue which leans towards violet. The paint lifted well from the pan.

An excellent, reliable watercolour paint.

PB60 INDANTHRONE BLUE WG II (216)		
PIGMENT DETAIL ON LABEL YES	WG **II** L'FAST	

OLD HOLLAND

CLASSIC WATERCOLOURS

OLD HOLLAND BLUE 223

As nearly always, he said wearily, an over bound paint from this company which handled far better when dilute.

PB15 PHTHALOCYANINE BLUE ASTM II (213)		
PIGMENT DETAIL ON LABEL CHEMICAL MAKE UP ONLY	ASTM **II** L'FAST	RATING ★★

OLD HOLLAND

CLASSIC WATERCOLOURS

OLD DELFT BLUE 220

Please see note to the left.

PB60 INDANTHRONE BLUE WG II (216)		
PIGMENT DETAIL ON LABEL CHEMICAL MAKE UP ONLY	WG **II** L'FAST	RATING ★★

OLD HOLLAND

CLASSIC WATERCOLOURS

OLD HOLLAND BLUE DEEP 217

Add a touch of Burnt Sienna to Ultramarine Blue and you will have this colour in a livelier form. A well made paint which washed out very evenly.

PB29 ULTRAMARINE BLUE ASTM I (215) PB60 INDANTHRONE BLUE WG II (216) PBk7 CARBON BLACK ASTM I (370)		
PIGMENT DETAIL ON LABEL CHEMICAL MAKE UP ONLY	WG **II** L'FAST	

OLD HOLLAND

CLASSIC WATERCOLOURS

OLD HOLLAND CYAN BLUE 247

Three blues and two whites, it could almost be a film title. Instead it is yet another example of a paint from this company which carries too much gum.

PB29 ULTRAMARINE BLUE ASTM I (215) PB28 COBALT BLUE ASTM I (215) PB15 PHTHALOCYANINE BLUE ASTM II (213) PW4 ZINC WHITE ASTM I (384) PW6 TITANIUM WHITE ASTM I (385)		
PIGMENT DETAIL ON LABEL CHEMICAL MAKE UP ONLY	ASTM **II** L'FAST	RATING ★★

OLD HOLLAND

CLASSIC WATERCOLOURS

OLD HOLLAND BLUE GREY 259

Amazingly, three quite separate components emerged from the sample tube. Brown gum, pale Ultramarine Blue and pale Prussian Blue. Mixed for sample.

PW4 ZINC WHITE ASTM I (384) PW6 TITANIUM WHITE ASTM I (385) PB29 ULTRAMARINE BLUE ASTM I (215) PB27:1 PRUSSIAN BLUE ASTM I (214)		
PIGMENT DETAIL ON LABEL CHEMICAL MAKE UP ONLY	ASTM **I** L'FAST	RATING ★

SCHMINCKE

HORADAM FINEST ARTISTS' WATER COLOURS

PARIS BLUE 491

A seemingly pointless mix of three very similar, transparent green-blues.

PB15:1 PHTHALOCYANINE BLUE ASTM II (213) PB27 PRUSSIAN BLUE ASTM I (214) PB15:3 PHTHALOCYANINE BLUE ASTM II (213)		
PIGMENT DETAIL ON LABEL YES	ASTM **II** L'FAST	

UMTON BARVY

ARTISTIC WATER COLOR

PARIS BLUE 2560

One of the few colours in this range to present difficulty when lifting from the pan.

Gave better thin washes than heavier.

PB27 PRUSSIAN BLUE ASTM I (214)		
PIGMENT DETAIL ON LABEL NO	ASTM **II** L'FAST	RATING ★ ★★

DALER ROWNEY

ARTISTS' WATER COLOUR

PERMANENT BLUE 137

If you use this companys' products do not make the mistake of purchasing their Ultramarine twice.

PB29 ULTRAMARINE BLUE ASTM I (215)		
PIGMENT DETAIL ON LABEL YES	ASTM **I** L'FAST	

PARISIAN (PRUSSIAN) BLUE EXTRA 34

OLD HOLLAND

CLASSIC WATERCOLOURS

Probably the widest range of watercolours on the market. Presented in a beautiful wooden box. Virtually every paint spoilt by an excess of gum. This is yet another example.

PB27:1 PRUSSIAN BLUE ASTM I (214) PB15 PHTHALOCYANINE BLUE ASTM II (213)		
PIGMENT DETAIL ON LABEL CHEMICAL MAKE UP ONLY	ASTM **II** L'FAST	RATING ★★

PERMANENT BLUE 473

WINSOR & NEWTON

ARTISTS' WATER COLOUR

Slightly less violet than the Ultramarine Blue produced by this company and gives a somewhat smoother wash. Transparent.

Discontinued

PB29 ULTRAMARINE BLUE ASTM I (215)		
PIGMENT DETAIL ON LABEL YES	ASTM **I** L'FAST	

PARIS BLUE 1133

LUKAS

ARTISTS' WATER COLOUR

Paris Blue was once a general term used for Prussian Blue, particularly in Germany. Reliable and transparent.

Pigment on tube given as 'Iron Hexcyano Ferrates'. And just as we were getting used to PB27.

PB27 PRUSSIAN BLUE ASTM I (214)		
PIGMENT DETAIL ON LABEL CHEMICAL MAKE UP ONLY	ASTM **I** L'FAST	RATING ★ ★★

PARIS BLUE EXTRA 418

OLD HOLLAND

CLASSIC WATERCOLOURS

Prussian Blue is absolutely lightfast, yet our sample deteriorated during exposure. Assessments not offered.

Discontinued

PB27 PRUSSIAN BLUE ASTM I (214)		
PIGMENT DETAIL ON LABEL CHEMICAL MAKE UP ONLY	ASTM L'FAST	RATING

PRIMARY BLUE 1118

LUKAS

ARTISTS' WATER COLOUR

As printed information was not supplied as requested, I have been obliged to gain pigment information from the tube. As only an imprecise description is available on the label I will not offer assessments.

COPPER PHTHALOCYANINE		
PIGMENT DETAIL ON LABEL CHEMICAL MAKE UP ONLY	ASTM L'FAST	RATING

PRIMARY BLUE-CYAN 400

MAIMERI

MAIMERIBLU SUPERIOR WATERCOLOURS

A very deep green blue when heavily applied. It takes on such a dark appearance because much of the light sinks into the paint layer.

A well produced watercolour paint.

PB15:3 PHTHALOCYANINE BLUE ASTM II (213)		
PIGMENT DETAIL ON LABEL YES	ASTM **II** L'FAST	

PRIMARY BLUE CYAN 400

MAIMERI

VENEZIA EXTRAFINE WATERCOLOURS

Bright, strong, very t r a n s p a r e n t, lightfast and staining.

The description of Phthalocyanine blue, in use yet again.

PB15:3 PHTHALOCYANINE BLUE ASTM II (213)		
PIGMENT DETAIL ON LABEL YES	ASTM **II** L'FAST	

PEACOCK BLUE W301

HOLBEIN

ARTISTS' WATER COLOR

Although further testing is required, PB17, which is a variety of Phthalocyanine Blue, would seem to be less than lightfast. Sample moved towards green. Transparent.

PB17 PHTHALOCYANINE BLUE WG III (214)		
PIGMENT DETAIL ON LABEL YES	WG **III** L'FAST	RATING ★★

REMBRANDT BLUE 520

TALENS

REMBRANDT ARTISTS' QUALITY EXTRA FINE

Yet another name under which to market Phthalocyanine Blue. Such practices only cause confusion. Transparent.

Discontinued

PB15 PHTHALOCYANINE BLUE ASTM II (213)		
PIGMENT DETAIL ON LABEL YES	ASTM **II** L'FAST	RATING ★ ★★

ROYAL BLUE No 61

PENTEL

WATER COLORS

Any manufacturer offering watercolour paints described as being for artistic use, can expect to find themselves in the pages of this book sooner or later.

PIGMENT INFORMATION NOT GIVEN ON THE PRODUCT LABEL OR IN THE LITERATURE SUPPLIED.		
PIGMENT DETAIL ON LABEL **NO**	ASTM L'FAST	RATING

RUSSIAN BLUE 204

St. PETERSBURG

ARTISTS' WATERCOLOURS

The literature published by the distributors of this popular range could win prizes for hype. But they do not have the first idea of what the paints are actually made of, whether or not they will fade and whether they might be more suitable for use in the classroom. And do they care?

PIGMENT INFORMATION DELIBERATELY KEPT - NOT FROM ME - BUT FROM YOU		
PIGMENT DETAIL ON LABEL **NO**	ASTM L'FAST	RATING

ROYAL BLUE W303

HOLBEIN

ARTISTS' WATER COLOR

Reasonably transparent when applied as a thin wash. Fairly easy to lift from the paper.

Due to the nature of the pigment this is a rather dull, slightly violet blue.

PB60 INDANTHRONE BLUE WG II (216)		
PIGMENT DETAIL ON LABEL YES	WG **II** L'FAST	

SCHEVENINGEN BLUE DEEP 226

OLD HOLLAND

Painted out reasonably well in thin applications, not so well in heavier. Transparent, staining and lightfast.

CLASSIC WATERCOLOURS

PB15 PHTHALOCYANINE BLUE ASTM II (213)

| PIGMENT DETAIL ON LABEL CHEMICAL MAKE UP ONLY | ASTM II L'FAST | RATING ★ ★★ |

SCHEVENINGEN BLUE LIGHT 40

OLD HOLLAND

As with some of the other examples from this range, I am curious as to why there should be two whites. There must be a subtlety in the finished result that I am missing. Reliable but rather gummy.

CLASSIC WATERCOLOURS

PB15 PHTHALOCYANINE BLUE ASTM II (213)
PW4 ZINC WHITE ASTM I (384)
PW6 TITANIUM WHITE ASTM I (385)

| PIGMENT DETAIL ON LABEL CHEMICAL MAKE UP ONLY | ASTM II L'FAST | RATING ★ ★★ |

SCHEVENINGEN BLUE 35

OLD HOLLAND

A reliable transparent green blue which washed out better in thin layers than in heavier.

CLASSIC WATERCOLOURS

PB15 PHTHALOCYANINE BLUE ASTM II (213)

| PIGMENT DETAIL ON LABEL CHEMICAL MAKE UP ONLY | ASTM II L'FAST | RATING ★ ★★ |

SPEEDBALL BLUE 5726

HUNTS

If the naming of colours was standardised and meaningful descriptions used, there would be a lot less confusion. Transparent, well made and lightfast

SPEEDBALL PROFESSIONAL WATERCOLOURS

PB15 PHTHALOCYANINE BLUE ASTM II (213)

| PIGMENT DETAIL ON LABEL NO | ASTM II L'FAST | |

SPECTRUM BLUE W60

ART SPECTRUM

The wash outs seem a little cloudy if just these two pigments are involved. I would have expected a much brighter, clearer colour.

ARTISTS' WATER COLOUR

PB29 ULTRAMARINE BLUE ASTM I (215)
PB15:3 PHTHALOCYANINE BLUE ASTM II (213)

| PIGMENT DETAIL ON LABEL YES | ASTM II L'FAST | RATING ★ ★★ |

SKY BLUE 131

AMERICAN JOURNEY

If you have either Phthalocyanine Blue or Prussian Blue, add a little white and you will be part of the American Journey.

A simple mix, lightfast, slight staining, semi opaque.

PROFESSIONAL ARTISTS' WATER COLOR

PB15 PHTHALOCYANINE BLUE ASTM II (213)
PW6 TITANIUM WHITE ASTM I (385)

| PIGMENT DETAIL ON LABEL YES | ASTM II L'FAST | |

TOUAREG BLUE 049

LEFRANC & BOURGEOIS

A simple mix, fancifully described.

Not used by the Touaregs as far as I am aware. Transparent.

PG7 PHTHALOCYANINE GREEN ASTM I (259)
PB15:1 PHTHALOCYANINE BLUE ASTM II (213)

LINEL EXTRA-FINE ARTISTS' WATERCOLOUR

| PIGMENT DETAIL ON LABEL CHEMICAL MAKE UP ONLY | ASTM II L'FAST | |

TASMAN BLUE W29

ART SPECTRUM

PW5 is widely used as an extender, or filler. This colour is easily mixed from any white and Ultramarine Blue. Handled well and is lightfast.

ARTISTS' WATER COLOUR

PW5 LITHOPONE WG I (384)
PB29 ULTRAMARINE BLUE ASTM I (215)

| PIGMENT DETAIL ON LABEL YES | ASTM I L'FAST | |

VERDITER BLUE W295

HOLBEIN

If you use this make and have their Cobalt Blue, just add white and you have instant Verditer Blue.

Semi-opaque, non staining and easy to lift.

ARTISTS' WATER COLOR

PB28 COBALT BLUE ASTM I (215)
PW6 TITANIUM WHITE ASTM I (385)

| PIGMENT DETAIL ON LABEL YES | ASTM I L'FAST | |

WINSOR BLUE 706

WINSOR & NEWTON

It would be a major step forward if all fancy and trade names were dropped and the common name used instead.

Discontinued

ARTISTS' WATER COLOUR

PB15 PHTHALOCYANINE BLUE ASTM II (213)

| PIGMENT DETAIL ON LABEL YES | ASTM II L'FAST | |

WINSOR BLUE (GREEN SHADE) 707

WINSOR & NEWTON

Sample appeared to be rather over bound. Sticky and difficult to apply. Smooth washes were possible but only after the paint had been worked with a very wet brush.

ARTISTS' WATER COLOUR

PB15 PHTHALOCYANINE BLUE ASTM II (213)

| PIGMENT DETAIL ON LABEL YES | ASTM II L'FAST | RATING ★★ |

WINSOR BLUE (RED SHADE) 709

WINSOR & NEWTON

A transparent, staining colour which handled better in the thinner washes.

Although I sometimes criticise the use of fancy or trade names, W&N have long used the name 'Winsor Blue' for Phthalocyanine Blue.

ARTISTS' WATER COLOUR

PB15 PHTHALOCYANINE BLUE ASTM II (213)

| PIGMENT DETAIL ON LABEL YES | ASTM II L'FAST | RATING ★ ★★ |

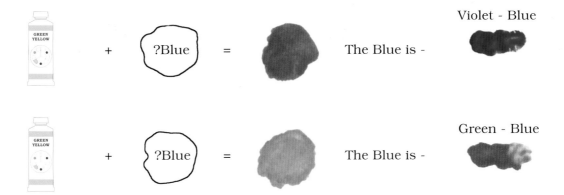

It is very simple to decide on colour type with blues.

Mix the blue with a green-yellow (Lemon Yellow). If you get a slightly dull, mid green, then the blue can be identified as being a violet-blue.

If the resulting mix is a bright green, the blue in question will have shown itself to be a green-blue. Green-blue and green-yellow make a bright green.

As with yellows, the actual name of a colour will give a good clue as to it's type. Ultramarine Blue is the only real violet-blue available, all others can be considered to be green-blues, apart from Indanthrone Blue, which is only slightly violet and rather dull.

Cobalt Blue is the odd one out. A well made Cobalt Blue will reflect not only blue but a reasonable amount of violet, as well as green, (usually more green than violet).

This will allow you to mix reasonable but not particularly bright greens and violets.

As many 'Cobalt Blues' are simply mixes of cheaper blues, such as Ultramarine and Phthalocyanine Blue with white, the colour-type will depend on the make up.

In every case it is recommended that you try the colour out in a mixing test first.

Pocket sized guide

Shortly after this book is published we will be releasing a pocket sized version,

Very much abbreviated, it will be a more convenient size to take to an art shop when making a selection.

For further information please contact us at any of the offices listed on page 407, or visit our website.

www.schoolofcolor.com

Greens

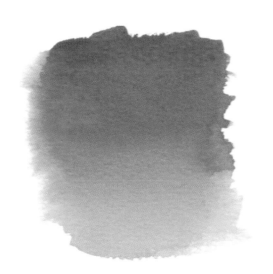

The earliest bright green available was probably the mineral, Malachite. Employed by the early Egyptians, Chinese and Japanese, it remained in use until the end of the 1700's. a coarse pigment with a texture not unlike fine sand.

An ancient pigment still with us is Terre Verte or Green Earth, a dull transparent colour. Found on many early works in India and Italy, it gained great popularity during the Renaissance as an underpainting colour for flesh tones.

Many of the better deposits of the green clay from which it is produced have been exhausted.

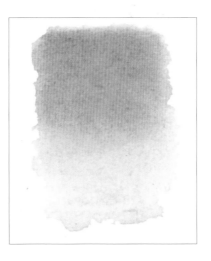

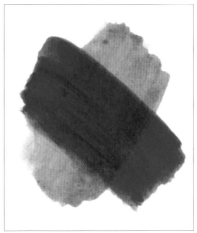

Terre Verte, or Green Earth, is a particularly weak pigment.

It lacks 'body' and strength of colour.

When mixing by glazing was widely practised, Terre Verte was often used in the underpainting.

Verdigris, an early bluish green, was a particularly troublesome colorant. Alternatives were not always available.

A type of Verdigris is formed when copper is exposed to the acids of the atmosphere, as on the roof of this Cathedral.

Verdigris, a blue-green acetate of copper, dates back to the early Greeks.

It was always a troublesome material to use as it was sus-

ceptible to moisture, reacted badly with many other pigments and was blackened by the gases of the atmosphere.

Many of the dull browns that we tend to admire on Renaissance paintings started life as rich blue - greens. The Verdigris with which they were painted darkened and changed colour due to a variety of factors.

During the 13th Century suitable substitute greens were discovered and rapidly developed.

Sap Green, produced from berries, was particularly fugitive. Many modern imitations are little better.

The most important of these were Sap and Iris Green. Sap Green, prepared form Buckthorn berries, gave a fairly versatile but impermanent colour. The name is still retained for various pre-mixed greens.

Poisonous Emerald Green, responsible for the death of many artists in the recent past is hopefully now obsolete. The name is still retained by many colourmen for substitute mixes. The genuine article was not only highly poisonous but was also incompatible with many other pigments, and darkened when exposed to metals and air. Not the best of pigments.

Cool, bluish, Cobalt Green has been available since the 19th Century. Its cost and poor covering power has led to a gradual decline in its popularity since the 1900's.

A particularly valuable artists' pigment made available in 1862 was Viridian, a bright, cool, very transparent permanent colour. Phthalocyanine Green, very similar in hue has not replaced Viridian as many artists find it a little harsh.

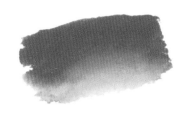

Low in tinctorial power, Chromium Green Oxide has remained a favourite with many due to its cool muted colour and permanence.

We are indeed fortunate to have a range of reliable green pigments available to us. Pigments which are far superior to those available to earlier generations.

Considering that we have lightfast greens and equally reliable blues and yellows with which to mix them, it is astounding to discover the number of green watercolours which are quite unsuitable for artistic use.

Hopefully time and awareness will remove them from the paint stands.

Modern Green Pigments

PG1 BRILLIANT GREEN .. 259

PG2 PERMANENT GREEN 259

PG7 PHTHALOCYANINE GREEN 259

PG8 HOOKERS GREEN .. 260

PG10 GREEN GOLD .. 260

PG12 NAPHTHOL GREEN 260

PG17 CHROMIUM OXIDE GREEN 261

PG18 VIRIDIAN .. 261

PG19 COBALT GREEN .. 261

PG23 GREEN EARTH/TERRE VERTE 262

PG26 COBALT CHROMITE GREEN SPINEL 262

PG36 PHTHALOCYANINE GREEN 262

PG50 LIGHT GREEN OXIDE 263

PG1 BRILLIANT GREEN

A reasonably bright, mid to bluish green. Primarily used for printing inks where its high tinctorial strength, clean colour and transparency are valued. The fact that it has very poor fastness to light is of secondary importance to the printer.

However, this factor might mean a great deal to the artist. The colour can be mixed easily and there are reliable alternatives available, your work need not suffer. The parent dye is Basic Green 1.

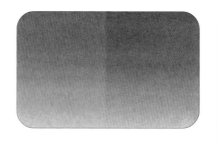

Exposure to light quickly faded the thinner wash of our sample and darkened the colour in mass tone. Most unreliable.

Poor alkali resistance also.

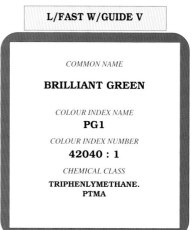

L/FAST W/GUIDE V

COMMON NAME

BRILLIANT GREEN

COLOUR INDEX NAME

PG1

COLOUR INDEX NUMBER

42040 : 1

CHEMICAL CLASS

TRIPHENLYMETHANE. PTMA

PG2 PERMANENT GREEN

PG2 is a rather bright mid-green. Despite the name, its lightfastness is very poor indeed. Thinly applied layers will fade and discolour, heavier applications darken and also discolour.

Poor alkali resistance in addition to poor lightfastness. With such obvious and well known failings, it is surprising that such a substance is used in artists' paints. Easily duplicated on the palette using more reliable pigments.

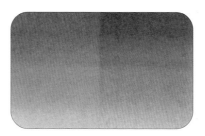

The parent dyes are Basic Green 1 and Basic Yellow 1.

Not yet subjected to ASTM testing. Our sample deteriorated rapidly as shown above. Particularly unreliable.

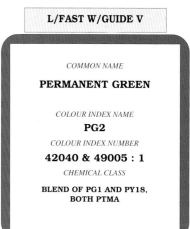

L/FAST W/GUIDE V

COMMON NAME

PERMANENT GREEN

COLOUR INDEX NAME

PG2

COLOUR INDEX NUMBER

42040 & 49005 : 1

CHEMICAL CLASS

BLEND OF PG1 AND PY18, BOTH PTMA

PG7 PHTHALOCYANINE GREEN

Produced by the further processing of Phthalocyanine Blue. Can be a little more expensive than the latter due to this extra step. This clear blue green is noted for its' high strength and purity of colour.

Its resistance properties to practically everything are excellent. In texture it is traditionally rather hard, but softer versions are now available. Particularly transparent, it gives very clear, clean washes on dilution. Very high in tinting strength.

Absolutely lightfast with an ASTM rating of I as a watercolour. A superb pigment all round.

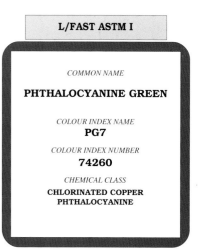

L/FAST ASTM I

COMMON NAME

PHTHALOCYANINE GREEN

COLOUR INDEX NAME

PG7

COLOUR INDEX NUMBER

74260

CHEMICAL CLASS

CHLORINATED COPPER PHTHALOCYANINE

PG8 HOOKER'S GREEN

A dull yellowish green which takes on a blackish appearance when applied heavily.

Semi-opaque, it possesses quite good covering power as well as giving reasonable washes. It is a pigment with limited use, being found almost exclusively in watercolours.

When tested for lightfastness under ASTM controls, it failed with a rating of III. (It appears to have had an earlier ASTM rating of IV and has perhaps been re-tested)

A unreliable pigment whose poor reputation was re-enforced by our own testing. Also called Prussian Green.

PG10 GREEN GOLD

Green Gold is a very definite yellow-green which is reasonably transparent when well diluted. Lacks 'body' and is rather low in covering power. Although not yet tested as a watercolour, there is every indication that it will do well when it is.

When made up into both an acrylic and an oil paint it rated ASTM I, excellent lightfastness. Without the protection of the binder we cannot necessarily expect the same results however.

Considering the findings in other media and the fact that our sample was virtually unaffected by light, I will rate it as W/Guide II for this book.

PG12 NAPHTHOL GREEN

PG12 is a rather dull yellowish to mid-green. There are only two Nitroso pigments available, PG8 and this. Both share the distinction of hopelessly failing ASTM lightfast testing. As with PG8, PG12 also received a rating of only IV. Such materials are quite unsuitable for artistic use where lightfastness is a consideration. The parent dye is Acid Green 1. Exposure to light caused our sample to fade quickly and become even duller in all values.

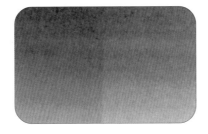

Manufacturers get away with the use of such appallingly bad pigments because artists allow them to. Also simply called PG12 Green.

PG17 CHROMIUM OXIDE GREEN

L/FAST ASTM I

COMMON NAME

CHROMIUM OXIDE GREEN

COLOUR INDEX NAME
PG17

COLOUR INDEX NUMBER
77288

CHEMICAL CLASS
ANHYDROUS CHROMIUM SESQUIOXIDE

Introduced as an artists' colorant in the mid 1800's, Chromium Oxide Green has a well deserved place on many a palette. A dull, yellow to mid green that is completely unaffected by light.

Reasonably strong in tinctorial power, it will successfully soften and cool other colours. Noted for its opacity, it has very good covering power. Unaffected by acids, alkalis, heat or light, it is a thoroughly reliable pigment. Received a rating of I as a watercolour following ASTM testing. An excellent all round pigment valued for its great permanence and opacity.

PG18 VIRIDIAN

L/FAST ASTM I

COMMON NAME

VIRIDIAN

COLOUR INDEX NAME
PG18

COLOUR INDEX NUMBER
77289

CHEMICAL CLASS
HYDROUS CHROMIUM SESQUIOXIDE

A bright, clear, mid to bluish green. Very transparent, it is highly valued as a glazing colour. Being fairly high in tinting strength it will readily play its part in any mix.

When applied in thin washes the true beauty of this pigment is revealed, laid on thickly it takes on a dull almost blackish appearance. An excellent pigment, in use since the mid 1800's.

As a watercolour it gained an ASTM rating of I. Viridian is a first rate pigment that would be difficult to fault.

PG19 COBALT GREEN

L/FAST ASTM I

COMMON NAME

COBALT GREEN

COLOUR INDEX NAME
PG19

COLOUR INDEX NUMBER
77335

CHEMICAL CLASS
OXIDES OF COBALT AND ZINC

First introduced as an artists' pigment in 1835. It was once a very popular and fashionable colorant.

Cobalt Green has declined in use since the turn of the century. Many of todays artists find that its lack of body, cost and low tinting strength make it easily dispensable. A rather dull, semi-opaque bluish green. Rated I following ASTM testing as a watercolour.

Lightfast but lacks body and tinting strength.

Not alkali proof should that be a consideration.

PG23 GREEN EARTH/TERRA VERTE

A naturally occurring green clay which is mined from open pits. Deposits are found in many parts of the world and vary in colour. After selection, the clay is ground and carefully washed. Nowadays the colour is often heightened by the introduction of a green dye or pigment as the known quality deposits have long been mined.

Very low in tinting strength and reasonably transparent unless heavy. With very little body it makes into a very gummy watercolour which is very difficult to handle. A dull greyed green.

When unadulterated this pigment has excellent lightfastness. The often undeclared addition of fugitive dyes and pigments can cause severe problems. Now tested as ASTM I, excellent.

L/FAST ASTM I

COMMON NAME

**GREEN EARTH/
TERRA VERTE**

COLOUR INDEX NAME

PG23

COLOUR INDEX NUMBER

77009

CHEMICAL CLASS

**FERROUS SILICATE
WITH CLAY. INORGANIC**

PG26 COBALT CHROMITE GREEN SPINEL

Also called Cobalt Chrome Aluminate (amongst other names) PG26 is a dull, opaque bluish green.

Not yet tested under ASTM conditions, such calcined mixed oxides have a reputation for extreme fastness to light. Reports state it to have outstanding resistance to light, chemicals and weathering.

This pigment is also used in camouflage paint as it reflects in the infrared, as does foliage.

Maybe you could use it to paint particularly realistic landscapes (I am not being serious). Given its make up and reputation I will rate it W/Guide II.

W/GUIDE II

COMMON NAME

**COBALT CHROMITE
GREEN SPINEL**

COLOUR INDEX NAME

PG26

COLOUR INDEX NUMBER

77344

CHEMICAL CLASS

**MIXED METAL OXIDES:
HIGH TEMPERATURE CALCINATION
OF MIXED OXIDES OF COBALT
AND CHROMIUM**

PG36 PHTHALOCYANINE GREEN

Pigment Green 36 extends the range of the Phthalocyanine greens. Pigment Green 7, covered on the page 259 is a bluish-green whereas PG36 varies from a mid-green to a yellow-green.

Available in a variety of types, 2Y, 3Y and 4Y. Each being yellower than the previous.

The types are not mentioned by paint manufacturers. A particularly transparent pigment giving very clear washes. May bronze if applied heavily.

Earlier tested as ASTM in oils and acrylics and now tested as ASTM I in watercolour. Our sample was unaffected by light.

L/FAST ASTM I

COMMON NAME

PHTHALOCYANINE GREEN

COLOUR INDEX NAME

PG36

COLOUR INDEX NUMBER

74265

CHEMICAL CLASS

**CHLORINATED & BROMINATED
PHTHALOCYANINE**

PG50 LIGHT GREEN OXIDE

A mid green of low tinting strength. Its weakness can be a drawback in mixing as it is easily swamped by many other colours.

I am often asked about the proportions of colours to use when mixing. It cannot come down to any sort of formula, as the strength of the different pigments varies enormously.

An opaque pigment, PG50 covers well in heavier applications. Thin washes are only moderately transparent.

An ASTM rating of I in oils and acrylics is an encouraging indicator. As our sample was unaffected I will rate it as W/Guide II for this publication.

L/FAST W/GUIDE II

COMMON NAME

LIGHT GREEN OXIDE

COLOUR INDEX NAME
PG50

COLOUR INDEX NUMBER
77377

CHEMICAL CLASS
OXIDES OF NICKEL, COBALT AND TITANIUM

Introducing further colours

Whenever I give a demonstration of colour mixing I ask my audience to outline their main concern. The answer is always the same, 'mixing greens'.

As the course develops you will find that a vast range of predictable greens can be mixed with ease. They will vary from the bright transparent greens found here to dull, heavy opaque colours elsewhere.

When you understand and employ the varying colour types and transparencies, you can extract virtually any green possible in paint form from the very limited range that we suggest.

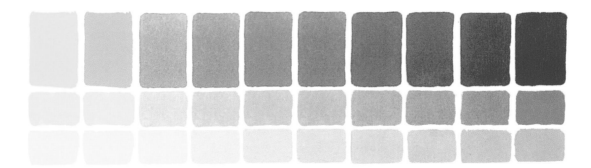

This combination will give a series of clear yellow-greens as the green-yellow that we use is a semi-transparent colour.

It is important to use a quality green-yellow (often called Lemon Yellow), if you wish to achieve such clear semi-transparent mixes. Poorly made varieties can be very chalky due to an excess of filler. They can also fade or darken quite dramatically.

Towards the green end of the range the colours will be even more transparent due to the nature of the Phthalocyanine Green.

Green Watercolours

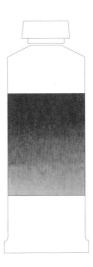

Contents

Cadmium Green ... 267

Chrome Green ... 268

Chromium Oxide Green 268

Cobalt Green .. 270

Emerald Green .. 272

Green Earth (Terre Verte) 274

Hooker's Green ... 276

Olive Green ... 280

Phthalocyanine Green 282

Sap Green ... 285

Viridian.. 288

Miscellaneous Greens 292

Cadmium Green

A green traditionally mixed by the colourmen from Cadmium Yellow and either Viridian or Phthalocyanine Green.

It is absolutely lightfast and usually handles well.

No more than a convenience colour, it is easily reproduced by the artist. Such mixes on the palette are usually brighter than the machine blended versions.

Easily mixed from standard colours.

CADMIUM GREEN LIGHT

OLD HOLLAND

Sample provided was over bound and difficult to use unless very thin. Reliable ingredients. Semi-transparent.

Reformulated >

CLASSIC WATERCOLOURS

| PY37 CADMIUM YELLOW MEDIUM OR DEEP ASTM I (42) |
| PG18 VIRIDIAN ASTM I (261) |

| PIGMENT DETAIL ON LABEL CHEMICAL MAKE UP ONLY | ASTM I L'FAST | RATING ★★ |

CADMIUM GREEN LIGHT 44

OLD HOLLAND

Superb, lightfast pigments used to make a paint that I can only describe as coloured gum.

CLASSIC WATERCOLOURS

| PW4 ZINC WHITE ASTM I (384) |
| PW6 TITANIUM WHITE ASTM I (385) |
| PY37 CADMIUM YELLOW MEDIUM OR DEEP ASTM I (42) |
| PG18 VIRIDIAN ASTM I (261) |

| PIGMENT DETAIL ON LABEL CHEMICAL MAKE UP ONLY | ASTM I L'FAST | RATING ★ |

CADMIUM GREEN DEEP 45

OLD HOLLAND

If you have the 'Light' version add a little more Viridian and you will have the 'Deep'. Reliable. Semi-transparent.

CLASSIC WATERCOLOURS

| PY37 CADMIUM YELLOW MEDIUM OR DEEP ASTM I (42) |
| PG18 VIRIDIAN ASTM I (261) |

| PIGMENT DETAIL ON LABEL CHEMICAL MAKE UP ONLY | ASTM I L'FAST | |

LIGHT CADMIUM GREEN 336

PÈBÈO

Absolutely lightfast ingredients, made up into a watercolour that brushed out very well. Easily mixed. Semi-transparent.

FRAGONARD ARTISTS' WATER COLOUR

| PY35 CADMIUM YELLOW LIGHT ASTM I (41) |
| PG7 PHTHALOCYANINE GREEN ASTM I (259) |

| PIGMENT DETAIL ON LABEL YES | ASTM I L'FAST | |

CADMIUM GREEN 558

MAIMERI

Not a unique colour but a simple mix of standard hues. Washed out very well. Semi-opaque.

Discontinued

ARTISTI EXTRA-FINE WATERCOLOURS

| PY35 CADMIUM YELLOW LIGHT ASTM I (41) |
| PG7 PHTHALOCYANINE GREEN ASTM I (259) |

| PIGMENT DETAIL ON LABEL NO | ASTM I L'FAST | |

CADMIUM GREEN 192

CARAN D'ACHE

The paint lifted from the pan with ease and washed out well at all values.

A standard, easily mixed colour.

FINEST WATERCOLOURS

| PY35 CADMIUM YELLOW LIGHT ASTM I (41) |
| PG7 PHTHALOCYANINE GREEN ASTM I (259) |

| PIGMENT DETAIL ON LABEL YES | ASTM I L'FAST | |

CADMIUM GREEN PALE W269

HOLBEIN

Excellent ingredients give a very smooth, easily duplicated, semi-transparent bright green.

ARTISTS' WATER COLOR

| PG18 VIRIDIAN ASTM I (261) |
| PY37 CADMIUM YELLOW MEDIUM OR DEEP ASTM I (42) |

| PIGMENT DETAIL ON LABEL YES | ASTM I L'FAST | |

CADMIUM GREEN DEEP W270

HOLBEIN

Reliable ingredients giving a green which is easy to mix on the palette. Semi-transparent. Hard to lift once painted out.

ARTISTS' WATER COLOR

| PY37 CADMIUM YELLOW MEDIUM OR DEEP ASTM I (42) |
| PG18 VIRIDIAN ASTM I (261) |
| PG7 PHTHALOCYANINE GREEN ASTM I (259) |

| PIGMENT DETAIL ON LABEL YES | ASTM I L'FAST | |

CADMIUM GREEN 823

SENNELIER

Such greens are easily mixed, either from these ingredients or a Lemon Yellow and Cerulean. Reliable. Semi-opaque.

EXTRA-FINE WATERCOLOUR

| PY35 CADMIUM YELLOW LIGHT ASTM I (41) |
| PG7 PHTHALOCYANINE GREEN ASTM I (259) |

| PIGMENT DETAIL ON LABEL YES | ASTM I L'FAST | |

Chrome Green

Originally produced by blending Chrome Yellow and Prussian Blue, it was available in a wide range of greens. Unreliable as a watercolour, the yellow component usually darkening.

Today the name is used to market simple mixes which are easily produced on the palette.

As I point out in my book 'Blue and Yellow Don't Make Green', control of colour mixing is only possible when the artist knows exactly what is happening within the mix.

When it is realised that the 'three primary system' is an unworkable invention, and a new approach is taken, greens such as these can be mixed with ease.

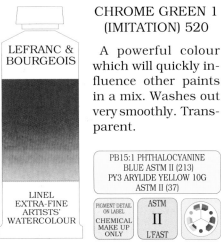

CHROME GREEN 1 (IMITATION) 520

A powerful colour which will quickly influence other paints in a mix. Washes out very smoothly. Transparent.

LEFRANC & BOURGEOIS

LINEL EXTRA-FINE ARTISTS' WATERCOLOUR

PB15:1 PHTHALOCYANINE BLUE ASTM II (213)
PY3 ARYLIDE YELLOW 10G ASTM II (37)

PIGMENT DETAIL ON LABEL
CHEMICAL MAKE UP ONLY

ASTM II L'FAST

Chromium Oxide Green

A superb pigment. It is absolutely lightfast and is unaffected by acids, alkali, heat or cold. Reasonably strong in tinting power and particularly opaque.

Introduced about 1862 as an artist's pigment, it has become a firm favourite with many painters.

Similar greens can be mixed from an orange-yellow (such as Cadmium Yellow) and a violet-blue (Ultramarine) with perhaps a little red.

Such mixes however, will not have quite the same properties of hue or opacity.

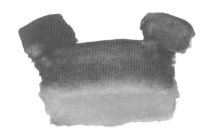

Provides soft, opaque, muted greens when mixed with an opaque green - blue such as Cerulean Blue.

ANTIQUE GREEN OXIDE 038

This is not Green Oxide, old or new. A standard mix of reliable pigments to give a green which is easily duplicated on the palette. Well made and gave smooth washes.

HOLBEIN

IRODORI ANTIQUE WATERCOLOR

PG7 PHTHALOCYANINE GREEN ASTM I (259)
PY3 ARYLIDE YELLOW 10G ASTM II (37)

PIGMENT DETAIL ON LABEL
YES

ASTM II L'FAST

CHROMIUM OXIDE GREEN 815

Sample brushed out particularly well. Opaque, with good covering power yet thin washes are reasonably transparent.

SENNELIER

EXTRA-FINE WATERCOLOUR

PG17 CHROMIUM OXIDE GREEN ASTM I (261)

PIGMENT DETAIL ON LABEL
YES

ASTM I L'FAST

CHROMIUM OXIDE GREEN 024

A superb pigment used to give a watercolour paint which handles beautifully over all values. Opaque.

DANIEL SMITH

EXTRA-FINE WATERCOLORS

PG17 CHROMIUM OXIDE GREEN ASTM I (261)

PIGMENT DETAIL ON LABEL
YES

ASTM I L'FAST

OLD HOLLAND

CLASSIC WATERCOLOURS

CHROMIUM OXIDE GREEN 50

Sample was rather over bound and washed out better in thinner applications.

A very reliable pigment.

PG17 CHROMIUM OXIDE GREEN ASTM I (261)

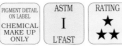

| PIGMENT DETAIL ON LABEL CHEMICAL MAKE UP ONLY | ASTM I L'FAST | RATING ★ ★★ |

TALENS

REMBRANDT ARTISTS' QUALITY EXTRA FINE

CHROMIUM OXIDE GREEN 668

Heavier applications somewhat difficult as sample rather over bound.

Brushed out well thinner. Absolutely lightfast. Opaque.

PG17 CHROMIUM OXIDE GREEN ASTM I (261)

| PIGMENT DETAIL ON LABEL YES | ASTM I L'FAST | RATING ★ ★★ |

CARAN D'ACHE

FINEST WATERCOLOURS

CHROMIUM OXIDE GREEN 212

Unlike some pan colours, the paint lifts well from most of this range.

Gave very smooth washes. An excellent product.

PG17 CHROMIUM OXIDE GREEN ASTM I (261)

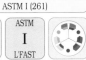

| PIGMENT DETAIL ON LABEL YES | ASTM I L'FAST |

CHROMIUM OXIDE GREEN 542

LEFRANC & BOURGEOIS

LINEL EXTRA-FINE ARTISTS' WATERCOLOUR

Particularly well made. Brushed out beautifully into very smooth washes. Absolutely lightfast. Opaque.

PG17 CHROMIUM OXIDE GREEN ASTM I (261)

| PIGMENT DETAIL ON LABEL CHEMICAL MAKE UP ONLY | ASTM I L'FAST |

OXIDE OF CHROMIUM 459

WINSOR & NEWTON

ARTISTS' WATER COLOUR

A smooth, well produced watercolour. Very pleasant to use. Reasonably strong tinctorially.

Absolutely lightfast. Opaque.

PG17 CHROMIUM OXIDE GREEN ASTM I (261)

| PIGMENT DETAIL ON LABEL YES | ASTM I L'FAST |

OXIDE OF CHROMIUM W42

ART SPECTRUM

ARTISTS' WATER COLOUR

A beautiful (to my eyes), dull, dense, opaque green.

It is good to see that virtually all manufacturers use the genuine pigment.

PG17 CHROMIUM OXIDE GREEN ASTM I (261)

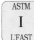

| PIGMENT DETAIL ON LABEL YES | ASTM I L'FAST |

CHROMIUM OXIDE GREEN A048

GRUMBACHER

ACADEMY ARTISTS' WATERCOLOR 2ND RANGE

Sample was overbound.

Fine for lighter washes but difficult at full strength. Absolutely lightfast. Opaque.

PG17 CHROMIUM OXIDE GREEN ASTM I (261)

| PIGMENT DETAIL ON LABEL YES | ASTM I L'FAST | RATING ★ ★★ |

CHROMIUM OXIDE GREEN W048

GRUMBACHER

FINEST ARTISTS' WATER COLOR

Unaffected by almost everything, a most reliable pigment.

Brushed out very smoothly. Opaque.

PG17 CHROMIUM OXIDE GREEN ASTM I (261)

| PIGMENT DETAIL ON LABEL YES | ASTM I L'FAST |

OXIDE OF CHROME OPAQUE 1153

LUKAS

ARTISTS' WATER COLOUR

Very pleasant to use. Washed out smoothy. Possesses good covering power and is reasonably strong. Opaque.

PG17 CHROMIUM OXIDE GREEN ASTM I (261)

| PIGMENT DETAIL ON LABEL CHEMICAL MAKE UP ONLY | ASTM I L'FAST |

OXIDE OF CHROMIUM GREEN 367

DALER ROWNEY

ARTISTS' WATER COLOUR

An ultra smooth, dense, dulled green. Absolutely lightfast, this colour will not alter under light. A well made example.

PG17 CHROMIUM OXIDE GREEN ASTM I (261)

| PIGMENT DETAIL ON LABEL NO | ASTM I L'FAST |

CHROMIUM OXIDE GREEN

SCHMINCKE

HORADAM FINEST ARTISTS' WATER COLOURS

Previously called Viridian Matt. Or maybe it still is as there is some confusion in the catalogue that we were supplied.

Either way, a superb product. Opaque.

PG17 CHROMIUM OXIDE GREEN ASTM I (261)

| PIGMENT DETAIL ON LABEL YES | ASTM I L'FAST |

UMTON BARVY

ARTISTIC WATER COLOR

OXIDE OF CHROME OPAQUE 2780

A well made example of this colour (as this is), is a joy to use. A dense, soft dull green which handles well.

PG17 CHROMIUM OXIDE GREEN ASTM I (261)

| PIGMENT DETAIL ON LABEL NO | ASTM I L'FAST |

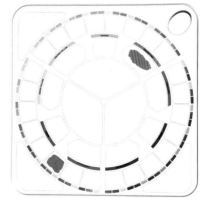
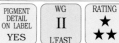

Invented by the Swedish chemist Rinmann in 1780. It was not until the 19th Century that the pigment was produced in commercial quantities.

Once a much sought after and fashionable colour, it has declined in popularity since the end of World War I.

Many painters find that the cost, poor covering ability and often poor handling qualities, make it dispensable.

An unimportant colour which is still quite widely offered. Easily duplicated through mixing.

A slightly bluish-green, mixing complementary is an orange-red.

COBALT GREEN (HUE) 235

DA VINCI PAINTS

PERMANENT ARTISTS' WATER COLOR

A recently introduced colour from this company. Easily mixed, if you do not have Prussian Blue then use Phthalocyanine Blue. A reliable convenience colour.

PG7 PHTHALOCYANINE GREEN ASTM I (259)
PB27 PRUSSIAN BLUE ASTM I (214)

PIGMENT DETAIL ON LABEL	ASTM	
YES	I L'FAST	

COBALT GREEN W263

HOLBEIN

ARTISTS' WATER COLOR

A mix of ingredients which do not include PG19, Cobalt Green. The name is surely misleading. Very reliable combination. Semi-transparent.

PG18 VIRIDIAN ASTM I (261)
PW6 TITANIUM WHITE ASTM I (385)
PB28 COBALT BLUE ASTM I (215)

PIGMENT DETAIL ON LABEL	ASTM	RATING
YES	I L'FAST	★ ★★

COBALT GREEN YELLOW SHADE W276

HOLBEIN

ARTISTS' WATER COLOR

A mid green low in tinting strength. This is not Cobalt Green, Yellow Shade or otherwise. As such the word 'Hue' or 'Imitation' should be added. Reliable and gave good washes.

PG50 LIGHT GREEN OXIDE WG II (263)

PIGMENT DETAIL ON LABEL	WG	RATING
YES	II L'FAST	★ ★★

COBALT GREEN 556

MAIMERI

ARTISTI EXTRA-FINE WATERCOLOURS

As with other watercolours employing PG19, our sample lacked body and painted out poorly. Semi-opaque.

Discontinued

PG19 COBALT GREEN ASTM I (261)

PIGMENT DETAIL ON LABEL	ASTM	RATING
NO	I L'FAST	★★

COBALT GREEN LIGHT 316

MAIMERI

MAIMERIBLU SUPERIOR WATERCOLOURS

A rather weak mid green which is easily swamped by other colours in a mix.

Although easily mixed, this is a well made product.

PG50 LIGHT GREEN OXIDE WG II (263)

PIGMENT DETAIL ON LABEL	WG	
YES	II L'FAST	

COBALT GREEN DEEP 317

MAIMERI

MAIMERIBLU SUPERIOR WATERCOLOURS

Sample washed out smoothly. A mid green which is rather low in tinting strength.

A reliable convenience colour.

PG50 LIGHT GREEN OXIDE WG II (263)

PIGMENT DETAIL ON LABEL	WG	
YES	II L'FAST	

COBALT GREEN TURQUOISE 266

OLD HOLLAND

CLASSIC WATERCOLOURS

A rather dull, semi-opaque, bluish-green.

The lack of tinting strength and body have ensured that PG19 has become less important to todays' artist than was once the case. Sample did not wash out well.

PG19 COBALT GREEN ASTM I (261)

PIGMENT DETAIL ON LABEL	ASTM	RATING
CHEMICAL MAKE UP ONLY	I L'FAST	★★

COBALT GREEN 268

OLD HOLLAND

CLASSIC WATERCOLOURS

Rather over bound, our sample did not wash out well.

A weak colour easily swamped by others in a mix.

PG50 LIGHT GREEN OXIDE WG II (263)

PIGMENT DETAIL ON LABEL	WG	RATING
CHEMICAL MAKE UP ONLY	II L'FAST	★★

COBALT GREEN DEEP 267

OLD HOLLAND

CLASSIC WATERCOLOURS

The substance that emerged from the tube was not paint but a rough mixture of some 80% heavy, dark brown gum and 20% gum laden pigment. An appalling mess.

PG26 COBALT CHROMITE GREEN SPINEL WG II (262)

PIGMENT DETAIL ON LABEL	WG	RATING
CHEMICAL MAKE UP ONLY	L'FAST	

COBALT GREEN 184

WINSOR & NEWTON
ARTISTS' WATER COLOUR

PG19 is rather weak and lacking in body. It would seem that this factor leads to very gummy watercolours. This example is no exception. Paints out poorly. Semi-transparent.

Reformulated >

PG19 COBALT GREEN ASTM I (261)		
PIGMENT DETAIL ON LABEL **YES**	ASTM **I** L'FAST	RATING ★★

COBALT GREEN 184

WINSOR & NEWTON
ARTISTS' WATER COLOUR

Sample was rather over bound and required working with a wet brush before application.

This is disappointing in a reformulated colour.

PG50 LIGHT GREEN OXIDE WG II (263)		
PIGMENT DETAIL ON LABEL **YES**	WG **II** L'FAST	RATING ★★

COBALT GREEN (YELLOW SHADE) 187

WINSOR & NEWTON
ARTISTS' WATER COLOUR

Our sampled handled very well indeed, giving smooth washes over the entire range.

A reliable watercolour paint.

PG50 LIGHT GREEN OXIDE WG II (263)		
PIGMENT DETAIL ON LABEL **YES**	WG **II** L'FAST	

COBALT GREEN 182

CARAN D'ACHE

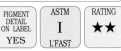

Due to the nature of the pigment, which is weak in tinting strength, this colour will not play an important part in colour mixing. The paint from this sample was difficult to wash out unless very dilute.

PG50 LIGHT GREEN OXIDE WG II (263)		
PIGMENT DETAIL ON LABEL **YES**	WG **II** L'FAST	RATING ★★

COBALT GREEN 324

DALER ROWNEY
ARTISTS' WATER COLOUR

The stated ingredients are absolutely lightfast, yet our sample became bluer and paler on exposure. No assessments offered.

PG19 COBALT GREEN ASTM I (261)		
PIGMENT DETAIL ON LABEL **YES**	ASTM L'FAST	RATING

COBALT GREEN DEEP 325

DALER ROWNEY
ARTISTS' WATER COLOUR

A reliable pigment which gave a very smooth series of washes. The colour is rather greener than I would expect from this pigment alone. It might be the version that has been used.

PB36 CERULEAN BLUE, CHROMIUM ASTM I (216)		
PIGMENT DETAIL ON LABEL **YES**	ASTM **II** L'FAST	

COBALT GREEN PURE 535

SCHMINCKE
HORADAM FINEST ARTISTS' WATER COLOURS

Colour number now changed from 522 to 535. The formula for this colour was completely overhauled several years ago (mentioned in case you have old stock).

Reliable and well made, semi-transparent.

PG19 COBALT GREEN ASTM I (261)		
PIGMENT DETAIL ON LABEL **YES**	ASTM **I** L'FAST	

COBALT GREEN 610

TALENS
REMBRANDT ARTISTS' QUALITY EXTRA FINE

Sample lacked body and was rather gummy.

This seems to be normal for genuine Cobalt Green. Semi-transparent.

PG19 COBALT GREEN ASTM I (261)		
PIGMENT DETAIL ON LABEL **YES**	ASTM **I** L'FAST	RATING ★★

COBALT GREEN 856

SENNELIER
EXTRA-FINE WATERCOLOUR

All of the stated ingredients are absolutely lightfast, yet our sample faded to a marked extent on exposure. No assessments can be offered until further testing.

PG7 PHTHALOCYANINE GREEN ASTM I (259) PB28 COBALT BLUE ASTM I (215) PW6 TITANIUM WHITE ASTM I (385)		
PIGMENT DETAIL ON LABEL **YES**	ASTM L'FAST	RATING

COBALT GREEN DEEP

SCHMINCKE
HORADAM FINEST ARTISTS' WATER COLOURS

A rather dull, deep green results from this cocktail of pigments. Brushed out well. Reliable ingredients Semi-transparent.

Reformulated >

PG50 LIGHT GREEN OXIDE WG II (263) PG19 COBALT GREEN ASTM I (261) PB29 ULTRAMARINE BLUE ASTM I (215) PG17 CHROMIUM OXIDE GREEN ASTM I (261)		
PIGMENT DETAIL ON LABEL **YES**	WG **II** L'FAST	

COBALT GREEN DARK 533

SCHMINCKE
HORADAM FINEST ARTISTS' WATER COLOURS

A rather dull green with a slight leaning towards blue.

Covers other colours quite well being rather opaque. Sample gave very good washes.

PG26 COBALT CHROMITE GREEN SPINEL WG II (262)		
PIGMENT DETAIL ON LABEL **YES**	WG **II** L'FAST	

COBALT GREEN 026

DANIEL SMITH
EXTRA-FINE WATERCOLORS

A watercolour made up with PG50 is easily dominated by other colours in a mix as it is very low in tinting strength. If you are happy to accept this you will have a reliable paint which handles quite well.

PG50 LIGHT GREEN OXIDE WG II (263)		
PIGMENT DETAIL ON LABEL **YES**	WG **II** L'FAST	

COBALT GREEN PALE 027

DANIEL SMITH

EXTRA-FINE WATERCOLORS

As with Cobalt Violet, Cobalt Green lacks in body and makes a rather poor watercolour. This sample goes to the extreme and is best described as unusable coloured gum.

PIGMENT DETAIL ON LABEL	ASTM	RATING
YES	I L'FAST	★

PG19 COBALT GREEN ASTM I (261)

COBALT GREEN DEEP 2750

UMTON BARVY

ARTISTIC WATER COLOR

With the PY36 being strong and transparent and the PG50 weak and opaque the result is a soft, dull semi opaque green. Should be described as an imitation.

PG36 PHTHALOCYANINE GREEN ASTM I (262)
PG50 LIGHT GREEN OXIDE WG II (263)

PIGMENT DETAIL ON LABEL	WG	RATING
NO	II L'FAST	★ ★★

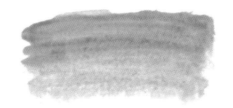

Rather weak and lacking in 'body'. Cobalt green tends to be difficult to brush out, unless in very thin washes.

Emerald Green

In general use after 1814, the original Emerald Green was darkened when mixed with certain other pigments. It also became blacker on contact with several metals and on exposure to the atmosphere. A further drawback was that it often killed the user, being particularly toxic.

In order to disguise the dangerous nature of the pigment, many manufacturers resorted to using fancy names.

At one time in Germany up to fifty different titles were used to hide the true nature of the pigment. There are many lurid stories linked to Emerald Green.

Today the name has become respectable and is used to market simple mixes. Such greens are very easy to produce on the palette and will often be brighter than the machine blended version.

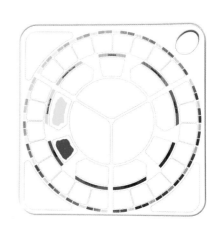

EMERALD GREEN 615

TALENS

REMBRANDT ARTISTS' QUALITY EXTRA FINE

Sample closer to a coloured gum than a watercolour paint.

Reformulated>

PG7 PHTHALOCYANINE GREEN ASTM I (259)
PY3 ARYLIDE YELLOW 10G ASTM II (37)

PIGMENT DETAIL ON LABEL	ASTM	RATING
YES	II L'FAST	★

EMERALD GREEN 563

TALENS

REMBRANDT ARTISTS' QUALITY EXTRA FINE

Sample was very difficult to paint out unless very thin. I realise that watercolours are commonly applied thinly, but there are occasions when heavier films are required. Lightfast

PG36 PHTHALOCYANINE GREEN ASTM I (262)

PIGMENT DETAIL ON LABEL	ASTM	RATING
YES	I L'FAST	★★

EMERALD GREEN 615

TALENS

WATER COLOUR 2ND RANGE

Sample was particularly over bound and difficult to work with. Reliable ingredients. Semi-transparent.

Range discontinued

PG7 PHTHALOCYANINE GREEN ASTM I (259)
PY3 ARYLIDE YELLOW 10G ASTM II (37)

PIGMENT DETAIL ON LABEL	ASTM	RATING
YES	II L'FAST	★★

WINSOR EMERALD 708

WINSOR & NEWTON

ARTISTS' WATER COLOUR

A typical 'Emerald Green'. This, and many similar greens are easily produced with standard colours as you work. Semi-transparent.

Reformulated >

PG7 PHTHALOCYANINE GREEN ASTM I (259)
PY3 ARYLIDE YELLOW 10G ASTM II (37)
PW4 ZINC WHITE ASTM I (384)

PIGMENT DETAIL ON LABEL	ASTM	
YES	L'FAST	

WINSOR EMERALD 708

WINSOR & NEWTON

ARTISTS' WATER COLOUR

Reliable pigments used in the production of a paint which handled very poorly, due, it would seem, to an excess of gum.

PG7 PHTHALOCYANINE GREEN ASTM I (259)
PY175 BENZIMIDAZOLONE YELLOW H6G WG II (51)
PW4 ZINC WHITE ASTM I (384)

PIGMENT DETAIL ON LABEL	WG	RATING
YES	II L'FAST	★★

EMERALD GREEN 847

SENNELIER

EXTRA-FINE WATERCOLOUR

Rather 'chalky' for Phthalocyanine Green, as if an excess of filler or white had been added. Lightfast. Semi-transparent.

PG36 PHTHALOCYANINE GREEN ASTM I (262)

PIGMENT DETAIL ON LABEL	ASTM	RATING
YES	I L'FAST	★ ★★

272

EMERALD 235

WINSOR & NEWTON

COTMAN WATER COLOURS 2ND RANGE

Easily reproduced on the palette. The PW5 seems to be more of a filler than a contributor to the hue. Washes out well. Semi-transparent.

Reformulated >

| PW5 LITHOPONE WG I (384) |
| PY3 ARYLIDE YELLOW 10G ASTM II (37) |
| PG7 PHTHALOCYANINE GREEN ASTM I (259) |

PIGMENT DETAIL ON LABEL	ASTM	RATING
YES	II L'FAST	★★

EMERALD 235

WINSOR & NEWTON

COTMAN WATER COLOURS 2ND RANGE

Best described as coloured gum which is suitable for very thin washes only.

| PG7 PHTHALOCYANINE GREEN ASTM I (259) |
| PY175 BENZIMIDAZOLONE YELLOW H6G WG II (51) |

PIGMENT DETAIL ON LABEL	WG	RATING
YES	II L'FAST	★

EMERALD GREEN (IMITATION) 550

LEFRANC & BOURGEOIS

LINEL EXTRA-FINE ARTISTS' WATERCOLOUR

The name Emerald Green is used to sell any combination which gives a reasonably bright mid-green.

Reliable ingredients. Semi- transparent.

Discontinued

| PY3 ARYLIDE YELLOW 10G ASTM II (37) |
| PW4 ZINC WHITE ASTM I (384) |
| PB33 MANGANESE BLUE ASTM II (215) |

PIGMENT DETAIL ON LABEL	ASTM	
CHEMICAL MAKE UP ONLY	II L'FAST	

EMERALD GREEN (HUE) 338

DALER ROWNEY

GEORGIAN WATER COLOUR 2ND RANGE

This colour can be mixed in so many ways that it hardly seems worth having it done for you. Reliable. Semi-transparent.

Reformulated >

| PW6 TITANIUM WHITE ASTM I (385) |
| PY3 ARYLIDE YELLOW 10G ASTM II (37) |
| PG7 PHTHALOCYANINE GREEN ASTM I (259) |

PIGMENT DETAIL ON LABEL	ASTM	
NO	II L'FAST	

EMERALD GREEN (HUE)

DALER ROWNEY

GEORGIAN WATER COLOUR 2ND RANGE

The inclusion of PR83:1 has lowered the lightfast rating dramatically. Was it really necessary?

| PR83:1 ALIZARIN CRIMSON ASTM IV (122) |
| PG7 PHTHALOCYANINE GREEN ASTM I (259) |
| PY3 ARYLIDE YELLOW 10G ASTM II (37) |

PIGMENT DETAIL ON LABEL	ASTM	RATING
NO	IV L'FAST	★

EMERALD GREEN A067

GRUMBACHER

ACADEMY ARTISTS' WATERCOLOR 2ND RANGE

If you desperately need this pre-mixed colour and use this make, the 'Artists Quality' is virtually the same but costs more. Transparent.

| PY3 ARYLIDE YELLOW 10G ASTM II (37) |
| PG7 PHTHALOCYANINE GREEN ASTM I (259) |

PIGMENT DETAIL ON LABEL	ASTM	
YES	II L'FAST	

EMERALD GREEN 274

OLD HOLLAND

CLASSIC WATERCOLOURS

Heavier applications dried to a beautiful shine thanks to the excess of gum in the paint. Very difficult to work with.

| PW4 ZINC WHITE ASTM I (384) |
| PW6 TITANIUM WHITE ASTM I (385) |
| PY151 BENZIMIDAZOLONE YELLOW H4G WG II (49) |
| PG7 PHTHALOCYANINE GREEN ASTM I (259) |

PIGMENT DETAIL ON LABEL	WG	RATING
CHEMICAL MAKE UP ONLY	II L'FAST	★★

EMERALD GREEN NOVA W264

HOLBEIN

ARTISTS' WATER COLOR

Such colours are easily produced on the palette, either from these or other pigments. Semi-transparent.

| PY3 ARYLIDE YELLOW 10G ASTM II (37) |
| PG7 PHTHALOCYANINE GREEN ASTM I (259) |
| PW6 TITANIUM WHITE ASTM I (385) |

PIGMENT DETAIL ON LABEL	ASTM	
YES	II L'FAST	

EMERALD GREEN W067

GRUMBACHER

FINEST ARTISTS' WATER COLOR

A convenience colour, easily mixed.

Both pigments are reliable and made into a smooth, semi transparent watercolour.

| PY3 ARYLIDE YELLOW 10G ASTM II (37) |
| PG7 PHTHALOCYANINE GREEN ASTM I (259) |

PIGMENT DETAIL ON LABEL	ASTM	
YES	II L'FAST	

EMERALD GREEN 1167

LUKAS

ARTISTS' WATER COLOUR

Rather cloudy, as if a little white had been added.

Sample was a little gum laden, but brushed out well in thinner application. Semi-transparent.

| PG7 PHTHALOCYANINE GREEN ASTM I (259) |

PIGMENT DETAIL ON LABEL	ASTM	RATING
CHEMICAL MAKE UP ONLY	I L'FAST	★★

EMERALD GREEN 545

MAIMERI

ARTISTI EXTRA-FINE WATERCOLOURS

An unimportant colour, easily duplicated on the palette. Reliable ingredients. The PW6 (Titanium White) once used has been changed to PW5. Semi-transparent.

Discontinued

| PW5 LITHOPONE WG I (384) |
| PG7 PHTHALOCYANINE GREEN ASTM I (259) |
| PY3 ARYLIDE YELLOW 10G ASTM II (37) |

PIGMENT DETAIL ON LABEL	ASTM	
NO	II L'FAST	

EMERALD GREEN 627

MAIMERI

STUDIO FINE WATER COLOR 2ND RANGE

A convenience colour. If mixing this yourself do not worry about adding the PW5, it is basically a filler. Washed well. Semi-transparent.

Discontinued

| PW5 LITHOPONE WG I (384) |
| PG7 PHTHALOCYANINE GREEN ASTM I (259) |
| PY3 ARYLIDE YELLOW 10G ASTM II (37) |

PIGMENT DETAIL ON LABEL	ASTM	RATING
NO	II L'FAST	★★

EMERALD GREEN 301

A rather harsh version of this colour.

I cannot tell you more because I do not know more. Neither do the distributors, despite their printed hype.

THE MANUFACTURERS HAVE MADE IT CLEAR THAT THEY DO NOT WISH YOU TO KNOW OF THE PIGMENTS THAT HAVE BEEN USED

ARTISTS' WATERCOLOURS

PIGMENT DETAIL ON LABEL	ASTM	RATING
NO	L'FAST	

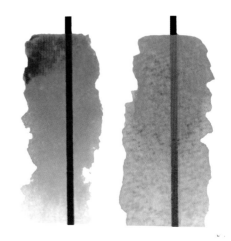

The original, genuine Emerald was so poisonous that it was employed as an insecticide and also to remove barnacles from boat hulls. Often used as a colorant for wallpapers. The dust from the paper is thought to have poisoned many people, including, it is speculated, Napoleon.

Instruments are required for accurate assessment of transparency. However you might wish to decide on a colour for yourself.

A simple and effective method is to paint out an area over a black line. As the information will be for your own use I suggest that you apply the paint as you would work.

Usually a light to medium wash. If the line is obliterated the paint is opaque, if it shows clearly you have a transparent watercolour. In these examples the colour to the left is transparent, that to the right appears to be semi-transparent.

Green Earth (Terre Verte)

A green clay dug from open pits at several locations. Varies in colour depending upon the source.

Bluish green from Verona, yellowish from Cyprus and dull, bluish green from Bohemia. The main deposits of an olive yellow earth are found in Czechoslovakia.

In use since pre-classical times, the best known deposits have long since been dug up and used.

A very weak pigment, it has little influence when mixing. Its lack of body, to my mind makes it unsuitable for use in watercolours as the paint is invariably over bound.

More of a coloured gum, it is only of use in very thin washes. The colour is often strengthened by blending in other pigments.

Amazingly, most of the imitations are also produced with an excess of gum. Perhaps the intention is to duplicate the poor handling qualities of the genuine pigment.

Basic colour mixing skills will enable you to simulate any of the following.

GREEN EARTH 52

OLD HOLLAND

Entire sample was lightly coloured gum.

It is difficult to offer an assessment without an actual paint to work with.

CLASSIC WATERCOLOURS

PG23 GREEN EARTH/TERRE VERTE ASTM I (262)

PIGMENT DETAIL ON LABEL	ASTM	RATING
CHEMICAL MAKE UP ONLY	I L'FAST	★

GREEN EARTH 296

MAIMERI

Sample handled fairly well, giving smooth even washes over the range.

Reliable ingredients.

MAIMERIBLU SUPERIOR WATERCOLOURS

PG17 CHROMIUM OXIDE GREEN ASTM I (261)
PG23 GREEN EARTH/TERRE VERTE ASTM I (262)

PIGMENT DETAIL ON LABEL	ASTM	RATING
YES	I L'FAST	★ ★★

GREEN EARTH 296

MAIMERI

PG23 strengthened with a little PG17. Like most of the paints containing PG23 it lacked 'body' somewhat. Lightfast.

VENEZIA EXTRAFINE WATERCOLOURS

PG17 CHROMIUM OXIDE GREEN ASTM I (261)
PG23 GREEN EARTH/TERRE VERTE ASTM I (262)

PIGMENT DETAIL ON LABEL	ASTM	RATING
YES	I L'FAST	★ ★★

GREEN EARTH W085

GRUMBACHER

Sample particularly gummy and unpleasant to use.

Thin washes only were possible from this imitation. Ingredients absolutely lightfast. Semi-transparent.

FINEST ARTISTS' WATER COLOR

PBr7 RAW UMBER ASTM I (309) PG18 VIRIDIAN ASTM I (261)		
PIGMENT DETAIL ON LABEL **YES**	ASTM **I** L'FAST	RATING ★★

GREEN EARTH HUE A085

GRUMBACHER

It seems that whatever ingredients are used, a weak, soap like paint is the desired result.

ACADEMY ARTISTS' WATERCOLOR 2ND RANGE

PBr7 RAW UMBER ASTM I (309) PG18 VIRIDIAN ASTM I (261)		
PIGMENT DETAIL ON LABEL **YES**	ASTM **I** L'FAST	RATING ★★

GREEN EARTH 137

PÈBÈO

Quality ingredients, absolutely lightfast. Brushed out very smoothly over the entire range. Should ideally be called 'Green Earth Hue' Semi-transparent.

FRAGONARD ARTISTS' WATER COLOUR

PG7 PHTHALOCYANINE GREEN ASTM I (259) PR101 MARS RED ASTM I (124)		
PIGMENT DETAIL ON LABEL **YES**	ASTM **I** L'FAST	RATING ★ ★★

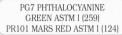

TERRE VERTE 637

WINSOR & NEWTON

Ingredients are reliable but the sample was very gummy, weak and unpleasant to use.

Transparent.

Reformulated ? >

ARTISTS' WATER COLOUR

PG23 GREEN EARTH/TERRE VERTE ASTM I (262) PG18 VIRIDIAN ASTM I (261)		
PIGMENT DETAIL ON LABEL **YES**	ASTM **I** L'FAST	RATING ★★

TERRE VERTE 637

WINSOR & NEWTON

This seems to be a reformulation although I cannot be certain.

I am afraid that I cannot offer assessments or a colour guide as a sample was not provided.

ARTISTS' WATER COLOUR

PG23 GREEN EARTH/TERRE VERTE ASTM I (262) PG18 VIRIDIAN ASTM I (261) PB28 COBALT BLUE ASTM I (215)		
PIGMENT DETAIL ON LABEL **YES**	ASTM **I** L'FAST	RATING

VERONA GREEN EARTH 1158

LUKAS

Previous confusion over the pigments used has now been resolved. The sample washed out very smoothly.

Reliable ingredients.

ARTISTS' WATER COLOUR

PG7 PHTHALOCYANINE GREEN ASTM I (259) PB15 PHTHALOCYANINE BLUE ASTM II (213) PY83HR70 DIARYLIDE YELLOW HR70 WG II (45) PBk7 CARBON BLACK ASTM I (370)		
PIGMENT DETAIL ON LABEL **CHEMICAL MAKE UP ONLY**	ASTM **II** L'FAST	RATING ★ ★★

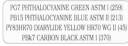

TERRE VERTE 213

SENNELIER

This pigment simply refuses to make up into a paint which is not gummy and weak.

Reformulated several years ago but still difficult to work with. Transparent.

EXTRA-FINE WATERCOLOUR

PG23 GREEN EARTH/TERRE VERTE ASTM I (262)		
PIGMENT DETAIL ON LABEL **YES**	ASTM **I** L'FAST	RATING ★★

GREEN EARTH 516

SCHMINCKE

A mix of 'Phthalo' Green and Burnt Sienna, easily duplicated on the palette.

The consistency has recently been improved. An imitation. Transparent.

HORADAM FINEST ARTISTS' WATER COLOURS

PG7 PHTHALOCYANINE GREEN ASTM I (259) PBr7 RAW UMBER ASTM I (309)		
PIGMENT DETAIL ON LABEL **YES**	ASTM **I** L'FAST	RATING ★ ★★

GREEN EARTH

TALENS

Fine in very thin washes, impossible to use in heavier applications.

Paint lacked body, (and spirit). Semi-transparent.

REMBRANDT ARTISTS' QUALITY EXTRA FINE

PG23 GREEN EARTH/TERRE VERTE ASTM I (262)		
PIGMENT DETAIL ON LABEL **YES**	ASTM **I** L'FAST	RATING ★★

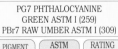
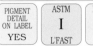

TERRE VERTE W265

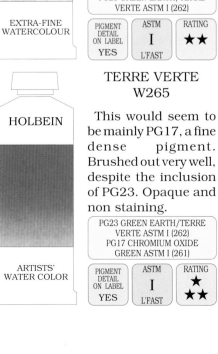

HOLBEIN

This would seem to be mainly PG17, a fine dense pigment. Brushed out very well, despite the inclusion of PG23. Opaque and non staining.

ARTISTS' WATER COLOR

PG23 GREEN EARTH/TERRE VERTE ASTM I (262) PG17 CHROMIUM OXIDE GREEN ASTM I (261)		
PIGMENT DETAIL ON LABEL **YES**	ASTM **I** L'FAST	RATING ★ ★★

TERRE VERTE 104

DANIEL SMITH

As in so many cases, this should be described as an imitation Terre Verte.

If you need such simple mixes carried out for you this will be reliable and semi-transparent. Sample slightly gummy.

EXTRA-FINE WATERCOLORS

PBr7 RAW UMBER ASTM I (309) PG18 VIRIDIAN ASTM I (261)		
PIGMENT DETAIL ON LABEL **YES**	ASTM **I** L'FAST	RATING ★ ★★

TERRE VERTE 483

LEFRANC & BOURGEOIS

As with earlier samples, this latest was most unpleasant to use, a little like painting with wet, raw pastry. Reliable ingredients. Semi-transparent.

LINEL EXTRA-FINE ARTISTS' WATERCOLOUR

PBr7 RAW UMBER ASTM I (309) PG36 PHTHALOCYANINE GREEN ASTM I (262)		
PIGMENT DETAIL ON LABEL **CHEMICAL MAKE UP ONLY**	ASTM **I** L'FAST	RATING ★

TERRE VERTE (HUE) 379

DALER ROWNEY

The consistency of this colour has been very much improved over earlier examples.

A lightfast, *declared* imitation Terre Verte which handles very well.

ARTISTS' WATER COLOUR

PG18 VIRIDIAN ASTM I (261)
PY42 MARS YELLOW ASTM I (43)

| PIGMENT DETAIL ON LABEL **YES** | ASTM **I** L'FAST | 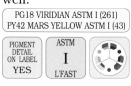 |

TERRE VERTE (HUE)

DALER ROWNEY

A rather dull 'heavy green produced using reliable pigments.

If you wish to darken a green, rather than adding black, try a little red.

ARTISTS' WATER COLOUR

PG18 VIRIDIAN ASTM I (261)
PY42 MARS YELLOW ASTM I (43)
PBk11 MARS BLACK ASTM I (371)

| PIGMENT DETAIL ON LABEL **YES** | ASTM **I** L'FAST | 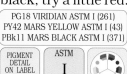 |

Hooker's Green

This was an inferior watercolour paint originally, produced by blending Prussian Blue and Gamboge. The Gamboge faded and the green turned blue as only the Prussian Blue was left.

Nowadays it is still often an inferior, and at best, unnecessary mix of standard colours. There is in fact now a pigment called Hooker's Green, it failed ASTM testing dis-

mally and is not worth considering.

Having examined the contributing pigments used in the modern versions of this colour, I have come to the conclusion that the only limit is the imagination of the blender and the range of pigments which are on hand.

Do not consider any of the Hooker's Greens to be unique in any way,

they are easily reproduced using reliable ingredients.

With basic colour mixing skills any of the following can be blended with ease. Even without such skills you can see the colours that have been used to pre-mix them.

HOOKER'S GREEN 163

UTRECHT

PG8 Hookers Green failed ASTM testing as a watercolour paint. This fact is well recorded.

Knowing this it is less than encouraging to see the pigment in use. Unreliable.

PROFESSIONAL ARTISTS' WATER COLOR

PG8 HOOKERS GREEN ASTM III (260)

| PIGMENT DETAIL ON LABEL **YES** | ASTM **III** L'FAST | RATING ★★ |

HOOKER'S GREEN LIGHT 059

AMERICAN JOURNEY

High quality, lightfast pigments have been employed.

The result is a lightfast paint which brushes out smoothly.

PROFESSIONAL ARTISTS' WATER COLOR

PG7 PHTHALOCYANINE GREEN ASTM I (259)
PY42 MARS YELLOW ASTM I (43)

| PIGMENT DETAIL ON LABEL **YES** | ASTM **I** L'FAST | |

HOOKER'S GREEN DARK 058

AMERICAN JOURNEY

I found the sample to be a little difficult to use unless in thinner washes. Very reliable pigments have been used.

PROFESSIONAL ARTISTS' WATER COLOR

PG7 PHTHALOCYANINE GREEN ASTM I (259)
PY42 MARS YELLOW ASTM I (43)

| PIGMENT DETAIL ON LABEL **YES** | ASTM **I** L'FAST | RATING ★ ★★ |

HOOKER'S GREEN LIGHT 244

DA VINCI PAINTS

Ingredients are most reliable. A strong colour which brushed out very smoothly over a wide range of values. Semi-transparent.

PERMANENT ARTISTS' WATER COLOR

PG7 PHTHALOCYANINE GREEN ASTM I (259)
PY42 MARS YELLOW ASTM I (43)

| PIGMENT DETAIL ON LABEL **YES** | ASTM **I** L'FAST | |

HOOKER'S GREEN LIGHT 644

DA VINCI PAINTS

Rather over bound and difficult to work.

This is a pity as very reliable pigments have been used.

SCUOLA 2ND RANGE

PG7 PHTHALOCYANINE GREEN ASTM I (259)
PY42 MARS YELLOW ASTM I (43)

| PIGMENT DETAIL ON LABEL **YES** | ASTM **I** L'FAST | RATING ★ ★★ |

HOOKER'S GREEN DARK 243

DA VINCI PAINTS

A lightfast, semi-transparent convenience green, easily duplicated on the palette. Excellent pigments have been used. Slightly better in thinner washes.

PERMANENT ARTISTS' WATER COLOR

PG7 PHTHALOCYANINE GREEN ASTM I (259)
PY42 MARS YELLOW ASTM I (43)

| PIGMENT DETAIL ON LABEL **YES** | ASTM **I** L'FAST | RATING ★ ★★ |

PERMANENT HOOKER'S GREEN 5717

HUNTS

I am afraid that I cannot offer assessments as I have insufficient information on PY73.

SPEEDBALL PROFESSIONAL WATERCOLOURS

PB15 PHTHALOCYANINE BLUE ASTM II (213)
PY73 L/FAST NOT OFFERED

PIGMENT DETAIL ON LABEL	ASTM	RATING
NO	L'FAST	

HOOKER'S GREEN 325

MAIMERI

The slight excess of binder causes the paint to dry with a soft, unnatural shine when applied at all heavily.

MAIMERIBLU SUPERIOR WATERCOLOURS

PV49 COBALT AMMONIUM VIOLET PHOSPHATE WG II (187)
PG7 PHTHALOCYANINE GREEN ASTM I (259)

PIGMENT DETAIL ON LABEL	WG	RATING
YES	II L'FAST	★★

HOOKER'S GREEN PERMANENT W41

ART SPECTRUM

A reliable paint which washed out better when well diluted.

Heavier applications were somewhat difficult to apply.

ARTISTS' WATER COLOUR

PY42 MARS YELLOW ASTM I (43)
PG7 PHTHALOCYANINE GREEN ASTM I (259)

PIGMENT DETAIL ON LABEL	ASTM	RATING
YES	I L'FAST	★★

HOOKER'S GREEN LIGHT HUE W107

GRUMBACHER

Completely reformulated from a fugitive to a lightfast colour. Semi-transparent. Washed out reasonably well.

FINEST ARTISTS' WATER COLOR

PB15:3 PHTHALOCYANINE BLUE ASTM II (213)
PG7 PHTHALOCYANINE GREEN ASTM I (259)
PY153 NICKEL DIOXINE YELLOW ASTM II (50)
PY154 BENZIMIDAZOLONE YELLOW H3G ASTM II (50)

PIGMENT DETAIL ON LABEL	ASTM	RATING
YES	II L'FAST	★★

HOOKER'S GREEN DEEP HUE W106

GRUMBACHER

The use of PY, a most unsuitable yellow, will ensure damage to the colour when exposed to light. Semi-transparent.

FINEST ARTISTS' WATER COLOR

PB15 PHTHALOCYANINE BLUE ASTM II (213)
PY1 ARYLIDE YELLOW G ASTM V (37)

PIGMENT DETAIL ON LABEL	ASTM	RATING
YES	V L'FAST	★

HOOKER'S GREEN DEEP HUE A106

GRUMBACHER

Previously produced from PG8 Hookers Green & PY1, a disastrous combination. Now very much improved and lightfast.

ACADEMY ARTISTS' WATERCOLOR 2ND RANGE

PB15:3 PHTHALOCYANINE BLUE ASTM II (213)
PY153 NICKEL DIOXINE YELLOW ASTM II (50)
PY97 ARYLIDE YELLOW FGL ASTM II (46)
PBk6 LAMP BLACK ASTM I (370)

PIGMENT DETAIL ON LABEL	ASTM	RATING
YES	II L'FAST	

HOOKER'S GREEN LIGHT 107

GRUMBACHER

In previous issues I had written 'Despite promises a sample was not provided. Rated on given ingredients only'.

Reformulated >

ACADEMY ARTISTS' WATERCOLOR 2ND RANGE

PY1 ARYLIDE YELLOW G ASTM V (37)
PG8 HOOKERS GREEN ASTM III (260)

PIGMENT DETAIL ON LABEL	ASTM	RATING
YES	V L'FAST	★

HOOKER'S GREEN LIGHT HUE

GRUMBACHER

At last, a sample to work with. It provided very good, smooth washes which were a pleasure to apply. A quality product.

ACADEMY ARTISTS' WATERCOLOR 2ND RANGE

PG7 PHTHALOCYANINE GREEN ASTM I (259)
PY97 ARYLIDE YELLOW FGL ASTM II (46)
PY65 ARYLIDE YELLOW RN ASTM II (44)
PBk9 IVORY BLACK ASTM I (371)

PIGMENT DETAIL ON LABEL	ASTM	RATING
YES	II L'FAST	

HOOKER'S GREEN 042

DANIEL SMITH

A strong, semi transparent mid green produced from tried and tested pigments. Handled very smoothly at all strengths.

EXTRA-FINE WATERCOLORS

PG36 PHTHALOCYANINE GREEN ASTM I (262)
PY3 ARYLIDE YELLOW 10G ASTM II (37)
PO49 QUINACRIDONE DEEP GOLD WG II (97)

PIGMENT DETAIL ON LABEL	ASTM	RATING
YES	II L'FAST	

HOOKER'S GREEN LAKE LIGHT EXTRA 304

OLD HOLLAND

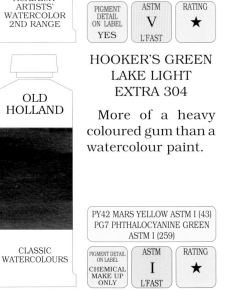

More of a heavy coloured gum than a watercolour paint.

CLASSIC WATERCOLOURS

PY42 MARS YELLOW ASTM I (43)
PG7 PHTHALOCYANINE GREEN ASTM I (259)

PIGMENT DETAIL ON LABEL	ASTM	RATING
CHEMICAL MAKE UP ONLY	I L'FAST	★

HOOKER'S GREEN LAKE DEEP EXTRA 301

OLD HOLLAND

Following on from the colour to the left, more of the same.

CLASSIC WATERCOLOURS

PR101 MARS RED ASTM I (124)
PG7 PHTHALOCYANINE GREEN ASTM I (259)
PBk7 CARBON BLACK ASTM I (370)

PIGMENT DETAIL ON LABEL	ASTM	RATING
CHEMICAL MAKE UP ONLY	I L'FAST	★

HOOKER'S GREEN 108

M.GRAHAM & CO.

From paints made with reliable pigments which washed out with great difficulty (to the left), to one with an unreliable pigment which washed out very well.

ARTISTS' WATERCOLOR

PG7 PHTHALOCYANINE GREEN ASTM I (259)
PY110 ISOINDOLINONE YELLOW R ASTM III (47)

PIGMENT DETAIL ON LABEL	ASTM	RATING
YES	III L'FAST	★★

HOOKER GREEN LIGHT 644

TALENS

REMBRANDT ARTISTS' QUALITY EXTRA FINE

Produced with reliable pigments. A reasonably strong colour which handled very smoothly over the full range. Semi-transparent.

Reformulated>

PG7 PHTHALOCYANINE GREEN ASTM I (259)
PBr7 RAW UMBER ASTM I (309)
PY3 ARYLIDE YELLOW 10G ASTM II (37)

PIGMENT DETAIL ON LABEL YES | ASTM II L'FAST |

HOOKER GREEN LIGHT 644

TALENS

REMBRANDT ARTISTS' QUALITY EXTRA FINE

A well made water-colour paint which handled smoothly across a useful range of values. Lightfast and transparent.

PG7 PHTHALOCYANINE GREEN ASTM I (259)
PY150 NICKEL AZO YELLOW ASTM I (49)

PIGMENT DETAIL ON LABEL YES | ASTM I L'FAST |

HOOKER GREEN LIGHT 644

TALENS

VAN GOGH 2ND RANGE

Sample slightly over bound. Thinner washes perfect but no so when applied heavier. A reliable watercolour paint.

PG7 PHTHALOCYANINE GREEN ASTM I (259)
PY154 BENZIMIDAZOLONE YELLOW H3G ASTM II (50)

PIGMENT DETAIL ON LABEL YES | ASTM II L'FAST | RATING ★ ★★

HOOKER GREEN DEEP 645

TALENS

REMBRANDT ARTISTS' QUALITY EXTRA FINE

Lightfast ingredients. Paint brushed very smoothly into even washes. Easily mixed convenience colour. Semi-transparent.

Reformulated>

PG7 PHTHALOCYANINE GREEN ASTM I (259)
PBr7 RAW UMBER ASTM I (309)
PY3 ARYLIDE YELLOW 10G ASTM II (37)

PIGMENT DETAIL ON LABEL YES | ASTM II L'FAST |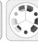

HOOKER GREEN DEEP 645

TALENS

REMBRANDT ARTISTS' QUALITY EXTRA FINE

It is so easy to mix any of the 'Hooker's' or 'Hooker Greens' that I wonder why any artist ever buys them. This is a well made, lightfast convenience colour.

PG7 PHTHALOCYANINE GREEN ASTM I (259)
PY150 NICKEL AZO YELLOW ASTM I (49)

PIGMENT DETAIL ON LABEL YES | ASTM I L'FAST |

HOOKER'S GREEN 1170

LUKAS

ARTISTS' WATER COLOUR

A bit of a concoction giving a reliable, deep green which washes out very well.

PG7 PHTHALOCYANINE GREEN ASTM I (259)
PB15 PHTHALOCYANINE BLUE ASTM II (213)
PR176 BENZIMIDAZOLONE CARMINE HF3C WG II (130)
PO62 BENZIMIDAZOLONE ORANGE H5G ASTM II (97)

PIGMENT DETAIL ON LABEL CHEMICAL MAKE UP ONLY | ASTM II L'FAST |

HOOKER'S GREEN DEEP 645

TALENS

WATER COLOUR 2ND RANGE

The same ingredients as are used in Talens 'Artists Quality'. A reliable paint which brushed out well. Semi-transparent.

Range discontinued

PG7 PHTHALOCYANINE GREEN ASTM I (259)
PBr7 RAW UMBER ASTM I (309)
PY3 ARYLIDE YELLOW 10G ASTM II (37)

PIGMENT DETAIL ON LABEL YES | ASTM II L'FAST |

HOOKER GREEN DEEP 645

TALENS

VAN GOGH 2ND RANGE

A convenience colour which will resist light. Sample handled better in thinner washes than heavy. Semi-transparent.

PG7 PHTHALOCYANINE GREEN ASTM I (259)
PY154 BENZIMIDAZOLONE YELLOW H3G ASTM II (50)

PIGMENT DETAIL ON LABEL YES | ASTM II L'FAST | RATING ★ ★★

HOOKER'S GREEN W262

HOLBEIN

ARTISTS' WATER COLOR

In earlier testing the yellow content had faded causing a marked colour change. Latest sample did not change in any way. A reliable, well made convenience colour. Semi-transparent.

PY83HR70 DIARYLIDE YELLOW HR70 WG II (45)
PG36 PHTHALOCYANINE GREEN ASTM I (262)

PIGMENT DETAIL ON LABEL YES | WG II L'FAST |

HOOKER'S GREEN 1 520

SCHMINCKE

HORADAM FINEST ARTISTS' WATER COLOURS

In the previous issue I had written 'A most un-reliable pigment used. It has failed all tests for which I have records. The company are now in the process of refor-mulating this colour'.

Discontinued

PG8 HOOKERS GREEN ASTM III (260)

PIGMENT DETAIL ON LABEL YES | ASTM III L'FAST | RATING ★★

HOOKER'S GREEN 2 521

SCHMINCKE

HORADAM FINEST ARTISTS' WATER COLOURS

A strong, deep green easily mixed on the palette. Reliable ingredients give a paint which brushes out very well. Semi-transparent.

PY42 MARS YELLOW ASTM I (43)
PB15:3 PHTHALOCYANINE BLUE ASTM II (213)
PG7 PHTHALOCYANINE GREEN ASTM I (259)

PIGMENT DETAIL ON LABEL YES | ASTM II L'FAST |

HOOKER'S GREEN 809

SENNELIER

EXTRA-FINE WATERCOLOUR

Completely reformu-lated several years ago and transformed from a fugitive colour to a reli-able one. (Check your old colours). The PY13 which once let the colour down has been removed. This is now a well made, reliable watercolour.

PY83HR70 DIARYLIDE YELLOW HR70 WG II (45)
PG7 PHTHALOCYANINE GREEN ASTM I (259)

PIGMENT DETAIL ON LABEL YES | WG II L'FAST |

HOOKER'S GREEN LIGHT 244

PÈBÈO

FRAGONARD ARTISTS' WATER COLOUR

A yellowish green which moves towards a blue-green as the PY74 content fades. Such colours are easily mixed from reliable ingredients. Semi-transparent.

| PG7 PHTHALOCYANINE GREEN ASTM I (259) |
| PY74LF ARYLIDE YELLOW 5GX ASTM III (44) |
| PY65 ARYLIDE YELLOW RN ASTM II (44) |

| PIGMENT DETAIL ON LABEL YES | ASTM III L'FAST | RATING ★★ |

HOOKER'S GREEN DARK 245

PÈBÈO

FRAGONARD ARTISTS' WATER COLOUR

On exposure the colour will move from a yellow to a mid-green as the PY74 content fades. Company claim PY74 is lightfast but seem to be using the wrong ASTM list. Use with caution.

| PY74LF ARYLIDE YELLOW 5GX ASTM III (44) |
| PY65 ARYLIDE YELLOW RN ASTM II (44) |
| PB15 PHTHALOCYANINE BLUE ASTM II (213) |

| PIGMENT DETAIL ON LABEL YES | ASTM III L'FAST | RATING ★★ |

HOOKER'S GREEN LIGHT 314 (022)

WINSOR & NEWTON

ARTISTS' WATER COLOUR

I had previously written.

'The confirmed ingredients give a paint which will have a very short life on exposure to light. Most unsuitable for artistic expression'.

Discontinued

| PG12 NAPHTHOL GREEN B ASTM IV (260) |
| PY100 TARTRAZINE LAKE ASTM V (46) |

| PIGMENT DETAIL ON LABEL YES | ASTM V L'FAST | RATING ★★ |

HOOKER'S GREEN 311

WINSOR & NEWTON

ARTISTS' WATER COLOUR

Poorly made, due, it would appear, to an excess of binder. Paint was rather sticky and difficult to apply unless in thin washes.

This is disappointing in a newly introduced colour.

| PO49 QUINACRIDONE DEEP GOLD WG II (97) |
| PG36 PHTHALOCYANINE GREEN ASTM I (262) |

| PIGMENT DETAIL ON LABEL YES | WG II L'FAST | RATING ★★ |

HOOKER'S GREEN LIGHT 314

WINSOR & NEWTON

COTMAN WATER COLOURS 2ND RANGE

A disastrous combination of short lived pigments. Easily duplicated using reliable ingredients. Semi-transparent.

Reformulated >

| PG12 NAPHTHOL GREEN B ASTM IV (260) |
| PY100 TARTRAZINE LAKE ASTM V (46) |

| PIGMENT DETAIL ON LABEL YES | ASTM V L'FAST | RATING ★★ |

HOOKER GREEN LIGHT 314

WINSOR & NEWTON

COTMAN WATER COLOURS 2ND RANGE

Lightfast ingredients but a poor watercolour paint. Rather gum laden, giving satisfactory washes in thin applications only.

| PG7 PHTHALOCYANINE GREEN ASTM I (259) |
| PO49 QUINACRIDONE DEEP GOLD WG II (97) |
| PB15 PHTHALOCYANINE BLUE ASTM II (213) |

| PIGMENT DETAIL ON LABEL YES | WG II L'FAST | RATING ★★ |

HOOKER'S GREEN DARK 312 (021)

WINSOR & NEWTON

ARTISTS' WATER COLOUR

Pigment Green 12 failed ASTM testing dismally. Colour will deteriorate on exposure to light. Not for serious work. Semi-transparent.

Discontinued

| PG7 PHTHALOCYANINE GREEN ASTM I (259) |
| PG12 NAPHTHOL GREEN B ASTM IV (260) |

| PIGMENT DETAIL ON LABEL YES | ASTM IV L'FAST | RATING ★ |

HOOKER'S GREEN DARK 312

WINSOR & NEWTON

COTMAN WATER COLOURS 2ND RANGE

Pigment Green 12 is an unreliable material. Sample faded and discoloured. Second range paints need not be like this.

Reformulated >

| PG7 PHTHALOCYANINE GREEN ASTM I (259) |
| PG12 NAPHTHOL GREEN B ASTM IV (260) |

| PIGMENT DETAIL ON LABEL YES | ASTM IV L'FAST | RATING ★ |

HOOKER GREEN DARK 312

WINSOR & NEWTON

COTMAN WATER COLOURS 2ND RANGE

A transparent, staining colour which did not handle well. A gummy consistency which tended to lay on in streaks unless well worked.

| PG7 PHTHALOCYANINE GREEN ASTM I (259) |
| PO49 QUINACRIDONE DEEP GOLD WG II (97) |
| PB15 PHTHALOCYANINE BLUE ASTM II (213) |

| PIGMENT DETAIL ON LABEL YES | ASTM II L'FAST | RATING ★★ |

HOOKER'S GREEN No 1 353

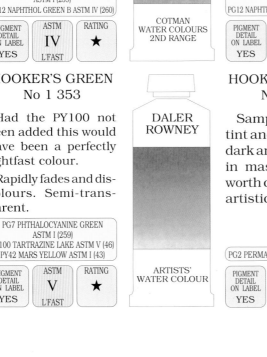

DALER ROWNEY

ARTISTS' WATER COLOUR

Had the PY100 not been added this would have been a perfectly lightfast colour.

Rapidly fades and discolours. Semi-transparent.

| PG7 PHTHALOCYANINE GREEN ASTM I (259) |
| PY100 TARTRAZINE LAKE ASTM V (46) |
| PY42 MARS YELLOW ASTM I (43) |

| PIGMENT DETAIL ON LABEL YES | ASTM V L'FAST | RATING ★ |

HOOKER'S GREEN No.2 354

DALER ROWNEY

ARTISTS' WATER COLOUR

Sample faded as a tint and became very dark and discoloured in mass tone. Not worth considering for artistic use.

| PG2 PERMANENT GREEN WG V (259) |

| PIGMENT DETAIL ON LABEL YES | WG V L'FAST | RATING ★ |

HOOKER'S GREEN 352

DALER ROWNEY

GEORGIAN WATER COLOUR 2ND RANGE

From stated ingredients I would have expected the colour to become brighter as the red faded. Instead it became far darker and greyer.

| PG7 PHTHALOCYANINE GREEN ASTM I (259) |
| PR83:1 ALIZARIN CRIMSON ASTM IV (122) |
| PY3 ARYLIDE YELLOW 10G ASTM II (37) |

| PIGMENT DETAIL ON LABEL NO | ASTM IV L'FAST | RATING ★ |

HOOKER'S GREEN LIGHT

DALER ROWNEY

Pigments which have passed the stringent requirements of ASTM test procedures have been used in this paint.

Brushes out very well, a quality product.

| PG7 PHTHALOCYANINE GREEN ASTM I (259) |
| PY153 NICKEL DIOXINE YELLOW ASTM II (50) |

ARTISTS' WATER COLOUR

| PIGMENT DETAIL ON LABEL YES | ASTM II L'FAST | |

HOOKER'S GREEN DARK

DALER ROWNEY

Reliable pigments which have been tested under the controlled conditions of the ASTM. Our sample handled very well, a quality product.

| PY3 ARYLIDE YELLOW 10G ASTM II (37) |
| PV19 QUINACRIDONE VIOLET ASTM II (185) |
| PG7 PHTHALOCYANINE GREEN ASTM I (259) |

ARTISTS' WATER COLOUR

| PIGMENT DETAIL ON LABEL YES | ASTM II L'FAST | |

HOOKER'S GREEN 533

LEFRANC & BOURGEOIS

Colour will move towards a mid-green and became paler. PY1 is most unreliable and will cause the damage. Semi-transparent.

| PG36 PHTHALOCYANINE GREEN ASTM I (262) |
| PY1 ARYLIDE YELLOW G ASTM V (37) |
| *UNSPECIFIED* PBr7 ASTM I (310) |

LINEL EXTRA-FINE ARTISTS' WATERCOLOUR

| PIGMENT DETAIL ON LABEL CHEMICAL MAKE UP ONLY | ASTM V L'FAST | RATING ★ |

Olive Green

A term used almost in an irresponsible manner, to describe any concoction that will give a dull brownish green.

As reliable ingredients are seldom employed I would suggest that this cannot even be considered a convenience colour.

Such greens can be mixed by applying a touch of either type of red to a standard or mixed yellow green. A little experimentation will soon show the way.

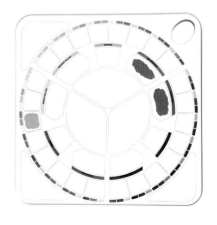

ANTIQUE OLIVE GREEN 040

HOLBEIN

The sample supplied washed our very well indeed. A quality product I thought, until I checked the ingredients. This will be a very short lived colour unless it is kept in the dark.

| PY17 DIARYLIDE YELLOW AO WG V (39) |
| PG8 HOOKERS GREEN ASTM III (260) |

IRODORI ANTIQUE WATERCOLOR

| PIGMENT DETAIL ON LABEL YES | WG V L'FAST | RATING ★ |

OLIVE GREEN 447

WINSOR & NEWTON

If this name must be retained at least quality ingredients such as these should be used.

Reliable and washed well. Semi-transparent.

| PG7 PHTHALOCYANINE GREEN ASTM I (259) |
| PY42 MARS YELLOW ASTM I (43) |

ARTISTS' WATER COLOUR

| PIGMENT DETAIL ON LABEL YES | ASTM I L'FAST | |

OLIVE GREEN 331

MAIMERI

If you already have Chromium Oxide Green, a colour which tends not to vary much between manufacturers, you will not need it a second time. This is a quality paint nevertheless.

| PG17 CHROMIUM OXIDE GREEN ASTM I (261) |

MAIMERIBLU SUPERIOR WATERCOLOURS

| PIGMENT DETAIL ON LABEL YES | ASTM I L'FAST | |

OLIVE GREEN HUE

GRUMBACHER

A bit of a mixture, but at least it is a lightfast mixture. Sample handled very well. A lightfast, convenience colour. Convenient to some that is, others will mix it from simpler ingredients.

| PY3 ARYLIDE YELLOW 10G ASTM II (37) |
| PG7 PHTHALOCYANINE GREEN ASTM I (259) |
| PY65 ARYLIDE YELLOW RN ASTM II (44) |
| *UNSPECIFIED* PBr7 (309/310) |

ACADEMY ARTISTS' WATERCOLOR 2ND RANGE

| PIGMENT DETAIL ON LABEL YES | ASTM II L'FAST | |

OLIVE GREEN 363

DALER ROWNEY

This really is a mobile disaster area. On exposure changes from dull yellow green to pale grey. Semi-transparent.

Reformulated >

| PG7 PHTHALOCYANINE GREEN ASTM I (259) |
| PR83:1 ALIZARIN CRIMSON ASTM IV (122) |
| PY100 TARTRAZINE LAKE ASTM V (46) |

ARTISTS' WATER COLOUR

| PIGMENT DETAIL ON LABEL YES | ASTM V L'FAST | RATING ★ |

OLIVE GREEN 363

DALER ROWNEY

It would be worth going to the bottom of page 137 if you wish to find out why I cannot offer an assessment on this colour.

| PY153 NICKEL DIOXINE YELLOW ASTM II (50) |
| PG7 PHTHALOCYANINE GREEN ASTM I (259) |
| PR264 COMMON NAME N/K LF NOT OFFERED (137) |

ARTISTS' WATER COLOUR

| PIGMENT DETAIL ON LABEL YES | ASTM L'FAST | RATING |

OLIVE GREEN 813

SENNELIER

A reliable conven-ience colour. The sample was slightly over bound but washed out very well over a good range of tints. Lightfast in-gredients.

EXTRA-FINE
WATERCOLOUR

PO49 QUINACRIDONE DEEP GOLD WG II (97)		
PG36 PHTHALOCYANINE GREEN ASTM I (262)		
PW21 BLANC FIXE WG I (386)		

PIGMENT DETAIL ON LABEL YES	WG II L'FAST	RATING ★ ★★

OLIVE GREEN 541

LEFRANC & BOURGEOIS

The use of PV23RS lowers the overall lightfast rating, but caused limited damage as little could have been used. Becomes a little brighter on exposure.

Reformulated >

LINEL
EXTRA-FINE
ARTISTS'
WATERCOLOUR

PV23RS DIOXAZINE PURPLE ASTM III-IV (186)		
PG7 PHTHALOCYANINE GREEN ASTM I (259)		
PY153 NICKEL DIOXINE YELLOW ASTM II (50)		

PIGMENT DETAIL ON LABEL CHEMICAL MAKE UP ONLY	ASTM III L'FAST	RATING ★

OLIVE GREEN 541

LEFRANC & BOURGEOIS

From all I can gather, it seems that the only difference between this and the previous make up (see left) is that the PV23 has been changed from RS (Red shade) to BS (Blue shade). Earth shattering.

LINEL
EXTRA-FINE
ARTISTS'
WATERCOLOUR

PV23BS DIOXAZINE PURPLE ASTM III-IV (186)		
PG7 PHTHALOCYANINE GREEN ASTM I (259)		
PY153 NICKEL DIOXINE YELLOW ASTM II (50)		

PIGMENT DETAIL ON LABEL CHEMICAL MAKE UP ONLY	ASTM IV L'FAST	RATING ★

OLIVE GREEN 620

TALENS

As the type of PY74 is unspecified I will assume it to be the less reliable HS ver-sion. Whichever it is the colour deterio-rates on exposure.

Reformulated >

REMBRANDT
ARTISTS'
QUALITY
EXTRA FINE

PBr7 BURNT SIENNA ASTM I (310)		
PY74LF ARYLIDE YELLOW 5GX ASTM III (44)		
PG7 PHTHALOCYANINE GREEN ASTM I (259)		

PIGMENT DETAIL ON LABEL YES	ASTM III L'FAST	RATING ★★

OLIVE GREEN

TALENS

Reliable ingredi-ents leading to a reli-able, well made watercolour paint.

Handled very well, giving very smooth washes.

REMBRANDT
ARTISTS'
QUALITY
EXTRA FINE

PG7 PHTHALOCYANINE GREEN ASTM I (259)		
PY150 NICKEL AZO YELLOW ASTM I (49)		
PV19 QUINACRIDONE VIOLET ASTM II (185)		

PIGMENT DETAIL ON LABEL YES	ASTM II L'FAST	

OLIVE GREEN PERMANENT W40

ART SPECTRUM

Reliable ingredi-ents, without a doubt, but the sam-ple was gum laden to the point of being unpleasant to use.

ARTISTS'
WATER COLOUR

PY42 MARS YELLOW ASTM I (43)		
PG7 PHTHALOCYANINE GREEN ASTM I (259)		

PIGMENT DETAIL ON LABEL YES	ASTM I L'FAST	RATING ★★

OLIVE GREEN 620

TALENS

As the PY74 fades, (as it surely must if exposed to light) the colour will become duller and fainter. Semi-transparent.

Range discontinued

WATER COLOUR
2ND RANGE

PBr7 BURNT SIENNA ASTM I (310)		
PY74LF ARYLIDE YELLOW 5GX ASTM III (44)		
PG7 PHTHALOCYANINE GREEN ASTM I (259)		

PIGMENT DETAIL ON LABEL YES	ASTM III L'FAST	RATING ★★

OLIVE GREEN 597

TALENS

Although some do find it convenient to have ready mixed greens at their fin-gertips, such colours are very easily mixed. Sample was well made and is lightfast.

VAN GOGH
2ND RANGE

PG7 PHTHALOCYANINE GREEN ASTM I (259)		
PY154 BENZIMIDAZOLONE YELLOW H3G ASTM II (50)		

PIGMENT DETAIL ON LABEL YES	ASTM II L'FAST	

OLIVE GREEN DARK 307

OLD HOLLAND

Although PY129 has been tested ASTM in resin/oils, it has yet to be examined as a watercol-our. I have insufficient back up information to offer an assessment

CLASSIC
WATERCOLOURS

PY129 AZOMETHINE YELLOW 5GT LF NOT OFFERED (48)		
PB60 INDANTHRONE BLUE WG II (216)		
PG7 PHTHALOCYANINE GREEN ASTM I (259)		
UNSPECIFIED PBr7 (309/310)		

PIGMENT DETAIL ON LABEL CHEMICAL MAKE UP ONLY	ASTM L'FAST	RATING

OLIVE GREEN W274

HOLBEIN

This colour is most unsuitable for normal artistic use. Changes alarmingly from a yel-low green to a paler grey green. Non staining.

ARTISTS'
WATER COLOR

PG36 PHTHALOCYANINE GREEN ASTM I (262)		
PY17 DIARYLIDE YELLOW AO WG V (39)		

PIGMENT DETAIL ON LABEL YES	WG V L'FAST	RATING ★

OLIVE 079

AMERICAN JOURNEY

I am afraid that I can-not offer assessments as a sample was not supplied.

The pigments used are superb and will make up into a light resistant paint.

PROFESSIONAL
ARTISTS'
WATER COLOR

PG7 PHTHALOCYANINE GREEN ASTM I (259)		
PY42 MARS YELLOW ASTM I (43)		

PIGMENT DETAIL ON LABEL YES	ASTM I L'FAST	RATING

OLIVE GREEN 1176

LUKAS

The PG7 is the only reliable pigment used in this paint. Expect the colour to become paler and greener un-less kept away from light. Semi transpar-ent.

ARTISTS'
WATER COLOUR

PR83 ROSE MADDER ALIZARIN ASTM IV (122)		
PY1 ARYLIDE YELLOW G ASTM V (37)		
PG7 PHTHALOCYANINE GREEN ASTM I (259)		

PIGMENT DETAIL ON LABEL CHEMICAL MAKE UP ONLY	ASTM V L'FAST	RATING ★

OLIVE GREEN 525

SCHMINCKE

PG8, Hookers Green failed ASTM testing as a water-colour and failed convincingly.

Discontinued

HORADAM FINEST ARTISTS' WATER COLOURS

PO62 BENZIMIDAZOLONE ORANGE H5G ASTM II (97) PG8 HOOKERS GREEN ASTM III (260)		
PIGMENT DETAIL ON LABEL YES	ASTM III L'FAST	RATING ★★

OLIVE GREEN YELLOWISH 525

SCHMINCKE

Very reliable pigments giving a watercolour paint which handles with ease.

A quality product if the sample is anything to go by.

HORADAM FINEST ARTISTS' WATER COLOURS

PG36 PHTHALOCYANINE GREEN ASTM I (262) PO62 BENZIMIDAZOLONE ORANGE H5G ASTM II (97)		
PIGMENT DETAIL ON LABEL YES	ASTM II L'FAST	

OLIVE GREEN 5724

HUNTS

Once again I have to ask 'which Hansa Yellow Pigment'? Quite a few are in use and vary from reliable to fugitive. Assessments are not possible without further information.

Discontinued

SPEEDBALL PROFESSIONAL WATERCOLOURS

HANSA YELLOW PIGMENT AND COPPER PHTHALOCYANINE		
PIGMENT DETAIL ON LABEL NO	ASTM L'FAST	RATING

PERMANENT OLIVE GREEN 515

SCHMINCKE

The most unreliable PG8 Hookers Green was replaced several years ago (check your old colours). A much improved lightfast green which handles very well. Semi-transparent.

HORADAM FINEST ARTISTS' WATER COLOURS

PB15:1 PHTHALOCYANINE BLUE ASTM II (213) PY153 NICKEL DIOXINE YELLOW ASTM II (50)		
PIGMENT DETAIL ON LABEL YES	ASTM II L'FAST	

OLIVE GREEN 537

SCHMINCKE

Very reliable pigments used to give a well produced paint.

Washed out very well.

HORADAM FINEST ARTISTS' WATER COLOURS

PO62 BENZIMIDAZOLONE ORANGE H5G ASTM II (97) PG7 PHTHALOCYANINE GREEN ASTM I (259)		
PIGMENT DETAIL ON LABEL YES	ASTM II L'FAST	

OLIVE GREEN 063

DANIEL SMITH

Typical 'Olive Green' dull and with a leaning towards yellow.

Painted out very well and the ingredients are all lightfast. Well made product.

EXTRA-FINE WATERCOLORS

PY40 AUREOLIN ASTM II (42) UNSPECIFIED PBr7 (309/310) PB29 ULTRAMARINE BLUE ASTM I (215)		
PIGMENT DETAIL ON LABEL YES	ASTM II L'FAST	

Phthalocyanine Green

A particularly clean, vibrant green with a slight leaning towards blue. High in tinting strength, it should be handled with care when mixing. Phthalo' Green can quickly dominates a painting due to its intensity of hue.

In colour it resembles Viridian and if anything, is even more intense.

Although very similar it has not replaced Viridian, as in mixes it will give a slightly different range of effects. Many artists also consider it to be a little harsh. It really is a matter of preference as either green has many admirable qualities.

Phthalocyanine Green is offered under a wide variety of fancy and trade names. Perhaps it is thought that the painter cannot manage words of more than two syllables. Until paints are correctly and uniformly labelled, confusion will continue to exist.

When mixing, the ideal partner is a transparent violet-red such as Pigment Violet 19. Their complementary relationship as far as hue is concerned is reasonably close.

As both are transparent it is easy to mix a range of neutrals and greys seething with subdued colour.

Please see palette diagram at end of this section.

PHTHALO GREEN 167

UTRECHT

A well made product, giving clear, even washes over a wide range of values.

Lightfast.

PROFESSIONAL ARTISTS' WATER COLOR

PG7 PHTHALOCYANINE GREEN ASTM I (259)		
PIGMENT DETAIL ON LABEL YES	ASTM I L'FAST	

PHTHALO GREEN W37

ART SPECTRUM

Slightly over bound but washed out well, particularly in thinner applications.

A quality pigment which will not let you down.

ARTISTS' WATER COLOUR

PG7 PHTHALOCYANINE GREEN ASTM I (259)		
PIGMENT DETAIL ON LABEL YES	ASTM I L'FAST	RATING ★ ★★

PHTHALO GREEN 361

DALER ROWNEY

Phthalocyanine Green is a unique hue which cannot be mixed from other colours.

This example is a well made quality product.

ARTISTS' WATER COLOUR

PG7 PHTHALOCYANINE GREEN ASTM I (259)		
PIGMENT DETAIL ON LABEL YES	ASTM I L'FAST	

PHTHALO GREEN 268

DA VINCI PAINTS

Phthalocyanine Green makes into an excellent watercolour paint. It is absolutely lightfast, bright and very transparent.

PERMANENT ARTISTS' WATER COLOR

PG7 PHTHALOCYANINE GREEN ASTM I (259)

PIGMENT DETAIL ON LABEL	ASTM	
YES	I L'FAST	

PHTHALO GREEN 668

DA VINCI PAINTS

The sample tube was under tremendous pressure and only washed out well in very thin layers. A few adjustments need to be made to this recently released range.

SCUOLA 2ND RANGE

PG7 PHTHALOCYANINE GREEN ASTM I (259)

PIGMENT DETAIL ON LABEL	ASTM	RATING
YES	I L'FAST	★

CARAN D'ACHE

FINEST WATERCOLOURS

PHTHALOCYANINE GREEN 710

The paint picked up very readily from the pan. It can be very frustrating to scrub away at a pan colour to lift the paint. A well made, quality product.

PG7 PHTHALOCYANINE GREEN ASTM I (259)

PIGMENT DETAIL ON LABEL	ASTM	
YES	I L'FAST	

PHTHALOCYANINE GREEN 150

M.GRAHAM & CO.

It is encouraging to see more manufacturers using the correct name instead of mainly hiding this excellent pigment behind fancy titles. This is a well made example.

ARTISTS' WATERCOLOR

PG7 PHTHALOCYANINE GREEN ASTM I (259)

PIGMENT DETAIL ON LABEL	ASTM	
YES	I L'FAST	

PHTHALO GREEN 675

TALENS

The over enthusiastic use of gum has given a paint which gives very good thin washes but is unpleasant to handle when at all heavy.

REMBRANDT ARTISTS' QUALITY EXTRA FINE

PG7 PHTHALOCYANINE GREEN ASTM I (259)

PIGMENT DETAIL ON LABEL	ASTM	RATING
YES	I L'FAST	★★

PHTHALO GREEN 675

TALENS

Please see remarks to the colour at left. They apply equally here.

VAN GOGH 2ND RANGE

PG7 PHTHALOCYANINE GREEN ASTM I (259)

PIGMENT DETAIL ON LABEL	ASTM	RATING
YES	I L'FAST	★★

PHTHALO GREEN (YS) 079

DANIEL SMITH

The YS stands for 'Yellow Shade' and the colour does have this leaning.

A bright (when thin) transparent, staining colour which handled very well.

EXTRA-FINE WATERCOLORS

PG36 PHTHALOCYANINE GREEN ASTM I (262)

PIGMENT DETAIL ON LABEL	ASTM	
YES	I L'FAST	

PHTHALO GREEN (BS) 078

DANIEL SMITH

The BS or 'Blue Shade' version appears to be the standard colour associated with this pigment, which does lean slightly towards blue.

A very well made colour in all respects.

EXTRA-FINE WATERCOLORS

PG7 PHTHALOCYANINE GREEN ASTM I (259)

PIGMENT DETAIL ON LABEL	ASTM	
YES	I L'FAST	

PHTHALO GREEN 321

MAIMERI

A bright, strong, clear blueish-green. Very dark when applied heavily, the true beauty is revealed when well diluted. Transparent.

VENEZIA EXTRAFINE WATERCOLOURS

PG7 PHTHALOCYANINE GREEN ASTM I (259)

PIGMENT DETAIL ON LABEL	ASTM	
YES	I L'FAST	

PHTHALO GREEN DEEP 807

SENNELIER

Name changed several years ago from 'Chrome Green Deep'. A powerful colour which can quickly dominate a painting. Transparent.

EXTRA-FINE WATERCOLOUR

PB15:3 PHTHALOCYANINE BLUE ASTM II (213)
PG7 PHTHALOCYANINE GREEN ASTM I (259)

PIGMENT DETAIL ON LABEL	ASTM	
YES	II L'FAST	

PHTHALO GREEN LIGHT 805

SENNELIER

A bright mid-green. The sample provided brushed out very well indeed, giving clear tints. Lightfast ingredients. An excellent all round colour.

EXTRA-FINE WATERCOLOUR

PG7 PHTHALOCYANINE GREEN ASTM I (259)
PY154 BENZIMIDAZOLONE YELLOW H3G ASTM I (50)

PIGMENT DETAIL ON LABEL	ASTM	
YES	I L'FAST	

PHTHALO GREEN 6H

If you have used this colour, or any from the range, in your work that is one thing. If you have sold such work I trust that you had more information than I have on the pigmentation.

DR. Ph. MARTINS

HYDRUS FINE ART WATERCOLOR

INFORMATION ON THE PIGMENTS USED NOT ON THE PRODUCT LABEL OR IN THE INFORMATION PROVIDED

PIGMENT DETAIL ON LABEL	ASTM	RATING
NO	L'FAST	

PHTHALO GREEN 519

SCHMINCKE

A superb all round watercolour. Bright, strong and pure in hue. Washed out beautifully over the full range. Transparent.

HORADAM FINEST ARTISTS' WATER COLOURS

PG7 PHTHALOCYANINE GREEN
ASTM I (259)

PIGMENT DETAIL ON LABEL	ASTM	
YES	I L'FAST	

THALO YELLOW GREEN A210

As with the 'Artist Quality' version, this colour is easily mixed.

Reliable ingredients, handles well. A quality product. Semi-transparent.

Reformulated >

GRUMBACHER

ACADEMY ARTISTS' WATERCOLOR 2ND RANGE

PG7 PHTHALOCYANINE GREEN
ASTM I (259)
PY3 ARYLIDE YELLOW 10G
ASTM II (37)

PIGMENT DETAIL ON LABEL	ASTM	
YES	II L'FAST	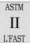

THALO YELLOW GREEN

A slightly over bound paint which handles better in thinner layers.

A bright, easily mixed, lightfast yellow green.

GRUMBACHER

ACADEMY ARTISTS' WATERCOLOR 2ND RANGE

PY3 ARYLIDE YELLOW 10G
ASTM II (37)
PG36 PHTHALOCYANINE GREEN
ASTM I (262)

PIGMENT DETAIL ON LABEL	ASTM	RATING
YES	II L'FAST	★ ★★

THALO YELLOW GREEN W210

GRUMBACHER

A colour easily produced on the palette. Reliable pigments which make up into a paint that handles particularly well. Semi-transparent.

FINEST ARTISTS' WATER COLOR

PY3 ARYLIDE YELLOW 10G
ASTM II (37)
PG7 PHTHALOCYANINE GREEN
ASTM I (259)

PIGMENT DETAIL ON LABEL	ASTM	
YES	II L'FAST	

THALO GREEN W205 (BLUE SHADE)

GRUMBACHER

Washed out very smoothly over a useful range of values.

Very thin clear washes are possible. An excellent watercolour. Transparent.

FINEST ARTISTS' WATER COLOR

PG7 PHTHALOCYANINE GREEN
ASTM I (259)

PIGMENT DETAIL ON LABEL	ASTM	
YES	I L'FAST	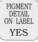

THALO GREEN W205 (BLUE SHADE)

GRUMBACHER

If you use this brand and wish to make savings, this is virtually identical to the 'Artist Quality'. Transparent.

ACADEMY ARTISTS' WATERCOLOR 2ND RANGE

PG7 PHTHALOCYANINE GREEN
ASTM I (259)

PIGMENT DETAIL ON LABEL	ASTM	
YES	I L'FAST	

Sap Green

Originally a fugitive 'lake' colour produced from the berries of the Buckthorn bush.

During Medieval times it was usually prepared without a binder as the juice was naturally tacky.

Allowed to thicken until it became very sticky, it was often kept in animal bladders. Later the colour was imitated by coal tar dyes, these were also usually fugitive.

Today, a variety of pigments are mixed to give 'Sap Greens'. These are still often fugitive.

This is not a unique colour in any way at all and it is either unsuitable for artistic use or an unimportant mix.

Such dull greens are easily blended. A violet-blue (Ultramarine), combined with an orange yellow such as Cadmium Yellow Light, will come close. Add a touch of either red to darken further.

SAP GREEN 623

All ingredients in this 'Sap Green' are reliable. Sample handled very well over a reasonable range of values.

Range discontinued

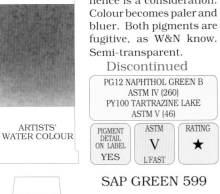

PG7 PHTHALOCYANINE GREEN
ASTM I (259)
PBr7 BURNT SIENNA ASTM I (310)
PG10 GREEN GOLD WG II (260)

PIGMENT DETAIL ON LABEL **YES**	**WG** **II** L'FAST	

TALENS
WATER COLOUR
2ND RANGE

SAP GREEN

Although PY129 has an ASTM rating of I in resin/oils, it could prove to be I, II or III as a watercolour.

Therefore I feel unable to offer an assessment on this paint. Sample was over bound.

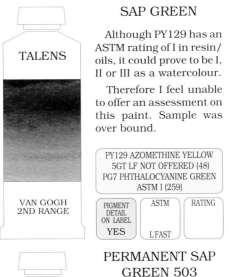

PY129 AZOMETHINE YELLOW
5GT LF NOT OFFERED (48)
PG7 PHTHALOCYANINE GREEN
ASTM I (259)

PIGMENT DETAIL ON LABEL **YES**	ASTM L'FAST	RATING

TALENS
VAN GOGH
2ND RANGE

SAP GREEN 550

There can be very few in the art materials industry who do not know that PG8 has failed ASTM testing as a watercolour.

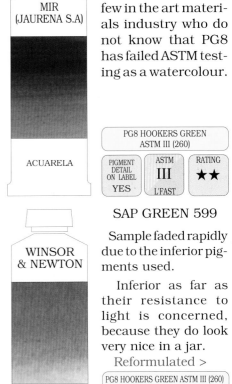

PG8 HOOKERS GREEN
ASTM III (260)

PIGMENT DETAIL ON LABEL **YES**	ASTM **III** L'FAST	RATING ★★

MIR
(JAURENA S.A)
ACUARELA

SAP GREEN 599
(043)

Unsuitable for artistic expression where permanence is a consideration. Colour becomes paler and bluer. Both pigments are fugitive, as W&N know. Semi-transparent.

Discontinued

PG12 NAPHTHOL GREEN B
ASTM IV (260)
PY100 TARTRAZINE LAKE
ASTM V (46)

PIGMENT DETAIL ON LABEL **YES**	ASTM **V** L'FAST	RATING ★

WINSOR & NEWTON
ARTISTS'
WATER COLOUR

PERMANENT SAP
GREEN 503

A newly introduced colour to this range. A rather sticky material which gave a range of washes with difficulty.

Heavier applications dry to a light shine.

PO49 QUINACRIDONE DEEP
GOLD WG II (97)
PG36 PHTHALOCYANINE
GREEN ASTM I (262)

PIGMENT DETAIL ON LABEL **YES**	**WG** **II** L'FAST	RATING ★★

WINSOR & NEWTON
ARTISTS'
WATER COLOUR

SAP GREEN 599

Sample faded rapidly due to the inferior pigments used.

Inferior as far as their resistance to light is concerned, because they do look very nice in a jar.

Reformulated >

PG8 HOOKERS GREEN ASTM III (260)
PY1 ARYLIDE YELLOW ASTM IV (37)

PIGMENT DETAIL ON LABEL **YES**	ASTM **IV** L'FAST	RATING ★

WINSOR & NEWTON
COTMAN
WATER COLOURS
2ND RANGE

SAP GREEN 599

Transparent, unworkable, coloured gum. But lightfast coloured gum.

PO49 QUINACRIDONE DEEP
GOLD WG II (97)
PG36 PHTHALOCYANINE
GREEN ASTM I (262)

PIGMENT DETAIL ON LABEL **YES**	**WG** **II** L'FAST	RATING ★

WINSOR & NEWTON
COTMAN
WATER COLOURS
2ND RANGE

SAP GREEN W187

Dependable ingredients give a watercolour paint which washes out very smoothly.

Dries with a slightly grainy appearance. Semi-transparent.

PO49 QUINACRIDONE DEEP
GOLD WG II (97)
PG7 PHTHALOCYANINE GREEN
ASTM I (259)

PIGMENT DETAIL ON LABEL **YES**	**WG** **II** L'FAST	

GRUMBACHER
FINEST
ARTISTS'
WATER COLOR

SAP GREEN A187

Reliable. Our sample stood up to light exposure testing very well. Brushed out smoothly. Semiopaque.

Reformulated >

PG7 PHTHALOCYANINE GREEN
ASTM I (259)
PO49 QUINACRIDONE DEEP
GOLD WG II (97)

PIGMENT DETAIL ON LABEL **YES**	**WG** **II** L'FAST	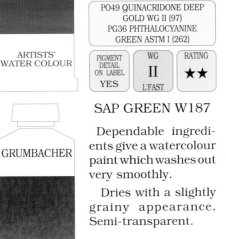

GRUMBACHER
ACADEMY
ARTISTS'
WATERCOLOR
2ND RANGE

SAP GREEN

GRUMBACHER

ACADEMY ARTISTS' WATERCOLOR 2ND RANGE

Rather a concoction to give a watercolour which washed out better in thin layers than when heavier. Slightly gummy. Lightfast.

PG7 PHTHALOCYANINE GREEN ASTM I (259)		
PO49 QUINACRIDONE DEEP GOLD WG II (97)		
PB15:4 PHTHALOCYANINE BLUE ASTM II (213)		
PY150 NICKEL AZO YELLOW ASTM I (49)		

PIGMENT DETAIL ON LABEL	ASTM	RATING
YES	II L'FAST	★ ★★

SAP GREEN 124

AMERICAN JOURNEY

PROFESSIONAL ARTISTS' WATER COLOR

Sample washed out well when light but not so well in heavier applications.

Reliable pigments have been employed.

PG7 PHTHALOCYANINE GREEN ASTM I (259)	
PY42 MARS YELLOW ASTM I (43)	

PIGMENT DETAIL ON LABEL	ASTM	RATING
YES	I L'FAST	★ ★★

SAP GREEN 102

DANIEL SMITH

EXTRA-FINE WATERCOLORS

A typical mixture to give the general idea of what a 'Sap Green' should look like. Such colours are so easily mixed. Well made, transparent and fast to light.

PO49 QUINACRIDONE DEEP GOLD WG II (97)	
PG7 PHTHALOCYANINE GREEN ASTM I (259)	

PIGMENT DETAIL ON LABEL	WG	
YES	II L'FAST	

SAP GREEN PERMANENT W36

ART SPECTRUM

ARTISTS' WATER COLOUR

By reputation PY15 is liable to fade on exposure to light. Given the wide range of suitable yellows which have been proven, why are such risks taken with your work? I have insufficient info. on PY15 to give an assessment.

PG10 GREEN GOLD WG II (260)	
PY15 DIARYLIDE YELLOW 5 LF NOT OFFERED (39)	
PG7 PHTHALOCYANINE GREEN ASTM I (259)	

PIGMENT DETAIL ON LABEL	ASTM	RATING
YES	L'FAST	

SAP GREEN 819

SENNELIER

EXTRA-FINE WATERCOLOUR

Reformulated from a fugitive colour to a lightfast one. (Check your old paints).

Now very reliable. Handles well over a wide range of values.

PB29 ULTRAMARINE BLUE ASTM I (215)	
PY154 BENZIMIDAZOLONE YELLOW H3G ASTM II (50)	

PIGMENT DETAIL ON LABEL	ASTM	
YES	II L'FAST	

SAP GREEN 1165

LUKAS

ARTISTS' WATER COLOUR

Another case of a mixed paint being let down by one of the ingredients, in this cases the PY1.

Colour change is serious on exposure. Semi-transparent.

PG7 PHTHALOCYANINE GREEN ASTM I (259)	
PY1 ARYLIDE YELLOW G ASTM V (37)	

PIGMENT DETAIL ON LABEL CHEMICAL MAKE UP ONLY	ASTM	RATING
	V L'FAST	★

SAP GREEN 23H

DR.Ph. MARTINS

HYDRUS FINE ART WATERCOLOR

All manufacturers of colorants described as being for artistic use should realise this:

I will be watching them very closely and very carefully on your behalf.

PIGMENTATION UNKNOWN AS DETAILS WERE NOT PROVIDED IN THE LITERATURE AND ARE NOT GIVEN ON THE LABEL

PIGMENT DETAIL ON LABEL	ASTM	RATING
NO	L'FAST	

SAP GREEN 375

DALER ROWNEY

ARTISTS' WATER COLOUR

The colour changes out of all recognition on contact with the light. Becomes a dull blue-green as the red and yellow components disappear. Semi-transparent, becoming very transparent.

Reformulated >

PR83:1 ALIZARIN CRIMSON ASTM IV (122)	
PY100 TARTRAZINE LAKE ASTM V (46)	
PG7 PHTHALOCYANINE GREEN ASTM I (259)	

PIGMENT DETAIL ON LABEL	ASTM	RATING
YES	V L'FAST	★

SAP GREEN

DALER ROWNEY

ARTISTS' WATER COLOUR

This is more like it, so it can be done. But it should not take commercial pressure applied by the artistic community to bring about such change.

A well made, reliable product.

PY153 NICKEL DIOXINE YELLOW ASTM II (50)	
PG7 PHTHALOCYANINE GREEN ASTM I (259)	
UNSPECIFIED PR101 ASTM I (123/124)	

PIGMENT DETAIL ON LABEL	ASTM	
NO	II L'FAST	

SAP GREEN

DALER ROWNEY

GEORGIAN WATER COLOUR 2ND RANGE

One glance at the ingredients will suggest that the yellow in this mix will quickly fade on exposure, altering the colour dramatically. Semi-transparent.

PB29 ULTRAMARINE BLUE ASTM I (215)	
PY1 ARYLIDE YELLOW G ASTM V (37)	

PIGMENT DETAIL ON LABEL	ASTM	RATING
NO	V L'FAST	★

SAP GREEN 623

TALENS

REMBRANDT ARTISTS' QUALITY EXTRA FINE

Lightfast ingredients give a reliable 'Sap Green'. Brushed out very smoothly giving even washes. Such colours are easily mixed. Semi-transparent.

Reformulated >

PG7 PHTHALOCYANINE GREEN ASTM I (259)	
PBr7 BURNT SIENNA ASTM I (310)	
PG10 GREEN GOLD WG II (260)	

PIGMENT DETAIL ON LABEL	WG	
YES	II L'FAST	

SAP GREEN 623

TALENS

REMBRANDT ARTISTS' QUALITY EXTRA FINE

The reformulated version handled in much the same way as the previous. Very satisfactory washes are obtainable in a useful range of values.

PY150 NICKEL AZO YELLOW ASTM I (49)	
PG7 PHTHALOCYANINE GREEN ASTM I (259)	

PIGMENT DETAIL ON LABEL	ASTM	
YES	I L'FAST	

SAP GREEN 247

PÈBÈO

FRAGONARD ARTISTS' WATER COLOUR

Produced from excellent, proven pigments this is a quality product which handles very well.

PG7 PHTHALOCYANINE GREEN ASTM I (259)
PY65 ARYLIDE YELLOW RN ASTM II (44)

| PIGMENT DETAIL ON LABEL YES | ASTM II L'FAST | |

SAP GREEN 358

MAIMERI

ARTISTI EXTRA FINE WATERCOLOURS

The inclusion of PG8, Hooker's Green, will cause overall fading and a change in colour. Semi-opaque. The PO43 once added has now been removed.

Discontinued

PY83HR70 DIARYLIDE YELLOW HR70 WG II (45)
PG8 HOOKERS GREEN ASTM III (260)

| PIGMENT DETAIL ON LABEL YES | ASTM III L'FAST | RATING ★★ |

SAP GREEN 358

MAIMERI

MAIMERIBLU SUPERIOR WATERCOLOURS

Typical of this colour type, being a dulled mid green, easily reproduced on the palette.

Reliable ingredients giving very smooth washes.

PV49 COBALT AMMONIUM VIOLET PHOSPHATE WG II (187)
PG36 PHTHALOCYANINE GREEN ASTM I (262)

| PIGMENT DETAIL ON LABEL YES | WG II L'FAST | |

SAP GREEN 358

MAIMERI

STUDIO FINE WATERCOLOURS

Once again PG8, Hooker's Green, is there to spoil the colour. It fades readily. Semi-opaque.

Discontinued

PY83HR70 DIARYLIDE YELLOW HR70 WG II (45)
PG8 HOOKERS GREEN ASTM III (260)

| PIGMENT DETAIL ON LABEL YES | ASTM III L'FAST | RATING ★★ |

SAP GREEN 358

MAIMERI

VENEZIA EXTRAFINE WATERCOLOURS

In keeping with the general idea of what a 'Sap Green' should look like.

Reliable ingredients making up into a convenience colour.

PV49 COBALT AMMONIUM VIOLET PHOSPHATE WG II (187)
PG7 PHTHALOCYANINE GREEN ASTM I (259)

| PIGMENT DETAIL ON LABEL YES | WG II L'FAST | |

SAP GREEN 277

DA VINCI PAINTS

PERMANENT ARTISTS' WATER COLOR

Both ingredients are very reliable. Sample brushed out smoothly. An easily mixed convenience colour. Semi transparent.

PG7 PHTHALOCYANINE GREEN ASTM I (259)
PY42 MARS YELLOW ASTM I (43)

| PIGMENT DETAIL ON LABEL YES | ASTM I L'FAST | |

SAP GREEN 677

DA VINCI PAINTS

SCUOLA 2ND RANGE

Reliable, well proven pigments have been used to produce a paint which did not handle well. Thinner washes were fine but the paint was unpleasant to use otherwise.

PG7 PHTHALOCYANINE GREEN ASTM I (259)
PY42 MARS YELLOW ASTM I (43)

| PIGMENT DETAIL ON LABEL YES | ASTM I L'FAST | RATING ★★ |

SAP GREEN LAKE EXTRA 292

OLD HOLLAND

CLASSIC WATERCOLOURS

A rather gum laden paint which washed out poorly unless very dilute. In all of the pigment descriptions PBk is given as PBL. You might come across this.

PY153 NICKEL DIOXINE YELLOW ASTM II (50)
PY42 MARS YELLOW ASTM I (43)
PG7 PHTHALOCYANINE GREEN ASTM I (259)
PBk7 CARBON BLACK ASTM I (370)

| PIGMENT DETAIL ON LABEL CHEMICAL MAKE UP ONLY | ASTM II L'FAST | RATING ★★ |

SAP GREEN 1 529

SCHMINCKE

HORADAM FINEST ARTISTS' WATER COLOURS

Expect a colour change on exposure. Becomes much paler and moves towards a yellow-green. PG8 is most unreliable.

Discontinued

PY83HR70 DIARYLIDE YELLOW HR70 WG II (45)
PO62 BENZIMIDAZOLONE ORANGE H5G ASTM II (97)
PG8 HOOKERS GREEN ASTM III (260)

| PIGMENT DETAIL ON LABEL YES | ASTM III L'FAST | RATING ★★ |

SAP GREEN 2 530

SCHMINCKE

HORADAM FINEST ARTISTS' WATER COLOURS

The Pigment Green 8, Hooker's Green, used in this colour is to be replaced with lightfast ingredients.

Reformulated >

PY138 QUINOPHTHALONE YELLOW ASTM II (48)
PG7 PHTHALOCYANINE GREEN ASTM I (259)
PG8 HOOKERS GREEN ASTM III (260)

| PIGMENT DETAIL ON LABEL YES | ASTM III L'FAST | RATING ★★ |

SAP GREEN 530

SCHMINCKE

HORADAM FINEST ARTISTS' WATER COLOURS

As both pigments are reasonably strong this is a colour which will play its part when mixing. Semi transparent and handles well. Semi staining.

PY153 NICKEL DIOXINE YELLOW ASTM II (50)
PG7 PHTHALOCYANINE GREEN ASTM I (259)

| PIGMENT DETAIL ON LABEL YES | ASTM II L'FAST | RATING |

SAP GREEN 553

LEFRANC & BOURGEOIS

LINEL EXTRA-FINE ARTISTS' WATERCOLOUR

Both given pigments are reliable and have been made up into a paint which handles very well.

PG7 PHTHALOCYANINE GREEN ASTM I (259)
PY153 NICKEL DIOXINE YELLOW ASTM II (50)

| PIGMENT DETAIL ON LABEL CHEMICAL MAKE UP ONLY | ASTM II L'FAST | |

SAP GREEN 174

M.GRAHAM & CO.

ARTISTS' WATERCOLOR

This watercolour paint handles very well at its various strengths. Unfortunately it will be prone to change as the yellow component has been proven to be less than lightfast.

PG7 PHTHALOCYANINE GREEN
ASTM I (259)
PY110 ISOINDOLINONE YELLOW R
ASTM III (47)

PIGMENT DETAIL ON LABEL	ASTM	RATING
YES	III L'FAST	★★

SAP GREEN W275

HOLBEIN

ARTISTS' WATER COLOR

The PG36 is the only reliable ingredient. Sample deteriorated rapidly from a fairly bright yellow-green to a dull, pale, blue green. Semi-opaque.

PG36 PHTHALOCYANINE GREEN
ASTM I (262)
PG8 HOOKERS GREEN ASTM III (260)
PY17 DIARYLIDE YELLOW AO WG V (39)

PIGMENT DETAIL ON LABEL	WG	RATING
YES	V L'FAST	★

Viridian

First class, quality Viridian takes considerable skill to manufacture. If it is not well ground it can be rather gritty and difficult to paint out unless very thin.

A bright, exceedingly clear blue green. Being very transparent it is highly valued as a glazing colour.

Compatible with all other pigments, unaffected by dilute acids and alkalis and completely lightfast, an excellent all round pigment.

Very similar in hue to Phthalocyanine Green but a little less intense.

For mixing purposes an ideal partner would be a transparent violet red such as Pigment Violet 19. Close as colour complementaries and both transparent.

Makes very clear blue greens with Phthalocyanine Blue and transparent yellow greens with a quality Lemon Yellow.

VIRIDIAN W232

GRUMBACHER

FINEST ARTISTS' WATER COLOR

Brushed out very well in thinner washes but heavier applications a little difficult to apply.

Pigment is absolutely lightfast. Transparent.

PG18 VIRIDIAN ASTM I (261)

PIGMENT DETAIL ON LABEL	ASTM	RATING
YES	I L'FAST	★ ★★

VIRIDIAN A232

GRUMBACHER

ACADEMY ARTISTS' WATER COLOR

A transparent colour which is absolutely lightfast.

Washes out well, particularly in thin applications.

PG7 PHTHALOCYANINE GREEN
ASTM I (259)
PG18 VIRIDIAN ASTM I (261)

PIGMENT DETAIL ON LABEL	ASTM	
YES	I L'FAST	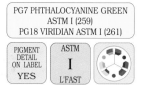

VIRIDIAN 529

LEFRANC & BOURGEOIS

LINEL EXTRA-FINE ARTISTS' WATERCOLOUR

Washed out well in thinner applications but difficult when heavier as sample rather over bound. Reliable.

Transparent.

PG18 VIRIDIAN ASTM I (261)

PIGMENT DETAIL ON LABEL	ASTM	RATING
CHEMICAL MAKE UP ONLY	I L'FAST	★ ★★

VIRIDIAN 348

MAIMERI

MAIMERIBLU SUPERIOR WATERCOLOURS

An excellent, all round watercolour with many admirable qualities. Well produced.

Transparent, giving very clear washes.

PG18 VIRIDIAN ASTM I (261)

PIGMENT DETAIL ON LABEL	ASTM	
YES	I L'FAST	

VIRIDIAN HUE 626

MAIMERI

STUDIO FINE WATER COLOUR 2ND RANGE

Phthalocyanine Green is a little brighter in colour than Viridian and can always be sold under its own name. The word 'Hue' has now been added to indicate an imitation colour. Transparent.

Discontinued

PG7 PHTHALOCYANINE GREEN
ASTM I (259)

PIGMENT DETAIL ON LABEL	ASTM	RATING
YES	I L'FAST	★ ★★

VIRIDIAN GLOWING 511

SCHMINCKE

HORADAM FINEST ARTISTS' WATER COLOURS

Sample rather over bound but brushed out smoothly in thinner washes.

Reliable ingredients. Transparent.

PG7 PHTHALOCYANINE GREEN
ASTM I (259)
PG18 VIRIDIAN ASTM I (261)

PIGMENT DETAIL ON LABEL	ASTM	RATING
YES	I L'FAST	★ ★★

VIRIDIAN 381

DALER ROWNEY

Like all transparent colours it takes on a very dark appearance at full strength.

An excellent all round watercolour. Transparent.

ARTISTS' WATER COLOUR

PG18 VIRIDIAN ASTM I (261)

PIGMENT DETAIL ON LABEL	ASTM	
YES	I L'FAST	

VIRIDIAN (HUE)

DALER ROWNEY

Why this is not offered simply as Phthalocyanine Green is somewhat of a mystery. It might have similar qualities but it is not Viridian.

Correctly named as a "Hue'. Transparent.

GEORGIAN WATER COLOUR 2ND RANGE

PG7 PHTHALOCYANINE GREEN ASTM I (259)

PIGMENT DETAIL ON LABEL	ASTM	
NO	I L'FAST	

VIRIDIAN 1154

LUKAS

A bright, strong blueish green. Sample washed out beautifully.

Pigment is absolutely lightfast. Transparent.

ARTISTS' WATER COLOUR

PG18 VIRIDIAN ASTM I (261)

PIGMENT DETAIL ON LABEL CHEMICAL MAKE UP ONLY	ASTM	
	I L'FAST	

VIRIDIAN GREEN 290

DA VINCI PAINTS

An excellent watercolour. Strong, particularly transparent and washes out smoothly. Tube well labelled. What more could be asked?

PERMANENT ARTISTS' WATER COLOR

PG18 VIRIDIAN ASTM I (261)

PIGMENT DETAIL ON LABEL	ASTM	
YES	I L'FAST	

VIRIDIAN GREEN 690

DA VINCI PAINTS

Sample was burdened with an excess of gum. Most unpleasant to use unless in extremely thin, very dilute layers.

SCUOLA 2ND RANGE

PG7 PHTHALOCYANINE GREEN ASTM I (259)

PIGMENT DETAIL ON LABEL	ASTM	RATING
YES	I L'FAST	★★

VIRIDIAN 112

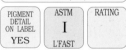

DANIEL SMITH

Sample slightly gummy but washed out well, particularly in dilute washes. Absolutely lightfast.

EXTRA-FINE WATERCOLORS

PG18 VIRIDIAN ASTM I (261)

PIGMENT DETAIL ON LABEL	ASTM	RATING
YES	I L'FAST	★ ★★

VIRIDIAN 692

WINSOR & NEWTON

Sample was very pasty. Only washed well when applied very thinly. Transparent and prone to granulating. (A quality that many seek).

ARTISTS' WATER COLOUR

PG18 VIRIDIAN ASTM I (261)

PIGMENT DETAIL ON LABEL	ASTM	RATING
YES	I L'FAST	★★

VIRIDIAN 698 (340)

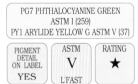

WINSOR & NEWTON

The use of PY1, a fugitive substance, will lead to a colour change on exposure to light. Transparent.

Discontinued

COTMAN WATER COLOURS 2ND RANGE

PG7 PHTHALOCYANINE GREEN ASTM I (259)
PY1 ARYLIDE YELLOW G ASTM V (37)

PIGMENT DETAIL ON LABEL	ASTM	RATING
YES	V L'FAST	★

VIRIDIAN HUE 696

WINSOR & NEWTON

I am afraid that I cannot offer assessments or a colour guide as a sample was not provided.

COTMAN WATER COLOURS 2ND RANGE

PG7 PHTHALOCYANINE GREEN ASTM I (259)

PIGMENT DETAIL ON LABEL	ASTM	RATING
YES	I L'FAST	

VIRIDIAN 692 (USA ONLY)

WINSOR & NEWTON

Sample was rather gum laden and did not brush out well. Transparent.

COTMAN WATER COLOURS 2ND RANGE

PG18 VIRIDIAN ASTM I (261)

PIGMENT DETAIL ON LABEL	ASTM	RATING
YES	I L'FAST	★★

VIRIDIAN GREEN DEEP 47

OLD HOLLAND

Sample was particularly gummy and unpleasant to use. Transparent.

CLASSIC WATERCOLOURS

PG18 VIRIDIAN ASTM I (261)

PIGMENT DETAIL ON LABEL CHEMICAL MAKE UP ONLY	ASTM	RATING
	I L'FAST	★

VIRIDIAN PALE 426

OLD HOLLAND

Sample was nearly all gum and most unpleasant to use. Lightfast.

CLASSIC WATERCOLOURS

PY37 CADMIUM YELLOW MEDIUM OR DEEP ASTM I (42)
PG18 VIRIDIAN ASTM I (261)

PIGMENT DETAIL ON LABEL CHEMICAL MAKE UP ONLY	ASTM	RATING
	I L'FAST	★

VIRIDIAN GREEN LIGHT 46

OLD HOLLAND

CLASSIC WATERCOLOURS

This company are certainly keen on the use of gum. Maybe Dutch artists like a well varnished look to their watercolours.

Sample unworkable.

PG18 VIRIDIAN ASTM I (261) PY3 ARYLIDE YELLOW 10G ASTM II (37)		
PIGMENT DETAIL ON LABEL CHEMICAL MAKE UP ONLY	ASTM **II** L'FAST	RATING ★

VIRIDIAN GREEN 18H

DR.Ph. MARTINS

HYDRUS FINE ART WATERCOLOR

Sample washed out to give a colour which is quite unlike Viridian Green.

I haven't a clue as to the colorant used.

INFORMATION ON THE PIGMENT/S USED IN THIS PRODUCT ARE NOT GIVEN		
PIGMENT DETAIL ON LABEL NO	ASTM L'FAST	RATING

VIRIDIAN 164

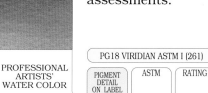

UTRECHT

PROFESSIONAL ARTISTS' WATER COLOR

As the colour has a different appearance to unadulterated Viridian, and no other pigments are listed, I will not offer assessments.

PG18 VIRIDIAN ASTM I (261)		
PIGMENT DETAIL ON LABEL YES	ASTM L'FAST	RATING

VIRIDIAN No.8

PENTEL

WATERCOLOR

The pigment information panel shown below says it all.

INFORMATION ON THE PIGMENT/S USED IN THIS PRODUCT ARE NOT GIVEN ON THE LABEL OR IN THE LITERATURE PROVIDED		
PIGMENT DETAIL ON LABEL NO	ASTM L'FAST	RATING

VIRIDIAN

PENTEL (POLY TUBE)

WATERCOLOR

Please see write up given with the colour to the left.

INFORMATION ON THE PIGMENT/S USED IN THIS PRODUCT ARE NOT GIVEN ON THE LABEL OR IN THE LITERATURE PROVIDED		
PIGMENT DETAIL ON LABEL NO	ASTM L'FAST	RATING

VIRIDIAN 195

M.GRAHAM & CO.

ARTISTS' WATERCOLOR

A reliable pigment used to produce a watercolour paint which brushed out very well. Transparent.

PG18 VIRIDIAN ASTM I (261)		
PIGMENT DETAIL ON LABEL YES	ASTM **I** L'FAST	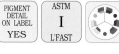

VIRIDIAN 545

MIR (JAURENA S.A)

ACUARELA

This is not Viridian at all. Phthalocyanine Green and Viridian might have certain admirable qualities in common: transparency, strength, brightness and similarities in hue, but they are not one and the same.

PG7 PHTHALOCYANINE GREEN ASTM I (259)		
PIGMENT DETAIL ON LABEL YES	ASTM **I** L'FAST	RATING ★ ★★

VIRIDIAN W35

ART SPECTRUM

ARTISTS' WATER COLOUR

A lightfast, transparent mid-green produced with the correct pigment.

Sample washed out fairly well overall but better when thinned.

Granulating, particularly on a rough surface. Many seek this quality.

PG18 VIRIDIAN ASTM I (261)		
PIGMENT DETAIL ON LABEL YES	ASTM **I** L'FAST	RATING ★ ★★

VIRIDIAN 616

TALENS

REMBRANDT ARTISTS' QUALITY EXTRA FINE

Viridian is extremely transparent and washes out to give very clear, pure tints. Bright and lightfast.

PG18 VIRIDIAN ASTM I (261)		
PIGMENT DETAIL ON LABEL YES	ASTM **I** L'FAST	

VIRIDIAN 616

TALENS

WATER COLOUR 2ND RANGE

A reliable watercolour which brushed out very smoothly at all strengths.

As lightfast as the 'Artist Quality' version. Transparent.

Range discontinued

PG18 VIRIDIAN ASTM I (261)		
PIGMENT DETAIL ON LABEL YES	ASTM **I** L'FAST	

VIRIDIAN 616

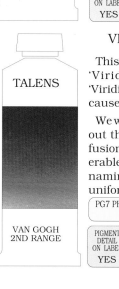

TALENS

VAN GOGH 2ND RANGE

This should be called 'Viridian Hue' or 'Viridian Imitation' because it is not Viridian.

We will not start to sort out the remaining confusion, which is considerable, until at least the naming of colours is uniform.

PG7 PHTHALOCYANINE GREEN ASTM I (259)		
PIGMENT DETAIL ON LABEL YES	ASTM **I** L'FAST	RATING ★ ★★

VIRIDIAN 837

SENNELIER

EXTRA-FINE WATERCOLOUR

A mix of two pigments which are very similar in hue and characteristics. Perhaps the 'Phthalo' Green gives a little extra brightness. Should be called 'Viridian Hue'. Transparent.

PG7 PHTHALOCYANINE GREEN ASTM I (259) PG18 VIRIDIAN ASTM I (261)		
PIGMENT DETAIL ON LABEL YES	ASTM **I** L'FAST	RATING ★ ★★

VIRIDIAN HUE W261

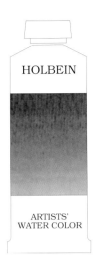

HOLBEIN

ARTISTS' WATER COLOR

This is not Viridian at all but Phthalocyanine Green. It should ideally be sold under its correct title to reduce confusion. Transparent and hard to lift.

PG7 PHTHALOCYANINE GREEN ASTM I (259)

PIGMENT DETAIL ON LABEL	ASTM	RATING
YES	I L'FAST	★ ★★

VIRIDIAN 142

AMERICAN JOURNEY

PROFESSIONAL ARTISTS' WATER COLOR

Sample washed out well when diluted but was less pleasant to use when at all heavy.

PG18 VIRIDIAN ASTM I (261)

PIGMENT DETAIL ON LABEL	ASTM	RATING
YES	I L'FAST	★ ★★

VIRIDIAN W260

HOLBEIN

ARTISTS' WATER COLOR

Sample was overbound. Brushed out well in thin washes but heavier applications a little difficult to apply. Lightfast, transparent and staining.

PG18 VIRIDIAN ASTM I (261)

PIGMENT DETAIL ON LABEL	ASTM	RATING
YES	I L'FAST	★ ★★

VIRIDIAN 2770

UMTON BARVY

ARTISTIC WATER COLOR

Although Phthalocyanine Green and Viridian share many admirable characteristics they are not one and the same.

By offering them as though they were, the artists choice is influenced.

PG7 PHTHALOCYANINE GREEN ASTM I (259)

PIGMENT DETAIL ON LABEL	ASTM	RATING
NO	I L'FAST	★ ★★

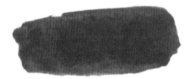

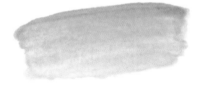

Viridian is particularly transparent. When applied heavily the light tends to sink into the paint film and much of it stays there.

This causes the paint to appear very dark. In effect it is similar to light sinking into thick green glass.

The true beauty of the colour is only revealed when the paint is applied well diluted. Unfortunately, too few artists seem to appreciate the particular characteristics of their paints, treating both transparent and opaque in much the same way.

Miscellaneous Greens

Many painters rely on the large range of greens available and set about collecting most, if not all, that are on offer. The belief seems to be that each is somehow unique and necessary for a full repertoire.

We have available a limited number of truly unique greens and a wide range of simple mixes.

In previous pages I have pointed out that colours such as Olive Green and Hooker's Green are no more than blends of readily available pigments, many being of dubious value.

In this section you will find further examples of simple mixes marketed under names which suggest a respectability not always deserved.

You will also find many basic pigments (such as Phthalocyanine Green), which have been given fanciful or trade names.

It is little wonder that many painters are confused. How can the artist be selective whilst such practices continue?

ALIZARIN GREEN 301

DALER ROWNEY

ARTISTS' WATER COLOUR

On exposure to light will change dramatically. Moves from a yellow green to a light blue green as the yellow departs.

Discontinued

PG7 PHTHALOCYANINE GREEN ASTM I (259)
PY100 TARTRAZINE LAKE ASTM V (46)

PIGMENT DETAIL ON LABEL	ASTM	RATING
YES	V	★
	L'FAST	

ANTIQUE OPAL GREEN 013

HOLBEIN

IRODORI ANTIQUE WATERCOLOR

If you have difficulty mixing white with Phthalocyanine Green, this is for you. Lightfast and washes very well, giving smooth, even layers.

PG7 PHTHALOCYANINE GREEN ASTM I (259)
PW6 TITANIUM WHITE ASTM I (385)

PIGMENT DETAIL ON LABEL	ASTM	
YES	I	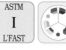
	L'FAST	

ANTIQUE YELLOW GREEN 012

HOLBEIN

IRODORI ANTIQUE WATERCOLOR

Another convenience colour which is easy to mix from standard paints.

Lightfast and washes out very nicely.

PG7 PHTHALOCYANINE GREEN ASTM I (259)
PY42 MARS YELLOW ASTM I (43)

PIGMENT DETAIL ON LABEL	ASTM	
YES	I	
	L'FAST	

ANTIQUE SEEDLING 037

HOLBEIN

IRODORI ANTIQUE WATERCOLOR

A green with a pronounced leaning towards yellow. Such yellow greens are best desaturated with a violet red when darkening.

Well made and with reliable pigments.

PG7 PHTHALOCYANINE GREEN ASTM I (259)
PY3 ARYLIDE YELLOW 10G ASTM II (37)

PIGMENT DETAIL ON LABEL	ASTM	
YES	II	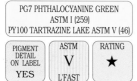
	L'FAST	

ANTIQUE JASPER GREEN 014

HOLBEIN

IRODORI ANTIQUE WATERCOLOR

This is a rather fancy name for good old Phthalocyanine Green, but I suppose that it keeps the sales going.

As reliable as this green always is.

PG7 PHTHALOCYANINE GREEN ASTM I (259)

PIGMENT DETAIL ON LABEL	ASTM	
YES	I	
	L'FAST	

ANTIQUE DARK GREEN 015

HOLBEIN

IRODORI ANTIQUE WATERCOLOR

There can be very few in the art material industry who do not know that PG8 is prone to damage when exposed to light.

PG8 HOOKERS GREEN ASTM III (260)
PY42 MARS YELLOW ASTM I (43)

PIGMENT DETAIL ON LABEL	ASTM	RATING
YES	III	★★
	L'FAST	

ANTIQUE BAMBOO 039

HOLBEIN

IRODORI ANTIQUE WATERCOLOR

If you use either Phthalocyanine Green or Viridian, simply add white and stir.

If you have already had enough challenges in life, this colour is lightfast, well made and handles well.

PG7 PHTHALOCYANINE GREEN ASTM I (259)
PW6 TITANIUM WHITE ASTM I (385)

PIGMENT DETAIL ON LABEL	ASTM	
YES	I	
	L'FAST	

ANTIQUE SPRING GREEN 011

HOLBEIN

IRODORI ANTIQUE WATERCOLOR

Starts life as a yellow green and then gradually becomes Phthalocyanine Green as the yellow casually departs.

PG7 PHTHALOCYANINE GREEN ASTM I (259)
PY14 DIARYLIDE YELLOW OT WG IV (39)

PIGMENT DETAIL ON LABEL	WG	RATING
YES	IV	★
	L'FAST	

ANTIQUE ELM GREEN 016

HOLBEIN

IRODORI ANTIQUE WATERCOLOR

A nice name, isn't it. Such a shame that the documented, proven unreliability of the PG8 will gradually move the colour towards a dull yellow.

PG8 HOOKERS GREEN ASTM III (260)
PY42 MARS YELLOW ASTM I (43)

PIGMENT DETAIL ON LABEL	ASTM	RATING
YES	III	★★
	L'FAST	

ANTIOCHE GREEN LIGHT 510

LEFRANC & BOURGEOIS

LINEL EXTRA-FINE ARTISTS' WATERCOLOUR

A fancy name used to sell a simple mix. Easily reproduced.

Reliable ingredients, handled well. Semi-transparent.

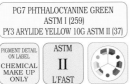

| PG7 PHTHALOCYANINE GREEN ASTM I (259) |
| PY3 ARYLIDE YELLOW 10G ASTM II (37) |

| PIGMENT DETAIL ON LABEL CHEMICAL MAKE UP ONLY | ASTM II L'FAST | |

ARMOR GREEN 512

LEFRANC & BOURGEOIS

LINEL EXTRA-FINE ARTISTS' WATERCOLOUR

This company does not offer the artist a Phthalocyanine Green as such, but markets it under this fancy and confusing title. Transparent and well made.

| PG7 PHTHALOCYANINE GREEN ASTM I (259) |

| PIGMENT DETAIL ON LABEL CHEMICAL MAKE UP ONLY | ASTM I L'FAST | |

AUSTRALIAN LEAF GREEN (DARK) W38

ART SPECTRUM

ARTISTS' WATER COLOUR

Sample was most unpleasant to use, gritty and handled poorly.

| PG7 PHTHALOCYANINE GREEN ASTM I (259) |
| PY42 MARS YELLOW ASTM I (43) |

| PIGMENT DETAIL ON LABEL YES | ASTM I L'FAST | RATING ★★ |

AUSTRALIAN GREEN GOLD W39

ART SPECTRUM

ARTISTS' WATER COLOUR

Did not handle well when at all heavy. This is almost certainly to do with the pigment, which lacks 'body', rather than production methods. Lightfast.

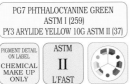

| PG10 GREEN GOLD WG II (260) |

| PIGMENT DETAIL ON LABEL YES | WG I L'FAST | RATING ★ ★★ |

BAMBOO GREEN W278

HOLBEIN

ARTISTS' WATER COLOR

This is good old Phthalocyanine Green again, under yet another fancy name. Don't fall for it.

Transparent, staining and hard to lift.

| PG36 PHTHALOCYANINE GREEN ASTM I (262) |

| PIGMENT DETAIL ON LABEL YES | ASTM I L'FAST | |

BLUISH GREEN 640

TALENS

REMBRANDT ARTISTS' QUALITY EXTRA FINE

Fine for very thin washes but becomes a coloured gum, which is unpleasant to use, when at all heavy.

But it is lightfast.

| PG7 PHTHALOCYANINE GREEN ASTM I (259) |
| PB15 PHTHALOCYANINE BLUE ASTM II (213) |

| PIGMENT DETAIL ON LABEL YES | ASTM II L'FAST | RATING ★★ |

BOHEMIAN GREEN EARTH - ORIGINAL 2710

UMTON BARVY

ARTISTIC WATER COLOR

An extremely weak paint which could only be applied in very thin layers.

Behaves in much the same way as all paints produced using this pigment behave.

| PG23 GREEN EARTH ASTM I (262) |

| PIGMENT DETAIL ON LABEL NO | ASTM I L'FAST | RATING ★★ |

BOHEMIAN GREEN EARTH - IM 2700

UMTON BARVY

ARTISTIC WATER COLOR

Rather weak and suitable only for thinner applications. In this respect it imitates 'Green Earth' very well.

| PG7 PHTHALOCYANINE GREEN ASTM I (259) |
| UNSPECIFIED PBr7 ASTM I (309-310) |

| PIGMENT DETAIL ON LABEL NO | ASTM I L'FAST | RATING ★ ★★ |

BOHEMIAN GREEN EARTH 007

DANIEL SMITH

EXTRA-FINE WATERCOLORS

I know that Natural green Earth lacks 'body' but this is overdoing it.

Thick coloured gum, quite appalling.

| NATURAL GREEN EARTH |

| PIGMENT DETAIL ON LABEL YES | ASTM I L'FAST | RATING ★ |

BRILLIANT YELLOW GREEN 1 917

SCHMINCKE

HORADAM FINEST ARTISTS' WATER COLOURS

I will not offer assessments as our sample darkened in mass tone. The stated ingredients would not normally do this.

Discontinued

| PG7 PHTHALOCYANINE GREEN ASTM I (259) |
| PY3 ARYLIDE YELLOW 10G ASTM II (37) |

| PIGMENT DETAIL ON LABEL YES | ASTM II L'FAST | RATING |

BRILLIANT YELLOW GREEN 2 918

SCHMINCKE

HORADAM FINEST ARTISTS' WATER COLOURS

The PY1 which once ruined this colour has been replaced by the reliable PY154. Now a superb, lightfast colour. Semi-transparent.

Discontinued

| PG7 PHTHALOCYANINE GREEN ASTM I (259) |
| PY3 ARYLIDE YELLOW 10G ASTM II (37) |
| PY154 BENZIMIDAZOLONE YELLOW H3G ASTM II (50) |

| PIGMENT DETAIL ON LABEL YES | ASTM II L'FAST | |

BRILLIANT GREEN 1 915

SCHMINCKE

HORADAM FINEST ARTISTS' WATER COLOURS

A disastrous substance which becomes a dark grey - green when subjected to light. Short lived brilliance. The PG1 causes the damage.

Discontinued

| PG1 BRILLIANT GREEN WG V (259) |
| PY3 ARYLIDE YELLOW 10G ASTM II (37) |

| PIGMENT DETAIL ON LABEL YES | ASTM V L'FAST | RATING ★ |

BRILLIANT GREEN 2

SCHMINCKE

Reliable ingredients give a bright green which will retain its colour. Brushed out very smoothly over the range. Semi-transparent.

HORADAM
FINEST
ARTISTS'
WATER COLOURS

PG7 PHTHALOCYANINE GREEN
ASTM I (259)
PY3 ARYLIDE YELLOW 10G ASTM II (37)

PIGMENT DETAIL ON LABEL	ASTM	
YES	II L'FAST	

CINNABAR GREEN 548

MIR (JAURENA S.A)

It is no secret that PG8 Hookers Green is susceptible to damage when exposed to light.

ACUARELA

PY42 MARS YELLOW ASTM I (43)
PG8 HOOKERS GREEN ASTM III (260)

PIGMENT DETAIL ON LABEL	ASTM	RATING
YES	III L'FAST	★★

COMPOSE GREEN 3 W273

HOLBEIN

Unreliable when exposed to light, (but how else will you be able to see it). Sample altered considerably, becoming paler and bluer. Semi-transparent.

ARTISTS'
WATER COLOR

PG8 HOOKERS GREEN ASTM III (260)
PY3 ARYLIDE YELLOW 10G ASTM II (37)
PY14 DIARYLIDE YELLOW OT
WG IV (39)

PIGMENT DETAIL ON LABEL	WG	RATING
YES	IV L'FAST	★

COMPOSE GREEN 1 W271

HOLBEIN

The addition of white takes the paint closer to a gouache than a traditional watercolour. Reliable. Semi-opaque.

ARTISTS'
WATER COLOR

PG7 PHTHALOCYANINE GREEN
ASTM I (259)
PW6 TITANIUM WHITE ASTM I (385)
PY3 ARYLIDE YELLOW 10G ASTM II (37)

PIGMENT DETAIL ON LABEL	ASTM	
YES	II L'FAST	

COMPOSE GREEN 2 W272

HOLBEIN

Despite the reliability of the stated ingredients, our sample showed a marked colour change, becoming bluer.

Not assessed pending retesting. Semi-opaque, non staining.

ARTISTS'
WATER COLOR

PG7 PHTHALOCYANINE GREEN
ASTM I (259)
PW6 TITANIUM WHITE ASTM I (385)
PY3 ARYLIDE YELLOW 10G ASTM II (37)

PIGMENT DETAIL ON LABEL	ASTM	RATING
YES	L'FAST	

CINNABAR GREEN PALE EXTRA 423

OLD HOLLAND

Cinnabar Green is the name once used for Chrome Green. Excellent ingredients.

Paint brushed out very smoothly over good range of values. Semi-opaque.

Reformulated>

CLASSIC
WATERCOLOURS

PY37 CADMIUM YELLOW MEDIUM
OR DEEP ASTM I (42)
PG18 VIRIDIAN ASTM I (261)

PIGMENT DETAIL ON LABEL	ASTM	
CHEMICAL MAKE UP ONLY	I L'FAST	

CINNABAR GREEN LIGHT EXTRA 43

OLD HOLLAND

Quality ingredients leading to a quality watercolour paint. Washed out very well at all strengths.

CLASSIC
WATERCOLOURS

PY35 CADMIUM YELLOW LIGHT
ASTM I (41)
PG18 VIRIDIAN ASTM I (261)
PB29 ULTRAMARINE BLUE ASTM I (215)

PIGMENT DETAIL ON LABEL	ASTM	
CHEMICAL MAKE UP ONLY	I L'FAST	

CINNABAR GREEN DEEP

OLD HOLLAND

The ingredients are all absolutely lightfast and make into a paint which brushes out very smoothly. Separates slightly on drying. Semi-opaque.

Reformulated >

CLASSIC
WATERCOLOURS

PG18 VIRIDIAN ASTM I (261)
PY37 CADMIUM YELLOW MEDIUM
OR DEEP ASTM I (42)
PBr7 RAW UMBER ASTM I (309)

PIGMENT DETAIL ON LABEL	ASTM	
CHEMICAL MAKE UP ONLY	I L'FAST	

CINNABAR GREEN DEEP EXTRA 51

OLD HOLLAND

Thick coloured gum. Unworkable.

As far as our sample is concerned, a waste of quality pigments.

CLASSIC
WATERCOLOURS

PG18 VIRIDIAN ASTM I (261)
PBr7 BURNT SIENNA ASTM I (310)
PY3 ARYLIDE YELLOW 10G
ASTM II (37)

PIGMENT DETAIL ON LABEL	ASTM	RATING
CHEMICAL MAKE UP ONLY	II L'FAST	★

CYPRUS GREEN 2 PERMANENT 526

LEFRANC & BOURGEOIS

Lighfast ingredients give a dependable green which is easily duplicated. Transparent and well produced.

LINEL
EXTRA-FINE
ARTISTS'
WATERCOLOUR

PG7 PHTHALOCYANINE GREEN
ASTM I (259)
PY3 ARYLIDE YELLOW 10G ASTM II (37)

PIGMENT DETAIL ON LABEL	ASTM	
CHEMICAL MAKE UP ONLY	II L'FAST	

CUPRIC GREEN LIGHT 322

MAIMERI

Phthalocyanine Green certainly comes in for some name bending.

Washed out well when thinned but not so when heavier.

MAIMERIBLU
SUPERIOR
WATERCOLOURS

PG36 PHTHALOCYANINE GREEN
ASTM I (262)

PIGMENT DETAIL ON LABEL	ASTM	RATING
YES	I L'FAST	★ ★★

CUPRIC GREEN DEEP 324

MAIMERI

This colour and that to the left illustrate the hue difference between PG36 (yellowish) and PG7 (bluish).

Well made, reliable, transparent and a silly name. What more could you ever want?

MAIMERIBLU
SUPERIOR
WATERCOLOURS

PG7 PHTHALOCYANINE GREEN
ASTM I (259)

PIGMENT DETAIL ON LABEL	ASTM	
YES	I L'FAST	

CINNABAR GREEN LIGHT 1171

LUKAS

Without the addition of PY1, this would have been a lightfast colour. Similar, reliable yellows are available for such mixes. Semi-transparent.

ARTISTS' WATER COLOUR

| PG7 PHTHALOCYANINE GREEN ASTM I (259) |
| PY1 ARYLIDE YELLOW G ASTM V (37) |
| PY42 MARS YELLOW ASTM I (43) |

| PIGMENT DETAIL ON LABEL CHEMICAL MAKE UP ONLY | ASTM V L'FAST | RATING ★ |

CINNABAR GREEN DEEP 1173

LUKAS

Built-in potential to self destruct on two fronts. PY1 and PB1 are both fugitive and unsuitable for lasting artistic work. Semi transparent.

Reformulated >

ARTISTS' WATER COLOUR

| PG7 PHTHALOCYANINE GREEN ASTM I (259) |
| PBk11 MARS BLACK ASTM I (371) |
| PY1 ARYLIDE YELLOW G ASTM V (37) |
| PB1 VICTORIA BLUE WG V (213) |

| PIGMENT DETAIL ON LABEL CHEMICAL MAKE UP ONLY | ASTM V L'FAST | RATING ★ |

CINNABAR GREEN DEEP 1173

LUKAS

I do not intend to decipher the chemical description found on the tube label.

As support literature was not supplied, assessments cannot be offered.

ARTISTS' WATER COLOUR

| PHTHALOCYANINE MONOAZO PIGMENT |

| PIGMENT DETAIL ON LABEL CHEMICAL MAKE UP ONLY | ASTM L'FAST | RATING |

CYANIN GREEN 246

PÈBÈO

If Phthalocyanine Green was offered as such, there would be a little less confusion.

Well produced, transparent.

FRAGONARD ARTISTS' WATER COLOUR

| PG7 PHTHALOCYANINE GREEN ASTM I (259) |

| PIGMENT DETAIL ON LABEL YES | ASTM I L'FAST | |

DEEP GREEN No.22

PENTEL

If you have used this colour, or any in the range, I hope that you understood more about the pigmentation that I do.

WATER COLOUR

| INFORMATION ON THE PIGMENT/S EMPLOYED NOT PROVIDED ON LABEL OR IN LITERATURE |

| PIGMENT DETAIL ON LABEL NO | ASTM L'FAST | RATING |

GREEN LAKE PERMANENT 548

LEFRANC & BOURGEOIS

The stated ingredients are normally reliable. Our sample however, faded dramatically. Assessments are not offered pending further enquiry. Semi-transparent.

Reformulated >

LINEL EXTRA-FINE ARTISTS' WATERCOLOUR

| PG7 PHTHALOCYANINE GREEN ASTM I (259) |
| PY153 NICKEL DIOXINE YELLOW ASTM II (50) |

| PIGMENT DETAIL ON LABEL CHEMICAL MAKE UP ONLY | ASTM L'FAST | RATING |

GREEN LAKE PERMANENT 548

LEFRANC & BOURGEOIS

Reliable, well proven ingredients give rise to an excellent watercolour paint. Brushed out very smoothly across the range. Very well made product.

LINEL EXTRA-FINE ARTISTS' WATERCOLOUR

| PB15:1 PHTHALOCYANINE BLUE ASTM II (213) |
| PG7 PHTHALOCYANINE GREEN ASTM I (259) |
| PY153 NICKEL DIOXINE YELLOW ASTM II (50) |

| PIGMENT DETAIL ON LABEL CHEMICAL MAKE UP ONLY | ASTM II L'FAST | |

GREEN GOLD 373

DALER ROWNEY

There is every possibility that PY129 will prove to be as lightfast as a watercolour as it was when made into an oil paint. However, there is also a possibility that it will not.

I am afraid that I cannot offer assessments.

ARTISTS' WATER COLOUR

| PY129 AZOMETHINE YELLOW 5GT LF NOT OFFERED (48) |

| PIGMENT DETAIL ON LABEL YES | ASTM L'FAST | RATING |

GREEN LAKE DEEP 518

SCHMINCKE

For whatever reason, PG8 is very popular with the colourmen.

As far as the artist is concerned, it is unreliable and will fade on exposure to light.

Discontinued

HORADAM FINEST ARTISTS' WATER COLOURS

| PB15:1 PHTHALOCYANINE BLUE ASTM II (213) |
| PG8 HOOKERS GREEN ASTM III (260) |
| PG7 PHTHALOCYANINE GREEN ASTM I (259) |

| PIGMENT DETAIL ON LABEL YES | ASTM III L'FAST | RATING ★★ |

GREENGOLD 237

PÈBÈO

A reliable bright yellow-green.

Such colours are easily mixed from a green-yellow and a green-blue. Semi-transparent.

FRAGONARD ARTISTS' WATER COLOUR

| PG10 GREEN GOLD WG II (260) |

| PIGMENT DETAIL ON LABEL YES | WG II L'FAST | |

GREEN GOLD 294

WINSOR & NEWTON

Coloured gum, an appalling substance to offer as an artists' quality watercolour paint.

ARTISTS' WATER COLOUR

| PY129 AZOMETHINE YELLOW 5GT LF NOT OFFERED (48) |

| PIGMENT DETAIL ON LABEL YES | ASTM L'FAST | RATING ★ |

GREEN UMBER 310

OLD HOLLAND

The sample tubes were supplied in a most beautiful wooden presentation case. Unfortunately the contents were, for the most part, over bound. Many, as in this case, no more than unworkable coloured gum.

CLASSIC WATERCOLOURS

| PG23 GREEN EARTH/TERRE VERTE ASTM I (262) |
| PG7 PHTHALOCYANINE GREEN ASTM I (259) |
| PB15 PHTHALOCYANINE BLUE ASTM II (213) |
| *UNSPECIFIED PBr7 (309/310)* |

| PIGMENT DETAIL ON LABEL CHEMICAL MAKE UP ONLY | ASTM I L'FAST | RATING ★ |

HELIO GENUINE GREEN LIGHT 1193

LUKAS — ARTISTS' WATER COLOUR

Pigment Yellow 1 is an unreliable colorant which is known to fade on exposure. It will cause damage to any mix. Semi-transparent.

| PG7 PHTHALOCYANINE GREEN ASTM I (259) |
| PY1 ARYLIDE YELLOW G ASTM V (37) |
| PY3 ARYLIDE YELLOW 10G ASTM II (37) |

| PIGMENT DETAIL ON LABEL CHEMICAL MAKE UP ONLY | ASTM V L'FAST | RATING ★ |

HELIO GENUINE GREEN DEEP 1195

LUKAS — ARTISTS' WATER COLOUR

If Phthalocyanine Green, (an excellent pigment), was marketed under it's own name, it would be in greater demand. Transparent.

| PG7 PHTHALOCYANINE GREEN ASTM I (259) |

| PIGMENT DETAIL ON LABEL CHEMICAL MAKE UP ONLY | ASTM I L'FAST | |

HELIO GREEN 514

SCHMINCKE — HORADAM FINEST ARTISTS' WATER COLOURS

The pigments previously used were absolutely lightfast, as is the PG36 now employed. Transparent.

This colour was previously called 'Permanent Green Deep'.

| PG36 PHTHALOCYANINE GREEN ASTM I (262) |

| PIGMENT DETAIL ON LABEL YES | ASTM I L'FAST | |

GREEN GREY W352

HOLBEIN — ARTISTS' WATER COLOR

Well produced watercolour paint employing lightfast pigments. Such dark greens are easily mixed by adding a touch of red to a green.

| PBk6 LAMP BLACK ASTM I (370) |
| PG23 GREEN EARTH/TERRE VERTE ASTM I (262) |
| PG17 CHROMIUM OXIDE GREEN ASTM I (261) |

| PIGMENT DETAIL ON LABEL YES | ASTM I L'FAST | |

INTENSE GREEN 329

WINSOR & NEWTON — COTMAN WATER COLOURS 2ND RANGE

Yet another name under which to market Phthalocyanine Green.

Lightfast and very transparent.

Reformulated >

| PG7 PHTHALOCYANINE GREEN ASTM I (259) |

| PIGMENT DETAIL ON LABEL YES | ASTM I L'FAST | |

INTENSE GREEN 329

WINSOR & NEWTON — COTMAN WATER COLOURS 2ND RANGE

An over bound watercolour paint which gave good thin washes, difficult medium and impossible heavy.

But it is lightfast.

| PG36 PHTHALOCYANINE GREEN ASTM I (262) |

| PIGMENT DETAIL ON LABEL YES | ASTM I L'FAST | RATING ★★ |

JOE'S GREEN (PHTHALO) 070

AMERICAN JOURNEY — PROFESSIONAL ARTISTS' WATER COLOR

In previous editions I have given a lower rating when ridiculous names have been used to describe a known colorant. I have stopped doing this now as I have simply given up. If such descriptions actually help to sell paints they will not cease. I will concentrate on the quality only.

| PG7 PHTHALOCYANINE GREEN ASTM I (259) |

| PIGMENT DETAIL ON LABEL YES | ASTM I L'FAST | |

LEAF GREEN

DALER ROWNEY — GEORGIAN WATER COLOUR 2ND RANGE

Another fancy title used to describe a simple mix of standard pigments. Reliable ingredients, handles very well. Semi-transparent.

| PG7 PHTHALOCYANINE GREEN ASTM I (259) |
| PY3 ARYLIDE YELLOW 10G ASTM II (37) |
| PW6 TITANIUM WHITE ASTM I (385) |

| PIGMENT DETAIL ON LABEL NO | ASTM II L'FAST | |

LEAF GREEN

GRUMBACHER — ACADEMY ARTISTS' WATERCOLOR 2ND RANGE

Sample washed out very evenly.

I cannot offer assessments as I do not have details of the pigments used.

| PIGMENT DETAILS NOT SUPPLIED |

| PIGMENT DETAIL ON LABEL NO | ASTM L'FAST | RATING |

LEAF GREEN W277

HOLBEIN — ARTISTS' WATER COLOR

A semi-transparent yellow green. Lightfast and washed out well.

In order to create a darker version of any yellow-green add a small touch of a violet-red such as Quinacridone violet.

| PG7 PHTHALOCYANINE GREEN ASTM I (259) |
| PY154 BENZIMIDAZOLONE YELLOW H3G ASTM II (50) |

| PIGMENT DETAIL ON LABEL YES | ASTM II L'FAST | |

LINDEN GREEN 517

SCHMINCKE — HORADAM FINEST ARTISTS' WATER COLOURS

Pigment Green 8, Hooker's Green, has fortunately been removed. All pigments are now lightfast. Semi-trans. Recent name change from 'Green Lake Light'.

Discontinued

| PY3 ARYLIDE YELLOW 10G ASTM II (37) |
| PG7 PHTHALOCYANINE GREEN ASTM I (259) |
| PBr7 BURNT SIENNA ASTM I (310) |

| PIGMENT DETAIL ON LABEL YES | ASTM II L'FAST | |

MALACHITE 037

DANIEL SMITH — EXTRA-FINE WATERCOLORS

This might be the genuine pigment but is it worth bothering if the final 'paint' is going to be anything like this.

Best described as a heavy coloured gum which is most unpleasant to use.

| GENUINE MALACHITE |

| PIGMENT DETAIL ON LABEL YES | ASTM L'FAST | RATING ★ |

MAGNESIUM GREEN A133

GRUMBACHER

PB36 Cerulean Blue was the only ingredient given. I have asked, without response, if any other pigment is involved as this is greener than I would expect. I will not offer an assessment.

ACADEMY ARTISTS' WATERCOLOR 2ND RANGE

PB36 CERULEAN BLUE, CHROMIUM ASTM I (216)		

PIGMENT DETAIL ON LABEL YES	ASTM I L'FAST	RATING

MONESTIAL GREEN 362

DALER ROWNEY

Rowney have always used this name, based on the original title 'Monastral' to market Phthalocyanine Green. Dependable and well produced.

Discontinued

ARTISTS' WATER COLOUR

PG7 PHTHALOCYANINE GREEN ASTM I (259)	

PIGMENT DETAIL ON LABEL YES	ASTM I L'FAST	

MAY GREEN 524

SCHMINCKE

Reformulated for the better. The fugitive PY1 has been removed and replaced with the lightfast PY154. A superb, lightfast yellow-green. Recommended.

Reformulated >

HORADAM FINEST ARTISTS' WATER COLOURS

PY3 ARYLIDE YELLOW 10G ASTM II (37)
PG7 PHTHALOCYANINE GREEN ASTM I (259)
PY154 BENZIMIDAZOLONE YELLOW H3G ASTM II (50)

PIGMENT DETAIL ON LABEL YES	ASTM II L'FAST	

MAY GREEN 524

SCHMINCKE

A reasonably transparent yellow green which behaved very well at all strengths.

PS151 is given in the literature. I have interpreted this to be PY151. Hopefully I am correct.

HORADAM FINEST ARTISTS' WATER COLOURS

PY151 BENZIMIDAZOLONE YELLOW H4G WG II (49)
PG7 PHTHALOCYANINE GREEN ASTM I (259)

PIGMENT DETAIL ON LABEL YES	WG II L'FAST	

OPAQUE GREEN LIGHT IMITATION 513

SCHMINCKE

Despite the stated ingredients, which are reliable, our sample darkened to a considerable extent. Assessment not offered.

Discontinued

HORADAM FINEST ARTISTS' WATER COLOURS

PW5 LITHOPONE WG I (384)
PY3 ARYLIDE YELLOW 10G ASTM II (37)
PG7 PHTHALOCYANINE GREEN ASTM I (259)

PIGMENT DETAIL ON LABEL YES	ASTM L'FAST	RATING

OLD HOLLAND YELLOW-GREEN 283

OLD HOLLAND

Everything left in the pigment store room must have gone into this one. Handled well and will be very reliable.

CLASSIC WATERCOLOURS

PY53 NICKEL TITANATE YELLOW ASTM I (43)
PY151 BENZIMIDAZOLONE YELLOW H4G WG II (49)
PY3 ARYLIDE YELLOW 10G ASTM II (37)
PG36 PHTHALOCYANINE GREEN ASTM I (262)
PW4 ZINC WHITE ASTM I (384)

PIGMENT DETAIL ON LABEL CHEMICAL MAKE UP ONLY	ASTM II L'FAST	

OLD HOLLAND BRIGHT GREEN 280

OLD HOLLAND

A slightly gummy paint which nevertheless washed out well. Dependable pigments have been used which will not let you down.

CLASSIC WATERCOLOURS

PY3 ARYLIDE YELLOW 10G ASTM II (37)
PB15 PHTHALOCYANINE BLUE ASTM II (213)
PG36 PHTHALOCYANINE GREEN ASTM II (262)

PIGMENT DETAIL ON LABEL CHEMICAL MAKE UP ONLY	ASTM II L'FAST	RATING ★ ★★

OLD HOLLAND GOLDEN GREEN 295

OLD HOLLAND

Not a paint but a very heavy, sticky coloured gum which was almost impossible to remove from the tube. I will certainly be leaving the rest of it there.

CLASSIC WATERCOLOURS

PY129 AZOMETHINE YELLOW 5GT LF NOT OFFERED (48)

PIGMENT DETAIL ON LABEL CHEMICAL MAKE UP ONLY	ASTM L'FAST	RATING ★

OLD HOLLAND GREEN LIGHT 286

OLD HOLLAND

Quality pigments turned into yet more sticky coloured gum. What goes on?

CLASSIC WATERCOLOURS

PY151 BENZIMIDAZOLONE YELLOW H4G WG II (49)
PY3 ARYLIDE YELLOW 10G ASTM II (37)
PG36 PHTHALOCYANINE GREEN ASTM I (262)

PIGMENT DETAIL ON LABEL CHEMICAL MAKE UP ONLY	ASTM II L'FAST	RATING ★

OLD HOLLAND GOLDEN GREEN DEEP 298

OLD HOLLAND

More heavy coloured gum from this company. Best used to stick things together. Don't try to paint with it.

CLASSIC WATERCOLOURS

PY129 AZOMETHINE YELLOW 5GT LF NOT OFFERED (48)
PG36 PHTHALOCYANINE GREEN ASTM I (262)

PIGMENT DETAIL ON LABEL CHEMICAL MAKE UP ONLY	ASTM L'FAST	RATING ★

PERMANENT GREEN LIGHT 161

UTRECHT

An easily mixed convenience colour. Ingredients are most reliable and make up into a watercolour paint which washes out very well.

PROFESSIONAL ARTISTS' WATER COLOR

PG7 PHTHALOCYANINE GREEN ASTM I (259)
PY3 ARYLIDE YELLOW 10G ASTM II (37)

PIGMENT DETAIL ON LABEL YES	ASTM II L'FAST	

PERMANENT GREEN LIGHT 130

M.GRAHAM & CO.

Given the resulting colour, there cannot be a great deal of the PY151 involved. Both are reliable and give a paint which handles with ease.

ARTISTS' WATERCOLOR

PG7 PHTHALOCYANINE GREEN ASTM I (259)
PY151 BENZIMIDAZOLONE YELLOW H4G WG II (49)

PIGMENT DETAIL ON LABEL YES	WG II L'FAST	

PERMANENT GREEN LIGHT 2371

A soft, dulled green which washed out beautifully. Very reliable, quality pigments used.

ARTISTIC
WATER COLOR

PY37 CADMIUM YELLOW MEDIUM OR DEEP ASTM I (42) PG50 LIGHT GREEN OXIDE WGII (263)		
PIGMENT DETAIL ON LABEL **NO**	WG **II** L'FAST	

PERMANENT GREEN LIGHT 162

GRUMBACHER

Despite promises, a sample was not provided.

Reformulated >

ACADEMY
ARTISTS'
WATERCOLOR
2ND RANGE

PG7 PHTHALOCYANINE GREEN ASTM I (259) PY3 ARYLIDE YELLOW 10G ASTM II (37)		
PIGMENT DETAIL ON LABEL **YES**	ASTM **II** L'FAST	RATING

PERMANENT GREEN LIGHT

GRUMBACHER

At last, for the third edition we have a sample, but still little in the way of cooperation.

A simple mix which washed out well and is reliable.

ACADEMY
ARTISTS'
WATERCOLOR
2ND RANGE

PY3 ARYLIDE YELLOW 10G ASTM II (37) PG36 PHTHALOCYANINE GREEN ASTM I (262)		
PIGMENT DETAIL ON LABEL **YES**	ASTM **II** L'FAST	

PERMANENT GREEN 544

MAIMERI

An easily mixed convenience colour. Both ingredients are absolutely lightfast. Paint brushed out well. Semi-transparent.

Discontinued

ARTISTI
EXTRA-FINE
WATERCOLOURS

PY37 CADMIUM YELLOW MEDIUM OR DEEP ASTM I (42) PG18 VIRIDIAN ASTM I (261)		
PIGMENT DETAIL ON LABEL **NO**	ASTM **I** L'FAST	

PERMANENT GREEN 625

MAIMERI

A reliable mid-green, easily duplicated on the palette from standard paints. Sample washed out very well, giving a useful range of values.

Discontinued

STUDIO
FINE
WATER COLOR
2ND RANGE

PY3 ARYLIDE YELLOW 10G ASTM II (37) PB15:3 PHTHALOCYANINE BLUE ASTM II (213)		
PIGMENT DETAIL ON LABEL **NO**	ASTM **II** L'FAST	

PERMANENT GREEN YELLOWISH 338

MAIMERI

Yellow with a touch of green rather than the other way round. A well produced paint giving smooth washes.

MAIMERIBLU
SUPERIOR
WATERCOLOURS

PY97 ARYLIDE YELLOW FGL ASTM II (46) PG36 PHTHALOCYANINE GREEN ASTM I (262)		
PIGMENT DETAIL ON LABEL **YES**	ASTM **II** L'FAST	

PERMANENT GREEN LIGHT 339

MAIMERI

Slightly gummy, washed out well when thin but not so in heavier applications. Reliable pigments employed.

MAIMERIBLU
SUPERIOR
WATERCOLOURS

PY175 BENZIMIDAZOLONE YELLOW H6G WG II (51) PG36 PHTHALOCYANINE GREEN ASTM I (262)		
PIGMENT DETAIL ON LABEL **YES**	WG **II** L'FAST	RATING ★★

PERMANENT GREEN LIGHT 339

MAIMERI

Coloured gum. The percentage of colours which are obviously over bound is definitely on the increase.

VENEZIA
EXTRAFINE
WATERCOLOURS

PY175 BENZIMIDAZOLONE YELLOW H6G WG II (51) PG36 PHTHALOCYANINE GREEN ASTM I (262)		
PIGMENT DETAIL ON LABEL **YES**	WG **II** L'FAST	RATING ★

PERMANENT GREEN DEEP 340

MAIMERI

The paint is well made and gave smooth, even, semi transparent washes.

MAIMERIBLU
SUPERIOR
WATERCOLOURS

PY175 BENZIMIDAZOLONE YELLOW H6G WG II (51) PG7 PHTHALOCYANINE GREEN ASTM I (259)		
PIGMENT DETAIL ON LABEL **YES**	WG **II** L'FAST	

PERMANENT GREEN DEEP 340

MAIMERI

A rather over bound paint which gave better washes when applied thinly.

VENEZIA
EXTRAFINE
WATERCOLOURS

PY175 BENZIMIDAZOLONE YELLOW H6G WG II (51) PG7 PHTHALOCYANINE GREEN ASTM I (259)		
PIGMENT DETAIL ON LABEL **YES**	WG **II** L'FAST	RATING ★★

PERMANENT GREEN No. 1 W266

HOLBEIN

Had the PY1 not been added, this would have been a reliable paint. Exposure will alter the colour to a marked extent. Semi-transparent.

ARTISTS'
WATER COLOR

PY1 ARYLIDE YELLOW G ASTM V (37) PG7 PHTHALOCYANINE GREEN ASTM I (259) PY53 NICKEL TITANATE YELLOW ASTM I (43)		
PIGMENT DETAIL ON LABEL **YES**	ASTM **V** L'FAST	RATING ★

PERMANENT GREEN No. 2 W267

HOLBEIN

Being fugitive, the PY14 will change the nature of the colour as it fades. Sample altered dramatically. Semi-opaque.

ARTISTS'
WATER COLOR

PY14 DIARYLIDE YELLOW OT WG IV (39) PG7 PHTHALOCYANINE GREEN ASTM I (259) PY53 NICKEL TITANATE YELLOW ASTM I (43)		
PIGMENT DETAIL ON LABEL **YES**	WG **IV** L'FAST	RATING ★

PERMANENT GREEN
No.3 W268

HOLBEIN

This is a 'Permanent Green' which is reasonably permanent. Reliable ingredients. Washes out well. Semi-transparent.

| PY53 NICKEL TITANATE YELLOW ASTM I (43) |
| PY3 ARYLIDE YELLOW 10G ASTM II (37) |
| PB15 PHTHALOCYANINE BLUE ASTM II (213) |

ARTISTS' WATER COLOR

| PIGMENT DETAIL ON LABEL **YES** | ASTM **II** L'FAST | |

PERMANENT
GREEN 070

DANIEL SMITH

It is encouraging to see the wider use of reliable pigments which have been subjected to ASTM testing.

A dependable watercolour which handled very well. Semi-trans.

| PY3 ARYLIDE YELLOW 10G ASTM II (37) |
| PG7 PHTHALOCYANINE GREEN ASTM I (259) |

EXTRA-FINE WATERCOLORS

| PIGMENT DETAIL ON LABEL **YES** | ASTM **II** L'FAST | |

PERMANENT GREEN
LIGHT 067

DANIEL SMITH

A strong, bright green which gave very smooth, easy washes.

Semi transparent, it gave very clear tints.

| PY3 ARYLIDE YELLOW 10G ASTM II (37) |
| PG7 PHTHALOCYANINE GREEN ASTM I (259) |

EXTRA-FINE WATERCOLORS

| PIGMENT DETAIL ON LABEL **YES** | ASTM **II** L'FAST | |

PERMANENT GREEN
LIGHT 811

SENNELIER

The inferior PY13 used up a few years ago has been removed and replaced with the superb PY40. Name recently changed from 'Light Green'. A well made watercolour.

| PY40 AUREOLIN ASTM II (42) |
| PG7 PHTHALOCYANINE GREEN ASTM I (259) |

EXTRA-FINE WATERCOLOUR

| PIGMENT DETAIL ON LABEL **YES** | ASTM **II** L'FAST | |

PERMANENT GREEN
LIGHT 618

TALENS

Reliable ingredients. A convenience colour which is easy to work. Simple to mix on the palette. Semi-transparent.

Discontinued

| PY3 ARYLIDE YELLOW 10G ASTM II (37) |
| PG7 PHTHALOCYANINE GREEN ASTM I (259) |

REMBRANDT ARTISTS' QUALITY EXTRA FINE

| PIGMENT DETAIL ON LABEL **YES** | ASTM **II** L'FAST | |

PERMANENT GREEN
LIGHT 618

TALENS

Convenience watercolour produced from reliable pigments. 'Second Range' paints need not be unreliable. Semi-transparent.

Range discontinued

| PY3 ARYLIDE YELLOW 10G ASTM II (37) |
| PG7 PHTHALOCYANINE GREEN ASTM I (259) |

WATER COLOUR 2ND RANGE

| PIGMENT DETAIL ON LABEL **YES** | ASTM **II** L'FAST | |

PERMANENT YELLOWISH
GREEN 633

TALENS

Handled better in thinner washes due to slight over binding. Reliable ingredients.

| PY154 BENZIMIDAZOLONE YELLOW H3G ASTM II (50) |
| PG7 PHTHALOCYANINE GREEN ASTM I (259) |

REMBRANDT ARTISTS' QUALITY EXTRA FINE

| PIGMENT DETAIL ON LABEL **YES** | ASTM **II** L'FAST | RATING ★ ★★ |

PERMANENT
YELLOWISH
GREEN 633

TALENS

A little gum laden. Washed out better in thin applications. Reliable pigments have been used.

| PY154 BENZIMIDAZOLONE YELLOW H3G ASTM II (50) |
| PG7 PHTHALOCYANINE GREEN ASTM I (259) |

VAN GOGH 2ND RANGE

| PIGMENT DETAIL ON LABEL **YES** | ASTM **II** L'FAST | RATING ★ ★★ |

PERMANENT
GREEN 662

TALENS

A reliable bright mid green which handled with ease over the available range. A quality product.

| PY154 BENZIMIDAZOLONE YELLOW H3G ASTM II (50) |
| PG7 PHTHALOCYANINE GREEN ASTM I (259) |

VAN GOGH 2ND RANGE

| PIGMENT DETAIL ON LABEL **YES** | ASTM **II** L'FAST | |

PERMANENT
GREEN 662

TALENS

Dependable ingredients used in a well made watercolour paint. Handled very well over a useful range of values.

| PY154 BENZIMIDAZOLONE YELLOW H3G ASTM II (50) |
| PG7 PHTHALOCYANINE GREEN ASTM I (259) |

REMBRANDT ARTISTS' QUALITY EXTRA FINE

| PIGMENT DETAIL ON LABEL **YES** | ASTM **II** L'FAST | |

PERMANENT
GREEN DEEP 1164

LUKAS

Reliable ingredients giving an easily mixed convenience colour. Semi-transparent.

| PG7 PHTHALOCYANINE GREEN ASTM I (259) |
| PY3 ARYLIDE YELLOW 10G ASTM II (37) |
| PG18 VIRIDIAN ASTM I (261) |

ARTISTS' WATER COLOUR

| PIGMENT DETAIL ON LABEL CHEMICAL MAKE UP ONLY | ASTM **II** L'FAST | |

PERMANENT GREEN
LIGHT 1163

LUKAS

Dependable ingredients giving a watercolour which handles very well. Absolutely lightfast. Such colours are easily mixed. Semi-transparent.

| PG7 PHTHALOCYANINE GREEN ASTM I (259) |
| PY42 MARS YELLOW ASTM I (43) |

ARTISTS' WATER COLOUR

| PIGMENT DETAIL ON LABEL CHEMICAL MAKE UP ONLY | ASTM **I** L'FAST | |

PERMANENT GREEN LIGHT 526

SCHMINCKE

Despite the reliability of the stated ingredients, our sample darkened considerably.

An assessment is not offered.

Discontinued

HORADAM FINEST ARTISTS' WATER COLOURS

PIGMENT DETAIL ON LABEL	ASTM	RATING
PY3 ARYLIDE YELLOW 10G ASTM II (37) PG7 PHTHALOCYANINE GREEN ASTM I (259)		
YES	II L'FAST	

PERMANENT GREEN 526

SCHMINCKE

Reliable pigments giving a bright mid green.

Handled very well.

HORADAM FINEST ARTISTS' WATER COLOURS

PIGMENT DETAIL ON LABEL	ASTM	RATING
PY154 BENZIMIDAZOLONE YELLOW H3G ASTM II (50) PG7 PHTHALOCYANINE GREEN ASTM I (259)		
YES	II L'FAST	

PRUSSIAN GREEN 528

SCHMINCKE

Pigment Green 8, Hooker's Green failed ASTM testing as a watercolour.

Reformulated >

HORADAM FINEST ARTISTS' WATER COLOURS

PIGMENT DETAIL ON LABEL	ASTM	RATING
PB15:1 PHTHALOCYANINE BLUE ASTM II (213) PV19 QUINACRIDONE VIOLET ASTM II (185) PG8 HOOKERS GREEN ASTM III (260)		
YES	III L'FAST	★★

PRUSSIAN GREEN 528

SCHMINCKE

A rather sticky, gummy consistency to the sample.

Difficult to wash out unless in thinner applications.

HORADAM FINEST ARTISTS' WATER COLOURS

PIGMENT DETAIL ON LABEL	WG	RATING
PG7 PHTHALOCYANINE GREEN ASTM I (259) PB60 INDANTHRONE BLUE WG II (216)		
YES	II L'FAST	★★

PRUSSIAN GREEN 540 (037)

WINSOR & NEWTON

This could have been a reliable watercolour had an alternative yellow been used. PY1 failed ASTM testing. Semi-transparent.

Discontinued

ARTISTS' WATER COLOUR

PIGMENT DETAIL ON LABEL	ASTM	RATING
PB27 PRUSSIAN BLUE ASTM I (214) PY1 ARYLIDE YELLOW G ASTM V (37)		
YES	V L'FAST	★

PERMANENT GREEN 289

OLD HOLLAND

An excess of gum spoils this paint. Lightfast pigments.

CLASSIC WATERCOLOURS

PIGMENT DETAIL ON LABEL	ASTM	RATING
PW4 ZINC WHITE ASTM I (384) PW6 TITANIUM WHITE ASTM I (385) PY151 BENZIMIDAZOLONE YELLOW H4G WG II (49) PB15 PHTHALOCYANINE BLUE ASTM II (213)		
CHEMICAL MAKE UP ONLY	II L'FAST	★★

PERMANENT GREEN LIGHT 277

OLD HOLLAND

If the use of two whites in the same colour adds a very subtle change in transparency, it is lost in the excessive gum.

CLASSIC WATERCOLOURS

PIGMENT DETAIL ON LABEL	ASTM	RATING
PW4 ZINC WHITE ASTM I (384) PW6 TITANIUM WHITE ASTM I (385) PY3 ARYLIDE YELLOW 10G ASTM II (37) PG36 PHTHALOCYANINE GREEN ASTM I (262)		
CHEMICAL MAKE UP ONLY	II L'FAST	★★

PERMANENT GREEN DEEP 271

OLD HOLLAND

I have come to associate a complex menu and an excess of gum with this company. Over bound but reliable pigments.

CLASSIC WATERCOLOURS

PIGMENT DETAIL ON LABEL	ASTM	RATING
PW4 ZINC WHITE ASTM I (384) PW6 TITANIUM WHITE ASTM I (385) PB29 ULTRAMARINE BLUE ASTM I (215) PG7 PHTHALOCYANINE GREEN ASTM I (259) PY3 ARYLIDE YELLOW 10G ASTM II (37)		
CHEMICAL MAKE UP ONLY	II L'FAST	★★

RICH GREEN GOLD 099

DANIEL SMITH

I am afraid that i cannot offer assessments without further information on PY129.

Sample washed out reasonably well.

EXTRA-FINE WATERCOLORS

PIGMENT DETAIL ON LABEL	ASTM	RATING
PY129 AZOMETHINE YELLOW 5GT LF NOT OFFERED (48)		
YES	L'FAST	

REMBRANDT BLUISH-GREEN 647

TALENS

Mix Phthalocyanines Blue and Green and you have the same colour. Washes out well. Lightfast and very transparent.

Discontinued

REMBRANDT ARTISTS' QUALITY EXTRA FINE

PIGMENT DETAIL ON LABEL	ASTM	RATING
PG7 PHTHALOCYANINE GREEN ASTM I (259) PB15 PHTHALOCYANINE BLUE ASTM II (213)		
YES	II L'FAST	

REMBRANDT GREEN 634

TALENS

The same simple mix as the previous colour, this time with more of the green added. Easy to reproduce. Transparent.

Discontinued

REMBRANDT ARTISTS' QUALITY EXTRA FINE

PIGMENT DETAIL ON LABEL	ASTM	RATING
PG7 PHTHALOCYANINE GREEN ASTM I (259) PB15 PHTHALOCYANINE BLUE ASTM II (213)		
YES	II L'FAST	

RUSSIAN GREEN

St. PETERSBURG

The next time you read the hype published by the distributor of this popular range, bear in mind that they do not have a clue as to the pigments that have been used.

ARTISTS' WATERCOLOURS

IT WOULD APPEAR TO BE COMPANY POLICY TO DELIBERATELY WITHHOLD INFORMATION ON THE PIGMENTS EMPLOYED		
PIGMENT DETAIL ON LABEL	ASTM	RATING
NO	L'FAST	

SPEEDBALL GREEN (PHTHALO) 5727

HUNTS

Phthalocyanine Green sold under yet another name. A little more is added to the confusion. Lightfast. Transparent.

Discontinued

SPEEDBALL PROFESSIONAL WATERCOLOURS

CHLORINATED COPPER PHTHALOCYANINE

PIGMENT DETAIL ON LABEL	ASTM	RATING
NO	I L'FAST	★ ★★

CARAN D'ACHE

SPRING GREEN 470

A rather weak paint which washed out poorly and will gradually self destruct as the green content fades. Hasn't got a great deal going for it really.

FINEST WATER COLOUR

PG8 HOOKERS GREEN ASTM III (260)
PY3 ARYLIDE YELLOW 10G ASTM II (37)

PIGMENT DETAIL ON LABEL	ASTM	RATING
YES	III L'FAST	★★

SPRING GREEN 136

AMERICAN JOURNEY

A semi-transparent watercolour paint produced from proven ingredients. Being a little over bound it handled better in thinner washes.

PROFESSIONAL ARTISTS' WATER COLOR

PY3 ARYLIDE YELLOW 10G ASTM II (37)
PG7 PHTHALOCYANINE GREEN ASTM I (259)

PIGMENT DETAIL ON LABEL	ASTM	RATING
YES	II L'FAST	★ ★★

SPRUCE GREEN 239

CARAN D'ACHE

Entirely trustworthy pigments have been used to produce a dark green which handled very well over a good range of values. Lifted well from the pan.

FINEST WATERCOLOURS

PY42 MARS YELLOW ASTM I (43)
PG7 PHTHALOCYANINE GREEN ASTM I (259)

PIGMENT DETAIL ON LABEL	ASTM	
YES	I L'FAST	

AMERICAN JOURNEY

SKIPS GREEN 130

If you have the 'Spring Green' offered in this range, (top right) plus their 'Sour Lemon (Hansa)', PY3, add some of the latter to the former and you will have this colour. Lightfast.

PROFESSIONAL ARTISTS' WATER COLOR

PY3 ARYLIDE YELLOW 10G ASTM II (37)
PG7 PHTHALOCYANINE GREEN ASTM I (259)

PIGMENT DETAIL ON LABEL	ASTM	
YES	II L'FAST	

SHADOW GREEN W279

HOLBEIN

I have insufficient information on PBk31 to offer assessments.

A black with a leaning towards green is the best way that I can describe it.

Washed out well.

ARTISTS' WATER COLOR

PBk31 PERYLENE BLACK L/F NOT OFFERED (369)

PIGMENT DETAIL ON LABEL	ASTM	RATING
YES	L'FAST	

SCHEVENINGEN GREEN 48

OLD HOLLAND

Sample supplied was not a paint but heavy coloured gum. Impossible to use.

CLASSIC WATERCOLOURS

PG36 PHTHALOCYANINE GREEN ASTM I (262)

PIGMENT DETAIL ON LABEL	ASTM	RATING
CHEMICAL MAKE UP ONLY	I L'FAST	★

OLD HOLLAND

SCHEVENINGEN GREEN DEEP 49

Another in the range of speciality coloured gums offered by this company. An appalling substance.

CLASSIC WATERCOLOURS

PG7 PHTHALOCYANINE GREEN ASTM I (259)

PIGMENT DETAIL ON LABEL	ASTM	RATING
CHEMICAL MAKE UP ONLY	I L'FAST	★

TURQUOISE GREEN 009

UTRECHT

A slight excess of gum has led to a watercolour paint which handles well in dilute washes but not so well when heavier. Lightfast.

PROFESSIONAL ARTISTS' WATER COLOR

PB16 PHTHALOCYANINE BLUE WG II (213)

PIGMENT DETAIL ON LABEL	WG	RATING
YES	II L'FAST	★ ★★

CARAN D'ACHE

TURQUOISE GREEN 191

A very simple mix, easily reproduced on the palette. Colour lifted with ease from the pan and gave smooth washes.

Reliable pigments.

FINEST WATER COLOUR

PB15:1 PHTHALOCYANINE BLUE ASTM II (213)
PG7 PHTHALOCYANINE GREEN ASTM I (259)

PIGMENT DETAIL ON LABEL	ASTM	
YES	II L'FAST	

MAIMERI

TURQUOISE GREEN 350

Please see notes at the bottom of page 213 concerning this pigment.

If PB16 has been used it is bright, transparent and very reliable. Handled with ease.

MAIMERIBLU SUPERIOR WATERCOLOURS

PB16 PHTHALOCYANINE BLUE WG II (213)

PIGMENT DETAIL ON LABEL	WG	
YES	II L'FAST	

TRUE GREEN 137

AMERICAN JOURNEY

At full strength this is a rather 'hard' green which does not brush out very smoothly. Fine in lighter applications. Very reliable pigments. Staining and semi-transparent.

PROFESSIONAL ARTISTS' WATER COLOR

PG7 PHTHALOCYANINE GREEN ASTM I (259)
PY43 YELLOW OCHRE ASTM I (43)

PIGMENT DETAIL ON LABEL	ASTM	RATING
YES	I L'FAST	★ ★★

UNDERSEA GREEN 109

DANIEL SMITH

EXTRA-FINE WATERCOLORS

Sample gave very smooth even washes. Being dark in mass tone and giving reasonably clear washes the range of values is very wide.

| PB29 ULTRAMARINE BLUE ASTM I (215) |
| PO49 QUINACRIDONE DEEP GOLD WG II (97) |

PIGMENT DETAIL ON LABEL	WG	
YES	**II** L'FAST	

UMTON BARVY

ARTISTIC WATER COLOR

VERT POLO VERONESE 2383

Easy to apply in smooth washes. A soft green with a slight leaning towards blue. Quality pigments have been used.

| PW4 ZINC WHITE ASTM I (384) |
| PY3 ARYLIDE YELLOW 10G ASTM II (37) |
| PG7 PHTHALOCYANINE GREEN ASTM I (259) |

PIGMENT DETAIL ON LABEL	ASTM	
NO	**II** L'FAST	

VERMILLION GREEN LIGHT 531

SCHMINCKE

HORADAM FINEST ARTISTS' WATER COLOURS

A veritable cocktail of pigments, giving a nondescript mid-green. The PY1 will let it down.

Discontinued

| PY119 ZINC IRON YELLOW WG II (47) |
| PG7 PHTHALOCYANINE GREEN ASTM I (259) |
| PW7 ZINC SULPHIDE WG I (385) |
| PY1 ARYLIDE YELLOW G ASTM V (37) |
| PY3 ARYLIDE YELLOW 10G ASTM II (37) |
| PB15:3 PHTHALOCYANINE BLUE ASTM II (213) |

PIGMENT DETAIL ON LABEL	ASTM	RATING
YES	**V** L'FAST	★

VERT EMERAUDE (VIRIDIAN) 337

PÈBÈO

FRAGONARD ARTISTS' WATER COLOUR

A mix of two very similar transparent blueish greens.

If you have either, this will be superfluous. Transparent and resistant to light.

| PG18 VIRIDIAN ASTM I (261) |
| PG7 PHTHALOCYANINE GREEN ASTM I (259) |

PIGMENT DETAIL ON LABEL	ASTM	
YES	**I** L'FAST	

VERONESE GREEN 138

PÈBÈO

FRAGONARD ARTISTS' WATER COLOUR

This name has long been used rather loosely to describe a variety of combinations.

Reliable ingredients. Semi-transparent.

| PW6 TITANIUM WHITE ASTM I (385) |
| PG7 PHTHALOCYANINE GREEN ASTM I (259) |
| PG10 GREEN GOLD WG II (260) |

PIGMENT DETAIL ON LABEL	WG	
YES	**II** L'FAST	

VERONESE GREEN HUE 551

LEFRANC & BOURGEOIS

LINEL EXTRA-FINE ARTISTS' WATERCOLOUR

A very smooth series of washes are available from this well made watercolour paint. Will resist damage from light.

| PW4 ZINC WHITE ASTM I (384) |
| PY3 ARYLIDE YELLOW 10G ASTM II (37) |
| PG7 PHTHALOCYANINE GREEN ASTM I (259) |

PIGMENT DETAIL ON LABEL	ASTM	
CHEMICAL MAKE UP ONLY	**II** L'FAST	

VERMILLION GREEN DEEP 532

SCHMINCKE

HORADAM FINEST ARTISTS' WATER COLOURS

The inclusion of PG8, Hooker's Green will lead to eventual deterioration of the colour.

Discontinued

| PY119 ZINC IRON YELLOW WG II (47) |
| PB15:1 PHTHALOCYANINE BLUE ASTM II (213) |
| PG8 HOOKERS GREEN ASTM III (260) |

PIGMENT DETAIL ON LABEL	ASTM	RATING
YES	**III** L'FAST	★★

VIVID GREEN 378

DALER ROWNEY

ARTISTS' WATER COLOUR

A vivid yellow green which moved to a green yellow in very thin washes.

A well produced watercolour paint which is light resistant.

| PY138 QUINOPHTHALONE YELLOW ASTM II (48) |
| PG7 PHTHALOCYANINE GREEN ASTM I (259) |

PIGMENT DETAIL ON LABEL	ASTM	
YES	**II** L'FAST	

WINSOR GREEN 720 (055)

WINSOR & NEWTON

ARTISTS' WATER COLOUR

If Phthalocyanine Green was always offered as such, a greater demand for it would be created and we would all be less confused.

Discontinued

| PG7 PHTHALOCYANINE GREEN ASTM I (259) |

PIGMENT DETAIL ON LABEL	ASTM	
YES	**I** L'FAST	

WINSOR GREEN (YELLOW SHADE) 721

WINSOR & NEWTON

ARTISTS' WATER COLOUR

Suitable for thin to medium washes only due to the gummy consistency of the paint.

| PG36 PHTHALOCYANINE GREEN ASTM I (262) |

PIGMENT DETAIL ON LABEL	ASTM	RATING
YES	**I** L'FAST	★★

WINSOR GREEN (BLUE SHADE) 719

WINSOR & NEWTON

ARTISTS' WATER COLOUR

Tube under pressure. The usual reason for this is an imbalance between pigment and binder. Paint was unworkable unless very thin. Heavy film dries to a shine.

| PG7 PHTHALOCYANINE GREEN ASTM I (259) |

PIGMENT DETAIL ON LABEL	ASTM	RATING
YES	**I** L'FAST	★★

WARM GREEN 534

LEFRANC & BOURGEOIS

LINEL EXTRA-FINE ARTISTS' WATERCOLOUR

A fancy title used to describe a brace of Phthalocyanine Greens. Reliable and transparent.

| PG7 PHTHALOCYANINE GREEN ASTM I (259) |
| PG36 PHTHALOCYANINE GREEN ASTM I (262) |

PIGMENT DETAIL ON LABEL	ASTM	
CHEMICAL MAKE UP ONLY	**I** L'FAST	

YELLOW GREEN 302

St. PETERSBURG

Considering the popularity of this make of pan colours, there must be a very large number of watercolourists who do not care much for the future of their work.

DETAILS OF THE PIGMENT/S USED KEPT FROM OURSELVES, THE DISTRIBUTORS AND FROM YOU, THE ARTIST

ARTISTS' WATERCOLOURS

PIGMENT DETAIL ON LABEL	ASTM	RATING
NO	L'FAST	

YELLOWISH GREEN 617

TALENS

A simple mix, easily reproduced on the palette from a Lemon Yellow and Phthalo. Green. Reliable and transparent.

Discontinued

PG7 PHTHALOCYANINE GREEN ASTM I (259)
PY3 ARYLIDE YELLOW 10G ASTM II (37)

REMBRANDT ARTISTS' QUALITY EXTRA FINE

PIGMENT DETAIL ON LABEL	ASTM	
YES	II L'FAST	

YELLOWISH GREEN 617

TALENS

If you have the previous colour, just add a little more yellow and you will have this one also. Semi-transparent.

Discontinued

PG7 PHTHALOCYANINE GREEN ASTM I (259)
PY3 ARYLIDE YELLOW 10G ASTM II (37)

VAN GOGH 2ND RANGE

PIGMENT DETAIL ON LABEL	ASTM	
YES	II L'FAST	

YELLOWISH GREEN 323

MAIMERI

More of a slightly green yellow that the other way round. In fact, if you have almost any 'Lemon Yellow' you will be close to this. Reliable and well made.

PY97 ARYLIDE YELLOW FGL ASTM II (46)
PG36 PHTHALOCYANINE GREEN ASTM I (262)

VENEZIA EXTRAFINE WATERCOLOURS

PIGMENT DETAIL ON LABEL	ASTM	
YES	II L'FAST	

YELLOW GREEN No.17

PENTEL

If this range of watercolours is not intended for artistic use they should not be offered as such.

If they are, the pigments used in their production should be disclosed.

PIGMENT DETAILS ARE NOT GIVEN ON THE PRODUCT OR IN THE LITERATURE SUPPLIED

WATERCOLOURS

PIGMENT DETAIL ON LABEL	ASTM	RATING
NO	L'FAST	

YELLOW GREEN No.17

PENTEL (POLY TUBE)

A yellowish green, I can tell you nothing more.

PIGMENT DETAILS ARE NOT GIVEN ON THE PRODUCT OR IN THE LITERATURE SUPPLIED

WATERCOLOURS

PIGMENT DETAIL ON LABEL	ASTM	RATING
NO	L'FAST	

The following are just a few of the greens which are easily mixed from standard lightfast colours. If you require help with your colour mixing please see page 406.

Reproduced from our Home Study Course 'Practical Colour Mixing'

Reproduced from our Home Study Course ' Practical Colour Mixing'

Browns

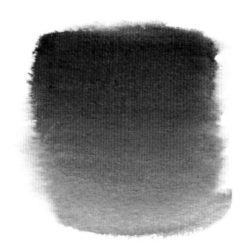

The majority of brown pigments have been and still are obtained from the earth.

Unaffected by humidity, light, temperature, alkalis and dilute acids, the earth pigments are almost the ideal. They are non toxic, cheap and possess fairly good tinting strength and covering power.

Earth pigments consist of three principle components: the main colouring matter, a modifying or secondary colouring agent and the base carrier.

Main colouring matter

The principle colour producing agent of nearly all earth pigments is iron oxide, a material found in most rocks and earths. Content varies from the tiny amount found in white clays and chalks, to the very high concentrations in iron ore.

Modifying Colouring Agent

Other matter present will affect the final colour.

Carbon, Manganese Oxides, Calcium, Silica and organic matter will lighten, darken, redden or otherwise influence the main colouring agent.

Base carrier

Virtually all earth pigments have a clay base.

The type of clay has a significant effect on the final colouring and the physical properties of the pigment.

 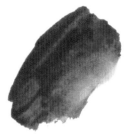

Several of the brown earth pigments in use today are little removed from the colours used by the cave painter. The materials used in Raw Sienna and Raw Umber are essentially the same coloured earths that were once smeared onto cave walls.

Raw Sienna, an excellent glazing colour, has been used in all painting techniques ever since records were started.

Although it has its modern, synthetic rivals, it remains unsurpassed for clarity of colour and permanence.

One type of iron ore, Dimonite, provides the colouring for the Ochres. As the iron oxide content increases, so the Ochres move into the Siennas.

An increase in the manganese oxide content of the Siennas leads to the Umbers.

Attempts have been made to replace many of the traditional earth colours with artificially prepared alternatives.

These are usually known as Mars colours. Although colour consistency between batches is more reliable and they are just as lightfast, many of the artificially made browns lack the subtlety of the more muted natural earth colours.

The natural red earth colours, in use from the time of the cave artist, have provided a range varying from a warm, light orange-red, to dark cold purples.

Many of these natural red earth colours have been replaced or duplicated by synthetic red oxides such as Mars Red and Venetian Red.

Originally made from the dried ink sacs of cuttlefish or squid, Sepia is now usually a simple mix of a brown and black.

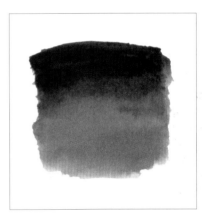

The most macabre of all brown pigments must surely be Mummy, produced from ground Egyptian mummies. Even more bizarre is the fact that it was used as a medicine before it was discovered that a paint could be produced from it. Mummy was considered to be an ideal shading colour.

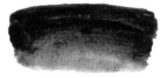

Bistre, a brown produced by boiling wood soot was replaced during the 18th century by Sepia.

Spanish Liquorice, a fugitive brown manufactured from the root of the liquorice plant, was so sticky that it did not require the addition of gum for watercolour painting.

Van Dyke Brown, produced from earth that is rich in organic matter, came into general use some time before the seventeenth century. Valued for its rich, deep colour, it was and still is used extensively. Countless paintings have been ruined by the use of this unreliable pigment yet it is still with us.

Until comparatively recent times few brown pigments found their way onto the artists' palette. In Europe, during the Middle ages in particular, brighter colours were favoured and browns and other nondescript browns were less frequently used. When a brown was required it was often mixed.

Modern Brown Pigments

PBr6	MARS BROWN	309
PBr7	RAW SIENNA	309
PBr7	RAW UMBER	309
PBr7	BURNT UMBER	310
PBr7	BURNT SIENNA	310
NBr8	VAN DYKE BROWN	310
PBr8	MANGANESE BROWN	311
PBr11	MANGANESE FERRITE	311
PBr23	DISAZO BROWN	311
PBr24	CHROME ANTIMONY TITANIUM BUFF RUTILE	312
PBr33	ZINC IRON CHROMITE BROWN SPINEL	312
PBr41	COMMON NAME NOT KNOWN	312
PBr25	BENZIMIDAZOLONE HFR	308

PBr25 BEZIMIDAZOLONE HFR

A transparent orange brown which has not yet been tested in any art material.
It seems mainly to be used in the automobile industry.
Too little is known to be able to offer a lightfastness rating at this stage.

L/FAST NOT OFFERED

COMMON NAME

BEZIMIDAZOLONE HFR

COLOUR INDEX NAME

PBr25

COLOUR INDEX NUMBER

12510

CHEMICAL CLASS

MONOAZO: BENZIMIDAZOLONE

PBr6 MARS BROWN

An artificially prepared iron oxide, with a similar chemical make-up to PBr7, PR101, PR102 and PBk11.

Available in a variety of colours from a light reddish brown to a deep chocolate.

The undercolour that is brought out when certain varieties are mixed with white can be quite purplish. A thoroughly reliable pigment with a good range of values. Possesses very good hiding and tinting strength.

Rated ASTM I in oils and acrylics but not yet tested as a watercolour. Sample unaffected by light and therefore rated I for this book. Also called Brown Iron Oxide.

PBr7 RAW SIENNA

Used by artists from the early cave painter to the present day, Raw Sienna is a native earth mined at many locations. Named after a particularly fine variety once produced at Sienna, Tuscany.

An excellent glazing colour, the better qualities being very transparent. Gives a golden tan when well diluted but takes on a very laboured appearance in heavy applications. Fairly good tinting strength. Absolutely lightfast with an ASTM rating of I in watercolour.

The crude 'Raw Sienna' used by the cave painter will not have changed in colour to this very day.

PBr7 RAW UMBER

Raw Umber is a native earth mined at various locations, a particularly fine variety coming from Cyprus. The name is thought to have originated from a production site at Umbria in Italy. An alternative explanation is that it is derived from the Latin 'Ombra', meaning shadow or shade. Raw Umber varies in colour, tending towards yellow, green or violet. Better grades are slightly greenish. Possesses high tinting strength and good

hiding power. Absolutely lightfast with an ASTM rating of I as a watercolour. An excellent all round pigment.

PBr7 BURNT UMBER

Prepared by roasting Raw Umber at a dull red heat until it has changed to the required hue. The pigment goes through many colour changes and the final result is very much dependant on the furnace operator. Used in antiquity, it came into general use from the early 1600's. A warm, rich, fairly heavy colour varying from an orange to a reddish brown. High in tinting strength with good hiding power. Not particularly transparent but can be when very dilute.

A thoroughly reliable pigment. ASTM I as a watercolour and on the list of approved pigments. Makes an excellent watercolour. Highly recommended.

PBr7 BURNT SIENNA

It was discovered in antiquity that Raw Sienna could be roasted to produce a warm, rich orange to reddish brown. Particularly valued for its transparency, it is one of the small group of ancient pigments whose beauty and permanence have not been equalled by any modern industrial substitute.

Tinting strength varies with different grades, as does clarity of hue and transparency. Choose carefully, a clear, fiery Burnt Sienna can be invaluable.

As a watercolour it rated ASTM I and is on the list of approved pigments. Good grades, unclouded by filler or other pigments, are worth seeking.

Highly recommended.

NBr8 VAN DYKE BROWN

Dug from the ground as a soft brown coal or as a peat like substance. Consists in the main of humus and humic acid from decayed wood. In reality it is obtained from an ancient 'compost heap', where it should have remained.

Referred to under a variety of names. Cassel Earth, Cologne Earth, Bituminous Earth, Cappagh Brown etc. Transparent to semi-transparent. Moderately strong. An unreliable mid-brown which is especially fugitive as a thin wash.

As a wash it will quickly move towards a cold dull grey and fade in mass tone. There are some absolutely lightfast browns in the same colour range, so why use this appalling substance in artists' paints?

PBr8 MANGANESE BROWN

Manganese Brown is seldom found in artists' materials. Being fast to lime it has many industrial applications, where it is better employed. Commonly used to colour lime, cement and artificial stone.

A mid brown which is easily duplicated on the palette. Manganese Brown is semi-transparent with a useful range of values. I have not come across any test results. Reported to be reliable, I will not regard it as such for the purposes of this publication as our sample faded very quickly.

Sample deteriorated rapidly, the tint moved towards grey and the mass tone faded also. Pending further testing I would suggest caution. Rated W/Guide IV.

PBr11 MAGNESIUM FERRITE

An opaque tan of weak tinting strength which has not been officially tested in any art material.

I have little further information apart from the fact that is has a reputation of possessing outstanding chemical, light and weather resistance.

Given its reputation and make up I will rate it as W/Guide II for the purposes of this publication.

Hopefully this pigment will one day be tested under controlled conditions as an artist material.

PBr23 DISAZO BROWN

A dull reddish brown, PBr23 is transparent and strong in tinting strength. Not yet subjected to ASTM testing as an art material, let alone a watercolour paint.

However, it does have a very good reputation for resistance to light. Pending ASTM testing, which will take place when manufacturers are prepared to pay for it, I will rate this pigment as W/Guide II on reputation only. I would still suggest some caution in its use.

PBr24 CHROME ANTIMONY TITANIUM BUFF RUTILE

PBr24 is a rather dull, light yellowish-brown. Reasonably opaque, it washes out to give fairly clear tints. Rather low in tinting strength it will have a limited influence on many other colours in a mix unless used liberally. This pigment has not been tested under ASTM conditions at the time of writing. Results from other, less exacting tests were very encouraging.

Our sample however did not stand up so well to light.

Despite an excellent reputation, which is more to do with its performance in printing inks, I would advise caution as our sample faded quickly. Rated W/Guide III for this publication.

PBr33 ZINC IRON CHROMITE BROWN SPINEL

A very dark opaque reddish brown which has yet to be subjected to testing under ASTM conditions.

Used mainly in ceramic glazes it has a reputation of possessing outstanding resistance to light, chemicals and the weather.

Given its reputation and chemical make up I will rate it as W/Guide II pending future testing.

Also known as Calf Skin Brown No 6, Cocoa Brown No 157, Dalpyroxide Brown 9220, Mahogany Brown No 12 and Walnut Brown No 10.

PBr41 COMMON NAME NOT KNOWN

A yellowish, opaque brown possessing fairly low tinting strength. A relatively new pigment which has not been subjected to ASTM testing procedures.

Almost no information is available about this pigment, particularly as far as its resistance to light is concerned. If you

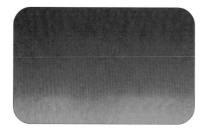

decide to use a watercolour containing this pigment you are taking a risk with your work.

Brown Watercolours

Contents

Brown Madder 315

Burnt Sienna .. 316

Burnt Umber .. 320

English Red ... 323

Indian Red ... 324

Light Red .. 326

Ochres... 327

Raw Sienna .. 330

Raw Umber .. 334

Sepia.. 337

Van Dyke Brown 341

Venetian Red 344

Yellow Ochre 345

Miscellaneous...................................... 350

Brown Madder

Brown Madder, or Alizarin Brown as it was also known, was at one time produced by gently heating natural Alizarin or Madder Lake. Paints sold under the name nowadays are usually synthetic Alizarin supported by other pigments.

The name has remained well past its time and is retained to market simple mixes or standard colours.

Alizarin Crimson is used in a wide variety of colours, despite the well known fact that it is unreliable.

Thin washes will fade, heavier applications are very dark and prone to cracking. These characteristics are carried with it to any 'Madder' that it takes part in.

It is difficult to suggest a way of mixing 'Brown Madder' using reliable ingredients, as the colour varies according to the whim of the manufacturer.

A violet-red, neutralised with a little of its complementary, yellow green, will give a colour close to the original Brown Madder. Alternatively, add a little reliable violet-red to Burnt Sienna or Light Red.

MADDER BROWN 670

SCHMINCKE

Previously called 'Brown Madder Alizarin Hue 368'. Although the pigment used has not been ASTM tested as a watercolour, it rated I in acrylics. A reliable colour which handles better in thinner washes than mass tone.

HORADAM FINEST ARTISTS' WATER COLOURS

PR206 QUINACRIDONE BURNT ORANGE WG II (133)

PIGMENT DETAIL ON LABEL	WG	RATING
YES	II L'FAST	★ ★★

MADDER BROWN REDDISH 658

SCHMINCKE

A one time very unreliable colour has been reformulated using slightly less fugitive colours. Not worth considering.

Discontinued

HORADAM FINEST ARTISTS' WATER COLOURS

PV19 QUINACRIDONE VIOLET ASTM II (185)
PBr7 RAW UMBER ASTM I (309)
PR83:1 ALIZARIN CRIMSON ASTM IV (122)
PR177 ANTHRAQUINOID RED ASTM III (130)

PIGMENT DETAIL ON LABEL	ASTM	RATING
YES	IV L'FAST	★

BROWN MADDER 471

SENNELIER

This colour used to contain PR83:1 Alizarin Crimson and was very prone to fading. Now reformulated using more reliable ingredients. Washed out smoothly.

EXTRA-FINE WATERCOLOUR

PY3 ARYLIDE YELLOW 10G ASTM II (37)
PBr23 DISAZO BROWN WG II (311)

PIGMENT DETAIL ON LABEL	ASTM	
YES	L'FAST	

BROWN MADDER (ALIZARINE) 063

WINSOR & NEWTON

I am told that the PR101 does not fit traditional classification but is a synthetic equivalent of Burnt Sienna. The colour will eventually spoil due to the use of PR83:1.

Discontinued

ARTISTS' WATER COLOUR

UNSPECIFIED PR101 ASTM I (123/124)
PR83:1 ALIZARIN CRIMSON ASTM IV (122)

PIGMENT DETAIL ON LABEL	ASTM	RATING
YES	IV L'FAST	★

BROWNISH MADDER ALIZARIN 333

TALENS

Becomes a pale, relatively dull reddish brown. The day that Alizarin Crimson finally becomes obsolete will be welcomed by all knowledgeable artists. Semi-transparent.

Discontinued

REMBRANDT ARTISTS' QUALITY EXTRA FINE

UNSPECIFIED PR101 ASTM I (123/124)
PR83:1 ALIZARIN CRIMSON ASTM IV (122)

PIGMENT DETAIL ON LABEL	ASTM	RATING
YES	IV L'FAST	★

PERMANENT MADDER LAKE BROWN 324

TALENS

I am afraid that there is insufficient information on PR264 to offer an assessment. I do know that it has not been ASTM tested as an art material in any media. Sample very gummy.

REMBRANDT ARTISTS' QUALITY EXTRA FINE

PR264 COMMON NAME N/K
LF NOT OFFERED (137)
UNSPECIFIED PR101 ASTM I (123/124)

PIGMENT DETAIL ON LABEL	ASTM	RATING
YES	L'FAST	

BROWN MADDER (ALIZARIN) 207

DALER ROWNEY

The use of Alizarin Crimson, a pigment known to be unreliable, will cause the colour to change considerably. Semi-transparent.

Discontinued

ARTISTS' WATER COLOUR

PR83:1 ALIZARIN CRIMSON ASTM IV (122)
PY42 MARS YELLOW ASTM I (43)

PIGMENT DETAIL ON LABEL	ASTM	RATING
YES	IV L'FAST	★

BROWN MADDER (QUINACRIDONE) 207

DA VINCI PAINTS

A relatively new colour from this company. Produced from top quality pigments, this is an excellent watercolour paint.

PERMANENT ARTISTS' WATER COLOR

PV19 QUINACRIDONE VIOLET ASTM II (185)
PR101 MARS RED ASTM I (124)

PIGMENT DETAIL ON LABEL	ASTM	
YES	II L'FAST	

BROWN MADDER 23

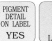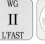

HOLBEIN

A rich red-brown which will retain its colour when under light. Well produced, our sample brushed out very smoothly over a wide range. Opaque, non staining.

ARTISTS' WATER COLOR

PR216 PYRANTHRONE RED WG II (135)

PIGMENT DETAIL ON LABEL	WG	
YES	II L'FAST	

BROWN MADDER (QUINACRIDONE) 010

AMERICAN JOURNEY

Everybody has to have their Brown Madder, even in the newly introduced ranges.

Lightfast, handles well, reasonably transparent.

PROFESSIONAL ARTISTS' WATER COLOR

PV19 QUINACRIDONE VIOLET ASTM II (185) PR101 MARS RED ASTM I (124)		
PIGMENT DETAIL ON LABEL YES	ASTM II L'FAST	

BROWN MADDER W021

GRUMBACHER

In previous editions I have said: 'This colour is included as a sample was promised. It did not materialise so a rating is not possible'. Once again there no sign of a sample.

Burnt Sienna under another name.

FINEST ARTISTS' WATER COLOR

PBr7 BURNT SIENNA ASTM I (310)		
PIGMENT DETAIL ON LABEL YES	ASTM L'FAST	RATING

BROWN MADDER

GRUMBACHER

It is very well known amongst art material manufacturers that PR83 has failed ASTM testing as a watercolour.

ACADEMY ARTISTS' WATERCOLOR 2ND RANGE

PR83 ROSE MADDER ALIZARIN ASTM IV (122) UNSPECIFIED PBr7 (309/310)		
PIGMENT DETAIL ON LABEL YES	ASTM IV L'FAST	RATING ★

BROWN MADDER 056

WINSOR & NEWTON

A newly introduced colour which is spoilt by what would appear to be an excessive use of gum.

Lightfast, staining and transparent.

ARTISTS' WATER COLOUR

PR206 QUINACRIDONE BURNT ORANGE WG II (133)		
PIGMENT DETAIL ON LABEL YES	WG II L'FAST	RATING ★★

As you will see in the typical example on the right, exposure to light can cause considerable damage to the colour if it is produced from pigments which include Alizarin Crimson.

Fine if you wish your work to alter to the same degree, otherwise worth avoiding.

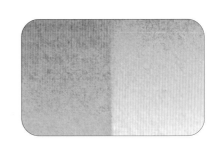

Burnt Sienna

It was discovered long ago that Raw Sienna could be roasted to produce a fiery, transparent neutral orange-red.

When applied as a thin layer the true beauty is revealed. Well produced 'Burnt Siennas' are particularly clear and vibrant when so applied. Unfortunately it is often painted out thickly where it is comparatively dull.

Such transparent colours were at one time highly valued for the clear washes that were available. As we have moved away from a real respect for the craft of painting, so we have lost much of our appreciation for such pigments.

Like a good wine, a quality Burnt Sienna is worth seeking out. I suggest that you try every example that comes your way.

In mixing it should be treated as a neutral, transparent orange. The ideal mixing complementary is Ultramarine Blue. Both colours are transparent and close to colour complementaries. They darken each other successfully and will give a superb range of neutrals and greys. Being transparent and efficient at destroying each other, they can provide an excellent black.

BURNT SIENNA 020

M.GRAHAM & CO.

A slightly dull version of this popular colour.

As with all pigments described as PBr 7 it will be absolutely lightfast.

ARTISTS' WATERCOLOR

PBr7 BURNT SIENNA (310)		
PIGMENT DETAIL ON LABEL YES	ASTM I L'FAST	

BURNT SIENNA 61

OLD HOLLAND

Despite a previous lengthy correspondence we were unable to establish the exact nature of the pigment. What Pbr7? Settled out somewhat on drying, giving a rather mottled appearance.

CLASSIC WATERCOLOURS

UNSPECIFIED PBr7 (309/310)		
PIGMENT DETAIL ON LABEL CHEMICAL MAKE UP ONLY	ASTM I L'FAST	RATING ★ ★★

BURNT SIENNA 016

AMERICAN JOURNEY

Burnt Sienna does not need the inclusion of one of the PR101s. It has qualities of its own. If the colour must be altered this should reflect in the title.

PROFESSIONAL ARTISTS' WATER COLOR

PBr7 BURNT SIENNA ASTM I (310) UNSPECIFIED PR101 ASTM I (123/124)		
PIGMENT DETAIL ON LABEL YES	ASTM I L'FAST	RATING ★ ★★

BURNT SIENNA 221

DALER ROWNEY

Superb. Washes out smoothly from one value to another. A well produced, fiery neutral orange. Particularly transparent.

Reformulated >

ARTISTS' WATER COLOUR

PBr7 BURNT SIENNA ASTM I (310)		
PIGMENT DETAIL ON LABEL **YES**	ASTM **I** L'FAST	

BURNT SIENNA 221

DALER ROWNEY

It appears that genuine Burnt Sienna, a naturally occurring earth has been replaced with one of the PR101s. This is surely a backward step. In fact several.

ARTISTS' WATER COLOUR

UNSPECIFIED PR101 ASTM I (123/124)		
PIGMENT DETAIL ON LABEL **YES**	ASTM **I** L'FAST	RATING ★ ★★

BURNT SIENNA 221

DALER ROWNEY

Washes out well and is very transparent. A good quality Burnt Sienna for a second range colour. Value for money

GEORGIAN WATER COLOUR 2ND RANGE

PBr7 BURNT SIENNA ASTM I (310)		
PIGMENT DETAIL ON LABEL **NO**	ASTM **I** L'FAST	

BURNT SIENNA 134

PÈBÈO

Mars Red, a synthetic iron oxide, should ideally be marketed as such. Or at least the word 'Hue' should be added to the title. An excellent watercolour nevertheless. Particularly transparent in thin washes.

FRAGONARD ARTISTS' WATER COLOUR

PR101 MARS RED ASTM I (124)		
PIGMENT DETAIL ON LABEL **YES**	ASTM **I** L'FAST	RATING ★ ★★

BURNT SIENNA 573

MIR (JAURENA S.A)

A rather pale, cloudy colour of limited transparency. Appears to contain a touch of white or possible filler. Rather lifeless.

ACUARELA

UNSPECIFIED PBr7 (309/310)		
PIGMENT DETAIL ON LABEL **YES**	ASTM **I** L'FAST	RATING ★ ★★

BURNT SIENNA 211

SENNELIER

A thoroughly well produced watercolour. Sample washed out very smoothly at all strengths. A rich neutralised orange of great value to the artist. Transparent.

EXTRA-FINE WATERCOLOUR

PBr7 BURNT SIENNA ASTM I (310)		
PIGMENT DETAIL ON LABEL **YES**	ASTM **I** L'FAST	

BURNT SIENNA 010

DANIEL SMITH

A well made example of this colour. Washed out very smoothly to give clear thin applications.

Absolutely lightfast.

EXTRA-FINE WATERCOLORS

PBr7 BURNT SIENNA ASTM I (310)		
PIGMENT DETAIL ON LABEL **YES**	ASTM **I** L'FAST	

ITALIAN BURNT SIENNA 047

DANIEL SMITH

Slightly redder than the 'Burnt Sienna' offered by this company (please see left).

The difference is so minimal and so easily duplicated that I would not be tempted to purchase both versions.

EXTRA-FINE WATERCOLORS

PBr7 BURNT SIENNA ASTM I (310)		
PIGMENT DETAIL ON LABEL **YES**	ASTM **I** L'FAST	

MONTE AMIATA BURNT SIENNA 055

DANIEL SMITH

I am afraid that I cannot offer assessments or a colour guide as a sample was not provided.

EXTRA-FINE WATERCOLORS

PBr7 BURNT SIENNA ASTM I (310)		
PIGMENT DETAIL ON LABEL **YES**	ASTM **I** L'FAST	RATING

BURNT SIENNA 184

UTRECHT

Sample washed out with ease. A very well made example of this watercolour paint. Thinner washes particularly clear.

PROFESSIONAL ARTISTS' WATER COLOR

PBr7 BURNT SIENNA (310)		
PIGMENT DETAIL ON LABEL **YES**	ASTM **I** L'FAST	

BURNT SIENNA 481

LEFRANC & BOURGEOIS

Whatever type of PR101 has been used it should be marketed as such. Or at least the word 'Hue' should be added to the title. A well made paint which blends smoothly from one value to another.

LINEL EXTRA-FINE ARTISTS' WATERCOLOUR

UNSPECIFIED PR101 ASTM I (123/124)		
PIGMENT DETAIL ON LABEL CHEMICAL MAKE UP ONLY	ASTM **I** L'FAST	RATING ★ ★★

BURNT SIENNA 34

HOLBEIN

Gives very delicate, soft neutral oranges when well diluted.

A wide range of strengths are available. Superb. Transparent and non staining.

ARTISTS' WATER COLOR

PBr7 BURNT SIENNA ASTM I (310)		
PIGMENT DETAIL ON LABEL **YES**	ASTM **I** L'FAST	

BURNT SIENNA 205

DA VINCI PAINTS

PERMANENT ARTISTS' WATER COLOR

Previously difficult to handle, this colour has been reformulated to give an excellent paint which brushes out very smoothly. Lightfast. Recommended.

Reformulated >

PBr7 BURNT SIENNA ASTM I (310)

PIGMENT DETAIL ON LABEL	ASTM	
YES	I L'FAST	

BURNT SIENNA

DA VINCI PAINTS

PERMANENT ARTISTS' WATER COLOR

A very well made watercolour paint which handled with absolute ease. It is a pity that PR101 has now been added as it takes the colour away from being a pure Burnt Sienna. Assessment lowered because of this.

PBr7 BURNT SIENNA ASTM I (310)
UNSPECIFIED PR101 ASTM I (123/124)

PIGMENT DETAIL ON LABEL	ASTM	RATING
YES	I L'FAST	★ ★★

BURNT SIENNA 605

DA VINCI PAINTS

SCUOLA 2ND RANGE

Tube under pressure. Sample handled far better as a wash than when applied at all heavily. Lightfast and transparent.

PBr7 BURNT SIENNA ASTM I (310)

PIGMENT DETAIL ON LABEL	ASTM	RATING
YES	I L'FAST	★ ★★

BURNT SIENNA 411

TALENS

REMBRANDT ARTISTS' QUALITY EXTRA FINE

The sample provided was slightly over bound making handling somewhat difficult. A rich, fiery colour. Transparent.

PBr7 BURNT SIENNA ASTM I (310)

PIGMENT DETAIL ON LABEL	ASTM	RATING
YES	I L'FAST	★ ★★

BURNT SIENNA 411

TALENS

WATER COLOUR 2ND RANGE

A quality product. Brushed out well, giving very smooth washes. Traditional Burnt Sienna colour, a rich warm orange - brown. Transparent.

Range discontinued

PBr7 BURNT SIENNA ASTM I (310)

PIGMENT DETAIL ON LABEL	ASTM	
YES	I L'FAST	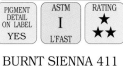

BURNT SIENNA

TALENS

VAN GOGH 2ND RANGE

This is not Burnt Sienna at all but a rather poor imitation which should at least display the word 'Hue'. The addition of black can only bring dullness.

UNSPECIFIED PR101 ASTM I (123/124)
PBk11 MARS BLACK ASTM I (371)

PIGMENT DETAIL ON LABEL	ASTM	RATING
YES	I L'FAST	★ ★★

BURNT SIENNA 074

WINSOR & NEWTON

ARTISTS' WATER COLOUR

A well produced Burnt Sienna. Extremely transparent in thin washes, rich in colour and handles well. Absolutely lightfast.

Reformulated >

PBr7 BURNT SIENNA ASTM I (310)

PIGMENT DETAIL ON LABEL	ASTM	
YES	I L'FAST	

BURNT SIENNA 074

WINSOR & NEWTON

ARTISTS' WATER COLOUR

To move from the use of the genuine pigment to one of the PR101s is a big step in the wrong direction.

Burnt Sienna has long been valued for its own characteristics, they are only echoed here.

UNSPECIFIED PR101 ASTM I (123/124)

PIGMENT DETAIL ON LABEL	ASTM	RATING
YES	I L'FAST	★ ★★

BURNT SIENNA W48

ART SPECTRUM

ARTISTS' WATER COLOUR

The various PR101s might have admirable qualities, but they are not Burnt Sienna. A semi-transparent imitation which should be labelled as such.

UNSPECIFIED PR101 ASTM I (123/124)

PIGMENT DETAIL ON LABEL	ASTM	RATING
YES	I L'FAST	★ ★★

BURNT SIENNA 278

CARAN D'ACHE

FINEST WATERCOLOURS

Lifted reasonably well from the pan but did not wash out very easily.

For thinner applications only I would suggest.

UNSPECIFIED PBr7 (309/310)

PIGMENT DETAIL ON LABEL	ASTM	RATING
YES	I L'FAST	★ ★★

BURNT SIENNA 278

MAIMERI

MAIMERIBLU SUPERIOR WATERCOLOURS

A rich, warm, neutral orange. Very well produced. Washed out smoothly and gave extremely clear washes. One of the better examples.

PBr7 BURNT SIENNA ASTM I (310)

PIGMENT DETAIL ON LABEL	ASTM	
YES	I L'FAST	

BURNT SIENNA 278

MAIMERI

VENEZIA EXTRAFINE WATERCOLOURS

A well produced Burnt Sienna. Of a quality superior to certain 'Artist' range paints. Very transparent.

PBr7 BURNT SIENNA ASTM I (310)

PIGMENT DETAIL ON LABEL	ASTM	
YES	I L'FAST	

UMTON BARVY

ARTISTIC WATER COLOR

BURNT SIENNA 2410

A slightly softer version of this colour than is usual.

Valued since the earliest times for its transparency, unadulterated Burnt Sienna cannot be successfully imitated.

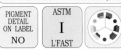

PBr7 BURNT SIENNA ASTM I (310)		
PIGMENT DETAIL ON LABEL **NO**	ASTM **I** L'FAST	

BURNT SIENNA 074

WINSOR & NEWTON

COTMAN WATER COLOURS 2ND RANGE

An excellent all round product. Rich in colour, very smoothly ground and transparent. Superior to many 'Artist Quality' Burnt Siennas.

Reformulated >

PBr7 BURNT SIENNA ASTM I (310)		
PIGMENT DETAIL ON LABEL **YES**	ASTM **I** L'FAST	

BURNT SIENNA

WINSOR & NEWTON

COTMAN WATER COLOURS 2ND RANGE

The paint handled well, giving very good washes. It will also resist damage from the light on a permanent basis. But it is not Burnt Sienna. To offer it as such is a practice only acceptable in this industry.

UNSPECIFIED PR101 ASTM I (123/124)		
PIGMENT DETAIL ON LABEL **YES**	ASTM **I** L'FAST	RATING ★★

HUNTS

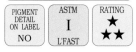

SPEEDBALL PROFESSIONAL WATERCOLOURS

BURNT SIENNA 5701

Despite the non cooperation of the company, a sample was obtained. Washed out well, if a little gritty. Transparent.

UNSPECIFIED PBr7 (309/310)		
PIGMENT DETAIL ON LABEL **NO**	ASTM **I** L'FAST	RATING ★ ★★

LUKAS

ARTISTS' WATER COLOUR

BURNT SIENNA 1109

Not genuine Burnt Sienna but an unspecified synthetic iron oxide sold under the name. Transparent. No details supplied with latest samples so pigment might have changed.

UNSPECIFIED PR101 ASTM I (123/124)		
PIGMENT DETAIL ON LABEL **CHEMICAL MAKE UP ONLY**	ASTM **I** L'FAST	RATING ★ ★★

SIENNA BURNT

St. PETERSBURG

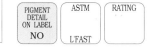

ARTISTS' WATERCOLOURS

This company appear to have been able to very successfully market a range of watercolour paints without informing anybody, customers or distributors of the pigments employed.

PIGMENT DETAILS NOT PROVIDED IN ANY FORM		
PIGMENT DETAIL ON LABEL **NO**	ASTM L'FAST	RATING

SCHMINCKE

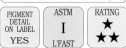

HORADAM FINEST ARTISTS' WATER COLOURS

BURNT SIENNA 661

The consistency of this paint has been improved lately. However, the new sample was still a little over bound. Handled well as a wash. Transparent.

Reformulated >

PBr7 BURNT SIENNA ASTM I (310)		
PIGMENT DETAIL ON LABEL **YES**	ASTM **I** L'FAST	RATING ★ ★★

SCHMINCKE

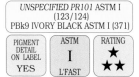

HORADAM FINEST ARTISTS' WATER COLOURS

BURNT SIENNA 661

Those who are unable to appreciate the true beauty and handling characteristics of genuine Burnt Sienna will find this to be 'near enough'.

Those who do appreciate will feel that they have been misled if they make a purchase.

UNSPECIFIED PR101 ASTM I (123/124)		
PBk9 IVORY BLACK ASTM I (371)		
PIGMENT DETAIL ON LABEL **YES**	ASTM **I** L'FAST	RATING ★ ★★

GRUMBACHER

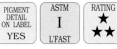

ACADEMY ARTISTS' WATERCOLOR 2ND RANGE

BURNT SIENNA A023

The sample was slightly gritty but brushed out reasonably well. Absolutely lightfast. Transparent.

PBr7 BURNT SIENNA ASTM I (310)		
PIGMENT DETAIL ON LABEL **YES**	ASTM **I** L'FAST	RATING ★ ★★

GRUMBACHER

FINEST ARTISTS' WATER COLOR

BURNT SIENNA 023

A rich, fiery orange brown, the colour is particularly intense. Washes out beautifully, particularly when well diluted. Transparent.

PBr7 BURNT SIENNA ASTM I (310)		
PIGMENT DETAIL ON LABEL **YES**	ASTM **I** L'FAST	

DR.Ph. MARTINS

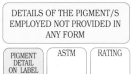

HYDRUS FINE ART WATERCOLOR

BURNT SIENNA 19H

Although I have no idea of the pigmentation, the paint is much darker than is usual. I would suspect the use of a PR101 plus black.

DETAILS OF THE PIGMENT/S EMPLOYED NOT PROVIDED IN ANY FORM		
PIGMENT DETAIL ON LABEL **NO**	ASTM L'FAST	RATING

Being a neutralised orange it works very well with Ultramarine Blue. They will give a wide range of neutrals and greys. Worth experimenting.

Burnt Umber

Available from the earliest times, Burnt Sienna became increasingly popular from the early 1600's.

It is produced by roasting Raw Umber. During heating it undergoes a series of changes. The final colour depends very much on the furnace operator and varies from a neutralised orange-brown to a rich reddish-brown.

Quite high in tinting strength, with good covering power. An excellent pigment, it is worth seeking out a variety that suits your way of working.

Before deciding on the possible results of mixing, it will be a useful exercise to paint out an area as a dilute wash.

Such a thin application will reveal the undercolour and give mixing guidance. It is surprising how seldom we exploit the differences between the mass tone (heavier applications) and diluted washes.

Mixed with Ultramarine Blue it will give rich, deep colourful darks. If you wish to avoid the dulling effect of using black, such a blend will provide an excellent alternative.

BURNT UMBER 668

SCHMINCKE

HORADAM FINEST ARTISTS' WATER COLOURS

Sample was ground a little coarsely. Brushed out well however, over a useful range. Completely unaffected by light. Semi staining and semi opaque.

PBr7 BURNT UMBER ASTM I (310)

| PIGMENT DETAIL ON LABEL YES | ASTM I L'FAST | RATING ★ ★★ |

BURNT UMBER 130

PÈBÈO

FRAGONARD ARTISTS' WATER COLOUR

The ingredients give a colour close in hue to genuine Burnt Umber. To my eye the black content introduces a certain dullness. Semi-opaque.

PR101 MARS RED ASTM I (124)
PBk7 CARBON BLACK ASTM I (370)

| PIGMENT DETAIL ON LABEL YES | ASTM I L'FAST | RATING ★ ★★ |

BURNT UMBER 202

SENNELIER

EXTRA-FINE WATERCOLOUR

Gives reasonably good covering power as well as clear washes when well diluted. A quality watercolour.

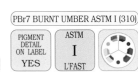

PBr7 BURNT UMBER ASTM I (310)

| PIGMENT DETAIL ON LABEL YES | ASTM I L'FAST | |

BURNT UMBER 011

DANIEL SMITH

EXTRA-FINE WATERCOLORS

Sample washed out very well over a useful range of values. A quality product.

Absolutely lightfast.

PBr7 BURNT UMBER ASTM I (310)

| PIGMENT DETAIL ON LABEL YES | ASTM I L'FAST | |

BURNT UMBER W024

GRUMBACHER

FINEST ARTISTS' WATER COLOR

A deep, rich colour. Covers well in heavier applications yet gives reasonably transparent washes when applied well diluted. Semi-opaque.

PBr7 BURNT UMBER ASTM I (310)

| PIGMENT DETAIL ON LABEL YES | ASTM I L'FAST | |

BURNT UMBER A024

GRUMBACHER

ACADEMY ARTISTS' WATERCOLOR 2ND RANGE

An intense, deep brown applied at full strength.

Handles very smoothly. A well produced watercolour. Semi-opaque.

PBr7 BURNT UMBER ASTM I (310)

| PIGMENT DETAIL ON LABEL YES | ASTM I L'FAST | |

BURNT UMBER 409

TALENS

REMBRANDT ARTISTS' QUALITY EXTRA FINE

Absolutely lightfast. Brushed out very smoothly giving good gradated washes.

Semi-transparent when thinned.

PBr7 BURNT UMBER ASTM I (310)

| PIGMENT DETAIL ON LABEL YES | ASTM I L'FAST | |

BURNT UMBER 409

TALENS

WATER COLOUR 2ND RANGE

Rather warm in hue, closer to Burnt Sienna than the traditional Burnt Umber. Handles beautifully. Semi-opaque.

Range discontinued

PBr7 BURNT UMBER ASTM I (310)

| PIGMENT DETAIL ON LABEL YES | ASTM I L'FAST | |

BURNT UMBER 409

TALENS

VAN GOGH 2ND RANGE

Not Burnt Umber but a simple imitation employing the dulling effects of black to great effect. Manufacturers get away with this because too few realise the value of the genuine article.

UNSPECIFIED PR101 ASTM I (123/124)
PBk6 LAMP BLACK ASTM I (370)

| PIGMENT DETAIL ON LABEL YES | ASTM I L'FAST | RATING ★ ★★ |

BURNT UMBER W53

ART SPECTRUM

A semi transparent, granulating watercolour. Lightfast, reliable ingredients but the addition of the Mars Yellow takes it away from the genuine article. Sample slightly over bound making heavier washes difficult.

ARTISTS' WATER COLOUR

PBr7 BURNT UMBER (310)
PY42 MARS YELLOW ASTM I (43)

PIGMENT DETAIL ON LABEL	ASTM	RATING
YES	I L'FAST	★ ★★

BURNT UMBER 223

DALER ROWNEY

A deep velvety brown when at full strength.

Brushes out well and gives reasonably transparent washes when very dilute. Semi-opaque.

ARTISTS' WATER COLOUR

PBr7 BURNT UMBER ASTM I (310)

PIGMENT DETAIL ON LABEL	ASTM	
YES	I L'FAST	

BURNT UMBER 223

DALER ROWNEY

Superb. Brushed out particularly well giving smooth gradated washes.

Covers well and provides quite transparent glazes. Lightfast. If the pigment details were on the label it would have everything.

GEORGIAN WATER COLOUR 2ND RANGE

PBr7 BURNT UMBER ASTM I (310)

PIGMENT DETAIL ON LABEL	ASTM	
NO	I L'FAST	

BURNT UMBER 5702

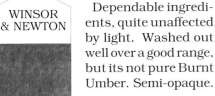

HUNTS

Brushed out very well. Semi-opaque. This is a good example of the colour.

To further darken a Burnt Umber add a little Ultramarine Blue.

SPEEDBALL PROFESSIONAL WATERCOLOURS

UNSPECIFIED PBr7 (309/310)

PIGMENT DETAIL ON LABEL	ASTM	
NO	I L'FAST	

CARAN D'ACHE

FINEST WATERCOLOURS

BURNT UMBER 549

Picked up from the pan reasonably well but was rather difficult to handle.

Washed out quite well when thin but not otherwise.

UNSPECIFIED PBr7 (309/310)

PIGMENT DETAIL ON LABEL	ASTM	RATING
YES	I L'FAST	★ ★★

BURNT UMBER 568

MIR (JAURENA S.A)

As with the Burnt Sienna in this range, this is a rather pale, cloudy colour.

Appears to contain a touch of white or possible filler and is rather lifeless.

ACUARELA

UNSPECIFIED PBr7 (309/310)

PIGMENT DETAIL ON LABEL	ASTM	RATING
YES	I L'FAST	★ ★★

BURNT UMBER 076

WINSOR & NEWTON

Dependable ingredients, quite unaffected by light. Washed out well over a good range, but its not pure Burnt Umber. Semi-opaque.

Reformulated >

ARTISTS' WATER COLOUR

PR101 MARS RED ASTM I (124)
PBr7 BURNT UMBER ASTM I (310)

PIGMENT DETAIL ON LABEL	ASTM	RATING
YES	I L'FAST	★ ★★

BURNT UMBER 076

WINSOR & NEWTON

There will be a great number of painters who have never experienced true Burnt Umber because they are loyal to a company offering an undeclared imitation. A very poor practice.

The paint is well made.

ARTISTS' WATER COLOUR

UNSPECIFIED PBr7 (309/310)
UNSPECIFIED PR101 ASTM I (123/124)
PY42 MARS YELLOW ASTM I (43)

PIGMENT DETAIL ON LABEL	ASTM	RATING
YES	I L'FAST	★ ★★

BURNT UMBER 1111

LUKAS

This is not Burnt Umber at all but an imitation. Close in hue to the genuine article but lacking its richness and 'life'. Semi-opaque. What other industry would get away with this practice?

ARTISTS' WATER COLOUR

PY42 MARS YELLOW ASTM I (43)
PBk11 MARS BLACK ASTM I (371)

PIGMENT DETAIL ON LABEL	ASTM	RATING
CHEMICAL MAKE UP ONLY	I L'FAST	★ ★★

BURNT UMBER 076

WINSOR & NEWTON

If you need to make savings by purchasing 'Second Range' colours, look to the earths first. Absolutely lightfast and the equivalent of many 'Artist Quality' examples.

Reformulated >

COTMAN WATER COLOURS 2ND RANGE

PBr7 BURNT UMBER ASTM I (310)

PIGMENT DETAIL ON LABEL	ASTM	
YES	I L'FAST	

BURNT UMBER 076

WINSOR & NEWTON

It is surely a backward step to reformulate from the use of the genuine pigment to an imitation.

The word 'Hue' would not go amiss.

COTMAN WATER COLOURS 2ND RANGE

UNSPECIFIED PBr7 (309/310)
PY42 MARS YELLOW ASTM I (43)

PIGMENT DETAIL ON LABEL	ASTM	RATING
YES	I L'FAST	★ ★★

BURNT UMBER 492

MAIMERI

A thoroughly reliable watercolour. Rich and deep in colour.

Brushed out beautifully over a useful series of values. Semi-opaque.

MAIMERIBLU SUPERIOR WATERCOLORS

PBr7 BURNT UMBER ASTM I (310)

PIGMENT DETAIL ON LABEL	ASTM	
YES	I L'FAST	

BURNT UMBER 492

MAIMERI

A velvety, deep brown in heavier application.

Washes out to give reasonably transparent glazes. Most reliable.

VENEZIA EXTRAFINE WATERCOLOURS

PBr7 BURNT UMBER ASTM I (310)

PIGMENT DETAIL ON LABEL	ASTM
YES	I L'FAST

BURNT UMBER 70

OLD HOLLAND

Had the actual type of PBr7 been identified I could have given a higher rating. Semi-transparent.

All of the PBrs' are lightfast but have their own characteristics.

CLASSIC WATERCOLOURS

UNSPECIFIED PBr7 ASTM I (309/310)

PIGMENT DETAIL ON LABEL CHEMICAL MAKE UP ONLY	ASTM I L'FAST	RATING ★ ★★

BURNT UMBER 24H

It might be that the company provide details of the ingredients that they use in another form. If they do it would have been a good idea if they had told me. If they do not then they are rather irresponsible.

DR.Ph. MARTINS

HYDRUS FINE ART WATERCOLOR

PIGMENT DETAILS NOT ON THE PRODUCT LABEL OR IN THE LITERATURE PROVIDED

PIGMENT DETAIL ON LABEL	ASTM	RATING
NO	L'FAST	

BURNT UMBER 019

AMERICAN JOURNEY

The actual type of PBr should always be declared (as here) as there are definite differences between them.

Differences which the knowledgeable artist will look for. Non staining and reasonably transparent.

PROFESSIONAL ARTISTS' WATER COLOR

BURNT UMBER PBr7 (310)

PIGMENT DETAIL ON LABEL	ASTM
YES	I L'FAST

BURNT UMBER 477

LEFRANC & BOURGEOIS

Very well ground paint giving smooth washes.

Reasonably transparent when well diluted. Absolutely lightfast.

LINEL EXTRA-FINE ARTISTS' WATERCOLOUR

PBr7 BURNT UMBER ASTM I (310)

PIGMENT DETAIL ON LABEL CHEMICAL MAKE UP ONLY	ASTM I L'FAST

BURNT UMBER 206

DA VINCI PAINTS

Handles particularly well.

Brushes out to give a reasonably wide range of values. Will not fade. Semi-opaque.

PERMANENT ARTISTS' WATER COLOR

PBr7 BURNT UMBER ASTM I (310)

PIGMENT DETAIL ON LABEL	ASTM
YES	I L'FAST

BURNT UMBER 2430

UMTON BARVY

The paint lifted with ease from the pan and washed out very smoothly.

A quality product. Pigment details on the label would be a great help.

ARTISTIC WATER COLOR

BURNT UMBER PBr7 (310)

PIGMENT DETAIL ON LABEL	ASTM
NO	I L'FAST

BURNT UMBER 606

DA VINCI PAINTS

Rather unpleasant to handle, particularly when other than a thin wash is required.

SCUOLA 2ND RANGE

UNSPECIFIED PBr7 (309/310)

PIGMENT DETAIL ON LABEL	ASTM I L'FAST	RATING ★★

BURNT UMBER 030

M.GRAHAM & CO.

Very smooth, even washes from this well made product.

To further darken Burnt Umber without the dulling effect of black, try a touch of Ultramarine Blue.

ARTISTS' WATERCOLOR

BURNT UMBER PBr7 (310)

PIGMENT DETAIL ON LABEL	ASTM
YES	I L'FAST

UMBER BURNT 403

ST. PETERSBURG

I believe that there is a very useful lesson to learn here. The hype put out by the distributors of this product (UK & USA) do not have a clue as to whether or not these paints are suitable for artistic use. The art materials industry often concentrates more on 'image' than on substance.

ARTISTS' WATERCOLOURS

PIGMENT DETAILS NOT ON THE PRODUCT LABEL OR IN THE LITERATURE PROVIDED

PIGMENT DETAIL ON LABEL	ASTM	RATING
NO	L'FAST	

BURNT UMBER 33

HOLBEIN

Very well produced. The paint flows smoothly in a wash and offers a good range of values, from a deep warm brown to a pale wash. Non staining.

ARTISTS' WATER COLOR

PBr7 BURNT UMBER ASTM I (310)

PIGMENT DETAIL ON LABEL	ASTM
YES	I L'FAST

BURNT UMBER 188

UTRECHT

Always look for the specification of the type of PBr7 which has been employed. There are important differences in the characteristics of each. Where not specified I have reduced the rating.

This is as a properly described, quality product.

PROFESSIONAL ARTISTS' WATER COLOR

PBr7 BURNT UMBER ASTM I (310)

PIGMENT DETAIL ON LABEL	ASTM
YES	I L'FAST

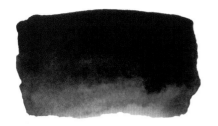

Burnt Umber is considered by many to be the only true brown available. Other 'browns' being easily identified as neutralised orange, red or yellow.

English Red

A synthetic iron oxide, English or Light Red Oxide is distinguished from its cousins, Venetian Red, Indian Red and Mars Red, by colour alone. Much confusion was created in the past as the terms were used loosely to describe iron oxides, whether natural or synthetic.

The work of the ASTM subcommittee on artists paints will hopefully lead to common descriptions.

As the colours are very similar in certain respects, many painters are undecided on which to select.

The real difference between them is particularly noticeable in the undercolour. When deciding between the various colour names or even choosing between one make or another, wash out a small area and note the colour of the tint.

In this section I have emphasised the colour of the paint as a thin wash. It is common for many artists to select a colour by opening a tube and looking at the full strength paint. When working later, the paint is often applied as a medium to thin wash where it changes in character. This applies to all colours but is particularly important when choosing from amongst the various PR101's on offer.

ENGLISH RED 63

OLD HOLLAND

CLASSIC WATERCOLOURS

Handles very well, giving particularly smooth washes. Undercolour is a subtle warm pink. Semi-opaque.

PR101 LIGHT OR ENGLISH RED OXIDE ASTM I (124)

PIGMENT DETAIL ON LABEL	ASTM	
CHEMICAL MAKE UP ONLY	I L'FAST	

ENGLISH RED 244

MAIMERI

VENEZIA EXTRAFINE WATERCOLOURS

Neutral red orange in mass tone with a slightly greyed pink undercolour.

Washes out very well into a useful series of values. Semi-opaque.

PR101 LIGHT OR ENGLISH RED OXIDE ASTM I (124)

PIGMENT DETAIL ON LABEL	ASTM	
YES	I L'FAST	

ENGLISH RED DEEP 650

SCHMINCKE

HORADAM FINEST ARTISTS' WATER COLOURS

An excellent watercolour, smoothly ground, absolutely lightfast and brushes superbly.

Has a soft violet-pink undercolour.

Discontinued

PR101 LIGHT OR ENGLISH RED OXIDE ASTM I (124)
PY42 MARS YELLOW ASTM I (43)

PIGMENT DETAIL ON LABEL	ASTM	RATING
YES	I L'FAST	★ ★★

ENGLISH RED LIGHT W068

GRUMBACHER

FINEST ARTISTS' WATER COLOR

The addition of Yellow Ochre makes the hue lighter but also causes the colour to become slightly 'chalky'. Absolutely lightfast.

PR101 LIGHT OR ENGLISH RED OXIDE ASTM I (124)
PY43 YELLOW OCHRE ASTM I (43)

PIGMENT DETAIL ON LABEL	ASTM	RATING
YES	I L'FAST	★ ★★

ENGLISH RED LIGHT 1054

LUKAS

ARTISTS' WATER COLOUR

The undercolour is a warm pink, mass tone a rich neutral red orange.

Wide range of values available. Semi-opaque. Superb.

PR101 LIGHT OR ENGLISH RED OXIDE ASTM I (124)

PIGMENT DETAIL ON LABEL	ASTM	
CHEMICAL MAKE UP ONLY	I L'FAST	

ENGLISH RED DEEP 1055

LUKAS

ARTISTS' WATER COLOUR

Well produced watercolour paint, smoothly ground and densely packed. Undercolour is a slightly violet-pink.

PR101 LIGHT OR ENGLISH RED OXIDE ASTM I (124)

PIGMENT DETAIL ON LABEL	ASTM	
CHEMICAL MAKE UP ONLY	I L'FAST	

CARAN D'ACHE

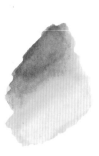

FINEST WATERCOLOURS

ENGLISH RED 63

The paint lifted very well from the pan, as it does with most of the colours in this range.

Brushed out evenly over a wide range of values.

UNSPECIFIED PR101 ASTM I (123/124)		
PIGMENT DETAIL ON LABEL **YES**	ASTM **I** L'FAST	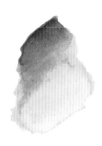

SCHMINCKE

HORADAM FINEST ARTISTS' WATER COLOURS

ENGLISH RED LIGHT 649

When well diluted, the tint or under colour, is a light dusky pink. Washes particularly well. Semi-opaque.

PR101 LIGHT OR ENGLISH RED OXIDE ASTM I (124)		
PIGMENT DETAIL ON LABEL **YES**	ASTM **I** L'FAST	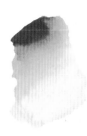

St. PETERSBURG

ARTISTS' WATERCOLOURS

ENGLISH RED

Whenever I come across what is clearly unsubstantiated 'hype', I tend to have a good look at the other products on offer from the same source.

Be it manufacturer or distributor.

DETAILS OF THE PIGMENT/S USED IN THIS WATERCOLOUR PAINT ARE DENIED TO THE ARTIST		
PIGMENT DETAIL ON LABEL **NO**	ASTM L'FAST	RATING

English Red is a reliable, first class watercolour. Medium applications are semi-opaque but it washes out to give reasonably clear, very subtle tints.

Indian Red

The name was originally used for a naturally occurring red ochre imported from India. It is now employed to describe an artificially made red iron oxide of great durability.

Distinguished from other Pigment Red 101's by colour alone, Indian Red possesses a slightly violet undercolour.

I would suggest the ideal method of determining between the different PR101's (or indeed when deciding which make of Indian Red to choose), is to paint out and note the undercolour.

I have made special mention here of this factor, but all colours should be so examined.

There can be considerable differences of basic hue between full strength applications and thin washes with any watercolour.

Treat as a neutralised, or dulled, violet-red when mixing and select a yellow-green as its partner.

DALER ROWNEY

ARTISTS' WATER COLOUR

INDIAN RED 523

Particularly well produced watercolour paint. Very smoothly ground and brushed out beautifully. Undercolour a soft salmon pink. Semi-opaque.

PR101 INDIAN RED ASTM I (123)		
PIGMENT DETAIL ON LABEL **YES**	ASTM **I** L'FAST	

WINSOR & NEWTON

ARTISTS' WATER COLOUR

INDIAN RED 317

Undercolour is a delicate, greyed pink. A very well prepared paint which brushed out smoothly. Semi-opaque.

PR101 INDIAN RED ASTM I (123)		
PIGMENT DETAIL ON LABEL **YES**	ASTM **I** L'FAST	

WINSOR & NEWTON

COTMAN WATER COLOURS 2ND RANGE

INDIAN RED 317

Not quite as smoothly made as the 'Artist Quality' in this make.

The pigment is quite unaffected by light, however strong and prolonged it might be.

PR101 INDIAN RED ASTM I (123)		
PIGMENT DETAIL ON LABEL **YES**	ASTM **I** L'FAST	RATING ★ ★★

INDIAN RED 35

HOLBEIN

Densely packed pigment, very finely ground. Brushed out particularly well giving reasonably transparent washes when very dilute. Soft pink undercolour. Semi staining.

ARTISTS' WATER COLOR

PR101 INDIAN RED ASTM I (123)

PIGMENT DETAIL ON LABEL	ASTM	
YES	I L'FAST	

INDIAN RED 044

DANIEL SMITH

As already outlined, there are differences in the characteristics of the various PR101s. For this reason they should always be specified.

The paint might be perfect but the description is not.

EXTRA-FINE WATERCOLORS

UNSPECIFIED PR101 ASTM I (123/124)

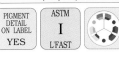

PIGMENT DETAIL ON LABEL	ASTM	
YES	I L'FAST	

CARAN D'ACHE

FINEST WATERCOLOURS

INDIAN RED 75

Add light and this watercolour paint will fade as smoothly as it washes out.

Avoid if you care at all about your work.

PR2 NAPTHOL RED FRR ASTM V (115)

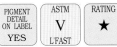

PIGMENT DETAIL ON LABEL	ASTM	RATING
YES	V L'FAST	★

INDIAN RED A110

GRUMBACHER

In both mass tone and undercolour is rather more orange than traditional Indian Red. This of course is due to the Yellow Ochre. Most reliable but contaminated. Semi-opaque. Previously called 'Indian Red (Venetian)'.

ACADEMY ARTISTS' WATERCOLOR 2ND RANGE

PR101 INDIAN RED ASTM I (123)
PY43 YELLOW OCHRE ASTM I (43)

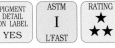

PIGMENT DETAIL ON LABEL	ASTM	RATING
YES	I L'FAST	★ ★★

INDIAN RED W110

GRUMBACHER

Brushes out from full strength to the clearest wash very smoothly.

A subtle, dusky pink under-colour. Absolutely lightfast.

FINEST ARTISTS' WATER COLOR

PR101 INDIAN RED ASTM I (123)

PIGMENT DETAIL ON LABEL	ASTM	
YES	I L'FAST	

INDIAN RED 17H

DR.Ph. MARTINS

One of the intentions of this book is to help bring about change in the quality of our materials and also in the provision of accurate and reliable information.

Manufacturers will only change when you hit them in the pocket.

HYDRUS FINE ART WATERCOLOR

PIGMENT DETAILS NOT PRINTED ON THE LABEL OR IN THE LITERATURE PROVIDED

PIGMENT DETAIL ON LABEL	ASTM	RATING
NO	L'FAST	

PERSIAN (INDIAN) RED 65

OLD HOLLAND

This is an unspecified PR101.

As the various versions are based on colour type alone, it can be classed as lightfast. Washes out smoothly. Previously called 'Persian Red'.

CLASSIC WATERCOLOURS

UNSPECIFIED PR101 ASTM I (123/124)

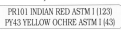

PIGMENT DETAIL ON LABEL	ASTM	
CHEMICAL MAKE UP ONLY	I L'FAST	

INDIAN RED 006

UTRECHT

A little over bound. Heavier washes handled fairly well but dried with a shine.

Thinner washes were fine.

PROFESSIONAL ARTISTS' WATER COLOR

PR101 INDIAN RED ASTM I (123)

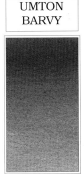

PIGMENT DETAIL ON LABEL	ASTM	RATING
YES	I L'FAST	★ ★★

UMTON BARVY

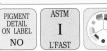

ARTISTIC WATER COLOR

INDIAN RED 2238

The different versions of PR101 make up into excellent watercolour paints when well balanced with the binder. This is no exception. Handled beautifully.

UNSPECIFIED PR101 ASTM I (123/124)

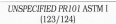

PIGMENT DETAIL ON LABEL	ASTM	
NO	I L'FAST	

INDIAN RED 347

TALENS

The inclusion of Alizarin Crimson lowers the overall lightfast rating. It gives the colour a slightly rosier look, for a while. An unnecessary addition. Semi-opaque.

Reformulated >

REMBRANDT ARTISTS' QUALITY EXTRA FINE

PR101 INDIAN RED ASTM I (123)
CHROMIUM ASTM I (216)
PR83:1 ALIZARIN CRIMSON ASTM IV (122)

PIGMENT DETAIL ON LABEL	ASTM	RATING
YES	IV L'FAST	★

INDIAN RED 347

TALENS

If the unspecified PR101 is actually Indian Red, why add the PR264? It is not what the customer will think they are purchasing as the word 'Hue' is missing. Insufficient information on PR264.

Overall assessments not offered.

REMBRANDT ARTISTS' QUALITY EXTRA FINE

UNSPECIFIED PR101 ASTM I (123/124)
PR264 COMMON NAME N/K LF NOT OFFERED (137)

PIGMENT DETAIL ON LABEL	ASTM	RATING
YES	L'FAST	

INDIAN RED W51

ART SPECTRUM

The sample provided washed out very well over a wide range of values.

But is it 'Indian Red' or one of the other PR101s? The aware artist will want to know.

ARTISTS' WATER COLOUR

UNSPECIFIED PR101 ASTM I (123/124)

PIGMENT DETAIL ON LABEL	ASTM	
YES	I L'FAST	

Light Red

A neutral orange to orange-red, produced by heating naturally occurring Yellow Ochre.

As with all pigments which alter as they are roasted, the final colour will depend very much on the furnace operator.

The colour will tend to vary somewhat between batches but each manufacturer tries to produce a regular result.

Available from opaque to reasonably transparent. Most commonly semi-opaque but brushes out to give reasonably clear washes.

When mixing, treat as a neutral mid or red-orange, depending on your selection. As the complementary of orange is blue, experiment with the various blues to find the ideal partner.

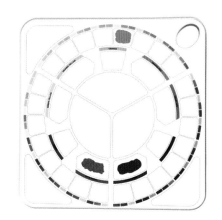

LIGHT RED 527

DALER ROWNEY — ARTISTS' WATER COLOUR

Smooth, well produced paint. Handles with great flexibility over a useful range of values. Subtle, greyed orange tint when very dilute. Semi-opaque. The word 'Hue' should be added as this is not pure Light Red.

Reformulated >

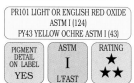

PR101 LIGHT OR ENGLISH RED OXIDE ASTM I (124) PY43 YELLOW OCHRE ASTM I (43)		
PIGMENT DETAIL ON LABEL **YES**	ASTM **I** L'FAST	RATING ★ ★★

LIGHT RED 527

DALER ROWNEY — ARTISTS' WATER COLOUR

If there were no differences between the various types of PR101, they would all have the same name.

As artists become more aware of the pigments to seek, they will demand such information via their purchasing power.

Well made product.

UNSPECIFIED PR101 ASTM I (123/124)		
PIGMENT DETAIL ON LABEL **YES**	ASTM **I** L'FAST	

LIGHT RED 527

DALER ROWNEY — GEORGIAN WATER COLOUR 2ND RANGE

Not Light Red at all but a close imitation requiring the word 'Hue'. Dense pigment and washed out very well. When dilute, the tint is a light, neutral mid-orange. Semi-opaque.

Reformulated >

PBr6 MARS BROWN WG I (309)		
PIGMENT DETAIL ON LABEL **NO**	WG **I** L'FAST	RATING ★ ★★

LIGHT RED 527

DALER ROWNEY — GEORGIAN WATER COLOUR 2ND RANGE

Densely packed pigment gave a watercolour paint which washed out with ease.

A first rate product. It is a pity that it is not pure Light Red but a mixture. This is not indicated in the title.

PY42 MARS YELLOW ASTM I (43) *UNSPECIFIED PR101* ASTM I (123/124)		
PIGMENT DETAIL ON LABEL **NO**	ASTM **I** L'FAST	RATING ★ ★★

LIGHT RED 362

WINSOR & NEWTON — ARTISTS' WATER COLOUR

Particularly well produced. Dense pigment, well ground and brushes out smoothly. Ingredients are completely lightfast. Recent change of pigment, the earlier PY43 Yellow Ochre being replaced by Mars Yellow. Should, I feel, be described as a 'Hue'.

PR101 LIGHT OR ENGLISH RED OXIDE ASTM I (124) PY42 MARS YELLOW ASTM I (43)		
PIGMENT DETAIL ON LABEL **YES**	ASTM **I** L'FAST	RATING ★ ★★

LIGHT RED 362

WINSOR & NEWTON — COTMAN WATER COLOURS 2ND RANGE

Warmer in colour than the 'Artist Quality' in this make as there are no additions. Handled very well. Has a soft red orange tint when diluted. Opaque.

PR101 LIGHT OR ENGLISH RED OXIDE ASTM I (124)		
PIGMENT DETAIL ON LABEL **YES**	ASTM **I** L'FAST	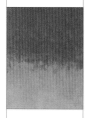

OLD HOLLAND LIGHT RED 340

OLD HOLLAND — CLASSIC WATERCOLOURS

Sample a little on the gummy side, washed smoothly in well diluted form but not so when heavier.

Absolutely lightfast.

PR102 LIGHT RED ASTM I (125)		
PIGMENT DETAIL ON LABEL **CHEMICAL MAKE UP ONLY**	ASTM **I** L'FAST	RATING ★ ★★

LIGHT RED

GRUMBACHER — ACADEMY ARTISTS' WATERCOLOR 2ND RANGE

If a manufacturer feels that it is sufficient to reluctantly supply an incomplete set of samples, withhold literature and not answer questions, they are not denying me information but they are you. Assessments are not possible.

NO PIGMENT INFORMATION GIVEN ON TUBE, LITERATURE NOT SUPPLIED		
PIGMENT DETAIL ON LABEL **YES**	ASTM L'FAST	RATING

LIGHT RED A120

GRUMBACHER — ACADEMY ARTISTS' WATERCOLOR 2ND RANGE

The addition of Yellow Ochre takes a little of the warmth from the Light Red. Well made, brushed out smoothly, but contaminated with PR43. Lightfast. Previously called Light Red (English Red Light). Now needs the word 'Hue'.

PR101 LIGHT OR ENGLISH RED OXIDE ASTM I (124) PY43 YELLOW OCHRE ASTM I (43)		
PIGMENT DETAIL ON LABEL **YES**	ASTM **I** L'FAST	RATING ★ ★★

LIGHT RED 30

HOLBEIN

ARTISTS' WATER COLOR

Brushes out particularly well.

Ranges from semiopaque to transparent when very dilute. A staining colour. Undercolour is a warm neutral orange.

PR101 LIGHT OR ENGLISH RED OXIDE ASTM I (124)

PIGMENT DETAIL ON LABEL	ASTM	
YES	I L'FAST	

LIGHT RED W50

ART SPECTRUM

ARTISTS' WATER COLOUR

A well produced watercolour which gave very smooth, even washes over a wide range of values.

The pigment has not been clearly identified.

UNSPECIFIED PR101 ASTM I (123/124)

PIGMENT DETAIL ON LABEL	ASTM	
YES	I L'FAST	

A thin wash will reveal the undercolour of Light Red, or any of the other colours in this family. Too often paint is applied heavily and the available delicate tint ignored.

Ochres

The difference between the variously coloured iron oxides has not always been clear. At one time they were all described as Yellow Ochre whether they were yellow, red or brown.

The descriptions have now generalised into yellow, gold, brown and red. As you will see, the Gold or Golden Ochres are based on Yellow Ochre.

Rather than worry too much about the actual colour name I suggest that you note the ingredients and decide if you need the colour, have it already under another name, or can mix it with ease.

BROWN OCHRE LIGHT 58

OLD HOLLAND

CLASSIC WATERCOLOURS

Sample brushed out very well. A quality product. For the artist to make a fully considered purchase the type of PBr7 should be specified, as there are definite differences between them.

UNSPECIFIED PBr7 (309/310)

PIGMENT DETAIL ON LABEL	ASTM	
CHEMICAL MAKE UP ONLY	I L'FAST	

BROWN OCHRE DEEP 67

OLD HOLLAND

CLASSIC WATERCOLOURS

Very well produced and brushed out smoothly. Clear washes are obtainable when well diluted. This is a superb paint in all respects.

PR102 LIGHT RED ASTM I (125)

PIGMENT DETAIL ON LABEL	ASTM	
CHEMICAL MAKE UP ONLY	I L'FAST	

BROWN OCHRE 525

CARAN D'ACHE

FINEST WATERCOLOURS

I find difficulty in seeing how this fits the description of an ochre as it appears to be mainly PG8.

At least this element will fade out in time.

PG8 HOOKERS GREEN ASTM III (260)
PY42 MARS YELLOW ASTM I (43)

PIGMENT DETAIL ON LABEL	ASTM	RATING
YES	III L'FAST	★★

UMTON
BARVY

ARTISTIC
WATER COLOR

BROWN OCHRE 2130

Unusually with this range, the paint was rather difficult to lift from the pan.

Handled very well across the range.

UNSPECIFIED PBr7 ASTM I (309/310)		
PIGMENT DETAIL ON LABEL	ASTM	RATING
NO	I L'FAST	★ ★★

OLD HOLLAND

CLASSIC WATERCOLOURS

DEEP OCHRE 443

It is a pity that full details of ingredients were not provided as this company produce a good range of ochres. They are most probably all lightfast but I cannot offer assessments.

Reformulated? >

EARTH COLOURS		
PIGMENT DETAIL ON LABEL CHEMICAL MAKE UP ONLY	ASTM L'FAST	RATING

OLD HOLLAND

CLASSIC WATERCOLOURS

DEEP OCHRE 68

I cannot be sure if this is a reformulation of the colour to the left or a clarification of pigment and a change in name No.

Whatever the situation, it is an appalling substance far removed from my idea of a paint.

PR102 LIGHT RED ASTM I (125)		
PIGMENT DETAIL ON LABEL CHEMICAL MAKE UP ONLY	ASTM I L'FAST	RATING ★

ST. PETERSBURG

ARTISTS' WATERCOLOURS

OCHRE RED 101

The fact that this company have created a healthy market for their products whist refusing to disclose the pigments that they use, says little for a large portion of the artistic community.

INFORMATION WHICH IS VITAL TO THE CARING ARTIST IS DENIED BY THIS COMPANY.		
PIGMENT DETAIL ON LABEL	ASTM	RATING
NO	L'FAST	

LEFRANC & BOURGEOIS

LINEL EXTRA-FINE ARTISTS' WATERCOLOUR

RED OCHRE 306

Brushed out beautifully, from a rich red - brown to a light neutral orange.

Was previously produced using Light Red, equally lightfast and at least it was specified. Semi-transparent.

UNSPECIFIED PR101 ASTM I (123/124)		
PIGMENT DETAIL ON LABEL CHEMICAL MAKE UP ONLY	ASTM I L'FAST	

SENNELIER

EXTRA-FINE WATERCOLOUR

RED OCHRE 259

Gave clear, smooth washes over a wide range. An excellent pigment used to make an equally excellent watercolour.

PR102 LIGHT RED ASTM I (125)		
PIGMENT DETAIL ON LABEL	ASTM I L'FAST	
YES		

HOLBEIN

IRODORI ANTIQUE WATERCOLOR

ANTIQUE RED OCHRE 033

If more artists looked for the characteristics associated with the various types of PR101 before purchasing ochres, the exact pigments would soon be specified.

UNSPECIFIED PR101 ASTM I (123/124)		
PIGMENT DETAIL ON LABEL	ASTM I L'FAST	
YES		

OLD HOLLAND

CLASSIC WATERCOLOURS

RED OCHRE 437

This company offers a good range of Ochres but failed to give exact information on the ingredients. As I cannot be too careful I will not make assessments.

Reformulated?

EARTH COLOURS		
PIGMENT DETAIL ON LABEL CHEMICAL MAKE UP ONLY	ASTM L'FAST	RATING

OLD HOLLAND

CLASSIC WATERCOLOURS

RED OCHRE 62

I am not sure if this is a reformulation of the colour to the left or a clarification of pigment and a change in colour number.

Whatever the detail, it is no more than coloured gum.

PR102 LIGHT RED ASTM I (125)		
PIGMENT DETAIL ON LABEL CHEMICAL MAKE UP ONLY	ASTM I L'FAST	RATING ★

SCHMINCKE

HORADAM FINEST ARTISTS' WATER COLOURS

GOLDEN OCHRE 651

Sample was rather over bound, making heavier application difficult. Thinner washes were fine and reasonably clear. Semi-transparent.
Discontinued

PY42 MARS YELLOW ASTM I (43) PBr7 RAW SIENNA ASTM I (309) PY43 YELLOW OCHRE ASTM I (43)		
PIGMENT DETAIL ON LABEL	ASTM I L'FAST	RATING ★★
YES		

SCHMINCKE

HORADAM FINEST ARTISTS' WATER COLOURS

TITANIUM GOLD OCHRE 659

The pigment has not been subjected to ASTM tests. Our own testing suggested that caution was advisable as the colour tends to fade. The company describe it as lightfast. Previous Colour No 646.

PBr24 CHROME ANTIMONY TITANIUM BUFF RUTILE WG III (312)		
PIGMENT DETAIL ON LABEL	WG III L'FAST	RATING ★★
YES		

SENNELIER

EXTRA-FINE WATERCOLOUR

GOLD OCHRE 257

A rather dark version of Yellow Ochre. Sample brushed out very well giving a wide range of values. Absolutely lightfast. Semi-transparent.

PY43 YELLOW OCHRE ASTM I (43) PBr7 RAW SIENNA ASTM I (309)		
PIGMENT DETAIL ON LABEL	ASTM I L'FAST	
YES		

GOLD OCHRE 231

TALENS

REMBRANDT ARTISTS' QUALITY EXTRA FINE

Sample handled very well and gave rather clear, even washes when applied dilute. Excellent. Semi-transparent. Previously contained one of the PR101s.

PY43 YELLOW OCHRE ASTM I (43)		
PIGMENT DETAIL ON LABEL **YES**	ASTM **I** L'FAST	

GOLD OCHRE 432

OLD HOLLAND

CLASSIC WATERCOLOURS

Once again, I cannot offer assessments without full and accurate information on the ingredients. Very well produced paint which washed out beautifully.

Reformulated? >

EARTH COLOURS		
PIGMENT DETAIL ON LABEL CHEMICAL MAKE UP ONLY	ASTM L'FAST	RATING

GOLD OCHRE 55

OLD HOLLAND

CLASSIC WATERCOLOURS

Either reformulated and a change of colour number or simply a clarification of pigment.

Whatever the situation, I will repeat the note that I made whilst carrying out examination of the sample: 'A vile substance, mainly gum'.

PY43 YELLOW OCHRE ASTM I (43)		
PIGMENT DETAIL ON LABEL CHEMICAL MAKE UP ONLY	ASTM **I** L'FAST	RATING ★

GOLDEN OCHRE 614

MAIMERI

STUDIO FINE WATER COLOR 2ND RANGE

Washed out very smoothly across a wide range of strengths. Reasonably clear washes when dilute. Rather dark for the ingredients. Semi-transparent.

Discontinued

PY43 YELLOW OCHRE ASTM I (43)		
PIGMENT DETAIL ON LABEL **NO**	ASTM **I** L'FAST	

GOLDEN OCHRE 529

MAIMERI

ARTISTI EXTRA FINE WATER COLOR

The sample provided was rather dark for Yellow Ochre.

Brushed out particularly well and gave smooth gradated washes. Semi-transparent.

Discontinued

PY43 YELLOW OCHRE ASTM I (43)		
PIGMENT DETAIL ON LABEL **NO**	ASTM **I** L'FAST	

GOLD OCHRE 285

WINSOR & NEWTON

ARTISTS' WATER COLOUR

New addition to the range. A reliable pigment used to produce a watercolour paint which would have benefited by a better binder to pigment ratio.

Painted out poorly in other than thin applications.

PY42 MARS YELLOW ASTM I (43)		
PIGMENT DETAIL ON LABEL **YES**	ASTM **I** L'FAST	RATING ★ ★★

GOLD OCHRE 1023

LUKAS

ARTISTS' WATER COLOUR

A useful convenience colour. The ingredients are all absolutely lightfast and made into a watercolour which brushed out very smoothly. Semi-opaque.

PBk11 MARS BLACK ASTM I (371)
PR101 INDIAN RED ASTM I (123)
PY43 YELLOW OCHRE ASTM I (43)

PIGMENT DETAIL ON LABEL CHEMICAL MAKE UP ONLY	ASTM **I** L'FAST	

UMTON BARVY

UMTON BARVY

ARTISTIC WATER COLOR

GOLD OCHRE 2150

A soft dull tan which gave very easily applied washes.

When laid on very thinly the undercolour moves towards a soft yellow orange.

PY43 YELLOW OCHRE ASTM I (43)		
PY3 ARYLIDE YELLOW 10G ASTM II (37)		
PIGMENT DETAIL ON LABEL **NO**	ASTM **II** L'FAST	

St. PETERSBURG

St. PETERSBURG

ARTISTS' WATERCOLOURS

OCHRE GOLDEN 005

New addition to the range.

I cannot offer assessments as I do not know what materials have been used to produce this paint.

Outside of the manufacturer, who does?

VITAL INFORMATION REQUIRED BY THE CARING ARTIST IS DENIED		
PIGMENT DETAIL ON LABEL **NO**	ASTM L'FAST	RATING

ANTIQUE OCHRE

HOLBEIN

IRODORI ANTIQUE WATERCOLOR

A synthetic 'Yellow Ochre' and its naturally occurring counterpart.

An unusual combination giving a smooth flowing, absolutely lightfast dull yellow.

PY42 MARS YELLOW ASTM I (43)		
PY43 YELLOW OCHRE ASTM I (43)		
PIGMENT DETAIL ON LABEL **YES**	ASTM **I** L'FAST	

GALLSTONE 565

SENNELIER

EXTRA-FINE WATERCOLOUR

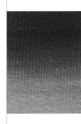

If it makes them happy to call Yellow Ochre, Gallstone, so be it. (The name was changed several years ago from Stone Gall). Brushes out well. Permanent pigment. Semi-opaque.

Discontinued

PY43 YELLOW OCHRE ASTM I (43)		
PIGMENT DETAIL ON LABEL **YES**	ASTM **I** L'FAST	

FRENCH OCHRE 565

SENNELIER

EXTRA-FINE WATERCOLOUR

Handled well. When at all heavy the paint film takes on a rough texture, almost like very fine sandpaper. This is due to the rather coarse nature of the pigment.

PG23 GREEN EARTH/TERRE VERTE ASTM I (262)
PY3 ARYLIDE YELLOW 10G ASTM II (37)
PO49 QUINACRIDONE DEEP GOLD WG II (97)

PIGMENT DETAIL ON LABEL **YES**	ASTM **II** L'FAST	RATING ★ ★★

OLD HOLLAND OCHRE 352

I have to say that the quality of the watercolours produced by this company has deteriorated over the past few years. This is another example of a 'paint' which has been hopelessly overloaded with gum. Unusable.

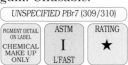

OLD HOLLAND

CLASSIC WATERCOLOURS

UNSPECIFIED PBr7 (309/310)		
PIGMENT DETAIL ON LABEL CHEMICAL MAKE UP ONLY	ASTM I L'FAST	RATING ★

Wash out an area of paint to determine the undercolour. Such thin layers reveal the true nature of the colour. A knowledge of such 'hidden' colours will extend your range of available possibilities.

Raw Sienna

A naturally occurring iron oxide, Raw Sienna has been in use since painting began on cave walls.

The name came into general use after a particularly fine variety at one time dug from deposits near Sienna, Tuscany. An ideal pigment with an admirable range of characteristics. A good quality Raw Sienna lies between Yellow Ochre and Burnt Sienna in colour. It has become very common to offer darker versions of Yellow Ochre under this name.

To my mind this is a poor practice. If the two pigments were identical in make-up, colour and handling they would long ago have merged under the one common name.

Raw Sienna has colour characteristics of its own and is usually rather more transparent.

For mixing purposes it can be considered to be a neutral orange yellow. Through experimentation you will find a blue-violet that will act as a mixing partner.

RAW SIENNA 273

Becoming a rare substance, Raw Sienna which actually is Raw Sienna. Handled particularly well giving smooth even washes. Absolutely lightfast. Semi-transparent.

DA VINCI PAINTS

PERMANENT ARTISTS' WATER COLOR

PBr7 RAW SIENNA ASTM I (309)		
PIGMENT DETAIL ON LABEL YES	ASTM I L'FAST	

RAW SIENNA 673

It is good to see the genuine pigment being used in second range paints.

Unfortunately, our sample did not wash out well unless very dilute.

DA VINCI PAINTS

SCUOLA 2ND RANGE

PBr7 RAW SIENNA ASTM I (309)		
PIGMENT DETAIL ON LABEL YES	ASTM I L'FAST	RATING ★ ★★

RAW SIENNA 183

A very well made watercolour paint which handled beautifully. Gave a wide range of values, from deep neutral orange yellow to the thinnest of washes.

UTRECHT

PROFESSIONAL ARTISTS' WATER COLOR

PBr7 RAW SIENNA ASTM I (309)		
PIGMENT DETAIL ON LABEL YES	ASTM I L'FAST	

RAW SIENNA 135

The sample provided for this edition brushed out as poorly as earlier examples had. An imitation which should be described as a 'Hue' or as an 'Imitation'.

PÈBÈO

FRAGONARD ARTISTS' WATER COLOUR

PR101 MARS RED ASTM I (124)		
PY42 MARS YELLOW ASTM I (43)		
PIGMENT DETAIL ON LABEL YES	ASTM I L'FAST	RATING ★ ★★

RAW SIENNA 112

Very well made. Brushed beautifully over a most useful range of values which have been extended due to the very fine washes that are available.

If you want to get the maximum from Raw Sienna, it pays to use the genuine article.

AMERICAN JOURNEY

PROFESSIONAL ARTISTS' WATER COLOR

PBr7 RAW SIENNA ASTM I (309)		
PIGMENT DETAIL ON LABEL YES	ASTM I L'FAST	

UMTON BARVY

ARTISTIC WATER COLOR

RAW SIENNA 2170

If you need to make savings in order to afford the artists' quality for colours such as Cadmiums Red and Yellow, you can make them with the earth colours. Equally lightfast and often as well made in both artist and 2nd range.

This is a quality paint.

UNSPECIFIED PBr7 ASTM I (309/310)		
PIGMENT DETAIL ON LABEL NO	ASTM I L'FAST	

330

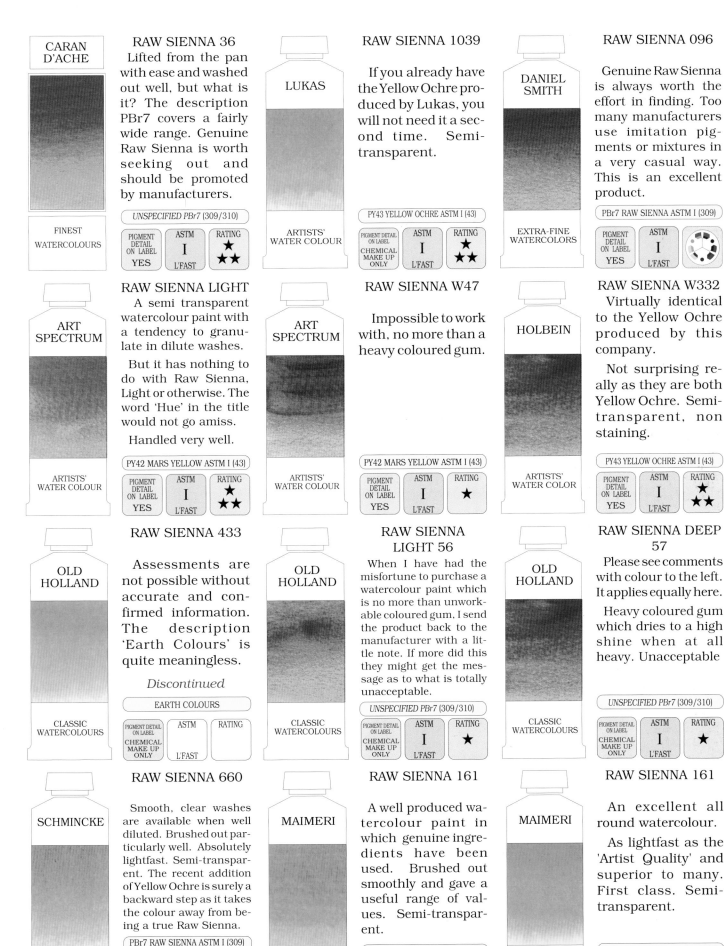

CARAN D'ACHE — FINEST WATERCOLOURS

RAW SIENNA 36
Lifted from the pan with ease and washed out well, but what is it? The description PBr7 covers a fairly wide range. Genuine Raw Sienna is worth seeking out and should be promoted by manufacturers.

UNSPECIFIED PBr7 (309/310)

PIGMENT DETAIL ON LABEL YES	ASTM I L'FAST	RATING ★★

LUKAS — ARTISTS' WATER COLOUR

RAW SIENNA 1039
If you already have the Yellow Ochre produced by Lukas, you will not need it a second time. Semi-transparent.

PY43 YELLOW OCHRE ASTM I (43)

PIGMENT DETAIL ON LABEL CHEMICAL MAKE UP ONLY	ASTM I L'FAST	RATING ★★

DANIEL SMITH — EXTRA-FINE WATERCOLORS

RAW SIENNA 096
Genuine Raw Sienna is always worth the effort in finding. Too many manufacturers use imitation pigments or mixtures in a very casual way. This is an excellent product.

PBr7 RAW SIENNA ASTM I (309)

PIGMENT DETAIL ON LABEL YES	ASTM I L'FAST	

ART SPECTRUM — ARTISTS' WATER COLOUR

RAW SIENNA LIGHT
A semi transparent watercolour paint with a tendency to granulate in dilute washes.

But it has nothing to do with Raw Sienna, Light or otherwise. The word 'Hue' in the title would not go amiss.

Handled very well.

PY42 MARS YELLOW ASTM I (43)

PIGMENT DETAIL ON LABEL YES	ASTM I L'FAST	RATING ★ ★★

ART SPECTRUM — ARTISTS' WATER COLOUR

RAW SIENNA W47
Impossible to work with, no more than a heavy coloured gum.

PY42 MARS YELLOW ASTM I (43)

PIGMENT DETAIL ON LABEL YES	ASTM I L'FAST	RATING ★

HOLBEIN — ARTISTS' WATER COLOR

RAW SIENNA W332
Virtually identical to the Yellow Ochre produced by this company.

Not surprising really as they are both Yellow Ochre. Semi-transparent, non staining.

PY43 YELLOW OCHRE ASTM I (43)

PIGMENT DETAIL ON LABEL YES	ASTM I L'FAST	RATING ★ ★★

OLD HOLLAND — CLASSIC WATERCOLOURS

RAW SIENNA 433
Assessments are not possible without accurate and confirmed information. The description 'Earth Colours' is quite meaningless.

Discontinued

EARTH COLOURS

PIGMENT DETAIL ON LABEL CHEMICAL MAKE UP	ASTM L'FAST	RATING

OLD HOLLAND — CLASSIC WATERCOLOURS

RAW SIENNA LIGHT 56
When I have had the misfortune to purchase a watercolour paint which is no more than unworkable coloured gum, I send the product back to the manufacturer with a little note. If more did this they might get the message as to what is totally unacceptable.

UNSPECIFIED PBr7 (309/310)

PIGMENT DETAIL ON LABEL CHEMICAL MAKE UP ONLY	ASTM I L'FAST	RATING ★

OLD HOLLAND — CLASSIC WATERCOLOURS

RAW SIENNA DEEP 57
Please see comments with colour to the left. It applies equally here.

Heavy coloured gum which dries to a high shine when at all heavy. Unacceptable

UNSPECIFIED PBr7 (309/310)

PIGMENT DETAIL ON LABEL CHEMICAL MAKE UP ONLY	ASTM I L'FAST	RATING ★

SCHMINCKE — HORADAM FINEST ARTISTS' WATER COLOURS

RAW SIENNA 660
Smooth, clear washes are available when well diluted. Brushed out particularly well. Absolutely lightfast. Semi-transparent. The recent addition of Yellow Ochre is surely a backward step as it takes the colour away from being a true Raw Sienna.

PBr7 RAW SIENNA ASTM I (309)
PY43 YELLOW OCHRE ASTM I (43)

PIGMENT DETAIL ON LABEL YES	ASTM I L'FAST	RATING ★ ★★

MAIMERI — MAIMERIBLU SUPERIOR WATERCOLOURS

RAW SIENNA 161
A well produced watercolour paint in which genuine ingredients have been used. Brushed out smoothly and gave a useful range of values. Semi-transparent.

PBr7 RAW SIENNA ASTM I (309)

PIGMENT DETAIL ON LABEL YES	ASTM I L'FAST	

MAIMERI — VENEZIA EXTRAFINE WATERCOLOURS

RAW SIENNA 161
An excellent all round watercolour.

As lightfast as the 'Artist Quality' and superior to many. First class. Semi-transparent.

PBr7 RAW SIENNA ASTM I (309)

PIGMENT DETAIL ON LABEL YES	ASTM L'FAST	

RAW SIENNA 482

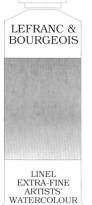

LEFRANC & BOURGEOIS

LINEL EXTRA-FINE ARTISTS' WATERCOLOUR

Not one company marketing Yellow Ochre as Raw Sienna describes the colour as Raw Sienna Hue.

This would at least identify it as an imitation and be rather more honest to the artist.

PY43 YELLOW OCHRE ASTM I (43)

PIGMENT DETAIL ON LABEL	ASTM	RATING
CHEMICAL MAKE UP ONLY	I L'FAST	★ ★★

RAW SIENNA 5730

HUNTS

SPEEDBALL PROFESSIONAL WATERCOLOURS

Without exact and confirmed pigment information I am not willing to commit myself to assessments.

Discontinued

PURIFIED EARTH COLOUR

PIGMENT DETAIL ON LABEL	ASTM	RATING
NO	L'FAST	

RAW SIENNA 667

DALER ROWNEY

ARTISTS' WATER COLOUR

Good quality Raw Sienna has its own unique properties. This is yet another simple imitation which should be labelled as a 'Hue' or an 'Imitation'.

Reformulated >

PY43 YELLOW OCHRE ASTM I (43)

PIGMENT DETAIL ON LABEL	ASTM	RATING
YES	I L'FAST	★ ★★

RAW SIENNA

DALER ROWNEY

ARTISTS' WATER COLOUR

Many of todays' manufacturers treat the description 'Raw Sienna' very casually. It is a pigment which the knowledgable artist will seek out. It is not Mars Yellow with an unspecified synthetic red iron oxide.

PY42 MARS YELLOW ASTM I (43)
UNSPECIFIED PR101 ASTM I (123/124)

PIGMENT DETAIL ON LABEL	ASTM	RATING
YES	I L'FAST	★ ★★

RAW SIENNA 667

DALER ROWNEY

GEORGIAN WATER COLOUR 2ND RANGE

Absolutely lightfast, handles well over a useful range of values but it is not Raw Sienna. It employs a pigment with valuable but alternative characteristics. Semi-transparent.

Reformulated >

PY43 YELLOW OCHRE ASTM I (43)

PIGMENT DETAIL ON LABEL	ASTM	RATING
NO	I L'FAST	★ ★★

RAW SIENNA

DALER ROWNEY

GEORGIAN WATER COLOUR 2ND RANGE

An over bound paint produced from an unidentified PBr7.

Handled poorly unless very dilute. Not good enough.

UNSPECIFIED PBr7 (309/310)

PIGMENT DETAIL ON LABEL	ASTM	RATING
NO	I L'FAST	★★

RAW SIENNA 160

M.GRAHAM & CO.

ARTISTS' WATERCOLOR

Why do so many manufacturers treat the identification of the pigment/s that they use in such a casual way? All that I can say is that this paint is produced from one of the PBr7s. I lower my assessment whenever a colorant is not properly identified, however good the paint might be.

UNSPECIFIED PBr7 (309/310)

PIGMENT DETAIL ON LABEL	ASTM	RATING
YES	I L'FAST	★ ★★

RAW SIENNA 208

SENNELIER

EXTRA-FINE WATERCOLOUR

The pigment was changed several years ago from PY43 Yellow Ochre to an unspecified Pigment Brown 7. Absolutely lightfast and handles well. Semi-transparent.

UNSPECIFIED PBr7 (309/310)

PIGMENT DETAIL ON LABEL	ASTM	RATING
YES	I L'FAST	★ ★★

RAW SIENNA 234

TALENS

REMBRANDT ARTISTS' QUALITY EXTRA FINE

A well produced watercolour. Handled fine but lacks the distinctive colour, handling characteristics and transparency of the genuine article.

PY43 YELLOW OCHRE ASTM I (43)

PIGMENT DETAIL ON LABEL	ASTM	RATING
YES	I L'FAST	★ ★★

RAW SIENNA 234

TALENS

WATER COLOUR 2ND RANGE

A simple imitation of Raw Sienna although the title does not make this clear. Lower assessment made for this reason alone. Absolutely lightfast. Semi-transparent.

Range discontinued

PY43 YELLOW OCHRE ASTM I (43)

PIGMENT DETAIL ON LABEL	ASTM	RATING
YES	I L'FAST	★ ★★

RAW SIENNA 234

TALENS

VAN GOGH 2ND RANGE

Mars Yellow is Mars Yellow and Raw Sienna is Raw Sienna.

Of all people, professional artists' paint manufacturers should be aware of this. If anything they should be promoting the differences.

PY42 MARS YELLOW ASTM I (43)

PIGMENT DETAIL ON LABEL	ASTM	RATING
YES	I L'FAST	★ ★★

RAW SIENNA 570

MIR (JAURENA S.A)

ACUARELA

An unspecified PBr7 again. It might well be Raw Sienna, who knows?

It will be lightfast and washed out quite well. But it could not be purchased with confidence as a Raw Sienna.

UNSPECIFIED PBr7 (309/310)

PIGMENT DETAIL ON LABEL	ASTM	RATING
YES	I L'FAST	★ ★★

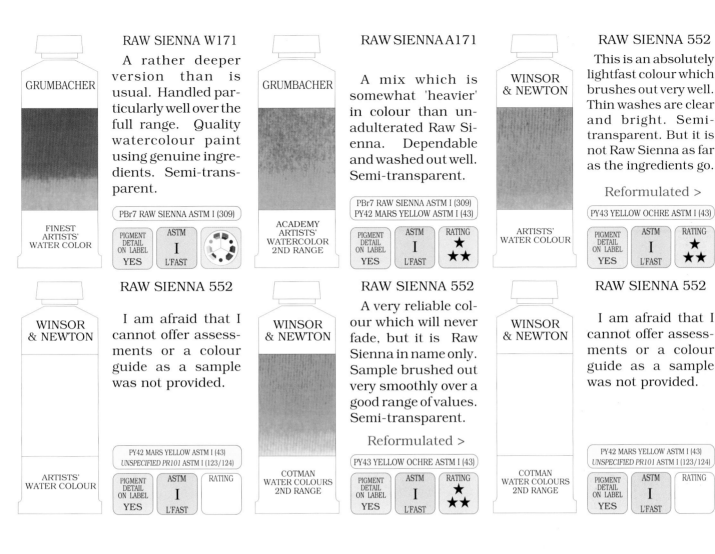

RAW SIENNA W171

A rather deeper version than is usual. Handled particularly well over the full range. Quality watercolour paint using genuine ingredients. Semi-transparent.

GRUMBACHER

FINEST ARTISTS' WATER COLOR

PBr7 RAW SIENNA ASTM I (309)

PIGMENT DETAIL ON LABEL	ASTM	
YES	I L'FAST	

RAW SIENNA A171

A mix which is somewhat 'heavier' in colour than unadulterated Raw Sienna. Dependable and washed out well. Semi-transparent.

GRUMBACHER

ACADEMY ARTISTS' WATERCOLOR 2ND RANGE

PBr7 RAW SIENNA ASTM I (309)
PY42 MARS YELLOW ASTM I (43)

PIGMENT DETAIL ON LABEL	ASTM	RATING
YES	I L'FAST	★ ★★

RAW SIENNA 552

This is an absolutely lightfast colour which brushes out very well. Thin washes are clear and bright. Semi-transparent. But it is not Raw Sienna as far as the ingredients go.

WINSOR & NEWTON

ARTISTS' WATER COLOUR

Reformulated >

PY43 YELLOW OCHRE ASTM I (43)

PIGMENT DETAIL ON LABEL	ASTM	RATING
YES	I L'FAST	★ ★★

RAW SIENNA 552

I am afraid that I cannot offer assessments or a colour guide as a sample was not provided.

WINSOR & NEWTON

ARTISTS' WATER COLOUR

PY42 MARS YELLOW ASTM I (43)
UNSPECIFIED PR101 ASTM I (123/124)

PIGMENT DETAIL ON LABEL	ASTM	RATING
YES	I L'FAST	

RAW SIENNA 552

A very reliable colour which will never fade, but it is Raw Sienna in name only. Sample brushed out very smoothly over a good range of values. Semi-transparent.

WINSOR & NEWTON

COTMAN WATER COLOURS 2ND RANGE

Reformulated >

PY43 YELLOW OCHRE ASTM I (43)

PIGMENT DETAIL ON LABEL	ASTM	RATING
YES	I L'FAST	★ ★★

RAW SIENNA 552

I am afraid that I cannot offer assessments or a colour guide as a sample was not provided.

WINSOR & NEWTON

COTMAN WATER COLOURS 2ND RANGE

PY42 MARS YELLOW ASTM I (43)
UNSPECIFIED PR101 ASTM I (123/124)

PIGMENT DETAIL ON LABEL	ASTM	RATING
YES	I L'FAST	

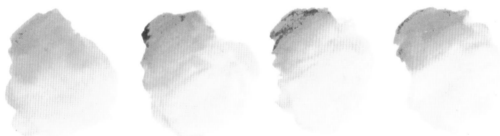

Raw Sienna has long been valued as a glazing colour. The better qualities are particularly transparent and wash out very smoothly.

I suggest that you avoid all versions which do not make it absolutely clear just what the pigment is.

Simply look for PBr7 Raw Sienna. If you have purchased an imitation and would like to try the real thing, why not take the substitute back to your supplier for a refund and look around for the genuine article.

If enough artists do this, pressure from the suppliers will get back to the manufacturer.

The latter will always make changes when profit levels are under threat.

This is part of a multi billion a year industry and artists are supplying the multi billions.

Raw Umber

Believed to have been in use from the earliest times although its employment was not mentioned in easel painting until the 11th Century.

Since then it has gained in popularity and is now widely used.

There are two schools of thought concerning the origins of the name. Some say it originated from a production site at Umbria, in Italy, although very little was produced there. The second version is that it is derived from the Latin 'Ombra' meaning shadow or shade.

A very pleasant, cool brown. The better qualities lean towards green.

Not particularly transparent, although some grades do give reasonably clear washes.

As far as its use in mixing is concerned I would suggest that it is used without further addition where possible.

It is a delicate colour which will soon lose its true character.

Darken carefully with a blue such as Ultramarine.

RAW UMBER 097

Handled with extreme ease over a series of gradated layers.

Reasonably transparent washes are available.

Absolutely lightfast, will never let you down.

DANIEL SMITH

EXTRA-FINE WATERCOLORS

PBr7 RAW UMBER ASTM I (309)		
PIGMENT DETAIL ON LABEL **YES**	**ASTM** I L'FAST	

RAW UMBER 5731

If the company decide to cooperate on the next edition, I will bring you further information and give assessments.

Discontinued

HUNTS

SPEEDBALL PROFESSIONAL WATERCOLOURS

PURIFIED EARTH COLOUR		
PIGMENT DETAIL ON LABEL **NO**	**ASTM** L'FAST	**RATING**

RAW UMBER 131

This paint has no relation to Raw Umber, either in composition or colour. Raw Umber, with untold centuries of proven value, deserves better than this.

PÈBÈO

FRAGONARD ARTISTS' WATER COLOUR

PR101 MARS RED ASTM I (124)
PY42 MARS YELLOW ASTM I (43)
PG10 GREEN GOLD WG II (260)
PBk7 CARBON BLACK ASTM I (370)

PIGMENT DETAIL ON LABEL **YES**	**WG** II L'FAST	**RATING** ★ ★★

RAW UMBER 205

At full strength it is a rich, deep brown with good covering power. Washed out to give fairly clear tints. An excellent water-colour. Semi-opaque.

SENNELIER

EXTRA-FINE WATERCOLOUR

PBr7 RAW UMBER ASTM I (309)		
PIGMENT DETAIL ON LABEL **YES**	**ASTM** I L'FAST	

RAW UMBER 247

A dark, dense velvety brown washing to a light, neutral tint. Handles very smoothly over the entire range. Semi-opaque.

DALER ROWNEY

ARTISTS' WATER COLOUR

PBr7 RAW UMBER ASTM I (309)		
PIGMENT DETAIL ON LABEL **YES**	**ASTM** I L'FAST	

RAW UMBER 247

Genuine ingredient leading to a paint which handled very well. Savings can usually be made with the earth colours as they are as lightfast as their 'Artist' quality cousins.

DALER ROWNEY

GEORGIAN WATER COLOUR 2ND RANGE

PBr7 RAW UMBER ASTM I (309)		
PIGMENT DETAIL ON LABEL **NO**	**ASTM** I L'FAST	

RAW UMBER 548

CARAN D'ACHE

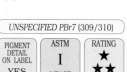

By appearance this would seem to be Raw Umber. If it is why not say so. PBr7 does not tell us much at all.

Washed out fairly well but in thinner applications.

FINEST WATERCOLOURS

UNSPECIFIED PBr7 (309/310)		
PIGMENT DETAIL ON LABEL **YES**	**ASTM** I L'FAST	**RATING** ★ ★★

RAW UMBER 31

Superb. Washes out smoothly, has good covering power but gives clear washes. Absolutely lightfast and well ground. Non staining. Previous Colour No was 691.

HOLBEIN

ARTISTS' WATER COLOR

PBr7 RAW UMBER ASTM I (309)		
PIGMENT DETAIL ON LABEL **YES**	**ASTM** I L'FAST	

UMBER 29

Handled well giving very satisfactory washes. Although it appears to be Umber I would want a more specific description before considering a purchase.

HOLBEIN

ARTISTS' WATER COLOR

UNSPECIFIED PBr7 (309/310)		
PIGMENT DETAIL ON LABEL **YES**	**ASTM** I L'FAST	**RATING** ★ ★★

RAW UMBER 478

LEFRANC & BOURGEOIS
LINEL EXTRA-FINE ARTISTS' WATERCOLOUR

Brushed out beautifully, a fine example of this colour. Has good covering power yet will give reasonably clear washes. First class. Semi-opaque.

PBr7 RAW UMBER ASTM I (309)		
PIGMENT DETAIL ON LABEL CHEMICAL MAKE UP ONLY	ASTM I L'FAST	

RAW UMBER W172

GRUMBACHER
FINEST ARTISTS' WATER COLOR

A particularly dark version of the colour mainly due to the inclusion of Burnt Sienna.

Reliable ingredients but a mongrel colour.

PBr7 BURNT SIENNA ASTM I (310)
PBr7 RAW UMBER ASTM I (309)
PY42 MARS YELLOW ASTM I (43)

PIGMENT DETAIL ON LABEL YES	ASTM I L'FAST	RATING ★ ★★

RAW UMBER A172

GRUMBACHER
ACADEMY ARTISTS' WATERCOLOR 2ND RANGE

The addition of further pigments moves the colour away from its true position. Personally I cannot see how Raw Umber can be improved upon. Semi-opaque.

PBr7 BURNT SIENNA ASTM I (310)
PY42 MARS YELLOW ASTM I (43)
PBr7 RAW UMBER ASTM I (309)

PIGMENT DETAIL ON LABEL YES	ASTM I L'FAST	RATING ★ ★★

RAW UMBER 187

UTRECHT
PROFESSIONAL ARTISTS' WATER COLOR

Sample contained a slight excess of binder.

Handled very well in the thinner washes but not so well when at all heavy. I would still choose it over an unspecified example.

PBr7 RAW UMBER ASTM I (309)		
PIGMENT DETAIL ON LABEL YES	ASTM I L'FAST	RATING ★ ★★

RAW UMBER 274

DA VINCI PAINTS
PERMANENT ARTISTS' WATER COLOR

A semi-opaque paint which gives a good range of values. Genuine Raw Umber is a colour worth seeking out as there are many imitations on the market. Lightfast.

PBr7 RAW UMBER ASTM I (309)		
PIGMENT DETAIL ON LABEL YES	ASTM I L'FAST	

RAW UMBER 674

DA VINCI PAINTS
SCUOLA 2ND RANGE

A very well produced watercolour paint employing genuine PBr7 Raw Umber pigment.

It will always pay you to be very fussy about the actual materials that you choose with which to carry out your work.

PBr7 RAW UMBER ASTM I (309)		
PIGMENT DETAIL ON LABEL YES	ASTM I L'FAST	

RAW UMBER 667

SCHMINCKE
HORADAM FINEST ARTISTS' WATER COLOURS

The earlier version of this colour contained Yellow Ochre. Its removal now gives the genuine article.

Brushed out very well. A quality product.

PBr7 RAW UMBER ASTM I (309)		
PIGMENT DETAIL ON LABEL YES	ASTM I L'FAST	

RAW UMBER W52

ART SPECTRUM
ARTISTS' WATER COLOUR

Raw Umber adulterated with Mars yellow. And I choose the word adulterated deliberately.

It is fine for any manufacturer to use whatever pigments suite them, but the word 'Hue' in the title would alert the artist to imitations.

PBr7 RAW UMBER ASTM I (309)
PY42 MARS YELLOW ASTM I (43)

PIGMENT DETAIL ON LABEL YES	ASTM I L'FAST	RATING ★ ★★

RAW UMBER 69

OLD HOLLAND
CLASSIC WATERCOLOURS

The earlier pigment description 'Earth Colours' could conceivably have include the unreliable Van Dyke Brown. Every effort was made to obtain accurate detail. We are getting closer now but still cannot identify the actual type of PBr7. Perhaps next time.

UNSPECIFIED PBr7 (309/310)		
PIGMENT DETAIL ON LABEL CHEMICAL MAKE UP ONLY	ASTM I L'FAST	RATING ★ ★★

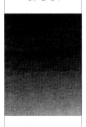

RAW UMBER 408

TALENS
REMBRANDT ARTISTS' QUALITY EXTRA FINE

An improvement over earlier samples, which had been rather over bound.

Painted out very well. Absolutely lightfast

PBr7 RAW UMBER ASTM I (309)		
PIGMENT DETAIL ON LABEL YES	ASTM I L'FAST	

RAW UMBER 170

M.GRAHAM & CO.
ARTISTS' WATERCOLOR

A very well made example. Handled with ease, genuine pigment, correct balance of pigment to binder and it is absolutely lightfast. Who could ask for more in a watercolour paint?

PBr7 RAW UMBER ASTM I (309)		
PIGMENT DETAIL ON LABEL YES	ASTM I L'FAST	

RAW UMBER 408

TALENS
WATER COLOUR 2ND RANGE

Sample was rather gum laden making application difficult. Lightfast.

Range discontinued

PBr7 RAW UMBER ASTM I (309)		
PIGMENT DETAIL ON LABEL YES	ASTM I L'FAST	RATING ★★

RAW UMBER 408

TALENS

PY42 Mars Yellow is a synthetic iron oxide as is an unspecified PR101.

Added together they have been made into a quality paint. But it is an imitation Raw Umber.

VAN GOGH
2ND RANGE

| PY42 MARS YELLOW ASTM I (43) |
| *UNSPECIFIED PR101 ASTM I (123/124)* |

PIGMENT DETAIL ON LABEL	ASTM	RATING
YES	I L'FAST	★ ★★

RAW UMBER 493

MAIMERI

A watercolour paint which handles particularly well. Quite strong in tinting power and covers well. Excellent. Semi-opaque.

MAIMERIBLU
SUPERIOR
WATERCOLOURS

| PBr7 RAW UMBER ASTM I (309) |

PIGMENT DETAIL ON LABEL	ASTM	
YES	I L'FAST	

RAW UMBER 493

MAIMERI

A well made watercolour paint. Reasonably good covering power and fairly clear tints.

Many 'Second Range' paints are as reliable as the 'Artist Quality' All of the PBr7s are lightfast.

VENEZIA
EXTRAFINE
WATERCOLOURS

| PBr7 RAW UMBER ASTM I (309) | |

PIGMENT DETAIL ON LABEL	ASTM	
YES	I L'FAST	

RAW UMBER 554

WINSOR & NEWTON

A well produced watercolour, preferable to many 'Artist Quality' Raw Umbers on the market. Covered well and gave reasonably clear washes. Semi-opaque.

Reformulated >

COTMAN
WATER COLOURS
2ND RANGE

| PBr7 RAW UMBER ASTM I (309) |

PIGMENT DETAIL ON LABEL	ASTM	
YES	I L'FAST	

RAW UMBER 554

WINSOR & NEWTON

One of the various PBr7s which might or might not be Raw Umber. Bolstered with a synthetic iron oxide. This is not Raw Umber and should be labelled as such.

COTMAN
WATER COLOURS
2ND RANGE

| *UNSPECIFIED PBr7 (309/310)* |
| PY42 MARS YELLOW ASTM I (43) |

PIGMENT DETAIL ON LABEL	ASTM	RATING
YES	I L'FAST	★ ★★

UMTON BARVY

RAW UMBER 2420

A rather weak (over bound?) paint which gave difficulty in heavier applications. As with all of the PBr7s it is absolutely lightfast.

ARTISTIC
WATER COLOR

| *UNSPECIFIED PBr7 (309/310)* |

PIGMENT DETAIL ON LABEL	ASTM	RATING
NO	I L'FAST	★ ★★

UMBER RAW

ST. PETERSBURG

With the awareness of todays' consumer, the area of art materials must be one of the last in which the make up of a product can be denied. Especially where that make up is of vital importance to the customer.

ARTISTS'
WATERCOLOURS

| INFORMATION ON THE PAINT CONTENTS NOT MADE AVAILABLE IN ANY FORM |

PIGMENT DETAIL ON LABEL	ASTM	RATING
NO	L'FAST	

RAW UMBER 565

MIR (JAURENA S.A)

Not particularly pleasant to use and handled far better in thin washes than when at all heavy.

I realise that thinner applications are the norm in watercolour painting, but there are times when heavier passages are required.

ACUARELA

| *UNSPECIFIED PBr7 (309/310)* |

PIGMENT DETAIL ON LABEL	ASTM	RATING
YES	I L'FAST	★★

RAW UMBER 554

WINSOR & NEWTON

Sample was rather over bound making only very light washes possible. Absolutely lightfast.

Reformulated >

ARTISTS'
WATER COLOUR

| PBr7 RAW UMBER ASTM I (309) |

PIGMENT DETAIL ON LABEL	ASTM	RATING
YES	I L'FAST	★★

RAW UMBER 554

WINSOR & NEWTON

I am afraid that I cannot offer assessments or a colour guide as a sample was not provided.

ARTISTS'
WATER COLOUR

| *UNSPECIFIED PBr7 (309/310)* |
| PY42 MARS YELLOW ASTM I (43) |

PIGMENT DETAIL ON LABEL	ASTM	RATING
YES	I L'FAST	

RAW UMBER 1110

LUKAS

This was previously made up using PY43 Yellow Ochre. Now reformulated to give a colour which resembles genuine Raw Umber. Once again it should be called a 'Hue'. Let down by the inclusion of the unreliable PY74.

ARTISTS'
WATER COLOUR

| PR176 BENZIMIDAZOLONE CARMINE HF3C WG II (130) |
| PY74LF ARYLIDE YELLOW 5GX ASTM III (44) |
| PBk7 CARBON BLACK ASTM I (370) |

PIGMENT DETAIL ON LABEL	ASTM	RATING
CHEMICAL MAKE UP ONLY	III L'FAST	★★

RAW UMBER 115

AMERICAN JOURNEY

The sample was slightly over bound, making other than light washes a little unpleasant to work with.

Absolutely lightfast pigment, correctly identified.

PROFESSIONAL
ARTISTS'
WATER COLOR

| PBr7 RAW UMBER ASTM I (309) |

PIGMENT DETAIL ON LABEL	ASTM	RATING
YES	I L'FAST	★ ★★

The very poor practise of adding further pigments such as Burnt Sienna and Mars Yellow to Raw Umber persists.

There are two disadvantages to this. On the one hand, genuine Raw Umber has its own unique range of characteristics which can only be altered by other pigments.

On the other, there will be many painters, loyal to the one make, who have yet to experience the subtleties of a well produced, unadulterated Raw Umber.

If they do not experience the genuine colour they will not appreciate it or seek it out. One more step away from the true craft of painting.

Sepia

Originally prepared from the dried ink sac of the cuttlefish or squid. It was a semi-transparent blackish brown with good tinting strength.

The contents of just one ink sac will make 1,000 gallons of water opaque in just a few seconds, it is that strong.

Genuine Sepia is fairly permanent but thin washes are liable to fade in sunlight. In use since classical times as a drawing ink, it became popular as a watercolour towards the end of the 18th Century.

The colour so named today is a simple mix of just about anything which will give a blackish brown. It is as if each manufacturer feels that their range will be incomplete unless it contains a 'Sepia'.

Amazingly some find it possible to produce a blackish brown which is less than lightfast.

Amazing because of the wide range of inexpensive lightfast blacks and browns which are readily available.

Let the name slip into obscurity by mixing such colours yourself.

SEPIA 486

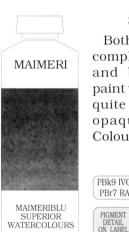

Both pigments are completely reliable and blend into a paint which handled quite well. Semi-opaque. Previous Colour No. was 535.

PBk9 IVORY BLACK ASTM I (371)
PBr7 RAW UMBER ASTM I (309)

MAIMERI · MAIMERIBLU SUPERIOR WATERCOLOURS

PIGMENT DETAIL ON LABEL	ASTM	
YES	I L'FAST	

SEPIA 486

A convenience colour which handles well.

Smoothly ground paint, covers economically and gives quite clear washes. Semi-opaque. Previous Colour No. was 631.

PBr7 BURNT SIENNA ASTM I (310)
PBk9 IVORY BLACK ASTM I (371)

MAIMERI · VENEZIA EXTRAFINE WATERCOLOURS

PIGMENT DETAIL ON LABEL	ASTM	
YES	I L'FAST	

SEPIA 21H

As I have said elsewhere, the details of the colorants used could be supplied in a form not presented to us for the purposes of this book.

If this is not the case, why would anyone take a chance in its use?

PIGMENT DETAILS COULD NOT BE FOUND ON THE LABEL OR IN THE LITERATURE SUPPLIED

DR.Ph. MARTINS · HYDRUS FINE ART WATERCOLOR

PIGMENT DETAIL ON LABEL	ASTM	RATING
NO	L'FAST	

SEPIA W55

As with virtually all examples of this colour type it is very simple to duplicate in a mix.

Sample washed out very well. Ingredients absolutely lightfast.

UNSPECIFIED PR101 ASTM I (123/124)
PBk6 LAMP BLACK ASTM I (370)

ART SPECTRUM · ARTISTS' WATER COLOUR

PIGMENT DETAIL ON LABEL	ASTM	
YES	I L'FAST	

SEPIA 1106

The particularly unreliable PY12 once included is no longer involved. Completely reformulated several years ago but let down by the inclusion of PY74. A pity is was added.

PR176 BENZIMIDAZOLONE CARMINE HF3C WG II (130)
PY74LF ARYLIDE YELLOW 5GX ASTM III (44)
PBk7 CARBON BLACK ASTM I (370)

LUKAS · ARTISTS' WATER COLOUR

PIGMENT DETAIL ON LABEL	ASTM	RATING
CHEMICAL MAKE UP ONLY	III L'FAST	★★

SEPIA 127

Non staining and semi transparent. A most reliable watercolour paint which brushed out well at all strengths.

It is still easy to mix though.

PBk6 LAMP BLACK ASTM I (370)
UNSPECIFIED PBr7 (309/310)

AMERICAN JOURNEY · PROFESSIONAL ARTISTS' WATER COLOR

PIGMENT DETAIL ON LABEL	ASTM	
YES	I L'FAST	

SEPIA 178

M.GRAHAM & CO.

ARTISTS' WATERCOLOR

Fine, even washes are on offer from this well made product.

Semi transparent when thinned but covers quite well when heavier.

UNSPECIFIED PBr7 (309/310)
PBk6 LAMP BLACK ASTM I (370)

PIGMENT DETAIL ON LABEL **YES** | ASTM **I** L'FAST |

ST. PETERSBURG

ARTISTS' WATERCOLOURS

SEPIA 501

You will probably be safe with this one as a manufacturer has to try hard to make this colour type unreliable.

But some do make the attempt and some do succeed.

INFORMATION ON THE PIGMENT/S EMPLOYED IN THIS WATERCOLOUR PAINT HAS BEEN DENIED

PIGMENT DETAIL ON LABEL **NO** | ASTM L'FAST | RATING

SEPIA 103

DANIEL SMITH

EXTRA-FINE WATERCOLORS

Very well made and handled with absolute ease. Semi trans.

If you favour this colour type and wish to avoid the dulling effect of the black, try adding a little Ultramarine Blue to Burnt Umber.

PBr7 BURNT UMBER ASTM I (310)
PBk9 IVORY BLACK ASTM I (371)

PIGMENT DETAIL ON LABEL **YES** | ASTM **I** L'FAST |

SEPIA 578

MIR (JAURENA S.A)

ACUARELA

A watercolour paint which handles better in thinner applications than heavier. Can be taken a long way down when very dilute, giving smooth, ultra thin washes.

UNSPECIFIED PBr7 (309/310)
PBk7 CARBON BLACK ASTM I (370)

PIGMENT DETAIL ON LABEL **YES** | ASTM **I** L'FAST | RATING ★ ★★ |

SEPIA 278

DA VINCI PAINTS

PERMANENT ARTISTS' WATER COLOR

Another mix of standard ingredients which are easy to stir together on the palette. Washed out well. Semi-opaque. Previously called 'Sepia Natural'.

PBr7 RAW UMBER ASTM I (309)
PBk6 LAMP BLACK ASTM I (370)

PIGMENT DETAIL ON LABEL **YES** | ASTM **I** L'FAST |

WARM SEPIA W54

ART SPECTRUM

ARTISTS' WATER COLOUR

Whereas I feel justified in lowering the assessment of, say a Burnt Umber where the PBr7 is not identified, in simple mixes such as these there is no standard formula. One PBr7 or PR 101 is as good as the next if the colour suites.

Handled very well.

UNSPECIFIED PR101 ASTM I (123/124)
PBk6 LAMP BLACK ASTM I (370)

PIGMENT DETAIL ON LABEL **YES** | ASTM **I** L'FAST |

SEPIA 133

PÈBÈO

FRAGONARD ARTISTS' WATER COLOUR

Dependable ingredient give a paint which handles well and provides a useful range of values. Semi-opaque.

PR101 MARS RED ASTM I (124)
PY42 MARS YELLOW ASTM I (43)
PBk7 CARBON BLACK ASTM I (370)

PIGMENT DETAIL ON LABEL **YES** | ASTM **I** L'FAST |

WARM SEPIA 120

LEFRANC & BOURGEOIS

LINEL EXTRA-FINE ARTISTS' WATERCOLOUR

Straight forward Ivory Black, produced from charred animal bones. Ivory Black has a natural leaning towards brown, this is particularly so in this example. Semi-opaque.

PBk9 IVORY BLACK ASTM I (371)

PIGMENT DETAIL ON LABEL CHEMICAL MAKE UP ONLY | ASTM **I** L'FAST |

RAW SEPIA 121

LEFRANC & BOURGEOIS

LINEL EXTRA-FINE ARTISTS' WATERCOLOUR

A well made paint employing lightfast pigments.

As you will see by the ingredients, such colours are very easy to mix.

PBr7 BURNT UMBER ASTM I (310)
PBk9 IVORY BLACK ASTM I (371)

PIGMENT DETAIL ON LABEL CHEMICAL MAKE UP ONLY | ASTM **I** L'FAST |

SEPIA 36

HOLBEIN

ARTISTS' WATER COLOR

Smooth, even washes, over a wide range of values.

Typical, even 'traditional', ingredients for the modern version of 'Sepia'. Lightfast. Semi-transparent, non staining and easy to lift.

PBr7 BURNT SIENNA ASTM I (310)
PBk6 LAMP BLACK ASTM I (370)

PIGMENT DETAIL ON LABEL **YES** | ASTM **I** L'FAST |

SEPIA BROWN TONE 662

SCHMINCKE

HORADAM FINEST ARTISTS' WATER COLOURS

A slightly reddish dark brown. Washed out well into quite clear washes when very dilute. Good covering power. Semi-opaque.

PR 166 DISAZO SCARLET WG II (128)
PBr7 RAW SIENNA ASTM I (309)
PBk9 IVORY BLACK ASTM I (371)

PIGMENT DETAIL ON LABEL **YES** | **WG II** L'FAST |

SEPIA BROWN 663

SCHMINCKE

HORADAM FINEST ARTISTS' WATER COLOURS

The fugitive PB66 Indigo Blue once used has been replaced by the very dependable Phthalocyanine Blue. Check earlier purchases.

A definite step in the right direction. Recommended. Semi-opaque.

PB15 PHTHALOCYANINE BLUE ASTM II (213)
PBr7 RAW SIENNA ASTM I (309)
PBk9 IVORY BLACK ASTM I (371)

PIGMENT DETAIL ON LABEL **YES** | ASTM **II** L'FAST |

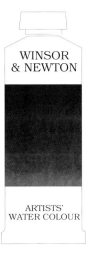

SEPIA 609

WINSOR & NEWTON

Reformulated several years ago from a blend of Burnt Sienna and Lamp Black to a variety of PR101 and black. Absolutely lightfast. Semi-opaque.

ARTISTS' WATER COLOUR

| UNSPECIFIED PR101 ASTM I (123/124) |
| PBk6 LAMP BLACK ASTM I (370) |

| PIGMENT DETAIL ON LABEL **YES** | ASTM **I** L'FAST | |

WARM SEPIA 613

WINSOR & NEWTON

The type of PR101 is unspecified but it will be lightfast. Gave good gradated washes. Very easily mixed. Semi-opaque.

Discontinued:
Company says it was too close to their Sepia

ARTISTS' WATER COLOUR

| UNSPECIFIED PR101 ASTM I (123/124) |
| PBk6 LAMP BLACK ASTM I (370) |

| PIGMENT DETAIL ON LABEL **YES** | ASTM **I** L'FAST | |

SEPIA 609

WINSOR & NEWTON

Sample brushed out well over a wide range of values.

A convenience colour which is easily mixed.

Semi-opaque.

COTMAN WATER COLOURS 2ND RANGE

| PBr7 BURNT UMBER ASTM I (310) |
| PBk7 CARBON BLACK ASTM I (370) |

| PIGMENT DETAIL ON LABEL **YES** | ASTM **I** L'FAST | |

SEPIA 5716

HUNTS

Without accurate pigment descriptions, the caring artist cannot select with confidence.

Assessments are not possible.

Discontinued

SPEEDBALL PROFESSIONAL WATERCOLOURS

| PURIFIED EARTH COLOUR |

| PIGMENT DETAIL ON LABEL **NO** | ASTM L'FAST | RATING |

RAW SEPIA 443

SENNELIER

This colour was reformulated several years ago (you might still have an earlier version) and improved beyond recognition.

Now handles particularly well, giving smooth, even washes. Absolutely lightfast.

EXTRA-FINE WATERCOLOUR

| UNSPECIFIED PBr7 (309/310) |
| PBk7 CARBON BLACK ASTM I (370) |

| PIGMENT DETAIL ON LABEL **YES** | ASTM **I** L'FAST | |

WARM SEPIA 440

SENNELIER

The pigments used are absolutely lightfast.

The sample handled well. Although the PBr7 is unspecified, it will be lightfast.

EXTRA-FINE WATERCOLOUR

| UNSPECIFIED PBr7 (309/310) |
| PBk7 CARBON BLACK ASTM I (370) |

| PIGMENT DETAIL ON LABEL **YES** | ASTM **I** L'FAST | |

PERMANENT SEPIA 251

DALER ROWNEY

The only 'Permanent Sepia' on the market and it isn't. On exposure, changes to the PR4 are liable to affect the colour.

Discontinued

| PR4 CHLORINATED PARA RED WG V (115) |
| PBk7 CARBON BLACK ASTM I (370) |
| PBr7 RAW SIENNA ASTM I (309) |

ARTISTS' WATER COLOUR

| PIGMENT DETAIL ON LABEL **YES** | WG **V** L'FAST | RATING ★ |

WARM SEPIA 250

DALER ROWNEY

With even very basic colour mixing skills you will be able to produce this, (as well as all other versions of 'Sepia) with ease. Lightfast. Semi-opaque.

ARTISTS' WATER COLOUR

| PBr7 RAW UMBER ASTM I (309) |
| PR101 VENETIAN RED ASTM I (124) |
| PBk11 MARS BLACK ASTM I (371) |

| PIGMENT DETAIL ON LABEL **YES** | ASTM **I** L'FAST | |

SEPIA (HUE) 251

DALER ROWNEY

Had the PR4 not been added this could have been a reliable colour. Washed out well. Semi-opaque.

GEORGIAN WATER COLOUR 2ND RANGE

| PR4 CHLORINATED PARA RED WG V (115) |
| PY42 MARS YELLOW ASTM I (43) |
| PBk7 CARBON BLACK ASTM I (370) |

| PIGMENT DETAIL ON LABEL **NO** | WG **V** L'FAST | RATING ★ |

SEPIA NATURAL W193

GRUMBACHER

An easily mixed convenience colour. Handled smoothly at all strengths and covered well. Semi-opaque. Previously called 'Sepia Natural (Mineral).

FINEST ARTISTS' WATER COLOR

| PBr7 BURNT UMBER ASTM I (310) |
| PBk6 LAMP BLACK ASTM I (370) |

| PIGMENT DETAIL ON LABEL **YES** | ASTM L'FAST | |

SEPIA WARM W194

GRUMBACHER

A dark velvety brown. Such colours are easily produced on the palette. Reliable and handles smoothly. Semi-opaque. Previously called 'Sepia Warm (Mineral).

FINEST ARTISTS' WATER COLOR

| PBr7 BURNT UMBER ASTM I (310) |
| PBr7 BURNT SIENNA ASTM I (309) |
| PBk6 LAMP BLACK ASTM I (370) |

| PIGMENT DETAIL ON LABEL **YES** | ASTM L'FAST | |

SEPIA HUE A192

GRUMBACHER

A collection of absolutely lightfast pigments making up into a paint which handled well. A convenience colour easily reproduced.

ACADEMY ARTISTS' WATERCOLOR 2ND RANGE

| PBr7 BURNT SIENNA ASTM I (310) |
| PY42 MARS YELLOW ASTM I (43) |
| PBk6 LAMP BLACK ASTM I (370) |

| PIGMENT DETAIL ON LABEL **YES** | ASTM L'FAST | |

SEPIA 2347

Whether in pan or tube, light, middle or dark, all versions of Sepia take only a few moments to mix.

Reliable and well made.

ARTISTIC
WATER COLOR

PBk9 IVORY BLACK ASTM I (371)
UNSPECIFIED PBr7 ASTM I (309/310)

PIGMENT DETAIL ON LABEL	ASTM	
NO	I L'FAST	

TALENS

WATER COLOUR
2ND RANGE

SEPIA 416

Reliable ingredients giving a paint which covers well and gives even washes. Absolutely lightfast. Semi-opaque. Previously called 'Sepia (Modern).

Range discontinued

PBk7 CARBON BLACK ASTM I (370)
PBr7 BURNT SIENNA ASTM I (310)

PIGMENT DETAIL ON LABEL	ASTM	
YES	I L'FAST	

TALENS

VAN GOGH
2ND RANGE

SEPIA 782

A deep velvety brown when applied heavily but, like virtually all 'Sepias' the thinner washes are dulled by the black content.

To avoid this factor, add a touch of Ultramarine to Burnt Umber or Burnt Sienna.

PBk7 CARBON BLACK ASTM I (370)
UNSPECIFIED PR101 ASTM I (123/124)

PIGMENT DETAIL ON LABEL	ASTM	
YES	I L'FAST	

TALENS

REMBRANDT
ARTISTS'
QUALITY
EXTRA FINE

SEPIA MODERN 416

A touch of Ultramarine Blue added to the Burnt Sienna would give a similar but 'cleaner' colour. Handled well. Semi-opaque.

Discontinued

PBk7 CARBON BLACK ASTM I (370)
PBr7 BURNT SIENNA ASTM I (310)

PIGMENT DETAIL ON LABEL	ASTM	
YES	I L'FAST	

TALENS

REMBRANDT
ARTISTS'
QUALITY
EXTRA FINE

SEPIA 416

A well made watercolour paint which handled with ease. Very pleasant to use.

PBk7 CARBON BLACK ASTM I (370)
UNSPECIFIED PR101 ASTM I (123/124)

PIGMENT DETAIL ON LABEL	ASTM	
YES	I L'FAST	

OLD
HOLLAND

CLASSIC
WATERCOLOURS

WARM SEPIA EXTRA 71

Simple ingredients which should give a smooth, easily worked paint. Instead we have a rather gum laden material which is only suitable for thin washes. How do they do it?

PBk7 CARBON BLACK ASTM I (370)
PR102 LIGHT RED ASTM I (125)
UNSPECIFIED PBr7 ASTM I (309/310)

PIGMENT DETAIL ON LABEL	ASTM	RATING
CHEMICAL MAKE UP ONLY	I L'FAST	★

OLD
HOLLAND

CLASSIC
WATERCOLOURS

SEPIA EXTRA 446

As the unreliable Van Dyke Brown could also be described as an 'earth colour', I cannot offer assessments. All manufacturers were asked repeatedly for clarification of ingredients.

Reformulated >

EARTH COLOUR
PBk9 IVORY BLACK ASTM I (371)

PIGMENT DETAIL ON LABEL	ASTM	RATING
CHEMICAL MAKE UP ONLY	L'FAST	

OLD
HOLLAND

CLASSIC
WATERCOLOURS

SEPIA EXTRA 355

Too much gum in the paint. Handled poorly.

PR102 LIGHT RED ASTM I (125)
PBk7 CARBON BLACK ASTM I (370)
UNSPECIFIED PBr7 (309/310)

PIGMENT DETAIL ON LABEL	ASTM	RATING
CHEMICAL MAKE UP ONLY	I L'FAST	★

A peat like substance formed by long decayed wood and other vegetable matter.

The pits from which it is dug can be considered similar to ancient compost heaps, this is the best way to think of them considering the final product.

Varies between transparent and semi-transparent, this quality led to its wide spread use as a glazing colour.

As a watercolour it will change to a dull, cold grey-brown after a relatively short exposure to light. This change can be seen on many finished watercolours within a short time of their completion. It is especially fugitive if applied as a thin wash. This of course will be the most common use for a transparent watercolour.

Named after the artist who was particularly fond of using it. Knowledgeable painters have avoided it for centuries. I have approached several manufacturers and asked why they still offer it.

The predictable answer is always 'because of demand'. That it sells well to the unwary artist is a poor reason for its continuation.

Often imitated by simple mixes of readily available colours, it is not worth considering.

VAN DYCK BROWN 575

MIR (JAURENA S.A)

ACUARELA

One of the PBr7s. It looks rather like Burnt Umber.

In fact it looks more like a Burnt Umber than the actual Burnt Umber put out by this company. Reliable and washed out well.

UNSPECIFIED PBr7 (309/310)

PIGMENT DETAIL ON LABEL	ASTM	
YES	I L'FAST	

VAN DYCK BROWN 122

PÈBÈO

FRAGONARD ARTISTS' WATER COLOUR

Personally I would sooner see the name fade away as most of the examples do. If it must be retained then ingredients such as these should be employed.

PR101 MARS RED ASTM I (124)
PY42 MARS YELLOW ASTM I (43)
PBk7 CARBON BLACK ASTM I (370)

PIGMENT DETAIL ON LABEL	ASTM	
YES	I L'FAST	

VAN DYCK BROWN 110

DANIEL SMITH

EXTRA-FINE WATERCOLORS

In appearance the colour looks rather like a blend of Burnt Umber and Black. Whatever the PB7s the paint will be lightfast. Brushed out with ease.

BLEND OF UMBERS AND SIENNA
UNSPECIFIED PBr7s (309/310)

PIGMENT DETAIL ON LABEL	ASTM	
YES	I L'FAST	

VAN DYCK BROWN W222

GRUMBACHER

FINEST ARTISTS' WATER COLOR

The disastrous substance, NBr8 Van Dyke Brown, once used, has been discarded. (Check if you have this colour which is several years old). Now produced using lightfast pigments.

PBk9 IVORY BLACK ASTM I (371)
PO48 QUINACRIDONE GOLD ASTM II (97)
PR101 LIGHT OR ENGLISH RED OXIDE ASTM I (124)

PIGMENT DETAIL ON LABEL	ASTM	
YES	II L'FAST	

VAN DYCK BROWN HUE A222

GRUMBACHER

ACADEMY ARTISTS' WATERCOLOR 2ND RANGE

Slightly gritty but brushed out well. Reliable imitation which is superior to the 'Artist' version of this make. Semi-opaque.

Reformulated? >

PBr7 BURNT SIENNA ASTM I (310)
PBr7 BURNT UMBER ASTM I (310)
PBk6 LAMP BLACK ASTM I (370)

PIGMENT DETAIL ON LABEL	ASTM	RATING
YES	I L'FAST	★★

VAN DYCK BROWN

GRUMBACHER

ACADEMY ARTISTS' WATERCOLOR 2ND RANGE

I presume that this is an update of the colour to the left. I have to presume as the company did not supply literature, a full set of samples or answer questions.

If my presumption is correct this is a very big step backwards. Don't fall for the old NBr8 trick.

NBr8 VAN DYKE BROWN WG IV (310)

PIGMENT DETAIL ON LABEL	WG	RATING
YES	IV L'FAST	★

VANDYKE BROWN 676

WINSOR & NEWTON

ARTISTS' WATER COLOUR

The PR101 is described as a synthetic equivalent of Burnt Sienna.

Our sample faded severely thanks to the inclusion of NBr 8. Semi-opaque.

Reformulated >

UNSPECIFIED PR101 ASTM I (123/124)
NBr8 VAN DYKE BROWN WG IV (310)

PIGMENT DETAIL ON LABEL	WG	RATING
YES	IV L'FAST	★

VANDYKE BROWN 676

WINSOR & NEWTON

ARTISTS' WATER COLOUR

I am afraid that I cannot offer assessments or a colour guide as a sample was not provided.

PBk6 LAMP BLACK ASTM I (370)
UNSPECIFIED PR101 ASTM I (123/124)

PIGMENT DETAIL ON LABEL	ASTM	RATING
YES	I L'FAST	

VANDYKE BROWN 45

CARAN D'ACHE

FINEST WATER COLOUR

Washed out very poorly and is suitable only for thin applications.

But it will be lightfast if you want to trade one factor off against the other.

UNSPECIFIED PBr7 (309/310)

PIGMENT DETAIL ON LABEL	ASTM	RATING
YES	I L'FAST	★★

VANDYKE BROWN 676

WINSOR & NEWTON

COTMAN WATER COLOURS 2ND RANGE

Slightly cooler than the actual 'Burnt Umber' available in this range, but nevertheless the same pigment. Superior to their previous 'Artist Quality' Van Dyke Brown, which you might still have.

Reformulated >

PBr7 BURNT UMBER ASTM I (310)		
PIGMENT DETAIL ON LABEL **YES**	ASTM **I** L'FAST	

VANDYKE BROWN 676

WINSOR & NEWTON

COTMAN WATER COLOURS 2ND RANGE

I am afraid that I cannot offer an assessment or a colour guide as a sample was not provided.

UNSPECIFIED PBr7 ASTM I (309/310)		
UNSPECIFIED PR101 ASTM I (123/124)		
PIGMENT DETAIL ON LABEL **YES**	ASTM **I** L'FAST	RATING

VANDYCK BROWN 111

LEFRANC & BOURGEOIS

LINEL EXTRA-FINE ARTISTS' WATERCOLOUR

Our sample faded to a marked extent suggesting that PBr8 is as unreliable as my rating. Washed out reasonably well. Semi-transparent.

PBr8 MANGANESE BROWN WG IV (311)		
PIGMENT DETAIL ON LABEL CHEMICAL MAKE UP ONLY	WG **IV** L'FAST	RATING ★

VANDYKE BROWN 263

DALER ROWNEY

ARTISTS' WATER COLOUR

The company informed me for the last edition that Natural Brown 8 is no longer available. When present stocks are exhausted they will reformulate. This is good news as our sample faded dramatically. Check, as you may still have old stock.

Discontinued

NBr8 VAN DYKE BROWN WG IV (310)		
PIGMENT DETAIL ON LABEL **YES**	WG **IV** L'FAST	RATING ★

VANDYKE BROWN (HUE) 264

DALER ROWNEY

ARTISTS' WATER COLOUR

A bit of a Burnt Umber look-alike. For commercial reasons most manufacturers want to have their own version of Vandyke Brown. It might be an interesting name but there isn't a great deal of substance behind it.

UNSPECIFIED PBr7 (309/310)		
PIGMENT DETAIL ON LABEL **YES**	ASTM **I** L'FAST	

VANDYKE BROWN

DALER ROWNEY

GEORGIAN WATER COLOUR 2ND RANGE

A simple mix giving a close imitation of genuine Van Dyke Brown.

At least it is reliable. This was previously called 'Vandyke Brown (Hue).

PBk7 CARBON BLACK ASTM I (370)		
PBr7 BURNT UMBER ASTM I (310)		
PIGMENT DETAIL ON LABEL **NO**	ASTM **I** L'FAST	

VANDYKE BROWN 403

TALENS

REMBRANDT ARTISTS' QUALITY EXTRA FINE

A simple mix giving a name to add to the colour chart. Same ingredients as Talens Sepia but with less black. Semi-opaque.

Reformulated >

PBk7 CARBON BLACK ASTM I (370)		
PBr7 BURNT SIENNA ASTM I (310)		
PIGMENT DETAIL ON LABEL **YES**	ASTM **I** L'FAST	

VANDYKE BROWN 403

TALENS

REMBRANDT ARTISTS' QUALITY EXTRA FINE

If you add a touch of Ultramarine to either Burnt Umber or Burnt Sienna you will have a wide range of dark browns (not just one), which will not be dulled by black.

Sample washed out very well and will never fade.

PBk7 CARBON BLACK ASTM I (370)		
UNSPECIFIED PR101 ASTM I (123/124)		
PIGMENT DETAIL ON LABEL **YES**	ASTM **I** L'FAST	

VANDYKE BROWN 484

MAIMERI

MAIMERIBLU SUPERIOR WATERCOLOURS

Some will find this a useful convenience colour, however easy and it is to mix. Pigments are absolutely lightfast. Brushed out very well.

PBk9 IVORY BLACK ASTM I (371)		
PBr7 BURNT SIENNA ASTM I (310)		
PIGMENT DETAIL ON LABEL **YES**	ASTM **I** L'FAST	

VANDYKE BROWN 484

MAIMERI

VENEZIA EXTRAFINE WATERCOLOURS

Simple ingredients giving a colour which can be mixed with absolute ease.

Both pigments are lightfast as opposed to the disastrous natural pigment of this name.

PBr7 BURNT SIENNA ASTM I (310)		
PBk9 IVORY BLACK ASTM I (371)		
PIGMENT DETAIL ON LABEL **YES**	ASTM **I** L'FAST	

VANDYKE BROWN 403

TALENS

WATER COLOUR 2ND RANGE

Similar in colour to genuine Van Dyke Brown but reliable. An easily mixed convenience colour but far superior to the real thing.

Range discontinued

PBr7 BURNT SIENNA ASTM I (310)		
PBk7 CARBON BLACK ASTM I (370)		
PIGMENT DETAIL ON LABEL **YES**	ASTM **I** L'FAST	

VANDYKE BROWN 403

TALENS

VAN GOGH 2ND RANGE

Very pleasant to use. Gave smooth easy washes over the entire range. Reliable pigments have been employed.

PBk6 LAMP BLACK ASTM I (370)		
UNSPECIFIED PR101 ASTM I (123/124)		
PIGMENT DETAIL ON LABEL **YES**	ASTM **I** L'FAST	

VAN DYKE BROWN 2343

UMTON BARVY

By using the blue to darken the earth colour (a type of dull orange), the use of black is avoided.

A well made product.

ARTISTIC WATER COLOR

UNSPECIFIED PBr7 ASTM I (309/310) PB29 ULTRAMARINE BLUE ASTM I (215)		
PIGMENT DETAIL ON LABEL **NO**	ASTM **I** L'FAST	

VANDYKE BROWN 669

SCHMINCKE

A very reliable deep brown. Handles well over a useful range of values.

Pigments are light resistant.

HORADAM FINEST ARTISTS' WATER COLOURS

PBk7 CARBON BLACK ASTM I (370) PBr7 RAW UMBER ASTM I (309) PY153 NICKEL DIOXINE YELLOW ASTM II (50)		
PIGMENT DETAIL ON LABEL **YES**	ASTM **II** L'FAST	

VANDYCK BROWN 407

SENNELIER

Natural Brown 8, Van Dyke Brown, will deteriorate rapidly on exposure to light. Most unreliable. Semi-transparent, becoming more so.

Reformulated >

EXTRA-FINE WATERCOLOUR

NBr8 VAN DYKE BROWN WG IV (310) PY43 YELLOW OCHRE ASTM I (43)		
PIGMENT DETAIL ON LABEL **YES**	WG **IV** L'FAST	RATING ★

VAN DYKE BROWN 407

SENNELIER

A very well produced watercolour paint which washed out beautifully.

EXTRA-FINE WATERCOLOUR

UNSPECIFIED PR101 ASTM I (123/124) PBk7 CARBON BLACK ASTM I (370)		
PIGMENT DETAIL ON LABEL **YES**	ASTM **I** L'FAST	

VAN DYKE BROWN (CASSEL) EXTRA 72

OLD HOLLAND

If the name must be retained at least reliable ingredients such as these should be used. Handled very well. Semi-opaque.

CLASSIC WATERCOLOURS

PR101 VENETIAN RED ASTM I (124) PBk9 IVORY BLACK ASTM I (371)		
PIGMENT DETAIL ON LABEL CHEMICAL MAKE UP ONLY	ASTM **I** L'FAST	

VANDYKE BROWN 39

HOLBEIN

On exposure our sample changed from a rich warm brown to a cold grey-brown. Certain impurities did not fade and gave a speckled finish to the 'new' colour. Interesting, if this is what you want.

ARTISTS' WATER COLOR

NBr8 VAN DYKE BROWN WG IV (310)		
PIGMENT DETAIL ON LABEL **YES**	WG **IV** L'FAST	RATING ★

VAN DYKE BROWN 194

M.GRAHAM & CO.

Handled particularly well in the more dilute washes. A most reliable pigment used. PB6 is fairly strong and covers well.

Of all the approaches to 'Van Dyke Brown', I prefer this as it does not include the use of black.

ARTISTS' WATERCOLOR

PB6 MARS BROWN WG I (309)		
PIGMENT DETAIL ON LABEL **YES**	WG **I** L'FAST	RATING

VAN DYKE BROWN 1112

LUKAS

Some confusion here. Lukas insist the colorant is Pigment Black 8, Brown Coal. NBr 8, Van Dyke Brown, is often called Brown Coal, PBk 8 is Charcoal Black. Whatever the pigment it quickly became a light, dull violet on exposure.

ARTISTS' WATER COLOUR

PBk8 BROWN COAL?		
PIGMENT DETAIL ON LABEL CHEMICAL MAKE UP ONLY	ASTM L'FAST	RATING

During testing it was found that raw Van Dyke Brown pigment burnt quite well. I suggest that the entire stock be so tested.

Help to make the genuine product obsolete and give your work a better chance of survival.

Venetian Red

Originally the name for a native earth colour, it is now coming into general use for a synthetic iron oxide with a leaning towards orange.

The various artificial oxides which come under the description Pigment Red 101 are separated only by the general colour.

Not all manufacturers work to the same guidelines. It is possible to find Venetian Reds more like Indian Red.

Light Reds identical to Venetian Red and so on. Check for colour type carefully. At least they are all equally lightfast.

When mixing, it can be considered as a neutralised red-orange. Mixing partner will be one or other of the green-blues.

It is also worth experimenting with Ultramarine, a violet - blue for further possibilities.

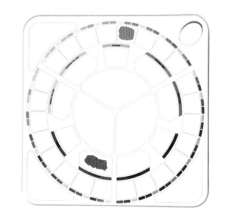

VENETIAN RED 583

DALER ROWNEY

A well produced watercolour.

Washed out beautifully giving a range varying from a deep neutral orange to a salmon pink. Excellent. Semi-opaque.

ARTISTS' WATER COLOUR

PR101 VENETIAN RED ASTM I (124)

| PIGMENT DETAIL ON LABEL YES | ASTM I L'FAST | |

VENETIAN RED 349

TALENS

I lowered the rating assessment when an unspecified PBr7 was used to produce a named earth colour such as Raw Sienna.

It is a different matter with the PR101s because, as I point out above, not all manufacturers work to the same guidelines

REMBRANDT ARTISTS' QUALITY EXTRA FINE

UNSPECIFIED PR101 ASTM I (123/124)

| PIGMENT DETAIL ON LABEL YES | ASTM I L'FAST | |

VENETIAN RED 563

MIR (JAURENA S.A)

Sample handled well and gave a useful range of values.

An absolutely lightfast pigment which will never let you down.

ACUARELA

UNSPECIFIED PR101 ASTM I (123/124)

| PIGMENT DETAIL ON LABEL YES | ASTM I L'FAST | 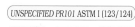 |

VENETIAN RED 678

WINSOR & NEWTON

Superb. An excellent range of values is offered from a deep velvety neutral orange to a subtle pale pink. Dense pigment. Semi-opaque.

ARTISTS' WATER COLOUR

PR101 VENETIAN RED ASTM I (124)

| PIGMENT DETAIL ON LABEL YES | ASTM I L'FAST | 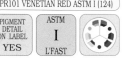 |

VENETIAN RED 623

SENNELIER

The unusual addition of Yellow Ochre tends to dull the colour somewhat. Washed out very smoothly.

Both pigments are completely lightfast. Semi-opaque.

EXTRA-FINE WATERCOLOUR

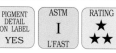

PY43 YELLOW OCHRE ASTM I (43)
PR101 VENETIAN RED ASTM I (124)

| PIGMENT DETAIL ON LABEL YES | ASTM I L'FAST | RATING ★ ★★ | |

VENETIAN RED 111

DANIEL SMITH

Washed out with absolute ease giving a wide range of values. From a rich, deep neutralised, (or dulled), orange to a reasonably clear, soft undercolour.

EXTRA-FINE WATERCOLORS

UNSPECIFIED PR101 ASTM I (123/124)

| PIGMENT DETAIL ON LABEL YES | ASTM I L'FAST | 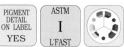 |

VENETIAN RED 64

OLD HOLLAND

Moving towards violet-red in hue. This is particularly noticeable in the thinner washes. An excellent all round watercolour.

CLASSIC WATERCOLOURS

PR101 VENETIAN RED ASTM I (124)

| PIGMENT DETAIL ON LABEL CHEMICAL MAKE UP ONLY | ASTM I L'FAST | 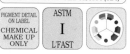 |

VENETIAN RED 288

DA VINCI PAINTS

A bright, 'clean' colour. Venetian red gives some very subtle undercolours when well diluted, varying between makes.

Absolutely lightfast. Semi-opaque.

PERMANENT ARTISTS' WATER COLOR

PR101 VENETIAN RED ASTM I (124)

| PIGMENT DETAIL ON LABEL YES | ASTM I L'FAST | |

VENETIAN RED 688

DA VINCI PAINTS

Washed out reasonably well in heavier layers but better when more dilute.

Being one of the PR101s this will be a most reliable pigment.

SCUOLA 2ND RANGE

UNSPECIFIED PR101 ASTM I (123/124)

| PIGMENT DETAIL ON LABEL YES | ASTM I L'FAST | RATING ★ ★★ | |

VENETIAN RED 392

LEFRANC & BOURGEOIS

Gradated washes run smoothly from one strength to another. A first class watercolour in every respect. Warm pink tints. Semi-opaque.

Reformulated >

LINEL EXTRA-FINE ARTISTS' WATERCOLOUR

PR101 VENETIAN RED ASTM I (124)

PIGMENT DETAIL ON LABEL	ASTM	
CHEMICAL MAKE UP ONLY	I L'FAST	

VENETIAN RED 392

LEFRANC & BOURGEOIS

Strictly speaking, the addition of PY42 to the PR101 should see the resulting paint described as a 'Hue'.

Gave very smooth, even washes.

LINEL EXTRA-FINE ARTISTS' WATERCOLOUR

UNSPECIFIED PR101 ASTM I (123/124)
PY42 MARS YELLOW ASTM I (43)

PIGMENT DETAIL ON LABEL	ASTM	RATING
CHEMICAL MAKE UP ONLY	I L'FAST	★ ★★

VENETIAN RED 262

MAIMERI

Brushed out beautifully, one of the better examples as far as ease of handling is concerned.

A first rate product.

MAIMERIBLU SUPERIOR WATERCOLOURS

UNSPECIFIED PR101 ASTM I (123/124)

PIGMENT DETAIL ON LABEL	ASTM	
YES	I L'FAST	

VENECIAN RED 132

PÈBÈO

An imitation which is rather too red to be realistic. Handled well, giving smooth washes. Resisted light during our testing but the PR 122 is less than reliable as a watercolour.

FRAGONARD ARTISTS' WATER COLOUR

PR101 MARS RED ASTM I (124)
PR122 QUINACRIDONE MAGENTA ASTM III (127)

PIGMENT DETAIL ON LABEL	ASTM	RATING
YES	III L'FAST	★★

VENETIAN RED 005

UTRECHT

I have no idea of what happened here as this company are usually careful. Instead of a paint, some 50% of the tube was gum with the rest being made up of coloured gum. Appalling.

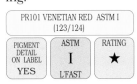

PROFESSIONAL ARTISTS' WATER COLOR

PR101 VENETIAN RED ASTM I (123/124)

PIGMENT DETAIL ON LABEL	ASTM	RATING
YES	I L'FAST	★

VENETIAN BROWN 10H

DR.Ph. MARTINS

A dark brown which handled reasonably well. I am afraid that is all that I can tell you.

If you have more information, I would be pleased to hear from you.

HYDRUS FINE ART WATERCOLOR

PIGMENTS NOT DISCLOSED ON THE PRODUCT LABEL OR IN THE LITERATURE SUPPLIED.

PIGMENT DETAIL ON LABEL	ASTM	RATING
NO	L'FAST	

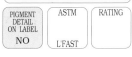
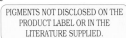

Yellow Ochre

Applied, as it was found, by the early cave painter, Yellow Ochre is one of the oldest inorganic pigments still in use.

Mined from open cast pits as a coloured clay, it is ground, washed and settled into tanks. Deposits are found all over the world.

The most important and widely used of the ochres, it is a soft golden yellow which brushes and mixes very well.

Good qualities are reasonably opaque but do brush out into clear washes when well diluted.

Mars Yellow, which can be considered to be a synthetic Yellow Ochre, is often sold under this name. Although virtually identical in colour, many consider it to be a little harsh when compared to the more muted colour of genuine Yellow Ochre.

For mixing purposes treat it as a neutralised orange-yellow and use accordingly. Complementary partner will be a blue-violet.

YELLOW OCHRE LIGHT 1031

LUKAS

Mars Yellow, the pigment used, can be considered to be a synthetic version of Yellow Ochre, which is a naturally occurring colorant.

Lowered rating only because this is an imitation. Well produced.

ARTISTS' WATER COLOUR

PY42 MARS YELLOW ASTM I (43)

PIGMENT DETAIL ON LABEL	ASTM	RATING
CHEMICAL MAKE UP ONLY	I L'FAST	★ ★★

YELLOW OCHRE 131

MAIMERI

A synthetically produced alternative to Yellow Ochre. As such it should be described as a 'Hue'. Both are superb pigments but there are subtle differences of hue between the two. Semi-opaque.

MAIMERIBLU SUPERIOR WATERCOLOURS

PY42 MARS YELLOW ASTM I (43)

PIGMENT DETAIL ON LABEL	ASTM	RATING
YES	I L'FAST	★ ★★

YELLOW OCHRE 131

MAIMERI

An excellent range of values are offered from this superb pigment. It is not, however, genuine Yellow Ochre and should be described as such. Semi-opaque.

VENEZIA EXTRAFINE WATERCOLOURS

PY42 MARS YELLOW ASTM I (43)

PIGMENT DETAIL ON LABEL	ASTM	RATING
YES	I L'FAST	★ ★★

CARAN D'ACHE

FINEST
WATER COLOUR

YELLOW OCHRE 34

To substitute Mars Yellow for Yellow Ochre is one thing. To liven the colour by adding a fairly bright yellow is another. An imitation and should be sold as such.

PY3 ARYLIDE YELLOW 10G ASTM II (37)
PY42 MARS YELLOW ASTM I (43)

 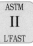

PIGMENT DETAIL ON LABEL	ASTM	RATING
YES	II L'FAST	★★

WINSOR & NEWTON

ARTISTS'
WATER COLOUR

YELLOW OCHRE 744

A first class Yellow Ochre which actually is Yellow Ochre.

Washed out very smoothly, covered well and gave fairly transparent washes.

Genuine ingredients. Semi-opaque.

PY43 YELLOW OCHRE ASTM I (43)

PIGMENT DETAIL ON LABEL	ASTM	
YES	I L'FAST	

WINSOR & NEWTON

COTMAN
WATER COLOURS
2ND RANGE

YELLOW OCHRE 744

Absolutely lightfast but it isn't Yellow Ochre and should be described as such.

Can be regarded as the synthetic equivalent of genuine Yellow Ochre. Semi-opaque.

PY42 MARS YELLOW ASTM I (43)

PIGMENT DETAIL ON LABEL	ASTM	RATING
YES	I L'FAST	★★

SCHMINCKE

HORADAM
FINEST
ARTISTS'
WATER COLOURS

YELLOW OCHRE 655

Mars Yellow is a superb pigment. It handles very well and is permanent. However, it has different characteristics to genuine Yellow Ochre. As an imitation this will have a lowered rating.

PY42 MARS YELLOW ASTM I (43)

PIGMENT DETAIL ON LABEL	ASTM	RATING
YES	I L'FAST	★ ★★

SCHMINCKE

HORADAM
FINEST
ARTISTS'
WATER COLOURS

BURNT YELLOW OCHRE 657

When Yellow Ochre is heated it does not turn into a mix of PY42 and PR101. Such colours are easily produced on the palette. Semi-opaque.

Discontinued

PY42 MARS YELLOW ASTM I (43)
PR101 MARS RED ASTM I (124)

PIGMENT DETAIL ON LABEL	ASTM	RATING
YES	I L'FAST	★ ★★

SCHMINCKE

HORADAM
FINEST
ARTISTS'
WATER COLOURS

YELLOW RAW OCHRE 656

Slightly yellower than the Yellow Ochre in this range. If you have either, the other will be superfluous. A lightfast, very well produced watercolour paint but it is not pure Yellow Ochre. Semi-opaque.

PY42 MARS YELLOW ASTM I (43)
PY43 YELLOW OCHRE ASTM I (43)

PIGMENT DETAIL ON LABEL	ASTM	RATING
YES	I L'FAST	★ ★★

ART SPECTRUM

ARTISTS'
WATER COLOUR

YELLOW OCHRE W46

I am sure than many think that I go over the top in what I expect from materials sold for artistic expression. But surely a paint sold as Yellow Ochre, which has its own characteristics, should contain Yellow Ochre. Not its synthetic equivalent.

PY42 MARS YELLOW ASTM I (43)

PIGMENT DETAIL ON LABEL	ASTM	RATING
YES	I L'FAST	★ ★★

DANIEL SMITH

EXTRA-FINE
WATERCOLORS

YELLOW OCHRE 114

A little over bound, our sample handled well over the range but slightly better in thinner layers.

I would always prefer this to a perfect imitation Yellow Ochre. I will ignore the slight excess of gum because this can easily be rectified.

PY43 YELLOW OCHRE ASTM I (43)

PIGMENT DETAIL ON LABEL	ASTM	
YES	I L'FAST	

HOLBEIN

ARTISTS'
WATER COLOR

YELLOW OCHRE 34

Genuine Yellow Ochre has a certain softness of hue, this is usually brought about by a small clay content. Mars Yellow lacks this softness. Opaque and non staining.

PY42 MARS YELLOW ASTM I (43)

PIGMENT DETAIL ON LABEL	ASTM	RATING
YES	I L'FAST	★ ★★

GRUMBACHER

FINEST
ARTISTS'
WATER COLOR

YELLOW OCHRE HUE W242

The subtlety of hue available from a quality Yellow Ochre is lost in this imitation. Mars Yellow is one thing but this mix rather oversteps the margins.

PBr7 RAW SIENNA ASTM I (309)
PY42 MARS YELLOW ASTM I (43)

PIGMENT DETAIL ON LABEL	ASTM	RATING
YES	I L'FAST	★ ★★

GRUMBACHER

ACADEMY
ARTISTS'
WATERCOLOR
2ND RANGE

YELLOW OCHRE HUE A242

Mars Yellow, being artificially produced, tends to be more predictable in colour between batches.

But it is not Yellow Ochre. Semi-opaque.

PY42 MARS YELLOW ASTM I (43)

PIGMENT DETAIL ON LABEL	ASTM	RATING
YES	I L'FAST	★ ★★

PÈBÈO

FRAGONARD
ARTISTS'
WATER
COLOUR

YELLOW OCHRE 129

To my eyes, Mars Yellow lacks the subtlety available from a quality Yellow Ochre.

Nevertheless, it makes an excellent watercolour. Semi-opaque.

PY42 MARS YELLOW ASTM I (43)

PIGMENT DETAIL ON LABEL	ASTM	RATING
YES	I L'FAST	★ ★★

YELLOW OCHRE 200

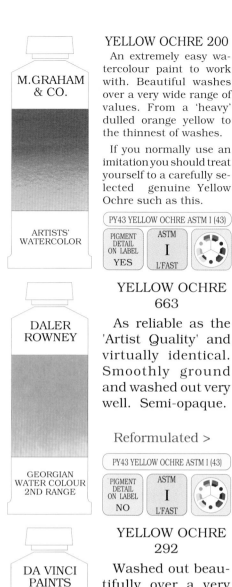

M.GRAHAM & CO.

ARTISTS' WATERCOLOR

An extremely easy watercolour paint to work with. Beautiful washes over a very wide range of values. From a 'heavy' dulled orange yellow to the thinnest of washes.

If you normally use an imitation you should treat yourself to a carefully selected genuine Yellow Ochre such as this.

PY43 YELLOW OCHRE ASTM I (43)

PIGMENT DETAIL ON LABEL	ASTM	
YES	I L'FAST	

YELLOW OCHRE 14H

DR.Ph. MARTINS

HYDRUS FINE ART WATERCOLOR

Judging by the colour and handling characteristics I would be surprised if this is genuine Yellow Ochre.

If you know what it is perhaps you would inform me. The manufacturers do not seem to want to.

PIGMENT DETAIL NOT SUPPLIED IN ANY FORM

PIGMENT DETAIL ON LABEL	ASTM	RATING
NO	L'FAST	

YELLOW OCHRE 148

AMERICAN JOURNEY

PROFESSIONAL ARTISTS' WATER COLOR

It is always pleasing to come across the use of the genuine pigment in a very well produced paint.

Gave excellent washes over a wide and useful range.

PY43 YELLOW OCHRE ASTM I (43)

PIGMENT DETAIL ON LABEL	ASTM	
YES	I L'FAST	

YELLOW OCHRE 663

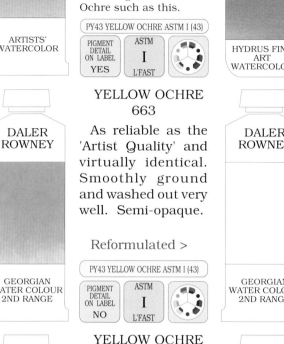

DALER ROWNEY

GEORGIAN WATER COLOUR 2ND RANGE

As reliable as the 'Artist Quality' and virtually identical. Smoothly ground and washed out very well. Semi-opaque.

Reformulated >

PY43 YELLOW OCHRE ASTM I (43)

PIGMENT DETAIL ON LABEL	ASTM	
NO	I L'FAST	

YELLOW OCHRE

DALER ROWNEY

GEORGIAN WATER COLOUR 2ND RANGE

If you purchased a silk shirt, you would not want to end up with cotton described as silk. But they would both keep you warm.

If you wanted genuine Yellow Ochre you would be misled if you went by this title. How about the little word 'Hue'?

PY42 MARS YELLOW ASTM I (43)

PIGMENT DETAIL ON LABEL	ASTM	RATING
NO	I L'FAST	★ ★★

YELLOW OCHRE

UTRECHT

PROFESSIONAL ARTISTS' WATER COLOR

A well produced example which gave all the valued characteristics of genuine Yellow Ochre.

High tinting and covering power, thin clear tints and a soft mellowing effect on other colours in a mix.

PY43 YELLOW OCHRE ASTM I (43)

PIGMENT DETAIL ON LABEL	ASTM	
YES	I L'FAST	

YELLOW OCHRE 292

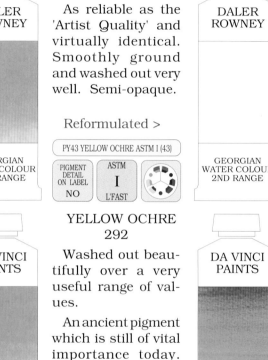

DA VINCI PAINTS

PERMANENT ARTISTS' WATER COLOR

Washed out beautifully over a very useful range of values.

An ancient pigment which is still of vital importance today. Semi-opaque.

PY43 YELLOW OCHRE ASTM I (43)

PIGMENT DETAIL ON LABEL	ASTM	
YES	I L'FAST	

YELLOW OCHRE 692

DA VINCI PAINTS

SCUOLA 2ND RANGE

Washed out very well, particularly in the lighter applications.

Absolutely lightfast.

PY43 YELLOW OCHRE ASTM I (43)

PIGMENT DETAIL ON LABEL	ASTM	
YES	I L'FAST	

YELLOW OCHRE 5736

HUNTS

SPEEDBALL PROFESSIONAL WATERCOLOURS

A watercolour paint employing the genuine pigment.

The previous description 'purified earth colour' had been insufficient to give assessments. It had also previously been over bound. I cannot offer an assessment as a fresh sample has not been provided.

PY43 YELLOW OCHRE ASTM I (43)
PURIFIED EARTH COLOUR

PIGMENT DETAIL ON LABEL	ASTM	RATING
NO	I L'FAST	

YELLOW OCHRE 663

DALER ROWNEY

ARTISTS' WATER COLOUR

Yellow Ochre is considered by many to be a little less brash than its artificial equivalent, Mars Yellow.

This is a superb example. Semi-opaque.

PY43 YELLOW OCHRE ASTM I (43)

PIGMENT DETAIL ON LABEL	ASTM	
YES	I L'FAST	

YELLOW OCHRE 663

DALER ROWNEY

ARTISTS' WATER COLOUR

A very well made example employing an imitation pigment.

As this fact has not been made clear in the title, I will offer a lower assessment than would otherwise have been the case.

PY42 MARS YELLOW ASTM I (43)

PIGMENT DETAIL ON LABEL	ASTM	RATING
YES	I L'FAST	★ ★★

YELLOW OCHRE 227

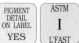

TALENS

REMBRANDT ARTISTS' QUALITY EXTRA FINE

This was previously just Mars Yellow. The addition of Yellow Ochre is welcome. Maybe the next step will be to remove the Mars Yellow to give the genuine article. Handled very well. Semi-opaque.

PY43 YELLOW OCHRE ASTM I (43)
PY42 MARS YELLOW ASTM I (43)

PIGMENT DETAIL ON LABEL	ASTM	RATING
YES	I L'FAST	★ ★★

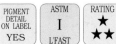

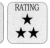

YELLOW OCHRE 227

TALENS

WATER COLOUR 2ND RANGE

Mars Yellow, regarded as the synthetic equivalent of Yellow Ochre, is equally reliable but lacks a certain subtlety. Semi-opaque.

Range discontinued

PY42 MARS YELLOW ASTM I (43)

PIGMENT DETAIL ON LABEL	ASTM	RATING
YES	I L'FAST	★ ★★

YELLOW OCHRE 227

TALENS

VAN GOGH 2ND RANGE

To those painters looking for a dulled orange yellow this will be fine, it handles very well and is a good product.

To the more discerning it will not be fine. They will be looking for certain subtleties possessed only by the genuine pigment.

PY42 MARS YELLOW ASTM I (43)

PIGMENT DETAIL ON LABEL	ASTM	RATING
YES	I L'FAST	★ ★★

YELLOW OCHRE LIGHT 2160

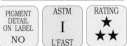

UMTON BARVY

ARTISTIC WATER COLOR

Washed out smoothly enough but a little difficult to lift enough paint for anything other than the lighter washes.

Absolutely lightfast.

PY43 YELLOW OCHRE ASTM I (43)

PIGMENT DETAIL ON LABEL	ASTM	RATING
NO	I L'FAST	★ ★★

BURNT YELLOW OCHRE 2140

UMTON BARVY

ARTISTIC WATER COLOR

A soft neutralised, (or dulled) orange. If you wish to darken the colour try adding one or other blue.

Handled better in the lighter ranges as was difficult to work up to a heavy layer.

PY43 YELLOW OCHRE ASTM I (43)

PIGMENT DETAIL ON LABEL	ASTM	RATING
NO	I L'FAST	★ ★★

YELLOW OCHRE No.6

PENTEL

WATER COLORS

I would suggest that by the time of the next edition this company will have either provided full information to the artist or will have declared on their packaging that the product is not intended for serious artistic use. >

NO INFORMATION IS PROVIDED ON THE PRODUCT OR IN THE LITERATURE AS SUPPLIED

PIGMENT DETAIL ON LABEL	ASTM	RATING
NO	L'FAST	

YELLOW OCHRE No.6

PENTEL (POLY TUBE)

WATER COLORS

In which case they will not appear.

I am only interested in bringing information about products that an artist might select from the written information available.

NO INFORMATION IS PROVIDED ON THE PRODUCT OR IN THE LITERATURE AS SUPPLIED

PIGMENT DETAIL ON LABEL	ASTM	RATING
NO	L'FAST	

YELLOW OCHRE 252

SENNELIER

EXTRA-FINE WATERCOLOUR

A very well produced watercolour paint. Smoothly ground, densely packed pigment. Covered well but also gave very clear washes. Semi-opaque.

Range discontinued

PY43 YELLOW OCHRE ASTM I (43)

PIGMENT DETAIL ON LABEL	ASTM	RATING
YES	I L'FAST	(pie chart)

YELLOW OCHRE 003

ST. PETERSBURG

ARTISTS' WATERCOLOURS

In the case of this company the absence of vital information concerning the pigment/s employed is not an oversight, or a lack of understanding. Please see the company outline on page 32

INFORMATION ON THE INGREDIENTS USED ARE DENIED TO THE ARTIST

PIGMENT DETAIL ON LABEL	ASTM	RATING
NO	L'FAST	

YELLOW OCHRE 560

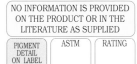

MIR (JAURENA S.A)

ACUARELA

The reluctance to add the word 'Hue' to the title in the case of Yellow Ochre, making clear that it is an imitation seems to be widespread amongst manufacturers. PY42, Mars Yellow, is a wonderful pigment but it is not Yellow Ochre.

PY42 MARS YELLOW ASTM I (43)

PIGMENT DETAIL ON LABEL	ASTM	RATING
YES	I L'FAST	★ ★★

YELLOW OCHRE LIGHT 430

OLD HOLLAND

CLASSIC WATERCOLOURS

By appearance this is probably either Yellow Ochre or Mars Yellow. I cannot offer assessments without full and detailed information on ingredients.

Reformulated >

EARTH COLOURS

PIGMENT DETAIL ON LABEL	ASTM	RATING
CHEMICAL MAKE UP ONLY	L'FAST	

YELLOW OCHRE LIGHT 53

OLD HOLLAND

CLASSIC WATERCOLOURS

PY43 is a wonderful pigment. Here it has been combined with binder to make an unworkable coloured gum.

Who decided the formulations for this company? A passer by?

PY43 YELLOW OCHRE ASTM I (43)

PIGMENT DETAIL ON LABEL	ASTM	RATING
CHEMICAL MAKE UP ONLY	I L'FAST	★

YELLOW OCHRE DEEP 431

OLD HOLLAND

CLASSIC WATERCOLOURS

I am afraid that 'earth colours' does not give me a lot to go on when it comes to making assessments. Washed out particularly well.

Reformulated >

EARTH COLOURS

PIGMENT DETAIL ON LABEL	ASTM	RATING
CHEMICAL MAKE UP ONLY	L'FAST	

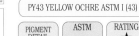

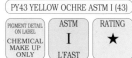

YELLOW OCHRE DEEP 54

OLD HOLLAND · CLASSIC WATERCOLOURS

Not a paint but thick, unworkable coloured gum.

But it is lightfast.

PY43 YELLOW OCHRE ASTM I (43)		
PIGMENT DETAIL ON LABEL CHEMICAL MAKE UP ONLY	ASTM I L'FAST	RATING ★

YELLOW OCHRE HALF BURNT 434

OLD HOLLAND · CLASSIC WATERCOLOURS

It might be 'Half Burnt Yellow Ochre or it might be something quite different'. The stated and confirmed ingredients offer few clues.

Reformulated >

EARTH COLOURS		
PIGMENT DETAIL ON LABEL CHEMICAL MAKE UP ONLY	ASTM L'FAST	RATING

YELLOW OCHRE HALF BURNT 59

OLD HOLLAND · CLASSIC WATERCOLOURS

Thick, unusable, coloured gum.

But presented in the finest wooden box in the art materials world.

PR102 LIGHT RED ASTM I (125)		
PIGMENT DETAIL ON LABEL CHEMICAL MAKE UP ONLY	ASTM I L'FAST	RATING ★

YELLOW OCHRE BURNT 436

OLD HOLLAND · CLASSIC WATERCOLOURS

A well produced watercolour, washed out well and has a good range of strengths. But what is it? The given ingredients do not give much away. Assessments not offered.

Reformulated >

EARTH COLOURS		
PIGMENT DETAIL ON LABEL CHEMICAL MAKE UP ONLY	ASTM L'FAST	RATING

YELLOW OCHRE BURNT 60

OLD HOLLAND · CLASSIC WATERCOLOURS

From the previous situation, outlined on the left, we now have yet more unworkable coloured gum.

But at least we know what the pigment is. Just a pity there is not more of it.

PR102 LIGHT RED ASTM I (125)		
PIGMENT DETAIL ON LABEL CHEMICAL MAKE UP ONLY	ASTM I L'FAST	RATING ★

YELLOW OCHRE 302

LEFRANC & BOURGEOIS · LINEL EXTRA-FINE ARTISTS' WATERCOLOUR

Genuine ingredients give a superb all round watercolour. A neutralised yellow orange with an excellent range of values.

PY43 YELLOW OCHRE ASTM I (43)		
PIGMENT DETAIL ON LABEL CHEMICAL MAKE UP ONLY	ASTM I L'FAST	⬤

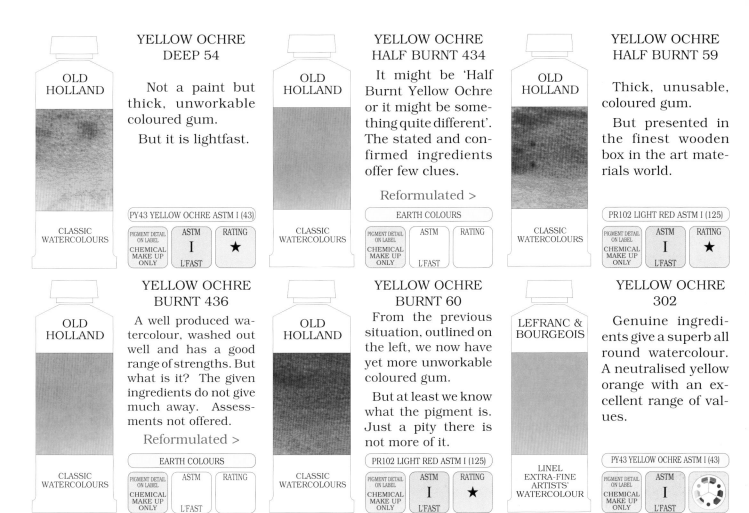

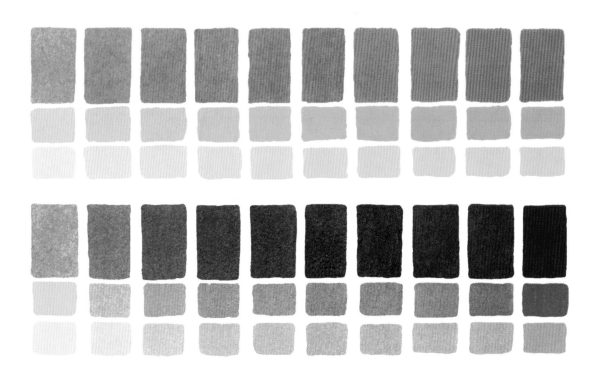

Yellow Ochre offers a wide range of useful values. Heavier layers are a brownish yellow which covers well. Medium applications a reasonably *bright neutral yellow and thin washes a very delicate soft yellow. It brings a certain calming effect to other hues in a mix.* *Soft, subdued oranges with Cadmium Red Light and very dull muted greens with Ultramarine Blue*

Miscellaneous Browns

A rather motley collection which adds little value to the overall range of available browns.

Many of the names used are extracted from the distant past and refer to paints which at one time would mostly have been avoided.

Bitume was originally an oil paint produced from bitumen or tar.

It never really dried and has destroyed or damaged just about every painting on which it was employed.

Bitume watercolour was sold in bottles in the 19th Century.

The word pink has come to mean a light red only quite recently. It was originally used as a noun to describe a yellow pigment. Usually produced from unripe Buckthorn berries it was particularly fugitive. The name Brown Pink has survived to describe the mixed colours shown here.

Caput Mortuum is a Latin name once used to describe a violet-brown produced from an industrial by-product. It has now lost all real meaning and is used loosely to describe synthetic iron oxides of similar hue.

Dragons Blood, my favourite colour title, is an ancient name used to describe a resinous substance which looks like dried blood. It was said to be the mingled blood of an elephant and a dragon as they fought to the death. But where did all the elephants come from?

ANTIQUE GREY BROWN 010

HOLBEIN

IRODORI ANTIQUE WATERCOLOR

A nondescript brown easily matched by adding a little Ultramarine to Burnt Sienna. Some manufacturers don't like me giving these tips, but I didn't write the book for them.

Handled very well.

| PBr6 MARS BROWN WG I (309) |
| UNSPECIFIED PBr7 (309/310) |

| PIGMENT DETAIL ON LABEL | WG |
| YES | I L'FAST |

ANTIQUE BROWN 009

HOLBEIN

IRODORI ANTIQUE WATERCOLOR

Very similar in hue to one of the synthetic iron oxides such as Venetian Red.

Pigments are totally lightfast. A very well made product.

| PY42 MARS YELLOW ASTM I (43) |
| UNSPECIFIED PBr7 (309/310) |

| PIGMENT DETAIL ON LABEL | ASTM |
| YES | I L'FAST |

ANTIQUE CYPRESS BARK 035

HOLBEIN

IRODORI ANTIQUE WATERCOLOR

Similar to standard Burnt Umber, which is what I rather suspect it is. If you have one version why buy another?

A well made watercolour paint which gave excellent washes.

| UNSPECIFIED PBr7 (309/310) |

| PIGMENT DETAIL ON LABEL | ASTM |
| YES | I L'FAST |

ANTIQUE RUSSET BROWN 034

HOLBEIN

IRODORI ANTIQUE WATERCOLOR

A synthetic iron oxide of the colour type often described as Mars Violet.

A well made watercolour paint. Tends to granulate when very dilute.

| UNSPECIFIED PR101 ASTM I (123/124) |

| PIGMENT DETAIL ON LABEL | ASTM |
| YES | I L'FAST |

ANTIQUE SMOKED BAMBOO 036

HOLBEIN

IRODORI ANTIQUE WATERCOLOR

The only paint in this range to be rather difficult to handle. Better in thinner washes.

Given the choice, I would sooner have smoked salmon.

| UNSPECIFIED PBr7 (309/310) |

| PIGMENT DETAIL ON LABEL | ASTM | RATING |
| YES | I L'FAST | ★ ★★ |

BURNT GREEN EARTH 653

SCHMINCKE

HORADAM FINEST ARTISTS' WATER COLOURS

Burnt Umber is Burnt Umber, it is not Burnt Green Earth. Semi-transparent. A well produced watercolour paint.

Discontinued

| PBr7 BURNT UMBER ASTM I (310) |

| PIGMENT DETAIL ON LABEL | ASTM |
| YES | I L'FAST |

BROWN PINK 664

SCHMINCKE

HORADAM FINEST ARTISTS' WATER COLOURS

Did not brush out particularly well unless in thin applications. All ingredients are absolutely lightfast. An unimportant colour easily duplicated.

Discontinued

| PBr7 RAW SIENNA ASTM I (309) |
| PY42 MARS YELLOW ASTM I (43) |
| PBk9 IVORY BLACK ASTM I (371) |

| PIGMENT DETAIL ON LABEL | ASTM | RATING |
| YES | I L'FAST | ★ ★★ |

BROWN PINK 215

DALER ROWNEY

ARTISTS' WATER COLOUR

PY100 failed ASTM testing in a big way. It is well known to be a fugitive pigment. Its use as an ingredient will spoil the colour when exposed to light. Semi-transparent.

Discontinued

| PY100 TARTRAZINE LAKE ASTM V (46) |
| PBk9 IVORY BLACK ASTM I (371) |
| PB29 ULTRAMARINE BLUE ASTM I (215) |

| PIGMENT DETAIL ON LABEL | ASTM | RATING |
| YES | V L'FAST | ★ |

BROWN STIL DE GRAIN 488

MAIMERI

ARTISTI EXTRA FINE WATERCOLORS

Our sample started off as brown, became pink as the yellow faded and then a light grey as the Alizarin Crimson departed.

Reformulated >

| PY17 DIARYLIDE YELLOW AO WG V (39) |
| PR83:1 ALIZARIN CRIMSON ASTM IV (122) |
| PG18 VIRIDIAN ASTM I (261) |

| PIGMENT DETAIL ON LABEL | WG | RATING |
| YES | V L'FAST | ★ |

BROWN STIL DE GRAIN

MAIMERI

In hue is similar to a darkened Burnt Sienna. Adding blue (Cerulean) to dull orange (Burnt Sienna) is a combination of mixing complementaries.

Spoilt by an excess of gum. Thin washes only handle well.

MAIMERIBLU SUPERIOR WATERCOLOURS

UNSPECIFIED PR101 ASTM I (123/124) PB36 CERULEAN BLUE, CHROMIUM ASTM I (216)		
PIGMENT DETAIL ON LABEL **YES**	**ASTM** **I** L'FAST	**RATING** ★★

BROWN No8

PENTEL

A simple name so I will keep the write up simple.

I haven't the first idea of what this material is all about.

WATER COLORS

INFORMATION ON THE PIGMENTS USED NOT SUPPLIED IN ANY FORM		
PIGMENT DETAIL ON LABEL **NO**	ASTM L'FAST	RATING

BROWN No 8

PENTEL (POLY TUBE)

Please see remarks with the colour to the left.

They apply equally here.

INFORMATION ON THE PIGMENTS USED NOT SUPPLIED IN ANY FORM		
PIGMENT DETAIL ON LABEL **NO**	ASTM L'FAST	RATING

BUFF TITANIUM 009

DANIEL SMITH

I find this one a bit of a puzzle. Thinking it to be a discoloured white I put it in with the whites in the last two issues.

As the actual colour is obviously intended I have placed it here. Just Titanium White? Sample slightly gummy.

EXTRA-FINE WATERCOLORS

PW6:1 TITANIUM WHITE ASTM I (385)		
PIGMENT DETAIL ON LABEL **YES**	**ASTM** **I** L'FAST	**RATING** ★ ★★

BURNT GREEN EARTH 1104

LUKAS

As the name suggests this was originally calcined Green Earth (Terre Verte). Here we have a simple mix giving a basic brown. Semi-opaque.

ARTISTS' WATER COLOUR

PR101 LIGHT OR ENGLISH RED OXIDE ASTM I (124) PY42 MARS YELLOW ASTM I (43) PBk11 MARS BLACK ASTM I (371)		
PIGMENT DETAIL ON LABEL CHEMICAL MAKE UP ONLY	**ASTM** **I** L'FAST	

COPPER 1014

LUKAS

Of all the metallic colours covered in this book this is the only one which painted out reasonably well.

Even so, I would sooner see it in a different binder sprayed onto an automobile.

ARTISTS' WATER COLOUR

PERLGLANZ PIGMENT NACREOUS PIGMENT		
PIGMENT DETAIL ON LABEL CHEMICAL MAKE UP ONLY	**ASTM** **I** L'FAST	**RATING** ★ ★★

CASSEL EARTH 46

CARAN D'ACHE

Quite unlike any PBr7 that I have ever seen. The word nondescript could have been invented for it.

Very weak and difficult to brush out. Not the pick of the bunch, but it does have a nice 'traditional' name.

FINEST WATER COLOUR

UNSPECIFIED PBr7 (309/310)		
PIGMENT DETAIL ON LABEL **YES**	**ASTM** **I** L'FAST	**RATING** ★★

CAPUT MORTUUM VIOLET (MARS) 66

OLD HOLLAND

One of the PR101s, in which case it will be absolutely fast to light.

Gave better light washes than heavier as the paint was a little over bound.

CLASSIC WATERCOLOURS

UNSPECIFIED PR101 ASTM I (123/124)		
PIGMENT DETAIL ON LABEL CHEMICAL MAKE UP ONLY	**ASTM** **I** L'FAST	**RATING** ★ ★★

CAPUT MORTUUM 645

SCHMINCKE

A Latin name which went out of general use several hundred years ago. The pigment would have been similar to Mars Violet in hue and make up. Dependable.

HORADAM FINEST ARTISTS' WATER COLOURS

PR101 MARS VIOLET ASTM I (123)		
PIGMENT DETAIL ON LABEL **YES**	**ASTM** L'FAST	

CAPUT MORTUUM DEEP 1052

LUKAS

A strong, deep, neutral violet brown. Washed out beautifully from one strength to another. Absolutely lightfast.

An ancient name used for a similar pigment.

ARTISTS' WATER COLOUR

PR101 INDIAN RED ASTM I (123)		
PIGMENT DETAIL ON LABEL CHEMICAL MAKE UP ONLY	**ASTM** **I** L'FAST	

CHOCOLATE No9

PENTEL

Not exactly a traditional colour name, sounds more like an ice cream order.

Washed out nicely, whatever it is.

The company knew of the nature of this book before sending samples and cooperating, so I go along with their product description as 'for artistic use'.

WATER COLORS

NO PIGMENT INFORMATION		
PIGMENT DETAIL ON LABEL **NO**	ASTM L'FAST	RATING

DRAGON'S BLOOD 270

MAIMERI

Originally said to have come from the mingled blood of an Elephant and a Dragon as they fought to the death.

Now a lightfast colour easily mixed on the palette.

MAIMERIBLU SUPERIOR WATERCOLOURS

PR209 QUINACRIDONE RED Y ASTM II (134) UNSPECIFIED PBr7 (309/310)		
PIGMENT DETAIL ON LABEL **YES**	**ASTM** **II** L'FAST	

FLESH OCHRE 343

OLD HOLLAND

CLASSIC WATERCOLOURS

Being somewhat over bound, the sample did not wash out well unless thin.

Reliable ingredients.

PY42 MARS YELLOW ASTM I (43) PR188 NAPHTHOL AS ASTM II (132) PR102 LIGHT RED ASTM I (125)		
PIGMENT DETAIL ON LABEL **CHEMICAL MAKE UP ONLY**	ASTM **II** L'FAST	RATING ★★

BROWN OCHRE 647

SCHMINCKE

HORADAM FINEST ARTISTS' WATER COLOURS

Very well produced, using excellent ingredients. Paint handled smoothly and gave a useful range of values. Semi-transparent.

Discontinued

PBr7 RAW SIENNA ASTM I (309) PY43 YELLOW OCHRE ASTM I (43)		
PIGMENT DETAIL ON LABEL **YES**	ASTM **I** L'FAST	

GOLD BROWN 654

A replacement for their 'Brown Ochre'

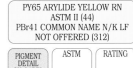

SCHMINCKE

HORADAM FINEST ARTISTS' WATER COLOURS

I am afraid that I cannot assessments as insufficient is known about PBr41.

PY65 ARYLIDE YELLOW RN ASTM II (44) PBr41 COMMON NAME N/K LF NOT OFFERED (312)		
PIGMENT DETAIL ON LABEL **YES**	ASTM L'FAST	RATING

ITALIAN EARTH 322

Over enthusiastic use of gum has spoiled yet another colour from this company.

OLD HOLLAND

CLASSIC WATERCOLOURS

UNSPECIFIED PBr7 ASTM I 309/ 310 (NATURAL SIENNA)		
PIGMENT DETAIL ON LABEL **CHEMICAL MAKE UP ONLY**	ASTM **I** L'FAST	RATING ★

ITALIAN EARTH PINK LAKE 331

OLD HOLLAND

CLASSIC WATERCOLOURS

Lightfast but unworkable due to excessive use of binder.

UNSPECIFIED PR101 ASTM I (123/124) PY83 HR70 DIARYLIDE YELLOW HR70 WG II (45)		
PIGMENT DETAIL ON LABEL **CHEMICAL MAKE UP ONLY**	WG **II** L'FAST	RATING ★

LIGHT BROWN 648

SCHMINCKE

HORADAM FINEST ARTISTS' WATER COLOURS

The company claim that this colour is lightfast. I have insufficient information in this regard to offer assessments. It might well prove to be reliable.

PBr41 COMMON NAME N/K LF NOT OFFERED (312)		
PIGMENT DETAIL ON LABEL **YES**	ASTM L'FAST	RATING

LIGHT OXIDE RED 339

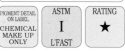

TALENS

REMBRANDT ARTISTS' QUALITY EXTRA FINE

A well prepared watercolour paint. Brushed out very evenly at all strengths.

Gives a salmon pink undercolour when very dilute. Excellent.

PR101 LIGHT OR ENGLISH RED OXIDE ASTM I (124)		
PIGMENT DETAIL ON LABEL **YES**	ASTM **I** L'FAST	

LIGHT OXIDE RED 339

TALENS

WATER COLOUR 2ND RANGE

A well produced watercolour. Good covering power but strong enough to give reasonably clear washes when well diluted.

Range discontinued

PR101 LIGHT OR ENGLISH RED OXIDE ASTM I (124)		
PIGMENT DETAIL ON LABEL **YES**	ASTM **I** L'FAST	

LIGHT OXIDE RED 339

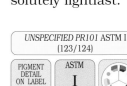

TALENS

VAN GOGH 2ND RANGE

A very well made watercolour paint. The colour laid easily over a very useful range of values. Absolutely lightfast.

UNSPECIFIED PR101 ASTM I (123/124)		
PIGMENT DETAIL ON LABEL **YES**	ASTM **I** L'FAST	

LUNAR EARTH 050

DANIEL SMITH

EXTRA-FINE WATERCOLORS

Sample handled very well, giving all that I would expect from a well made watercolour paint.

PBr11 MANGANESE FERRITE WG II (311)		
PIGMENT DETAIL ON LABEL **YES**	WG **II** L'FAST	

MARS BROWN

ST. PETERSBURG

ARTISTS' WATERCOLOURS

That a company can produce, export and successfully market a range of 'artists' paints, without giving a clue as to the pigments used, does not say very much for many in the artistic community.

INFORMATION ON THE COLORANTS USED WITHHELD		
PIGMENT DETAIL ON LABEL **NO**	ASTM L'FAST	RATING

MARS BROWN 346

Over use of the gum pot has spoiled yet another watercolour paint.

OLD HOLLAND

CLASSIC WATERCOLOURS

UNSPECIFIED PR101 ASTM I (123/124)		
PIGMENT DETAIL ON LABEL **CHEMICAL MAKE UP ONLY**	ASTM **I** L'FAST	RATING ★

OLD HOLLAND YELLOW-BROWN 325

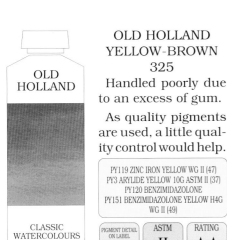

OLD HOLLAND

CLASSIC WATERCOLOURS

Handled poorly due to an excess of gum.

As quality pigments are used, a little quality control would help.

PY119 ZINC IRON YELLOW WG II (47)
PY3 ARYLIDE YELLOW 10G ASTM II (37)
PY120 BENZIMIDAZOLONE
PY151 BENZIMIDAZOLONE YELLOW H4G WG II (49)

| PIGMENT DETAIL ON LABEL CHEMICAL MAKE UP ONLY | ASTM II L'FAST | RATING ★★ |

POZZUOLI EARTH 1083

LUKAS

ARTISTS' WATER COLOUR

An extremely well made paint. Densely packed pigment gave a colour which sprang into life as soon as it was touched to damp paper. Very smooth washes available.

EARTH PIGMENT SYNTHETIC IRON OXIDE

| PIGMENT DETAIL ON LABEL CHEMICAL MAKE UP ONLY | ASTM I L'FAST | |

POZZUOLI EARTH 1083

LUKAS

ARTISTS' WATER COLOUR

If Indian Red, Light Red, Mars Red and Venetian Red were marketed under their correct titles, artists would become more familiar with them. This colour is lightfast, semi-opaque and washes well.

PR101 INDIAN RED ASTM I (123)

| PIGMENT DETAIL ON LABEL CHEMICAL MAKE UP ONLY | ASTM I L'FAST | |

POZZUOLI EARTH 666

SCHMINCKE

HORADAM FINEST ARTISTS' WATER COLOURS

An ancient name used to market Mars Red. Washes out very smoothly and is completely fast to light. Semi-opaque, but gives quite clear washes.

PR101 MARS RED ASTM I (124)

| PIGMENT DETAIL ON LABEL YES | ASTM I L'FAST | |

POZZUOLI EARTH 532

MAIMERI

ARTISTI EXTRA-FINE WATERCOLOURS

Originally a native iron oxide of volcanic origin, from Pozzuoli, near Naples. This is a simple mix. Both ingredients are reliable. Neither is specified exactly. Semi-opaque.

Discontinued

UNSPECIFIED PR101 ASTM I (123/124)
UNSPECIFIED PBr7 ASTM I (309/310)

| PIGMENT DETAIL ON LABEL NO | ASTM I L'FAST | 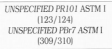 |

POZZUOLI EARTH 617

MAIMERI

STUDIO FINE WATER COLOR 2ND RANGE

A simple mix of lightfast ingredients. Relies heavily on Venetian Red for main colorant. Easily mixed. Semi-opaque but gives clear washes.

Discontinued

PR101 VENETIAN RED ASTM I (124)
PBr7 RAW UMBER ASTM I (309)
PBr7 RAW SIENNA ASTM I (309)

| PIGMENT DETAIL ON LABEL NO | ASTM I L'FAST | |

POZZUOLI EARTH 2250

UMTON BARVY

ARTISTIC WATER COLOR

When made into a well balanced paint, as in this case, any of the PR101s' give excellent value.

They possess good covering power yet give very subtle undertones when washed out.

UNSPECIFIED PR101 ASTM I (123/124)

| PIGMENT DETAIL ON LABEL NO | ASTM I L'FAST | 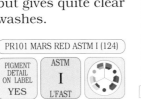 |

PERMANENT BROWN 068

DANIEL SMITH

EXTRA-FINE WATERCOLORS

I am afraid that I cannot offer assessments as very little is known about this pigment apart from the fact that it has not been tested as an art material.

PBr25 BENZIMIDAZOLONE HFR LF NOT OFFERED (308)

| PIGMENT DETAIL ON LABEL YES | ASTM L'FAST | RATING |

QUINACRIDONE GOLD 089

DANIEL SMITH

EXTRA-FINE WATERCOLORS

Due to excessive gum, impossible to use unless extremely thin.

PO49 QUINACRIDONE DEEP GOLD WG II (97)

| PIGMENT DETAIL ON LABEL YES | WG II L'FAST | RATING ★ |

QUINACRIDONE SIENNA 093

DANIEL SMITH

EXTRA-FINE WATERCOLORS

Handled very well. In appearance a brighter version of Burnt Sienna.

Reliable ingredients used to produce a well balanced watercolour paint.

PO49 QUINACRIDONE DEEP GOLD WG II (97)
PR209 QUINACRIDONE RED Y ASTM II (134)

| PIGMENT DETAIL ON LABEL YES | ASTM II L'FAST | |

RED UMBER 349

OLD HOLLAND

CLASSIC WATERCOLOURS

Suffers from a little too much binder. Thinner washes only available.

UNSPECIFIED PBr7 (309/310)

| PIGMENT DETAIL ON LABEL CHEMICAL MAKE UP ONLY | ASTM I L'FAST | RATING ★★ |

RED BROWN 405

SENNELIER

EXTRA-FINE WATERCOLOUR

Neither the PBr7 or PR101 is specified but both will be absolutely lightfast. Sample washed out smoothly. Semi-opaque.

UNSPECIFIED PBr7 (309/310)
UNSPECIFIED PR101 ASTM I (123/124)

| PIGMENT DETAIL ON LABEL YES | ASTM I L'FAST | |

STIL DE GRAIN VERTE 665

SCHMINCKE

HORADAM FINEST ARTISTS' WATER COLOURS

PY129 has not been subjected to ASTM testing in any art media. It is reputed to be lightfast and this is claimed by the company. However, I do not feel that I have sufficient information to offer an assessment. Discontinued.

PY42 MARS YELLOW ASTM I (43)
PY129 AZOMETHINE YELLOW 5GT
LF NOT OFFERED (48)

PIGMENT DETAIL ON LABEL	ASTM	RATING
YES	L'FAST	

TRANSPARENT MARS BROWN 477

MAIMERI

MAIMERIBLU SUPERIOR WATERCOLOURS

Thick, heavy, sticky coloured gum.

UNSPECIFIED PR101 ASTM I (123/124)

PIGMENT DETAIL ON LABEL	ASTM	RATING
YES	I L'FAST	★

TRANSPARENT OXIDE-RED LAKE 334

OLD HOLLAND

CLASSIC WATERCOLOURS

Washed out poorly due to the usual overdose of binder.

UNSPECIFIED PR101 ASTM I (123/124)

PIGMENT DETAIL ON LABEL	ASTM	RATING
CHEMICAL MAKE UP ONLY	I L'FAST	★

TRANSPARENT OXIDE-YELLOW LAKE 328

OLD HOLLAND

CLASSIC WATERCOLOURS

Unworkable, sticky coloured gum.

Had I purchased this material, it would be sent to the manufacturer with a little note.

PY42 MARS YELLOW ASTM I (43)

PIGMENT DETAIL ON LABEL	ASTM	RATING
CHEMICAL MAKE UP ONLY	I L'FAST	★

TRANSPARENT BROWN 110

LEFRANC & BOURGEOIS

LINEL EXTRA-FINE ARTISTS' WATERCOLOUR

PY83 has not yet been tested as a watercolour but it did rate ASTM I as an acrylic and oil paint. Following these tests I have raised my previous rating. Reliable Semi-transparent.

PY83 HR70 DIARYLIDE YELLOW
HR70 WG II (45)
PBk7 CARBON BLACK
ASTM I (370)

PIGMENT DETAIL ON LABEL	WG	
CHEMICAL MAKE UP ONLY	II L'FAST	

TRANSPARENT OXIDE YELLOW 265

TALENS

REMBRANDT ARTISTS' QUALITY EXTRA FINE

Mars Yellow under yet another name. Absolutely lightfast.

This is a superb pigment, good tinting and gives smooth even washes when the paint is well made.

PY42 MARS YELLOW ASTM I (43)

PIGMENT DETAIL ON LABEL	ASTM	
YES	I L'FAST	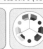

TRANSPARENT OXIDE RED 378

TALENS

REMBRANDT ARTISTS' QUALITY EXTRA FINE

The type of PR101 is unspecified. As the various versions are usually described by colour type, we can be sure this is absolutely lightfast. Semi-transparent.

UNSPECIFIED PR101 ASTM I (123/124)

PIGMENT DETAIL ON LABEL	ASTM	
YES	I L'FAST	

TRANSPARENT BROWN 435

SENNELIER

EXTRA-FINE WATERCOLOUR

Previously named 'Bitume' (Asphalt). A reliable colour, if easily mixed. Washed out well, giving a useful range of values. Semiopaque.

Reformulated >

UNSPECIFIED PR101 ASTM I (123/124)
PBr7 RAW UMBER ASTM I (309)
PY3 ARYLIDE YELLOW 10G ASTM II (37)

PIGMENT DETAIL ON LABEL	ASTM	
YES	II L'FAST	

TRANSPARENT BROWN

SENNELIER

EXTRA-FINE WATERCOLOUR

A bit of a melting pot, the ingredients combining to give a colour not unlike Burnt Umber.

Lightfast and washed out with ease.

UNSPECIFIED PBr7 (309/310)
UNSPECIFIED PR101 ASTM I (123/124)
PBk11 MARS BLACK ASTM I (371)
PG17 CHROMIUM OXIDE GREEN ASTM I (261)

PIGMENT DETAIL ON LABEL	ASTM	
YES	I L'FAST	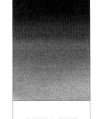

TRANSPARENT OXIDE BROWN 426

TALENS

REMBRANDT ARTISTS' QUALITY EXTRA FINE

An unspecified variety of PR101. It will be particularly lightfast. Washed out very smoothly. Semi-transparent.

UNSPECIFIED PR101 ASTM I (123/124)

PIGMENT DETAIL ON LABEL	ASTM	
YES	I L'FAST	

TRANSPARENT RED BROWN 261

DALER ROWNEY

ARTISTS' WATER COLOUR

Almost the equivalent of a bright Burnt Sienna.

Handled extremely well giving a useful range of values.

PR206 QUINACRIDONE BURNT ORANGE WG II (133)

PIGMENT DETAIL ON LABEL	WG	
YES	II L'FAST	

NUT BROWN or WALNUT BROWN 652

SCHMINCKE

HORADAM FINEST ARTISTS' WATER COLOURS

PBr33 has not been subjected to ASTM lightfast testing in any art media.

However, it does have a good reputation.

Sample handled very well indeed.

PBr33 ZINC IRON CHROMITE BROWN SPINEL WG II (312)

PIGMENT DETAIL ON LABEL	WG	
YES	II L'FAST	

Greys

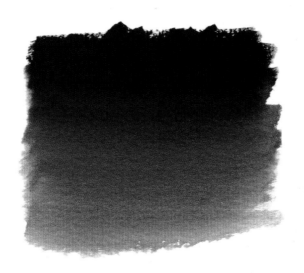

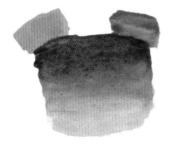
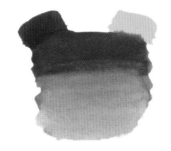
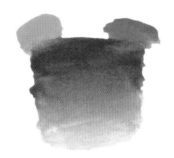

A wide range of subtle coloured greys can be produced on the palette by mixing complementary colours. Unfortunately many of todays artists do not realise the incredible range available by this method and reach instead for a pre-mixed grey.

Charcoal has long been used to give a dark blackish grey. It is difficult to produce a satisfactory watercolour paint from it and the colour has often been bolstered by other pigments. The better qualities come from Willow.

Modern, prepared greys are crude when compared to the vast range available to the skilled colour mixer.

Earlier artists often had a quite different approach. A mixed neutral grey, set within warm colours was frequently used in place of blue for example. The grey was then surrounded by warm colours, which, through the effect of after image, caused the grey to move towards a very subtle soft blue. Our use of greys is invariably rather crude in comparison. We tend to rely on a limited number of greys and neutrals which have been blended by the colourmen for us. A painter with colour mixing skills would have little use for any of these.

Grey Watercolours

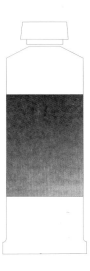

Davy's Grey ... 358
Neutral Tints ... 359
Payne's Grey.. 361
Miscellaneous Greys .. 364

A mid-grey which sometimes has a slightly greenish bias.

At one time the colour was mainly based on powdered slate. Nowadays it is a simple mix involving a variety of ingredients which are usually standard, and found in most paint boxes.

I have described several paints, such as Naples Yellow, as convenience colours. Although they can be mixed on the palette, many artists find it useful to have them ready prepared.

I do not regard any of the ready blended greys to be in this category, for the following reasons:

Virtually all of them include black amongst the ingredients. To my eye the use of black always dulls colours when mixed further.

My main objection to them however is that they lead to limitations in colour mixing and understanding. This in turn leads to work of a limited nature.

An understanding of the way in which complementaries behave when mixed will give you a range of neutrals and greys which can be made to harmonise readily, giving vastly improved colour work.

A vast range of greys which are simple to mix and will work smoothly with neighbouring colours is available to the artist able to control mixing.

DAVY'S GREY W064

GRUMBACHER

FINEST ARTISTS' WATER COLOR

The texture of our sample was rather course. An unimportant colour, easily produced on the palette without the use of Black.

PB15 PHTHALOCYANINE BLUE ASTM II (213)		
PBk9 IVORY BLACK ASTM I (371)		
UNSPECIFIED PBr7 (309/310)		
PIGMENT DETAIL ON LABEL YES	ASTM II L'FAST	RATING ★ ★★

DAVY'S GREY A064

GRUMBACHER

ACADEMY ARTISTS' WATERCOLOR 2ND RANGE

Black with a hint of green. Such colours are easily mixed without using black. Viridian or Phthalocyanine Green mixed with a transparent violet red such as Quinacridone Violet will come very close.

PB15 PHTHALOCYANINE BLUE ASTM II (213)		
PBk9 IVORY BLACK ASTM I (371)		
UNSPECIFIED PBr7 (309/310)		
PIGMENT DETAIL ON LABEL YES	ASTM II L'FAST	

DAVY'S GREY 066

DALER ROWNEY

ARTISTS' WATER COLOUR

Give me wet, raw pastry any day over this substance. Impossible to use unless in very thin washes, poor texture and overbound.

Discontinued

PBk19 GRAY HYDRATED ALUMINUM SILICATE ASTM I (372)		
PBk11 MARS BLACK ASTM I (371)		
PIGMENT DETAIL ON LABEL YES	ASTM I L'FAST	RATING ★

DAVY'S GREY 358

OLD HOLLAND

CLASSIC WATERCOLOURS

Assessments and a colour guide cannot be offered because a sample was not supplied.

The pigments used are all lightfast.

PG23 GREEN EARTH/TERRE VERTE ASTM I (262)		
PW4 ZINC WHITE ASTM I (384)		
PBk7 CARBON BLACK ASTM I (370)		
UNSPECIFIED PBr7 (309/310)		
PIGMENT DETAIL ON LABEL CHEMICAL MAKE UP ONLY	ASTM I L'FAST	RATING

DAVY GREY W355

HOLBEIN

ARTISTS' WATER COLOR

Particularly weak and brushed out rather poorly.

Reliable ingredients but easily produced on the palette. Opaque and non staining

PW6 TITANIUM WHITE ASTM I (385)		
PBk6 LAMP BLACK ASTM I (370)		
UNSPECIFIED PBr7 (309/310)		
PIGMENT DETAIL ON LABEL YES	ASTM I L'FAST	RATING ★★

DAVY'S GREY 217

WINSOR & NEWTON

ARTISTS' WATER COLOUR

A bit of a cocktail but at least it is produced from very reliable pigments. Such colours are easily reproduced on the palette. Brushed out rather poorly

PBk19 GRAY HYDRATED ALUMINUM SILICATE ASTM I (372)		
PG17 CHROMIUM OXIDE GREEN ASTM I (261)		
PBk6 LAMP BLACK ASTM I (370)		
PW4 ZINC WHITE ASTM I (384)		
PIGMENT DETAIL ON LABEL YES	ASTM I L'FAST	RATING ★★

Neutral Tint

A quick glance at the range of 'Neutral Tints' on the market will show that it is simply a name to add to a list in order to sell yet another simple, nondescript colour.

It cannot be argued that the name fits any particular colour description. As you can see, it ranges from a blackish-blue through dull violet to a straightforward black.

As I have said elsewhere, the paint ranges to take seriously are those with a limited number of well produced and well labelled quality colours.

Any company offering a huge range of colours will have amongst them many that are unreliable or are simple mixes.

For too long now the race has been on to offer yet one more colour under yet another fancy or irrelevant name.

Do not join those who feel ill equipped to work unless they have a paint box requiring wheels.

NEUTRAL TINT 620

LEFRANC & BOURGEOIS

LINEL EXTRA-FINE ARTISTS' WATERCOLOUR

A blackish semi-opaque violet. The PV23 BS will tend to resist light quite well for some time but will eventually fade to a marked extent.

| PV23BS DIOXAZINE PURPLE ASTM IV (186) |
| PBk7 CARBON BLACK ASTM I (370) |

| PIGMENT DETAIL ON LABEL CHEMICAL MAKE UP ONLY | ASTM IV L'FAST | RATING ★ |

NEUTRAL TINT 448

OLD HOLLAND

CLASSIC WATERCOLOURS

An amazing paint. The pigment had separated and came out as two distinct colours, roughly intermingled. They go back together when diluted. Novelty value perhaps.

Reformulated >

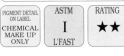

| PB27 PRUSSIAN BLUE ASTM I (214) |
| PBr7 BURNT SIENNA ASTM I (310) |

| PIGMENT DETAIL ON LABEL CHEMICAL MAKE UP ONLY | ASTM I L'FAST | RATING ★★ |

NEUTRAL TINT 211

OLD HOLLAND

CLASSIC WATERCOLOURS

Lightfast, quality pigments used as a base to produce a thick, sticky, dark grey gum more suited to road resurfacing than to artistic expression.

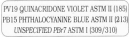

| PV19 QUINACRIDONE VIOLET ASTM II (185) |
| PB15 PHTHALOCYANINE BLUE ASTM II (213) |
| *UNSPECIFIED PBr7 ASTM I (309/310)* |

| PIGMENT DETAIL ON LABEL CHEMICAL MAKE UP ONLY | ASTM II L'FAST | RATING ★ |

NEUTRAL TINT 715

TALENS

REMBRANDT ARTISTS' QUALITY EXTRA FINE

Will move towards black even more as the PV23 fades on exposure.

If you need the final colour why not simply start off with black.

| PV23BS DIOXAZINE PURPLE ASTM IV (186) |
| PBk7 CARBON BLACK ASTM I (370) |

| PIGMENT DETAIL ON LABEL YES | ASTM IV L'FAST | RATING ★ |

NEUTRAL TINT 715

TALENS

REMBRANDT ARTISTS' QUALITY EXTRA FINE

A slightly softened black which some will find useful and others will wonder what its all about. Reliable ingredients, well produced.

| PBk6 LAMP BLACK ASTM I (370) |
| PV19 QUINACRIDONE VIOLET ASTM II (185) |

| PIGMENT DETAIL ON LABEL YES | ASTM II L'FAST | 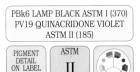 |

NEUTRAL TINT 430

WINSOR & NEWTON

ARTISTS' WATER COLOUR

A blackish-blue which is very easy to mix if you really need it. All ingredients are lightfast. Our sample washed out well. Semi-opaque.

| PV19 QUINACRIDONE VIOLET ASTM II (185) |
| PB15 PHTHALOCYANINE BLUE ASTM II (213) |
| PBk6 LAMP BLACK ASTM I (370) |

| PIGMENT DETAIL ON LABEL YES | ASTM II L'FAST | 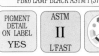 |

NEUTRAL TINT 063

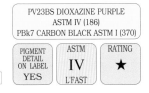

DALER ROWNEY

ARTISTS' WATER COLOUR

You will not get much more neutral than black, which is all this is. If you already have a black watercolour you will probably not require another.

Reformulated >

| PBk11 MARS BLACK ASTM I (371) |

| PIGMENT DETAIL ON LABEL YES | ASTM I L'FAST | 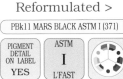 |

NEUTRAL TINT 854

DALER ROWNEY

ARTISTS' WATER COLOUR

Reliable ingredients to produce a rather nondescript dark grey.

Fast to light and well made.

| PBk11 MARS BLACK ASTM I (371) |
| PB29 ULTRAMARINE BLUE ASTM I (215) |
| *UNSPECIFIED PR101 ASTM I (123/124)* |

| PIGMENT DETAIL ON LABEL YES | ASTM I L'FAST | 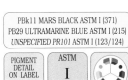 |

NEUTRAL TINT W57

ART SPECTRUM

ARTISTS' WATER COLOUR

A black with the faintest of violet undertones.

Reliable and well produced.

| PB15:3 PHTHALOCYANINE BLUE ASTM II (213) |
| PBk6 LAMP BLACK ASTM I (370) |
| PV19 QUINACRIDONE VIOLET ASTM II (185) |

| PIGMENT DETAIL ON LABEL YES | ASTM II L'FAST | |

NEUTRAL TINT 560

MAIMERI

MAIMERIBLU
SUPERIOR
WATERCOLOURS

This is basically the same Ultramarine/ black mix as used in most 'Payne's Greys with an extra portion of black. Worth considering if you cannot add black to blue.

| PB29 ULTRAMARINE BLUE ASTM I (215) |
| PBk7 CARBON BLACK ASTM I (370) |

| PIGMENT DETAIL ON LABEL YES | ASTM I L'FAST | |

NEUTRAL TINT 624

MAIMERI

STUDIO
FINE WATER
COLOR 2ND
RANGE

Virtually the same as the 'Artist Quality'. A tip in case you wish to make savings and are desperate for this near black.

Discontinued

| PB29 ULTRAMARINE BLUE ASTM I (215) |
| PBk7 CARBON BLACK ASTM I (370) |
| PBr7 BURNT UMBER ASTM I (310) |

| PIGMENT DETAIL ON LABEL NO | ASTM I L'FAST | |

NEUTRAL TINT W357

HOLBEIN

ARTISTS'
WATER COLOR

The inclusion of Pigment Red 23, a fugitive substance, brings the overall lightfast rating down from a possible ASTM II. A nondescript blackish-blue.

| PB29 ULTRAMARINE BLUE ASTM I (215) |
| PR23 NAPHTHOL RED LF NOT OFFERED (118) |
| PBk6 LAMP BLACK ASTM I (370) |

| PIGMENT DETAIL ON LABEL YES | ASTM L'FAST | RATING |

NEUTRAL TINT 136

PÈBÈO

FRAGONARD
ARTISTS'
WATER
COLOUR

To my mind this is a rather pointless mix of blacks sold under a meaningless name. Perhaps I am missing the point somehow.

Reformulated >

| PBk7 CARBON BLACK ASTM I (370) |
| PBk9 IVORY BLACK ASTM I (371) |

| PIGMENT DETAIL ON LABEL YES | ASTM I L'FAST | |

NEUTRAL TINT 136

PÈBÈO

FRAGONARD
ARTISTS'
WATER
COLOUR

A soft, dark grey unnecessarily let down by the use of PR9.

I say unnecessary because the influence of the red is almost impossible to detect.

| PBk7 CARBON BLACK ASTM I (370) |
| PR9 NAPHTHOL AS-OL ASTM III (117) |

| PIGMENT DETAIL ON LABEL YES | ASTM III L'FAST | RATING ★★ |

NEUTRAL TINT 122

M.GRAHAM & CO.

ARTISTS'
WATERCOLOR

A softened, mixed black which seems unusually deep not to have an addition of black pigment.

Reliable ingredients, washed out very well.

| PV19 QUINACRIDONE VIOLET ASTM II (185) |
| PG7 PHTHALOCYANINE GREEN ASTM I (259) |

| PIGMENT DETAIL ON LABEL YES | ASTM II L'FAST | |

NEUTRAL TINT 1186

LUKAS

ARTISTS'
WATER COLOUR

The overall lightfast rating was once lowered by the use of PG8, Hooker's Green. This has now been removed but the rating is still lowered by the use of the PR122.

| PG7 PHTHALOCYANINE GREEN ASTM I (259) |
| PR122 QUINACRIDONE MAGENTA ASTM III (127) |
| PY83 HR70 DIARYLIDE YELLOW HR70 WG II (45) |
| PBk7 CARBON BLACK ASTM I (370) |
| PB15 PHTHALOCYANINE BLUE ASTM II (213) |

| PIGMENT DETAIL ON LABEL CHEMICAL MAKE UP ONLY | ASTM III L'FAST | RATING ★★ |

NEUTRAL TINT 931

SENNELIER

EXTRA-FINE
WATERCOLOUR

Previously contained the unreliable Crimson Alizarin. The colour has now been reformulated using reliable ingredients throughout. Washed out well.

Reformulated >

| PBk7 CARBON BLACK ASTM I (370) |
| PB60 INDANTHRONE BLUE WG II (216) |
| PR209 QUINACRIDONE RED Y ASTM II (134) |

| PIGMENT DETAIL ON LABEL YES | ASTM II L'FAST | |

NEUTRAL TINT 931

SENNELIER

EXTRA-FINE
WATERCOLOUR

A rather complicated approach to end up with a deep grey exhibiting the slightest touch of blue.

Well produced and handled with ease.

| PBk7 CARBON BLACK ASTM I (370) |
| PB60 INDANTHRONE BLUE WG II (216) |
| PR209 QUINACRIDONE RED Y ASTM II (134) |

| PIGMENT DETAIL ON LABEL YES | ASTM II L'FAST | |

NEUTRAL TINT 782

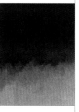

SCHMINCKE

HORADAM
FINEST
ARTISTS'
WATER COLOURS

The fugitive PB66, Indigo Blue once added has been discarded. Now reformulated using reliable pigments. Semi-opaque.

Reformulated >

| PB15 PHTHALOCYANINE BLUE ASTM II (213) |
| PV19 QUINACRIDONE RED ASTM II (185) |
| PBk7 CARBON BLACK ASTM I (370) |

| PIGMENT DETAIL ON LABEL YES | ASTM II L'FAST | |

NEUTRAL TINT 782

SCHMINCKE

HORADAM
FINEST
ARTISTS'
WATER COLOURS

I do not understand this. The company are very aware of this book and would, I am sure, welcome good coverage of their products.

Yet they use an unreliable red in a *completely pointless* way. They must know how I will react.

| PBk7 CARBON BLACK ASTM I (370) |
| PB60 INDANTHRONE BLUE WG II (216) |
| PR122 QUINACRIDONE MAGENTA ASTM III (127) |

| PIGMENT DETAIL ON LABEL YES | ASTM III L'FAST | RATING ★★ |

A very popular blackish-blue produced from standard colours.

Although easily duplicated on the palette, many artists find it convenient to purchase the ready prepared paint. Perhaps it is because they do not quite realise the simple make up of the colour.

If you do need this rather dull 'heavy' colour and your brand is mixed from, say, Ultramarine and Ivory Black, try taking a moment to mix the two paints together yourself.

You will end up with exactly the same colour for a few moments of paint stirring. It will be one less colour to worry about.

Alternatively, and this is by far the better way to work, mix the colour from the complementary pair, Burnt Sienna and Ultramarine Blue. This way you will have a wide range of 'Payne's Greys' as you will have control over the amount of each colour.

You will also have a result that does not include the dulling effect of black but will be rich in both colour and intrigue.

I used to point out how easy it is to mix such colours to customers in an art materials shop I once had. The common response was, "Oh no dear, I must have me Payne's Grey".

PAYNE'S GREY W56

ART SPECTRUM

A semi transparent staining colour which handles very well.

The very slight green undercolour is only visible in extremely thin applications.

ARTISTS' WATER COLOUR

PB15:3 PHTHALOCYANINE BLUE ASTM II (213)
PBk6 LAMP BLACK ASTM I (370)
PV19 QUINACRIDONE VIOLET ASTM II (185)

PIGMENT DETAIL ON LABEL	ASTM
YES	II L'FAST

PAYNE'S GREY 514

MAIMERI

This the standard Payne's Grey. Ultramarine and Black. A convenience colour which is easy to mix on the palette. Semi-opaque.

MAIMERIBLU SUPERIOR WATERCOLOURS

PB29 ULTRAMARINE BLUE ASTM I (215)
PBk9 IVORY BLACK ASTM I (371)

PIGMENT DETAIL ON LABEL	ASTM
YES	I L'FAST

PAYNE'S GREY 514

MAIMERI

A soft dark grey with the slightest of blue undertones. This is only visible in very thin washes.

Well made and handled with ease.

VENEZIA EXTRAFINE WATERCOLOURS

PB29 ULTRAMARINE BLUE ASTM I (215)
PBk9 IVORY BLACK ASTM I (371)

PIGMENT DETAIL ON LABEL	ASTM
YES	I L'FAST

PAYNE'S GRAY 5737

HUNTS

Reliable ingredients give a black with a hint of blue. Our sample washed out reasonably well. Semi-opaque.

SPEEDBALL PROFESSIONAL WATERCOLOURS

PB29 ULTRAMARINE BLUE ASTM I (215)
PBk9 IVORY BLACK ASTM I (371)

PIGMENT DETAIL ON LABEL	ASTM	RATING
NO	I L'FAST	★ ★★

PAYNE'S GREY W356

HOLBEIN

Unfortunately the addition of PR83 lowers the overall assessment, even if its eventual fading will make little difference to the colour. Transparent, non staining and intense.

ARTISTS' WATER COLOR

PR83 ROSE MADDER ALIZARIN ASTM IV (122)
PB29 ULTRAMARINE BLUE ASTM I (215)
PB27 PRUSSIAN BLUE ASTM I (214)
PBk7 CARBON BLACK ASTM I (370)

PIGMENT DETAIL ON LABEL	ASTM	RATING
YES	IV L'FAST	★

PAYNE'S GREY 261

LEFRANC & BOURGEOIS

In the thinnest washes there is possibly a hint of blueness. Otherwise use simply as a black watercolour. Handles well and is reliable. Semi-opaque.

LINEL EXTRA-FINE ARTISTS' WATERCOLOUR

PB60 INDANTHRONE BLUE WG II (216)
PBk7 CARBON BLACK ASTM I (370)

PIGMENT DETAIL ON LABEL	WG
CHEMICAL MAKE UP ONLY	II L'FAST

PAYNE'S GRAY 128

M. GRAHAM & CO.

A deep blackish grey with a slight blue undercolour.

Washed out very smoothly, running effortlessly from one value to another.

ARTISTS' WATERCOLOR

PBk6 LAMP BLACK ASTM I (370)
PB29 ULTRAMARINE BLUE ASTM I (215)

PIGMENT DETAIL ON LABEL	ASTM
YES	I L'FAST

PAYNE'S GRAY 465

WINSOR & NEWTON

Reliable ingredients giving a possible convenience colour.

The blue content is quite obvious in mid to light washes. Washed out well. An opaque, staining watercolour.

ARTISTS' WATER COLOUR

PB15 PHTHALOCYANINE BLUE ASTM II (213)
PBk6 LAMP BLACK ASTM I (370)
PV19 QUINACRIDONE VIOLET ASTM II (185)

PIGMENT DETAIL ON LABEL	ASTM
YES	II L'FAST

PAYNE'S GRAY 465

WINSOR & NEWTON

The blue content is visible in mid to light washes.

Dependable ingredients employed, washes out well. Semi-opaque.

COTMAN WATER COLOURS 2ND RANGE

PB15 PHTHALOCYANINE BLUE ASTM II (213)
PBk7 CARBON BLACK ASTM I (370)
PB29 ULTRAMARINE BLUE ASTM I (215)

PIGMENT DETAIL ON LABEL	ASTM
YES	II L'FAST

SCHMINCKE PAYNE'S GREY 783

SCHMINCKE

A slightly 'warm' black. Recently reformulated using reliable ingredients throughout. A lightfast colour easily duplicated on the palette. Was previously called simply 'Payne's Grey'.

PR101 MARS RED ASTM I (124)
PB29 ULTRAMARINE BLUE ASTM I (215)
PBk7 CARBON BLACK ASTM I (370)

HORADAM FINEST ARTISTS' WATER COLOURS

| PIGMENT DETAIL ON LABEL YES | ASTM I L'FAST | |

PAYNE'S GREY 214

OLD HOLLAND

Over bound and washed out with difficulty.

CLASSIC WATERCOLOURS

PB29 ULTRAMARINE BLUE ASTM I (215)
PBk9 IVORY BLACK ASTM I (371)

| PIGMENT DETAIL ON LABEL CHEMICAL MAKE UP ONLY | ASTM I L'FAST | RATING ★★ |

PAYNE'S GRAY 193

UTRECHT

I could not detect any influence from the Ultramarine Blue. If you need this colour you will probably have it already under the name Ivory Black.

Seems pointless but is very well made.

PB29 ULTRAMARINE BLUE ASTM I (215)
PBk9 IVORY BLACK ASTM I (371)

PROFESSIONAL ARTISTS' WATER COLOR

| PIGMENT DETAIL ON LABEL YES | ASTM I L'FAST | |

PAYNE'S GRAY W156

GRUMBACHER

The blue content is noticeable in mid to light washes. A velvety black in heavier application. The PR88 is a recent addition. Lightfast. Semi-opaque.

PBk9 IVORY BLACK ASTM I (371)
PB29 ULTRAMARINE BLUE ASTM I (215)
PR88 MRS THIOINDIGOID VIOLET ASTM II (122)

FINEST ARTISTS' WATER COLOR

| PIGMENT DETAIL ON LABEL YES | ASTM L'FAST | |

PAYNE'S GRAY A156

GRUMBACHER

The 'traditional' blue for Payne's Grey is Ultramarine, a violet-blue, rather than a green-blue such as Phthalocyanine. Semi-opaque.

Reformulated

PB15 PHTHALOCYANINE BLUE ASTM II (213)
PBk6 LAMP BLACK ASTM I (370)

ACADEMY ARTISTS' WATERCOLOR 2ND RANGE

| PIGMENT DETAIL ON LABEL YES | ASTM II L'FAST | |

PAYNE'S GRAY

GRUMBACHER

One unreliable pigment in any paint is enough to lower the overall lightfast rating. Why add the PV 3 when the final result does not depend on it?

A nondescript well produced dark grey.

PB15 PHTHALOCYANINE BLUE ASTM II (213)
PV3 METHYL VIOLET WG V (182)
PBk6 LAMP BLACK ASTM I (370)

ACADEMY ARTISTS' WATERCOLOR 2ND RANGE

| PIGMENT DETAIL ON LABEL YES | WG V L'FAST | RATING ★ |

PAYNE'S GRAY 085

AMERICAN JOURNEY

The general colour description 'Payne's Grey' refers to a mix which seems to have moved from being a very dark blue to a soft black, with just a faint trace of blue.

Well produced and washed out with ease.

PBk6 LAMP BLACK ASTM I (370)
PB27 PRUSSIAN BLUE ASTM I (214)

PROFESSIONAL ARTISTS' WATER COLOR

| PIGMENT DETAIL ON LABEL YES | ASTM I L'FAST | |

PAYNE'S GREY BLUISH 787

SCHMINCKE

A semi opaque, semi staining very deep grey with a slight green bias to the tint. Reliable, and well made.

PBk6 LAMP BLACK ASTM I (370)
PB15:6 PHTHALOCYANINE BLUE ASTM II (213)

HORADAM FINEST ARTISTS' WATER COLOURS

| PIGMENT DETAIL ON LABEL YES | ASTM II L'FAST | |

PAYNE'S GREY 065

DALER ROWNEY

I wonder whether certain of these Payne's Greys are really worth considering.

They are so close to black that they could only be used as such. Reliable. Opaque.

PB29 ULTRAMARINE BLUE ASTM I (215)
PBk7 CARBON BLACK ASTM I (370)

ARTISTS' WATER COLOUR

| PIGMENT DETAIL ON LABEL YES | ASTM I L'FAST | |

PAYNE'S GREY

DALER ROWNEY

A neutral black - grey with the faintest hint of blue in the tint. Little removed from a straightforward black.

PBk7 CARBON BLACK ASTM I (370)
PB29 ULTRAMARINE BLUE ASTM I (215)

GEORGIAN WATER COLOUR 2ND RANGE

| PIGMENT DETAIL ON LABEL NO | ASTM I L'FAST | |

PAYNE'S GRAY 261

DA VINCI PAINTS

A blackish green blue. Heavier applications can take on a reddish overlay, visible at certain angles. This is due to the 'bronzing' which Prussian Blue is particularly susceptible to.

PBk6 LAMP BLACK ASTM I (370)
PB27 PRUSSIAN BLUE ASTM I (214)

PERMANENT ARTISTS' WATER COLOR

| PIGMENT DETAIL ON LABEL YES | ASTM I L'FAST | |

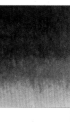

PAYNE'S GRAY 661

DA VINCI PAINTS

Sample tube was under considerable pressure. Handling was less than satisfactory;

I feel sure that the initial problems with this new range will quickly be overcome.

PBk6 LAMP BLACK ASTM I (370)
PB27 PRUSSIAN BLUE ASTM I (214)

SCUOLA 2ND RANGE

| PIGMENT DETAIL ON LABEL YES | ASTM I L'FAST | RATING ★★ |

PAYNE'S GREY 708

TALENS

WATER COLOUR 2ND RANGE

Treat as a black watercolour rather than the traditional blackish blue. I am sure the other pigments are in there somewhere, just a bit shy.

Discontinued

PB15 PHTHALOCYANINE BLUE ASTM II (213)
PBk7 CARBON BLACK ASTM I (370)
PV19 QUINACRIDONE VIOLET ASTM II (185)

PIGMENT DETAIL ON LABEL YES | ASTM II L'FAST |

PAYNE'S GREY 708

TALENS

VAN GOGH 2ND RANGE

A dark grey. If it has an undercolour apart from a pale neutral grey I cannot detect it.

Performed well across the range of washes.

PBk6 LAMP BLACK ASTM I (370)
PV19 QUINACRIDONE VIOLET ASTM II (185)

PIGMENT DETAIL ON LABEL YES | ASTM II L'FAST |

PAYNE'S GREY 123

PÈBÈO

FRAGONARD ARTISTS' WATER COLOUR

In appearance it is black with the slightest hint of brown, and it is slight! Reliable and well produced. Semi-opaque.

PR88 MRS THIOINDIGOID VIOLET ASTM II (122)
PBk7 CARBON BLACK ASTM I (370)
PB15 PHTHALOCYANINE BLUE ASTM II (213)

PIGMENT DETAIL ON LABEL YES | ASTM II L'FAST |

PAYNE'S GREY 708

TALENS

REMBRANDT ARTISTS' QUALITY EXTRA FINE

There can be little of the blue or violet involved as the colour is all but black. Reliable ingredients. Washes out well. Semi-opaque.

Reformulated >

PB15 PHTHALOCYANINE BLUE ASTM II (213)
PV19 QUINACRIDONE VIOLET ASTM II (185)
PBk7 CARBON BLACK ASTM I (370)

PIGMENT DETAIL ON LABEL YES | ASTM II L'FAST |

PAYNE'S GREY 708

TALENS

REMBRANDT ARTISTS' QUALITY EXTRA FINE

I do wonder what modern 'Payne's Grey' is all about. It used to have a definite leaning towards violet blue.

Now it is more of a nondescript dark grey, as in this example.

Well produced.

PB15 PHTHALOCYANINE BLUE ASTM II (213)
PBk6 LAMP BLACK ASTM I (370)

PIGMENT DETAIL ON LABEL YES | ASTM II L'FAST |

PAYNE'S GREY 1184

LUKAS

ARTISTS' WATER COLOUR

Very thin applications have the slightest hint of blue about them.

Otherwise treat as black. Semi-opaque.

PB15 PHTHALOCYANINE BLUE ASTM II (213)
PBk7 CARBON BLACK ASTM I (370)

PIGMENT DETAIL ON LABEL CHEMICAL MAKE UP ONLY | ASTM II L'FAST |

PAYNE'S GREY 2387

UMTON BARVY

ARTISTIC WATER COLOR

Judging by the colour wash the PR177 plays little or no role. Yet it causes the overall lightfast rating to drop from ASTM I to III. Assessed accordingly. Handled very well.

PB27 PRUSSIAN BLUE ASTM I (214)
PBk9 IVORY BLACK ASTM I (371)
PR177 ANTHRAQUINOID RED ASTM III (130)

PIGMENT DETAIL ON LABEL NO | ASTM III L'FAST | RATING ★★

PAYNE'S GRAY 065

DANIEL SMITH

EXTRA-FINE WATERCOLORS

A very dark neutral grey. I could not detect the presence of the Ultramarine Blue content.

Well produced and washed out evenly.

PB29 ULTRAMARINE BLUE ASTM I (215)
PBk9 IVORY BLACK ASTM I (371)

PIGMENT DETAIL ON LABEL YES | ASTM I L'FAST |

PAYNE'S GREY 508

CARAN D'ACHE

FINEST WATER COLOUR

A black with an almost undetectable hint of blue about it. Lifted from the pan easily and well behaved during wash outs.

PB29 ULTRAMARINE BLUE ASTM I (215)
PBk7 CARBON BLACK ASTM I (370)

PIGMENT DETAIL ON LABEL YES | ASTM I L'FAST |

PAYNE'S GREY 555

MIR (JAURENA S.A)

ACUARELA

I could not detect any trace at all of the Ultramarine Blue content.

Treat as a black. But a well produced black giving smooth even washes.

PB29 ULTRAMARINE BLUE ASTM I (215)
PBk7 CARBON BLACK ASTM I (370)

PIGMENT DETAIL ON LABEL YES | ASTM I L'FAST |

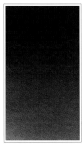

PAYNES GREY 703

SENNELIER

EXTRA-FINE ARTISTS' WATER COLORS

The unreliable PBk1, once added, has been removed and the colour reformulated using lightfast pigments throughout. Sample gave very smooth, even washes.

PB15:3 PHTHALOCYANINE BLUE ASTM II (213)
PV19 QUINACRIDONE VIOLET ASTM II (185)
PBk7 CARBON BLACK ASTM I (370)

PIGMENT DETAIL ON LABEL YES | ASTM II L'FAST |

PAYNE'S GRAY

DR.Ph. MARTINS

HYDRUS FINE ART WATERCOLOR

Close to the traditional idea of Paynes Grey, even if the undercolour leans a little towards green.

How the colour came about I haven't a clue.

PIGMENT INFORMATION NOT DISCLOSED

PIGMENT DETAIL ON LABEL NO | ASTM L'FAST | RATING

Miscellaneous Greys

What can I say? If any of these greys or blacks are vital to your way of working than go ahead.

My view is that they are added onto lists in order to provide yet another colour name and are of very limited worth as individual paints. Each could be mixed with ease.

AUSTRALIAN GREY W43

ART SPECTRUM

ARTISTS' WATER COLOUR

This is a fairly opaque, granulating paint which many will purchase to help in the painting of instant Australian landscapes.

Washed out better when thin.

PY42 MARS YELLOW ASTM I (43)
UNSPECIFIED PBr7 (309/310)

PIGMENT DETAIL ON LABEL	ASTM	
YES	I L'FAST	

ANTIQUE SILVER GREY 046

HOLBEIN

IRODORI ANTIQUE WATERCOLOR

Add black to white and you have 'Antique Silver Grey'. Or any other name that you like to give it.

Washed out very evenly.

PBk6 LAMP BLACK ASTM I (370)
PW6 TITANIUM WHITE ASTM I (385)

PIGMENT DETAIL ON LABEL	ASTM	
YES	I L'FAST	

OLD HOLLAND COLD GREY 364

OLD HOLLAND

CLASSIC WATERCOLOURS

I am afraid that I cannot offer a colour guide or assessments as a sample was not provided.

PW4 ZINC WHITE ASTM I (384)
PW6 TITANIUM WHITE ASTM I (385)
PB29 ULTRAMARINE BLUE ASTM I (215)
PBk7 CARBON BLACK ASTM I (370)

PIGMENT DETAIL ON LABEL CHEMICAL MAKE UP ONLY	ASTM I L'FAST	RATING

OLD HOLLAND WARM GREY LIGHT 361

OLD HOLLAND

CLASSIC WATERCOLOURS

I am afraid that I cannot offer a colour guide or assessments as a sample was not provided.

PW4 ZINC WHITE ASTM I (384)
PW6 TITANIUM WHITE ASTM I (385)
PB29 ULTRAMARINE BLUE ASTM I (215)
PBk7 CARBON BLACK ASTM I (370)

PIGMENT DETAIL ON LABEL CHEMICAL MAKE UP ONLY	ASTM I L'FAST	RATING

GREY OF GREY W353

HOLBEIN

ARTISTS' WATER COLOR

Cracks readily even when applied at mid strength. PBk1 is less than reliable. If you need this colour, add white to black and stir. Opaque and non staining.

PBk1 ANILINE BLACK WG III (370)
PW6 TITANIUM WHITE ASTM I (385)

PIGMENT DETAIL ON LABEL	WG III L'FAST	RATING ★★
YES		

CHARCOAL GREY 786

SCHMINCKE

HORADAM FINEST ARTISTS' WATER COLOURS

A lightly staining, straightforward black which covers well.

I have shown the undercolour rather than mass tone to illustrate the very faint leaning towards brown.

PBk7 CARBON BLACK ASTM I (370)

PIGMENT DETAIL ON LABEL	ASTM	
YES	I L'FAST	

CHARCOAL GREY 142

WINSOR & NEWTON

ARTISTS' WATER COLOUR

Sample was rather gritty but brushed out reasonably well. Treat as a general black rather than anything special. Lightfast. Semi-opaque.

Reformulated >

PBk8 CHARCOAL BLACK WG I (371)

PIGMENT DETAIL ON LABEL	WG I L'FAST	
YES		

CHARCOAL GREY 142

WINSOR & NEWTON

ARTISTS' WATER COLOUR

I am afraid that I cannot offer a colour guide or assessments as a sample was not provided.

PBk7 CARBON BLACK ASTM I (370)
UNSPECIFIED PBr7 (309/310)

PIGMENT DETAIL ON LABEL	ASTM	RATING
YES	I L'FAST	

GRAPHITE GRAY 038

DANIEL SMITH

EXTRA-FINE WATERCOLORS

A dark neutral grey with a soft, almost metallic feel about it. Produced from crystalised carbon.

ASTM I in acrylics and will almost certainly be lightfast in watercolours. I do not have sufficient information at this stage to offer an assessment.

PBk10 GRAPHITE GRAY

PIGMENT DETAIL ON LABEL	ASTM L'FAST	RATING
YES		

OLD HOLLAND VIOLET-GREY 208 ★★

OLD HOLLAND

CLASSIC WATERCOLOURS

Any paint employing two whites gets off to an exotic start. The subtlety is soon lost however, once an over generous amount of gum has been added.

PW4 ZINC WHITE ASTM I (384)
PW6 TITANIUM WHITE ASTM I (385)
PB29 ULTRAMARINE BLUE ASTM I (215)
PBk7 CARBON BLACK ASTM I (370)

PIGMENT DETAIL ON LABEL CHEMICAL MAKE UP ONLY	ASTM I L'FAST	RATING ★★

CHARCOAL GREY 726

TALENS

REMBRANDT ARTISTS' QUALITY EXTRA FINE

A nondescript black which leans towards brown.

To my mind a rather pointless mix of two black pigments. Semi-opaque.

Discontinued

PBk7 CARBON BLACK ASTM I (370)
PBk9 IVORY BLACK ASTM I (371)

PIGMENT DETAIL ON LABEL	ASTM	
YES	I L'FAST	

CHARCOAL GRAY A042

GRUMBACHER

If you also purchase the actual Lamp Black available in this range, you will have a matching pair, in every respect. Do not buy the same thing twice unless you collect paint names.

PBk6 LAMP BLACK ASTM I (370)

| PIGMENT DETAIL ON LABEL YES | ASTM I L'FAST | |

ACADEMY ARTISTS' WATERCOLOR 2ND RANGE

SCHEVENINGEN WARM GREY 73

OLD HOLLAND

I am afraid that I cannot offer a colour guide or assessments as a sample was not provided.

PW4 ZINC WHITE ASTM I (384)
PW6 TITANIUM WHITE ASTM I (385)
PBk9 IVORY BLACK ASTM I (371)
UNSPECIFIED PBr7 (309/310)

| PIGMENT DETAIL ON LABEL CHEMICAL MAKE UP ONLY | ASTM I L'FAST | RATING |

CLASSIC WATERCOLOURS

GETZ GRAY (DAVY'S) 052

AMERICAN JOURNEY

Black, white and a touch of green to give a rather nondescript mid grey. But it does have an interesting name, so many will buy it. Reliable and well produced.

PW6 TITANIUM WHITE ASTM I (385)
PBk6 LAMP BLACK ASTM I (370)
PG7 PHTHALOCYANINE GREEN ASTM I (259)

| PIGMENT DETAIL ON LABEL YES | ASTM I L'FAST | |

PROFESSIONAL ARTISTS' WATER COLOR

NEUTRAL GREY 785

SCHMINCKE

A very dark neutral grey.

It is difficult to see what part the blue and green have played.

Handled well.

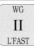

PR251 COMMON NAME N/K WG II (136)
PB60 INDANTHRONE BLUE WG II (216)
PG7 PHTHALOCYANINE GREEN ASTM I (259)

| PIGMENT DETAIL ON LABEL YES | WG II L'FAST | |

HORADAM FINEST ARTISTS' WATER COLOURS

YELLOW GREY W351

HOLBEIN

Reliable ingredients. Brushed out well. Colour is easily duplicated on the palette. Opaque, non staining.

PBk9 IVORY BLACK ASTM I (371)
PY42 MARS YELLOW ASTM I (43)
PW6 TITANIUM WHITE ASTM I (385)

| PIGMENT DETAIL ON LABEL YES | ASTM I L'FAST | |

ARTISTS' WATER COLOR

When Burnt Sienna is added to Ultramarine Blue it will darken it very successfully and produce a range of more traditional 'Payne's Greys'.

Other types of greys and neutral can also be produced this way. Both are close as complementaries and are also transparent. Worth trying.

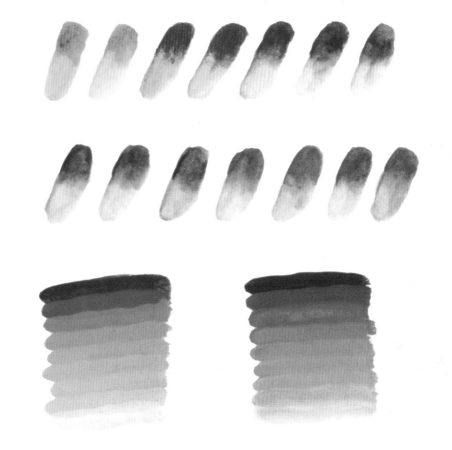

As carefully chosen mixing complementaries absorb each others' light, coloured greys start to emerge. It is very easy to produce a wide range of reliable greys this way.
Reproduced from our Home Study Course ' Practical Colour Mixing'

Neutrals and coloured greys

Exercise 13 The complementaries: yellow and violet

This exercise calls for the prior blending of one of the mixing colours, the bright violet (leaning neither towards the red or the blue).

Although it appears that three colours are being used, in practice only two are ever involved in this approach to colour mixing.

Once the violet has been mixed it is used as a single colour. It is easily reproduced at a future date if the same range is required.

Further amounts of red or blue are not added during use as this would remove control. One minute you would be working with a blue violet, the next with a red violet.

Neutrals are dulled or darkened hues, such as the darkened yellows and violets shown above.

Coloured greys appear about the middle of the range where the two contributing colours are absorbing each others light.

For this exercise, the violet is pre-mixed from the violet-red and the violet-blue (as in

exercise 1, page 15), and then placed into the violet mixing well.

When colours known as complementaries are mixed they start to absorb each others light as soon as one is added to the other.

For this reason they give both neutralised (or dulled) colours as well as the coloured greys.

Blacks

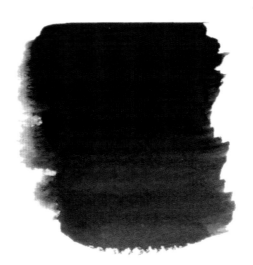

The first paint ever to be used was almost certainly soot, either rubbed directly onto the surface or mixed with a binder such as animal fat or blood.

A wide variety of substances have been burnt for their soot or charred to give black pigments. Many have been greasy and difficult to use.

Soot from the cave mans' fire was probably the first material ever to be employed as a pigment.

It was either rubbed onto the cave wall or made into a rough paint with a binder such as animal fat, sap, blood or a similar sticky substance. The basic material is still with us as Lamp Black.

Lamp Black was one of the standard black pigments of the Middle Ages, its main drawback was the fact that it was often greasy and tended to 'dirty' mixes.

An advantage was its ease of manufacture and low cost if purchased ready prepared.

Most of the black pigments available today are still produced from carbon obtained by burning various materials.

Such blacks are either almost pure carbon obtained from the soot of burnt oils and tars, or the slightly impure carbons derived form animal or vegetable origins.

Certain charcoals of high quality were valued by the Medieval artist. One of the more common, Vine Black, being made from charred grape vines.

Vine Black and other vegetable blacks tended to be rather brownish and had an unpleasant consistency.

Some particularly fine blacks were obtained from charred fruit stones, especially peach.

Willow charcoal was often made into a paint, but was found to be rather greyish and difficult to work with.

An extremely permanent black made from charred animal bones has been in use since earliest times and is still with us, masquerading as Ivory Black.

Nowadays the paint sold as Ivory Black is in fact Bone Black, an inferior product. Genuine Ivory Black, made from charred ivory is, thankfully, no longer available. As far as the source of the ivory is concerned that is.

A recent addition has been Mars Black, an artificial mineral pigment. Dense and reliable, the better qualities have been generally welcomed by today's artists.

Modern Black Pigments

PBk1 ANILINE BLACK ... 370

PBk6 LAMP BLACK ... 370

PBk7 CARBON BLACK ... 370

PBk8 CHARCOAL BLACK .. 371

PBk9 IVORY BLACK .. 371

PBk11 MARS BLACK .. 371

PBk19 GRAY HYDRATED ALUMINUM SILICATE 372

PBk31 PERYLENE BLACK ... 372

PBk1 ANILINE BLACK

This is a rather unusual black to find in artists' watercolours as it is well known that it will tend to fade as a tint. Watercolours of course are often applied thinly, where they are particularly vulnerable to the light.

Why a black which is less than reliable is ever employed is rather mysterious. After all, there are a reasonably wide selection of absolutely lightfast products available. Semiopaque. Rarely used in artists paints.

The first 'coal tar dye'. By reputation and our own testing rated WG III. Unreliable and unnecessary.

PBk6 LAMP BLACK

Produced by burning mineral oil, pitch or tar in brick chambers and collecting the soot which is given off. Any oily residues are then removed by heat treatment.

This material been used since the dawn of civilisation. A very fine, light pigment, it tends to float on the surface of a wash and settle elsewhere. High in tinting strength, it should be handled with some care. Excellent hiding power. Reasonably transparent when well diluted.

Absolutely lightfast, with an ASTM rating of I as a watercolour.

On the list of recommended colours. A cool bluish-black.

PBk7 CARBON BLACK

Carbon blacks have been produced by charring a wide variety of materials. Today it is usually made by burning natural gas and allowing the flame to impinge onto a metal plate. The resulting soot can be made into a paint without further process.

Being very light, the pigment tends to float to the edges of a very wet wash. Opaque, with excellent hiding power. Transparent only when well diluted. An intense velvety black.

Tested ASTM I as a watercolour. Absolutely lightfast, it will never alter in colour. On the ASTM list of approved pigments.

PBk8 CHARCOAL BLACK

A grey-black powder made from charcoal. The better qualities come from charred Willow, but other materials can be used such as twigs from the vine. Usually considered to make an inferior pigment as far as brushability is concerned.

However, when blended with other pigments this drawback is largely overcome. The denser charcoals produce the better pigment. Semi-opaque. PBk8 is seldom found in modern watercolours, more as a colorant in cement.

Charcoal Black has an excellent reputation for reliability.

I do not have test results to back this up but carbon is quite unaffected by light. Also called Bideford Black.

PBk9 IVORY BLACK

Originally obtained by charring ivory scraps in sealed crucibles. The resultant black material was ground into a intense, velvety black. This pigment was sold alongside an inferior black made from charred animal bones (Bone Black).

When the supply of ivory dried up, the name Ivory Black was simply switched to Bone Black. Modern Ivory Black is still made from animal bones.

Semi-opaque with brownish tints.

Sometimes darkened with other pigments. Completely lightfast. ASTM I in watercolour and on the list of approved pigments.

PBk11 MARS BLACK

Mars Black varies in colour from a dark bluish-grey to black. It is opaque, with very good hiding power. When applied very dilute it can settle out into small pockets of colour. PBk11 has a similar chemical make up to PR101 - PR102 - PBr7 and PBr6.

High in tinting strength it will quickly influence virtually all other colours when mixed. Varies in quality between pigment manufacturers. The better grades are good value for money.

An excellent dense blue-grey to black. Absolutely lightfast, with an ASTM rating of I it is on the list of approved pigments. Possesses valuable qualities. Also called Iron Oxide Black.

PBk19 GRAY HYDRATED ALUMINUM SILICATE

PBk19 has many industrial uses and is often found as an inert extender in cheap paints of various types.

It is also used in grey fillers and stoppers and to colour artificial stone and cement. Mid Grey. Excellent lightfastness. ASTM I as a watercolour and on the list of approved pigments. It is also called Slate Grey.

PBk31 PERYLENE BLACK

The only information I have on this pigment is that it is an intense bluish black which, as with far too many other pigments, has not been tested in any art material.

A lightfastness rating cannot be offered.

Black Watercolours

Ivory Black .. 374
Lamp Black .. 376
Miscellaneous Blacks .. 378

Ivory Black is produced by charring animal bones in closed crucibles. The bones are first boiled to remove fat and gristle. It is not known for certain when this material was first employed as a pigment, although we can be fairly sure that it was one of the earliest materials used for painting.

The original Ivory Black was produced by charring ivory scraps, usually off-cuts from the comb making trade or similar. It was a rich velvety black, in great demand. Bone Black, an inferior pigment was also offered to the less discerning.

When the supply of reasonably cheap ivory dried up, the Colourmen were left with a dilemma. Genuine Ivory Black was in wide demand and sold for a good price, but the pigment could not be supplied.

To make everyone happy (particularly the Colourmen) they simply switched names and called Bone Black, Ivory Black.

The colour of the product has changed over recent years. Normally possessing a warm brown undercolour, manufacturers now strive to produce a darker, more neutral black. Modern Bone Black, sorry, Ivory Black, is of a far better quality than it used to be as all the fat is now removed during manufacture.

IVORY BLACK EXTRA 74

OLD HOLLAND — CLASSIC WATERCOLOURS

Previously simply called 'Ivory Black 450'. This is a well produced paint, dense pigment and smoothly milled. Washed out very well over a useful range of values. Semi-opaque.

PBk9 IVORY BLACK ASTM I (371)
PIGMENT DETAIL ON LABEL — CHEMICAL MAKE UP ONLY | ASTM I L'FAST

IVORY BLACK 110

M. GRAHAM & CO. — ARTISTS' WATERCOLOR

Very smooth even gradations from this high quality product.

Well balanced between pigment and binder and absolutely lightfast.

PBk9 IVORY BLACK ASTM I (371)
PIGMENT DETAIL ON LABEL YES | ASTM I L'FAST

IVORY BLACK 755

SENNELIER — EXTRA-FINE WATERCOLOUR

Gave smooth even washes over a very wide range of values. A quality product.

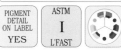

PBk9 IVORY BLACK ASTM I (371)
PIGMENT DETAIL ON LABEL YES | ASTM I L'FAST

IVORY BLACK 496

CARAN D'ACHE — FINEST WATERCOLOURS

Difficult to lift from the pan and did not handle well.

Gave reasonable washes in thinner applications but hard to work when any heavier.

PBk9 IVORY BLACK ASTM I (371)
PIGMENT DETAIL ON LABEL YES | ASTM I L'FAST | RATING ★★

IVORY BLACK 331

WINSOR & NEWTON — ARTISTS' WATER COLOUR

A warm black with a hint of brown in the tints.

Gave very smooth washes over the full range of values. Semi-opaque.

PBk9 IVORY BLACK ASTM I (371)
PIGMENT DETAIL ON LABEL YES | ASTM I L'FAST

IVORY BLACK 331

WINSOR & NEWTON — COTMAN WATER COLOURS 2ND RANGE

If you need to make savings this is as reliable as any 'Artist Quality' Ivory Black. Handled well. Semi-opaque.

PBk9 IVORY BLACK ASTM I (371)
PIGMENT DETAIL ON LABEL YES | ASTM I L'FAST

IVORY BLACK W338

HOLBEIN — ARTISTS' WATER COLOR

An intense velvety black. A particularly well produced watercolour paint, it washed out smoothly over a wide range of values. Non staining.

PBk9 IVORY BLACK ASTM I (371)
PIGMENT DETAIL ON LABEL YES | ASTM I L'FAST

IVORY BLACK 535

MAIMERI — MAIMERIBLU SUPERIOR WATERCOLOURS

Absolutely lightfast. Well produced watercolour paint which handles with ease, giving smooth washes. Semi-opaque.

PBk9 IVORY BLACK ASTM I (371)
PIGMENT DETAIL ON LABEL YES | ASTM I L'FAST

IVORY BLACK 535

MAIMERI — VENEZIA EXTRAFINE WATERCOLOURS

A little on the gummy side causing it to brush out better when applied as either a medium or a thin wash.

PBk9 IVORY BLACK ASTM I (371)
PIGMENT DETAIL ON LABEL YES | ASTM I L'FAST | RATING ★ ★★

IVORY BLACK 269

LEFRANC & BOURGEOIS

Ivory Black is semi-opaque and covers well.

It is strong enough however, to give reasonably clear washes when fully diluted. Handles well.

LINEL
EXTRA-FINE
ARTISTS'
WATERCOLOUR

PBk9 IVORY BLACK ASTM I (371)
PIGMENT DETAIL ON LABEL CHEMICAL MAKE UP ONLY — ASTM I L'FAST

IVORY BLACK 1182

LUKAS

I feel that this should, ideally, be described as 'Ivory Black Hue' as it is an imitation. Carbon Black has its own particular characteristics of handling and hue. Opaque.

ARTISTS'
WATER COLOUR

PBk7 CARBON BLACK ASTM I (370)
PIGMENT DETAIL ON LABEL CHEMICAL MAKE UP ONLY — ASTM I L'FAST

IVORY BLACK 5739

HUNTS

Densely packed pigment. A well produced watercolour paint which handled very smoothly.

Good covering power and quite strong tinctorially. Semi-opaque.

SPEEDBALL
PROFESSIONAL
WATERCOLOURS

PBk9 IVORY BLACK ASTM I (371)
PIGMENT DETAIL ON LABEL NO — ASTM I L'FAST

IVORY BLACK W58

ART SPECTRUM

Due to the nature of the pigment did not give particularly dense blacks at full saturation.

Semi transparent and granulating when very dilute. Well produced.

ARTISTS'
WATER COLOUR

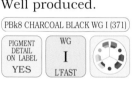

PBk8 CHARCOAL BLACK WG I (371)
PIGMENT DETAIL ON LABEL YES — WG I L'FAST

IVORY BLACK A115

GRUMBACHER

A soft, warm black which handles very well. Unaffected by light of any strength and duration.

ACADEMY
ARTISTS'
WATERCOLOR
2ND RANGE

PBk9 IVORY BLACK ASTM I (371)
PIGMENT DETAIL ON LABEL YES — ASTM I L'FAST

IVORY BLACK W115

GRUMBACHER

Full strength applications dry as a soft velvety matt black.

Washed out well over a particularly wide range of values.

FINEST
ARTISTS'
WATER COLOR

PBk9 IVORY BLACK ASTM I (371)
PIGMENT DETAIL ON LABEL YES — ASTM I L'FAST

IVORY BLACK 034

DALER ROWNEY

Rich, velvety black at full strength, brushing out to light mid-greys when well diluted. Handled very smoothly. Semi-opaque.

ARTISTS'
WATER COLOUR

PBk9 IVORY BLACK ASTM I (371)
PIGMENT DETAIL ON LABEL NO — ASTM I L'FAST

IVORY BLACK

DALER ROWNEY

Sample was rather over bound and brushed out with some difficulty unless well diluted. Absolutely lightfast. Semi-opaque.

GEORGIAN
WATER COLOUR
2ND RANGE

PBk9 IVORY BLACK ASTM I (371)
PIGMENT DETAIL ON LABEL NO — ASTM I L'FAST — RATING ★★

IVORY BLACK 2850

UMTON BARVY

A soft velvety black pigment made up into a well balanced paint.

Lifted easily from the pan and gave smooth washes over a very wide range of values.

ARTISTIC
WATER COLOR

PBk9 IVORY BLACK ASTM I (371)
PIGMENT DETAIL ON LABEL NO — ASTM I L'FAST

IVORY BLACK 048

DANIEL SMITH

A thick mass of sticky, heavy black gum emerged from the tube.

An appalling substance to be sold as an artists watercolour paint.

EXTRA-FINE
WATERCOLORS

PBk9 IVORY BLACK ASTM I (371)
PIGMENT DETAIL ON LABEL YES — ASTM I L'FAST — RATING ★

IVORY BLACK 701

TALENS

This should, strictly speaking be described as 'Ivory Black Hue' as an imitation pigment has been used.

It is still absolutely lightfast and handles well.

REMBRANDT
ARTISTS'
QUALITY
EXTRA FINE

PBk6 LAMP BLACK ASTM I (370)
PIGMENT DETAIL ON LABEL YES — ASTM I L'FAST

IVORY BLACK 701

TALENS

Does not have the brown undercolour associated with unadulterated Ivory Black. Reliable. Semi-opaque.

Range discontinued

WATER COLOUR
2ND RANGE

PBk7 CARBON BLACK ASTM I (370)
PBk9 IVORY BLACK ASTM I (371)
PIGMENT DETAIL ON LABEL YES — ASTM I L'FAST — RATING ★ ★★

IVORY BLACK 707

TALENS

A somewhat unusual combination giving a dense velvety black.

Handled well over a very wide range of values.

VAN GOGH
2ND RANGE

PBk6 LAMP BLACK ASTM I (370)
PBk9 IVORY BLACK ASTM I (371)

PIGMENT DETAIL ON LABEL	ASTM	
YES	I L'FAST	

IVORY BLACK 191

UTRECHT

Washed out very smoothly giving a wide and useful range of values, from a deep dense black to the thinnest of pale grey washes.

PROFESSIONAL
ARTISTS'
WATER COLOR

PBk9 IVORY BLACK ASTM I (371)

PIGMENT DETAIL ON LABEL	ASTM	
YES	I L'FAST	

IVORY BLACK 1 128

PÈBÈO

Opaque, with excellent covering power. Gives reasonable washes when very dilute. An imitation Ivory Black which should be described as a 'Hue'.

FRAGONARD
ARTISTS'
WATER
COLOUR

PBk7 CARBON BLACK ASTM I (370)

PIGMENT DETAIL ON LABEL	ASTM	
YES	I L'FAST	

IVORY BLACK 780

SCHMINCKE

A particularly dense black at full strength.

Washes out well and has good covering power.

HORADAM
FINEST
ARTISTS'
WATER COLOURS

PBk9 IVORY BLACK ASTM I (371)

PIGMENT DETAIL ON LABEL	ASTM	
YES	I L'FAST	

Lamp Black

Mineral oil, tar, pitch or a similar substance is burnt in brick chambers and the soot is collected. Oily residues are normally present, these are removed by heat treatment. Being a fine, soft powder it does not require further grinding.

Soot given off from the fire was probably the first pigment ever to be used, either rubbed onto the wall of the cave or possibly mixed with animal fats. Lamp Black, produced by burning a wide variety of substances, has been in use ever since.

Used extensively for Chinese ink work from the earliest times, it was usually made by burning resinous pine wood or Tung oil nuts and cake.

A cool mid-black, often with a very slight blue bias. Very high in tinting strength and covering power it should be handled with some care. Washes out to give reasonably clear tints.

The pigment is particularly light and fluffy. When applied in a very wet layer it is apt to float on the surface of the film and settle near the edges, causing a dark band around the wash. This is especially noticeable in small areas.

LAMP BLACK 003

DANIEL SMITH

An extremely dense, velvety black at full saturation, coming down to very light greys at the other end of the scale.

EXTRA-FINE
WATERCOLORS

PBk6 LAMP BLACK ASTM I (370)

PIGMENT DETAIL ON LABEL	ASTM	
YES	I L'FAST	

LAMP BLACK A116

GRUMBACHER

At full strength is a dense black with excellent covering power.

Washes out very smoothly, giving fairly clear washes. Opaque.

FINEST
ARTISTS'
WATER COLOR

PBk6 LAMP BLACK ASTM I (370)

PIGMENT DETAIL ON LABEL	ASTM	
YES	I L'FAST	

LAMP BLACK W116

GRUMBACHER

Soft, matt black at full strength with very good covering power.

Handles well. Why pay more for the 'Artist Quality'? Most reliable. Opaque

ACADEMY
ARTISTS'
WATERCOLOR
2ND RANGE

PBk6 LAMP BLACK ASTM I (370)

PIGMENT DETAIL ON LABEL	ASTM	
YES	I L'FAST	

LAMP BLACK 266

LEFRANC & BOURGEOIS

LINEL EXTRA-FINE ARTISTS' WATERCOLOUR

Carbon Black is virtually the same as Lamp Black in hue and handling characteristics.

It is absolutely lightfast.

PBk7 CARBON BLACK ASTM I (370)

PIGMENT DETAIL ON LABEL CHEMICAL MAKE UP ONLY | ASTM I L'FAST

LAMP BLACK 337

WINSOR & NEWTON

ARTISTS' WATER COLOUR

Being a very fine pigments they make into a paint which washes out well, giving smooth even washes. Most reliable. Lightfast and opaque.

PBk6 LAMP BLACK ASTM I (370)
PBk7 CARBON BLACK ASTM I (370)

PIGMENT DETAIL ON LABEL YES | ASTM I L'FAST

LAMP BLACK 337

WINSOR & NEWTON

COTMAN WATER COLOURS 2ND RANGE

A wide range of values are available, from a particularly dense black at full strength, to soft, light grey washes when diluted. Opaque.

PBk6 LAMP BLACK ASTM I (370)
PBk7 CARBON BLACK ASTM I (370)

PIGMENT DETAIL ON LABEL YES | ASTM I L'FAST

LAMP BLACK W340

HOLBEIN

ARTISTS' WATER COLOR

At full strength is a particularly dense, smooth, matt black. Handled well but should be used with care due to its high strength. Opaque.

PBk6 LAMP BLACK ASTM I (370)

PIGMENT DETAIL ON LABEL YES | ASTM I L'FAST

LAMP BLACK 035

DALER ROWNEY

ARTISTS' WATER COLOUR

Ranges in value from an intense deep black to a pale mid-grey in a wash.

Covers very well and washes evenly. Opaque.

PBk7 CARBON BLACK ASTM I (370)

PIGMENT DETAIL ON LABEL YES | ASTM I L'FAST

LAMP BLACK

DALER ROWNEY

GEORGIAN WATER COLOUR 2ND RANGE

Why purchase the 'Artist Quality' version when this will be less expensive but as well produced and reliable. Opaque.

PBk7 CARBON BLACK ASTM I (370)

PIGMENT DETAIL ON LABEL NO | ASTM I L'FAST

LAMP BLACK 071

AMERICAN JOURNEY

PROFESSIONAL ARTISTS' WATER COLOR

A quality product giving a wide range of values from easily applied washes.

Absolutely lightfast.

PBk6 LAMP BLACK ASTM I (370)

PIGMENT DETAIL ON LABEL YES | ASTM I L'FAST

LAMP BLACK W59

ART SPECTRUM

ARTISTS' WATER COLOUR

A series of easily laid washes are available from this well balanced and well made watercolour paint.

PBk6 LAMP BLACK ASTM I (370)

PIGMENT DETAIL ON LABEL YES | ASTM I L'FAST

LAMP BLACK 702

TALENS

REMBRANDT ARTISTS' QUALITY EXTRA FINE

A particularly dense black at full strength.

Washes out well over an extensive range of values. Excellent. Opaque.

PBk6 LAMP BLACK ASTM I (370)
PBk9 IVORY BLACK ASTM I (371)

PIGMENT DETAIL ON LABEL YES | ASTM I L'FAST

LAMP BLACK 112

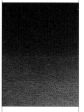

M.GRAHAM & CO.

ARTISTS' WATERCOLOR

Sample washed out beautifully from soft, velvety deep blacks to pale greys.

A very well made and reliable product.

PBk6 LAMP BLACK ASTM I (370)

PIGMENT DETAIL ON LABEL YES | ASTM I L'FAST

LAMP BLACK 127

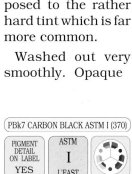

PÈBÈO

FRAGONARD ARTISTS' WATER COLOUR

Has a soft, warm undercolour as apposed to the rather hard tint which is far more common.

Washed out very smoothly. Opaque

PBk7 CARBON BLACK ASTM I (370)

PIGMENT DETAIL ON LABEL YES | ASTM I L'FAST

LAMP BLACK 251

DA VINCI PAINTS

PERMANENT ARTISTS' WATER COLOR

Lamp Black is very high in tinting strength and will quickly influence other colours in a mix.

Covers well but gives reasonably clear washes.

PBk6 LAMP BLACK ASTM I (370)

PIGMENT DETAIL ON LABEL YES | ASTM I L'FAST

LAMP BLACK 753

SENNELIER

EXTRA-FINE
WATERCOLOUR

The pigment previously used was Carbon Black rather than Lamp Black. Now reformulated. Brushed out well. Absolutely lightfast. Opaque.

PBk6 LAMP BLACK ASTM I (370)
PY42 MARS YELLOW ASTM I (43)

PIGMENT DETAIL ON LABEL	ASTM	
YES	I L'FAST	

LAMP BLACK 651

DA VINCI PAINTS

SCUOLA
2ND RANGE

A little on the gum laden side making medium to heavy applications less that satisfactory.

PBk6 LAMP BLACK ASTM I (370)

PIGMENT DETAIL ON LABEL	ASTM	RATING
YES	I L'FAST	★ ★

LAMP BLACK 781

SCHMINCKE

HORADAM
FINEST
ARTISTS'
WATER COLOURS

Reformulated several years ago from a rather complicated mix containing the unreliable PBk1 to this example of an absolutely lightfast, smooth dense black. Opaque.

PBk6 LAMP BLACK ASTM I (370)

PIGMENT DETAIL ON LABEL	ASTM	
YES	I L'FAST	

Miscellaneous Blacks

As you will see, these are either very simple mixes or standard blacks sold under another name.

Be careful that you do not purchase the same colour twice. With a little imagination a basic black such as Ivory Black could be given another five or six names and all be sold to the unwary. Perhaps it might also be called Bone Black again, or is that going too far?

BLACK NO 028

PENTEL (POLY TUBE)

WATER
COLORS

I am afraid that I cannot offer any more than a colour guide as I have no idea of the pigment/s used..

PIGMENT INFORMATION NOT GIVEN ON THE PRODUCT LABEL OR IN THE LITERATURE PROVIDED

PIGMENT DETAIL ON LABEL	ASTM	RATING
NO	L'FAST	

BLACK NO 028

PENTEL

WATER
COLORS

Please see my remarks with the colour to the left, as they apply equally here.

PIGMENT INFORMATION NOT GIVEN ON THE PRODUCT LABEL OR IN THE LITERATURE PROVIDED

PIGMENT DETAIL ON LABEL	ASTM	RATING
NO	L'FAST	

BLUE BLACK
034

WINSOR & NEWTON

ARTISTS'
WATER COLOUR

I could not detect any real difference between this 'Lamp Black' and the actual Lamp Black offered by the company.

The latter maintain that this is 'bluish' compared to the 'brownish' Lamp Black.

PBk6 LAMP BLACK ASTM I (370)

PIGMENT DETAIL ON LABEL	ASTM	
YES	I L'FAST	

BLACK 612

MAIMERI

STUDIO
FINE WATER
COLOR 2ND
RANGE

A simple name for a simple mix of two standard blacks. Soft, slightly warm undercolour. Handled well. Opaque.

Discontinued

PBk7 CARBON BLACK ASTM I (370)
PBk9 IVORY BLACK ASTM I (371)

PIGMENT DETAIL ON LABEL	ASTM	
NO	I L'FAST	

BLUE BLACK 449

OLD HOLLAND

CLASSIC
WATERCOLOURS

A simple mix giving a blackish green blue. Handled well.

Easily mixed using either Prussian or Phthalocyanine Blue and almost any black. Semi-opaque

Discontinued

PBk9 IVORY BLACK ASTM I (371)
PB27 PRUSSIAN BLUE ASTM I (214)

PIGMENT DETAIL ON LABEL	ASTM	
CHEMICAL MAKE UP ONLY	I L'FAST	

St. PETERSBURG

ARTISTS'
WATERCOLOURS

BLACK NEUTRAL 502

More a range of greys than a dense black moving to pale grey.

I cannot give assessments as I do not have any indication as to the pigment/s used.

PIGMENT INFORMATION NOT DISCLOSED

PIGMENT DETAIL ON LABEL	ASTM	RATING
NO	L'FAST	

CARBON BLACK 537

MAIMERI

MAIMERIBLU SUPERIOR WATERCOLOURS

Washed out reasonably well over the usual wide range of values.

A black pigment which will never fade.

PBk7 CARBON BLACK ASTM I (370)

PIGMENT DETAIL ON LABEL	ASTM	RATING
YES	I L'FAST	★★

CARBON BLACK 11H

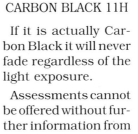

DR.Ph. MARTINS

HYDRUS FINE ART WATERCOLOR

If it is actually Carbon Black it will never fade regardless of the light exposure.

Assessments cannot be offered without further information from the manufacturer.

PIGMENT INFORMATION NOT GIVEN ON THE PRODUCT LABEL OR IN THE LITERATURE PROVIDED

PIGMENT DETAIL ON LABEL	ASTM	RATING
NO	L'FAST	

LUNAR BLACK 049

DANIEL SMITH

EXTRA-FINE WATERCOLORS

Granulated readily when applied as a dilute wash.

Well produced and washed out with ease.

PBk11 MARS BLACK ASTM I (371)

PIGMENT DETAIL ON LABEL	ASTM	
YES	I L'FAST	

MARS BLACK 370

OLD HOLLAND

CLASSIC WATERCOLOURS

I am afraid that I cannot show a colour guide or offer assessments as a sample was not provided.

The stated pigment is absolutely lightfast.

PBk11 MARS BLACK ASTM I (371)

PIGMENT DETAIL ON LABEL	ASTM	RATING
CHEMICAL MAKE UP ONLY	L'FAST	

PEACH BLACK W337

HOLBEIN

ARTISTS' WATER COLOR

PBk1 is less than reliable and can have added little to the final colour. Washed out well. It seems a rather pointless way to lower the lightfast rating. In practice the colour will not change.

PBk1 ANILINE BLACK WG III (370)
PBk6 LAMP BLACK ASTM I (370)

PIGMENT DETAIL ON LABEL	WG	RATING
YES	III L'FAST	★★

PEACH BLACK 757

SENNELIER

EXTRA-FINE WATERCOLOUR

The name was originally used for a black produced from charred peach stones. In this case it is a simple mix. Used to contain the unreliable PBk1.

Now produced using lightfast pigments.

PBk7 CARBON BLACK ASTM I (370)
PB29 ULTRAMARINE BLUE ASTM I (215)

PIGMENT DETAIL ON LABEL	ASTM	
YES	I L'FAST	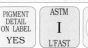

PEACH BLACK 272

LEFRANC & BOURGEOIS

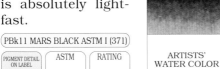

LINEL EXTRA-FINE ARTISTS' WATERCOLOUR

The company already market this pigment under its correct name, Ivory Black. I could detect no difference between the two. Do not purchase the same paint twice unless that's how you get your kicks.

Reformulated >

PBk9 IVORY BLACK ASTM I (371)

PIGMENT DETAIL ON LABEL	ASTM	
CHEMICAL MAKE UP ONLY	I L'FAST	

PEACH BLACK 272

LEFRANC & BOURGEOIS

LINEL EXTRA-FINE ARTISTS' WATERCOLOUR

Although PW4 Zinc White is given as one of the pigments, I could not detect its presence in the sample wash out.

For practical purposes treat as a straightforward black.

PBk9 IVORY BLACK ASTM I (371)
PW4 ZINC WHITE ASTM I (384)

PIGMENT DETAIL ON LABEL	ASTM	
CHEMICAL MAKE UP ONLY	I L'FAST	

SCHEVENINGEN INTENS BLACK

OLD HOLLAND

CLASSIC WATERCOLOURS

I am afraid that I cannot show a colour guide or offer assessments as a sample was not provided.

PBk7 CARBON BLACK ASTM I (370)

PIGMENT DETAIL ON LABEL	ASTM	RATING
CHEMICAL MAKE UP ONLY	L'FAST	

VINE BLACK 367

OLD HOLLAND

CLASSIC WATERCOLOURS

Sample not supplied. I did not 'chase up' companies who did not supply a complete set of samples as it was a long drawn out and confusing operation to get as far as we did with many of them.

PBk8 CHARCOAL BLACK WG I (371)

PIGMENT DETAIL ON LABEL	ASTM	RATING
CHEMICAL MAKE UP ONLY	L'FAST	

VINE BLACK 784

SCHMINCKE

HORADAM FINEST ARTISTS' WATER COLOURS

The inclusion of PB66, a fugitive substance, once lowered the overall rating. This has now been removed. An absolutely lightfast, soft velvety black. Opaque.

Discontinued

PBk6 LAMP BLACK ASTM I (370)
PBk9 IVORY BLACK ASTM I (371)

PIGMENT DETAIL ON LABEL	ASTM	
YES	I L'FAST	

ANTIQUE BLACK 023

HOLBEIN

IRODORI ANTIQUE WATERCOLOR

Very dense, velvety blacks from a pigment first used by the cave painter.

It has not let them down and it will not do so for you. A well made product.

PBk6 LAMP BLACK ASTM I (370)

PIGMENT DETAIL ON LABEL	ASTM	
YES	I L'FAST	

Very dark greys, approaching black can be mixed with ease. Such darks do not have the deadening effect of black pigment.
Reproduced from our Home Study Course ' Practical Colour Mixing'

Introducing further colours

Exercise 26 Burnt Sienna and violet-blue

Think of transparent paints in the same way as coloured glass.

One layer of, say blue glass, placed on a white piece of paper will appear as a bright blue. This is because the light sinks into the glass and is reflected back by the white background.

Add another piece of blue glass and the colour deepens as less light is able to return to the surface. As subsequent pieces are added the colour become even darker.

Transparent paint behaves in much the same way. A thin wash on a white background acts as did the single piece of glass.

As the paint layer becomes thicker it darkens for the same reason that the stack of coloured glass darkens.

This loss of light can be used in mixing.

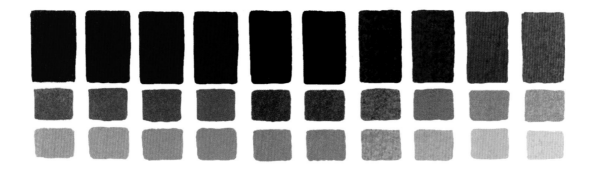

Place the Burnt Sienna in the outer well to the red side of the orange mixing well. This is appropriate as it is a 'neutralised, (slightly red) orange' as far as 'colour type' is concerned. Burnt Sienna has long been valued for its transparency, revealing its true beauty only in thin applications.

Being transparent it will give darks approaching black when mixed with the equally transparent Ultramarine Blue (violet-blue).

The colour becomes very dark when applied at all heavily because any light left over after the two complementaries (blue and orange) have cancelled each other out sinks into the transparent paint layer.

Such soft velvety darks are the ideal replacement for black, which can have a deadening effect in a piece of work.

Whites

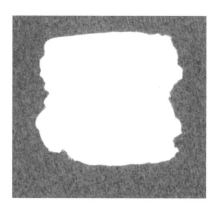

A brief history of white pigments

Oyster shells, burnt and crushed into a fine powder provided a white of great importance to early Japanese painting.

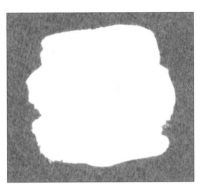

A particularly dense type of Zinc White is employed in the manufacture of Chinese White. It is absolutely lightfast.

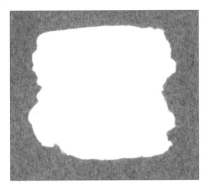

Titanium White, the whitest of the whites, makes a particularly useful watercolour.

The advancement of the technique of oil painting owes its success largely to the use of Lead White.

The fine brushing quality, opacity and warmth have made it popular with artists for many hundreds of years.

This fine pigment is unfortunately not suitable for use in watercolours as it darkens when exposed to the Hydrogen Sulphide of the atmosphere. (Amazingly this has not prevented its use by at least one watercolour manufacturer in very recent times)

Various substances have been used in water based colours to give a white. Calcined chicken bones have been employed to make an inferior white colorant which brushed out poorly.

Burnt and ground egg shells gave another poor pigment.

Chalk has been used since the cave painter, either in lump form, or ground for use as a coarse paint.

Oyster shells, burnt and powdered, provided a white which was widely used throughout Japan and China. It became one of the standard pigments. Oyster Shell White was also used to some extent in Medieval England.

Zinc White was suggested in 1746 as a possible alternative to Lead White in oil paints. It was non toxic and unaffected by sulphur fumes. Produced first as a watercolour, it is still widely available, usually under the name Chinese White.

Titanium White, used more extensively in other mediums, makes a perfectly reliable watercolour white.

The watercolourist is well served with the range of whites available today.

PW1	FLAKE WHITE	384
PW4	ZINC WHITE	384
PW5	LITHOPONE	384
PW6	TITANIUM WHITE	385
PW7	ZINC SULPHIDE	385
PW18	CHALK	385
PW20	MICA	386
PW21	BLANC FIXE	386
PW22	BARYTE	386
PW27	SILICA	383

TITANATED MICA, PERGLAZ, NECREOUS AND COATED MICA 383

TITANATED MICA, PERGLAZ, NECREOUS AND COATED MICA

Such descriptions are starting to appear on watercolour labels and in the associated literature. They are amongst the various attempts to describe 'interference' pigments. The colour is due to interference between light reflected from the surface and from the interior of the microscopically thin particles. Like an oil slick or beetles' back, the colour depends on the thickness of the particle layers and the incident and viewing angles.

Most are very lightfast since there is no 'coloured' pigment to fade. They are often produced by coating Mica with a very precise layer of Titanium Dioxide. The iron oxides may also be used. Some have a metallic appearance, some an iridescent appearance. Lightfastness only enters the picture if a manufacturer mixes the particles in a coloured paint.

There are new versions of interference colours which make astounding changes in appearance when seen from different angles. These are beginning to appear on automobiles, which can look red at one angle and black at another.

Although I have not examined the recently added interference watercolours for this book, all of the metallic silvers and golds that I have tested have been very difficult to apply, mainly due to their consistency.

PW27 SILICA

Widely used as an extender in a variety of paints, and as a base for lake colours where transparency is required. If used simply as a filler, it can tend to 'cloud' colours, reducing their transparency.

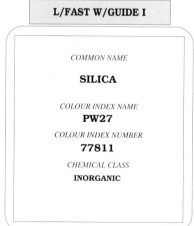

L/FAST W/GUIDE I

COMMON NAME

SILICA

COLOUR INDEX NAME
PW27

COLOUR INDEX NUMBER
77811

CHEMICAL CLASS
INORGANIC

PW1 FLAKE WHITE

Produced corroding lead in various ways. Flake White or White Lead is one of the earliest manufactured pigments on record. Very opaque and brushes out well. It has been known for centuries that it cannot successfully be used as a watercolour. The Hydrogen Sulphide of the atmosphere will react with the pigment and darken it to a marked extent. I am absolutely amazed that it should actually have recently been used in a watercolour. Fortunately the colour has now been discontinued but there will be many an artist still using it.

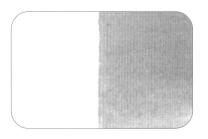

Sample darkened within a short time. It will spoil any colour that has been mixed with it. Probably the most unsuitable pigment for use in watercolour.

Also called White Lead.

L/FAST W/GUIDE V

COMMON NAME

FLAKE WHITE

COLOUR INDEX NAME

PW1

COLOUR INDEX NUMBER

77597

CHEMICAL CLASS

BASIC LEAD CARBONATE (SS)

PW4 ZINC WHITE

Zinc White was first produced on a commercial scale in the 1830's. A major advantage of the pigment was that it did not darken on exposure to the atmosphere, as did Flake White. It soon became the most important white watercolour. A very cold, pure white with good reducing power, (it will lighten other colours economically). The prepared watercolour pigment is a specially produced, very dense type of zinc oxide with greater covering power than the oils version.

Rated ASTM I as a watercolour and on the list of recommended pigments. Thoroughly reliable.

Also called Chinese White.

L/FAST ASTM I

COMMON NAME

ZINC WHITE

COLOUR INDEX NAME

PW4

COLOUR INDEX NUMBER

77949

CHEMICAL CLASS

ZINC OXIDE

PW5 LITHOPONE

A semi-opaque to opaque white, widely used as an extender or filler.

Although it possesses excellent lightfastness, its use can damage the clarity of an otherwise transparent paint.

L/FAST W/GUIDE I

COMMON NAME

LITHOPONE

COLOUR INDEX NAME

PW5

COLOUR INDEX NUMBER

77115

CHEMICAL CLASS

INORGANIC: MIXED PRECIPITATE PW7, ZINC SULPHIDE, PW22 AND BARYTES

PW6 TITANIUM WHITE

The whitest of the whites. Absolutely inert and unaffected by other pigments, light, weak acids or alkalis. Earlier problems of yellowing and chalking were overcome and commercial production had started by 1920. Since then it has become a popular addition to the palette, although not as widely available as Zinc or Chinese White. This brilliant white is strong and possesses great covering power. Titanium White makes a very satisfactory watercolour pigment.

Titanium White possesses excellent lightfastness. Rated ASTM I as a watercolour and is on the list of approved pigments. A first class pigment.

PW7 ZINC SULPHIDE

Semi-opaque, with excellent lightfastness. This pigment reflects in the ultraviolet, making it appear luminous. It is seldom found in watercolours.

PW18 CHALK

Varies in colour from a reasonably clean white to a pale grey. Opaque and with excellent lightfastness, it is widely used as an extender in a variety of paints. Over use can reduce the transparency of the parent pigment to which it is added.

PW20 MICA

Mica varies from white to a pale grey. It becomes opaque in water but is otherwise transparent, a little like the drink Ouzo. In use as a synthetic extender in paints, its unique platelets give a flexibility which enables paint films to withstand weathering.

This, of course, is not normally a factor in watercolour paints. In this area it is mainly used in the preparation of 'interference' colours.

Has not been tested in any art material and will not need to be as it is known to be absolutely lightfast.

COMMON NAME

MICA

COLOUR INDEX NAME

PW20

COLOUR INDEX NUMBER

77019

CHEMICAL CLASS

**INORGANIC.
EXTENDER PIGMENT**

PW21 BLANC FIXE

A bright white which is inert to acids, alkalies, light and heat. Blanc Fixe is a synthetic extender usually used as a filler to reduce the cost of a paint or to improve its handling qualities.

Not subjected to ASTM testing as a watercolour and will not need to be, as it is undoubtedly lightfast. Rated W/Guide I.

COMMON NAME

BLANC FIXE

COLOUR INDEX NAME

PW21

COLOUR INDEX NUMBER

77120

CHEMICAL CLASS

**INORGANIC.
PRECIPITATED BARIUM SULFATE**

PW22 BARYTE

A heavy white to greyish white powder obtained from the mineral Baryte. Particularly inert, it is unaffected by light or chemicals.

Used extensively as a filler for cheaper paints or as a base for certain 'lake' colours. Rarely used alone as a pigment. Opaque and absolutely lightfast.

COMMON NAME

BARYTE

COLOUR INDEX NAME

PW22

COLOUR INDEX NUMBER

77120

CHEMICAL CLASS

INORGANIC

White watercolours

Chinese White ... 388

Titanium White .. 390

Miscellaneous Whites .. 391

Chinese White

The vapour given off from molten metallic zinc is burnt in a draft of air, The resultant smoke is collected into chambers and compressed into powder whilst still hot.

Chinese White is a specially produced, very dense type of Zinc Oxide with greater covering power than the Zinc White of the oil painter.

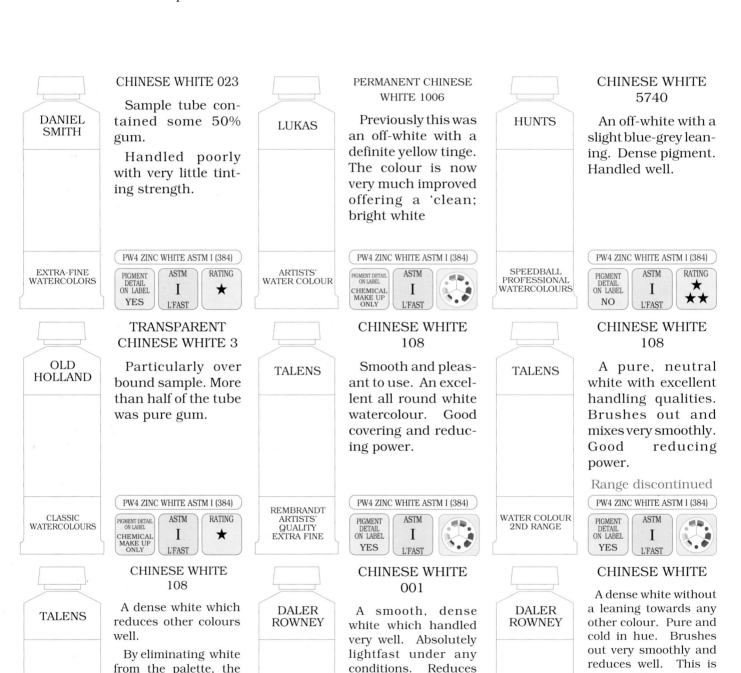

DANIEL SMITH

EXTRA-FINE WATERCOLORS

CHINESE WHITE 023

Sample tube contained some 50% gum.

Handled poorly with very little tinting strength.

PW4 ZINC WHITE ASTM I (384)

| PIGMENT DETAIL ON LABEL YES | ASTM I L'FAST | RATING ★ |

LUKAS

ARTISTS' WATER COLOUR

PERMANENT CHINESE WHITE 1006

Previously this was an off-white with a definite yellow tinge. The colour is now very much improved offering a 'clean; bright white

PW4 ZINC WHITE ASTM I (384)

| PIGMENT DETAIL ON LABEL CHEMICAL MAKE UP ONLY | ASTM I L'FAST | |

HUNTS

SPEEDBALL PROFESSIONAL WATERCOLOURS

CHINESE WHITE 5740

An off-white with a slight blue-grey leaning. Dense pigment. Handled well.

PW4 ZINC WHITE ASTM I (384)

| PIGMENT DETAIL ON LABEL NO | ASTM I L'FAST | RATING ★ ★★ |

OLD HOLLAND

CLASSIC WATERCOLOURS

TRANSPARENT CHINESE WHITE 3

Particularly over bound sample. More than half of the tube was pure gum.

PW4 ZINC WHITE ASTM I (384)

| PIGMENT DETAIL ON LABEL CHEMICAL MAKE UP ONLY | ASTM I L'FAST | RATING ★ |

TALENS

REMBRANDT ARTISTS' QUALITY EXTRA FINE

CHINESE WHITE 108

Smooth and pleasant to use. An excellent all round white watercolour. Good covering and reducing power.

PW4 ZINC WHITE ASTM I (384)

| PIGMENT DETAIL ON LABEL YES | ASTM I L'FAST | |

TALENS

WATER COLOUR 2ND RANGE

CHINESE WHITE 108

A pure, neutral white with excellent handling qualities. Brushes out and mixes very smoothly. Good reducing power.

Range discontinued

PW4 ZINC WHITE ASTM I (384)

| PIGMENT DETAIL ON LABEL YES | ASTM I L'FAST | |

TALENS

VAN GOGH 2ND RANGE

CHINESE WHITE 108

A dense white which reduces other colours well.

By eliminating white from the palette, the watercolour purist also eliminates a vast range of possible tint

PW4 ZINC WHITE ASTM I (384)

| PIGMENT DETAIL ON LABEL YES | ASTM I L'FAST | |

DALER ROWNEY

ARTISTS' WATER COLOUR

CHINESE WHITE 001

A smooth, dense white which handled very well. Absolutely lightfast under any conditions. Reduces other colours very well. This should really be described as a 'Hue'.

PW4 ZINC WHITE ASTM I (384)
PW6 TITANIUM WHITE ASTM I (385)

| PIGMENT DETAIL ON LABEL yes | ASTM I L'FAST | |

DALER ROWNEY

GEORGIAN WATER COLOUR 2ND RANGE

CHINESE WHITE

A dense white without a leaning towards any other colour. Pure and cold in hue. Brushes out very smoothly and reduces well. This is not pure 'Chinese White' but a mix with Titanium White.

PW4 ZINC WHITE ASTM I (384)
PW6 TITANIUM WHITE ASTM I (385)

| PIGMENT DETAIL ON LABEL NO | ASTM I L'FAST | |

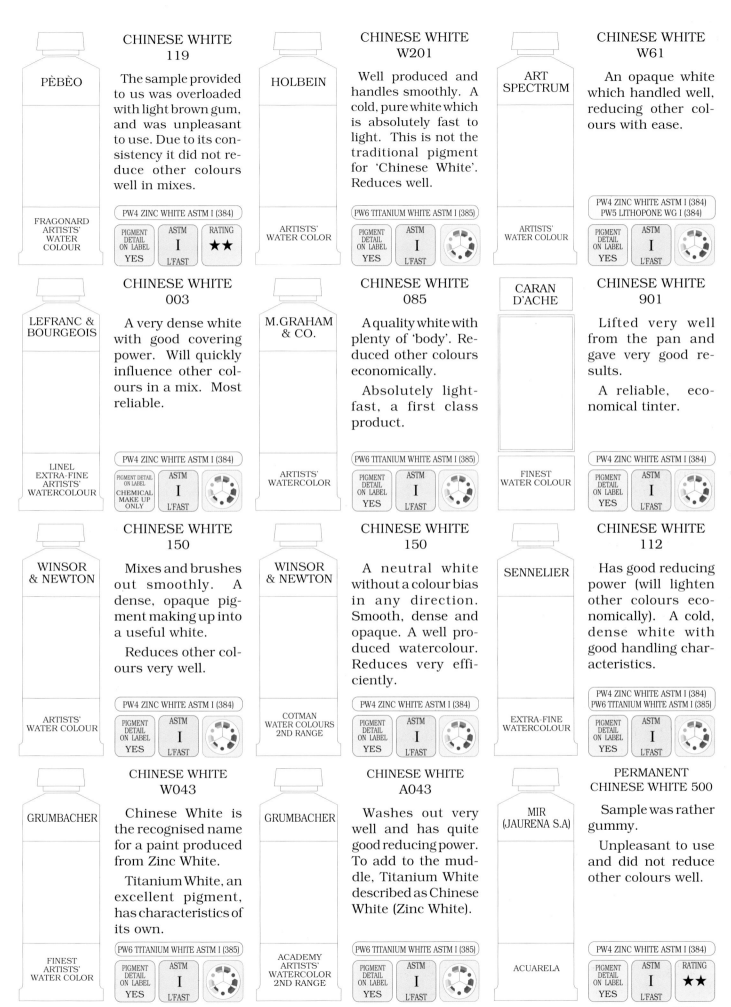

CHINESE WHITE 119

PÈBÈO

The sample provided to us was overloaded with light brown gum, and was unpleasant to use. Due to its consistency it did not reduce other colours well in mixes.

FRAGONARD ARTISTS' WATER COLOUR

PW4 ZINC WHITE ASTM I (384)

PIGMENT DETAIL ON LABEL	ASTM	RATING
YES	I L'FAST	★★

CHINESE WHITE W201

HOLBEIN

Well produced and handles smoothly. A cold, pure white which is absolutely fast to light. This is not the traditional pigment for 'Chinese White'. Reduces well.

ARTISTS' WATER COLOR

PW6 TITANIUM WHITE ASTM I (385)

PIGMENT DETAIL ON LABEL	ASTM	
YES	I L'FAST	

CHINESE WHITE W61

ART SPECTRUM

An opaque white which handled well, reducing other colours with ease.

ARTISTS' WATER COLOUR

PW4 ZINC WHITE ASTM I (384)
PW5 LITHOPONE WG I (384)

PIGMENT DETAIL ON LABEL	ASTM	
YES	I L'FAST	

CHINESE WHITE 003

LEFRANC & BOURGEOIS

A very dense white with good covering power. Will quickly influence other colours in a mix. Most reliable.

LINEL EXTRA-FINE ARTISTS' WATERCOLOUR

PW4 ZINC WHITE ASTM I (384)

PIGMENT DETAIL ON LABEL	ASTM	
CHEMICAL MAKE UP ONLY	I L'FAST	

CHINESE WHITE 085

M.GRAHAM & CO.

A quality white with plenty of 'body'. Reduced other colours economically.

Absolutely light-fast, a first class product.

ARTISTS' WATERCOLOR

PW6 TITANIUM WHITE ASTM I (385)

PIGMENT DETAIL ON LABEL	ASTM	
YES	I L'FAST	

CHINESE WHITE 901

CARAN D'ACHE

Lifted very well from the pan and gave very good results.

A reliable, economical tinter.

FINEST WATER COLOUR

PW4 ZINC WHITE ASTM I (384)

PIGMENT DETAIL ON LABEL	ASTM	
YES	I L'FAST	

CHINESE WHITE 150

WINSOR & NEWTON

Mixes and brushes out smoothly. A dense, opaque pigment making up into a useful white.

Reduces other colours very well.

ARTISTS' WATER COLOUR

PW4 ZINC WHITE ASTM I (384)

PIGMENT DETAIL ON LABEL	ASTM	
YES	I L'FAST	

CHINESE WHITE 150

WINSOR & NEWTON

A neutral white without a colour bias in any direction. Smooth, dense and opaque. A well produced watercolour. Reduces very efficiently.

COTMAN WATER COLOURS 2ND RANGE

PW4 ZINC WHITE ASTM I (384)

PIGMENT DETAIL ON LABEL	ASTM	
YES	I L'FAST	

CHINESE WHITE 112

SENNELIER

Has good reducing power (will lighten other colours economically). A cold, dense white with good handling characteristics.

EXTRA-FINE WATERCOLOUR

PW4 ZINC WHITE ASTM I (384)
PW6 TITANIUM WHITE ASTM I (385)

PIGMENT DETAIL ON LABEL	ASTM	
YES	I L'FAST	

CHINESE WHITE W043

GRUMBACHER

Chinese White is the recognised name for a paint produced from Zinc White.

Titanium White, an excellent pigment, has characteristics of its own.

FINEST ARTISTS' WATER COLOR

PW6 TITANIUM WHITE ASTM I (385)

PIGMENT DETAIL ON LABEL	ASTM	
YES	I L'FAST	

CHINESE WHITE A043

GRUMBACHER

Washes out very well and has quite good reducing power. To add to the muddle, Titanium White described as Chinese White (Zinc White).

ACADEMY ARTISTS' WATERCOLOR 2ND RANGE

PW6 TITANIUM WHITE ASTM I (385)

PIGMENT DETAIL ON LABEL	ASTM	
YES	I L'FAST	

PERMANENT CHINESE WHITE 500

MIR (JAURENA S.A)

Sample was rather gummy.

Unpleasant to use and did not reduce other colours well.

ACUARELA

PW4 ZINC WHITE ASTM I (384)

PIGMENT DETAIL ON LABEL	ASTM	RATING
YES	I L'FAST	★★

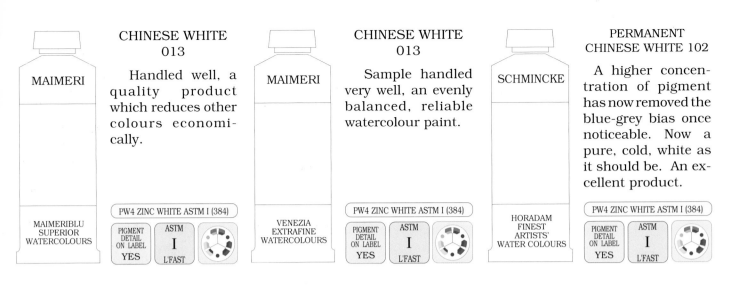

MAIMERI — MAIMERIBLU SUPERIOR WATERCOLOURS

CHINESE WHITE 013

Handled well, a quality product which reduces other colours economically.

PW4 ZINC WHITE ASTM I (384) | PIGMENT DETAIL ON LABEL YES | ASTM I L'FAST

MAIMERI — VENEZIA EXTRAFINE WATERCOLOURS

CHINESE WHITE 013

Sample handled very well, an evenly balanced, reliable watercolour paint.

PW4 ZINC WHITE ASTM I (384) | PIGMENT DETAIL ON LABEL YES | ASTM I L'FAST

SCHMINCKE — HORADAM FINEST ARTISTS' WATER COLOURS

PERMANENT CHINESE WHITE 102

A higher concentration of pigment has now removed the blue-grey bias once noticeable. Now a pure, cold, white as it should be. An excellent product.

PW4 ZINC WHITE ASTM I (384) | PIGMENT DETAIL ON LABEL YES | ASTM I L'FAST

Titanium White

The whitest of the whites, Titanium White is only now finding popularity as a watercolour.

It is strong and covers well. The choice between Chinese White (Zinc White) and Titanium White is very much an individual matter as they are both excellent whites.

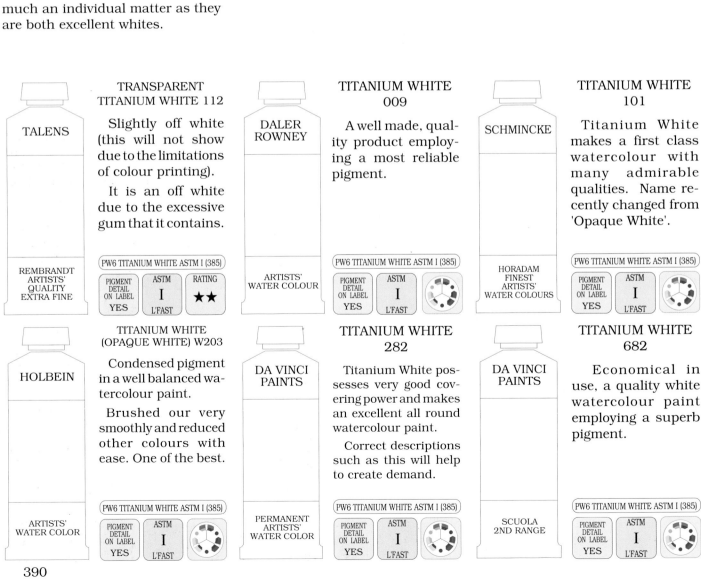

TALENS — REMBRANDT ARTISTS' QUALITY EXTRA FINE

TRANSPARENT TITANIUM WHITE 112

Slightly off white (this will not show due to the limitations of colour printing).

It is an off white due to the excessive gum that it contains.

PW6 TITANIUM WHITE ASTM I (385) | PIGMENT DETAIL ON LABEL YES | ASTM I L'FAST | RATING ★★

DALER ROWNEY — ARTISTS' WATER COLOUR

TITANIUM WHITE 009

A well made, quality product employing a most reliable pigment.

PW6 TITANIUM WHITE ASTM I (385) | PIGMENT DETAIL ON LABEL YES | ASTM I L'FAST

SCHMINCKE — HORADAM FINEST ARTISTS' WATER COLOURS

TITANIUM WHITE 101

Titanium White makes a first class watercolour with many admirable qualities. Name recently changed from 'Opaque White'.

PW6 TITANIUM WHITE ASTM I (385) | PIGMENT DETAIL ON LABEL YES | ASTM I L'FAST

HOLBEIN — ARTISTS' WATER COLOR

TITANIUM WHITE (OPAQUE WHITE) W203

Condensed pigment in a well balanced watercolour paint.

Brushed our very smoothly and reduced other colours with ease. One of the best.

PW6 TITANIUM WHITE ASTM I (385) | PIGMENT DETAIL ON LABEL YES | ASTM I L'FAST

DA VINCI PAINTS — PERMANENT ARTISTS' WATER COLOR

TITANIUM WHITE 282

Titanium White possesses very good covering power and makes an excellent all round watercolour paint.

Correct descriptions such as this will help to create demand.

PW6 TITANIUM WHITE ASTM I (385) | PIGMENT DETAIL ON LABEL YES | ASTM I L'FAST

DA VINCI PAINTS — SCUOLA 2ND RANGE

TITANIUM WHITE 682

Economical in use, a quality white watercolour paint employing a superb pigment.

PW6 TITANIUM WHITE ASTM I (385) | PIGMENT DETAIL ON LABEL YES | ASTM I L'FAST

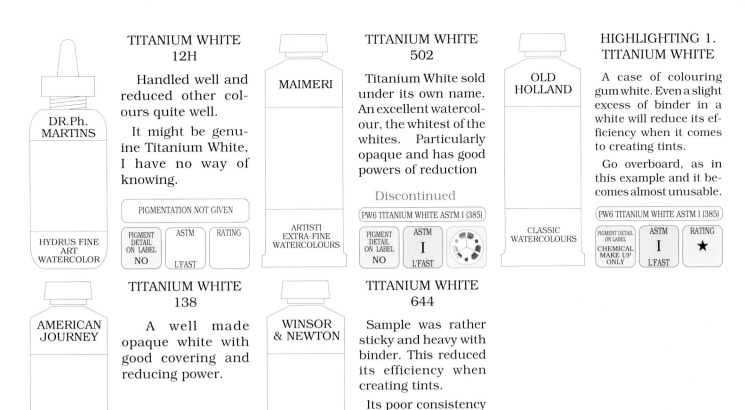

TITANIUM WHITE 12H

DR.Ph. MARTINS

HYDRUS FINE ART WATERCOLOR

Handled well and reduced other colours quite well.

It might be genuine Titanium White, I have no way of knowing.

PIGMENTATION NOT GIVEN		
PIGMENT DETAIL ON LABEL NO	ASTM L'FAST	RATING

TITANIUM WHITE 502

MAIMERI

ARTISTI EXTRA-FINE WATERCOLOURS

Titanium White sold under its own name. An excellent watercolour, the whitest of the whites. Particularly opaque and has good powers of reduction

Discontinued

PW6 TITANIUM WHITE ASTM I (385)		
PIGMENT DETAIL ON LABEL NO	ASTM I L'FAST	

HIGHLIGHTING 1. TITANIUM WHITE

OLD HOLLAND

CLASSIC WATERCOLOURS

A case of colouring gum white. Even a slight excess of binder in a white will reduce its efficiency when it comes to creating tints.

Go overboard, as in this example and it becomes almost unusable.

PW6 TITANIUM WHITE ASTM I (385)		
PIGMENT DETAIL ON LABEL CHEMICAL MAKE UP ONLY	ASTM I L'FAST	RATING ★

TITANIUM WHITE 138

AMERICAN JOURNEY

PROFESSIONAL ARTISTS' WATER COLOR

A well made opaque white with good covering and reducing power.

PW6 TITANIUM WHITE ASTM I (385)		
PIGMENT DETAIL ON LABEL YES	ASTM I L'FAST	

TITANIUM WHITE 644

WINSOR & NEWTON

ARTISTS' WATER COLOUR

Sample was rather sticky and heavy with binder. This reduced its efficiency when creating tints.

Its poor consistency was passed to other colours when mixed.

PW6 TITANIUM WHITE ASTM I (385)		
PIGMENT DETAIL ON LABEL YES	ASTM I L'FAST	RATING ★★

Miscellaneous Whites

The most unexpected of these is Flake White produced from genuine Flake or Lead White (now happily discontinued). Confirmation on its earlier use was sought and given. It has been common knowledge for centuries that it is most unsuitable for use as a watercolour. To offer a pigment which will darken when exposed to the atmosphere and is also poisonous to the unwary, is nothing short of reckless, in fact it is outrageous.

If you have the substance may I suggest that you either dispose of it safely or return it to the retailer and ask for a full refund. Whatever you do please do not use it in an airbrush without wearing a mask and do not lick your brush into shape. It should also be kept off the skin.

In the last edition of this book I said that if Titanium White were described as such we would all benefit. A little of the confusion would be cleared up, artists would come to recognise its qualities and demand it for sound reasons. This demand has now commenced and many more manufacturers are using this excellent pigment, and using its name correctly, than I recorded in the last edition.

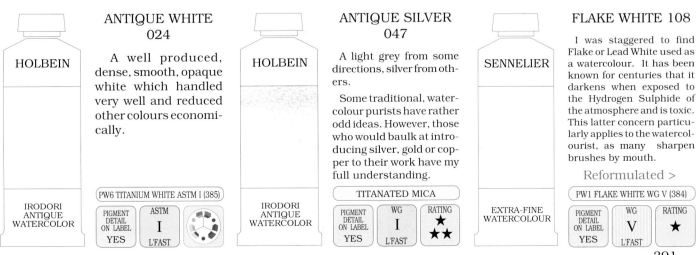

ANTIQUE WHITE 024

HOLBEIN

IRODORI ANTIQUE WATERCOLOR

A well produced, dense, smooth, opaque white which handled very well and reduced other colours economically.

PW6 TITANIUM WHITE ASTM I (385)		
PIGMENT DETAIL ON LABEL YES	ASTM I L'FAST	

ANTIQUE SILVER 047

HOLBEIN

IRODORI ANTIQUE WATERCOLOR

A light grey from some directions, silver from others.

Some traditional, watercolour purists have rather odd ideas. However, those who would baulk at introducing silver, gold or copper to their work have my full understanding.

TITANATED MICA		
PIGMENT DETAIL ON LABEL YES	WG I L'FAST	RATING ★★

FLAKE WHITE 108

SENNELIER

EXTRA-FINE WATERCOLOUR

I was staggered to find Flake or Lead White used as a watercolour. It has been known for centuries that it darkens when exposed to the Hydrogen Sulphide of the atmosphere and is toxic. This latter concern particularly applies to the watercolourist, as many sharpen brushes by mouth.

Reformulated >

PW1 FLAKE WHITE WG V (384)		
PIGMENT DETAIL ON LABEL YES	WG V L'FAST	RATING ★

FLAKE WHITE (IMIT) 002

LEFRANC & BOURGEOIS

PW5 is usually considered to be more of a filler or extender than a white pigment. All samples provided, for all issues, have been particularly gum laden.

LINEL EXTRA-FINE ARTISTS' WATERCOLOUR

PW5 LITHOPONE WG I (384)

| PIGMENT DETAIL ON LABEL CHEMICAL MAKE UP ONLY | WG I L'FAST | RATING ★★ |

MIXED WHITE 5

OLD HOLLAND

A little too much binder has reduced the tinting power of this mixed white. It has insufficient 'body' to do its job well.

CLASSIC WATERCOLOURS

PW4 ZINC WHITE ASTM I (384)
PW6 TITANIUM WHITE ASTM I (385)

| PIGMENT DETAIL ON LABEL CHEMICAL MAKE UP ONLY | ASTM I L'FAST | RATING ★ ★★ |

OPAQUE WHITE 1007

LUKAS

A brilliant white which handled well. Possesses good covering power, even a medium wash will hide other colours well. Absolutely lightfast.

ARTISTS' WATER COLOUR

PW5 LITHOPONE WG I (384)
PW6 TITANIUM WHITE ASTM I (385)

| PIGMENT DETAIL ON LABEL CHEMICAL MAKE UP ONLY | ASTM I L'FAST | |

OPAQUE WHITE 4

OLD HOLLAND

Titanium White should ideally be sold under its own name. The consumer would then come to recognise it and create a demand for this excellent pigment.

CLASSIC WATERCOLOURS

PW6 TITANIUM WHITE ASTM I (385)

| PIGMENT DETAIL ON LABEL CHEMICAL MAKE UP ONLY | ASTM I L'FAST | |

UMTON BARVY

ARTISTIC WATER COLOR

OPAQUE WHITE 2010

A smooth, dense white which handled well and reduced other colours efficiently.

Lifted well from the pan.

PW6 TITANIUM WHITE ASTM I (385)
PW5 LITHOPONE WG I (384)

| PIGMENT DETAIL ON LABEL NO | ASTM I L'FAST | |

PERMANENT WHITE (TITANIUM WHITE) 115

UTRECHT

A useful white which handled well. It is good to see the more widespread use of PW6.

It is an excellent pigment bringing its own set of qualities.

PROFESSIONAL ARTISTS' WATER COLOR

PW6 TITANIUM WHITE ASTM I (385)

| PIGMENT DETAIL ON LABEL YES | ASTM I L'FAST | |

SILVER 1013

LUKAS

A pale off white from some viewing angles, a soft silver from others.

Handles fairly well, if a little streaky in thinner layers.

ARTISTS' WATER COLOUR

PERLGLAZ PIGMENTS NECREOUS PIGMENT

| PIGMENT DETAIL ON LABEL CHEMICAL MAKE UP ONLY | WG I L'FAST | RATING ★ ★★ |

SILVER W391

HOLBEIN

All of the 'Silvers' that I have examined behave in much the same way, appearing either light grey or silver depending on the viewing angle. They also paint out with some difficulty, can be mixed with other colours and are semi opaque. All are absolutely lightfast.

ARTISTS' WATER COLOR

PW20 WG I (386)

| PIGMENT DETAIL ON LABEL YES | WG I L'FAST | RATING ★ ★★ |

SILVER 894

SCHMINCKE

Some would say that the use of metallic paints is best left to the automobile industry or to the producers of Christmas cards.

I would not suggest this of course because I do not make such comments.

HORADAM FINEST ARTISTS' WATER COLOURS

COATED MICA TITANIUM DIOXIDE & ZINC OXIDE

| PIGMENT DETAIL ON LABEL YES | WG I L'FAST | RATING ★ ★★ |

TINTING ZINC WHITE 2

OLD HOLLAND

A well made white which handled well and quickly influenced other colours in a mix.

CLASSIC WATERCOLOURS

PW4 ZINC WHITE ASTM I (384)

| PIGMENT DETAIL ON LABEL CHEMICAL MAKE UP ONLY | ASTM I L'FAST | |

WHITE 602

MAIMERI

A bright, pure white.

Why be shy about the nature of the pigment Maimeri? Call it Titanium White and cut down a little on the confusion.

Discontinued

STUDIO FINE WATERCOLOURS

PW6 TITANIUM WHITE ASTM I (385)

| PIGMENT DETAIL ON LABEL NO | ASTM I L'FAST | |

WHITE

PENTEL

Contains an excess of gum, reducing its use in colour mixing.

WATER COLORS

INFORMATION NOT GIVEN ON THE PRODUCT OR IN THE LITERATURE SUPPLIED.

| PIGMENT DETAIL ON LABEL NO | ASTM L'FAST | RATING |

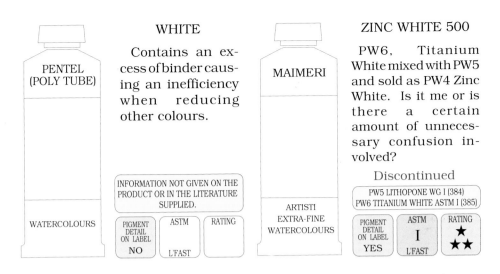

WHITE

PENTEL (POLY TUBE)

Contains an excess of binder causing an inefficiency when reducing other colours.

WATERCOLOURS

INFORMATION NOT GIVEN ON THE PRODUCT OR IN THE LITERATURE SUPPLIED.

PIGMENT DETAIL ON LABEL	ASTM	RATING
NO	L'FAST	

ZINC WHITE 500

MAIMERI

PW6, Titanium White mixed with PW5 and sold as PW4 Zinc White. Is it me or is there a certain amount of unnecessary confusion involved?

Discontinued

ARTISTI EXTRA-FINE WATERCOLOURS

PW5 LITHOPONE WG I (384)
PW6 TITANIUM WHITE ASTM I (385)

PIGMENT DETAIL ON LABEL	ASTM	RATING
YES	I L'FAST	★ ★★

Blockx

The Blockx range of watercolour paints finds itself in this section of the book because samples were not received for this edition.

As several changes have been made since the last edition I could not show the colours involved both prior and subsequent to reformulation.

Being obliged to treat this range somewhat differently I have placed them outside the main body of the book.

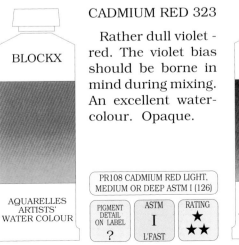

CADMIUM RED 323

BLOCKX

Rather dull violet - red. The violet bias should be borne in mind during mixing. An excellent watercolour. Opaque.

AQUARELLES ARTISTS' WATER COLOUR

PR108 CADMIUM RED LIGHT, MEDIUM OR DEEP ASTM I (126)

PIGMENT DETAIL ON LABEL	ASTM	RATING
?	I L'FAST	★ ★★

CARMINE MADDER 224

BLOCKX

There can be very little of the reliable PV19 in this particular watercolour. Sample faded dramatically to a faint red - brown. Transparent.

AQUARELLES ARTISTS' WATER COLOUR

PR83:1 ALIZARIN CRIMSON
ASTM IV (122)
PV19 QUINACRIDONE VIOLET
ASTM II (185)

PIGMENT DETAIL ON LABEL	ASTM	RATING
?	IV L'FAST	★

ROSE MADDER PALE 221

BLOCKX

Sample was very gummy, most unpleasant to use unless applied as a thin wash. The PR83 content will spoil the colour after short exposure. Transparent.

PR83 ROSE MADDER ALIZARIN
ASTM IV (122)
QUINACRIDONE

AQUARELLES ARTISTS' WATER COLOUR

PIGMENT DETAIL ON LABEL	ASTM	RATING
?	IV L'FAST	★

ROSE MADDER 222

The company state that it is their intention to replace Alizarin with Quinacridone. Depending on the Quinacridone, it will be an excellent move. Trans-parent.

BLOCKX

AQUARELLES ARTISTS' WATER COLOUR

PR83 ROSE MADDER ALIZARIN ASTM IV (122)

PIGMENT DETAIL ON LABEL	ASTM	RATING
?	IV L'FAST	★

ROSE MADDER DEEP 223

The failings of this pigment are so well known in the industry it is surprising how often it is used. Most unreliable. Transparent.

BLOCKX

AQUARELLES ARTISTS' WATER COLOUR

PR83:1 ALIZARIN CRIMSON ASTM IV (122)

PIGMENT DETAIL ON LABEL	ASTM	RATING
?	IV L'FAST	★

VERMILION 320

The use of genuine Vermilion pigment will guarantee that the colour will quickly move towards a dull greyed - red on exposure. Can deteriorate more than the ASTM rating would suggest. Opaque.

BLOCKX

AQUARELLES ARTISTS' WATER COLOUR

MERCURIC SULPHIDE

PIGMENT DETAIL ON LABEL	ASTM	RATING
?	III L'FAST	★

BLOCKX RED 225

Dullish, weak and fades readily. Surely a better pigment could be found to carry the company name. Semi-opaque.

BLOCKX

AQUARELLES ARTISTS' WATER COLOUR

PR3 TOLUIDINE RED WG V (115)

PIGMENT DETAIL ON LABEL	ASTM	RATING
?	V L'FAST	★

COBALT VIOLET 331

It would seem that the company have replaced PV14 with PV49. Reliable but brushed out very poorly. Semi-transparent.

BLOCKX

AQUARELLES ARTISTS' WATER COLOUR

PV49 COBALT AMMONIUM VIOLET PHOSPHATE WG II (187)

PIGMENT DETAIL ON LABEL	ASTM	RATING
?	II L'FAST	★★

MAGENTA 232

An excellent pigment has been used to give a reliable watercolour which brushes out smoothly. Transparent.

BLOCKX

AQUARELLES ARTISTS' WATER COLOUR

PV19 QUINACRIDONE VIOLET ASTM II (185)

PIGMENT DETAIL ON LABEL	ASTM	
?	II L'FAST	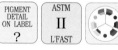

CADMIUM PURPLE 325

It is always worth seeking out paints produced with such excellent pigments. Brushes out beautifully. Opaque.

BLOCKX

AQUARELLES ARTISTS' WATER COLOUR

PR108 CADMIUM RED LIGHT, MEDIUM OR DEEP ASTM I (126)

PIGMENT DETAIL ON LABEL	ASTM	
?	I L'FAST	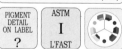

ULTRAMARINE VIOLET 234

Very close to Ultramarine in hue. Gives smooth washes over a useful range of values. Absolutely lightfast. Semi-opaque.

BLOCKX

AQUARELLES ARTISTS' WATER COLOUR

PV15 ULTRAMARINE RED ASTM I (184)

PIGMENT DETAIL ON LABEL	ASTM	
?	I L'FAST	

CERULEAN BLUE 351

Brighter than most Cerulean Blues. Sample gave particularly smooth, even washes over the full range. Absolutely lightfast. Opaque.

BLOCKX

AQUARELLES ARTISTS' WATER COLOUR

PB35 CERULEAN BLUE ASTM I (216)

PIGMENT DETAIL ON LABEL	ASTM	
?	I L'FAST	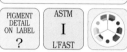

COBALT BLUE 352

Tubes with a black cap, ('moist' watercolours), are best applied thinly or they resist drying. Select white capped version for 'normal' application. Transparent.

BLOCKX

AQUARELLES ARTISTS' WATER COLOUR

PB28 COBALT BLUE ASTM I (215)

PIGMENT DETAIL ON LABEL	ASTM	
?	I L'FAST	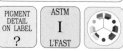

MANGANESE BLUE 250

The nature of the pigment leads to a rather gummy watercolour paint. Difficult to use unless in thin washes. Semi-transparent.

BLOCKX

AQUARELLES ARTISTS' WATER COLOUR

PB33 MANGANESE BLUE ASTM I (215)

PIGMENT DETAIL ON LABEL	ASTM	RATING
?	I L'FAST	★★

ULTRAMARINE BLUE LIGHT 251

Bright, vibrant colour. Handled very well over the full range of values. Well produced. Transparent.

BLOCKX

AQUARELLES ARTISTS' WATER COLOUR

PB29 ULTRAMARINE BLUE ASTM I (215)

PIGMENT DETAIL ON LABEL	ASTM	
?	I L'FAST	

ULTRAMARINE BLUE DEEP 253

BLOCKX

Slightly deeper than the 'Light' version. I would suggest that you select one or the other as it would not be worth holding both. Washed out well. Transparent.

AQUARELLES ARTISTS' WATER COLOUR

PB29 ULTRAMARINE BLUE ASTM I (215)		
PIGMENT DETAIL ON LABEL	ASTM	
?	I L'FAST	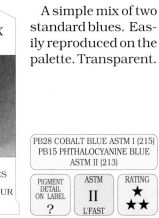

BLOCKX BLUE 254

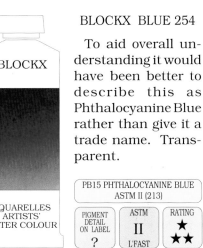

BLOCKX

To aid overall understanding it would have been better to describe this as Phthalocyanine Blue rather than give it a trade name. Transparent.

AQUARELLES ARTISTS' WATER COLOUR

PB15 PHTHALOCYANINE BLUE ASTM II (213)		
PIGMENT DETAIL ON LABEL	ASTM	RATING
?	II L'FAST	★★

CYANINE BLUE 354

BLOCKX

A simple mix of two standard blues. Easily reproduced on the palette. Transparent.

AQUARELLES ARTISTS' WATER COLOUR

PB28 COBALT BLUE ASTM I (215) PB15 PHTHALOCYANINE BLUE ASTM II (213)		
PIGMENT DETAIL ON LABEL	ASTM	RATING
?	II L'FAST	★★

EMERALD GREEN 261

BLOCKX

Emerald Green is a general colour description. If you already have Viridian you will not need it again. Transparent.

AQUARELLES ARTISTS' WATER COLOUR

PG18 VIRIDIAN ASTM I (261)		
PIGMENT DETAIL ON LABEL	ASTM	RATING
?	I L'FAST	★ ★★

TERRE VERTE 161

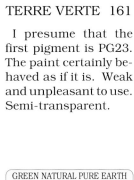

BLOCKX

I presume that the first pigment is PG23. The paint certainly behaved as if it is. Weak and unpleasant to use. Semi-transparent.

AQUARELLES ARTISTS' WATER COLOUR

GREEN NATURAL PURE EARTH PY42 MARS YELLOW ASTM I (43)		
PIGMENT DETAIL ON LABEL	ASTM	RATING
?	II L'FAST	★★

HOOKER'S GREEN 264

BLOCKX

Quickly moves from a yellow to a mid-green as the PY1 fades. This particular yellow is well known for its failings. Transparent.

AQUARELLES ARTISTS' WATER COLOUR

PG18 VIRIDIAN ASTM I (261) PY1 ARYLIDE YELLOW G ASTM V (37)		
PIGMENT DETAIL ON LABEL	ASTM	RATING
?	V L'FAST	★

OLIVE GREEN 265

BLOCKX

It is depressing to have to report yet another unsuitable paint. Depressing because of the careful work which will have been spoilt through its use.

AQUARELLES ARTISTS' WATER COLOUR

PR83 ROSE MADDER ALIZARIN ASTM IV (122) PY1 ARYLIDE YELLOW G ASTM V (37) PG7 PHTHALOCYANINE GREEN ASTM I (259)		
PIGMENT DETAIL ON LABEL	ASTM	RATING
?	V L'FAST	★

SAP GREEN 361

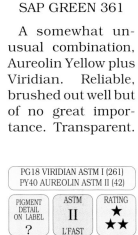

BLOCKX

A somewhat unusual combination, Aureolin Yellow plus Viridian. Reliable, brushed out well but of no great importance. Transparent.

AQUARELLES ARTISTS' WATER COLOUR

PG18 VIRIDIAN ASTM I (261) PY40 AUREOLIN ASTM II (42)		
PIGMENT DETAIL ON LABEL	ASTM	RATING
?	II L'FAST	★ ★★

BLOCKX GREEN 263

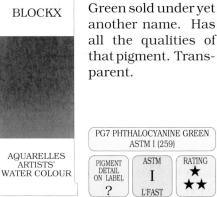

BLOCKX

Phthalocyanine Green sold under yet another name. Has all the qualities of that pigment. Transparent.

AQUARELLES ARTISTS' WATER COLOUR

PG7 PHTHALOCYANINE GREEN ASTM I (259)		
PIGMENT DETAIL ON LABEL	ASTM	RATING
?	I L'FAST	★ ★★

LAMORINIERE GREEN 262

BLOCKX

The prevalent use of fancy names to describe standard pigments can only add to the confusion that still exists. Excellent product.

AQUARELLES ARTISTS' WATER COLOUR

PG17 CHROMIUM OXIDE GREEN ASTM I (261)		
PIGMENT DETAIL ON LABEL	ASTM	RATING
?	I L'FAST	★ ★★

BURNT SIENNA LIGHT 141

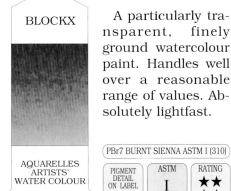

BLOCKX

A particularly transparent, finely ground watercolour paint. Handles well over a reasonable range of values. Absolutely lightfast.

AQUARELLES ARTISTS' WATER COLOUR

PBr7 BURNT SIENNA ASTM I (310)		
PIGMENT DETAIL ON LABEL	ASTM	RATING
?	I L'FAST	★★ ★★

BURNT SIENNA DEEP 143

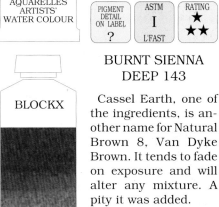

BLOCKX

Cassel Earth, one of the ingredients, is another name for Natural Brown 8, Van Dyke Brown. It tends to fade on exposure and will alter any mixture. A pity it was added.

AQUARELLES ARTISTS' WATER COLOUR

CASSEL EARTH PBk7 CARBON BLACK ASTM I (370)		
PIGMENT DETAIL ON LABEL	ASTM	RATING
?	IV L'FAST	★

BURNT UMBER 148

A well produced watercolour paint. Gave smooth washes and a useful range of values. Absolutely lightfast. Semi-opaque.

BLOCKX

AQUARELLES ARTISTS' WATER COLOUR

PBr7 BURNT UMBER ASTM I (310)		
PIGMENT DETAIL ON LABEL ?	ASTM I L'FAST	

LIGHT RED 123

Sample was overbound, making handling difficult. Thin washes were fine.

Absolutely lightfast. Semi-opaque.

BLOCKX

AQUARELLES ARTISTS' WATER COLOUR

PR101 LIGHT OR ENGLISH RED OXIDE ASTM I (124)		
PIGMENT DETAIL ON LABEL ?	ASTM I L'FAST	RATING ★★

GOLD OCHRE 113

Yellow Ochre under another name. A well produced watercolour which brushed out beautifully, giving clear washes. Absolutely lightfast. Semi-transparent.

BLOCKX

AQUARELLES ARTISTS' WATER COLOUR

PY43 YELLOW OCHRE ASTM I (43)		
PIGMENT DETAIL ON LABEL ?	ASTM I L'FAST	RATING ★★

SEPIA 144

The ingredients have not been made clear enough for me to give confident assessments or guidance. All companies were asked to provide full and accurate information.

BLOCKX

AQUARELLES ARTISTS' WATER COLOUR

PBk UNSPECIFIED PBr7 (309/310)		
PIGMENT DETAIL ON LABEL ?	ASTM L'FAST	RATING

VANDYKE BROWN 142

Reliable ingredients giving a paint which handled well. The PBr7 is unspecified. Semi-opaque.

BLOCKX

AQUARELLES ARTISTS' WATER COLOUR

PBr PG18 VIRIDIAN ASTM I (261)		
PIGMENT DETAIL ON LABEL ?	ASTM I L'FAST	RATING ★ ★★

VENETIAN RED 121

Whereas I feel that this will either be one of the PBr7's or a PR101 I do not feel able to offer assessments. Washed out very well.

BLOCKX

AQUARELLES ARTISTS' WATER COLOUR

NATURAL PURE EARTH		
PIGMENT DETAIL ON LABEL ?	ASTM L'FAST	RATING

YELLOW OCHRE 111

Mars Yellow sold under another name. Although considered to be a synthetic version of genuine Yellow Ochre, certain subtleties of hue can be lost.

BLOCKX

AQUARELLES ARTISTS' WATER COLOUR

PY42 MARS YELLOW ASTM I (43)		
PIGMENT DETAIL ON LABEL ?	ASTM I L'FAST	RATING ★ ★★

ITALIAN EARTH 117

The name was at one time used to describe Raw Sienna. With such a vague pigment description I have no idea what this is and do not care to guess. Assessments not offered.

BLOCKX

AQUARELLES ARTISTS' WATER COLOUR

NATURAL PURE EARTH		
PIGMENT DETAIL ON LABEL ?	ASTM L'FAST	RATING

NEUTRAL TINT 177

Crimson Alizarin certainly creeps in here and there. Whenever it does so it causes damage to the overall colour, particulary in thinner washes.

BLOCKX

AQUARELLES ARTISTS' WATER COLOUR

BLACK PB15 PHTHALOCYANINE BLUE ASTM II (213) PR83:1 ALIZARIN CRIMSON ASTM IV (122)		
PIGMENT DETAIL ON LABEL ?	ASTM IV L'FAST	RATING ★

PAYNE'S GREY 175

Black with the slightest hint of green. Reliable ingredients but as close to black as would seem possible. The black is unspecified. Semi-opaque.

BLOCKX

AQUARELLES ARTISTS' WATER COLOUR

BLACK PB29 ULTRAMARINE BLUE ASTM I (215) PB15 PHTHALOCYANINE BLUE ASTM II (213)		
PIGMENT DETAIL ON LABEL ?	ASTM II L'FAST	RATING ★ ★★

IVORY BLACK 171

A neutral black, leaning neither towards brown or blue. Washed out well over an extensive range of strengths. Semi-opaque.

BLOCKX

AQUARELLES ARTISTS' WATER COLOUR

PBk9 IVORY BLACK ASTM I (371)		
PIGMENT DETAIL ON LABEL ?	ASTM I L'FAST	

CHINESE WHITE 184

Well produced watercolour paint. Handled very smoothly. A cold pure white with good covering power.

BLOCKX

AQUARELLES ARTISTS' WATER COLOUR

PW4 ZINC WHITE ASTM I (384)		
PIGMENT DETAIL ON LABEL ?	ASTM I L'FAST	

Index of Colours

DALER ROWNEY Artists' Quality398

DALER ROWNEY Georgian - 2nd Range398

DA VINCI PAINTS Artists' Quality....................398

DA VINCI PAINTS Scuola 2nd Range................398

WINSOR & NEWTON Artists' Quality...............398

WINSOR & NEWTON Cotman 2nd Range..........398

HOLBEIN Artists' and Irodori...........................399

BLOCKX Aquarelles.......................................399

GRUMBACHER Artists' Quality.......................399

GRUMBACHER Academy 2nd Range................399

MAIMERI Artists' Quality................................399

MAIMERI 2nd Range...................................... 400

TALENS Rembrandt Artists' Quality.................400

TALENS Van Gogh 2nd Range........................400

SCHMINCKE Horadam Artists' Quality.............400

OLD HOLLAND Artists' Quality........................401

LUKAS Artists' Quality....................................401

SENNELIER Artists' Quality............................401

LEFRANC & BOURGEOIS Artists' Quality.........402

PEBEO Fragonard Artists' Quality....................402

HUNTS Speedball Artists' Quality.....................402

ART SPECTRUM Artists' Quality......................402

AMERICAN JOURNEY Artists' Quality.............. 403

DANIEL SMITH Artists' Quality........................403

CARAN D'ACHE Artists' Quality.......................403

UTRECHT Artist' Quality................................ 403

M. GRAHAM & Co. Artists' Quality...................404

UMTON BARVY Artists' Quality....................... 404

ST. PETERSBURG Artists' Quality....................404

MIR Aquarela Artists' Quality.......................... 404

DR. Ph MARTINS Hydrus Fine Art....................404

PENTEL Watercolours......................................404

PENTEL Poly Tubes Watercolours....................404

DALER ROWNEY
Artists' Quality Page
Aureolin 56
Cadmium Yellow Pale 57
Cadmium Yellow 62
Cadmium Yellow Deep 63
Chrome Yellow 65
Gamboge (Hue) 67
Indian Yellow 71
Lemon Yellow 72
Chrome Lemon 66
Naples Yellow 77
Bismuth Yellow 81
Nickel Titanate Yellow 84
Permanent Yellow 85
Cadmium Orange 105
Cadmium Orange (Hue) 105
Chrome Orange 105
Chrome Orange Deep 105
Warm Orange 110
Alizarin Crimson 142
Alizarin Crimson Hue 142
Cadmium Red Pale 143
Cadmium Red Pale Hue 143
Cadmium Red 146
Cadmium Red Hue 146
Cadmium Red Deep 148
Cadmium Red Deep Hue 148
Crimson Lake 153
Quinacridone Red 160
Scarlet Alizarin 161
Scarlet Lake 161
Rowney Vermillion Hue 165
Vermillion (Hue) 165
Permanent Rose 172
Permanent Red 173
Perylene Maroon 173
Perylene Red 173
Rose Dore (Alizarin) 174
Permanent Magenta 194
Quinacridone Magenta 194
Cobalt Magenta 194
Permanent mauve 195
Purple Lake 197
Purple madder (Alizarin) 197
Mars Violet 201
Ultramarine Violet 206
Violet Alizarin 207
Coeruleum 222
Cobalt Blue 226
Cobalt Blue Deep 226
Indigo 231
Manganese Blue 233
Manganese Blue (Hue) 233
Phthalo Blue 235
Prussian Blue 237
Cobalt Turquoise 241
Transparent Turquoise 241
French Ultramarine 245
Indanthrene Blue 248
Monestial Blue 249
Monestial Blue (Phthalo) ... 250
Permanent Blue 250
Oxide of Chromium 269
Cobalt Green 271
Cobalt Green Deep 271
Terre Verte 276
Terre Verte (Hue) 276
Hooker's Green 279
Hooker's Green Light 280
Hooker's Green Dark 280
Olive Green 280
Phthalo Green 282
Sap Green 286
Veridian 289
Alizarin Green 292
Green Gold 295
Monestial Green 297
Vivid Green 302
Brown Madder (Alizarian) ... 315
Burnt Sienna 317
Burnt Umber 321
Indian Red 324
Light Red 326
Raw Sienna 332
Raw Umber 334
Permanent Sepia 339
Warm Sepia 339
Vandyke Brown 342

Vandyke Brown (Hue) 342
Venetian Red 344
Yellow Ochre 347
Brown Pink 350
Transparent Red Brown 354
Davy's Grey 358
Neutral Tint 359
Payne's Grey 362
Ivory Black 375
Lamp Black 377
Chinese White 388
Titanium White 390

DALER ROWNEY
Georgian - 2nd Range
Gamboge (Hue) 67

Lemon Yellow 72
Cadmium Orange (Hue) 105
Rowney Orange 109
Crimson Alizarin 142
Cadmium Red (Hue) 146
Carmine 151
Crimson Lake 153
Rose Madder Hue 159
Scarlet Lake 161
Vermillion Hue 165
Permanent Rose 172
Mauve 195
Purple 197
Coeruleum (Hue) 222
Cobalt Blue (Hue) 226
Indigo 232
Prussian Blue 237
Ultramarine 245
Emerald Green (Hue) 273
Hooker's Green 279
Sap Green 286
Viridian (Hue) 289
Leaf Green 296
Burnt Sienna 317
Burnt Umber 321
Light Red 326
Raw Sienna 332
Raw Umber 334
Sepia (Hue) 339
Vandyke Brown 342
Payne's Grey 362
Ivory Black 375
Lamp Black 377
Chinese White 388

DA VINCI PAINTS
Artists' Quality
Aureolin (mixture) 56
Cadmium Yellow Light 58
Cadmium Yellow Deep 64
Gamboge (Hue) 66
Indian Yellow 70
Cadmium Yellow Lemon 74
Cadmium Yellow Medium 60
Naples Yellow 78
Arylide Yellow 80
Hansa Yellow Light 83
Cadmium Orange 102
Benzimida Orange 106
Alizarin Crimson 141
Cadmium Red Light 143
Medium Red Medium 145
Cadmium Red Deep 150
Carmine Quinacridone 151
Rose Madder Quinacridone ... 157
Cadmium Scarlet 162
Vermillion Hue 164
Permanent Rose Quin 170
Permanent Red 170
Rose Dore Quinacridone 174
Red Rose Quinacridone 175
Red Rose Deep 175
Cobalt Violet 190
Cobalt Violet Deep 190
Permanent Magenta 194
Mauve 196
Manganese Violet 202
Thioindigo Violet 205
Cerulean Blue Genuine 221
Cerulean Blue (Hue) 221
Cobalt Blue 227
Indigo 229
Manganese Blue (Mixture) .. 233
Phthalo Blue 235

Prussian Blue 236
Cobalt Turquoise 240
Ultramarine Blue 243
Cobalt Green (Hue) 270
Hooker's Green Light 276
Hooker's Green Dark 276
Phthalo Green 283
Sap Green 287
Viridian Green 289
Brown Madder (Quin) 315
Burnt Sienna 318
Burnt Umber 322
Raw Sienna 330
Raw Umber 335
Sepia 338
Yellow Ochre 347
Venetian Red 344
Yellow Ochre 347
Payne's Grey 362
Lamp Black 377
Titanium White 390

DA VINCI
Scuola - 2nd Range
Cadmium Yellow Light 59
Cadmium Yellow Deep 64
Gamboge (Hue) 66
Hansa Yellow (Lemon) . 83
Cadmium Orange (Hue) 102
Alizarin Crimson 141
Cadmium Red Light (Hue) .. 143
Permanent Red 170
Mauve 196
Cerulean Blue (Hue) 221
Cobalt Blue 227
Phthalo Blue 235
Prussian Blue 236
Ultramarine Blue 244
Hooker's Green Light 276
Phthalo Green 283
Sap Green 287
Viridian Green 289
Burnt Sienna 318
Burnt Umber 322
Raw Sienna 330
Raw Umber 335
Venetian Red 344
Yellow Ochre 347
Payne's Grey 362
Lamp Black 378
Titanium White 390

WINSOR & NEWTON
Artists' quality
Aureolin 56
Cadmium Yellow Pale 57
Cadmium Yellow 60
Cadmium Yellow Deep 62
Chrome Yellow 65
Chrome Yellow Deep 65
Gamboge 67
Gamboge New 67
Indian Yellow 70
Lemon Yellow 72
Winsor Lemon 72
Chrome Lemon 66
Cadmium Yellow 74
Naples Yellow 77
Naples Yellow Deep 77
Aurora Yellow 80
Bismuth Yellow 81
Quinacridone Gold 86
Transparent Yellow 87
Winsor Yellow 88
Winsor Yellow Deep 88
Cadmium Orange 103
Chrome Orange 105
Winsor Orange 110
Cobalt Violet 192
Alizarin Crimson 142
Permanent Alizarin Crimson 142
Cadmium Red 145
Cadmium Red Deep 148
Alizarin Carmine 150
Carmine 150
Permanent Carmine 150
Crimson Lake 153
Rose Madder Genuine 158
Rose Madder Alizarin 158
Quinacridone Red 160
Scarlet Lake 161

Cadmium Scarlet 161
Vermillion Hue 165
Bright Red 167
Permanent Rose 171
Rose Dore 174
Rose Carthame 174
Winsor Red 177
Perry Lane Maroon 177
Permanent Magenta 194
Mauve 195
Permanent Mauve 196
Purple Lake 199
Purple Madder (Alizarin) 199
Caput Mortuum Violet 201
Purple Madder 204
Quinacridone Magenta 204
Thioindigo Violet 205
Ultramarine Violet 206
Violet Carmine 207
Winsor Violet 207
Winsor Violet Dioxazine 207
Cerulean Blue 223
Azure Cobalt 225
Cobalt Blue 225
Cobalt Blue Deep 225
Indigo 230
Manganese Blue 233
Manganese Blue Hue 233
Prussian Blue 236
Cobalt Turquoise 239
Cobalt Turquoise Light 240
French Ultramarine 241
Ultramarine Green Shade ... 242
Antwerp Blue 246
Cyanine Blue 248
Inadanthrene Blue 249
Permanent Blue 251
Winsor Blue 252
Winsor Blue (Green Shade) . 252
Winsor Blue (Red Shade) ... 252
Oxide of Chromium 269
Cobalt Green 271
Cobalt Green (Yellow Shade) 271
Winsor Emerald 272
Terre Verte 275
Hooker's Green Light 279
Hooker's Green 279
Hooker's Green Dark 279
Olive Green 280
Sap Green 285
Permanent Sap Green 285
Viridian 289
Green Gold 295
Prussian Green 300
Winsor Green 302
Winsor Green Yellow Shade 302
Winsor Green Blue Shade .. 302
Brown Madder (Alizarian) ... 315
Brown Madder 316
Burnt Sienna 318
Burnt Umber 321
Indian Red 324
Light Red 326
Gold Ochre 329
Raw Sienna 333
Raw Umber 336
Sepia 339
Warm Sepia 339
Vandyke Brown 341
Venetian Red 344
Yellow Ochre 346
Davy's Grey 358
Neutral Tint 359
Payne's Grey 361
Charcoal Grey 364
Ivory Black 374
Lamp Black 377
Blue Black 378
Chinese White 389
Titanium White 391

WINSOR & NEWTON
Cotman - 2nd Range
Cadmium Yellow Light (USA) .. 57
Cadmium Yellow Pale Hue 57
Cadmium Yellow Hue 60
Cadmium Yellow (USA) 61
Gamboge 67
Lemon Yellow Hue 71
Lemon Yellow Hue (USA) 71
Lemon Yellow 71
Cadmium Orange (USA) 103

Cadmium Orange Hue 103
Alizarin Crimson 142
Alizarin Crimson Hue 142
Cadmium Red (USA) 145
Cadmium Red Pale (Azo) 145
Cadmium Red Pale Hue 145
Cadmium Red Hue 146
Cadmium Red (USA) 146
Cadmium Red Deep Hue 148
Rose Madder 158
Rose Madder Hue 158
Permanent Rose 171
Cobalt Violet (USA) 192
Mauve 196
Purple Lake 199
Dioxazine Violet 200
Cerulean Blue Hue 223
Cerulean Blue (USA) 223
Cobalt Blue Hue 225
Cobalt Blue (USA) 225
Indigo 230
Prussian Blue 236
Turquoise 240
Ultra Marine 241
Intense Blue 249
Emerald 273
Hooker's Green Light 279
Hooker's Green Dark 279
Sap Green 285
Viridian 289
Viridian Hue 289
Viridian USA 289
Intense Green 296
Burnt Sienna 319
Burnt Umber 321
Indian Red 324
Light Red 326
Raw Sienna 333
Raw Umber 336
Sepia 339
Vandyke Brown 342
Yellow Ochre 346
Payne's Gray 361
Ivory Black 374
Lamp Black 377
Chinese White 389

HOLBEIN
Artists' Quality
Aureolin 55
Cadmium Yellow Light 58
Cadmium Yellow Pale 58
Cadmium Yellow Deep 64
Gamboge Nova 68
Indian Yellow 69
Lemon Yellow 72
Permanent Yellow Lemon 73
Cadmium Yellow Lemon 74
Mars Yellow 75
Naples Yellow 76
Antique Amber 79
Antique Bright Yellow 79
Antique Dandelion 79
Antique Gold 79
Antique Lemon 79
Antique Sun Yellow 79
Antique Orange Yellow 80
Greenish Yellow 82
Gold 82
Permanent Yellow Light 85
Permanent Yellow Deep 85
Antique Orange 106
Antique Red Orange 106
Antique Jaune Brilliant 106
Antique Coral Red 106
Brilliant Orange 107
Jaune Brilliant 107
Permanent Yellow Orange ... 108
Permanent Alizarin Crimson 141
Cadmium Red Light 144
Cadmium Red Deep 149
Carmine 152
Crimson Lake 154
Antique Crimson 154
Rose Madder 159
Scarlet Lake 161
Vermillion Hue 164
Vermillion 164
Antique Pink 166
Antique Deep Red 166
Antique Purple Red 166
Antique Rose 166

Bright (Luminous) Rose 167
Brilliant Pink 167
Cherry Red (Quinacridone) . 167
Opera 170
Permanent Red 171
Permanent Rose 171
Shell Pink 176
Cobalt Violet Light 190
Antique Magenta 193
Permanent magenta 194
Cadmium Red Purple 198
Antique Tyrian Purple 198
Antique Violet 199
Antique Violet Blue 200
Bright Violet (Luminous) 200
Mars Violet 201
Mineral Violet 202
Permanent Violet 203
Rose Violet 205
Violet Grey 207
Lavender 208
Lilac 208
Cerulean Blue 223
Cobalt Blue 228
Cobalt Blue (Hue) 229
Manganese Blue Nova 233
Prussian Blue 236
Antique Turquoise 239
Cobalt Turquoise Light 239
Turquoise 239
Ultramarine Light 242
Ultramarine Deep 242
Antique Ultramarine 243
Antique Pale Blue 246
Antique Pompadour 246
Antique Peacock Blue 246
Antique Sky Blue 246
Antique Bronze Blue 246
Blue Grey 247
Compose Blue 248
Horizon Blue 248
Marine Blue 250
Peacock Blue 251
Royal Blue 251
Verditer Blue 252
Cadmium Green Pale 267
Cadmium Green Deep 267
Antique Green Oxide 268
Cobalt Green 270
Cobalt Green Yellow Shade . 270
Emerald Green Nova 273
Terre Verte 275
Hooker's Green 278
Antique Green Olive 280
Olive Green 281
Sap Green 288
Viridian Hue 291
Viridian 291
Antique Opal Green 292
Antique Yellow Green 292
Antique Seedling 292
Antique Jasper Green 292
Antique Dark Green 292
Antique Bamboo 292
Antique Spring Green 292
Antique Elm Green 292
Compose Green 292
Bamboo Green 293
Green Grey 296
Leaf Green 296
Permanent Green 298
Shadow Green 301
Brown Madder 315
Burnt Sienna 317
Burnt Umber 322
Indian Red 325
Light Red 327
Antique Red Ochre 328
Antique Ochre 329
Raw Sienna 331
Raw Umber 334
Umber 334
Sepia 338
Vandyke Brown 343
Yellow Ochre 346
Antique Grey Brown 350
Antique Brown 350
Antique Cypress Bark 350
Antique Russet Brown 350
Antique Smoked Bamboo ... 350
Davy Grey 358
Neutral Tint 360

Payne's Grey 361
Antique Silver Grey 364
Grey of Grey 364
Yellow Grey 365
Ivory Black 374
Lamp Black 377
Antique Black 378
Peach Black 379
Chinese White 389
Titanium White 390
Antique White 391
Antique silver 391
Silver 392

BLOCKX
Aquarelles - Artists' Quality
Aureolin 394
Cadmium Pale 394
Cadmium Medium 394
Gamboge 394
Lemon Yellow 394
Naples Yellow 394
Blockx Yellow 394
Cadmium Orange 394
Cadmium Red Orange 394

GRUMBACHER
Artists' Quality
Cadmium Yellow Light 59
Cadmium Yellow Medium 61
Cadmium Yellow Deep 63
Gamboge (Hue) 67
Indian Yellow 70
Lemon Yellow 72
Cadmium Yellow Lemon 75
Naples Yellow (hie) 78
Cadmium Orange 102
Cobalt Violet 190
Alizarin Crimson 142
Alizarin Crimson Golden 143
Cadmium Red Light 144
Cadmium Red Medium 147
Cadmium Red Deep 148
Thalo Crimson 153
Rose Madder Hue 158
Vermillion Light Hue 163
Vermillion Deep Hue 163
Grumbacher Red 169
Thalo Crimson 176
Thalo Red 176
Thalo Purple 199
Thio Violet 205
Cerulean Blue 221
Cobalt Blue 226
Indigo 230
Manganese Blue 233
Thalo Blue 235
Prussian Blue 236
Turquoise 239
Ultramarine Blue 242
French Ultramarine Blue 242
Chromium Oxide Green 269
Emerald Green 273
Green Earth 275
Hooker's Green Light Hue .. 277
Hooker's Green Deep Hue ... 277
Thalo Yellow Green 284
Thalo Green (Blue Shade) ... 284
Sap Green 285
Viridian 288
Brown Madder 316
Burnt Sienna 319
Burnt Umber 320
English Red Light 323
Indian Red 325
Raw Sienna 333
Raw Umber 335
Sepia Natural 339
Sepia Warm 339
Van Dyck Brown 341
Yellow Ochre Hue 346
Davy's Grey 358
Payne's Gray 362
Ivory Black 375
Lamp Black 376
Chinese White 389

GRUMBACHER
Academy - 2nd Range
Cadmium Yellow Pale Hue 59

Cadmium Yellow Medium 61
Cadmium Yellow Deep 63
Gamboge Hue 67
Lemon Yellow 72
Indian Yellow Hue 70
Naples Yellow (Hue) 78
Golden Yellow 82
Cadmium Orange 102
Alizarin Orange 106
Alizarin Crimson 142
Cadmium Red Light Hue 144
Cadmium Red Medium Hue 147
Cadmium Red Deep 148
Cadmium Red Deep Hue 148
Carmine Hue 151
Thalo Crimson 153
Rose Madder Hue 158
Scarlet Lake 162
Vermillion Hue 163
Geranium Lake 168
Geranium Red 168
Grumbacher Red 169
Perylene Maroon 173
Thalo Crimson 176
Thalo Red 176
Mauve 195
Thio Violet 205
Violet 206
Cerulean Blue 221
Cerulean Blue (Hie) 221
Cobalt Blue (Hue) 226
Indigo 230
Manganese Blue 233
Thalo Blue 235
Prussian Blue 236
Ultramarine Blue 242
Chromium Oxide Green 269
Green Earth Hue 275
Hooker's Green Deep Hue ... 277
Hooker's Green Light Hue .. 277
Thalo Yellow Green 284
Thalo Green (Blue Shade) ... 284
Sap Green 285
Viridian 288
Leaf Green 296
Magnesium Green 297
Permanent Green Light 298
Brown Madder 316
Burnt Sienna 319
Burnt Umber 320
Raw Umber 335
Sepia Hue 339
Van Dyck Brown Hue 341
Van Dyck Brown 341
Yellow Ochre Hue 346
Davy's Grey 358
Payne's Gray 362
Charcoal Gray 365
Ivory Black 375
Lamp Black 376
Chinese White 389

MAIMERI
Artists' Quality
Cadmium Yellow Light 58
Cadmium Yellow Deep 63
Gamboge (Hue) 69
Indian Yellow (Hue) 69
Permanent Yellow Lemon 73
Cadmium Yellow Lemon 74
Naples Yellow 76
Brilliant Yellow 81
Deep Yellow 81
Golden Lake 82
Nickel Titanate Yellow 84
Permanent Yellow Deep 85
Primary Yellow 86
Yellow Stil de Grain 88
Cadmium Orange 105
Avignon Orange 106
Brilliant Orange 107
Orange Lake 108
Permanent Orange 108
Alizarin Crimson 142
Cadmium Red Light 144
Cadmium Red Deep 149
Alizarin Carmine 152
Crimson Lake 154
Madder Alizarin Crimson 156
Rose Madder Alizarin 157
Quinacridone Rose 160

Vermillion Light 164
Vermillion Deep 164
Flesh Tint 168
Geranium Lake 168
Permanent Red Light 171
Permanent Red Deep 171
Rose Lake 174
Sandal Red 176
Tiziano Red 176
Transparent Mars Red 177
Cobalt Violet 191
Primary Red Magenta 193
Mineral Violet 202
Permanent Violet Bluish 202
Permanent Violet Reddish .. 203
Quinacridone Violet 204
Ultramarine Violet 205
Violet Lake 207
Cerulean 222
Cobalt Blue Light 228
Cobalt Blue Deep 228
Indigo 230
Manganese Blue 232
Phthalocyanine Blue 234
Prussian Blue 237
Ultramarine Light 244
Ultramarine Deep 244
Sky Blue Ultramarine 244
Ultramarine 244
Berlin Blue 247
Faience Blue 248
Green Blue 248
Primary Blue Cyan 251
Cadmium Green 267
Cobalt Green Light 270
Cobalt Green Deep 270
Emerald Green 273
Green Earth 274
Hooker's Green 277
Olive Green 280
Phthalo Green 283
Sap Green 287
Viridian 288
Cupric Green Light 294
Cupric Green Deep 294
Permanent Green 298
Permanent Green Yellowish 298
Permanent Green Light 298
Permanent Green Deep 298
Turquoise Green 301
Yellowish Green 303
Burnt Sienna 318
Burnt Umber 321
English Red 323
Golden Ochre 329
Raw Sienna 331
Indian Red 325
Light Red 326
Raw Sienna 333
Raw Umber 336
Sepia 337
Vandyke Brown 342
Venetian Red 345
Yellow Ochre 345
Brown Stil de Grain 350
Dragon's Blood 351
Pozzuoli Earth 353
Transparent Mars Brown 354
Neutral Tint 360
Payne's Grey 361
Ivory Black 374
Carbon Black 379
Chinese White 390
Titanium White 391
White 392
Zinc White 393

MAIMERI
2nd Range
Lemon Yellow 73
Naples Yellow Light 76
Naples Yellow Reddish 76
Primary Yellow 86
Stil de Grain 87
Orange 108
Permanent Orange 108
Cadmium Red 147
Carmine 152
Crimson Lake 154
Rose Madder Alizarin Deep . 157
Scarlet 161

Vermillion Hue 164
Garnet Lake 168
Permanent Red Light 171
Permanent Red Deep 171
Rose Lake 174
Cobalt Violet 191
Primary Red Magenta 193
Permanent Violet Bluish 202
Permanent violet Reddish ... 203
Violet 207
Verzino Violet 207
Cerulean 222
Cobalt Blue (Hue) 228
Indigo 230
Prussian Blue 237
Ultramarine Deep 244
Ultramarine 244
Primary Blue Cyan 251
Cobalt Green 270
Emerald Green 273
Green Earth 274
Sap Green 287
Viridian Hue 288
Permanent Green 298
Permanent Green Light 298
Permanent Green Deep 298
Burnt Sienna 318
Burnt Umber 322
Golden Ochre 329
Raw Sienna 331
Raw Umber 336
Sepia 337
Vandyke Brown 342
Yellow Ochre 345
Brown Stil de Grain 351
Pozzuoli Earth 353
Neutral Tint 360
Payne's Grey 361
Ivory Black 374
Black 378
Chinese White 390

TALENS
Rembrandt - Artists' Quality
Aureolin 56
Cadmium Yellow Light 58
Cadmium Yellow 61
Cadmium Yellow Medium 61
Cadmium Yellow Deep 62
Gamboge 68
Permanent Lemon Yellow 72
Talens Yellow Lemon 72
Cadmium Lemon 75
Naples Yellow Red 78
Naples Yellow Light 78
Naples Yellow Reddish 78
Naples Yellow Deep 78
Azo Yellow Light 80
Azo Yellow Medium 80
Azo Yellow Deep 80
Talens Yellow 87
Talens Yellow Deep 87
Talens Yellow Light 88
Cadmium Orange 104
Permanent Orange 109
Talens Orange 110
Alizarin Crimson 141
Cadmium Red Light 145
Cadmium Red Medium 146
Cadmium Red 146
Cadmium Red Deep 149
Carmine 151
Madder Lake Light 155
Permanent Madder Lake Lt .. 155
Permanent Madder Lake 155
Madder Lake Deep 155
Rose Madder 158
Quinacridone Rose 160
Vermillion 164
Permanent Red Light 172
Permanent Red Medium 172
Permanent Red Deep 172
Rembrant Rose 175
Talens Red Light 177
Talens Red Deep 177
Cobalt Violet 190
Mauve 195
Permanent Madder Purple .. 198
Purple Madder (Alizarin) 199
Permanent Blue Violet 203
Permanent Red Violet 203

Ultramarine Violet 206
Violet 206
Phthalo Blue 208
Cerulean Blue 224
Cobalt Blue 227
Cobalt Blue (Ultram) 227
Indigo Modern 231
Indigo 231
Phthalo Blue Green 234
Phthalo Blue Red 234
Prussian Blue 238
Turquoise Blue 240
Ultramarine Light 243
Ultramarine Deep 243
French Ultramarine 243
Indantherene Blue 249
Rembrant Blue 251
Chromium Oxide Green 269
Cobalt Green 271
Emerald Green 272
Green Earth 275
Hooker Green Light 278
Hooker Green Deep 278
Olive Green 281
Phthalo Green 283
Sap Green 286
Viridian 290
Bluish Green 293
Permanent Green Light 299
Permanent Yellowish Green 299
Permanent Green 299
Rembrant Bluish-Green 300
Rembrant Green 300
Yellowish Green 303
Brownish Madder Alizarin .. 315
Perm Madder Lake Brown .. 315
Burnt Sienna 318
Burnt Umber 320
Indian Red 325
Gold Ochre 329
Raw Sienna 332
Raw Umber 335
Sepia Modern 340
Sepia 340
Vandyke Brown 342
Venetian Red 344
Yellow Ochre 347
Light Oxide Red 352
Trans Oxide Yellow 354
Trans oxide Red 354
Trans Oxide Brown 354
Neutral Tint 359
Payne's Grey 363
Charcoal Grey 364
Ivory Black 375
Lamp Black 377
Chinese White 388
Trans Titanium White 390

TALENS
Van Gogh - 2nd Range
Cadmium Yellow Light 58
Cadmium Yellow Deep 62
Gamboge 68
Permanent Lemon Yellow 72
Cadmium Lemon 75
Naples Yellow Red 78
Azo Yellow Light 80
Azo Yellow Medium 80
Azo Yellow Deep 80
Cadmium Orange (Azo) 104
Permanent Orange 109
Cadmium Red Light (Azo) ... 145
Cadmium Red Deep 149
Madder Lake Light 155
Madder Lake Deep 155
Quinacridone Rose 160
Vermillion 164
Permanent Red Light 172
Permanent Red Deep 172
Permanent Blue Violet 203
Permanent Red Violet 203
Red Violet 204
Violet 206
Cerulean Blue (Thalo) 224
Cobalt Blue Ultram 227
Cobalt Blue Ultramarine 227
Indigo Modern 231
Indigo 231
Phthalo Blue 234
Prussian Blue 238

Ultramarine Deep 243
Emerald Green 272
Hookers Green Light 278
Hookers Green Deep 278
Olive Green 281
Phthalo Green 283
Sap Green 285
Viridian 290
Permanent Green Light 299
Permanent Yellowish Green 299
Permanent Green 299
Yellowish Green 303
Burnt Sienna 318
Burnt Umber 320
Raw Sienna 332
Raw Umber 335
Sepia 340
Vandyke Brown 342
Yellow Ochre 348
Light Oxide Red 352
Payne's Grey 363
Ivory Black 375
Chinese White 388

SCHMINCKE
Horadam - Artists' Quality
Cadmium Yellow Light 57
Cadmium Yellow Middle 60
Cadmium Yellow Deep 63
Chrome Yellow Light 65
Chrome Yellow Deep Hue 66
Indian Yellow 71
Lemon Yellow 73
Aureolin Modern 56
Gamboge Hue 68
Naples Yellow Reddish 78
Naples Yellow 78
Brilliant Yellow Light 80
Brilliant Yellow 81
Brilliant Yellow Dark 81
Gold 82
Green Pink 82
Green Yellow 82
Trans Yellow 84
Permanent Yellow Deep 85
Permanent Yellow Middle 85
Pure Yellow 85
Titanium Yellow 88
Cadmium Orange Light 103
Cadmium Orange Deep 103
Chrome Orange 105
Brilliant Orange 106
Lasur Orange 107
Permanent Orange 109
Translucent Orange 109
Madder carmine 143
Cadmium Red Light 144
Cadmium Red Orange 147
Cadmium Red Middle 147
Cadmium Red Deep 147
Cadmium Red 151
Permanent Carmine 151
Madder Red Dark 155
Madder Lake Deep 156
Madder Lake Light 158
Rose Madder Hue 158
Scarlet Lake 161
Vermillion 164
Deep Red 168
Permanent Red Orange 172
Permanent Red 172
Permanent Red Deep 172
Ruby Red 175
Magenta 194
Mauve 195
Purple Magenta 197
Brilliant Purple 197
Brilliant Violet 200
Brilliant Blue Violet 200
Brilliant Red Violet 200
Glowing Violet 201
Manganese Violet 201
Old Violet 202
Permanent Violet 203
Purple Violet 204
Quinacridone Violet 204
Ultramarine Violet 206
Cerulean Blue Hue 223
Cobalt Cerulean 223
Cobalt Blue Light 225
Cobalt Blue Deep 225

Cobalt Blue Tone 225
Indigo 231
Indigo Blue Dark 231
Phthalo Blue 235
Prussian Blue 238
Helio Turquoise 240
Cobalt Turquoise 240
Cobalt Green Turquoise 240
Ultramarine Finest 244
Ultramarine Blue 245
Brilliant Blue 247
Helio Cerulean 247
Delft Blue 248
Helio Cerulean 248
Helio Blue Reddish 248
Mountain Blue 249
Paris Blue 250
Chromium Oxide Green 269
Cobalt Green Pure 271
Cobalt Green Deep 271
Cobalt Green Dark 271
Green Earth 275
Hookers Green 278
Olive Green 282
Olive Green Yellowish 282
Permanent Olive Green 282
Phthalo Green 284
Sap Green 287
Viridian Glowing 288
Brilliant Yellow Green 293
Brilliant Green 293
Green Lake Deep 295
Helio Green 296
Linden Green 296
May Green 297
Opaque Green Light Im 297
Permanent Green 300
Prussian Green 300
Vermillion Green Deep 302
Vermillion Green Light 302
Madder Brown 315
Madder Brown Reddish 315
Burnt Sienna 319
Burnt Umber 320
English Red Deep 323
English Red Light 324
Golden Ochre 328
Titanium Gold Ochre 328
Raw Sienna 331
Raw Umber 335
Sepia Brown Tone 335
Sepia Brown 338
Vandyke Brown 343
Yellow Ochre 346
Burnt Yellow Ochre 346
Yellow Raw Ochre 346
Burnt Green Earth 350
Brown Pink 350
Caput Mortuum 351
Brown Ochre 352
Gold Brown 352
Light Brown 352
Pozzuoli Earth 353
Stil de Grain Verte 354
Nut Brown 354
Neutral Tint 360
Schmincke Payne's Grey 362
Payne's Grey Bluish 362
Charcoal Grey 364
Neutral Grey 365
Lamp Black 378
Vine Black 379
Perm Chinese White 390
Titanium White 390
Silver 392

OLD HOLLAND
Artists' Quality
Cobalt (Aureolin) -Yellow Lake .. 56
Cadmium Yellow Light 58
Cadmium Yellow Medium 61
Cadmium Yellow Deep 64
Gamboge Lake 67
Indian Yellow-Green Lake 71
Indian Yellow-Brown Lake 71
Indian Yellow-Orange Lake .. 71
Cadmium Yellow Lemon 74
Mars Yellow 75
Naples Yellow Extra 77
Naples Yellow Deep Extra 77
Naples Yellow Reddish Extra 77

Brilliant Yellow Light 81
Brilliant Yellow 81
Brilliant Yellow Reddish 81
Nickel Titanium Yellow 84
Yellow Light 84
Yellow Medium 84
Yellow Medium 84
Yellow Deep 84
Yellow Deep 84
Scheveningen Yellow Lemon . 87
Scheveningen Yellow Medium 87
Scheveningen Yellow Deep ... 87
Scheveningen Yellow Light ... 87
Vanadium 88
Cadmium Yellow Orange 103
Cadmium Red Orange 103
Cadmium Orange 104
Cadmium Orange 17 104
Cadmium Yellow Orange 107
Coral Orange 107
Chinese Orange 107
Scheveningen Orange 110
Alizarin Crimson Lake 142
Cadmium Red Light 144
Cadmium Red Scarlet 146
Cadmium Red Medium 147
Cadmium Red Deep 149
Carmine Lake Extra 151
Madder lake Light 156
Madder (Geranium Lake Lt . 156
Madder Lake Deep 156
Madder (Crimson) Lake Dp . 156
Scarlet Lake Extra 162
Vermillion Extra 163
Burgundy Wine Red 166
Brilliant Pink 167
Flesh Tint 168
Golden Barok Red 169
Mars Orange Red 169
Old Holland Bright Red 170
Old Holland Red Gold Lake 170
Rose Dore Madder Lake 174
Ruby Lake 175
Scheveningen Red Scarlet .. 175
Scheveningen Rose Deep 175
Scheveningen Red Medium . 175
Scheveningen Red Light 176
Scheveningen Red Deep 176
Ultramarine Red-Pink 177
Cobalt Violet Light 192
Cobalt Violet Dark 192
Old Holland Magenta 193
Dioxazine Mauve 196
Scheveningen Purple Brown 198
Cadmium Red Purple 198
Royal Purple Lake 198
Manganese Violet-Blueness 201
Manganese Violet-Reddish . 201
Old Holland Blue Violet 202
Old Holland Bright Violet ... 202
Scheveningen Violet 205
Ultramarine Violet 205
Cerulean Blue Light 224
Cerulean Blue 224
Cobalt Blue 228
Cobalt Blue Turquoise 229
Cobalt Blue Deep 229
Indigo Extra 231
Manganese Blue 233
Manganese Blue Deep 233
Cobalt Blue Turquoise Light 239
Turquoise Blue Deep 239
French Ultramarine Light ... 243
Ultramarine Blue 243
Ultramarine Blue Deep 243
Blue Lake 247
Caribbean Blue 247
King's Blue Light 249
King's Blue Deep 249
Old Holland Blue 250
Old Holland Delft Blue 250
Old Holland Blue Deep 250
Old Holland Cyan Blue 250
Old Holland Blue Grey 250
Parisian (Prussian) Blue 251
Paris Blue Extra 251
Scheveningen Blue Deep 252
Scheveningen Blue Light 252
Scheveningen Blue 252
Cadmium Green Light 267
Cadmium Green Deep 267

Chromium Oxide Green 269
Cobalt Green Turquoise 270
Cobalt Green 270
Cobalt Green Deep 270
Emerald Green 273
Green Earth 274
Hooker's Green lake Light .. 277
Hooker's Green Lake Deep . 277
Olive Green Dark 281
Sap Green Lake Extra 287
Viridian Green Deep 289
Viridian Pale 289
Viridian Green Light 290
Cinnabar Green Extra 294
Cinnabar Green Light Extra 294
Cinnabar Green Deep 294
Cinnabar Green Deep Extra 294
Green Umber 295
Old Holland Yellow-Green .. 297
Old Holland Bright Green ... 297
Old Holland Golden Green .. 297
Old Holland Green Light 297
Old Holland Golden Green D297
Permanent Green Deep 300
Permanent Green Light 300
Permanent Green 300
Scheveningen Green 301
Scheveningen Green Deep .. 301
Burnt Sienna 316
Burnt Umber 322
English Red 323
Persian (Indian) Red 325
Old Holland Light Red 326
Brown Ochre Light 327
Brown Ochre Deep 327
Deep Ochre 328
Red Ochre 328
Gold Ochre 329
Old Holland Ochre 330
Raw Sienna 331
Raw Sienna Light 331
Raw Sienna Deep 331
Raw Umber 335
Sepia Extra 340
Warm Sepia Extra 340
Van Dycke Brown (Cassel) .. 343
Venetian Red 344
Yellow Ochre Light 348
Yellow Ochre Deep 348
Yellow Ochre Half Burnt 349
Yellow Ochre Burnt 349
Caput Mortuum Violet 351
Flesh Ochre 352
Italian Earth 352
Italian Brown Pink Lake 352
Mars Brown 352
Old Holland Yellow-Brown .. 353
Red Umber 353
Trans Oxide-Red Lake 354
Trans Oxide Yellow-Lake ... 354
Davy Grey 358
Neutral Tint 359
Payne's Grey 362
Old Holland Cold Grey 364
Old Holland Warm Grey Lt . 364
Old Holland Violet-Grey 364
Scheveningen Warm Grey .. 365
Ivory Black Extra 374
Blue Black 378
Mars Black 379
Scheveningen Intens Black . 379
Vine Black 379
Trans Chinese White 388
Titanium White 391
Opaque White 392
Tinting Zinc White 392
Mixed White 392

LUKAS - Artists' Quality
Cadmium Yellow Light 58
Cadmium Yellow Deep 64
Indian Yellow 69
Naples Yellow 79
Naples Yellow Reddish 79
Gold 82
Helio Genuine Yellow Light .. 83
Helio Genuine Yellow Deep .. 83
Helio Genuine Yellow Lemon 83
Primary Yellow 86
Helio Genuine Orange 107
Cobalt Violet Deep 190

Cadmium Red Light 143
Cadmium Red Deep 149
Cadmium Red 152
Alizarin Madder Lake Light . 156
Alizarin Madder Lake Deep . 157
Vermillion Red 165
Geranium Lake Bluish 169
Geranium Rose 169
Permanent Red Light 170
Permanent Red Deep 170
Primary Red 174
Magenta 194
Mauve 196
Ultramarine Red 206
Violet Lake 207
Cerulean Blue 223
Cobalt Blue Deep 228
Cobalt Blue Imitation 228
Indigo 229
Manganese Blue 232
Prussian Blue 237
Ultramarine Finest 245
Helio Blue 248
Paris Blue 251
Primary Blue 251
Oxide of Chrome Opaque 269
Emerald Green 273
Verona Green Earth 275
Hooker's Green 278
Olive Green 281
Sap Green 286
Viridian 289
Cinnabar Green Light 295
Cinnabar Green Deep 295
Helio Genuine Green Light . 296
Helio Genuine Green Deep . 296
Permanent Green Light 299
Permanent Green Deep 299
Burnt Sienna 319
Burnt Umber 321
English Red Light 323
English Red Deep 323
Gold Ochre 329
Raw Sienna 331
Raw Umber 336
Sepia 337
Van Dyke Brown 343
Yellow Ochre Light 345
Burnt Green Earth 351
Copper 351
Caput Mortuum Deep 351
Puzzuoli Earth 353
Neutral Tint 360
Payne's Grey 363
Ivory Black 375
Perm Chinese White 388
Opaque White 392
Silver 392

SENNELIER
Artists' Quality
Cadmium Yellow Light 58
Cadmium Yellow Deep 63
Chrome Yellow Light 65
Chrome Yellow Deep 65
Indian Yellow 70
Lemon Yellow 72
Cadmium Yellow Lemon 74
Mars Yellow 76
Naples Yellow 77
Aureolin 55
Quinacridone Gold 86
Brown Pink 86
Yellow Light 87
Yellow Deep 87
Yellow Lake 88
Cadmium Yellow Orange 104
Cadmium Red Orange 104
Lead Red 107
Quinacridone Orange 109
Red Orange 109
Alizarin Crimson 142
Cadmium Red Light 144
Carmine Genuine 151
Carmine 151
Crimson Lake 154
Rose Madder Lake 156
Rose Dore Madder 156
French Vermillion 164
Chinese Vermillion 165
Bright Red 167

Rose Pink 174
Tyrien Rose 174
Sennelier Red 176
Cobalt Violet Rose 191
Cobalt Violet Light Hue 191
Cobalt Violet Deep Hue 191
Cobalt Violet Pale Genuine . 191
Cobalt Violet Deep Genuine 191
Permanent Magenta 193
Cadmium Red Purple 198
Quinacridone Purple 198
Alizarine Violet Lake 199
Blue Violet 200
Manganese Violet 202
Red Violet 204
Cerulean Blue 222
Cobalt Blue 227
Indigo 231
Phthalo Blue 235
Prussian Blue 238
Ultramarine Light 245
Ultramarine Deep 245
Cinerous Blue 247
Cadmium Green 267
Chromium Oxide Green 268
Cobalt Green 271
Emerald Green 272
Terre Verte 275
Hooker's Green 278
Olive Green 281
Phthalo Green Deep........... 283
Phthalo Green Light 283
Sap Green 286
Viridian 290
Permanent Green Light 299
Brown Madder 315
Burnt Sienna 317
Burnt Umber 320
Red Ochre 328
Gold Ochre 328
Gallstone 329
French Ochre 329
Raw Sienna 332
Raw Umber 334
Raw Sepia 339
Warm Sepia 339
Vandyck Brown 343
Van Dyke Brown 343
Venetian Red 344
Yellow Ochre 348
Red Brown 353
Transparent Brown 354
Neutral Tint 360
Payne's Grey 363
Ivory Black 374
Lamp Black 378
Peach Black 379
Chinese White 389
Flake White 392

LEFRANC & BOURGEOIS
Lintel - Artists' Quality
Cadmium Yellow Light 58
Cadmium Yellow Medium 62
Cadmium Yellow Deep 64
Chrome Yellow Light 65
Gamboge (Substitute) 68
Indian Yellow 70
Cadmium Yellow Lemon 74
Chrome Yellow Lemon 66
Naples Yellow Imitation 76
Flanders Yellow 81
Gold Yellow 81
Gallstone 82
Helios Yellow 83
Sahara Yellow 87
Cadmium Yellow Orange 103
Cadmium Yellow Red 107
Mars Orange 108
Cadmium Red Carmine 152
Madder Carmine 152
Carmine Permanent........... 152
Crimson Lake 153
Deep Madder 156
Rose Madder 157
Cadmium Red Vermillion ... 165
Vermillion Red Permanent .. 165
Angelico Red 166
Breughel Red 166
Bright Red 167
Carthamus Rose 167

Malmaison Rose 169
Ruby Red 174
Tyrian Rose 177
Uccello Red 177
Bayeux Violet 200
Egypt Violet 201
Permanent Violet 203
Violet Extra Light 207
Cerulean Blue 223
Cobalt Blue 226
Permanent Indigo 230
Manganese Azure Blue 232
Prussian Blue 236
Ultramarine Light 245
Ultramarine Deep 245
Blue Verditer (Imitation) 247
Indian Blue 249
Touareg Blue 252
Chrome Green (Imitation) .. 268
Chromium Oxide Green 269
Emerald Green (Imitation) .. 273
Terre Verte 275
Hooker's Green 280
Olive Green 281
Sap Green 287
Veridian 288
Antioche Green Light 293
Armor Green 293
Cyprus Green Perm 294
Green Lake Permanent 295
Veronese Green Hue 302
Warm Green 302
Burnt Sienna 317
Burnt Umber 322
Red Ochre 328
Raw Sienna 332
Raw Umber 335
Warm Sepia 338
Raw Sepia 338
Vandyck Brown 342
Venetian Red 345
Yellow Ochre 349
Transparent Brown 354
Neutral Tint 359
Payne's Grey 361
Ivory Black 375
Lamp Black 377
Peach Black 379
Chinese White 389
Flake White 391

PEBEO
Fragonard - Artists' Quality
Light Cadmium Yellow 58
Dark Cadmium Yellow 64
Gamboge 68
Permanent Lemon Yellow 72
Lemon Cadmium Yellow 74
Naples Yellow 77
Permanent Light Yellow 85
Permanent Dark Yellow 86
Orange Cadmium Yellow 103
Permanent Orange 109
Cadmium Red 145
Permanent Carmine 150
Ruby Madder 156
Pink Madder 156
Pink Madder 157
Permanent Scarlet 161
Vermillion Red 163
Cobalt Violet 190
Permanent Magenta 193
Permanent Violet 203
Cerulean Blue 222
Cobalt Blue 228
Indigo 231
Prussian Blue Imitation...... 238
Turquoise Blue 240
Ultramarine 245
Cyanin Blue 247
Hoggar Blue 248
Hortensia Blue 248
Mineral Blue Permanent 250
Light Cadmium Green 267
Green Earth 275
Hooker's Green Light 279
Hooker's Green Dark 279
Sap Green 287
Cyanin Green 295
Greengold 295
Vert Emeraude (Viridian) 302

Veronese Green 302
Burnt Sienna 317
Burnt Umber 320
Raw Sienna 330
Raw Umber 334
Sepia 338
Van Dyck Brown 341
Venecian Red 345
Yellow Ochre 346
Neutral Tint 360
Payne's Grey 363
Lamp Black 377
Chinese White 389

HUNTS
Speedball - Artists' Quality
Cadmium Yellow Light 59
Cadmium Yellow Medium 61
New Gamboge 67
Lemon Yellow 73
Cadmium Yellow Lemon 75
Cadmium Orange 103
Permanent Orange 108
Alizarin Crimson 143
Cadmium Red Deep 148
Cadmium Scarlet 162
Vermillion 163
Permanent Rose 170
Speedball Red 176
Permanent Magenta 193
Speedball Violet 205
Cerulean Blue 222
Cobalt Blue (Hue) 228
Ultra Blue 244
Speedball Blue 252
Permanent Hooker's Green . 277
Olive Green 282
Speedball Green 301
Burnt Sienna 319
Burnt Umber 321
Raw Sienna 332
Raw Umber 334
Sepia 339
Yellow Ochre 347
Payne's Grey 361
Ivory Black 375
Chinese White 388

ART SPECTRUM
Artists' Quality
Aureolin 55
Cadmium Yellow Pale 57
Cadmium Yellow 62
Cadmium Yellow Deep 63
Permanent Gamboge 66
Permanent Indian Yellow 69
Lemon Yellow 73
Naples Yellow 77
Naples Yellow Reddish 77
Spectrum Yellow 86
Cadmium Orange 102
Australian Red Gold 106
Permanent Orange 109
Cadmium Red 147
Cadmium Red Deep 150
Permanent Crimson 153
Rose Madder 158
Vermillion Permanent 165
Brilliant Red 167
Coral 167
Permanent Rose 171
Pilbara Red 173
Spectrum Red 176
Cobalt Violet 192
Permanent Magenta 193
Permanent Mauve 196
Mars Violet 201
Mineral Violet 202
Thio Violet 205
Ultramarine Violet 205
Cerulean Blue 222
Cobalt Blue 226
Indigo Blue 231
Phthalo Blue 234
Prussian Blue 237
Australian Turquoise 239
Ultramarine Blue 242
French Ultramarine 242
Antwerp Blue 246
Spectrum Blue 252

Tasman Blue 252
Oxide of Chromium 269
Hooker's Green Permanent . 271
Olive Green Permanent 281
Phthalo Green 282
Sap Green Permanent 286
Viridian 290
Australian Leaf Green Dark 293
Australian Green Gold 293
Bohemian Green earth 293
Malachite 296
Permanent Green 299
Permanent Green Light 299
Rich Green Gold 300
Undersea Green 302
Burnt Sienna 318
Burnt Umber 321
Indian Red 325
Light Red 327
Raw Sienna Light 331
Raw Sienna 331
Raw Umber 335
Sepia 337
Warm Sepia 338
Yellow Ochre 346
Neutral Tint 359
Payne's Grey 361
Australian Grey 364
Ivory Black 375
Lamp Black 377
Chinese White 389

AMERICAN JOURNEY

Aureolin 55
Cadmium Yellow Light 59
Cadmium Yellow Medium 60
Gambode 68
Indian Yellow 70
Naples Yellow 76
Bumblebee Yellow 81
Sour Lemon (Hans) 87
Cadmium Orange 102
Halloween Orange 107
Peachy Keen 108
Alizarin Crimson 141
Cadmium Red 147
Rose Madder Quinacridone 158
Cadmium Scarlet 162
Fire Engine Red 168
Permanent Rose (Quin) 171
Red Hot Momma 175
Rambling Rose 175
Wild Fuschia 177
Cobalt Violet 192
Permanent Magenta 193
Passionate Purple 197
Quinacridone Violet 204
Cerulean Blue 223
Cobalt Blue 226
Indigo 230
Manganese Blue 232
Prussian Blue 237
Andrews Turquoise 239
Ultramarine Blue 241
Joe's Blue (Phthalo) 249
Sky Blue 252
Hooker's Green Light 276
Hooker's Green Dark 276
Olive 281
Sap Green 286
Viridian 291
Joe's Green 296
Spring Green 301
Skips Green 301
True Green 301
Brown Madder (Quin) 316
Burnt Sienna 316
Burnt Umber 322
Raw Sienna 330
Raw Umber 336
Sepia 337
Yellow Ochre 347
Payne's Green 362
Getz Gray 365
Lamp Black 377
Titanium White 391

DANIEL SMITH

Aureolin (Cobalt Yellow) 55
Cadmium Yellow Light 59
Cadmium Yellow Medium 60
Cadmium Yellow Deep 63
New Gamboge 69
Indian Yellow 69
Mars Yellow 75
Naples Yellow 78
Hansa Yellow Light 83
Hansa Yellow Medium 83
Hansa Yellow Deep 83
Nickel Yellow 84
Nickel Titanate Yellow 84
Cadmium Orange 104
Perinone Orange 108
Permanent Orange 109
Quinacridone Burnt Orange 109
Cadmium Red Medium 146
Alizarin Crimson 141
Cadmium Red Scarlet 147
Cadmium Red Deep 149
Carmine 150
Rose Madder Genuine 158
Quinacridone Rose 159
Quinacridone Red 159
Quinacridone Pink 159
Quinacridone Coral 160
Quinacridone Burnt Scarlet 162
Deep Scarlet 162
Perylene Scarlet 162
Organic Vermillion 164
Anthraquinoid Red 166
Bordeaux 167
Naphthamide maroon 169
Permanent Red 170
Permanent Red Deep 170
Perylene Red 173
Perylene Maroon 173
Pyrrol Scarlet 173
Pyrrol Red 173
Pink Colour 173
Ultramarine Red 177
Cobalt Blue Violet 191
Cobalt Violet 191
Quinacridone Magenta 194
Cote d'Azur Violet 200
Carbazole Violet 200
Mars Violet 201
Manganese Violet 202
Permanent Violet 202
Quinacridone Violet 204
Raw Umber Violet 205
Ultramarine Violet 206
Moonglow 208
Rose of Ultramarine 208
Cerulean Blue 223
Cobalt Blue 228
Cobalt Teal Blue 229
Indigo 230
Manganese Blue Hue 233
Phthalo Blue 234
Prussian Blue 237
Cobalt Turquoise 240
Phthalo Turquoise 240
Ultramarine Turquoise 241
Ultramarine Blue 243
French Ultramarine 243
Azurite 247
Indanthrone Blue 249
lapis Lazuli 249
Chromium Oxide Green 268
Cobalt Green 271
Cobalt Green Pale 272
Terre Verte 275
Hooker's Green 277
Olive Green 282
Phthalo Green 283
Sap Green 286
Viridian 289
Burnt Sienna 317
Italian Burnt Sienna 317
Monte Amiata Burnt Sienna 317
Burnt Umber 320
Indian Red 325
Raw Sienna 331
Raw Umber 334
Sepia 338
Van Dyck Brown 341
Venetian Red 344
Yellow Ochre 346
Buff Titanium 351
Lunar Earth 352
Permanent Brown 353

Quinacridone Gold 353
Quinacridone Sienna 353
Payne's Grey 363
Graphite Grey 364
Ivory Black 375
Lamp Black 376
Lunar Black 379
Chinese White 388

CARAN D'ACHE

Aureolin 56
Light Cadmium Yellow 59
Middle Cadmium Yellow 61
Golden Cadmium Yellow 61
Lemon Yellow 73
Lemon Cadmium Yellow 74
Cadmium Orange 104
Cadmium Red Orange 104
Dark Cadmium Orange 104
Light Cadmium Red 144
Carmine 152
Helvetic Red 169
Permanent Red 171
Cobalt Violet 191
Light Purple 198
Manganese Violet 201
Ultramarine Violet 206
Ultramarine Pink 208
Cerulean Blue 223
Middle Cobalt Blue 227
Indigo Blue 230
Phthalocyanine Blue 235
Prussian Blue 237
Dark Ultramarine 242
Blue 247
Ice Blue 249
Night Blue 250
Cadmium Green 267
Chromium Green Oxide 269
Cobalt Green 271
Phthalocyanine Green 283
Spring Green 301
Spruce Green 301
Turquoise Green 301
Burnt Sienna 318
Burnt Umber 321
English Red 324
Indian Red 325
Brown Ochre 327
Raw Sienna 331
Raw Umber 334
Vandyke Brown 341
Yellow Ochre 346
Cassel Earth 351
Payne's Grey 363
Ivory Black 374
Chinese White 389

UTRECHT

Cadmium Yellow Light 57
Cadmium Yellow Deep 62
Indian Yellow Hue 70
Lemon Yellow 73
Hansa Yellow Deep 82
Iron Oxide Yeilow 83
Pure Cadmium Orange 102
Perinone Orange 108
Alizarin Crimson 141
Cadmium Red Light 143
Cadmium Red Medium 147
Cadmium Red Deep 148
Quinacridone Red 160
Cobalt Violet Light 190
Cobalt Violet Deep 190
Quinacridone Magenta 194
Dioxazine Purple 197
Permanent Violet 203
Quinacridone Violet 204
Cerulean Blue Chromium ... 221
Cerulean Blue 221
Cobalt Blue 227
Cobalt Teal 227
Manganese Blue Hue 232
Phthalo Blue 234
Prussian Blue 238
French Ultramarine Blue 244
Ultramarine Blue 244
Hooker's Green 276

Phthalo Green 282
Viridian 290
Permanent Green Light 297
Turquoise Green 301
Burnt Sienna 317
Burnt Umber 322
Indian Red 325
Raw Sienna 330
Raw Umber 335
Venetian Red 345
Yellow Ochre 347
Payne's Grey 362
Perm White (Titanium) 392

M.GRAHAM & CO.
Cadmium Yellow Light 58
Cadmium Yellow 60
Gamboge 68
Azo Yellow 80
Cadmium Orange 103
Alizarin Crimson 141
Cadmium Red Light 144
Cadmium Red 146
Quinacridone Red 160
Quinacridone Rose 160
Naphthol Red 169
Dioxazine Purple 198
Quinacridone Violet 204
Quinacridone Rose 208
Cerulean Blue 222
Cobalt Blue 226
Phthalocyanine Blue 235
Prussian Blue 236
Ultramarine Blue 242
Hooker's Green 277
Phthalocyanine Green 283
Sap Green 288
Viridian 290
Permanent Green Light 297
Burnt Sienna 316
Burnt Umber 322
Raw Sienna 332
Raw Umber 335
Sepia 338
Van Dyke Brown 343
Yellow Ochre 347
Neutral Tint 360
Payne's Grey 361
Ivory Black 374
Lamp Black 377
Chinese White 389

UMTON BARVY
Cadmium Yellow Lightest 59
Cadmium Yellow Light 59
Cadmium Yellow Middle 61
Cadmium Yellow Deep 64
Naples Yellow Light 77
Cadmium Deep Orange 102
Cadmium Orange Light 102
Cadmium Red Light 144
Cadmium Red Middle 147
Cadmium Red Deep 149
Madder Lake Deep 157
Flesh Colour 168
Cobalt Violet Light 192
Cadmium Orange 192
Cadmium Purple 198
Manganese Violet 201
Ultramarine Red 206
Cerulean Blue 221
Cobalt Blue Light 226
Cobalt Blue Deep 226
Cobalt Turquoise 240
Ultramarine Deep 242
Paris Blue 250
Oxide of Chrome Opaque 269
Cobalt Green deep 272
Viridian 291
Bohemian Green Earth Or .. 293
Bohemian Green Earth Im .. 293
Permanent Green Light 298
Vert Polo Veronese 302
Burnt Sienna 319
Burnt Umber 322
Indian Red 325
Brown Ochre 328
Gold Ochre 329

Raw Sienna 330
Raw Umber 336
Sepia 340
Van Dyke Brown 343
Yellow Ochre Light 348
Burnt Yellow Ochre 348
Pozzuoli Earth 353
Payne's Grey 363
Ivory Black 375
Opaque White 392

ST. PETERSBURG
Artist's Quality
Cadmium Yellow 61
Cadmium Yellow 75
Cadmium Orange 104
Carmine 152
Madder Lake 155
English Red 168
Violet 206
Cobalt Blue 229
Ultramarine 245
Russian Blue 251
Emerald Green 274
Russian Green 300
Yellow Green 303
Sienna Burnt 319
Umber Burnt 322
English Red 324
Ochre Red 328
Ochre Golden 329
Umber Raw 336
Sepia 338
Yellow Ochre 348
Mars Brown 352
Black Neutral 378

MIR (JAURENA S.A)
Acuarela - Artist's Quality
Cadmium Yellow Deep 63
Cadmium Yellow Lemon 74
Cadmium Yellow Lemon Hue 74
Royal Yellow 86
Cadmium Orange 104
Cobalt Violet Hue 192
Cadmium Red Light 144
Cadmium Red Deep 148
Carmine 150
Vermillion 163
Permanent Violet 203
Cerulean Blue 223
Cobalt Blue 226
Indigo 230
Prussian Blue 237
Ultramarine Deep 245
Sap Green 285
Viridian 290
Cinnabar Green 294
Burnt Sienna 317
Burnt Umber 321
Raw Sienna 330
Raw Umber 336
Sepia 338
Van Dyck Brown 341
Venetian Red 344
Yellow Ochre 348
Payne's Grey 363
Perm Chinese White 389

DR. Ph. MARTIN'S
Artist's Quality
Gamboge 69
Hansa Yellow Light 83
Hansa Deep Yellow 83
Permanent Yellow 85
Alizarin Crimson 141
Brilliant Cadmium Red 145
Deep Red Rose 168
Permanent Red 171
Cobalt Violet 191
Quinacridone Magenta 194
Cobalt Blue 227
Phthalo Blue 234
Ultramarine 244
Phthalo Green 283
Sap Green 286
Viridian Green 290
Burnt Sienna 319

Burnt Umber 322
Indian Red 325
Sepia 337
Venetian Brown 345
Yellow Ochre 347
Payne's Grey 363
Carbon Black 379
Titanium White 391

PENTEL
Artist's Quality
Lemon Yellow 73
Yellow 88
Orange 108
Vermillion 163
Pink 173
Red 175
Purple 198
Cobalt Blue 227
Prussian Blue 237
Royal Blue 251
Viridian 290
Deep Green 295
Yellow Green 303
Yellow Ochre 348
Brown 351
Chocolate 351
Black 378
White 392

PENTEL
2nd Range
Lemon Yellow 73
Vermillion 163
Red 175
Cobalt Blue 227
Prussian Blue 237
Viridian 290
Yellow Green 303
Yellow Ochre 348
Brown 351
Black 378
White 392

Our overall aim

Earlier artists had many difficulties to overcome. Reliable pigments were in short supply and invariably expensive.

Information on technique was often kept secret, either by the individual painter or the local Guild.

Common knowledge on the nature of colour and light was inaccurate and misleading.

Yet, despite all this, they produced much wonderful work.

The main advantage that these early painters had over us today is that they had a thorough and very lengthy training, many serving apprenticeships of 15-16 years.

Over the years the trainee would become familiar with the materials and techniques of the Master.

Those who eventually became Masters in their own right also understood their craft and practised it diligently.

The 'secrets' of the Old Masters are largely known to us. Yet despite this wealth of information on technique and the superb materials at our disposal, we produce work which is often of a temporary nature.

The average five year old painting is in a worse condition than most that are five hundred years old. We have inherited a rich collection of paintings, yet will pass on few of our own.

Despite our advanced knowledge and the inspiration of the Impressionists, most users of colour have little understanding of this most powerful element.

I believe that our limitations as far as sound technique and an understanding of colour are concerned has come about because for most of the past century we have been moving away from the craft of painting. Art for Arts' sake has been the cry and we are now paying the price.

The 'School of Colour' was formed to encourage a return to the true craft of painting and an understanding of colour.

By helping to bring art and science together again and incorporating knowledge from the past it should be possible to put right the muddle of centuries.

If the artist can select materials with confidence, mix colours accurately and apply the colour with meaning, creativity will be released and not stifled.

The first coming together of art and science led to the Renaissance, the second to the Impressionist era.

With the information and materials at our disposal a third coming together should produce some truly amazing work.

I believe that information is the essential back up required for inspiration.

We see our work as helping to provide such information.

Home Study Colour Courses

Tackle any subject in the sure knowledge that you fully understand all aspects of colour mixing, colour theory, colour harmony and colour contrast and can depict light and shade with confidence. Your work will improve dramatically as you gain access to more (easily followed) information on colour than even the Impressionists had!

Most artists use colour in their work, yet few have any real understanding or control over what has, up to now, been a very complex subject. Over the past number of years we have been refining our courses to make them fully integrated. This work is now complete and we will be issuing the courses on a regular basis, in the following order:

Practical Colour Mixing - Advanced Colour Mixing - Colour Theory
Colour Harmony - Mixing by Glazing - Depicting Light and Shade
Paints and Pigments - Colour Planning - Optical Mixing.

Although the first of these courses are available, it will take some time to issue all of them. If you would like further information please contact us, details on opposite page.